TREASURED
from the Renaissance to the Enlightenment
POSSESSIONS

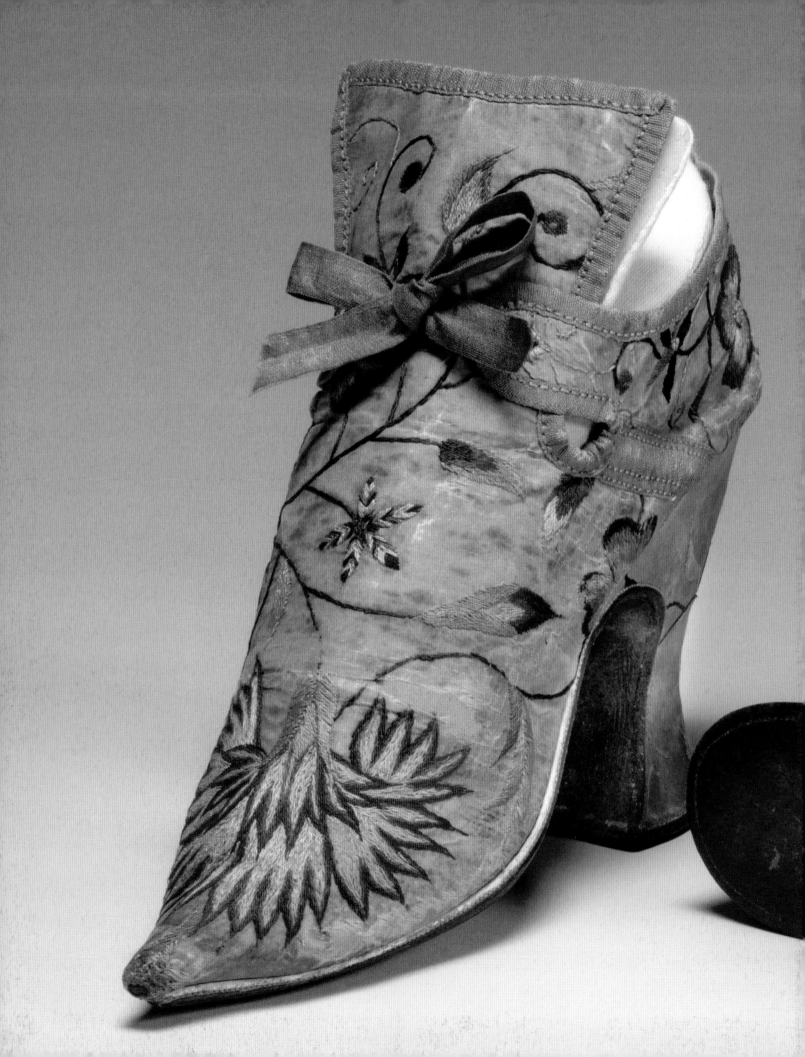

TREASURED
from the Renaissance to the Enlightenment
POSSESSIONS

Edited by

Victoria Avery Melissa Calaresu Mary Laven

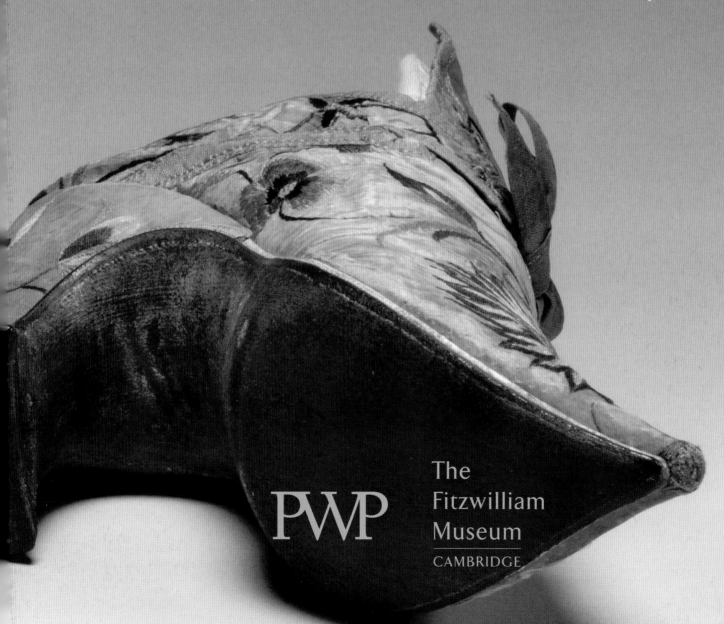

PWP

The
Fitzwilliam
Museum
CAMBRIDGE

For Julia Poole
with affection, admiration
and grateful thanks

First published in 2015
by Philip Wilson Publishers
an imprint of I.B.Tauris & Co Ltd
www.ibtauris.com

Distributed worldwide by I.B.Tauris & Co Ltd
Registered office: 6 Salem Road, London W2 4BU

ISBN Hardback: 978 1 78130 033 6
ISBN Softcover: 978 1 78130 037 4

A full CIP record for this book is available from the British Library
A full CIP record is available from the Library of Congress
Library of Congress Catalog Card Number: available

Designed by E&P Design
Printed and bound in China by 1010 Printing

The Fitzwilliam Museum gratefully acknowledges the support of the Monument Trust

CONTENTS

ACKNOWLEDGEMENTS

It is a pleasure to thank all those individuals and institutions that have generously assisted with this research project, which has culminated in this book and the accompanying exhibition, *Treasured Possessions from the Renaissance to the Enlightenment* (Fitzwilliam Museum, Cambridge: 24 March–6 September 2015).

We would like to thank the University of Cambridge for a Humanities Research Grant and the History Faculty for further funding which enabled us to employ current doctoral and post-doctoral History students on the project. We are also extremely grateful to the following donors, whose generous financial support has permitted many objects to be conserved, loans to be included, the exhibition to be mounted and publicized, and for this book to be produced: Peter Frankopan and Jessica Sainsbury (The Staples Trust), Gordon Morrison (Chaldean Charitable Trust), Sir Douglas Myers, the Aurelius Charitable Trust, the Barbara Whatmore Charitable Trust, the Drapers' Charitable Fund, the Stuart Heath Charitable Settlement and Sworders Fine Art Auctioneers. Heartfelt thanks are due to Penny Brittain, Edward Dolman, Peter Frankopan, Margaret Mair, Neil McKendrick and Felicity Pugh, who formed our wonderful fundraising committee, as well as to Sue Rhodes, Development Officer at the Museum, who oversaw the fundraising campaign.

We are indebted to all the lending institutions for their support (listed in full under 'Lenders', p. 275), and would like to single out the following individuals within these institutions for promoting our cause: Andreas Pampoulides at Coll & Cortes, Michael Wood and Yao Liang of Gonville and Caius College, Jane Hughes of Magdalene College, Imogen Gunn at the Museum of Archaeology and Anthropology, David McKitterick of Trinity College, Josh Nall and Claire Wallace at the Whipple Museum, and Wendy Monkhouse and Iain Stewart at Wimpole Hall. We are also most grateful to Poppy Singer and Annabel Wylie for so expertly conserving many of the textiles, and to Jenny Rose and her team at the Hamilton Kerr Institute for returning several canvases to their original splendour.

We would also like to acknowledge the academic input and expertise of many friends and colleagues: Trisha M. Biers, Amy Blakeway, Craig Cessford, Ivan Day, Rebecca Earle, John Edgeler, Heidi Egginton, Hazel Forsyth, Albert Garcia Espuche, Christopher Hartop, Joy Jarrett, Mark Kilfoyle, José Ramón Marcaida, Alexander Marr, Andrew Morrall, Tessa Murdoch, William O'Reilly, Kate Peters, Giorgio Riello, Jason Scott-Warren, Emma Spary, Tom Stammers, Jenny Tiramani, Chris Wingfield and Heike Zech.

In addition to the Director, Tim Knox, and the Assistant Directors, Lucilla Burn (Collections), Kate Carreno (Central Services) and Rupert Featherstone (Conservation), many other colleagues at the Fitzwilliam Museum need thanking for their unstinting support, invaluable expertise and extraordinary patience, above all Michael Jones (Head of Photography) and his wonderful team (Amy Jugg, Andrew Norman, Jaymes Sinclair and Katie Young) for the spectacular new images reproduced in this book, Lynda Clark (Image Library Manager), Helen Strudwick and Mella Shaw (respectively, former and current Exhibition Officers) for overseeing the show in close conjunction with David Packer (Senior Registrar) and David Evans (Exhibitions Technician), Rachel Sinfield (Head of Education), Lucy Theobold and Tracy Harding (Press and Marketing), Shaun Osborne (ICT Manager), Georgina Doji (Computer Associate) and Ayshea Carter (in-house designer). We would also like to thank our colleagues in the Curatorial Division: Elenor Ling (Research Assistant, Prints), Jane Munro (Keeper, Paintings, Drawings and Prints), Stella Panayotova (Keeper, Manuscripts and Printed Books) and Adrian Popescu (Keeper, Coins and Medals).

The staff, associates and volunteers of the Applied Arts Department deserve particular thanks for incredible and sustained help over the past three years: Penny Bendall (ceramics conservation), Margaret Clarke, Andrew Maloney and Nik Zolman (respectively, Senior Technician, Technician and Senior Chief Technician/Collections Manager), Jo Dillon (Senior Conservator of Objects), Trevor Emmett (combined FORS and Raman spectroscopy examination of gemstones), Jane Ewart (silver), Carol Humphrey (Honorary Keeper of Textiles), Brian Jackson (watches), James Lin (Senior Assistant Keeper), Anna Lloyd-Griffiths (Secretary to Keepers) and Kay Smith (Armoury Refurbishment Consultant). At the History Faculty we are especially grateful for the encouragement and practical support that we have received from David Reynolds and Joanne Pearson.

This book could not have been produced without the expert help and incredible dedication of Rebecca Norris (*Treasured Possessions* Project Assistant), Emma Jones (general editing, bibliography and index) and Clare Cambridge (additional proof-reading) – all of whom went far beyond the call of duty. We are also grateful to the staff at Philip Wilson publishers, above all Anne Jackson (Commissioning Editor), David Hawkins (Production Editor) and Sarah Steele (Copyeditor), as well as Ian Parfitt (Designer).

Without the unconditional love and unstinting support of our partners and families, this project would never have reached completion, so we gratefully thank Emma Jones, Joan-Pau Rubiés and Jason Scott-Warren.

This book is dedicated with affection, admiration and grateful thanks to Julia Poole, former Keeper of the Applied Arts Department, and certainly one of the Museum's most 'treasured possessions'. Her knowledge of the Fitzwilliam's vast collections and the applied arts in general is staggering, and she has been a generous font of knowledge throughout the project, as well as a wise counsellor and an indefatigable helpmeet.

Victoria Avery
Melissa Calaresu
Mary Laven
Editors

FOREWORD

Treasured Possessions began as an unprecedented collaboration between the Applied Arts Department of the Fitzwilliam Museum and staff and students from the History Faculty at Cambridge University. Over a period of three years, undergraduates who opted to do a final-year paper in 'The Material Culture of the Early Modern World' were encouraged to get to know the artefacts on display in the Museum, and – under the close supervision of the Keeper of Applied Arts and her team – were issued with purple latex gloves and invited to handle some of the Museum's treasures. It was a process of discovery that neither they nor their tutors would forget; just as the students were given a taste of how curatorial expertise could expand their understanding of the past, so the curators were challenged by the interpretative questions posed by historians, as they worked together to shed new light on old objects.

I am delighted that this exciting synergy, ignited in the University's leading museum, has now given birth to a wonderful exhibition, accompanied by a book that includes contributions by distinguished historians, art historians and curators as well as younger scholars producing cutting-edge research in the field. On the eve of the Museum's bicentenary, this is a superb opportunity to put on view some of the finest and most intriguing items (both functional and decorative) from the Fitzwilliam's outstanding Applied Arts collections. It is a particular pleasure to reveal to the public a considerable number of unique and exquisite items from the Museum's reserves, the delicacy of which prevents them from being regularly exhibited. The conservation and cleaning of objects for display is just one area in which we have benefited from the generosity of our sponsors, without whose support this exhibition would not have been possible. Sincere thanks are also due to all the Museum staff and outside experts involved in the exhibition, above all the four curators – Dr Victoria Avery (Keeper, Applied Arts) and Dr Melissa Calaresu, Dr Mary Laven and Professor Ulinka Rublack (all from the University's History Faculty) – the first three of whom are also responsible for masterminding this splendid publication.

Tim Knox
Director, Fitzwilliam Museum

PREFACE

Four dark-haired sisters, close in age, and revealing a strong family resemblance, gaze out from the canvas (see jacket and fig. 256). Their appearance is just as it should be: skin pearly white, cheeks rosy, mouths small and neat, curls carefully drawn back to reveal their pale foreheads. But it is to the sisters' exquisite clothes, perhaps even more than their faces, that our eyes are immediately attracted: the two older girls wear radiant golden gowns of finest silk; their younger sisters are dressed in floral-patterned frocks, embroidered in reds, blues and yellows. With the care of a seamstress, the artist Jan van Meyer paints the tucks, stitching and trimmings that differentiate each dress. From these gorgeous fabrics, our attention turns next to the objects that are laid out on top of a carved stone plinth in front of the girls. The youngest snub-nosed child reaches out and touches a doll, as elegantly dressed as her mistress. In the centre of the plinth, fruit tumbles out from a basket. One of the older girls holds up a bunch of grapes, another a bouquet of flowers. On the right-hand side, hanging over the edge of the plinth is a costly Turkish rug, upon which a lapdog sits. The scene is framed by an elegant architectural setting with hints of a quintessentially English landscape in the background.

The portrait serves to record not only the four beloved daughters of Sir Matthew Decker – a Dutch merchant who had settled in England in 1702, became a Director of the East India Company and an MP, and was created a baronet in 1716, two years before this painting was commissioned – but also the material world that they inhabited. The clothes, furnishings and luxuries on display testify at once to the extraordinary success of the merchant and to the moral and social rectitude of the family. The unblemished grapes allude to the virginity of the daughters; the dog symbolizes their good breeding. The possessions of the Deckers provide a gauge to their character and worth. At the same time, the objects in the painting subtly condition our perception of Decker's daughters, who are as doll-like as their doll, as fragrant as their flowers and as wholesome as their fruit.

It is a truism of modern life that we express our identities through our purchases and our possessions. In the developed world, our lives are a continual series of shopping trips, and most of what we buy is inessential. Many of our acquisitions end up on the scrapheap or boxed away in a garage or attic. And yet the development of one's tastes in material things – food and drink, furniture, cars, shoes or perfume – plays a crucial role in the development of one's self. Moreover, even within our own throwaway culture, certain objects assume a status of permanence and irreplaceability, not just because they were expensive or invested with particular sentimental value (your engagement ring, or the trinkets bequeathed to you by your grandparents) but because they have accompanied you through a long and significant period of your life (the jumper with worn elbows, or the chipped mug you used at college).

In writing the book *Treasured Possessions from the Renaissance to the Enlightenment*, and curating the exhibition that accompanies it, our goal has been to reconstruct the significance of objects to their owners before the age of industrial mass production. The period we focus on, from the fifteenth to the eighteenth centuries, witnessed a massive increase in the diversity and availability of commodities. New technologies allowed artisans to tempt their clients with the most delicate crystal glassware, intricate bronzes or colourful maiolica. Shoemakers and tailors endlessly innovated to ensure that their customers would feel compelled to replenish their wardrobes. Exotic goods imported from the Far East boosted the repertoire of designs that might be emulated, while the domestication of tea, coffee, chocolate and sugar in Europe led to the creation of a whole new material apparatus surrounding the consumption of hot drinks. These changes pre-dated the Industrial Revolution and the advent of the department store. Acquisition took skill and effort, and was often the result of complex negotiations between maker and shopper. Although increased productivity led to declining prices, this was no disposable culture – as we can see from the survival of broken, repaired and recycled items.

Treasured Possessions juxtaposes iconic artefacts – a ravishing example of Venetian metalwork or a prized piece of Meissen porcelain – with quirky objects that are sometimes passed over because they fail to fit with modern criteria for 'high art': a Delftware birdcage, a child's mourning ring, a pilgrimage souvenir or a pair of yellow embroidered shoes. We evoke the world of skilled artisans, traders and shoppers who brought such objects into being, and draw attention to the forms of sociability and display that gave them meaning and flavour. Our focus is on the things that surrounded and attended upon the body, and which allow us to imagine the intense sensory experiences that this new world of goods made possible. We show how particular domestic spaces and situations – the dining-table, the sideboard, the study – became intricate stage-sets to which our ancestors brought endless reserves of colour and creativity. The things in one's life were not just bought and sold, but were also made in the home, or were customized to give them personal significance as their owners passed through different stages of the life cycle. Tiny objects could bear a great emotional freight. The world of commerce responded to this paradox of scale by creating innumerable small but beautiful artefacts that posed the great questions of life, death and salvation in portable accessories that could be opened, closed, touched and pondered. For a thing to be of value it needed to be prismatic: to perform a multiplicity of functions as it mingled pleasures with duties, morality with the assertion of style and status.

As historians and curators, we have attempted to contextualize the objects on display in order to explain their past significance. But we hope that we have not depersonalized them. The challenge for us is to imagine what these treasured possessions meant for their generations of owners, to guess at the secrets that they keep.

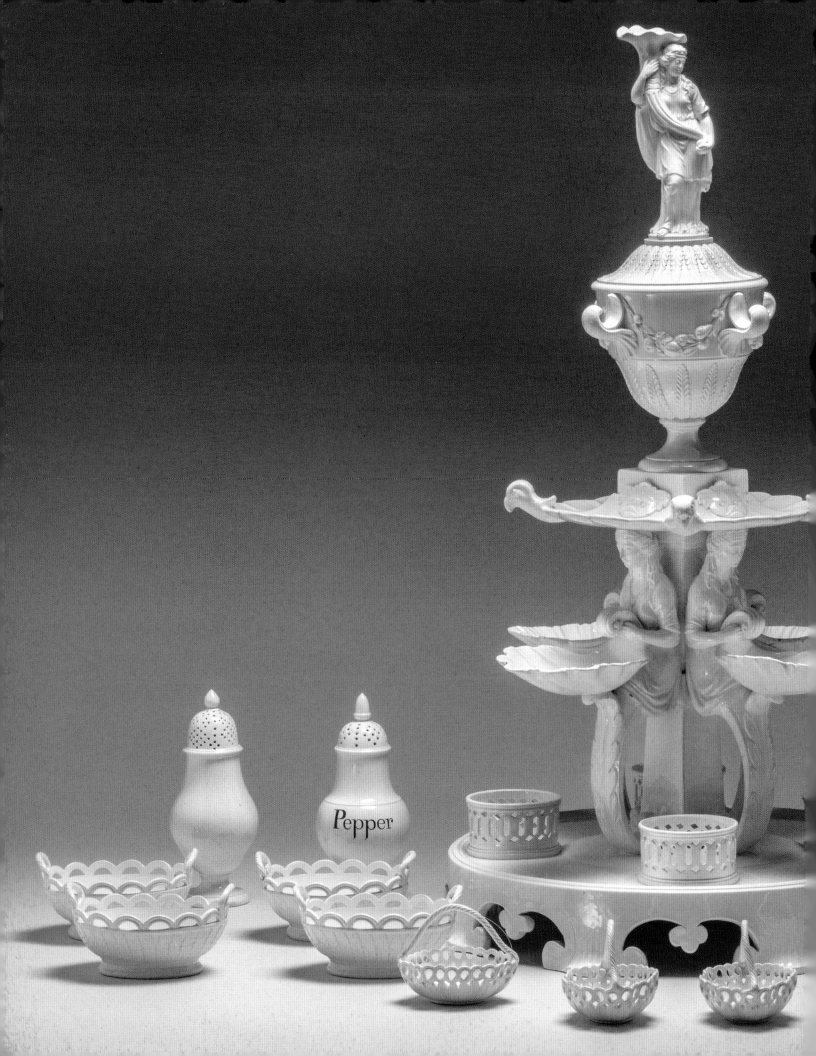

TREASURED
POSSESSIONS

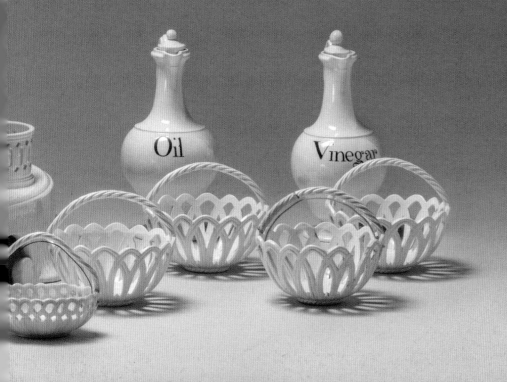

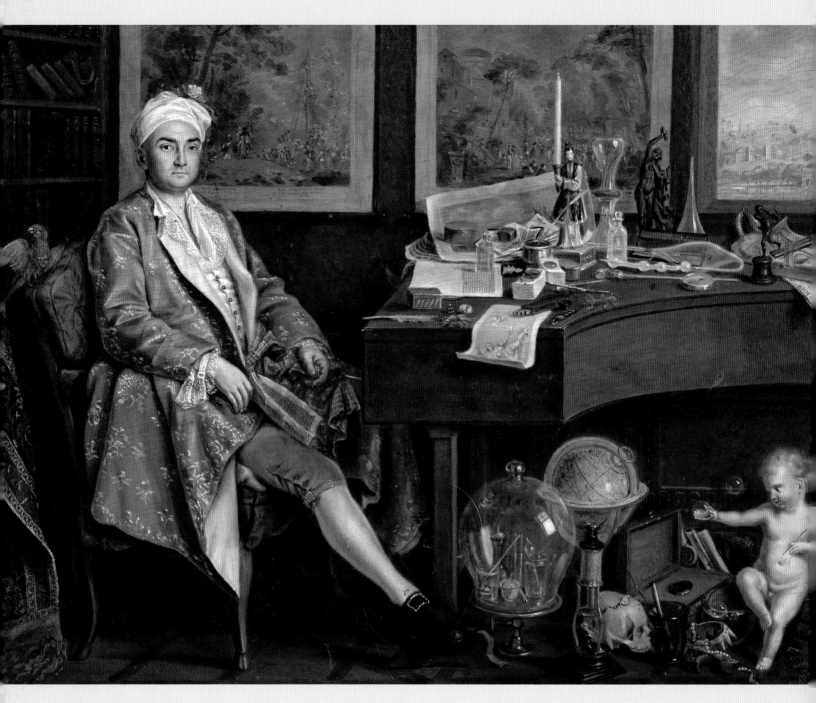

FIG. 1 | CAT. 173

AN ITALIAN COLLECTOR IN HIS STUDY

Venceslao Verlin, Italian | 1768

THE MEANING OF THINGS IN THE EARLY MODERN WORLD

Peter Burke

In the 1970s, a social psychologist named Mihaly Csikszentmihalyi conducted interviews with 315 men, women and children in the Chicago area, asking such questions as 'If you had a fire in your home, what objects would you save?'[1] It is this fundamental concern with the value or significance of things, whether as outward-facing status symbols or more intimate, cherished objects, that has for some time preoccupied sociologists, psychologists and anthropologists and that has more recently come to intrigue historians.

In order to introduce an exhibition of objects that date from different centuries, originated in different places and served different purposes, it may be illuminating to consider the variety of meanings attributed to these objects in the course of their long careers.[2] This exhibition comes at a good moment, the moment of the discovery of material culture by historians, who have come to see the importance of things as clues to a whole culture, including the culture of early modern Europe, from the Renaissance (considered from this point of view by Lisa Jardine and Evelyn Welch) to the Enlightenment (studied by John Brewer and Daniel Roche).[3] Directly or indirectly, these studies are inspired by what is sometimes described as 'thing theory', the work of sociologists and anthropologists, among them Jean Baudrillard, Mary Douglas, Pierre Bourdieu and Arjun Appadurai.[4]

More exactly, this discovery, driven by the awareness of the importance of consumption in our own time, is a rediscovery. Archaeologists have been trying to reconstruct cultures from their material remains since the beginning of their discipline in the early nineteenth century. Folklorists in Scandinavia and elsewhere were collecting traditional objects from the late nineteenth century onwards and still publish on the subject.[5] Curators in the many museums founded in Europe in the nineteenth and twentieth centuries have been writing about things as well as looking after them and displaying them. Wilhelm von Bode, for example, Director of the Kaiser Friedrich Museum in Berlin, wrote on table bronzes, carpets and ceramics as well as on Botticelli and Elsheimer.[6]

Sociologists and anthropologists have also examined things as clues to the cultures that produced them. Pioneers include Thorstein Veblen, whose *Theory of the Leisure Class* (1899) studied items of what he called 'conspicuous consumption' as symbols of social status, and Franz Boas, who took his interest in material culture with him when he moved from being a museum curator to teaching anthropology at Columbia University (1896).[7]

However, even the nineteenth-century discovery of things by professional academics and curators was a rediscovery. In the sixteenth and seventeenth centuries, a number of amateurs, who were known as 'antiquaries', both collected old or exotic things for their 'cabinets of curiosities' and wrote about them.[8] Among the seventeenth-century studies of this kind are books by Giulio Negrone and Benoît Baudouin on ancient boots and shoes, Fortunio Liceti on ancient lamps, Johann Kirchmann on rings, Johann Scheffer on ships and Thomas Bartholin on bracelets.[9]

Historians of early modern Europe concerned with the meanings of things for people living at that time are unfortunately unable, much as they would like to do so, to follow the example of Csikszentmihalyi, in asking direct questions, or that of the anthropologists who observe while sharing the lives of the people they study. They cannot even make use of the findings of these colleagues because the world of things has changed so much since the year 1800. Since the Industrial Revolution, for instance, the number of objects per household has increased to a vertiginous extent. The contrast between the emptiness of a fifteenth-century Florentine palace and the cluttered house of a middle-class Victorian family, for example, is a dramatic one.[10] Things have also become less durable, partly because they are expected to be less durable, and to be thrown away after a few years, rather than passed down the generations.

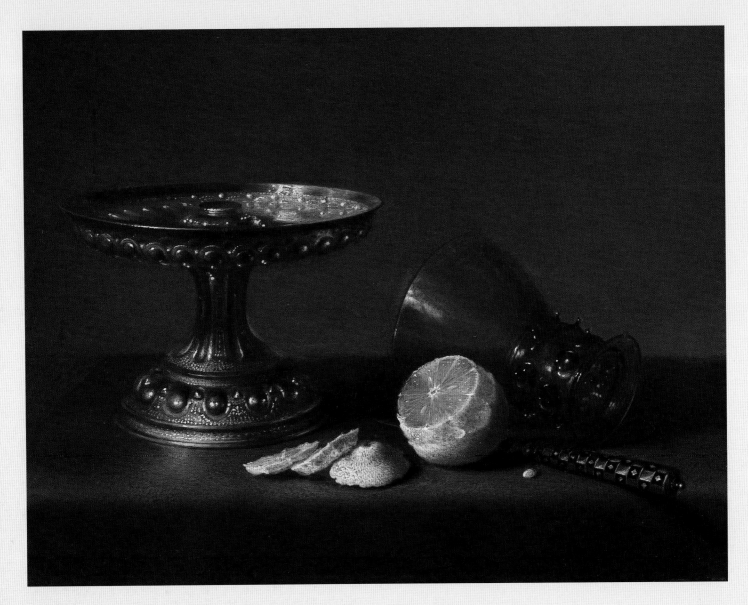

FIG. 2 | CAT. 201

STILL LIFE WITH GLASS,
LEMON AND A KNIFE

Pieter Claesz, Haarlem | 1630

What early modern historians can do is to try to fit together different kinds of evidence. In the first place, the evidence of things themselves, including signs of wear (such as a pair of repaired Elizabethan leather shoes: fig. 125) and also inscriptions – proverbs, quotations from the Bible, poems or songs, like the early sixteenth-century maiolica lustreware dish from Deruta quoting a verse of Petrarch's, or the 1729 Vauxhall stoneware hunting mug with the first verse of John Dyer's song 'Down among the Dead Men' (fig. 89).[11] Then there are documents such as inventories and wills and literary texts such as poems, plays and romances. There are also images, paintings or engravings representing different kinds of object. The inventories tell us about the uses of different things and their place in the home. Wills, letters, memoirs and other literary texts often refer to attachment to particular things by their owners (or attachment to people through things). Pictures of interiors show which things were associated in the same room (see, for example, fig. 202). On the other hand, the evidence of still-life paintings needs to be treated with care since this increasingly popular genre of the period (especially in the seventeenth-century Netherlands) has its own agenda, notably to reveal the folly of attachment to things by showing clocks, hourglasses and skulls, as well as overturned and empty glasses, as symbols of the transience and the 'vanity' of human life (fig. 2).[12]

From these varied sources a rough typology of meanings emerges, with variations according to the uses of things for everyday or for special occasions and for different kinds of people – male or female, old or young, rich or poor, urban or rural, living in different parts of Europe and in different centuries. Although Wittgenstein famously defined meaning as use, in what follows I should like to extend the idea to include the associations evoked by things in the minds of their owners and other viewers. It may be useful to distinguish six main kinds of meaning for things in early modern Europe. They were items of display, devotional objects, gifts, souvenirs, symbols of identity and finally collectibles.

In the first place, display, which has had the lion's share of sociological attention from Veblen to Bourdieu, though anthropologists such as Mary Douglas place less emphasis on it, while Csikszentmihalyi regrets that 'this one dimension has so overshadowed the rest'.[13] All the same, there can be little doubt that objects were often used in early modern times to impress visitors with the wealth, status, taste or education of their owners and thus to distinguish them from their rivals. Bourdieu's key term, 'distinction', was already used by the seventeenth-century Florentine patrician Jacopo Soldani, who referred in one of his satires to 'the distinction from others that a rich man claims today' ('*la distinzione/Che 'l ricco sopra gli altri oggi pretende*').[14] Again, the Neapolitan lawyer Francesco d'Andrea, writing to his nephews in the 1690s, referred to the 'desire to outdo others' ('*appetito di soprafar gli altri*') and 'the obligation to live with splendour' ('*l'obbligazione di viver con fasto*').[15]

In other words, things might be status symbols, not only in a narrow sense of the term 'status' but including a good education and good taste. Busts of Roman emperors, for instance, ancient statues or *all'antica* bronze statuettes, medals and domestic artefacts might suggest to guests that their host was interested in what we call the 'Renaissance', the movement to revive the culture of classical antiquity (see, for example, figs 24, 177, 178 and 180).[16] The sixteenth-century Lombard nobleman Sabba da Castiglione advised his readers to decorate their house with classical statues or, if these were not available, with works by Donatello or Michelangelo.[17] Although the term 'fashion', more exactly *la mode*, emerged only in the seventeenth century, it seems appropriate to speak of the interest in Ancient Greek or Roman objects or of objects imitating them as a fashion, or even, perhaps, as 'Renaissance chic'.

In the second place, devotion. For most of us today, the number of religious objects to be found in early modern European homes, especially but not exclusively in Catholic regions, is one sign that 'the past is a foreign country'. Even the poor owned some of these things, while the houses of the better-off were filled with religious paintings and statues, often small in size (see, for example, fig. 275). From the late Middle Ages, these aids to private devotion in the homes of the laity multiplied. In a treatise on the family, a fifteenth-century Italian friar recommended parents to display sacred images in the house for their effect on the behaviour of the children. The friar would clearly have agreed with Csikszentmihalyi that 'interaction with objects promotes socialization'.[18] Images of the Virgin Mary or the Crucifixion were coming to be used more and more frequently as aids to meditation, prompting a shift in style and composition 'from icon to narrative'.[19] It is, of course, necessary to ask who bought these images and used them in this way. A study of objects in seventeenth-century Rome, based mainly on inventories, concludes that 'the paintings women owned in large part depicted devotional images', while 'men preferred profane subjects'.[20] In Protestant cultures there was less scope for devotional objects, but quotations from the Bible, on the façades of dwellings and on household objects, were not uncommon, like the Staffordshire slipware dish inscribed – somewhat mysteriously, so far as posterity is concerned – 'Remember Lot's Wife, Luke: 17:32, 1726, SM',[21] or the roughly contemporary Dutch Delftware oval wall-plaque showing Christ in a boat rowed by

a female oarswoman, with the biblical verse from Philippians 3:14, 'I press toward the mark for the prize of the high calling of God in Christ Jesus' and the explanatory phrase: 'The soul steadily rowing against the stream of sin' (fig. 273).

In the third place, gifts. Gift-giving was an important practice in the social life of early modern people and took many forms. Gifts were exchanges not only between equals such as relatives, friends and neighbours, but also between superiors and inferiors, moving in both directions, since powerful patrons, like women, needed to be courted. Favourite gifts included rings and gloves (common 'courtship objects'), books and ancient coins, especially for scholars, and food, from the chickens that peasants might give to their doctor or lawyer in lieu of a fee to the more noble birds and animals (pheasants or venison, for example) exchanged by the upper classes. New Year, rather than Christmas, was a favourite occasion for gift exchange, for example the jewels that courtiers gave Elizabeth I.[22] Gifts were often given to celebrate births and christenings, such as the eighteenth-century ivory silk christening robe with detachable sleeves (fig. 3), the linen infant's cap embroidered with the words 'sweet babe' in hollie point (fig. 251), the dog-shaped money-box recording the birth of Ann Wittin on 14 October 1717 (fig. 255) and the pearlware tea caddy commemorating the birth of Elizabeth Taylor on 18 March 1795 (fig. 5). Engagements and weddings were also occasions when gifts were exchanged, such as the simple silver heart-shaped brooch, inscribed on the reverse (and close to the wearer's heart): 'My hart and I untill I dy' (fig. 4).

As the brooch's inscription reveals, one reason for giving was for the giver to be remembered. In the fourth place, things were valued as souvenirs or mementos, known in early modern English as 'remembrances'.[23] The word 'souvenir' will be employed in what follows to refer to any object intended by the maker, donor or owner to evoke certain memories. Some of these souvenirs were heirlooms: family portraits, jewels or weapons that were inherited and so reminded the owner of his or her father or mother or grandparents, such as the portrait of *The Daughters of Sir Matthew Decker*, which was inherited by Richard, 7th Viscount Fitzwilliam (fig. 256), or the plaster head incorporating the death mask of John Howard (1726–90), which was sent all the way from Cherson in Russia to his 'kinsman and executor' Samuel Whitbread, who, in turn, bequeathed it to his son of the same name, who then gave it to George Garrard, who presented it to the Fitzwilliam Museum in 1822 (fig. 252).

Mourning rings were made and worn in memory of particular persons, for example the ring containing the hair of the six-month-old Catharine Harris, who died on 29 April 1793 (fig. 264) or the ring made for a child to wear and remember the 61-year-old Frances Greene, possibly a relative or benefactor, who had died on 27 July 1767 (fig. 268). Wills made frequent reference to objects bequeathed to family and friends so that they would remember the donor with affection, including tables, cauldrons, gowns and mattresses, a reminder of the long life of the kinds of object that later generations might throw away every decade. These wills also illustrate 'affection for objects'.[24]

Other souvenirs were gifts made to newlyweds, for instance, in memory of an occasion, like the so-called 'friendship jugs' (*'pichets d'amitié'*) from mid-nineteenth-century Normandy, inscribed with the names of the couple and the word 'souvenir'.[25] Yet other souvenirs had an individual meaning: religious objects brought back from a pilgrimage to Jerusalem, Santiago de Compostela or Loreto (see the pilgrim bowl: fig. 284), for instance; trophies, such as weapons taken from the enemy in battle; or objects brought back from the Grand Tour that many young noblemen, from England to Poland, undertook at this time as part of their education. In the eighteenth century, portraits of these 'Grand Tourists' by Pompeo Batoni, who worked in Rome, show them with some of their prized possessions, some of which may still be seen in English country houses.[26] Other objects commemorated events such as the launching of a ship ('Success to the John and Mary', 1756).[27] Marriages in particular were commemorated in this way. The marriage chests or *cassoni* of the Italian Renaissance were useful objects but they were also mementos of marriage, like plates (fig. 258) or paired portraits of man and wife inscribed with the date of the event.[28] A similar event may lie in the background of a Staffordshire posset-pot of 1697, inscribed 'the best is not too good for you', together with the initials IB and WS.[29]

The cult of friendship was also expressed by material objects such as portraits of friends together, images of communal drinking and dining (see, for example, figs 79 and 93) or the *album amicorum* in which friends wrote their names, poems and sentiments.[30] A more unusual object with a similar purpose is an English mug, dated 1748, inscribed 'Prosperous and Happy May They Be/Who Give Ben Brown Their Company'.[31]

What might be called 'institutional souvenirs' should not be forgotten. For example, Cambridge colleges are full of silver, much of it dating from the seventeenth and eighteenth centuries, given or bequeathed to them by former students and fellows. The donors gave these objects remembering their time in the college, and the college remembered and indeed still remembers them by naming

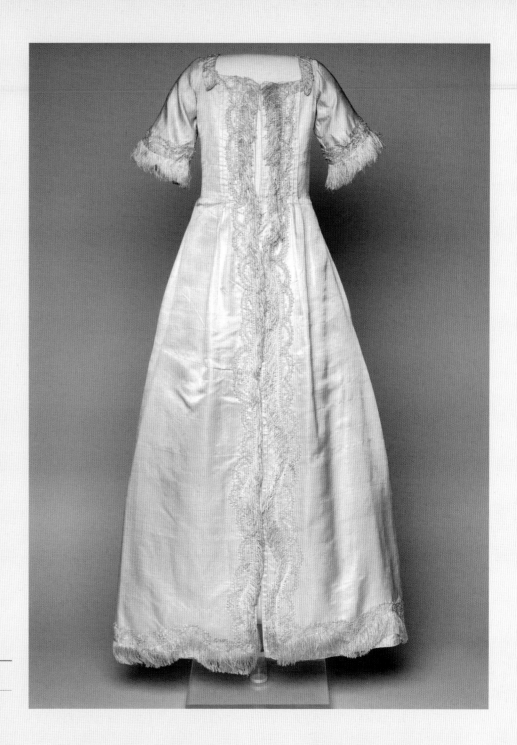

FIG. 3 | CAT. 228

CHRISTENING ROBE

English | 1750–80

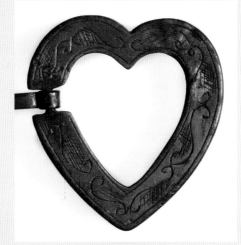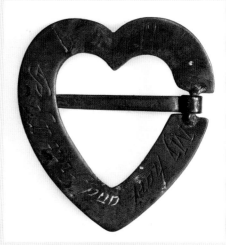

FIG. 4 | CAT. 236

HEART-SHAPED BROOCH

English or Scottish | 17th century

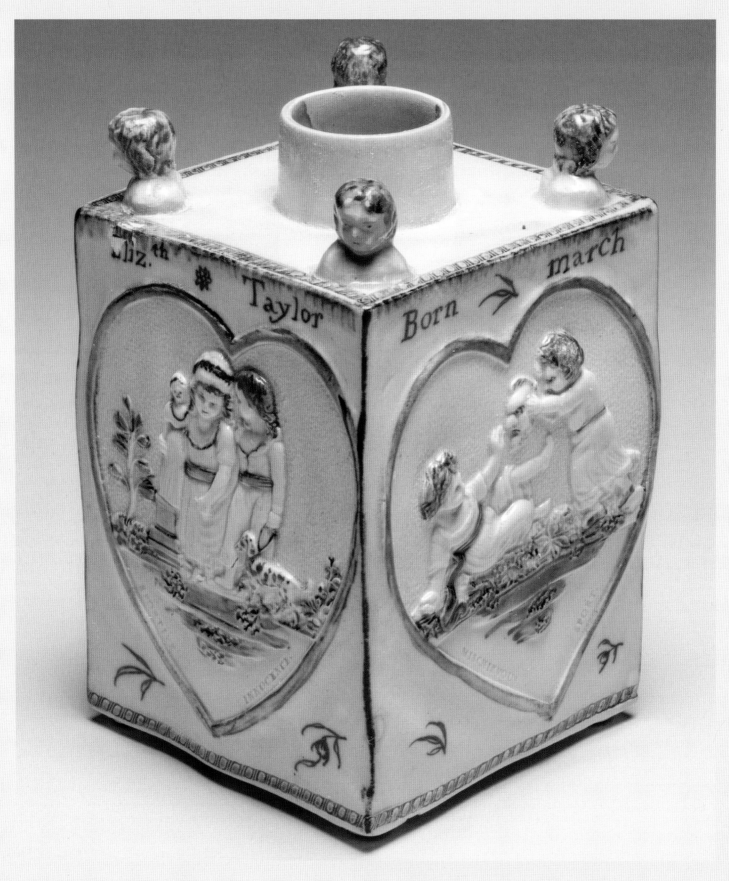

FIG. 5 | CAT. 233

TEA CADDY

English, probably Bovey Heathfield Pottery,
Bovey Tracey, Devon | 1795

the objects 'The Founder's Cup', 'Dr Brown's candlestick' and so on. In any case, the name of the donor and the date of the donation are often inscribed on the things themselves, as is the case with 'Ralph Lord Hopton's Little Kitchin of Silver Plate' that Ralph, 1st Lord Hopton (c.1596–1652) bequeathed to his chaplain, Richard Watson, and which Watson, in turn, bequeathed in 1684 to his college, Gonville and Caius, where it has remained ever since (fig. 61).

In the fifth place, things had particular meanings for individuals, indeed they helped individuals to construct their identities. The critique of the theory of things as status symbols has emphasized the varieties of meaning that similar objects may have for different individuals, along the lines of the famous argument advanced by Michel de Certeau, in a study of France in the 1970s, to the effect that consumers are not passive but active, giving their own meanings even to mass-produced objects by selecting and arranging them, so much so that consumption may be regarded as a form of production.[32] In similar fashion, Csikszentmihalyi described things as a 'means of individual differentiation', while Mary Douglas noted that novelists such as Henry James were sensitive to the point that a room full of objects reveals 'the occupant's life and personality' as well as his or her place in society.[33]

In early modern times, individualized things included objects that carried the name or the initials of the owner, or, in the case of the nobility, a coat-of-arms, and of course portraits. Portraits not only represented the sitter, they illustrated the sitter's self-presentation (aided, of course, by the artist). Individuals were often represented together with objects that were presumably dear to them and acted as so many props to their identity.[34] Just as kings were painted together with their crowns and sceptres or bishops with their mitres, soldiers had their arms and armour, generals their batons, scholars their own books, physicians their copy of Hippocrates or Galen, lawyers the Codex of Justinian, notaries their quills, inkpots and parchment rolls (fig. 176), lovers the poems of Petrarch and other individuals their favourite books, including Montesquieu's *Esprit des Lois* or the works of Shakespeare or Rousseau. Lady Anne Clifford had herself painted with no fewer than 41 books, representing her credentials as a learned lady.

Representations of individual identity have received a good deal of attention, from Jacob Burckhardt's famous discussion of Renaissance individualism to Stephen Greenblatt's account of Renaissance self-fashioning.[35] However, signs of collective identity were at least equally important in the early modern period. Portraits of individuals, which may appear to us as symbols of individualism, were often intended to be displayed in groups, whether of family members or holders of a particular office, such as mayor, over the generations. Other portraits, such as the mass-produced images of Martin Luther or Queen Elizabeth I, were signs of allegiance to a form of religion or a ruler. At times, images of rulers represented political choices or loyal allegiances, like the pro-Stuart snuffboxes – one with a small worn oval image of Charles II datable to the late seventeenth century, the other with silver plaques of Charles I and his grand-daughter Queen Anne of shortly after 1707 (see figs 159 and 94 respectively) – as well as Mary Culliford's patriotic stoneware hunting mug dated 1729 with the paired busts of George II and Queen Caroline and beefeaters (fig. 89) and Lady Mary Hervey's soft-paste porcelain Capodimonte scent bottle of the mid-1750s with her arms and motto on one side and a portrait of Bonnie Prince Charlie on the other (fig. 158). Other kinds of object, with collective owners such as guilds, fraternities, colleges, clubs and regiments, symbolized the group and might be used in rituals that affirmed the solidarity of that group, like the silver 'standing cups' or glass ceremonial goblets that were passed round the table at a feast (see, for example, fig. 81).

In the sixth and final place come things as collectibles, in a period that saw the rise of collections of old, exotic or beautiful objects, housed in galleries, 'cabinets of curiosities' or *Wunderkammern*.[36] Collecting was another prop to identity, witness a number of portraits of collectors holding their beloved objects (coins, statues, shells) or surrounded by them (fig. 1). Collections were also a form of display, winning respect for their owners. All the same, collectibles offer the clearest examples of objects (whether a part of nature or made by human hands) that were valued primarily for their own sake rather than for their associations: collected because they were old, because they were beautiful, because they were rare, because they came from faraway places such as Japan or Africa, or because they were made of some precious or unusual material (figs 9 and 10). These things were decontextualized, taken from their original settings and recontextualized as collectors' items.

From the sixteenth century onwards, treatises were published advising collectors on what to collect (how to detect fakes, for instance) and how to classify, organize or 'methodize' their collections. Early examples include Enea Vico's *Discorsi sopra le medaglie* (1558) and Samuel Quiccheberg's *Inscriptiones* (1568). By the eighteenth century, the figure of the collector, especially the collector of antiquities, was so well known as to be the target of satires and comedies, including Carlo Goldoni's *La Famiglia dell'Antiquario* (1749). Count Anselmo, the collector, is presented as uninterested in the outside world and obsessed with what his wife calls 'the usual medal madness' ('*la solita pazzia delle medaglie*'), his ambition being to own a complete series of the coins and medals of the Roman emperors. It was at

exactly this time that John Evelyn's grandson, William Draper II, was having a pair of luxury medal cabinets made by English craftsmen, each personalized with his coat-of-arms (figs 293–294).

From the end of the eighteenth century, these private collections (to which select visitors might be admitted) were supplemented by public ones, which were at least nominally open to everyone. The epoch of museums, among them the Fitzwilliam, had arrived. A great variety of things now became accessible to many more people – visually accessible, at least, while glass cases now protected most objects from touch.

This movement of 'museumification' provoked debate right from the start. On one side, supporters of the museum movement emphasized not only the accessibility of interesting things but their conservation and their display in an environment that enabled them to be seen much more easily than (say) in a dark church. On the other side, critics of museums lamented the fact that the objects had been torn from their original environment and had lost their original meanings. In 1796, for instance, in a letter to General Miranda, and again in 1815, the French scholar Quatremère de Quincy denounced the looting of Italian works of art by Napoleon, Lord Elgin and others on the grounds that this uprooting or *déplacement* deprived the objects of their cultural value. Quatremère's point was that the associations, meaning and power of an artefact depended on its uses and its location. To displace it was to destroy it. The appropriate setting for Italian artefacts was Italy itself, which he described as a kind of museum without walls, '*le museum intégral*'.[37]

The power of museums should not be underestimated. 'Museums teach us what to see when we look at art.'[38] They support both the aesthetic gaze and the historical gaze. However, when we look with curiosity or admiration at what have become 'museum pieces', we should not forget the variety of the meanings that these things once had, both for their original and their later owners.

1. Csikszentmihalyi 1981.
2. On the idea of the 'career' of an object, see Kopytoff 1986.
3. Jardine 1996; Welch 2005; Brewer and Porter 1993; and Roche 1997 respectively.
4. Baudrillard 1968; Douglas and Isherwood 1978; Bourdieu 1979; and Appadurai 1986. See also Brown 2004.
5. Stoklund 2003.
6. Bode 1908 and 1911.
7. Veblen 1899; and Jacknis 1985 on Boas. The ideas of Veblen were popularized by the journalist Vance Packard. See Packard 1960.
8. Impey and MacGregor 1985.
9. Nigronus 1667; Balduinus 1647; Licetus 1621; Kirchmann 1657; Scheffer 1643; and Bartholin 1647 respectively.
10. On the paucity of objects in early modern times, see Stoianovich 1970–1 and Goldthwaite 1980.
11. For the Deruta dish, see Fitzwilliam Museum: C.24-1932.
12. Koozin 1990.
13. Douglas and Isherwood 1978, p. 4, criticizing Veblen for a 'crude' emphasis on 'competitive display'; Csikszentmihalyi 1981, p. 29. See also Plotz 2005.
14. Soldani 1751, p. 189.
15. D'Andrea 1923, pp. 168, 208.
16. Burke 1998, p. 187.
17. Da Castiglione 1554, no.109.
18. Dominici 1860; Csikszentmihalyi 1981, p. 50.
19. Ringbom 1965.
20. Ago 2013, p. 144.

21. Fitzwilliam Museum: C.201-1928. The same episode may be recorded on the English Delftware posset-pot dated 1685: see here fig. 207.
22. Cunnally 1994; Davis 2000; Scott-Warren 2001.
23. Orlin 2010, pp. 301–3.
24. Ago 2013, p. 58.
25. These objects may be seen at the Musée de Normandie, Caen, together with a cooking-pot dated 1700, a wedding present inscribed once again with the names of the couple.
26. For example, Batoni's portrait of the 7th Earl of Northampton, dated 1758: Fitzwilliam Museum: PD.4-1950.
27. Fitzwilliam Museum: C.1723-1928.
28. Baskins 1998; Musacchio 2008.
29. Fitzwilliam Museum: C.248-1928. See also fig. 189, for a similarly inscribed posset-pot.
30. Burke 1999.
31. Fitzwilliam Museum: C.1204-1928.
32. De Certeau 1980.
33. Douglas and Isherwood 1978, pp. 5–6; Csikszentmihalyi 1981, p. 33. See also Miller 2008.
34. Burke 1987.
35. Burckhardt 1878, chapter 2; Greenblatt 1980.
36. There is an extensive secondary literature on this topic, much of it recent, including the *Journal of the History of Collections*. See also Impey and MacGregor 1985; Pomian 1990; Elsner and Cardinal 1994.
37. Maleuvre 1999.
38. Sheehan 2000, p. xi.

FIG. 6 | CAT. 245

MOURNING PENDANT

English | 1790

Within this rose gold fluted pendant, the material memory of a loved and lost child has been preserved for posterity. Underneath the protective glass cover, locks of the child's brassy tresses have been delicately woven into a basket-weave pattern. Mourning jewellery, a tradition that became common in seventeenth-century Europe, reached new heights of popularity in the eighteenth century, especially in England. Previously, such jewellery might contain a lock of hair, but it was not until the eighteenth century that these strands were intricately woven into aesthetically pleasing designs.

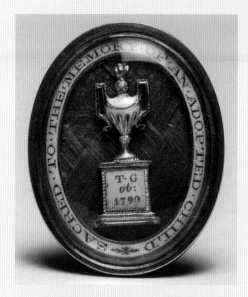

Atop the hair, an enamelled white neoclassical urn, adorned with gilt accents, has been placed to represent death and loss, but also preservation. The urn is supported on a gilded pedestal with a white plaque inscribed 'T.G / ob: / 1790' recording the child's initials and date of death. Around the edge of the pendant, the words 'SACRED TO THE MEMORY OF AN ADOPTED CHILD' ensure that this adopted orphan would be remembered for ever. Since the inscription states that the object is 'sacred', the hair within becomes a treasured relic, and the pendant, a reliquary. Suspended on a chain and hanging near the heart, the pendant's face would have been almost invisible, requiring the wearer to actively show it off in order to convey the loss and legacy of the child.

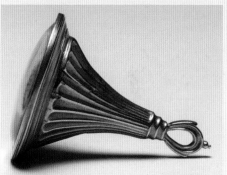

The accessory's unusual shape recalls that of a contemporary signet pendant used to seal private letters and personal documents. However, rather than having an intaglio design on its surface (to create an imprint in molten wax), this pendant's face is made of clear glass. Instead of using the object to make a permanent impression, the imprint has already been permanently made on the wearer by the person whose hair it contained, sealed for eternity behind the glass. KT

See: Holm 2004; Llewellyn 1991; Pointon 1999b; Pointon 2009c.

ONE

A NEW WORLD
OF GOODS

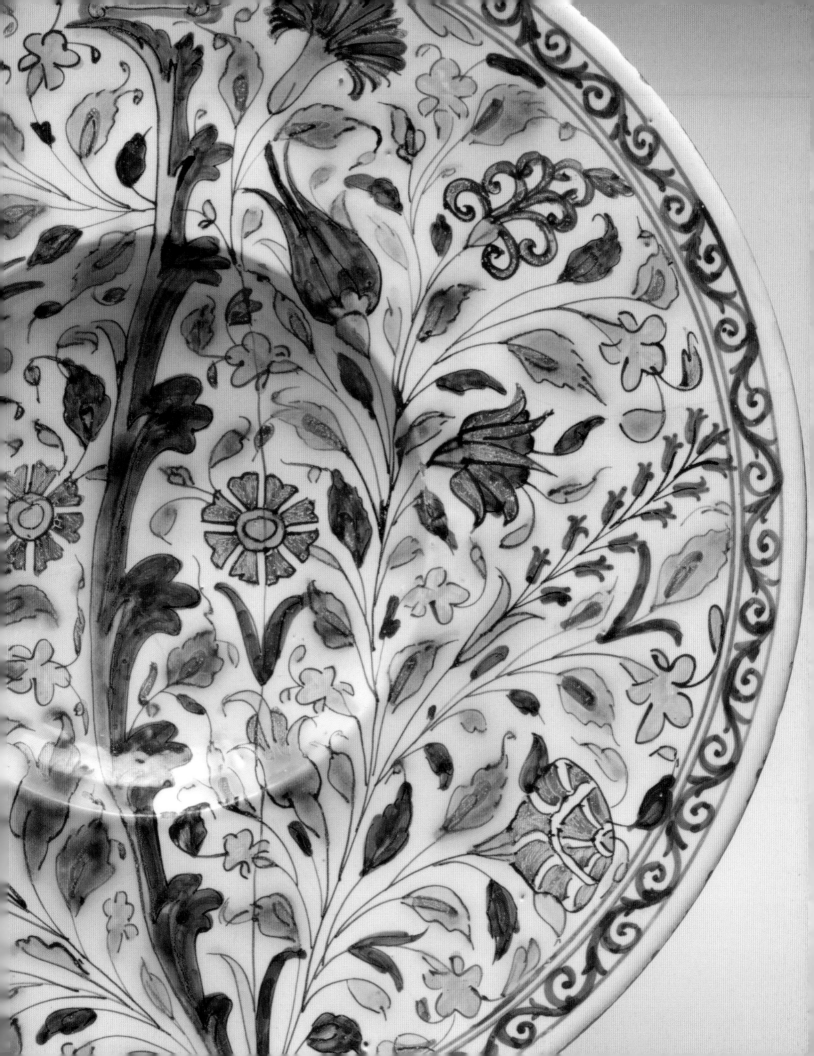

INTRODUCTION

Waffle iron, pronged fork, chestnut roaster, candle snuffer, urine pot, pair of bellows, spice-box, board game, footwarmer, cheeseboard, mirror, tape measure, lavender-press, fish-slice, butter dish, vomit bowl: these are just a few of the things that a notary was advised to take into account when settling the affairs of a deceased person, according to a legal manual published in Antwerp in 1582.[1] The sample list of household possessions, which ran on for several pages, and ranged through the categories of kitchen and dining ware, clothing and accessories, jewellery, bed linen and soft furnishings, silver, storage and tools is revealing of the great variety of objects that a prosperous urban dweller might have expected to own by the late sixteenth century. The volume of possessions is immediately striking; so too their specificity, many of these ordinary household objects bearing witness to new expectations of comfort, convenience, taste and pleasure.

This was the new world of goods that Europeans were discovering from the fifteenth to the eighteenth centuries: the age before industrialization and mass production, when non-essential commodities nevertheless became widely available to purchasers across the social spectrum. Economic historians have perceived a 'massive transfer of resources from savings and investment to consumption'.[2] Greater wealth was of course a precondition for the rise in acquisition. In turn, the new shoppers spurred artisans and merchants to innovate in design, decoration and quality. This frenzied circle of supply and demand would affect the very structures of society. As the historian Richard Goldthwaite has observed, 'At the time of Dante, Florence had a population organised around the wool industry with its large component of unskilled labour; two centuries later, it had a richly textured society of artisans famous for the variety and quality of their skills.'[3]

Renaissance Florence was famed for its home-grown artisanal culture, which nurtured furniture-makers, leather-workers and embroiderers as well as painters and goldsmiths. However, the new world of goods was also profoundly shaped by the availability of high-quality foreign commodities. Merchants of course imported goods from other regions, countries and continents. But artisans also moved around the globe. In 1571, the Venetian glass-blower Jacopo Verzelini arrived in London and joined the glasshouse of Jean Carré at the Hall of the Crutched Friars. The following year, after Carré's death, he took charge of the glasshouse and in 1574 Elizabeth I granted him exclusive rights for 21 years to produce 'Venetian' glass in England (fig. 68).[4] Venetian *cristallo* or crystal glass was the height of fashion in Elizabethan London. Rhenish salt-glazed stoneware drinking vessels, imported in vast numbers, could be transformed into luxury objects by the addition of elaborately decorated silver-gilt mounts. The value accorded to a brown salt-glazed stoneware flagon from Germany is suggested by the very elaborate mount added by an English silversmith (fig. 83).[5] To innovation and importation may be added imitation: another feature of the expanding world of goods. Non-Christian lands provided European craftsmen with an infinite repository of designs to emulate, often leading to the creation of hybrid objects and new fashions, as in this Venetian Saracenic-style dish (fig. 7). The objects included in this book may not always please the modern eye, but they testify to an astonishing period of experimentation. MRL

See: Charleston 1984; Englander et al. 1990; Gaimster 1997a; Glanville 1990; Goldthwaite 1993; Hale 1993; Howell 2010; Jardine 1996.

1. Englander et al. 1990, pp. 133–7.
2. Goldthwaite 1993, p. 12.
3. Ibid., p. 25.
4. On Jacopo Verzelini, see Charleston 1984, pp. 53–61.
5. Gaimster 1997a, pp. 78–98, 196–7, no. 34, and 212, no. 49, pl. 9; Glanville 1990, pp. 420–9, nos. 37–48.

FIG. 7 | CAT. 11

BASIN DISH

Italian, probably Venetian
first half 16th century

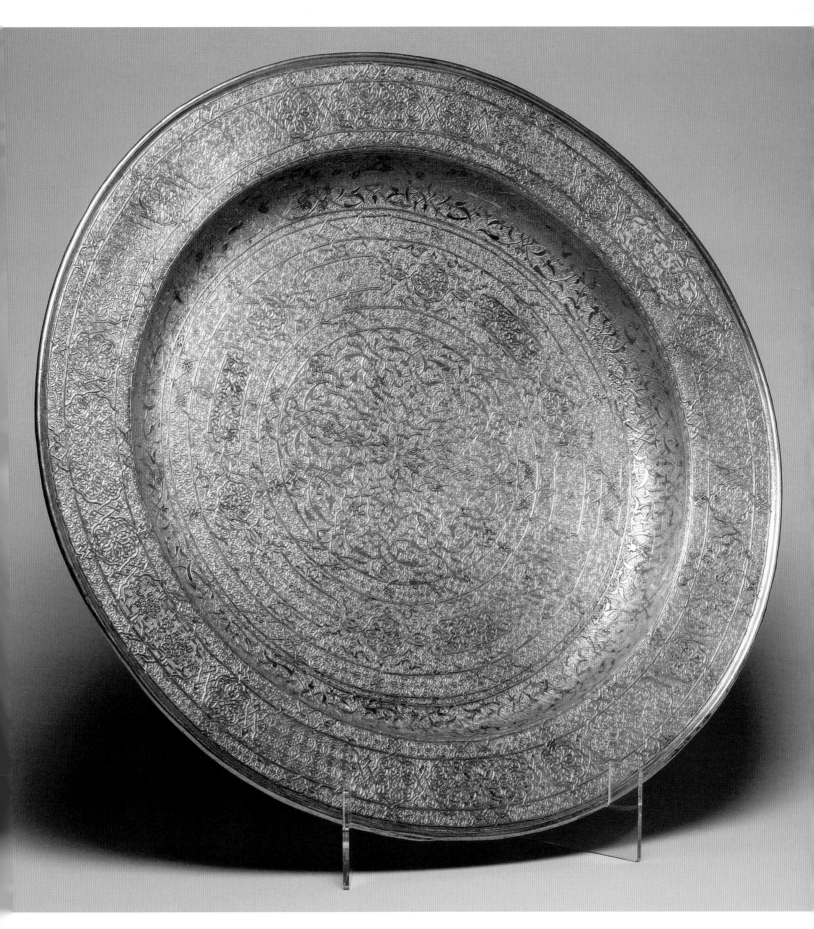

THE GLOBAL MARKETPLACE

A luminous depiction of *The Feast of the Gods* – painted by the Venetian artist Giovanni Bellini in 1514 with subsequent additions by Dosso Dossi and Titian – includes three figures ostentatiously carrying blue and white Ming porcelain dishes.[1] The painting appealed to Italian connoisseurs who were just beginning to acquire such dining ware, usually sourced via the Middle East. By the end of the sixteenth century, European merchants were importing large quantities of Ming porcelain, although the costs of transportation and frequency of breakages kept prices high. The prevalence of Chinese items with metal mounts attests to a meeting of cultural styles, but may also disguise chips (fig. 73).[2]

Alongside Chinese porcelain, *naturalia* – such as mounted shells (fig. 10) or coconuts (fig. 9) – are emblematic of the craze for exotica. The demand for foreign goods, however, was not just the fad of elite collectors. It was deeply embedded, above all because of Europe's dependence on East Asian spices: camphor, cinnamon, nutmeg, ginger, mace, cardamom, pepper and cloves, which were used in medicinal recipes as well as to flavour meats. From the end of the fifteenth century, new sea routes would enable European merchants to travel the world and to bring back not just spices but also new materials, designs and techniques, especially in ceramics and textiles. Reports written by missionaries across the globe fuelled enthusiasm for the exotic. New knowledge profoundly affected the material culture of Europe.

Trade created many startlingly beautiful objects. Alongside the Fitzwilliam's celebrated collection of Iznik pottery (fig. 11), we find a north Italian dish painted to resemble one from Iznik in Anatolia (fig. 8), and, moving beyond Europe altogether, an arresting piece of porcelain embellished with verses from the Qur'an. This was made in China for export to Muslim customers, probably in India (fig. 13). MRL

See: Cook 2007; Jackson and Jaffer 2004; Jardine and Brotton 2000.

1. Jackson and Jaffer 2004, pp. 49–50.
2. Ibid., p. 51.

FIG. 8 | CAT. 10

LARGE DISH

Italian, probably the Veneto, either Padua or Manardi factory, Bassano | 17th century

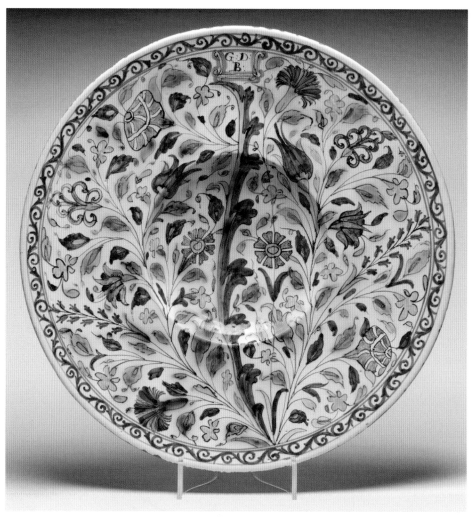

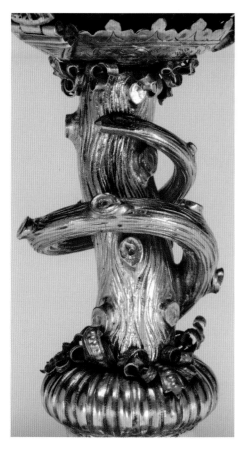

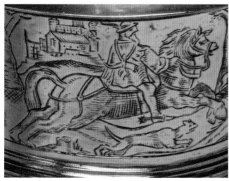

FIG. 9 │ CAT. 4

COCONUT CUP AND COVER

Probably German │ *c.*1560–1600

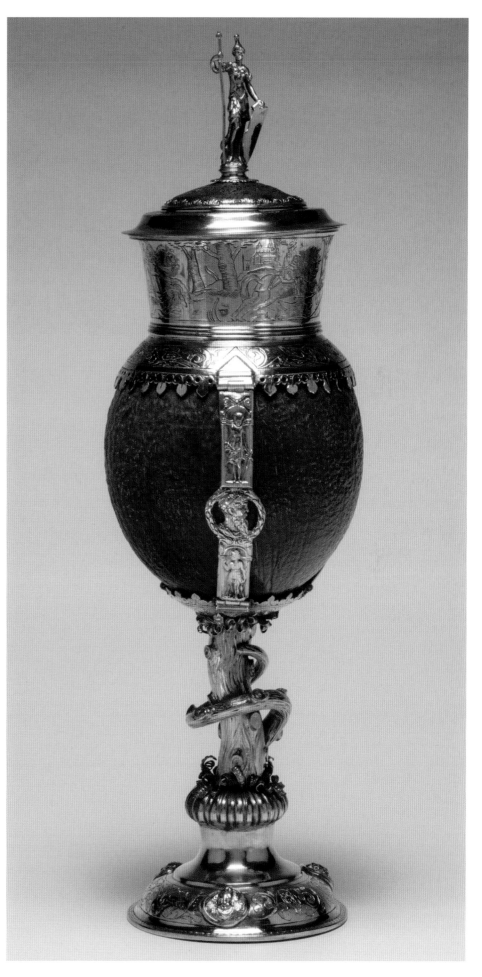

FIG. 10 | CAT. 3

NAUTILUS SHELL CUP

China and London | *c*.1580–6

Numerous trade routes enabled the passage of nautilus shells from the tropical seas around South-east Asia to Europe in the early modern period. A growing appetite for exotica had made it fashionable to mount these shells in elaborate and expensive fittings in the form of a cup. This is a rare example of a shell engraved in China with Chinese scenes mounted in silver-gilt in London in 1585/6.[1] The shell and mount are curiously combined, with little attempt to marry the iconographies. The emphasis is rather on the striking lobster and Neptune riding a dolphin. The intricate play between *naturalia* and *artificialia* is typically Mannerist.[2] This object is testament not only to the circulation of materials, but also of skills and knowledge. Given the similarity of the mount to the work of Antwerp goldsmiths, it is likely to have been made in London by an as yet unidentified European master, possibly from Antwerp.[3] SI

See: Hayward 1976; Tait 1991; Woldbye 1984.

1. Woldbye 1984, p. 157. See also other Chinese examples in Tait 1991, pp. 81 and 83.
2. Hayward 1976, pp. 305–6.
3. Tait 1991, p. 86.

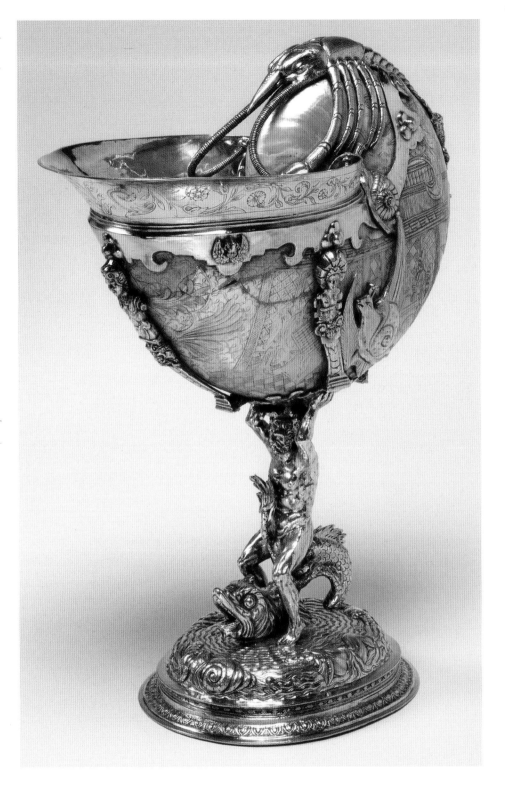

FIG. 11 | CAT. 7

LIDDED JUG OR FLAGON

Iznik and London | *c.*1580–93

This fritware jug with 'sealing-wax' red hyacinths and blue pomegranates was made in Iznik (Ottoman Anatolia) and exported to Elizabethan London where, in 1592/3, it was fitted with fashionable edge-protecting silver-gilt mounts. Ewer shaped, it was actually meant for consuming ale or beer: as a French visitor remarked in 1558, the English drank beer 'not out of glasses but from earthen pots with silver handles and covers & this even in houses of persons of middling fortune'.[1] Iznik ware examples such as this were expensive luxury items used only by the upper classes. The less affluent had to make do with German stoneware imports (fig. 83) or English earthenware ones. The handle-mount has been pricked with the letters 'E T', almost certainly the initials of Elizabeth Tollemache, Countess of Dysart (1626–98). She may have inherited the jug from her father, William Murray (c.1600–55) along with the family home, Ham House, where it remained a treasured possession until 1948. vja

See: Atasoy et al. 1989; Carswell 1998; Scrase et al. 2005, p. 140; Yenişehirlioğlu 2004.

1. Quotation taken from the V&A online catalogue entry for a similar Iznik ewer with English silver mounts (acc. no. 1561–1904) at http://collections.vam.ac.uk.

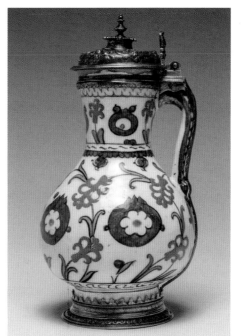
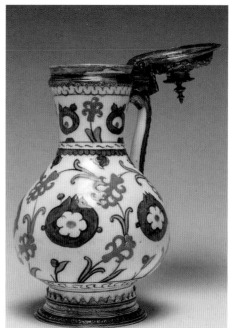
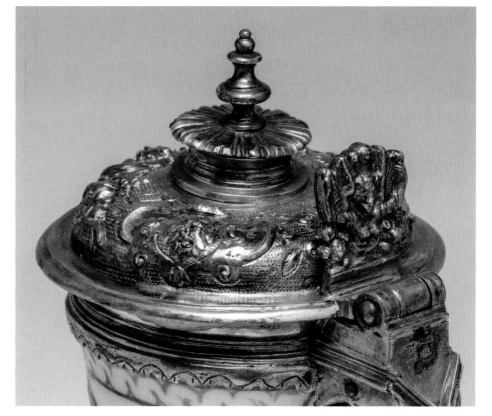

FIG. 12 | CAT. 1

STANDING CUP AND COVER

Franz Fischer, Nuremberg | early 17th century

Traditionally (if incorrectly) described as 'pine-apple cups', these silver or silver-gilt standing cups with ovoid bodies and inter-locking covers embossed with imbricated lobes are, in fact, supposed to represent a bunch of grapes, and hence the German name: *Traubenpokale* or 'grape cups'.[1] Many include wine-related imagery, such as stems with vines and grape-holding or axe-wielding vintners (as seen here) or stems formed as Bacchus, Roman god of wine.[2] Invented in Southern Germany in the late fifteenth century, they became characteristic products of Nuremberg silversmiths in the late sixteenth and early seventeenth centuries, made to a standard formula but in different sizes. They were also popular in England: an example in the V&A bears London hallmarks for 1608/9, indicating that it was either imported from Germany and marked on arrival, or made by a London-based German silversmith.[3]

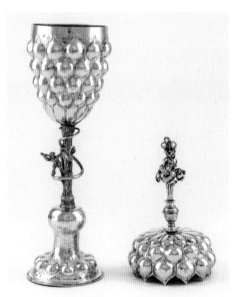

Given the costly materials, skill and time required in their manufacture, *Traubenpokale* were expensive luxury items. The largest (intended primarily for display) were commissioned by wealthy corporations and individuals and either given away as diplomatic gifts or presentation cups, or retained as 'welcome cups' for wine, offered on arrival to important guests. Smaller examples were bought by the middle classes for personal use. The present example has the marks of Nuremberg and the silversmith Franz Fischer or Vischer (active 1600–53). The inscription 'HERMEN FISSING[E]R ANNO 1618' engraved on the underside of the foot presumably records the name of its original owner and the year of acquisition. Whether purchased or presented, it was clearly a prized possession. Having entered the Fissinger family treasury, it was kept as a cherished heirloom, which explains why it was not melted down – the fate of so much early modern German domestic silver. VJA

See: Hayward 1976; Hernmarck 1977; Honour 1971; Pechstein et al. 1985; Tebbe 2007, pp. 179–82.

1. In 1610, Nuremberg City Council purchased several silver cups including some '*in Form eines Weintraubens*': British Museum online catalogue for WB.103 at www.britishmuseum.org.
2. V&A: M.370&A-1910 (vine and axe-man). British Museum: WB.103; and Walters Art Museum, Baltimore: 57.1870 (Bacchus).
3. V&A: Gilbert.533:1, 2-2008.

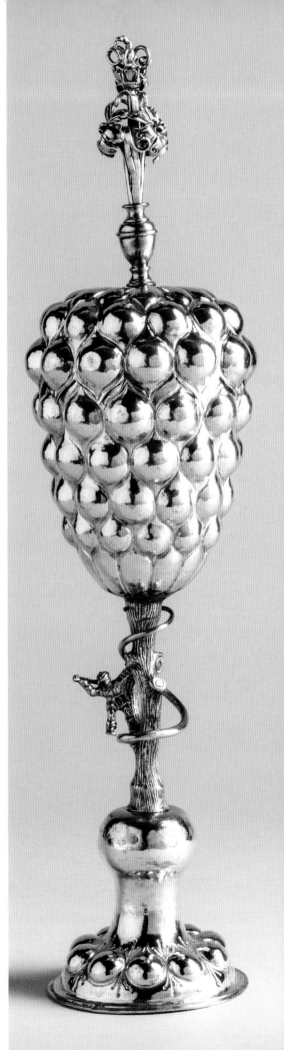

FIG. 13 | CAT. 8

SAUCER DISH

Zhangzhou | late 16th century

Decorated with Arabic inscriptions from
the Qur'an and Islamic Creed in overglaze
turquoise-blue and black enamels, this saucer
dish belongs to a type of provincial Chinese
export porcelain known as Zhangzhou ware or
swatow ware. Less refined than the porcelains
produced at Jingdezhen (for which, see fig. 73),
it was mass-produced in independent kilns to
the south of Zhangzhou (modern-day Pinghe
county, Fujian province) from the late sixteenth
to mid-seventeenth centuries, and exported to
Japan, South-east Asia (Indonesia, Philippines,
Malaysia and Brunei) and, in much smaller
quantities, to Europe.

Since dishes of this type are commonly found
in Indonesia – where they were used for serving
food at traditional feasts and kept as treasured
heirlooms – and their design may be based on
the Indonesian royal Nine-fold seal, it has been
suggested that they were ordered by the sultans
of Aceh (north-west Sumatra).[1] Whilst this may
be true for most, the present dish includes an
inscription that states it was made for Fantad
Khan, servant of Akbar Kahn, third Mughal
Emperor (1556–1605), which indicates an
Indian connection. VJA

See: Adhyatman 1999; Jörg 1999; Welsh 2006.

1. Jörg 1999, p. 75; Adhyatman 1999, pp. 33–4.

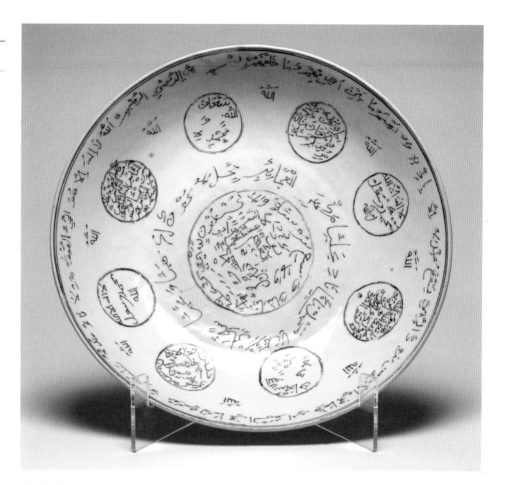

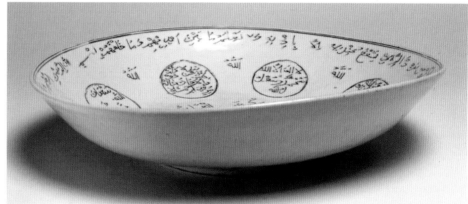

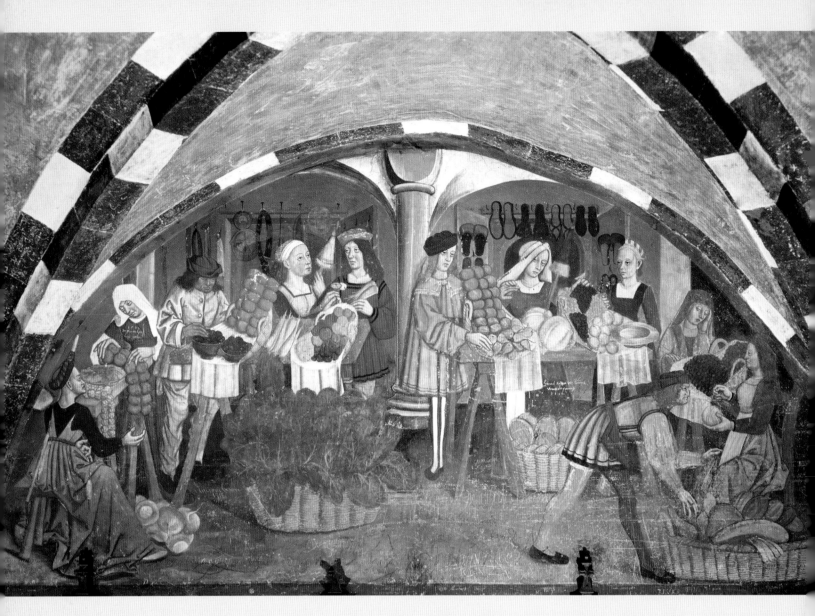

FIG. 14

FRUIT AND VEGETABLE MARKET

Italian, Castello di Issogne, Val d'Aosta
Fresco, late 15th/early 16th century

SHOPPING IN THE RENAISSANCE

Evelyn Welch

The portico of the Castle of Issogne in Val d'Aosta, northern Italy, contains a series of colourful late fifteenth- to early sixteenth-century painted lunettes depicting shopping activities that range from buying beer in a tavern, to clothing from a tailor. The images are as much about morality and governance as they are about purchasing. For example, in the fresco depicting an open marketplace, the male shoppers' attempts to touch the female sellers as well as their fruits and vegetables are thwarted by the young women who push their hands away (fig. 14); in another, showing a well-stocked apothecary's shop, the security provided by the even row of carefully labelled pots, the weights and measures, and the literacy and accountancy skills of the pharmacist make it possible for a well-dressed aristocratic woman to shop alone in safety (fig. 19).

The images are remarkably detailed. The apothecary stands behind a wooden counter, where boxes of pills and sweets are on offer, while sponges, wax candles and votive images hang down on display. The shelves to the rear are dominated by ceramic and straw jugs and flasks. These convenient, water-tight containers were an essential element in providing visual security for shoppers (figs 15–18 and 20). An expensive investment, they offered assurance that the apothecary was well off and able to provide high-quality, freshly acquired ingredients that still had potency.[1] One way to ensure that customers knew the apothecary had cash was to use pots with the latest designs, many of which could be ordered as complete sets. In 1550, for example, when the Genoese merchant Nicola Carlizia commissioned a set of 300 jars from a Castel Durante pottery, he asked for groups, *a trofeo, a quartieri e alla veneziana* (with trophies, in quarters and in the Venetian style).[2] If required, the potter could ensure that the ingredients they were designed to hold were clearly inscribed on the pot itself. For example, we can see that this colourful mid-sixteenth-century *albarello* (fig. 18) was supposed to hold *unguentum cerussa*, a white lead ointment that was widely used both for skin potions and as part of cures for diseases such as dropsy, epilepsy and gout.

The 1504 inventory of the Apothecary at the Lily, the *Speziale al Giglio*, in Florence shows that it had a large sales counter that resembled the almost contemporary image in Issogne.[3] The counter had 55 drawers below and numerous shelves above. These stored pre-prepared compositions of drugs: one held 20 boxes of pills and the other 33 boxes of pills. There were additional cupboards with drawers that held ingredients, recipe books and boxes and vials for dispensing goods. The shop also displayed over 200 *albarelli* jars of different sizes as well as 44 syrup jars, 30 ceramic oil flasks and 58 glass flasks for distilled waters. Pills were held in small boxes while 40 boxes of dried herbs provided stock ingredients. There were also 18 'long boxes', perhaps the same as those sold as packaging when customers bought large quantities of sweets. Finally, there were a large number of coloured glass bottles used to store syrups and other liquid medicaments.[4]

An inventory taken about the same time of another apothecary shop in Florence also listed over 500 *albarelli*, 16 wooden boxes, 32 pill boxes, a 'great cupboard with seventy-four drawers' and numerous other cabinets.[5] The presence of a 'writing desk with a doctor's chair' makes it clear that diagnosis and prescribing took place within the shop.[6] The apothecary's shop encouraged sociability partly because clients often had to wait a long time to be served, and partly because medicines were usually made up according to individual prescription, rather than being ready-made products. Drugs were supposed to be tailored to the individual constitution, which meant considerable discussion between patient, doctor and the apothecary inside or outside the shop. The periods of waiting and consumption meant that these spaces were often equipped with benches and even with chess sets.[7] By the sixteenth century, these shops were associated with formal literary academies such as the famous Florentine academy of the *Umidi*, a trend that was also true in seventeenth-century Venice.[8] More worryingly for the political authorities, the long periods of idleness, and the marked social mix of clientele, where gentlemen waited alongside artisans and serving girls, made these shops potentially subversive sites for political discussion and the exchange of illicit information.[9]

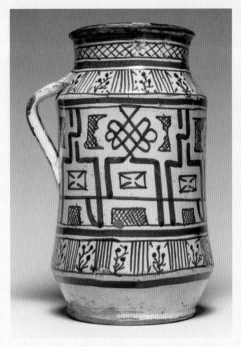

FIG. 15 | CAT. 20

PHARMACY JAR WITH ONE HANDLE

Italian, probably Florence or Siena
*c.*1440–60

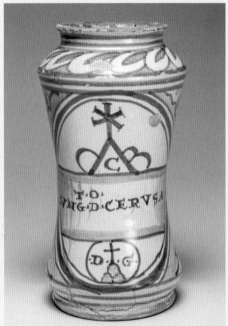

FIG. 16 | CAT. 21

PHARMACY JAR

Italian, probably Pesaro | *c.*1470–90

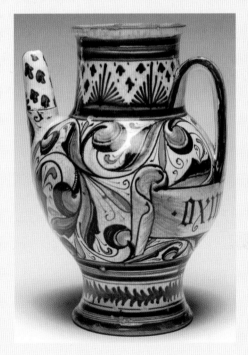

FIG. 17 | CAT. 22

SPOUTED PHARMACY JAR

Italian, probably Pesaro | *c.*1470–1500

FIG. 18 | CAT. 23

PHARMACY JAR

Italian, probably Castel Durante | *c.*1530–60

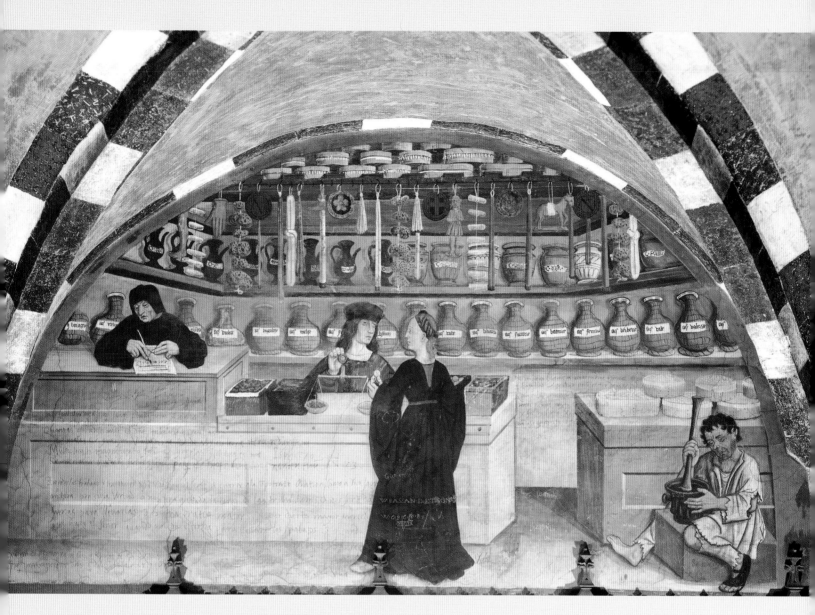

FIG. 19

INTERIOR OF A PHARMACY

Italian, Castello di Issogne, Val d'Aosta
Fresco, late 15th/early 16th century

The two inventories described above give a strong sense of the capital investment that was required to ensure success. In the late sixteenth century, satirical writers such as Tommaso Garzoni mocked the assumption that expensive shop displays guaranteed the quality of their contents. He accused apothecaries of having:

> amongst them frauds and tricks, not only of ridiculous appearance – like those jugs, those jars and boxes with large capital letters, which tell of a thousand unguents or confections or precious aromatics – but they are empty inside, carrying these ridiculous inscriptions outside, as the jars of master Grillo of Conigliano do – but there are also evil acts of sinister souls, making dangerous medications by switching one thing for another, or mixing poor quality stuff, old and rotting in their goblets, and sometimes they are aware of this, and other times it is due to the shameful ignorance with which they buy goods from Levantine barbarians at a cheap price in order to cobble together a shop as best they can [...][10]

While this attack was delivered in 1585, the concept that fine packaging might mask a poor product was a long-standing one, as were broader concerns over fraud and seductive salesmanship. While anxious to ensure that shopkeepers maintained quality products, regulators were even more worried about the mobile sellers that made up a large part of urban and rural marketplaces. Throughout Europe, pedlars, male and female, sold foodstuffs and carried small-scale wares such as knives, mirrors, scissors, buttons, beads, hooks, ribbons, gloves, belts, cloth and clothing (both new and second-hand), as well as books, printed playing cards and pamphlets.[11] The wide variety of goods sold on the street and at the door in both urban and rural environments was celebrated and criticized in equal measure, with numerous sixteenth- and seventeenth-century images pinning down these most transient of vendors.[12] For example, an English print which played on a long tradition of a sleeping pedlar robbed by apes (fig. 21) carried the inscription:

> And as hee slept the Apes gott to his pack
> They make fine work among his toyes & glasses
> They wonder at the sight of every knack
> Which he had theare to please the co[u]ntry lasses.[13]

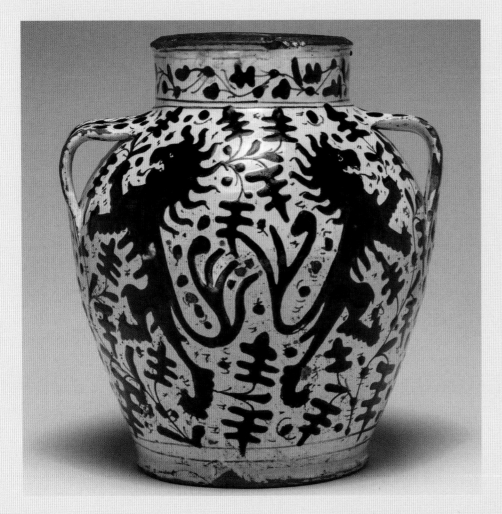

FIG. 20 | CAT. 24

TWO-HANDLED PHARMACY JAR

Italian, Florence or surroundings | *c.*1420–50

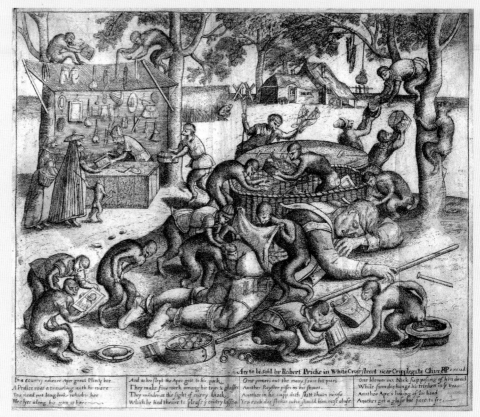

FIG. 21

PEDLAR ROBBED BY APES

After Pieter van der Borcht
etching | 1660–80

Again, behind the amusement of the imagery lay more serious concerns. The travelling pedlar had access to 'country lasses' who might have little knowledge either of the quality of the goods on offer or their price. In the late sixteenth century, the Milanese mercers' guild attacked pedlars who went about the streets 'with boxes in order to sell headbands, snoods, ribbons, cloth and other such things'.[14] They were particularly concerned about such vendors' access to women:

> How easy it is to deceive women, everyone knows. Because they are vagabonds and do not have a fixed shop in the city [...] they commit frauds and then they cannot be found to be punished and moreover as they have the occasion to enter into anyone's house, under the guise of selling ribbons and caps, they commit evil deeds.[15]

Likewise, the 1597 English Act against rogues, vagabonds and sturdy beggars outlawed 'all juglers, tynkers, peddlers and petty chapmen'.[16] Pedlars, particularly Jewish pedlars, were similarly regulated and stereotyped as dangerous and seductive.[17] The association of pedlars with jugglers is not surprising: the origins of Italian theatre were closely linked to the performances of mountebanks and charlatans selling medicines by drawing crowds through their antics.[18] Just as roving groups of actors were often invited to perform within palaces, so too the songs of pedlars found their way into more conventional compositions. At the same time as cities were busy regulating mobile vendors, images of the same figures were being circulated as prints while their cries were transformed into poetry and song.[19] For example, the sixteenth-century French composers Claude de Sermisy and Clément Janequin produced settings for 'Voulez ouyr les cris de Paris?', while Richard Dering's *Country Cries* and *Cries of London* (1599) and Orlando Gibbons' *The Cryes of London* (1614) shifted traditional English calls to buy oysters or have their knives sharpened into evocative polyphonic versions that could be sung by professional choirs.[20]

When printmakers copied foreign versions of city street cries, they were careful to adapt them to their own local conditions. Thus while German and English versions of street vendors included women, their Italian variations did not (fig. 35). Although all the prints described 'trifling goods' for sale, such as tennis racquets and children's toys, they often concentrated on the foods that were on offer locally: oysters, pasta, garlic and onions in Rome; strawberries, mussels, hot pies in London. A sixteenth-century traveller, such as the Englishman Fynes Moryson, was alert to the variety of the many markets and fairs that he encountered in Northern and Southern Europe as he travelled through Ireland, Scotland, Germany and on into Italy, Turkey and Greece. From his perspective, Dutch marketplaces were dominated by female buyers and sellers, while in Italy and Turkey it was rare to see women in public at all. In the late sixteenth century, one Venetian ambassador to England

noted with surprise how, unlike in his own home, 'the Englishwomen have great freedom to go out of the house without men-folk [...] many of these women serve in the shops'.[21] In contrast English observers were shocked by the fact that Venetian aristocratic men bought their own groceries in the Rialto marketplace. Moryson noted how in Venice, 'only the men, and the masters of the family, go into the market and buy the victuals, for servants are never sent to that purpose, much less women'.[22] He was even more surprised to find that they went as far as to carry their own groceries noting that 'The very gentlemen of Venice [...] carry home what they buy to eat, either in the sleeves of their gown or in a clean handkerchief'.[23]

This behaviour also shocked his fellow Englishman, Thomas Coryate, who commented that:

> *I have observed a thing amongst the Venetians that I have not a little wondered at, that their Gentlemen and greatest Senators, a man worth perhaps two million of duckats, will come into the market, and buy their flesh, fish, fruites and other things as are necessary for the maintenance of their family; a token indeed of frugality, which is commendable in all men; but methinks it not an argument of true generosity, that a noble spirit should deject itself to these petty and base matters, that are fitter to be done by servants than men of a generous parentage.*[24]

But even in England men did play a major role in the marketplace as discerning consumers. Although scholars have often associated the creation of new indoor elite spaces for shopping, such as the Royal and New Exchange in London, the Bourse in Amsterdam and the Merceria in Venice, with the emergence of female consumption, much of the activity still centred around male spectatorship and display. This interest in new fashions was mocked in plays such Ben Jonson's 1614 *Bartholomew Fayre* and Molière's 1664 *Tartuffe*, which satirized excessive consumption. But when Lord Burghley, Robert Cecil, opened his New Exchange in 1609 in front of an assembled crowd that included the King and Queen of England, he commissioned Jonson to write a piece in celebration of the occasion.[25] The play, *The Entertainment at Britain's Burse*, opens with a shop-boy emerging to ask the audience:

> *What do you lack? What is't you buy? Very fine China stuffs of all kinds and qualities? China chains, China bracelets, China scarves, China fans, China girdles, China knives, China boxes, China cabinets, caskets, umbrellas, sundials, hourglasses, looking-glasses, buring glasses, concave glasses, triangular glasses, convex glasses, crystal globes, waxen pictures, ostrich eggs, birds of paradise, musk-cast, Indian rats, China dogs and China cats, Flowers of silk, mosaic fishes? Waxen fruit and porcelain dishes? Best fine cages for birds, billiard balls, purses, pipes, rattles, basins, ewers, cups, can voiders, toothpicks, targets, falchions, beards of all ages, vizards, spectacles? See, what you lack?*[26]

The notion that the early seventeenth-century audience might 'lack' these goods, in the sense that they were now essentials required for everyday use, was part of Jonson's overall theatrical conceit. But it also hints that in places like London, sensory excitements that might once have been regarded as rare or unobtainable had increased in both desirability and availability. Although still expensive, spices and perfumes, sugar, cotton fabrics, furs and felts, dyes such as cochineal, and medicinal products such as sarsaparilla, guaiacum or holy wood (all of which were thought to cure syphilis), joined porcelain, colourful feathers, coffee, tobacco and tea alongside new fashions such as fans, wax pictures and billiard balls. While some of these goods, such as coffee and tea, would take more time to embed themselves into the European landscape, others – such as new perfumes, medicines, tobacco or beaver felt hats – became part of the elite urban market landscape with remarkable speed.

A few years after the opening of the New Exchange in London, Parisians established a rival venue, the *Galerie du Palais Royale*. This too was the setting for plays and prints. For example, the play-wright Corneille's *La Galerie* of the 1630s was set against the backdrop of the stalls of a mercer, linen-draper and bookseller.[27] The same site was depicted in an almost contemporary engraving of 1638 by the French engraver, Abraham Bosse (fig. 22). In the print, young well-dressed aristocratic men and women gather in the covered Gallery to explore the goods on offer. Examining books, gloves, fans and lace collars, the print seems initially to celebrate the more elegant forms of sale, particularly since a box in the mercer's stall marked '*eventails de Bosse*' makes it clear that these were the printed fans that we know were produced by the engraver himself in that same year. Here we seem to have moved far from the moralising ideals described above, to a more con-temporary notion of shopping as a leisure activity for men and women alike.

But the print's caption offers a warning. Although it celebrates the fact that all of human ingenuity is represented in the Gallery, the meeting between male '*courtisans*' and the beauties whom they are trying to attract with *galanteries* is overlaid with sexual overtones.[28] The flirtatious discussions over the 'trifles' on sale are in stark contrast with the worthy classical tomes that they should be purchasing. It cannot be a coincidence that the item shown by the young bookseller to her customer is not one of the serious philosophical texts listed above, but a play entitled *Mariane: trajédie*, which

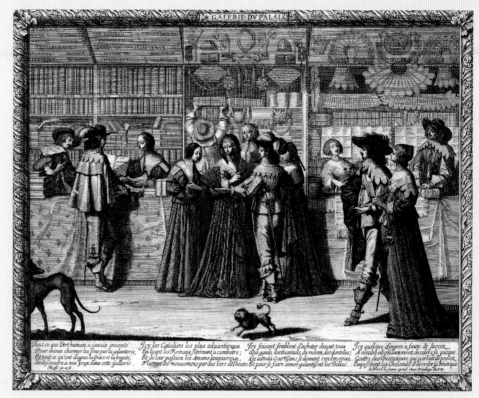

FIG. 22

LA GALERIE DU PALAIS

Abraham Bosse, etching | *c.*1637–40

was first published in 1637 (the same year as Corneille's play was first printed) with a frontispiece by Bosse. Likewise, the woman walking through the Gallery wears a watch and a mirror on her girdle, both symbols of vanity and the passage of time as well as signs of fashionable status. We need to be wary, therefore, of seeing this print as an unproblematic celebration of elegant acquisition. It is also a very traditional warning about the dangers of worldly goods. Although there was over a century between the images in Issogne and the Bosse print, the appearance of new, elegant (and expensive) spaces did not necessarily signal the erasure of old anxieties. Despite all the changes over time, shopping remained a moment when men and women displayed their morals, knowledge and ability to discern between the true and the false as much as their desires.

1. Welch 2008a.
2. Ibid., p. 142.
3. Shaw and Welch 2011, p. 58.
4. Ibid., p. 59.
5. Ibid., p. 59.
6. Ibid., p. 59.
7. Bénézet 1999, pp. 263–4.
8. *Itinerario* 1969; Romano 1981, p. 5.
9. De Vivo 2007 and Eamon 2003.
10. Garzoni 1996, vol. 2, p. 1063. See also Laughran 2003, p. 103.
11. Welch 2012, p. 238. See also Spufford 1984 and Lemire 1991.
12. Nichols 2007; Shesgreen 2002. See also Fontaine 1996.
13. Friedman 2008.
14. Welch 2005, p. 40.
15. Ibid., p. 41.
16. Spufford 1984, p. 8.
17. Wood 1981; Korda 2008, p. 120.
18. Gentilcore 2003a; Gentilcore 2003b; Gentilcore 2006.
19. Wilson 1995; Honig 1998; Calaresu 2013a.

20. Korda 2008; Wilson 1995.
21. Welch 2005, p. 218.
22. Ibid., p. 218.
23. Moryson 1617, vol. 1, p. 112.
24. Coryate 1978, p. 268. See also Welch 2005, p. 23.
25. Scott 2006.
26. Baker 2005; Baker 2012, pp. 93–120.
27. Corneille 1637.
28. The inscription on the print reads: *Tout ce que l'Art humain a jamais inuenté / Pour mieux charmer les sens par la galanterie, / Et tout ce qu'ont d'appas la Grace et la beauté, / Se descouure à nos yeux dans cette Gallerie. // Jcy les Caualiers les plus aduantureux / En lisant les Romans, s'animent à combatre ; / Et de leur passion les Amans langoureux, / Flattent les mouuemens par des vers de Theatre. // Jcy faisant semblant d'acheter deuant tous / Des gands, des Euantails, du ruban, des danteles ; / Les adroits Courtisans se donnent rendez-vous, / Et pour se faire aimer, galantisent les Belles. // Jcy quelque Lingere à faute de succez / A vendre abondamment, de colere se picque / Contre des Chiccaneurs qui parlant de procez / Empeschent les Chalands d'aborder sa Boutique.*

CITIES OF LUXURY

Cleanliness, godliness, wealth. These were the three characteristics that the French diarist Michel de Montaigne seized upon when travelling to Augsburg in the autumn of 1580. He was astonished by the fastidiousness that he encountered at the inn where he was staying (the stairs were scrubbed and covered with linen, 'we never noticed any cobwebs or mud'). He was intrigued by the coexistence of Catholic and Lutheran devotion within the biconfessional city, and he was bowled over by the riches generated by the leading banking house, presided over by the Fugger family ('one of this family, dying a few years ago, left two millions of French crowns to his heirs,' he marvelled).[1]

From the mid-fifteenth century, Augsburg's star had been in the ascendant. The Holy Roman Emperor Maximilian I (1459–1519) had made the city the location of the Imperial Diet (the occasion for which Matthäus Schwarz, chief accountant to the Fuggers, would in 1530 commission a new outfit of dazzling red and yellow) (figs 129 and 130). The patronage of the Habsburg Court and the rise of wealthy banking houses ensured that Augsburg would become a centre of artistic production. Even the upheavals of the Reformation only briefly threatened the prosperity of the city. By the time that Montaigne visited, civic pride had been re-established, as is illustrated by the contemporary silver tankard (fig. 23), a virtuoso object with tapering sides, elaborately patterned and incorporating three medallions that proclaim the virtues of Charity, Hope and Temperance. The underside displays the maker's initials and a pine-cone, symbol of eternity, and of the city where it was made.

Venice, the next major stopping-point on Montaigne's journey, lay only a few days' horse-ride away, across an Alpine pass. Considerable cultural traffic passed along that route, and the cities of southern Germany responded quickly to Renaissance ideas coming from Italy. Venice, like Augsburg, was a city of intense craft production, as well as a centre of international trade. It also shared a reputation for metalwork, and the foundries of the city – both state run and independent – produced vast quantities of bronze objects for domestic consumption and the export market (figs 27 and 31).[2] This stunning perfume burner (fig. 24), probably made in nearby Padua, may well have been commissioned by a wealthy Venetian patrician to adorn a palace in the lagoon city or a villa on the *Terraferma*. The ultimate luxury, it bathed its owners in sweet smells as well as providing a feast for the eyes. MRL

See: Avery 2011; Frame 1983.

1. Frame 1983, pp. 33–40.
2. Avery 2011.

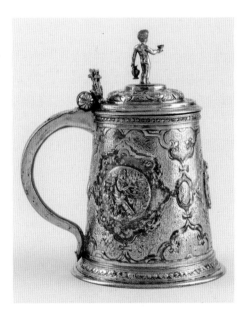 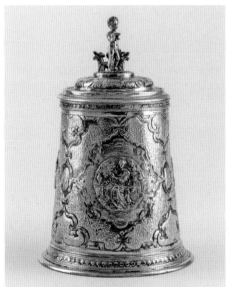 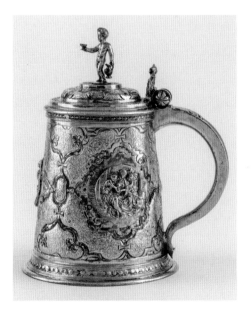

FIG. 23 | CAT. 15

LIDDED TANKARD

Augsburg | *c*.1570–1600

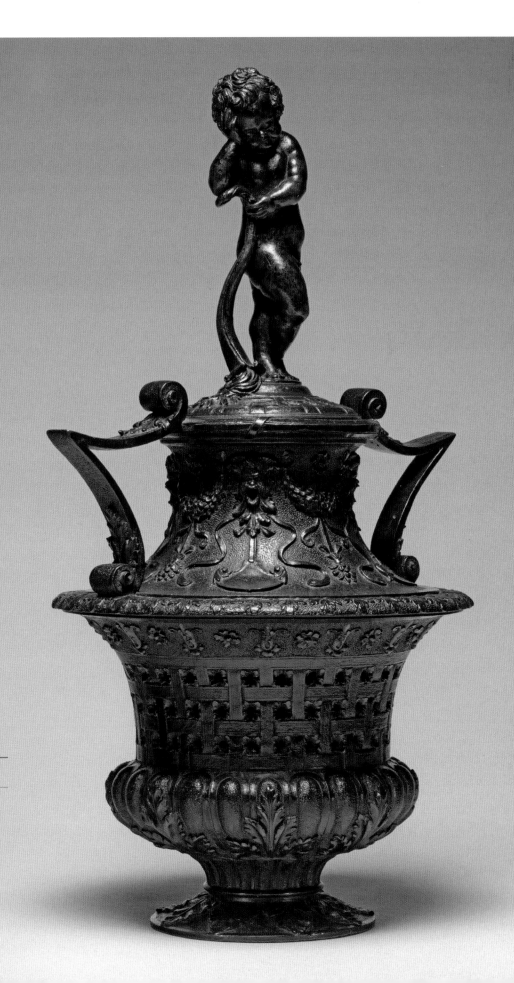

FIG. 24 | CAT. 19

PERFUME BURNER

Vincenzo and/or Gian Girolamo Grandi,
Padua | *c.*1530–60

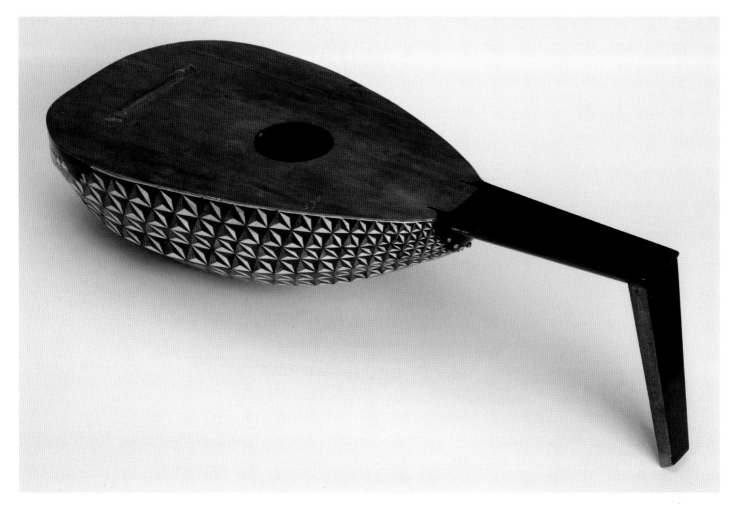

FIG. 25 | CAT. 16

LUTE

Marx Unverdorben, Venice | *c.*1550–80

The lute was at the heart of sixteenth-century musical life, providing an ideal accompaniment to the human voice. Lutes were treasured possessions in wealthy households, especially if made from exotic materials, such as ebony and ivory. While the sound of the lute – often performed by the women in a family – would animate sociability in the domestic setting and entertain guests, when lying silent the lute performed another role as a precious decorative item.

This lute was made by Marx (Max) Unverdorben, probably a member of the influential school of German lute-makers active in mid-sixteenth-century Venice. Clearly high-quality products, Unverdorben's lutes were sought after by discerning patrons, including Raymund Fugger, of the powerful Augsburg family.[1] Its bowl (the only original part) is composed of ivory, ebony, walnut and yew in a *trompe l'oeil* geometric pattern, whose three-dimensional quality recalls contemporary marquetry and paved floors. AF

See: Baines 1998, pp. 30–1; Brondi 1926; Grijp and Mook 1988; Schreiner 2011; Smith 1980; Smith 2002; Woodfield 1984.

1. His 1566 inventory of musical instruments includes 141 lutes. Smith 1980.

FIG. 26 | CAT. 14

DIPTYCH SUNDIAL

Paul Reinmann, Nuremberg | 1608

By the fifteenth century, Nuremberg, a free imperial city, was one of the most important European political and commercial centres. Ivory sundials were one phenomenon to emerge from this.[1] This sundial, made by Paul Reinmann in 1608, opens at right angles with the 'gnomon', or shadow-caster, fixed between the two panels in order to mark the time. The compass pointed north so that the string was parallel to the earth's axis. Due to the specialization and standardization combined in these objects, the design could not fluctuate greatly, but marginal details could be individualized. For example, this device names 45 towns with latitudes ranging from 54–39° and the 'epact' table allowed the user to convert between the old Julian and new Gregorian calendars.[2] Finally, the inscription 'SOLI DEO GLORIA' (Glory to God alone) reflects how this new scientific technology was inextricably linked with divine power and knowledge, combining religion, technology and luxury. SI

See Gouk 1988.

1. Gouk 1988, pp. 36–9 and 48.
2. Ibid., p. 23.

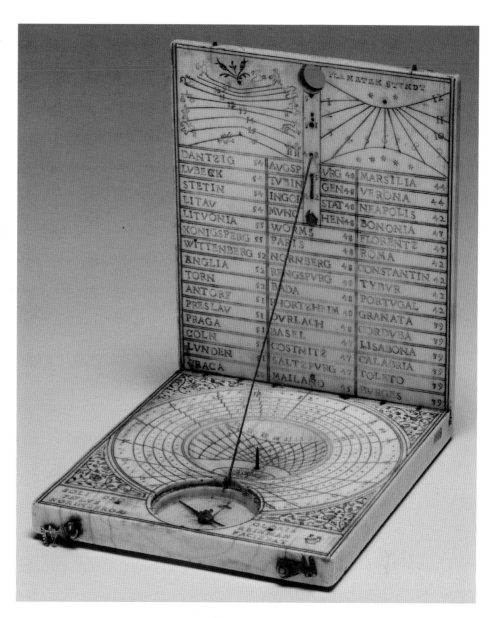

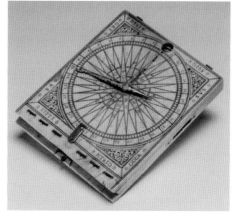

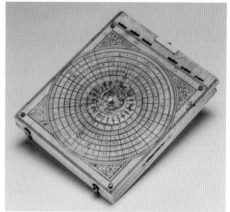

FIG. 27 | CAT. 17

DOOR-KNOCKER

Venice | late 16th century

Functional and aesthetic, this door-knocker with Hercules and two lions is a characteristic product of the bronze-foundries of early modern Venice. It conforms to the most common lyre-shaped type with shield (top), two animals (sides), standing figure (centre) and shell-shaped grip (bottom). In addition to marine creatures, lions were popular and appear on door-knockers flanking St Mark, St Paul the Hermit, Daniel and Samson.

Door-knockers were such a prominent part of Venice's visual culture that, in 1758, the patrician Pietro Gradenigo commissioned Giovanni Grevembroch to record all the models he could find in the city. The resulting manuscript contains 45 types, including a similar Hercules door-knocker on the Palazzo Longo.[1] As with many other domestic bronzes, door-knockers were often personalized through the inclusion of the owner's coat-of-arms or initials. In this case, the shield was left blank, suggesting it was made for speculative sale rather than for a specific patron. VJA

See: Avery 2011, pp. 140–1; Brusa 1879; Fortini Brown 2004, pp. 53–7.

1. Brusa 1879, no. 5.

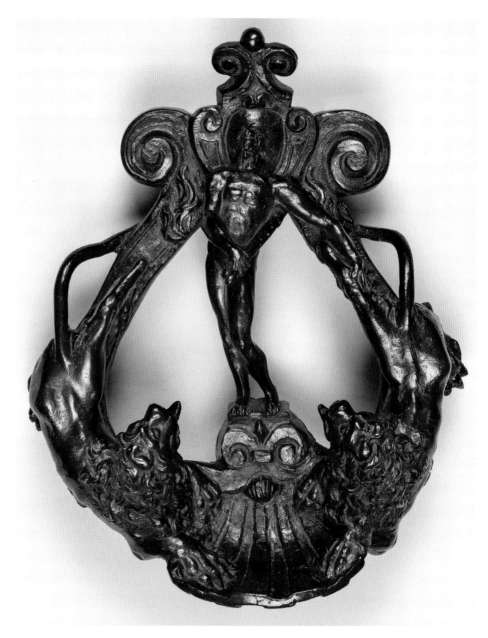

FIG. 28 | CAT. 13

TAZZA

Venice | late 16th/early 17th century

By the 1450s, Venice was the world's leading producer of luxury glass. Its Murano-based furnaces produced milky-white opaque glass in imitation of Chinese porcelain, marbled 'chalcedony' and coloured glass (often embellished with enamelled decorations and gilding) as well as clear, almost colourless soda-glass known as *cristallo* because of its resemblance to rock crystal.

During the sixteenth century, the art of blowing and manipulating *cristallo* into imaginatively-shaped vessels reached unbelievable heights of virtuosity.[1] Its lightness and clarity made it an ideal alternative to silver for luxurious drinking vessels. As seen in Paolo Veronese's *Marriage of Cana* (1562–3), wealthy Venetians drank red wine from glasses with a tall stem and wide shallow bowl, now called *tazze*, which they held precariously by the foot or stem.[2] This *tazza* has an undulating bowl with a wavy rim, and must have been difficult to drink from without spillage. Little wonder that *tazze* were also used to serve sweetmeats, such as sugared and spiced fruits and confectionary, during the final 'sweet' course of banquets. VJA JEP

See: Liefkes 2006; McCray 1999; Tait 1979.

1. Tait 1979; McCray 1999, pp. 66–95.
2. Musée du Louvre, Paris: inv. 142.

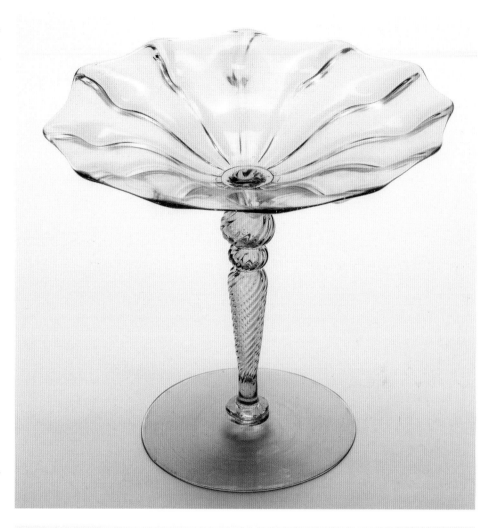

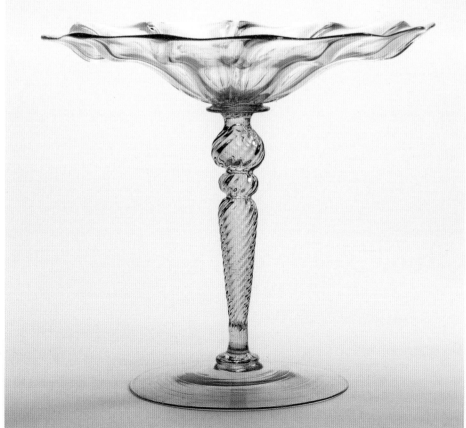

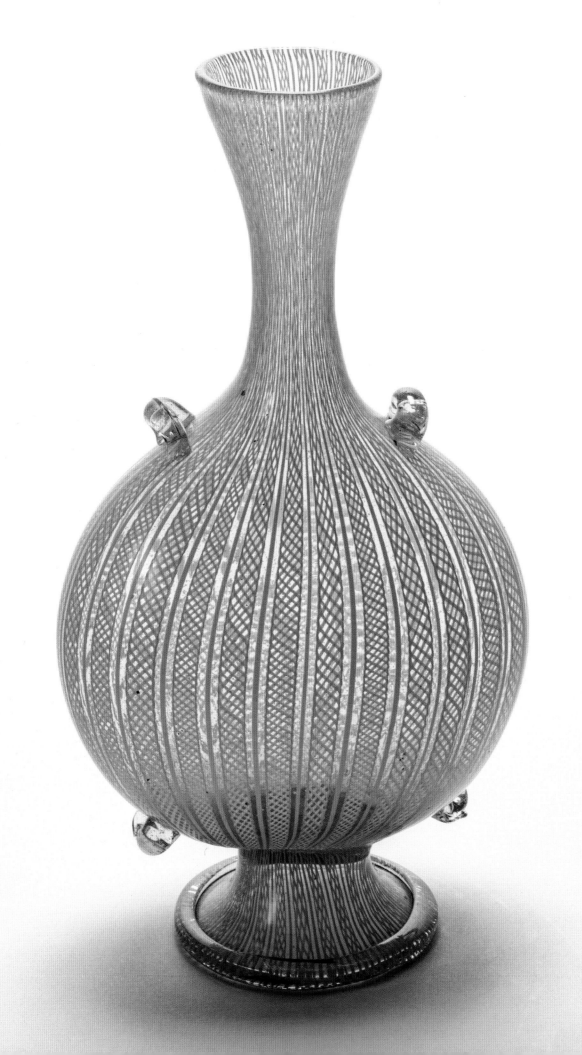

MATERIAL INVENTION FROM THE RENAISSANCE TO THE ENLIGHTENMENT

Ulinka Rublack

The year 1591 found Galileo Galilei busily planning for his sister Virginia's wedding. Part of her dowry would be precious 'silken bed-hangings' from Lucca. He excitedly explained to his daughter that these were woven:

> so that, though the fabric is of a wide width, it will cost me only three carlini the yard. It is a striped material, and I think you will be much pleased with it. I have ordered silk fringes to match, and could very easily get the bedstead made, too. But do not say a word to anyone, that it may come to her quite unexpectedly.[1]

This quotation elucidates four crucial aspects of early modern attitudes to material invention. They were shaped by an active conversation between customers and craftspeople, which constantly readjusted the relationship between quality and price. This was underpinned by a willingness to invest considerable time in planning an object commission. Men prominently involved themselves in this process. Creating a beautiful and surprising object was experienced as emotionally enriching – in fact, such gifts constituted relationships inside the family and society as a whole.

SOPHISTICATED THINGS

The period between 1450 and 1800 was characterized by vigorous debates about how to evaluate luxury as well as by such fascination with cleverly made, 'ingenious', sophisticated things (fig. 30). More social groups were incorporated into an increasingly monetized market society in which consumption created a 'powerful symbolic space'.[2] For any sixteenth-century urban bourgeois, regardless of their religion, wonderful bed-hangings with the right colours and patterns symbolized taste as much as status and would have been shown to visitors. They were the new 'must-haves', validating the successful economic exchange an appropriate wedding signalled, in the attempt to accumulate honour for the family, as much as generating the experience of attachment through pleasure in mutual possessions.

To resource and think about the right objects in a household thus framed emotional experiences to a surprising degree. These ranged from delight to anxiety. Take Magdalena and Balthasar Behaim, a sixteenth-century Nuremberg couple who traded textiles. Balthasar worked in northern Italian cities, where he looked out for new materials and goods. He needed information about how well new fabrics absorbed dye, how durable they were, and who would process them most reliably. Behaim once commissioned a substantial piece of precious crimson-red cloth for himself and Magdalena, to report enthusiastically: 'It is a beautiful, high colour, which pleases me well.' The fabric, he added, was going to be 'like the most beautiful (thing) as we ourselves desire it'.[3] Magdalena's response was disappointing: she worried about costs and wondered whether an investment in silver would have better retained its value.[4] The Behaims' experience of being a couple was built on their shared knowledge about what they spent on and how much. To communicate views about objects and their role in life was a process of forming a view on what constituted value and the legitimacy of expenditure, and on what would count as necessity and what as extravagance. In this sense, material consumption and the definition of consumption strategies continued to define a married relationship after any wedding, as a couple needed to set up a household and furnish it according to the social role they assumed at different stages in their lives.

We see the same dynamic at work in the eighteenth century as we find Benjamin Franklin sitting down for breakfast. This 'First American' usually endorsed a 'plain & simple' life, which meant that he breakfasted on 'Bread & Milk (no Tea,) and I ate it out of a twopenny earthen Porringer with a Pewter Spoon'. Unexpectedly, his wife decided that they needed more luxury to keep up with their neighbours. Franklin ambivalently recounted:

FIG. 29 | CAT. 12

PILGRIM FLASK

Venice | 16th century

But mark how Luxury will enter Families, and make a Progress, in spite of Principle [...] Call'd one Morning to Breakfast, I found it in a China Bowl with a Spoon of Silver. They had been bought for me without my knowledge by my Wife, and had cost her the enormous Sum of three and twenty Shillings, for which she had no other Excuse or Apology to make, but that she thought her Husband deserv'd a Silver Spoon & China Bowl as well as any of his Neighbours. This was the first Appearance of plate & China in our House, which afterwards in a Course of Years as our Wealth encreas'd amounted gradually to several Hundred Pounds in Value.[5]

Material objects, in other words, open a window onto an entire early modern emotional universe which those who entered into cycles of acquisition and possession needed to manage day after day. Even Franklin, whom the sociologist Max Weber famously thought of as a model of Protestant asceticism, succumbed to costly, shiny and delicate things. Protestants as much as Catholics, however, could record pleasure and excitement as well as shame, shock and frustration. Such mixed feelings of pride and remorse were brought on by the entrenched idea that once luxury had entered domestic life it was implanted and would unstoppably grow.

The Enlightenment writer Denis Diderot thus penned several pages about a luxurious new dressing-gown given to him by a famous *salonnière* in 1769, a comfortable garment to wear at home while working. It completely unsettled him, as his old, simple one had fitted in with the style of all his other belongings. This one elegant item made the philosopher's home look ugly, and he felt angry:

My old dressing-gown was at one with the other tatters which surrounded me. A straw-bottomed chair, a wooden table, a Bergamo tapestry, a deal shelf which held a few smoke-stained, unframed prints, nailed at the corners onto this tapestry, and three or four busts hanging between them, used to form, with my old dressing-gown, a most harmonious indigence. Now everything is out of tune. No more cohesion, no more unity, no more beauty.[6]

Yet his ambitious project of the *Encyclopédie* celebrated ingenious craft achievements in many areas of luxury productions, such as ribbon-making or silks, which together attracted 402 articles.[7]

CONSUMING NOVELTY

The driving force which brought these sophisticated things into people's lives and changed entire domestic displays was an intense engagement with new wares which were seen on the streets, in open workshops, market stalls, fairs and auctions, at sociable gatherings, or read about in magazines. Astonishment about their effects easily fuelled passionate investments in possessions. Magdalena Behaim, for instance, relaxed with age. After attending a Nuremberg patrician's wedding in 1591 she reported on magnificent male dress: 'Paulus Scheurl, Bendict and Hans Imhoff wore three beautiful *completely new* saffron-coloured atlas breeches and doublets with golden trims; at the after-wedding event Anthon Tucher wore the same kind of breeches and doublet.' Then followed an astonishing sentence: 'And so the old world has renewed.'[8]

It is therefore difficult to be clear about whether consumption was mostly conformist or competitive in spirit, and, in fact, whether either of these alternatives captures everything consumption could be about. Keith Thomas has influentially argued that:

most people bought commodities out of a desire to keep in line with the accepted standards of their own peer group rather than to emulate those of the one above: similarity in living styles was an important source of social cohesion; and anxiety to do the right thing was more common than the urge to stand out.[9]

This fits the Franklins at breakfast, but not trendsetters and their admirers, as well as all those who looked for similarly *new* effects or even a *renewal of the old world* through inventively utilizing cheaper goods. This desire for novelty makes us realize an important aspect of Old Europe, a society which is often said to have been stuck in tradition. The joint forces of extended trade, improved marketing, communication and developed making skills ensured that superior objects could be seen to mark civilization. Around 1580, the Flemish painter Jan van der Straet (also known as Giovanni Stradano) issued a famous series of engravings to showcase 'new discoveries' ('Nova Reperta'): the Americas, the compass, gunpowder, printing, the mechanical clock, American wood used to treat syphilis, distillation, the cultivation of silkworms and the harnessing of horses. *Nova* had become a keyword of the period.

FIG. 30

A CLOUDBURST OF MATERIAL POSSESSIONS

**Leonardo da Vinci
pen and ink with black chalk on paper
c.1510**

A WORLD IN THE MAKING

The skills of making were broadly distributed in many areas. Sixteenth-century natural philosophy, for example, foregrounds ways in which making led to knowing and inventions.[10] This inspired a surprisingly widespread culture of making among elites, which ranged from ivory-turning and life-casting to chemistry and revealed their deep fascination with questions of generation and transformation.[11] The greatly widened tastes for collecting or medal-making likewise document that such circles not only bought and stored, but also often possessed specialized knowledge about making and qualities of matter, which they acquired by observing and talking to craftspeople.[12] Elite practitioners, ranging from natural philosophers to pharmaceutically enterprising nuns, were no longer absorbed merely in texts, but became 'bodily engaged producers' training discernment through smelling, tasting or touching.[13]

Almost everyone in this society, moreover, in some way lived from or experimented with transforming matter, through their labour, interests or quotidian practices of cooking, baking, preserving, making drinks, scents and medicines. Much effort would be invested in preserving materials in some types of objects, while making skills were also interrelated with substantial knowledge about how made things were best undone or repaired.

A rare surviving pair of Elizabethan slashed shoes (fig. 125), for example, suggests that these fashionable items were first worn by a well-off person until they showed too much wear on the sides, then were passed on, sold or simply discarded, to be roughly patched up at the sides by a cobbler or new owner with matching pieces of leather. This mending was invisible from the front, so that a new, lower-class owner would be seen to be wearing a very desirable accessory.

This, then, was a made world and a world in the making. Historians still need to chart fully how this period was aesthetically dedicated to the display of decorously distinctive and often technologically advanced things. This means establishing not just patterns of consumption through the social life of finished goods, but how objects were made and rendered fascinating through their transformation of matter.[14] Such research demonstrates that material culture already played a distinctive role in initiating, reproducing as well as complicating social identifications. It shifts our sense of what it meant to live at this time.

TRANSFORMING MATTER

In contrast to our contemporary experience, early modern people were closely in touch with raw matter – they saw hides being scraped to produce leather, or linen, chalk and pigments being carted into a tiny town such as Saxon Wittenberg, to be transformed by the Cranach workshop into paintings for export. In 1523, the artist charged for 700 kg of painting materials to decorate Castle Hartenfels in Torgau.[15]

The scale of much specialized production is astonishing. Venetians would have been aware of endless barges transporting up to 572 tons of ash and other materials annually to the glass-producing island of Murano by the late sixteenth century (fig. 29). Some of this was soda-ash from maritime plants specially imported from Syria. Two centuries later, this figure had risen to 1,192 tons.[16]

European ports saw ships filled with exotic flora and fauna arrive, which transformed medicine as much as gardening. A great range of small medicines, purgatives, oils, pastilles, sweets and syrups could be bought on markets or in pharmacies and added up to long lists for those eager to describe them – Tommaso Garzoni's 1585 *Piazza Universale*, for instance, listed radicchio syrup, rhubarb pastilles and many other items, including 'so many kinds of pills' ('tante sorti di pillole'), such as Indian and Arab varieties.[17] Only a very small percentage of the population during this period went to university. Those who did were constantly reminded not to study books for too long lest melancholy muddle their minds. From their early teenage years onwards, most people across society learnt how to do things with vegetable, mineral or animal matter and were open to innovation.

Specialized achievement could be formidable. Venetian glass-makers perfected *cristallo* glass by 1450, which stood out for its exceptional transparency (fig. 28). It was one of the secrets that spies desperately tried to obtain on account of the fact that this glass could be worked at a lower temperature than ordinary glass. In addition, small amounts of manganese sufficed as a decolourizer. Yet the whole point of painstaking experiments and long practice was that real knowledge of how to achieve such effects remained tacit and was passed on through training which blended both cognitive and bodily skills. Recipe manuscripts and books, which were abundantly copied and bought, remained frustrating through instructions such as this:

Add manganese at your discretion [...] and know that as all glass itself tends towards green, manganese will discolour it, but be careful to add it little by little and not add too much or the glass will turn purple. Actual practice is everything, because there are no quantities or rules.[18]

'Try it!' was something of a mantra in such writing, but it was the migration of trained craftsmen that continued to have the most significant impact on the diffusion of skills from centres of excellence, making Europe a 'more unified technological space' in some areas.[19]

Then there were all the products that were simpler to make and consequently advertised as inexpensive. Soap-balls made from cheap compounds entered the realm of affordable luxuries and could be picked up ready-made in mercers' shops (fig. 32).[20] Such commerce was part of a growing informal sector of craft labour, which was un-guilded and therefore has left few sources. But it is obvious that women, who were mostly excluded from guilds, would have played an important part in it.[21] Personal-hygiene items were popular in an age in which comportment denoted civility but people avoided washing themselves or their clothes very much. The range of perfumed items rose exponentially, as the rich survival of pomanders, flasks for perfumed waters or perfume burners (fig. 24) in museum collections attests.[22]

Toothpicks were particularly prized by sixteenth-century male elites as a piece of jewellery to be hung on a chain or ribbon. Whether they were actually used is unclear, but it is easy to imagine how they would complement a gentleman's attire as he set off for a dinner, to which he would also often bring his own foldable silver fork (fig. 241). These elaborate products, which were typically enamelled, engraved or embossed, complemented other types of metal consumption for secular purposes, such as armour (fig. 133), clocks and automata, pomanders, tableware, or mortars (fig. 31) which were in frequent use to grind substances at the time.

This, needless to say, went alongside the flourishing production of religious objects from metal, particularly in the Catholic lands. Our sense of their cultural meaning as beautiful, sophisticated things once more depends on an understanding of how they were made. Take the Kimbell Art Museum *Virgin and Child* produced in 1486 for Wilhelm von Reichenau, Bishop of Eichstätt in south Germany, which was disassembled in order to study which skills were involved in its making.[23] The statue is hollow, to minimize costs, weight and production problems. Three sheets of silver were used to craft the back, face and neck, dress and a moon. These were joined onto the interior by a series of silver tabs fitted into silver posts on the adjoining sheets. This permitted the goldsmith to check the registration and appearance of the parts of the whole during production. The soldered joints are skilfully chased, making the edges very difficult to discern on the outer surface. The sheets were then embossed, chased and punched. Mary's jewel-studded crown was another extremely complex piece of craftsmanship. The Virgin's hands were cast separately, and while the left hand was placed in a threaded tube and pinned into position, the right hand slipped into a tube with 'inset threading attached inside her cuff and secured by a screw'.[24]

This prompts interesting questions about craft choices for or against standardization. Did the maker simply want to try out different possibilities for attaching the hands? Even at this elaborate level of production, we find the same ideals of balancing innovation, cost and quality through experiment that drove much of the dynamic that created the early modern world of goods.

1. Sobel 1999, p. 21.
2. Illouz 1997, p. 1.
3. Steinhausen 1895, p. 61.
4. Ibid., p. 64.
5. Lemay and Zall 1981, p. 76.
6. Quoted in Roche 1996, pp. 450–1.
7. Roche 1996, p. 458.
8. 'Ist also die alte welt wider ney worn.' Steinhausen 1895, p.150, my emphasis.
9. Thomas 2009, p. 126.
10. Smith 2004.
11. See the excellent exploration of Cardinal Granvelle by Fernando Bouza: Bouza 2007.
12. Smith and Beentjes 2010.
13. Roberts et al. 2007, p. xvi. On nuns, see Strocchia 2011.

14. Raff 1994. On the philosophical relevance of this approach, see Bennett 2010.
15. Heydenreich 2007, p. 129.
16. Trivellato 2000, p. 226.
17. Garzoni 1993, p. 623.
18. Wheeler 2009, pp. 16–17.
19. Epstein 2004, p. 251.
20. Wheeler 2009, p. 35.
21. For considerations on this informal sector, see Ogilvie 2011.
22. Welch 2011, p. 16.
23. AP.2002.03. For images and further details, see: https://www.kimbellart.org/collection-object/virgin-and-child (accessed 24 September 2104).
24. Smith 2006, p. 36.

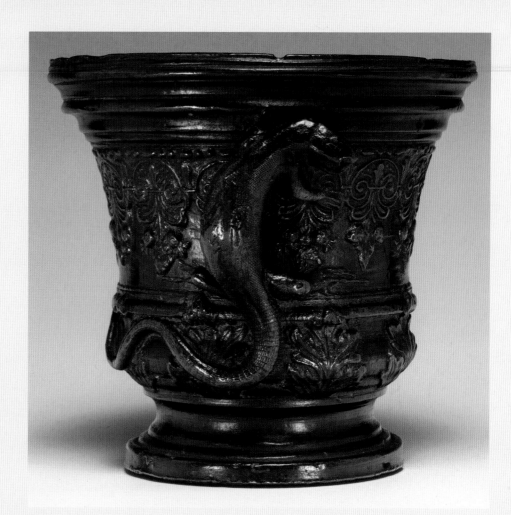

FIG. 31 | CAT. 18

MORTAR

Venice | early 16th century

First used in antiquity, mortars were made in vast numbers across Europe from the thirteenth century onwards, in various sizes and materials, including stone, tufa, bronze, lead, wood and clay. Integral to everyday life, they were used in the home to grind seeds, grains, spices, herbs, cakes of sugar and other ingredients for cooking, and to prepare simple medicines, cosmetics, soaps and perfumes. Mortars were also employed by apothecaries to make drugs, alchemists to grind chemicals, and artists to prepare pigments, enamel and gold.

Thanks to its inherent strength and durability, bronze was considered ideal for mortars until the late seventeenth century when the dangers of using copper-based materials in the preparation of food and medicine were finally heeded. Many bronze mortars are simple in shape and unadorned, likely produced in batches, using the indirect lost-wax casting technique for speculative sale by the bronze-caster. Others are more elaborately decorated and personalized prior to purchase, with inscriptions, coats-of-arms and/or emblems, which could be applied either before or after casting.

Bronze mortars were produced in their hundreds in Renaissance Venice; hardly surprising given that the city had a thriving bronze industry and was at the epicentre of the drug trade in Europe. The inverted-bell shape, profusion and type of decoration, and dark patination of the present heavy (5.2 kg) mortar suggest that it was made in Venice in the early sixteenth century. Its most arresting feature is the large, open-mouthed lizard crawling up one side. Cast from nature, either directly from the dead reptile's carcass using the burn-out process or indirectly from moulds, this unusual addition was surely incorporated at the patron's behest. No doubt intended to amuse, it might also provide a key to the patron's identity (a pun on his name or that of his shop) or indicate his profession or interests: lizards were regarded as an attribute of Logic as well as an alchemical symbol due to their supposed abilities to regenerate in fire. VJA

See: Avery 2011, p. 140; Gramaccini 1985; Lise and Bearzi 1975; Motture 2001, esp. pp. 37–47; Smith 2010; Smith 2014.

JAMES WADE,

At the SHOP the Upper-End of Broad-street,
(Late of Mrs. ELIZABETH NOBLETT, his Partner, Deceas'd)
Continues to sell WHOLESALE or RETAIL,

All Sorts of Tea, Coffee, and Chocolate,

Of the finest Flavour and Quality, as Cheap as in London.

☞ The TEA and COFFEE were purchased at the last *India* Sale, and are of the newest Import; and the CHOCOLATE is made in the neatest Manner.

ALSO, SNUFFS of all SORTS.

✱✱✱ STARCH and BLEWS, and LOAF-SUGAR, on the *lowest* Terms.

+++

Printed by EDWARD WARD, at the King's-Arms on the Tolzey.

April 5. 75.
Gubbins

GUBBINS, TOW
AND
WHITEHEAD,
Successors to the late Mr. BAXTE
AT THE
NAKED-BOY, in HENRIETTA-STREET, COVENT-G
SELL ALL SORTS OF

Childbed Linen, trimmed and untrimmed
Cradle and Cradle Quilts
Sattin Blankets
Baskets, Cushions, and Lines
Sattin and Dimity Robes
Casting Mantles and Blankets
Cotton and Dimity Waistcoats
Childrens Callico and Flannel Coats
Stays, Frocks, and Jams
Childrens Cloaks, Caps and Feathers

Quartered and Quilted C
Diaper and Damask Clouti
Sattin and Beaver Hats for
Ladies Riding-Habits
Hats and Feathers
Sattin and Sarsnet Cloaks and
Quilted Coats of all Sorts
Callico, Flannel, and Dimity c
Womens Quilted Bed-Gowns, wit
Necessaries for Ladies lying-in

ALSO ALL SORTS OF

Foreign and English Lace and Edgings
Clergymens Gowns and Cassocks
Scarfs, Roses, and Bands
Mantuas, Sarsnets, and Persians

Flannel of all Kinds
Holland and Long Lawns
Callico and India Dimity
Figured and Corded ditto

WHOLESALE and RETAIL.

Esq. Blathwayt London Mar: 22. 1766

Bought of John Pitts, Ironmonger & Brazier

at ye Three Bells, in Great-Queen-Street, Lincolns Inn Fields.

Benjamin Layton,
China-Man and Glass-Seller,

(From LONDON)

At his CHINA, GLASS, and Staffordshire WARE-HOUSE
opposite St. Michael's Church, Walcot-Street, BATH;

SELLS ALL SORTS OF

Foreign and English CHINA;

LIKEWISE

A great Variety of fine Cut GLASSES,

With both *Flower'd* and *Plain* ditto.

ALSO A GREAT ASSORTMENT OF

Best Cream-Colour WARE,

Such as *Plates* and *Dishes*, &c.

WITH

Stone and Earthen WARES,

WHOLESALE or RETALE, at the very lowest Prices.

Good STONE PLATES at 2s. per Dozen.

Smaller ditto at 1s. 6d. per Dozen.

And all other GOODS Cheap in Proportion.

N. B. CHINA Rivetted and Rim'd in the neatest Manner.

BATH: Pr

Mrs Blathwayt London,

Bought, of JOHN
HOSIER and HABERD
At the Seven Stars, in Tyler-Str
Market; Who Sells Silk, Thread
Worsted Hose; Knit and Wove
Waistcoats and Breeches, Worsted
Caps, Silk Handkerchiefs, Ribbon
Tapes and Haberdashery Goods;
best Gloves. Wholesale and Retale a
Prices.

To 6 pr white thread hose at 2/
6 pr Bro thread Do at 1/9
6 pr Cotton hose at 5/
1 sheet small pins
1 Short Do Do
1 midling Do

Recn the above in full by M

Mrs Blathwayt

Papegay,
Ladies Shoe Maker,
FROM PARIS.
No 77

DESIRING AND ACQUIRING THINGS

INTRODUCTION

During 2004–5, the anthropologist Daniel Miller conducted a study of more than 30 households in one south London street in order to understand their relationship with 'things': the clutter in their houses, its absence, things treasured in boxes, things displayed on mantelpieces, and things thrown into the back of cupboards. Miller was determined to open up the complexity of our relationship with objects. In place of negative critiques of materialism, he urged us to consider the 'comfort of things'; that is, the way in which objects give meaning to our lives and are meaningful to us.[1] Historians of early modern Europe have been encouraged by this work on 'things' by anthropologists like Miller. However, they are unable to interrogate their owners over months for hours at a time. Instead, we need to find other ways of determining the value of things in early modern lives.

Renato Ago's study of seventeenth-century inventories from Rome, *Gusto for Things*, reveals the extraordinary variety of goods which cluttered people's lives – prints of 'great men' and philosophers, silk flowers made in convents, tobacco pipes, rings, rosary beads, handkerchiefs, dolls, maiolica salt cellars, silverware, even watches, and, as you go up the social scale, fans, snuffboxes, paintings, mugs for chocolate, crystal carafes for liqueurs, French playing cards, lutes and globes.[2] Many of these things are given monetary values in inventories made on the death of their owner or when households came together in a marriage. Art historians and economic historians have used these documents to build up stories of broader changes in taste and style and to write histories of production and consumption.[3] Unfortunately, only rarely can we match particular things to particular lives and, if we can, their histories, or 'object biographies', can usually only be traced to the wealthy and powerful, such as the Roman cameos collected by Isabella d'Este or the leather wall coverings of the German banker Hans Fugger.[4]

We know, however, that people valued particular possessions beyond their intrinsic material value.[5] The fame or skill of the artist, the technological innovation required to make the object, or its fashionability were also valued by buyers and owners for a range of objects from a painted canvas by Giovanni Bellini to an agateware bowl by a Staffordshire pottery to coloured calico-printed cloth.[6] But how do we determine the emotional attachment to a particular object or set of objects from the early modern period as Miller's work does for contemporary London? Some objects in the present volume have been named and dated in order to commemorate an important event, for example, the posset-pot commissioned by a groom's family (fig. 189) or the mourning pendant made with the twisted hair of a dead adopted child (fig. 6). Their emotional resonance is inscribed on the objects themselves. Other objects of little or no financial value, such as a manuscript of recipes and remedies or battered kitchenware, were passed down from one generation to the next, from mother to daughter, or from aunt to niece, and they do not always appear in inventories.[7]

Clearly, however, emotions such as desire and affection were attached to objects such as these and so, as historians, we continue to explore the ways by which we can know more about the 'comfort of things'.[8] MTC

See: Ago 2013; Berg 2005; De Vries 2008; Goldthwaite 1993; Miller 2008; O'Malley and Welch 2007; Pennell 2009; Richardson 2010; Riello 2013a; Rublack 2013; Weatherill 1996; Welch 2005.

1. Miller 2008.
2. Ago 2013.
3. Goldthwaite 1993; Weatherill 1996; De Vries 2008; on the limits of inventories, see Riello 2013a.
4. Welch 2005, chapter 9; and Rublack 2013.
5. On the complexities of value in the Renaissance, see O'Malley and Welch 2007, chapters 3, 4, and 5.
6. See Welch 2005, chapter 9; Berg 2005, chapter 3; and Styles 2007.
7. Pennell 2009.
8. Richardson 2010.

SHOPPING IN RENAISSANCE ITALY

The Renaissance is often defined as a period of elite consumption of art fuelled by increased wealth, in which customers commissioned great masterpieces, purchased luxurious household furnishings and collected rare antiquities. However, scholars have recently started to explore the daily life of ordinary Renaissance Italians, uncovering fascinating information about their material worlds. Virtuosic paintings, lifelike sculptures, intricate metalwork, colourful ceramics – objects that survive – offer only a glimpse into the vast array of goods available to Renaissance shoppers. Ephemeral items were often just as treasured as more permanent ones.

This engraving of a *piazza* illustrates the multi-layered 'shopping scene' of Italian cities and villages (fig. 32). In the foreground, street vendors hawk their wares, which range from household tools, such as brooms, to foodstuffs like the freshly roasted chestnuts that the young boys eagerly await. Ambulant vendors could roam the city streets and even take their goods to the nearby countryside. As this marketplace engraving demonstrates, fixed shops were often located on the ground floor of *palazzi* with large windows or semi-open *loggie* facilitating the display of products. Signs, often using symbols to aid the semi-literate masses, announced the name of the shop or the goods it sold, such as the one that proclaims 'BALLE MVSC ROSA' in the engraving. In this shop, rose- and musk-scented balls, used as perfume and protection from illness, were available along with the gloves hanging on display.

Though the sensory experience of shopping is difficult to reconstruct, a poem expresses the sounds of the market in Bologna:

> *From every* Arte, *that makes goods, and every trade / One hears their cries throughout the day / […] Go to the Piazza and stand and listen / […] Who wants my chestnut roaster? / For three lira, a dress […] / A cage for a bird […] musk balls and pomanders […].*[1] KT

See: Ajmar-Wollheim and Dennis 2006; Goldthwaite 1993; Goldthwaite 2009; Jardine 1996; Shaw and Welch 2011; Syson and Thornton 2001; Thornton 1997; Welch 2005.

1. Croce 1625, fols 1v–4v, as cited in Welch 2005, pp. 29–30.

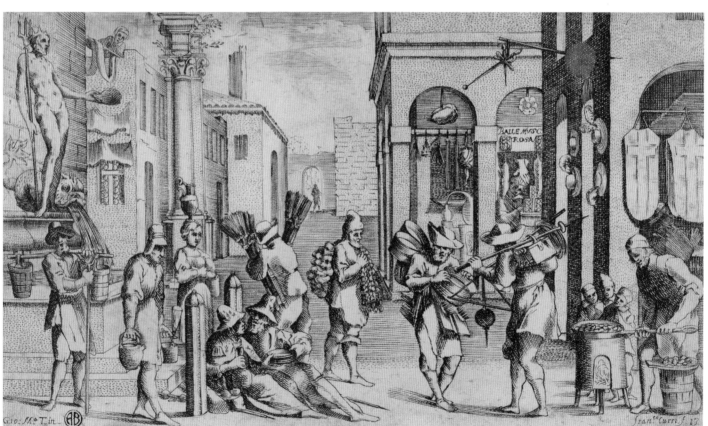

CIVICA RACCOLTA DELLE STAMPE "ACHILLE BERTARELLI", CASTELLO SFORZESCO, MILAN ("COSTUMI", p. 2–7)

FIG. 32

AN ITALIAN PIAZZA

From the series *Le Virtù et arte essercitate in Bologna*; Francesco Curti (engraver) and Giovanni Battista Tamburini (designer)
Etching | *c.*1650

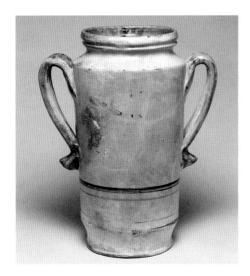

FIG. 33 | CAT. 25

TWO-HANDLED PHARMACY JAR

Tuscan | *c.*1510–30

An idealized woman resting on a shield and holding a spear graces the central medallion on the front of this early sixteenth-century two-handled maiolica pharmacy jar (*albarello*). Standing before a cloth of honour within a rustic setting, the woman – perhaps a personification of Fortitude – reflects early sixteenth-century ideals of beauty.[1] Resembling contemporary paintings by Sienese artists such as Neroccio de' Landi (1447–1500) and Luca Signorelli (active 1470–1523), this *albarello* may have come from Siena, or perhaps Montelupo.[2]

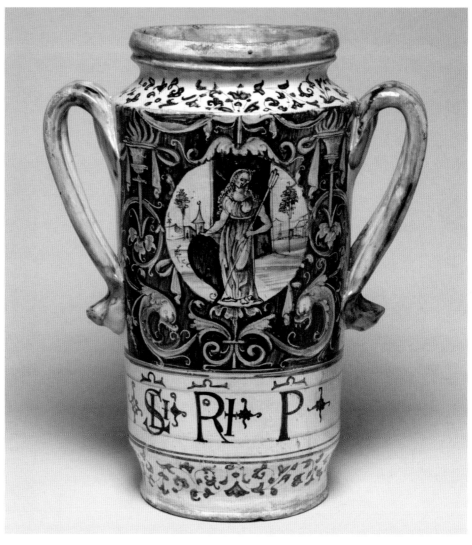

Symmetrical grotesque decorations surrounding the medallion, including dolphins, flaming torches and yellow ribbons, are set against a blue ground in contrast to the jar's white body. While its front has been densely painted with these designs as well as with blue *alla porcellana* floral patterns along the top and bottom, its white tin-glazed back remains unembellished, indicating its orientation for display.

Beautiful though it is, the contents of the jar would have been as valuable, if not more so, than the *albarello* itself. It was once part of a set, of which nine other examples are known. Their inscriptions reveal the variety of spices they once contained: from *gentziana* (gentian) and *zafarano* (saffron) to *comino pesto* (crushed cara-way seed).[3] Used as spices or in cosmetics, these substances might also have been ingredients in remedies. This *albarello* reads 'SLI Rᵒ I P', likely for *'salvia ridotto praeparatio'* (reduced sage preparation). The renowned German naturalist Conrad Gessner (1516–65) noted the medicinal value of sage distillation in his 1552 *Thesaurus Euonymi Philiatri*. According to George Baker's English translation, 'two or three drops of oyle of Sage doth more profite in the Palsie [...] than one pound of those decoctions not dystilled'.[4]

Owned by a pharmacy in a religious institution or an apothecary's shop (*speziale*), these *albarelli* would have been displayed on shelves or counters (see, for example, fig. 19). To protect their costly contents they would have been covered with parchment, paper or leather fastened with string. KT

See: Ajmar-Wollheim and Dennis 2006; Gessner 1552; Gessner 1576; Luccarelli 2002; Pantin 2013; Poole 1995a; Poole 1997; Shaw and Welch 2011; Syson and Thornton 2001; Thornton and Wilson 2009; Welch 2005; Wilson 1996.

1. The fresco of *Fortitude, Temperance and Six Ancient Heroes* by Pietro Perugino (Audience Chamber, Collegio del Cambio, Perugia), *c.*1496–1500, shows a similar depiction of Fortitude.
2. Luccarelli 2002, p. 59, pl. XXXV, a Sienese tile.
3. V&A: 7840-1861 (for gentian) and 7841-1861 (for saffron); and British Museum: 1885,0508.23 (for crushed caraway seed).
4. Gessner 1576, fol. A3v, cited in Pantin 2013, p. 166.

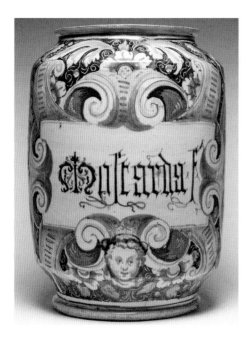

FIG. 34 │ CAT. 26

PHARMACY JAR

Venice │ *c.*1560–75

Often highly embellished, these maiolica vessels, known as *albarelli* (pharmacy jars), generally contained either medicinal ingredients or foodstuffs. The youth depicted on this Venetian *albarello* wears a doublet, ruff and large wine-coloured cap, known as a *beretta a tozzo* – a popular accessory, especially with Venetian patricians. Decorated with strapwork ornamentation, acorns, foliage, flowers and fruit, the inscription 'Mostarda Fᴬ' on the opposite side reveals its original contents: *mostarda fina*. Renaissance *mostarde* differed regionally and were either a delicate mustard sauce or a fruit compote made from fruits like those depicted on this *albarello*. One sixteenth-century Venetian recipe called for quinces to be boiled with water, mixed with coarse sugar and stored in a jar; when ready to eat, the mixture would be combined with ground mustard seeds, additional sugar, cinnamon, cloves and nutmeg, as well as an optional orange peel garnish.[1] KT

See: Fioravanti 1564; Mazzarotto 1961; Poole 1995a; Poole 1997; Wheeler 2009.

1. Fioravanti 1564, fols 164v–165r; cited in Wheeler 2009, pp. 88–9.

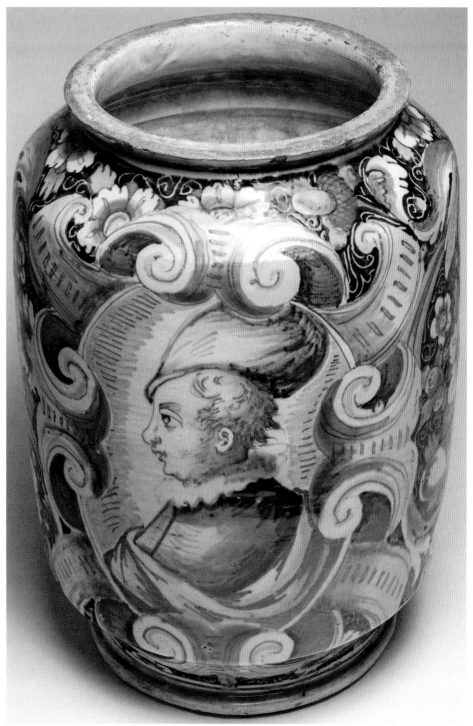

FIG. 35

RITRATTO DI QVELLI CHE VANNO VENDENDO E LAVORANDO PER ROMA

Ambrogio Brambilla, etching | 1612

Visitors to early modern Rome would often bring home prints of the ancient and modern sites of the city, and sometimes also this printed grid of Roman street vendors, as reminders of their visit.[1] Most common were monochrome versions such as this one from 1612, which was obtained by Samuel Pepys' nephew in Rome and is now in the Pepys Library, Magdalene College, Cambridge.[2] Hand-coloured versions were also available.[3]

Brambilla's design, entitled *Those who go selling and working around Rome*, shows the extraordinary variety of goods sold on the streets of the city, including hot and cold food, household items and beauty products. Recent work has shown that the 'consumer revolution' was not restricted to Northern Europe.[4] Many of the objects depicted by Brambilla are rarely mentioned in contemporary inventories and have not survived in museum collections, such as the wooden spoons and cutting boards (*cochiari e taglieri*; see details illustrated on p. 182). MTC

See: Ago 2013; Bury 2001; Calaresu 2013a; Cavallo and Storey 2013; Florio 1611; Storey 2011; Witcombe 2008; Zorach 2008.

1. Zorach 2008, Calaresu 2013a.
2. The Pepys etching measures 29 x 50.7 cm.
3. For example, the one found interleaved in a handwritten guide to Rome: 'Roma española y discursos modernos de heroicas grandezas del Alma ciudad de Roma', Prado, Madrid (Manuscritos, Sign. Ms/16. 1616. 175 h), pp. 116–17. I would like to thank José Ramón Marcaida for bringing this manuscript to my attention.
4. Ago 2013.

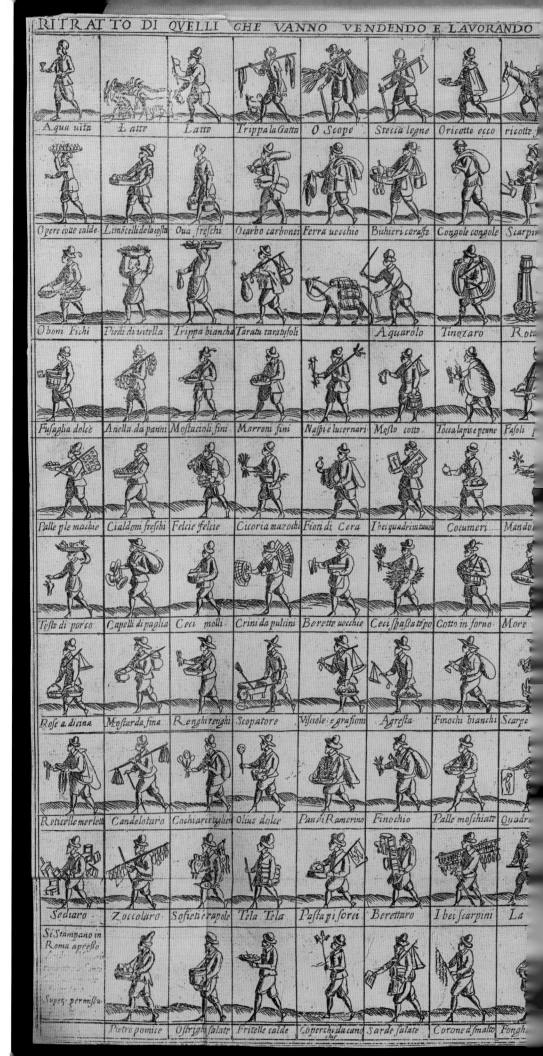

elle fresche | Spaza Camino | O cott' adeß' adeßo | Salina biancho | O sarde tiche trighe | Operi meli no chie | Gambari grossi | Tartaru tartaruga | Caua denti | Telli telline | Afopon genouese | Zafarà zafarano

calza tori | Galline capponi | Legne | Legne | Herbarole | Cascio carne salata | Vermicelli | Pastinazi caldi | Aceto forte | Olio | Olio | Cicoria cicoria

celli | Chiauaro | Concia caldari | Le belle historie | Tinta da scriuere | Spechi e pomata | Lunario nouo | Agora maglieta | Lino e canipo | Fusa donne | Sanguinaci grassi | Belli collari fini

paglia | Neue Neue | Ostriche fresche | Zingaro | ferraro | Camomilla | Calzette di bābagia | Catenelle g lampade | Legne Legne | Pastici caldi | Librare | Cipolle dolce

rose | Lumache a cento | Quarti di capretto | Ecco grilli da cātare | Ventarole | Cocuze | Nespole a scorzo | Aghi damaschini | Il bello aglio | Fiaschetti di caccio | Noci a Scorzo | Scopette fine

chi | Pisellie scaffe | Solfaroli | Fiori fiori | Storni grassi | Canochie donne | Presciuti di mōtag | Regaglie d galline | Stracci da uedre | Chi a le medaglie | Lupolie spargi | Cetrioli boni

ini | Lanterne e inhotata | Noci fresche picoli | Porchette grasse | Schizzetti | Datteri | Piatti di maiolica | Velettaro | Lamprede uiue | Cardi bianchi | Carozzaro | a uettura

i dolci | Escaper il fuoco | Carne di | saluaticina | Petini da lino | Rauoggioli grassi | Spazza destro | Vicelli da cantare | I bei Canestri | Maroni a scorzo | Calde alesse | Riso bianco

ra | Matarazaro | I bei Setacci | Mondezaro | Le belle | pile | Venditor d arme | Frauole fresche | Oua tinti | Frasuiella | Triuli | Bichieri introna

rla | Ranochie | Confortini fini | Il bell' amito | I bei bottoni | I bei lardatori | Bachette cauallia | Spillette fine | Filo malfetano | Carsiofi | Vesciche di muschio | Fonghi freschi

FROM THE STREET TO THE TABLE

In early modern Europe, most households bought their food and many of their household goods from market stalls and ambulant vendors. While the history of consumption is often dominated by the history of shops and the history of food at the table, new research is beginning to explore selling and eating in the open spaces of early modern European cities.[1] The early eighteenth-century painting of a market stall by the Dutch painter, Willem van Mieris (fig. 36), depicts some of the goods sold on the streets of a city. It was bought by Matthew Decker, the grandfather of the Fitzwilliam Museum's founder, whose family had already acquired an impressive collection of Dutch and Flemish paintings at the end of the seventeenth century before migrating to England.[2]

The painting shows a woman with a basket of dead, undressed poultry, pointing to some chestnuts, with an older female vendor at her side. There are small weights and scales on the table and, behind them, some drying onions, eggs in a basket, dried fish hanging on a nail, and gingerbread in the shape of a stag and a militia man.[3] To the right of the young shopper is some more dried fish and, in the background, some brooms hanging near the door of a house. Early modern viewers of painted market scenes such as this would have interpreted them in different ways. Certainly the artist's skill in depicting different objects and their surfaces would have been valued by contemporaries – the dried edges of the eviscerated fish bellies, the roundness of the chestnuts, the shine of the copper basket, the translucence of the onion skin. There is probably more going on in this painting, however, than virtuosic pictorial skill, as images such as these were often bound to moralistic story-telling about female virtue.[4]

Nonetheless, van Mieris' painting sheds some light on the provisioning of cities in the early modern period, a mammoth task of municipal organization which has left a long paper trail of regulation, only just beginning to be explored.[5] Guild membership was often too expensive for independent women and so it appears that the old woman is selling from just outside her own home rather than at a regulated market stall. Some of these food items she would have grown, prepared or collected herself on a smallholding outside the city walls, or in a city garden and then sold without a licence in the city. These 'gaps' in the municipal regulations, as well as the urban environment, allowed women who could not afford to be members of guilds some financial independence, and they also helped in the provisioning of a growing urban population, the needs of which could not always be met by the guilds.[6]

The porcelain figures of street vendors produced at Meissen and other manufactories, by contrast, were far removed from the day-to-day business of selling food on the street (figs 37–44). As Julia Poole has written elsewhere in this volume (p. 52), by the middle of the eighteenth century, such figures were being used to decorate dessert tables across Europe. The whiteness of the porcelain, decorated with bright colours, would shine in candle-light, making an interesting contrast to the gleaming white sugar sculptures placed beside them on the table.[7] Despite their outlandish costumes and poses, these elite objects do represent some of the goods found in earlier images (fig. 35) – cheese, fresh fish, fruit (figs 39, 40 and 41) as well as trinkets, printed ephemera and kitchen utensils (figs 37 and 42–44) in the baskets, bags and trays held by street vendors. MTC

Detail of fig. 35 (pp. 48–9). The seller cries his wares: '*Ricotte*, here are fresh *ricotte*'

See: Calaresu 2015; Calaresu and Van den Heuvel 2015; Calaresu forthcoming; Day 2002; Honig 1998; Pennell 2000; Revel 1979; Stone-Ferrier 1991; Van den Heuvel 2008; Van den Heuvel 2012; Van den Heuvel 2013; Van den Heuvel 2015; Welch 2005; Woudhuysen 1988.

1. See Van den Heuvel 2012, and the introduction in Calaresu and Van den Heuvel 2015.
2. Woudhuysen 1988.
3. Many thanks to the food historian Ivan Day for his help in identifying the gingerbread forms. According to Day, this is an autumnal scene and the gingerbread would have indicated that the beginning of the Christmas season was nearing.
4. On market scenes of selling and seduction, see Welch 2005, pp. 32–55; on Dutch market scenes, see Honig 1998 and Stone-Ferrier 1991.
5. On Rome, see Revel 1979 and Calaresu forthcoming.
6. Van den Heuvel 2013, pp.126–7.
7. Day 2002, p. 31.

FIG. 36 | CAT. 27

THE MARKET STALL

Willem van Mieris, Netherlands | *c.*1730

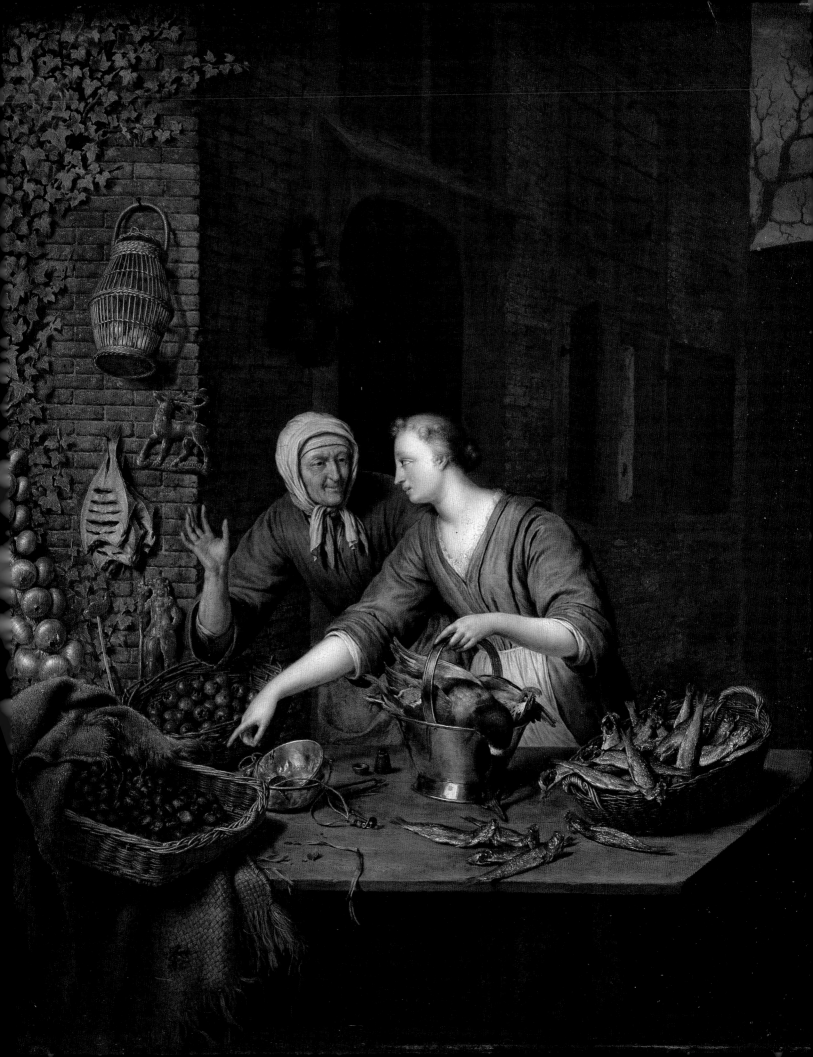

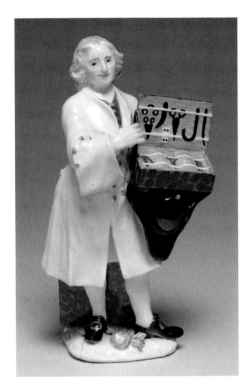

FIG. 37 | CAT. 35

KNIFE, SCISSOR AND COMB SELLER

Meissen | *c.1745–7*

FIG. 38 | CAT. 30

STREET COOK WITH STOVE

Bow | *c.1757–60*

The use of Meissen porcelain figures as decoration for the dessert table spread through Europe from the Electoral Court at Dresden. By 1750, small numbers of figures were entering England and, despite restrictions on the importation of porcelain for resale, they were all the rage by 1753.[1] Demand exceeded supply and English factory proprietors were quick to market soft-paste versions of Meissen models at cheaper prices. This Bow street cook copies a Meissen model of about 1755 from a series of *Cries of Paris* mainly modelled by Pieter Reinicke (1711–68) after lively coloured designs made for the factory in 1753 by the French artist Christophe Huet (1700–59).[2] Bow also copied two cooks from an earlier set of Meissen *Cries of Paris*, adapted from engravings after drawings by Edmé Bouchardon (1689–1762).[3] JEP

See: Adams 2001; Adams and Redstone 1981; Scott 2013; Young 1999.

1. Young 1999, pp. 81–2.
2. Adams 2001, pp. 19–37, esp. p. 25, pls 40–41.
3. Adams and Redstone 1981, p. 93; for prices of Bow figures in 1756, see p. 92. For the *Cries of Paris*, see Scott 2013.

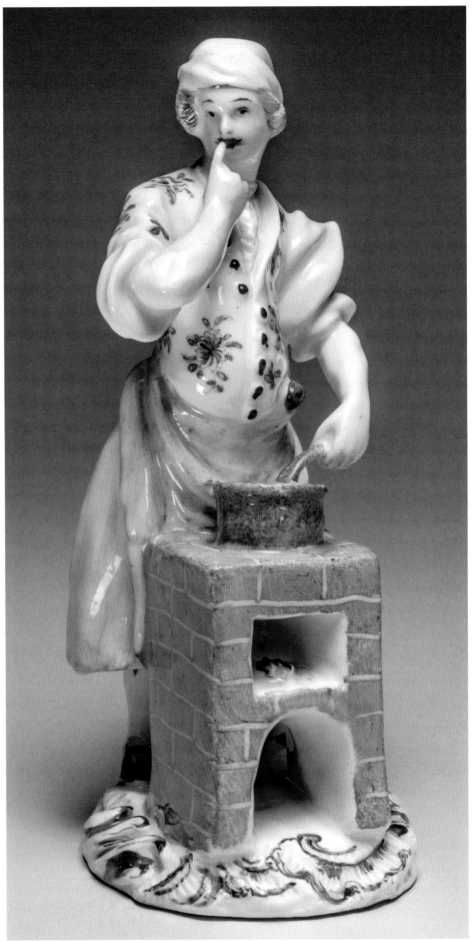

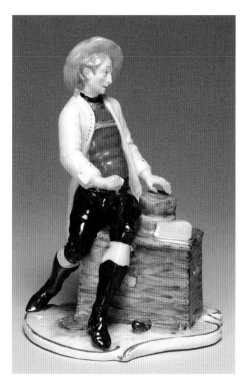

FIG. 39 | CAT. 31

CHEESEMONGER

Neudeck or Nymphenburg | *c.*1755–65

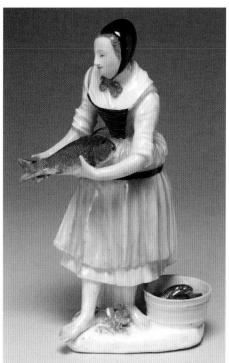

FIG. 40 | CAT. 28

GIRL SELLING CARP

Meissen | *c.*1745–50

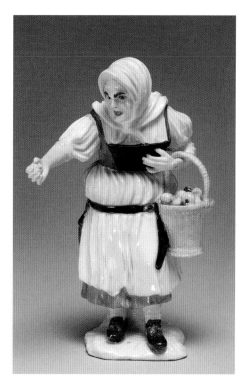

FIG. 41 | CAT. 29

PEASANT WOMAN SELLING APPLES

Meissen | *c.*1745–50

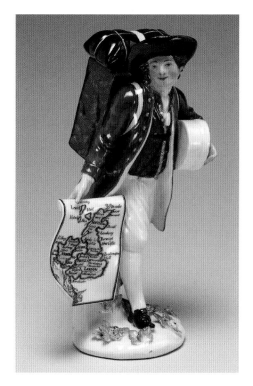

FIG. 42 | CAT. 34

MAP SELLER

Meissen | *c.*1750

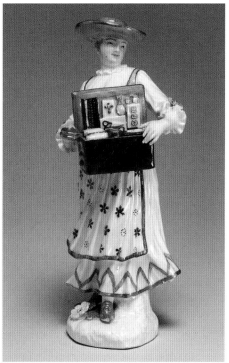

FIG. 43 | CAT. 33

*TYROLEAN WOMAN
SELLING TRINKETS*

Meissen | *c.*1745–50

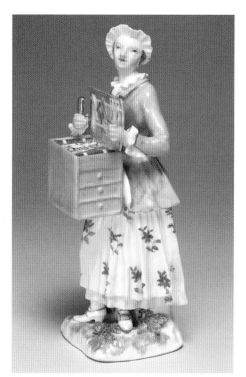

FIG. 44 | CAT. 32

TRINKET SELLER

Meissen | *c.*1745–50

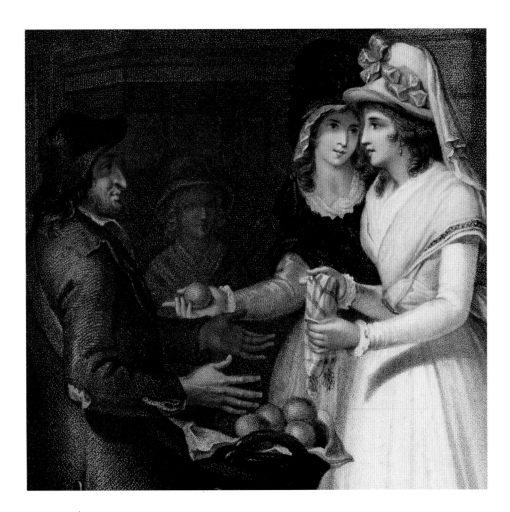

FIGS 45–48 | CATS 36–9

THE CRIES OF LONDON

After Francis Wheatley | 1794–5

Once described as the 'nadir of the genre', the *Cries of London* by Francis Wheatley (1747–1801) represent a tradition of depicting street vendors that stretches back to the sixteenth century.[1] Throughout the early modern period, the 'street cries' genre was incredibly popular with a range of audiences. Although Wheatley enjoyed early success as a portrait painter, he turned to more lucrative printmaking later in his life.[2] The collapse of the print market during the French Revolution encouraged the entrepreneurial publisher Paul Colnaghi (1751–1833) to publish guaranteed bestsellers, such as portraits of military heroes, topical narratives such as the last interview with Louis XVI, and this series of street cries.[3]

Although the picturesque qualities of these cries have been criticized, historians are just beginning to peel back the 'saccharine' layers of images such as these to help construct a new cultural history of selling on the street.[4] The vendors depicted here were not unlike the many women who made a living on the streets of European cities selling household necessities such as matches (fig. 45), seasonal fresh fruit and vegetables grown in market gardens on the edges of the city (fig. 46), exotic novelties – 'little luxuries' – like the oranges depicted here (fig. 47), or food staples such as the mackerel from nearby wharves (fig. 48).[5] The popularization of these types of images in various media, such as ceramics (figs 37–44) and textiles, and the success, for example, of Henry Mayhew's account of *London Labour and the London Poor* (1851), are testament to their enduring interest well into the nineteenth century.[6] MTC

See: Calaresu 2007; Calaresu 2013a; Clayton 1997; Mayhew 2010; Milliot 1995; Scott 2013; Shesgreen 1990; Shesgreen 2002; Stammers 2015; Van den Heuvel 2015; Webster 2004.

1. Shesgreen 1990, p. 41.
2. Webster 2004; see Wheatley's portrait of *Benjamin Bond Hopkins* (before 1791), in the Fitzwilliam Museum (PD.6-1953).
3. See the advertisement for the first six prints produced by Colnaghi in *The Star*, issue 2028 (18 February 1795). My thanks to Elenor Ling, Department of Prints, Fitzwilliam Museum, for this reference.
4. For example, Calaresu 2007, Scott 2013 and Stammers 2015.
5. Van den Heuvel 2015.
6. Mayhew 2010.

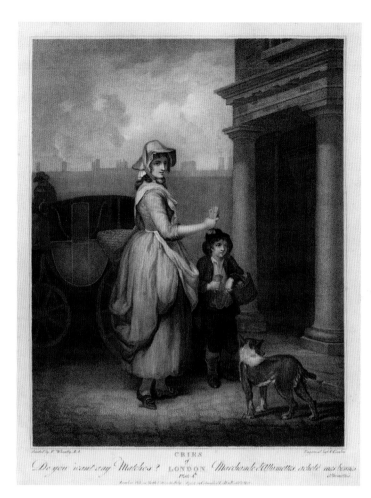

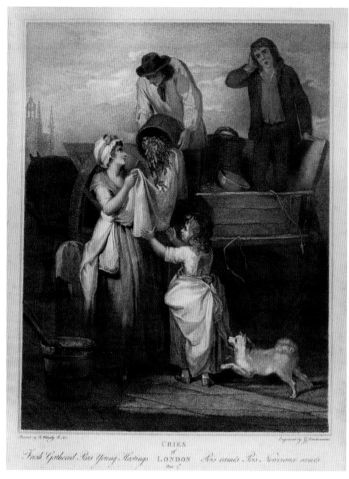

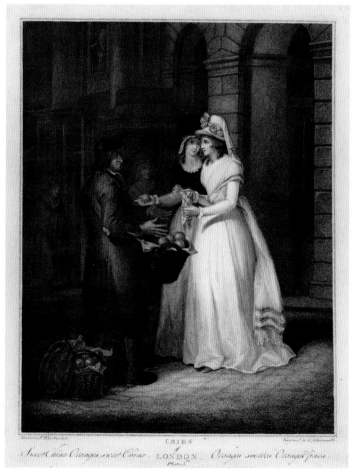

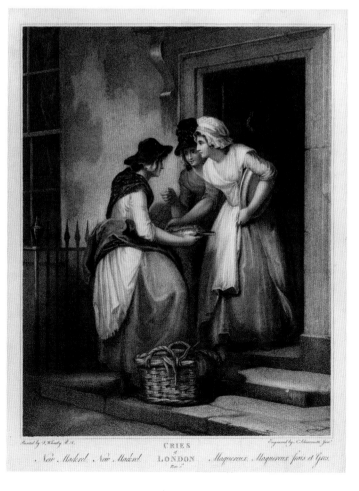

SHOPPING IN GEORGIAN LONDON

In the eighteenth century, shopping became more than just about acquiring goods. It was a pastime and leisure activity, especially for the rising middling classes. Shops appeared in many British and continental European cities. They replaced market stalls and itinerant pedlars, offering a new experience for customers increasingly allured by the goods displayed in their windows. This was particularly the case in major European capitals – London was well known for the number and quality of its shops, attracting customers from all over England and from abroad. Cheapside (fig. 54) and the area of the City of London around St Paul's had long been centres for shopping. By the early decades of the eighteenth century, the shops of the West End (Oxford Street, Bond Street and later Regent Street) came to rival those of the City. The German Johann Wilhelm von Archenholz, in his *A Picture of England* (1789), marvelled at the fact that 'In Oxford-Street alone […] all the shops are open till ten o'clock at night, and exceedingly well lighted'.[1]

London shopkeepers were also at the forefront of marketing innovation. They advertised their wares and services in newspapers and through trade cards and bill heads given to customers that often recorded their purchases (figs 49–53, 55–60).[2] Trade cards also reminded customers of specific shops. This was particularly important for the sellers of new and exotic products such as the tea and coffee sold by Francis Morley, grocer and tea dealer in Cheapside (fig. 49). Others like Benjamin Layton, 'China-Man and Glass-Seller' in the city of Bath, advertised their metropolitan connection, suggesting that customers could purchase the latest London products at his 'Staffordshire warehouse' (fig. 50).[3] GR

See: Archenholz 1789; Berg 2005; Berg and Clifford 1998; Berg and Clifford 2007; Cox and Dannehl 2007; George 1925; Greig 2013; Hildyard 2004; Walsh 1995.

1. Archenholz 1789, vol. 1, pp. 134–5.
2. For further information about the Fitzwilliam's collection of trade cards and bills, from the Blathwayt family, see Elenor Ling's online exhibtion: www.fitzwilliam.cam.ac.uk/gallery/tradebills.
3. Hildyard 2004, p. 482.

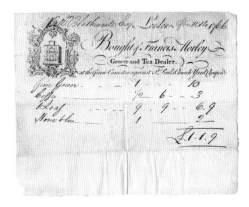

FIG. 49 | CAT. 46

BILL HEAD OF FRANCIS MORLEY

London | 1766

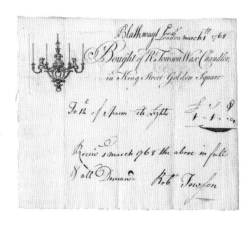

FIG. 51 | CAT. 42

BILL HEAD OF ROBERT TOWSON

London | c.1768

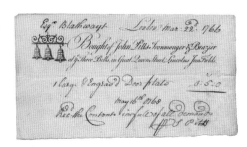

FIG. 53 | CAT. 47

BILL HEAD OF JOHN PITTS

London | 1766

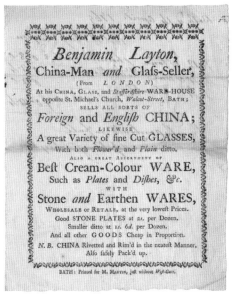

FIG. 50 | CAT. 41

TRADE CARD OF BENJAMIN LAYTON

London | c.1769

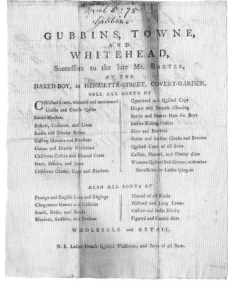

FIG. 52 | CAT. 49

TRADESMAN'S LIST OF GUBBINS, TOWNE AND WHITEHEAD

London | c.1775

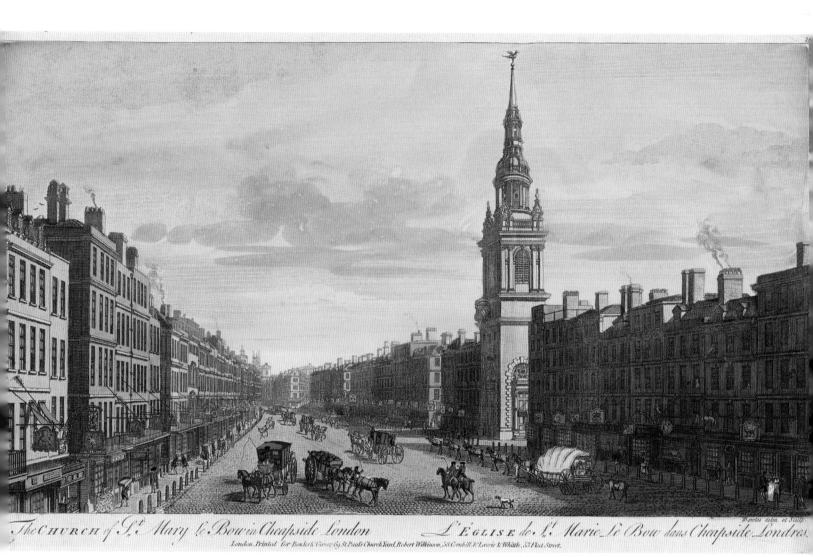

The CHURCH of St Mary le Bow in Cheapside London L'ÉGLISE de St Marie Le Bow dans Cheapside Londres

London Printed for Bowles & Carver, 69 St Pauls Church Yard, Robert Wilkinson, 58 Cornhill & Laurie & Whittle, 53 Fleet Street.

FIG. 54 | CAT. 40

THE CHURCH OF ST MARY-LE-BOW IN CHEAPSIDE, LONDON

Thomas III Bowles, London | c.1762–3

Cheapside was historically the main processional route through the City of London and a centre of commerce and high-quality trade and retail, particularly renowned for goldsmiths, drapers and mercers. This engraved hand-coloured print from the early 1760s (a reissue of an early eighteenth-century print) shows a view from the west end of Cheapside, looking towards St Mary-le-Bow. The width and length of the street, for which Cheapside was celebrated, is emphasized from this perspective.

For 'middling and upper sorts', shopping was a primary metropolitan leisure pursuit. Browsing in shops, interactions with shopkeepers and the negotiation of prices were understood to be complex rituals requiring considerable cultural knowledge and social capital. The exterior and interior of shops along Cheapside were carefully designed to demonstrate the reputation of the seller and the authenticity and quality of the material goods. Emblematic trade signs and painted signboards were crucial visual reference points for consumers negotiating the dense urban environment. Glazed projecting or bow windows, prominent pillars, arches, painted and gilded cornices and specialized display-fittings confirmed fashionability and enticed shoppers to browse and purchase a range of luxury products.

This is a 'polite' representation of the busiest route through the city – with uniform buildings flanking the street and a steady but ordered stream of carriages, carts and porters – designed to enhance the reputation of the urban environment. Labelled 'no. 18', this print of Cheapside was one of a set of London views intended for a collector or tourist. Conspicuous by their absence are signs of poverty, crime and pollution. At the turn of the eighteenth century, the writer William King described the city as 'pestered with Hackney Coaches and insolent Carmen, shops and taverns, noise and […] a cloud of sea coals'.[1] JKT

See: Berry 2002; Blumin 2008; Brett-James 1935; Gordon 2005; Harding 2008; King 1698; Morrison 2003; Walsh 1995.

1. King 1698; taken from Brett-James 1935, p. 440.

FIG. 55 | CAT. 44

TRADE CARD OF JAMES WADE

Bristol | c.1754

This mid-eighteenth-century trade card for a
grocer's shop in Bristol also served (on the reverse)
as an invoice for purchases made by the Blathwayt
family of Somerset, including Bohea tea and
chocolate. Reports from the *London Evening
Post* demonstrate that James Wade ran the shop
with his business partner, Elizabeth Noblett,
until her death in 1752, when she was hailed
as 'one of the greatest Dealers in Tea, Coffee
&c., in the West of England'.[1] Advertising a
wide range of imported, novel and high-quality
consumable products purchased at the East India
Company sales, Wade's shopkeeper's bill was
designed to appeal to the 'middling' and 'better'
sorts of provincial society, a growing market of
consumers for exotic foods. The trade card also
demonstrates a keen awareness of metropolitan
competition and the significance of 'polite'
language and identities; Wade's commodities
are described as being 'as Cheap as in London'
and produced 'in the neatest Manner'. JKT

See: Berg and Clifford 2007; Stobart 2008; Stobart 2013.

1. *London Evening Post*, 27–30 June 1752.

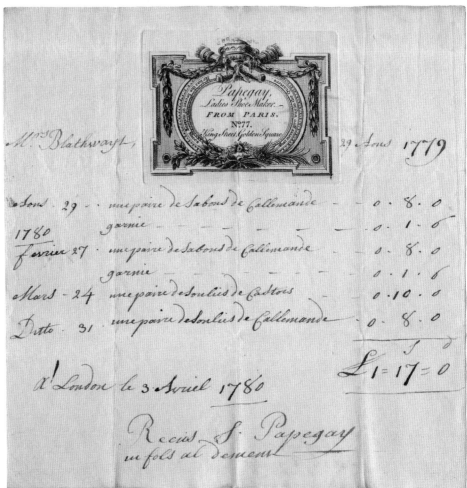

FIG. 56 | CAT. 45

TRADE CARD OF PAPEGAY

London | 1779

This trade card from the 'Ladies' Shoe Maker'
Papegay, located at 77 King Street, Golden
Square, London, records the purchase of four
pairs of shoes and two decorations or garnishes,
by Mrs Blathwayt, member of a prominent
gentry family from Somerset. Papegay's origins
were important to his advertising strategy,
for Paris was the fashion capital of eighteenth-
century Europe and innovative French products
were highly desirable in the English market.

For eighteenth-century women of the 'middling
and upper sorts', shopping in the capital and
provincial towns was an essential element of the
'polite lifestyle'. It is noteworthy that the shoes
bought by Mrs Blathwayt and itemized on this
bill are described as 'callemande', a fine, glossy
woollen cloth. While fashionable men's leather
shoes were suitable for outdoor use, women's
shoes were ideally made from delicate materials,
including silk, satin or cloth, best suited to the
domestic sphere. JKT

See: McNeil and Riello 2005; Ribeiro 1984; Riello 2003.

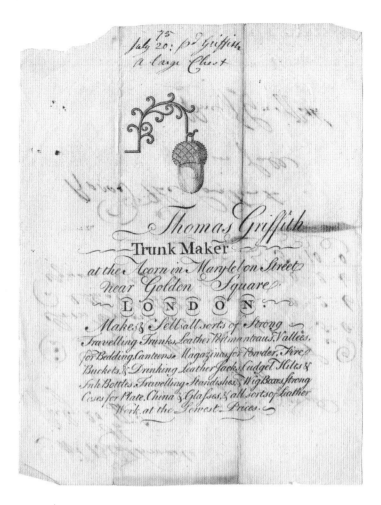

FIG. 57 | CAT. 43

TRADE CARD OF THOMAS GRIFFITH

London | 1775

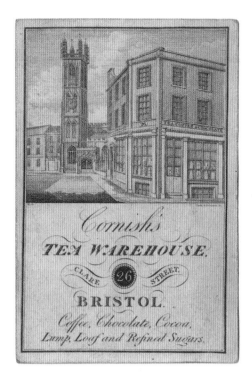

FIG. 58 | CAT. 51

TRADE CARD OF WILLIAM CORNISH

Bristol | c.1790–1800

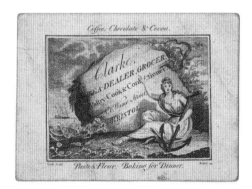

FIG. 59 | CAT. 52

**TRADE CARD OF
JOHN VAUGHAN CLARKE**

Bristol | c.1790–1800

FIG. 60 | CAT. 48 ▶

TRADE CARD OF ROWE BROWN

London | c.1772

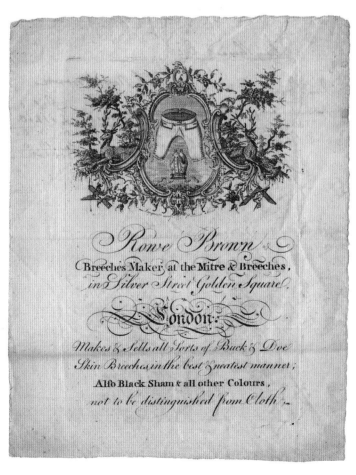

ON THE GO

Throughout Europe, journeymen craftsmen, political ambassadors and exiles, religious refugees and pilgrims, merchants and tourists travelled across unfamiliar landscapes and challenging terrain by waggon, sledge and boat, on horseback and on foot, and later by the comparative comfort of carriage or coach. Mode of transport, size of entourage and the material comfort of lodgings depended upon the social status of the traveller.

A network of inns – of highly variable quality according to contemporary travel accounts – provided beds, food and drink for weary travellers. These later eighteenth-century bills from the Blathwayt family collection show sums spent at inns while travelling in Yorkshire (figs 62 and 63). There was evidently a disparity in terms of the types and quality of victuals provided for the family and for their servants; provisions for the latter were itemized separately under the heading 'Servants Eating and Liq[uid]'.

The nest of three silver beakers and caster, with domed cover inscribed 'Ralph Lord Hopton's Little Kitchin of Silver Plate', was purposefully designed for an owner 'on the go' (fig. 61). The drinking vessels could be stacked, a highly convenient design for a traveller.[1]

The beakers' scratched and bruised surfaces and the distortions to the outer cover attest to this having been a well-used set. Hopton (c.1596–1652) was a Royalist army officer, created Baron Hopton of Stratton in 1643 and Lieutenant-General of the King's forces in 1645.

Hopton was exiled from England following defeat at the hands of the New Model Army at Truro in March 1646 and the silver beakers were almost certainly commissioned while he was travelling across Europe. The largest beaker, c.1645–50, is stamped with the mark of the Parisian goldsmith Pierre Maugin (master 1630).[2] The smaller beakers, c.1649–50, have been attributed to the workshops of the Monten family from The Hague. Following Hopton's death in Bruges in September 1652, the 'Little Kitchin' was bestowed to his chaplain, Richard Watson, fellow of Gonville and Caius College, Cambridge and Headmaster of the Perse School, Cambridge (1636–42). Watson, whose name is inscribed on the largest vessel, bequeathed the nest of silver beakers to Gonville and Caius in 1684. JKT

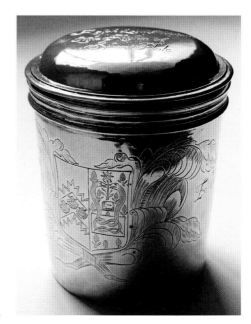

FIG. 61 | CAT. 53

RALPH LORD HOPTON'S LITTLE KITCHIN OF SILVER PLATE

Paris and possibly The Hague | *c.1645–50*

See: Bimbenet-Privat 2002; Hutton 2008; Jones 1928; Mączak 1995; Peacey 2008.

1. Jones 1928, pp. 192–3.
2. Bimbenet-Privat 2002, vol. 1, pp. 443–4.

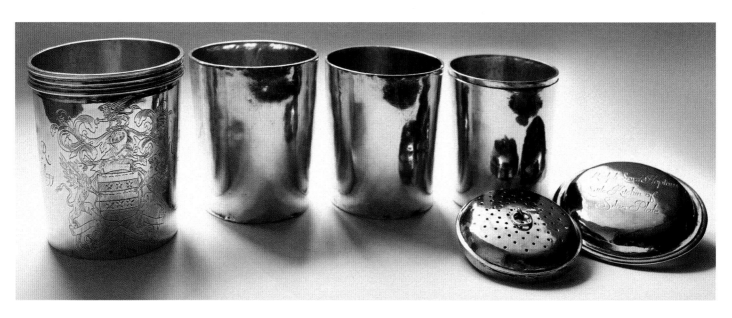

see fig. 61

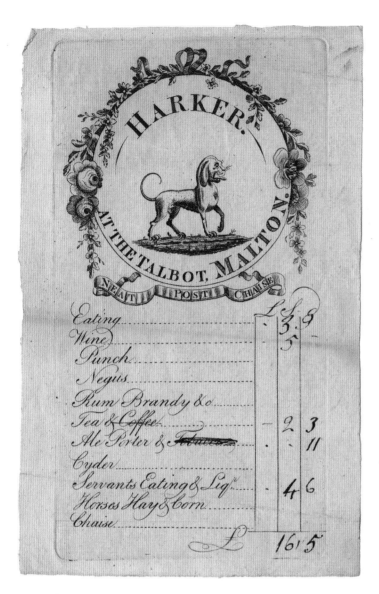

FIG. 62 | CAT. 63

TRADE CARD OF HARKER

The Talbot, Malton | *c.*1765–80

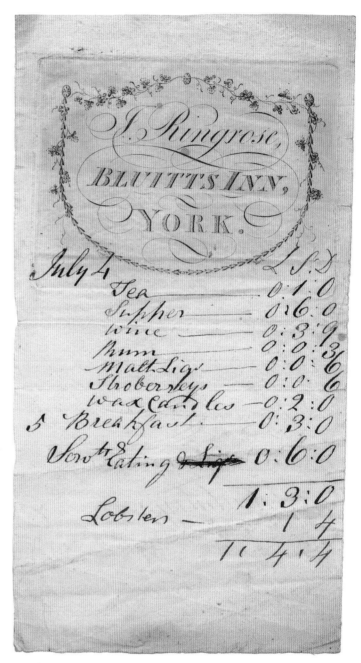

FIG. 63 | CAT. 64

TRADE CARD OF JOHN RINGROSE

Bluitt's Inn, York | *c.*1786–90

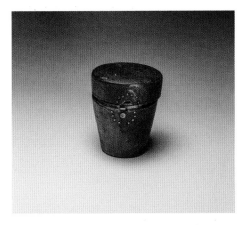
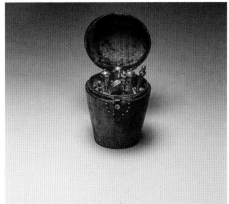
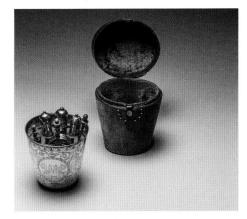
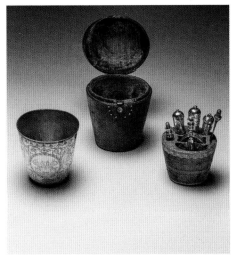
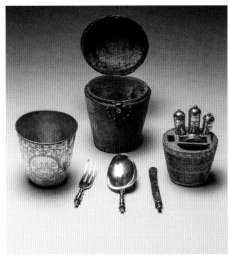
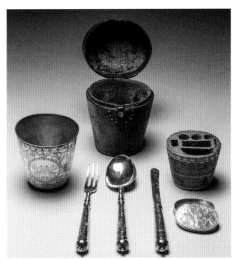

FIG. 64 | CAT. 55

TRAVELLING CANTEEN

Thomas Townley, London | c.1685

Luxury travelling equipages containing
a personal set of cutlery were designed for
fastidious nobles suspicious of the lack of
cleanliness at inns and post houses. Nestling
within a (once-lockable) robust shagreen case
is a silver beaker, inside which is a snugly fitting
removable holder with slots for a small silver
spice-box, steel-bladed knife, fork and spoon
– everything necessary to ensure refined and
hygienic eating and drinking when 'on the go'.
To make the 'canteen' as compact as possible,
the cutlery has detachable handles. The inside
of the case and outside of the cutlery-holder
are covered in matching green velvet, adding
luxury but also providing padding to protect the
delicately engraved dining implements.

The beaker's decoration is especially elabor-
ate, with scrolling foliage, seated putti hold-
ing flowers and birds, and a roundel with the
monogram 'JEM', presumably the initials of
the original owner. Its underside is inscribed:
'The Guift [sic] of The Hono[ura]^ble Lady
Tipping April y^e 15. 1708.' Judging from its
current condition, this was an oft-used but
carefully looked-after canteen, which must
have given sustenance to many a hungry
traveller since the late seventeenth century.
Such canteens remained popular well into
the eighteenth century, as witnessed by the
31-piece silver-gilt canteen made in 1740/1
by the Edinburgh goldsmith Ebenezer
Oliphant for Bonnie Prince Charlie,
seemingly as a 21st-birthday present.[1] VJA

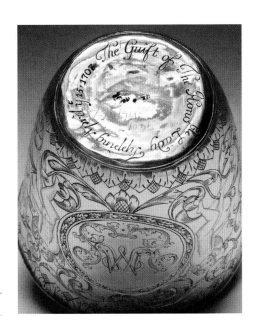

See: Clifford 2002; Hughes 1955.

1. National Museums Scotland, Edinburgh: H.MEQ 1584.

FIG. 65 | CAT. 56

VERGE ALARM COACH WATCH

Thomas Windmills, London | *c.1725*

Made by Thomas Windmills of Great Tower Street, London, *c.*1725, this large and ornate coach watch is a luxury timepiece specially designed for travel. When fully wound, it runs for eight days without the need for rewinding. It also has an in-built alarm feature, essential when 'on the go'. The silvery face allowed the watch to be read by moonlight; in complete darkness, the pull 'repeat mechanism' (below 'VII' o'clock) sounded the time to within a quarter hour: a single chime for every hour, followed by a double chime for every quarter.

As with all watches made before *c.*1760, the balance (which regulates the time) is driven by a verge escapement, which permits accuracy to within five minutes per day.

The watch is protected by a silver case decorated with four *repoussé* cartouches with scenes from Aesop's fables, likely made by Sarah Jaques and John Lee of Angel Court, Snow Hill, London. VJA

See: Britten 1982, p. 648; Grimwade 1976; Koslofsky 2011; Neale 1999.

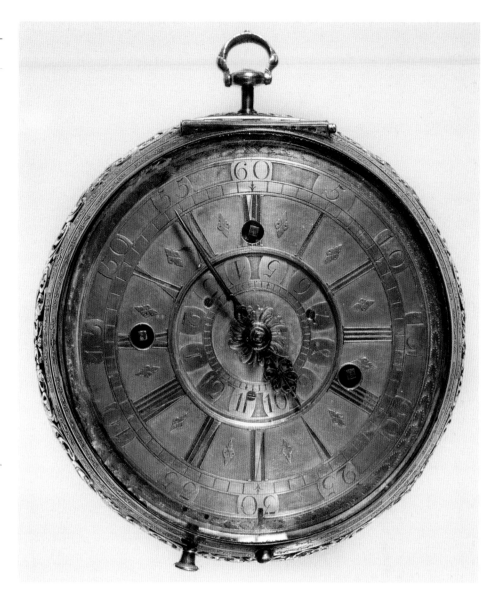

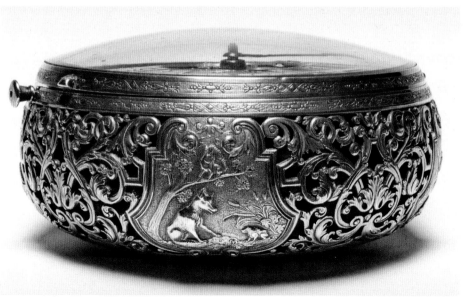

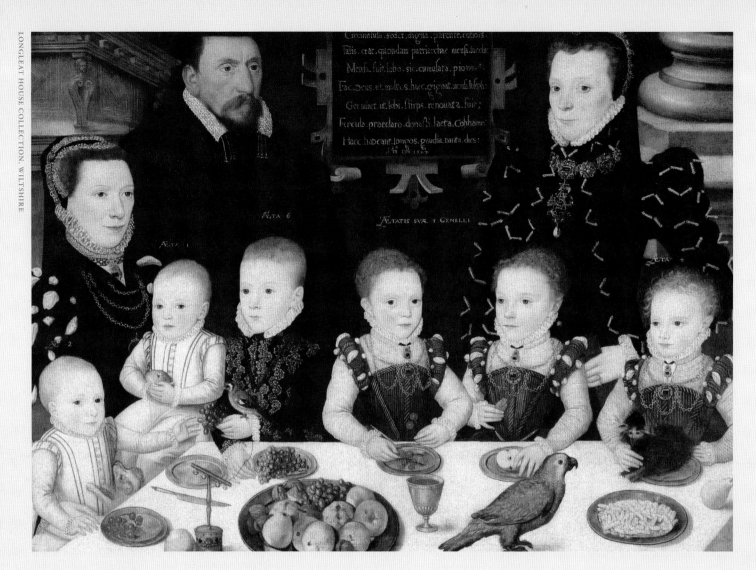

FIG. 66

WILLIAM BROOKE, 10TH LORD COBHAM AND HIS FAMILY

Master of the Countess of Warwick | 1567

TREASURED POSSESSIONS IN TUDOR AND STUART ENGLAND

Alexander Marr

In 1567, William Brooke, Lord Cobham commissioned a fine group portrait to commemorate his dynastic success (fig. 66). Attributed to the Master of the Countess of Warwick, the painting depicts the nobleman with his second wife, his wife's sister, and his six offspring – along with their pets – at a table dressed with elegant cutlery, a platter piled with fruit, and pewter fruit trenchers. In the background are interior furnishings in the modern style: a fluted, classical column on the right and a wooden buffet with *all'antica* ornament and mouldings on the left. The sitters are dressed in clothes which, while of sober hue, are made from fine materials and fashionably cut. The women and the girls are heavily bejewelled – Cobham's wife especially, in her elaborate choker with ship-shaped pendant and her bodice sewn all over with gold aglets, ensuring she rattled delicately when she moved.[1] The Latin inscription in the central cartouche compares Cobham to the patriarch Jacob, the fecundity of his seed to that of Job.[2]

The painting is a perfect example of what we might term the restrained luxury of early Elizabethan England's social elite. The family's wealth and status are clearly signified by the surroundings in which they live, the clothes and jewels they wear, the foodstuffs they consume and the metalware they use to consume them. The emerging penchant for the exotic is denoted by some of the children's pets – the parrot and monkey, for example. Yet these animals – along with the Latin text – alert us to the fact that religion and manners were constant attendants to treasured possessions in this staunchly Protestant nation. From left to right, the small dog in the lap of the young boy signifies Christian aptitude and fidelity, to parents and to God; the goldfinch is a symbol of Christ; the parrot and the monkey – both animals that imitate (although the monkey is also mischievous) – stand for learning, the image as a whole was perhaps informed by Erasmus' recommendation that a meal is the perfect occasion for a lesson in manners and courtesy.

Let us compare this picture of a materially satisfied but godly household to a very different image of consumption from some 40 years later, the opening in 1609 of early Stuart London's latest, swankiest shopping mall: the New Exchange.[3] Ben Jonson's entertainment to celebrate this event – *Britain's Burse* – begins with a speech from the building's porter.[4] Addressing the most important member of the audience – King James VI and I – the 'Key Keeper' jokes about the local multitude's puzzlement over the building's function as it was being raised. Was it to be a bank or a pawn shop? A storehouse or an arsenal? A study, a library or simply 'a fayre front, builte onely to grace the streete'?[5] None of these; it was made for shopkeepers, some of whom 'are come here; and one or two of [th]em are furnish'd. Especiall our China man'.[6] There follows a cry from one of the Exchange's shop-boys: 'What doe you lacke? what is't you buy? Veary fine China stuffes, of all kindes and quallityes? China Chaynes, China Braceletts, China scarfes, China fannes, China girdles, China kniues, China boxes, China Cabinetts, [...] Estrich Egges, Birds of Paradise, [...] Indian Mice, Indian ratts, China dogges and China Cattes?' Here the emphasis, perhaps gently mocking, is firmly on excess and the exotic: on objects fit for a cabinet of curiosities, such as the nautilus shell (possibly engraved in China) and Chinese porcelain bowl, both embellished by silver mounts made by London silversmiths in the later sixteenth century (figs 10 and 73).[7] In Jonson's masque, the 'china-howses about towne' have clearly come to rival the Godly household of the Cobham portrait; the fraught process of the 'demoralization of luxury' that presaged the consumer society of the eighteenth century had begun.[8]

As a plethora of surviving trade cards show, by the middle of the eighteenth century shoppers in England – not only in London but in provincial cities such as Bath and Bristol – could contentedly peruse an abundance of premises to purchase an array of luxury goods and comestibles, chinaware not least among them (see, for example, fig 50). While England's rise to prominence as one of the world's great emporia is often thought of as an eighteenth-century phenomenon, coeval with the acceleration of Britain's colonial enterprise, Jonson's entertainment shows that this trend was already in full swing by the turn of the sixteenth century.[9] The New Exchange was a venture fuelled by

apparent consumer demand: a battery of shops intended to rival Thomas Gresham's Royal Exchange (opened 1571, fig. 67), which had itself challenged the dominance of traditional shopping streets such as Cheapside, then home to shops of some of London's most eminent jewellers.[10]

The market for treasured possessions that had emerged in the Elizabethan era accelerated under the Stuarts, albeit with notable disruption caused by the civil wars and the Interregnum.[11] It was characterized by an expansion of customers, as the traditional consumers of luxury goods – the aristocracy – were joined by the 'middling sort'. These were merchants and other professional classes with increasing disposable income, who availed themselves of an ever-growing variety of things to buy and places in which to purchase them.

The opening of new trade routes, both west and east, eased the flow of exotic goods into the English market, while an influx of skilled foreign artisans (mostly religious exiles from continental Europe) brought innovations in techniques, new products and a sharpening of quality – not to mention competition with local tradesmen. However, while it is tempting to see the growth of consumerism in pre-Georgian England as driven both by foreigners and foreignness, non-native materials, techniques and motifs were often intricately entangled with local forms and traditions. From the Elizabethan silver mounts on an Iznik jug to chinoiserie ornamentation on a pair of classicizing, late Stuart sconces, the story of high-end English goods in this period is marked by hybridity (figs 11 and 199). While there are many facets to the material culture of Tudor and Stuart England – popular subjects and modes of decoration, for example, or everyday objects – this essay considers the mingling of foreign and indigenous techniques, styles and materials as a response to and driver of habits in the consumption of luxury goods.

The large-scale immigration of Huguenots into England, especially London, that took place throughout the second half of the sixteenth century was perhaps the greatest spur to the production of luxury commodities. Religious refugees, many of them skilled artisans, arrived in their thousands, bringing with them advanced techniques in all manner of arts and crafts. The 'returns of aliens' for the period from the reign of Henry VIII to that of James VI and I record a plethora of artisans with highly specialized skills: 'agate cutters', 'glasiers', 'gold-wire-drawers', 'locket-makers' and 'pot-painters', to name but a few.[12] Many were clustered together in particular neighbourhoods, such as Blackfriars or Southwark (then in Surrey), just over the river. Living cheek-by-jowl provided ample opportunities for collaboration and the sharing of skills and knowledge. For example, in 1571, the locket-maker William Canwey was registered in the Old Bailey quarter as a neighbour of the goldsmith Peter Oliver, father of Isaac Oliver, who went on to become one of the period's most successful painters of portrait miniatures (which were frequently worn in a locket) (fig. 144).[13]

While many of these London immigrants found employment in the businesses of established, indigenous masters, some struck out on their own, seeking to stimulate a market for novel wares through their unique skills. A good example is the production of *façon de Venise* glassware. This was a highy desirable commodity synonymous with elegance and refinement, the popularity of which had been growing gradually in England since the beginning of the sixteenth century.[14] By mid-century the market was evidently big enough for the French glassmaker Jean Carré (who had previously plied his trade in Antwerp) to establish a furnace for the manufacture of Venetian-style wares in London, a licence for which he obtained in 1567. In 1570, Carré employed the Venetian Jacopo Verzelini (also previously of the Antwerp trade), who took over the premises on Carré's death, growing the business into a monopoly. As Sir Hugh Platt wrote in 1594, 'For want of Glasses with broade skirts […] I doe think there are enough to bee had if you can be so gracious with master Iacob of the glashouse.'[15]

Only a handful of Verzelini's wares have survived, among them a goblet dated 1578 that is traditionally attributed to him (fig. 68), with diamond-point engraving probably by the Frenchman Anthony de Lysle – another immigrant, described in 1583 as a 'graver in puter [pewter] and glasse'.[16] While the shape and the material of Verzelini's glass are in certain respects 'foreign' – appealing to period consumers in part for this very reason – de Lysle's engraving would have been rather more familiar to English consumers. While de Lysle's decoration could not be described as natively English per se (his repertoire is generically pan-European), the glass's hunting scene with hounds chasing a unicorn, and its bands of scrolling foliate ornament are not dissimilar to the types of patterns employed in traditional English embroidery of the period (figs 69 and 70). An imitation of Venetian glass made in England by an Italian who had previously worked in Antwerp, engraved by a French émigré using a suite of motifs comparable to English embroidered work, this object indicates the potentially complex genealogy of luxury goods in Elizabethan England.

Chinese porcelain and its European imitations – the blue and white tin-glazed earthenware commonly referred to as 'Delftware' – present comparable, indeed even more elaborate complexities. Chinese porcelain was exceptionally rare and thus highly prized in Tudor England, although it

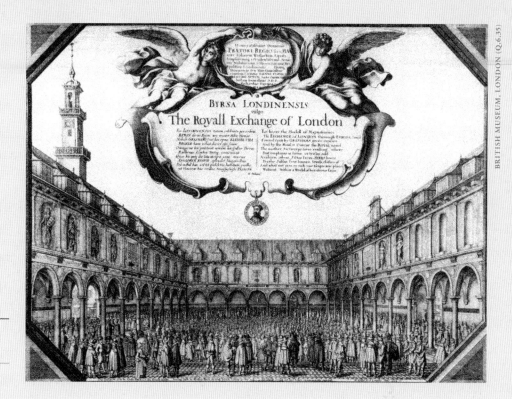

FIG. 67

BYRSA LONDINENSIS VULGO THE ROYALL EXCHANGE OF LONDON

Wenceslaus Hollar, print | 1645–7

FIG. 68 | CAT. 5

GOBLET

Jacopo Verzelini and Anthony de Lysle,
London | *c.*1577–8

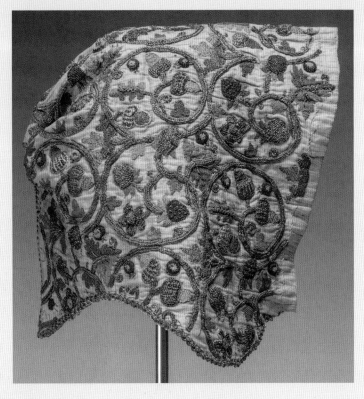

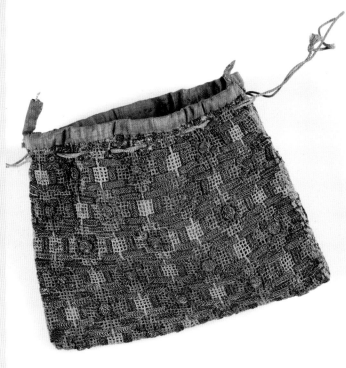

FIG. 69 | CAT. 122

WOMAN'S COIF

English | *c.1575–1625*

FIG. 70 | CAT. 123

PURSE

English | *c.1580–1600*

began to arrive in significantly greater quantities from around 1600 on, so much so that it started to be treated not as a special type of collectable suitable for display, but as ordinary tableware.[17] In the Elizabethan era, however, those few pieces owned by the elite – often given as gifts – were proudly displayed as curiosities.[18] Recording his visit to the famous curiosity cabinet of Walter Cope, the Swiss traveller Thomas Platter described 'an apartment stuffed with queer foreign objects in every corner, and amongst other things I saw there, the following seemed of interest [...] 25. Artful little Chinese box. 26 earthen pitchers from China [...] 33. Porcelain from China.'[19]

Cope's collection was unusual for the number of pieces of Chinese ceramics he owned, but also because it seems as though his porcelain was displayed unmounted. By far the majority of Chinese porcelain objects owned by Elizabethans were embellished with silver mounts made by local silver-smiths in a European, classicizing style (fig. 73).[20] To a certain extent, mounts were added to signify the preciousness of the porcelain piece, as is presumably also the case with other mounted 'exotic' wares of the period (fig. 11). However, since cheap stoneware vessels that were imported in their thousands from the Rhineland were also mounted in silver (fig. 83), preciousness and rarity were evidently not the sole factors. Rather, the mounting of ceramic objects was a broad fashion, popular until at least 1580.[21]

From the turn of the century on, as Chinese porcelain became more widely available, the fashion for mounting wares in silver diminished. Concurrently, there was a massive expansion in the pro-duction and consumption of European imitations of porcelain made from tin-glazed earthenware. This 'Delftware' – so-called because Delft was a major centre of production – was already being imported into England in some quantity by the end of the sixteenth century and remained popular well into the eighteenth century (figs 205, 208 and 209). Indeed, certain passages in Jonson's *Britain's Burse* suggest that Delftware was so plentiful by the first decade of the seventeenth century that the word 'Dutch' had become a term of abuse in relation to porcelain or porcelain-style products. In response to the cry of the shop-boy we encountered earlier, Jonson has the 'Master' of one of the New Exchange's shops criticize other 'china houses' with the words 'what ha' they? [...] Trash? Dutch trenchers? A fewe of these dishes counterfayte? you'll fayrely giue me creditt now. Not a peece of Pursla[ne] about this towne, but is most false and adulterate, except what you see on this shelfe. [...] Here is a peece of it now; tra[ns]lucent as Amber, and Subtler then Christall.'[22] Given such a

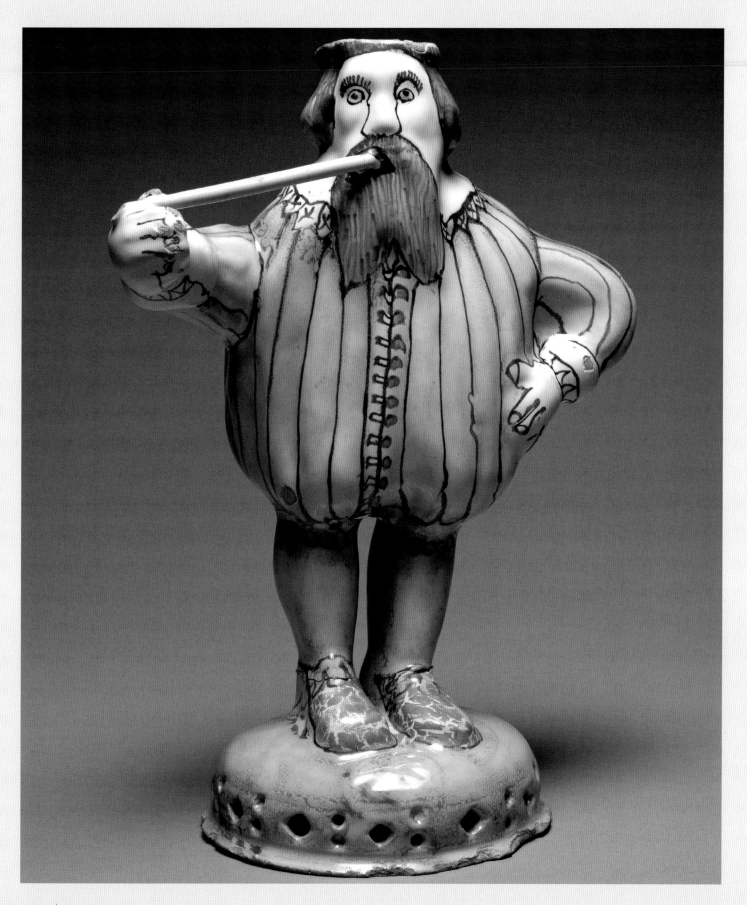

FIG. 71 | CAT. 79

NOBODY SMOKING A PIPE

Probably Brislington, Somerset | 1675

statement, it is not unreasonable to think that a culture of connoisseurship had emerged around the consumption of chinaware by the first years of the seventeenth century.

Yet if the audience for Jonson's masque was concerned about 'counterfeit', substandard European imitations of true Chinese porcelain, by mid-century the mingling of Chinese and European forms and decoration had become standard and accepted – desirable, even. At Southwark's Pickleherring Pottery, tin-glazed earthenware that blended Chinese and European forms and motifs was being produced as early as the 1620s (fig. 72).[23] By the second half of the seventeenth century idiosyncratic English object-types, such as puzzle jugs, were being rendered as blue and white Delftware with Chinese-style decoration (fig. 87).[24] Figurines of stock characters from popular culture started to be produced in English tin-glazed earthenware (fig. 71).[25] What had begun as an imitation of both an exotic material *and* an exotic style had – by the last quarter of the seventeenth century – become thoroughly native.

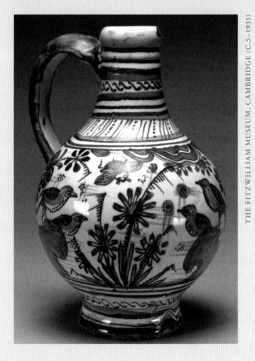

FIG. 72

WINE BOTTLE

Pickleherring Pottery, Southwark
tin-glazed earthenware | 1628

1. On elite clothing in the period, see, for example, Reynolds 2013. The slashing of the bodice of Lord Cobham's sister-in-law, Johanna Newton, may be compared to that of the leather slashed shoes (fig. 125).
2. Hearn 1995, pp. 99–100. See fig. 259, a similar, but significantly later, family portrait lacking the religious overtones of the Cobham group.
3. On the material aspects of the 'godly' household in the period, see Hamling 2010.
4. On the founding of the New Exchange and its role in London's luxury goods market, see Peck 2005, pp. 42–61.
5. Knowles 1999, p. 133. Inigo Jones produced a design for the New Exchange, but the finished building differed from the drawing, now in Worcester College, Oxford. See Stone 1957. One wonders whether the remark about the implicit uselessness of 'a fayre front' could be a jibe at Jones, indicative of the growing tensions between the then collaborating poet and designer.
6. Jonson's use of the phrase 'China man' to denote a seller of porcelain as opposed to a native of the country is notable. The OED states that the use of the word 'China' to mean either 'China-ware' (i.e. goods from China) or porcelain was introduced only later in the seventeenth century (1634 is the earliest occurrence given). Yet this meaning was clearly in circulation in the Elizabethan period. For example, in the English translation of Cesare Federici's account of his journeys in the East Indies we find the phrase 'peeces of China'. Federici 1588, p. 11.
7. Although rediscovered only recently, there is a growing body of literature on Jonson's masque, which questions whether he intended the entertainment's praise of luxury goods to be an unironic endorsement of commerce or a satirical commentary on the anxieties surrounding consumption in early Stuart London. See Baker 2005; Scott 2006.
8. See Peck 2005, p. 347. For Jonson's masque in the wider context of London's commercial expansion, see, for example, Archer 2000.
9. The foundational work arguing for a re-evaluation of the earlier period as seminal for the development of a consumer society in England is Fisher 1948. Most recently, see Peck 2005.
10. As Peck notes, the New Exchange did not initially live up to commercial expectations, although it became profitable in later years. On Cheapside's trade in the period, see Forsyth 2013.

11. Even scholars keen to stress continuity in patterns of consumption across the seventeenth century acknowledge the 'divide' of the civil wars and the Interregnum. See, for example, Peck 2005, p. 2.
12. Kirk and Kirk 1900–8. On immigrant artisans in the period, see, for example, Luu 2005. For the sharing of expertise in these communities, see Mitchell 1995; Harkness 2007.
13. Kirk and Kirk 1900–8, vol. 1, p. 425. On Isaac Oliver, see, for example, Finsten 1981.
14. See Willmott 2004.
15. Hugh Platt, *The Jewell House of Art and Nature* (1594), quoted in Willmott 2004, p. 278
16. Kirk and Kirk 1900–8, vol. 2, p. 309.
17. Glanville 1990, p. 342; Pierson 2007, pp. 19–32, who notes that towards the end of the sixteenth century a fair quantity of Chinese porcelain came into the West Country as a result of Sir Francis Drake's piracy.
18. While several pieces of Chinese porcelain were given as gifts to the highest-ranking members of Elizabethan society, such as Lord Burghley, it is notable that the only gifts described using the word 'China' in the Queen's New Year's Gift Rolls are fabrics. Lawson 2013, nos. 97.76, 97.195, 99.175, 00.92 and 00.133.
19. Williams 1937, pp. 171–2. On the cabinet of curiosities in early modern England, see, for example, Swann 2001.
20. Glanville 1990, pp. 342–51.
21. Glanville 1990, pp. 329–39.
22. Knowles 1999, p. 134–5. As part of this section of his speech, the Master discourses on the type of clay and firing required to make 'genuine' porcelain: Ibid., p. 135. On early English curiosity about the processes and materials of making porcelain, see Pierson 2007, pp. 21–2.
23. Archer 2013, p. 221. Compare the slightly later, simpler 'claret jug' (fig. 84), which retains the blue and white colour scheme of Chinese porcelain but which does not bear any hint of Chinese decoration. On the Pickleherring Pottery, see Tyler et al. 2008, pp. 26–59.
24. Similarly, Chinese porcelain bowl-shapes were now being made from traditional European materials such as silver (fig. 100).
25. Compare Snodin and Styles 2004, p. 84, figs 29 and 30. Strikingly, as Archer notes, two other near-contemporary figures of 'Nobody' seem to have been originals for identical Chinese porcelain copies made for the export market. Archer 2013, p. 339.

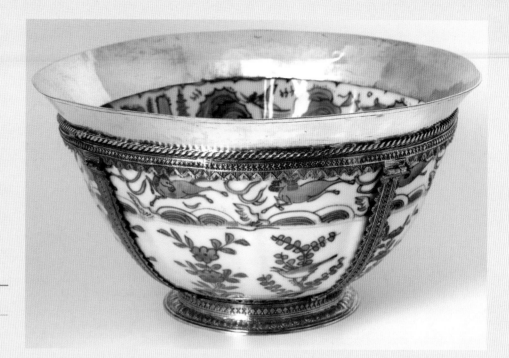

FIG. 73 | CAT. 9

LOBED BOWL

Jingdezhen (with English mounts)
*c.*1580–1600

This bowl is a particularly fine example of late Ming blue and white export porcelain produced in the provincial kilns at Jingdezhen (Jiangxi province) during the reign of the Wanli Emperor (1572–1620) until about 1640.[1] Known as *kraak* porcelain (probably after the Dutch word 'carrack', meaning a Portuguese galleon that traded with the East Indies),[2] it was the first type of Chinese export ware to reach Europe in bulk, initially via Portuguese traders and subsequently via the Dutch East India Company (VOC).[3] Impervious to water, unlike other luxury imports such as textiles or spices, *kraak* was used as ballast cargo, and has been discovered in great quantities in shipwrecks.[4] The inspiration behind certain types of Imari porcelain (made at Arita, Japan), Persian Safavid blue and white ceramics and Dutch and English Delftware pottery, *kraak* porcelain features prominently in seventeenth-century Dutch still-life paintings of exotica (fig. 228), and was often fitted with fashionable silver-gilt mounts, as here, to protect its edges and increase its preciousness.

Although not of imperial quality, this bowl is thinly potted and vigorously painted, and is of a much higher quality than many Chinese export ceramics, such as contemporary *swatow* ware (fig. 13) or *kraak* ware of the 1630s and 1640s. Indeed, its glazed recessed base bears the good wish mark *fu gui jia qi*, proclaiming it to be a 'fine vessel for wealth and honour', which appears on very few examples.

Its basic shape with high foot-ring and high, slightly flared sides is typically Chinese, but its bracket-lobed rim and sides moulded in low relief with ten slightly lobed panels are not. Similarly, its decoration has been modified to suit Western taste. While the motifs are typically Chinese (rocky landscapes with pagodas and banners, birds perched on flowering branches, floral sprays and horses leaping over crested waves and flames) and also include specific Buddhist auspicious emblems (alternating flaming wheels [*chakras*][5] and *ruyi*-heads), their specific placement on the bowl (repeating designs arranged in radial segments and distinct horizontal bands around a central medallion on the interior) is based on a Western aesthetic.

It is almost identical to 'The Walsingham Bowl' in the Burghley House collection, fitted with silver-gilt mounts dating to *c.*1580–1600, traditionally believed to have been presented by Queen Elizabeth I as a christening gift. It also resembles an example in the Danisches National Museum, Copenhagen, with silver-gilt mounts by Jacob Borch dated 1608.[6]

The typically Elizabethan silver-gilt mount of the present bowl's rim is struck twice with an unidentified maker's mark (an 'R' in a tudor rose?) but no date or town mark, and pricked with an unidentified coat-of-arms, presumably that of a former owner. VJA

See: Canepa and van der Pijl-Ketel 2008, esp. pp. 277–80; Cao and Luo 2006; Crowe 2002; Howard and Ayers 1978; Jörg 2001; Ketel 2011; Pierson 2001; Rinaldi 1989.

1. Cao and Luo 2006, p. 21.
2. Likely derived from the Arab word '*qaraquir*' for merchant vessels: see Rinaldi 1989, p. 32.
3. The VOC ship *Vlissingen*, which sailed from the trading post of Bantam (Indonesia) to Holland in 1613, had a cargo of 38,641 pieces of Chinese blue and white porcelain onboard, both *kraak* wares and ordinary Chinese wares (*minyao*): see Ketel 2011.
4. Howard and Ayers 1978, p. 6; Jörg 2001; Crowe 2002, p. 20.
5. A symbol of enlightenment and sovereignty, the *chakra* (Sanskrit word for wheel) is one of the Eight Buddhist Emblems (*bajixiang*) and an attribute of the Hindu god Vishnu: see Pierson 2001, p. 83, no. 80; and Rinaldi 1989, p. 140.
6. Canepa and van der Pijl-Ketel 2008, p. 279.

THREE

THE IRRESISTIBLE

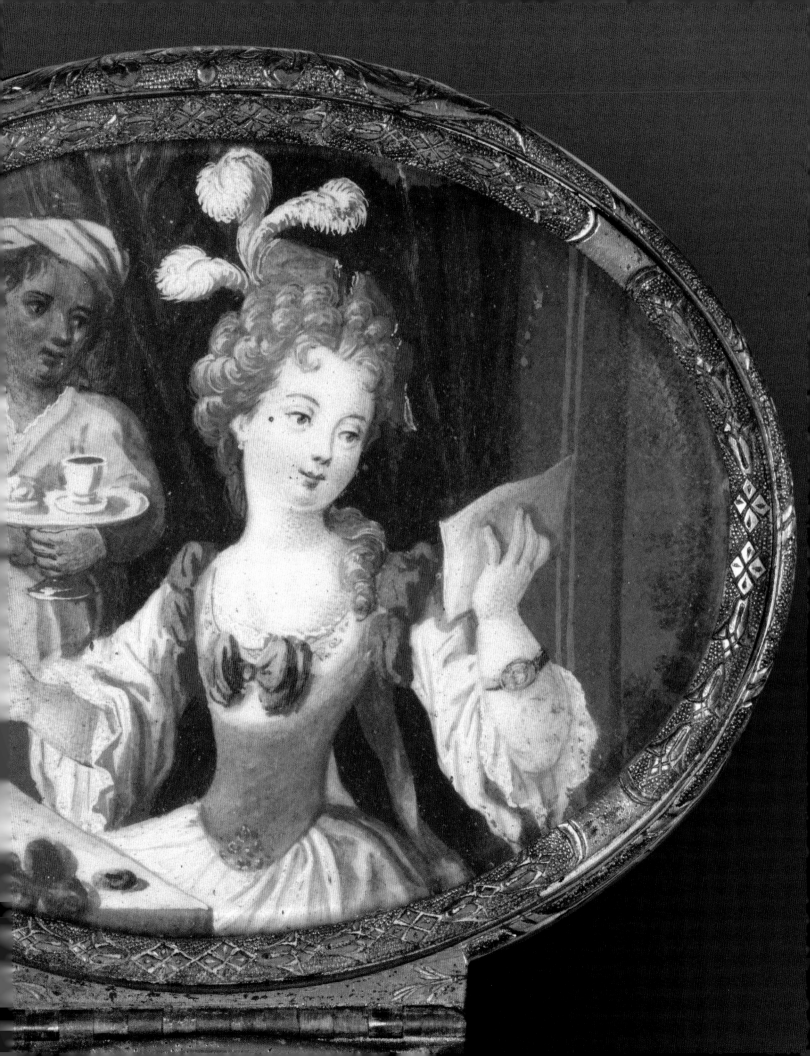

INTRODUCTION

Antonio de Pereda's painting *Still Life with an Ebony Chest*, 1652 (fig. 76) shows a Spanish vision of the irresistible at the middle of the seventeenth century: ebony from Africa, porcelain from China, chocolate and sugar from America, and lustreware from Valencia. The value of these enticing commodities did not only lie with their rarity – the porcelain tea bowl from China – but also with the workmanship required to create some of them – the ebony cabinet, possibly made in the Spanish Netherlands. Their allure also lay in their potential to generate pleasure – the chocolate pot on the left of the canvas, recognizable by the handle emerging from its belly and the *molinillo*, the wooden implement beside it, could transform, with the right knowledge, the cacao paste and sugar, on the right, into a hot frothy chocolate drink so desirable to the Spanish.[1]

De Pereda's image forms part of a tradition of still-life painting from the Netherlands (fig. 2) which was reworked by Spanish painters in the late seventeenth and early eighteenth centuries. This genre reflected ongoing anxieties about luxury, already present in the writings of the Ancient Roman moralists, which were in turn refracted by Renaissance Humanism and Reformation attitudes to consumption in both the Catholic and Protestant worlds. However, these paintings were also a meditation on the joys of living 'in the here and now', hence the beauty in the shine of an ordinary pewter plate, the chipped lip of a treasured earthenware jug, the prospect of biting into one of the *melindros* or soft biscuits nestled in the waxed paper.

Although the irresistible could also be the ordinary, it was inextricably tied up to the expansion of Europe and European contact with the wider world. In seventeenth-century Barcelona, there were 54 varieties of tobacco and 45 varieties of sugar sold in the city's *adrogueries* or grocers, and their names often denoted where they came from – tobacco from Virginia, Havana, England and Brazil, and sugar-loaves from Amsterdam, Marseilles, Venice and the Levant.[2] The irresistible was here attached to the idea of the exotic, which changed constantly in response to the exploration of 'new' worlds. The Medici court desired the colourful and stylized designs of Iznik pottery, and later were the first European connoisseurs of Chinese porcelain.[3]

Contact with America not only brought chocolate and sugar but also encouraged a new interest in the natural wonders of the New World: new plants with miraculous medicinal qualities and exotic animals not recorded in the Bible (such as the macaws in fig. 228) as well as ethnographic artefacts which materialized the religion and culture of its peoples for European collectors. However, the value attached to these new 'exotica' did not always correspond to new knowledge, but sometimes lay in novelty itself. Medici and Habsburg inventories from this period show that 'Indian' was used to describe interchangeably a number of objects from Asia, Africa and America.[4]

The material impact of European expansion is clear. By the end of the eighteenth century, tobacco, chocolate, tea and coffee had all been domesticated by Europeans. This was not an entirely one-way process and it was not uniform throughout Europe.[5] Some Italians, for example, embraced all of the new stimulants at the beginning of the eighteenth century, as this illustration shows (fig. 74), but had largely relinquished tea by its end. Meanwhile, the spread of coffee to the plebeian classes in France and Italy, purveyed by street-sellers (fig. 75), did not leave any significant material culture. Other novelties such as ice cream have been left out of a history dominated by coffee and tea.[6] The topography and chronology of the irresistible remains to be charted, but new social practices, new objects, new behaviours and new social spaces were certainly created for and by the consumption of these new stimulants in Europe, as an early eighteenth-century painting shows (fig. 96).[7] We should not forget, however, that drinking alcohol – ale, beer, wine, punch and port – did not become less irresistible, but even a mid-eighteenth-century ale jug decorated with European figures dining and drinking could have a border pattern inspired by Oriental blue and white porcelain (fig. 79).[8]
MTC

See: Berg 2005; Brennan 1988; Calaresu 2013c; Cowan 2005; Garcia Espuche 2010; Keating and Markey 2011; Kumin 2007; Norton 2006; Norton 2008; Schmidt 2011; Spallanzani 1978; Spallanzani 1994; Spary 2012; Withington 2011.

1. Norton 2006, and, on the painting by de Pereda p. 685.
2. Garcia Espuche 2010, pp. 418–20 and 592–4.
3. Spallanzani 1978 and 1994.
4. Keating and Markey 2011.
5. Norton 2006.
6. Calaresu 2013c.
7. Berg 2005, chapter 6; Cowan 2005; and Norton 2006.
8. Brennan 1988; Kumin 2007; and Withington 2011.

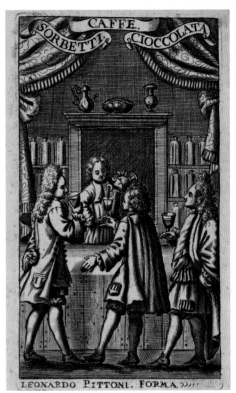

FIG. 74

SORBETTI, CAFFE, CIOCCOLATA

Frontispiece of Domenico Magri's *Virtù del caffè: bevanda, la più salutisera, e la men conosciuta ...*, Venice | **1716**

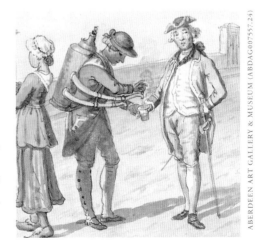

FIG. 75

PONT NEUF, PARIS [detail]

From *A Collection of Dresses by David Allan Mostly from Nature*, **pen, ink and watercolour on paper** | **1776**

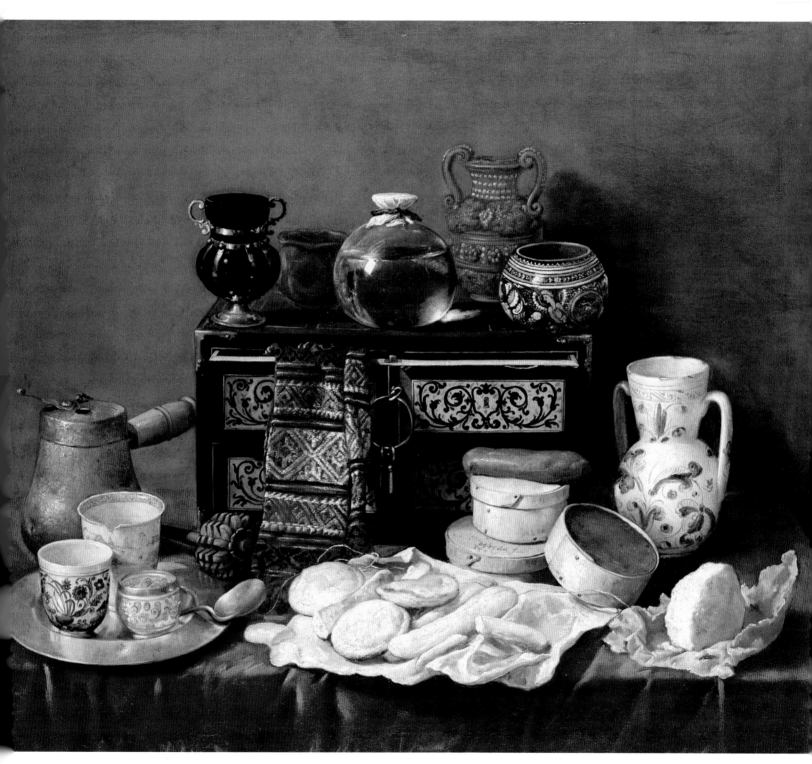

FIG. 76

STILL LIFE WITH AN EBONY CHEST

Antonio de Pereda y Salgado
oil on canvas | 1652

ALCOHOL

A small boy in a fancy costume raises his almost-full beer glass to toast the viewer (fig. 77), a teenage girl heady with wine and love waves an empty glass in the air while her companion takes a break from his beer to puff on his pipe (fig. 78), and, on the front of a jug (fig. 79), a winged cherub descends from heaven with a punch bowl, presumably to sustain the guests at a large family meal. Whether home-brewed or purchased, alcohol was a fundamental part of daily life and was consumed by all, irrespective of gender, age, rank or wealth. It was imbibed with food and between meals, alone and in company, at home, in public inns and post-houses (figs 62 and 63), during corporate or civic functions (fig. 81), out in the field and on the road (figs 61, 64 and 88). In addition to celebrating and commemorating birthdays, marriages (figs 189 and 207), anniversaries, saints' days, military and political victories, good harvests (fig. 192), successful hunts (figs 89 and 90) and business ventures, alcohol was consumed to prove bravura in drinking games and contests (fig. 87), to cure ailments and to obliterate pain.

While liberality in offering alcohol was admired, moderation and personal restraint were also valued, as is seen in the late sixteenth-century silver-gilt tankard where Temperance (rather than Faith) accompanies Hope and Charity (fig. 23).

Excessive drinking, deemed to lead to debauched and lascivious behaviour, was disdained in principal if not in practice. 'The English are too apt to reproach Foreigners, particularly the Germans and Dutch with the vice of Drunkenness, yet none are more guilty of it than them-selves' remarked one commentator in 1730.[1]

Alcohol took many forms: ale and strong beer or 'white ale' and 'small' beer (the low-alcohol equivalents brewed over a very short period) were drunk especially by the 'middling sorts' and poor as a safer alternative to water. Wine (red, claret or white) was consumed by the more affluent, and port, sherry, rum and gin were all very popular. Small quantities were included in pick-me-ups, such as caudle or posset (figs 189 and 207); copious quantities were combined to create intoxicating cocktails, such as punch, a foreign import based on Arrack (a raw spirit from Goa or Batavia), which became popular in the 1680s and was often drunk to excess. Although one could, of course, serve and drink alcohol from any container one had to hand, changing fashions influenced the material from which a vessel was made, as well as its shape and decoration.

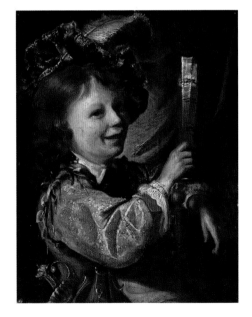

FIG. 77 | CAT. 58

A BOY DRINKING

**Cornelis Picolet, Netherlands
mid-17th century**

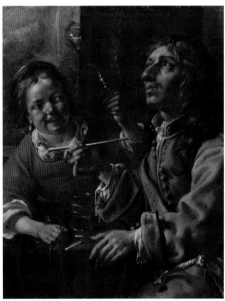

FIG. 78 | CAT. 57

SOLDIER WITH A GIRL

Jacob A. Duck, Netherlands | *c.1650–60*

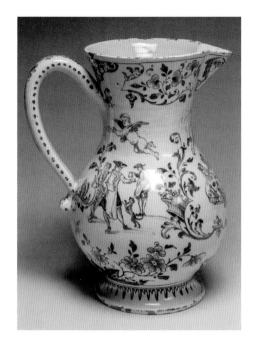

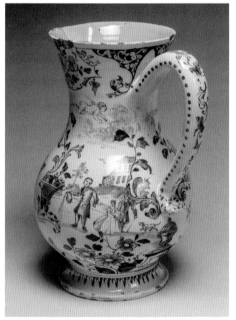

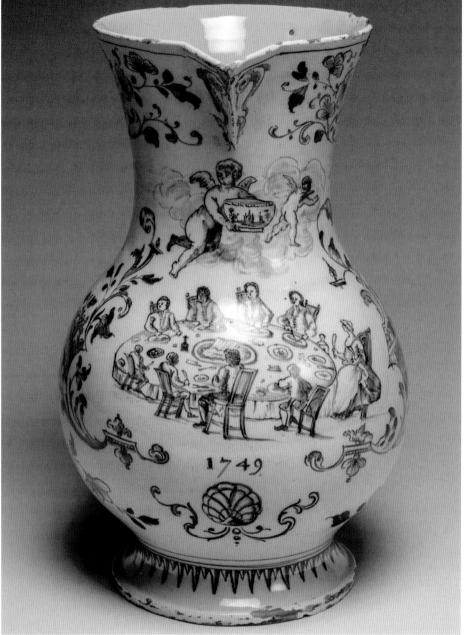

FIG. 79 | CAT. 68

JUG

London or Bristol | 1749

For those with sufficient disposable income, it was important to keep up with such trends. Thus, William Harrison, in his 1586 *Description of England*, observed how the aristocracy now preferred to drink wine and beer from *cristallo* glasses rather than precious metal ones, and how social climbers followed suit: 'It is a world to see in these our days, wherein gold and silver most aboundeth, how that our gentility, as loathing those metals (because of the plenty) do now generally choose rather the Venice glasses, both for our wine and beer […] And as this is seen in the gentility, so in the wealthy communalty the like desire of glass is not neglected.'[2]

However, it was not only the rarity of crystal glass that made it so desirable: its lightness made it a pleasure to pick up, its clarity and transparency permitted the colour of the wine to be admired, its non-metallic composition allowed the liquid's taste and smell to be properly appreciated, and it did not retain odour or taints. It was this demand for elegant glassware that encouraged Venetian artisans to leave Murano and set up glasshouses in other cities, where they made glasses *á la façon de Venise*: one such was Jacopo Verzelini, who moved to London in 1571 (fig. 68). Further experiments led to the invention of lead glass by George Ravenscroft in the 1670s; imitating rock crystal, this glass was clearer and more lustrous than *cristallo*, as well as being stronger, heavier and more robust. The first lead glasses continued to emulate the delicate forms of Venetian models, as can be seen in the elaborate ceremonial cup (fig. 81), but more simplified designs were rapidly adopted to compensate for the slower setting time of lead glass. Baluster stems with large 'knops', modelled after contemporary furniture, were the new fashion. Later still, straight stems were developed, incorporating bubbles, 'air twists' – as in the elegant ale glass with its long tapering bowl (fig. 80) – or coloured glass, as seen in the small wine glass, perhaps intended for female use (fig. 82), whose curving bowl has been engraved with sprays.

Although glass was the material of choice for luxury wine and ale glasses and decanters, silver continued to be used for certain types of wine vessel, such as ecclesiastical chalices, ceremonial standing cups, 'welcome cups' and loving cups, as well as for paraphernalia such as 'monteiths' (bowls used for cooling or rinsing glasses), wine tasters and punch ladles. Silver also continued to be used by the wealthy for beer and ale, being fashioned into lidded flagons, tankards, beakers and jugs (figs 23 and 193). The less well-off used cheaper equivalents made of salt-glazed stoneware (figs 83 and 89), tin-glazed earthenware (figs 79 and 84) and pewter (fig. 86), their shapes often mimicking more expensive models.

Many vessels were produced in bulk for speculative sale and have little or standardized decoration; these would have been relatively cheap and intended for everyday use. Others were commissioned for special events, such as marriages, when they would be decorated appropriately with amorous iconography (hearts, birds, flowers) or expressions of love, and often with the couple's initials and/or coats-of-arms (if they possessed them) and the year of the union (figs 85, 87 and 192). Used only occasionally, these would have been carefully stored away or put on display out of harm's way, and passed down the generations as treasured heirlooms. VJA

See: Hildyard 2002; Liefkes 2002; Newton 2002; Shirley 2002; Winterbottom 2011b.

1. Taken from Winterbottom 2011b, p. 45.
2. Taken from Liefkes 2002, p. 76.

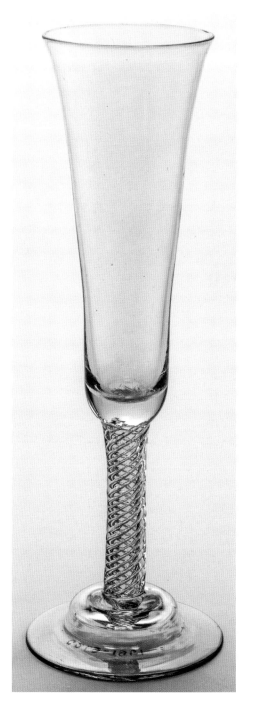

FIG. 80 | CAT. 62

ALE GLASS

English | *c.*1750

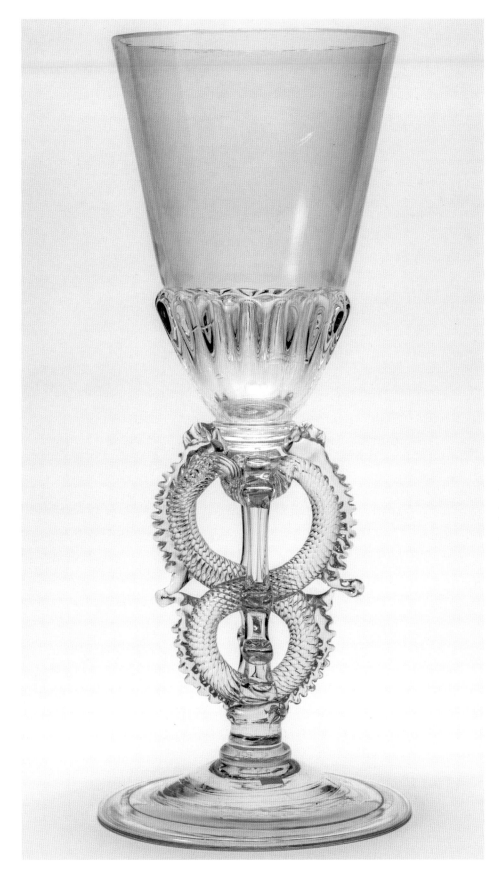

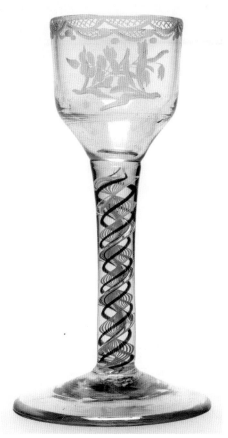

FIG. 82 | CAT. 73

DRINKING GLASS

English | *c.*1765

FIG. 81 | CAT. 72

CEREMONIAL GOBLET

**English, or possibly Norwegian
late 17th century**

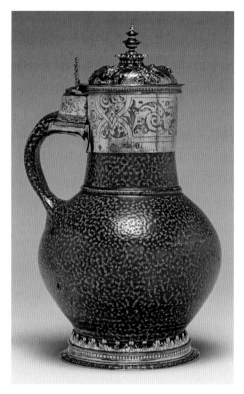

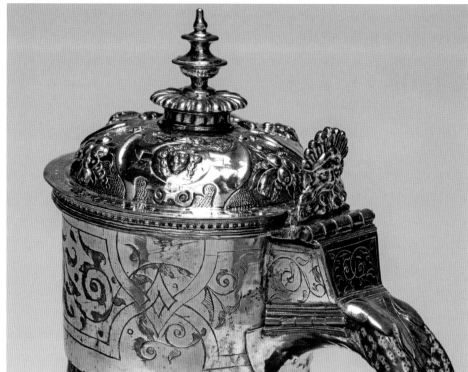

FIG. 83 | CAT. 6

LIDDED JUG OR FLAGON

German, probably Frechen,
with English mounts | *c.1570–77*

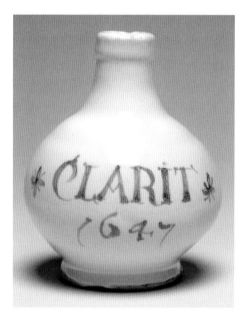

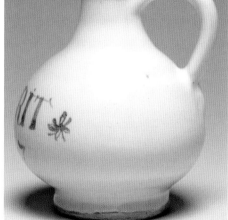

FIG. 84 | CAT. 69

BOTTLE FOR CLARET

Probably Southwark | 1647

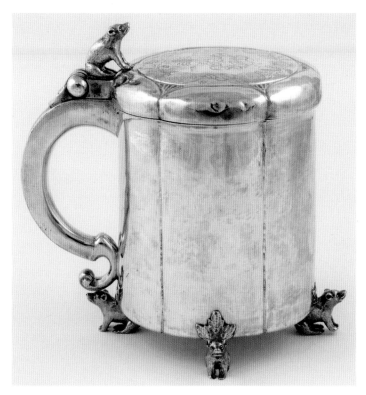
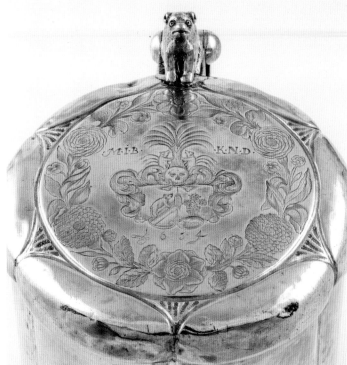

FIG. 85 | CAT. 59

LIDDED PEG TANKARD

Neils Enevoldsen, Copenhagen | 1648

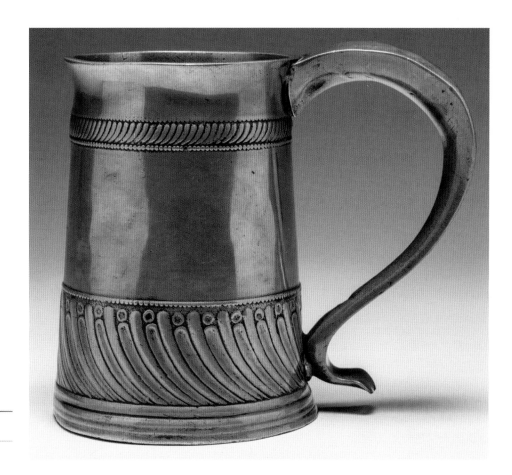

FIG. 86 | CAT. 60

TANKARD

English | early 18th century

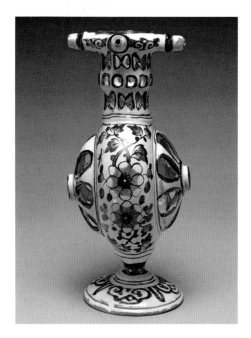

FIG. 87 | CAT. 65

PUZZLE JUG

Probably London | 1686

Drinking games are perhaps as old as alcohol itself; Ancient Greeks recorded them in the fifth century BC. Puzzle jugs were one popular game across early modern Europe.[1] The 'puzzle' was how the player could drink without spilling wine or ale out of the many holes and spouts.

The solution is in the jug's deceptive form. The handle and rim are actually hollow, so to drink liquid from the base the player must suck one spout while covering the rest. This English Delftware jug is trickier than others – to gain suction, the player must close a secret hole under the handle with their finger.

Though usually owned by inns and taverns, this jug is personalized with the date 1686 and the initials of a couple (P over N and M), and may commemorate their marriage. Inside the spoked wheel, hidden lovebirds hint at romance. Blue and manganese-purple Chinese *ju-i* motifs and flowers made this a fashionable possession, as well as an entertaining one. SP

See: Archer 2013, p. 195, no. D.11; Chrzan 2013; Crossley 1993; Glanville and Lee 2007.

1. Crossley 1993.

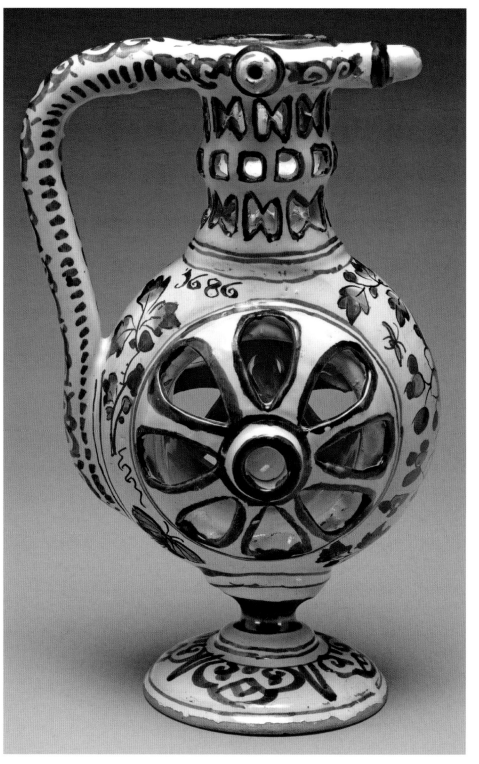

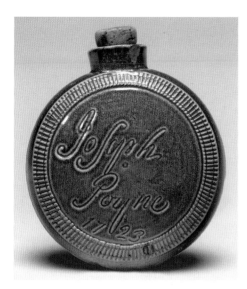

FIG. 88 | CAT. 71

SPIRIT FLASK

Nottingham | 1723

The earliest Nottingham brown salt-glazed stoneware was made in the 1690s by a brick-maker, James Morley. The industry expanded in the early eighteenth century, but because few items are marked it is rarely possible to attribute Nottingham stoneware to a specific pottery. This small brown salt-glazed flask, designed to be used 'on the go', is incised with the name of its owner 'Joseph/Poyne' over the date '1723' and may have been a gift or a commission. Since 'Poyne' is almost unheard of as a surname, but 'Payne' is well known, it is possible that the spelling reflects the accent of the person who commissioned the flask. It was probably used for liquor, such as gin or rum. Judging by the many named and dated examples, Nottingham two-handled cups, mugs and flasks seem to have been popular commemoratives for people unable to afford silver ones. Some cups bear the names of married couples,[1] and other items have amorous sentiments, such as 'My love is pure and shall endure', which appears on a very similar flask initialled and dated 'J.B/1723'.[2] JEP

See: Oswald et al. 1982; Poole 1995b; Rackham 1935.

1. Rackham 1935, vol. 1, p. 159; Poole 1995b, pp. 21–2, no. 21.
2. Oswald et al. 1982, p. 138, pl. 97.

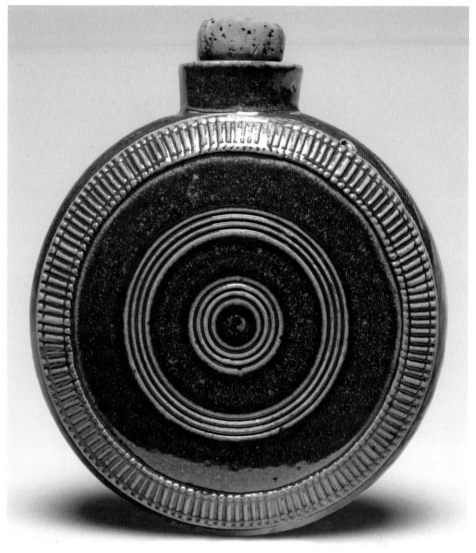

FIG. 89 | CAT. 61

HUNTING MUG

Vauxhall | 1729

In 1686 Richard Blome recorded that hare-hunting was a sport enjoyed by gentlemen and 'men of lower rank' and that 'of all Chase, the Hare makes the best diversion'.[1] The moulded reliefs on this brown salt-glazed stoneware ale or beer mug attest to the continuing popularity of hare-hunting in the first half of the eighteenth century, and to the public's desire to display loyalty to the monarchy, represented by George II (r. 1727–60) and Queen Caroline. The mug also illustrates the influence of hunting and drinking ballads on ceramic decoration.[2] The inscription around the top is from the first verse of John Dyer's song 'Down among the Dead Men', beginning 'Here's a health to the Queen/King'. The mug is one of 57 dated between 1713 and 1744 attributed to the Vauxhall Pottery, near London.[3] Women's names are rarely inscribed alone on these or other hunting mugs. Mary Culliford may have been the widow of John Culliford, a Freeman of the City of London (d. 1727),[4] whose brother, Christopher Bell, was a brewer. The name was also recorded in Bristol. JEP

See: Blome 1686; Foyn 2000; Poole 1985.

1. Blome 1686, Second Part, Chapter XII, pp. 91–5.
2. Poole 1985.
3. Foyn 2000, pp. 265–9.
4. National Archives, Kew, Prob. 116/614/131, Will of John Culliford.

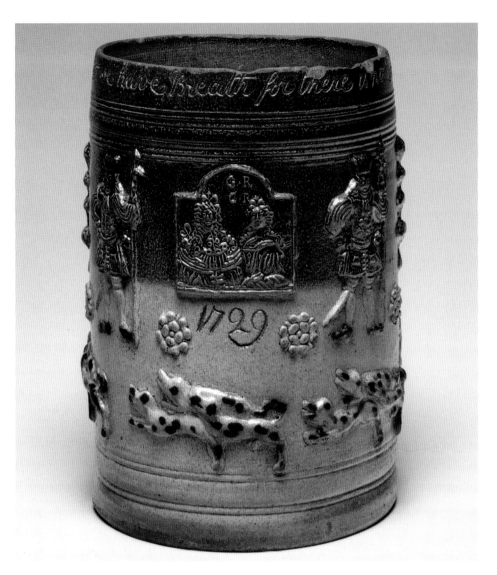

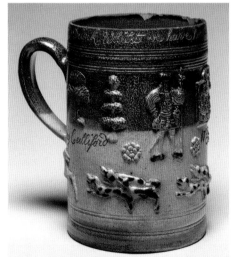

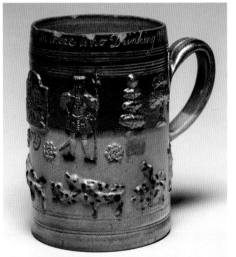

FIG. 90 | CAT. 74

PUNCH BOWL

London | 1758

English Delftware punch bowls survive in large numbers from the early 1680s onwards. This large and finely painted blue and white bowl was probably made at the Lambeth High Street pottery, although it has an inside border of *bianco-sopra-bianco*, a technique used extensively in Bristol. The decoration reflects the increasing popularity of fox-hunting in the mid-eighteenth century,[1] and another English passion – all things Chinese. No incongruity was seen in combining a tranquil Chinese coastal scene on the outside with an English fox-hunt on the inside. Its Rococo-style border incorporates a ribbon inscribed 'Prosperity to Fox Hunting 1758', a toast which also occurs on drinking glasses.[2] The scene is reminiscent of a fox-hunt in the background of *Death of the Fox*, a print by Arthur Sully from *c*.1683–5.[3] JEP

See: Archer 2013, p. 108, no. B.45; Bonham's 2013; Griffin 2007, pp. 124–9.

1. Griffin 2007, pp. 124–9.
2. Bonham's London, 1 May 2013, lot 98.
3. British Museum: 1847,0306.312.

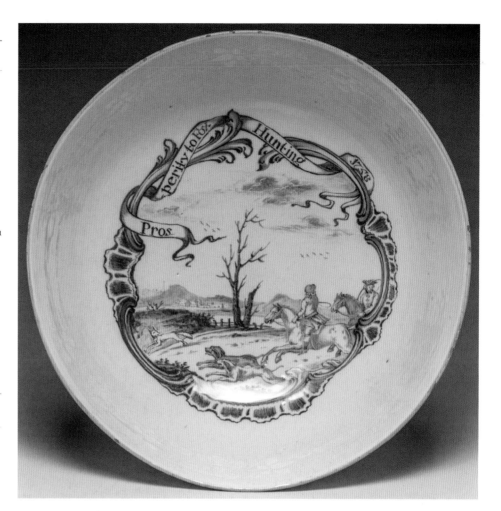

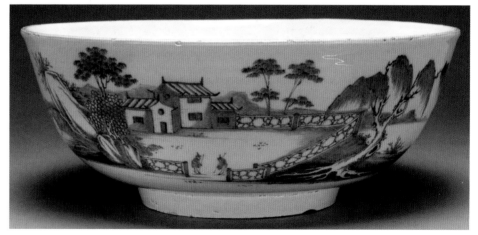

TOBACCO AND SNUFF

One hundred years ago, Mr Hugh Scott began to unearth a number of early modern clay pipes at the bottom of the garden of his house on Millington Road in Cambridge and continued to collect them for the rest of his life. The survival of the well-preserved tobacco pipe from his collection (fig. 91), with its long thin stem of almost 40 cm, small bowl in which to light the tobacco and narrow heel on which to rest the pipe, is extraordinary and unlikely to have come from an archaeological context.[1] By contrast, 8,000 broken fragments of clay pipes from England and Holland were found in an archaeological site from the same period in the Born neighbourhood of Barcelona.[2] Almost half of these were located on the site of a well-known neighbourhood tavern and many of the others at nearby ball courts.[3] The fragility of these pipes, mostly unglazed but sometimes decorated and marked by their makers, was recognized by contemporaries: Dutch merchants sold fifteen for the price of twelve, knowing that some would be broken by the time they arrived in Barcelona.[4] Far more collectible was the elaborate and colourful example, made in the form of a serpent consuming a fish (fig. 92).

While archaeological evidence attests to the ubiquity of pipes in seventeenth-century Europe, smoking also attracted disapproval. A poem written in celebration of the birthday of the boy-king Charles II of Spain in 1669 described chocolate as 'manna' but tobacco as 'mania'.[5] Like chocolate, tobacco was feared and indulged for its transformative properties and association with the New World. In the Dutch Republic, tobacco smoking – unlike the more aristocratic snuff-taking – became associated with low-life and was often depicted in paintings of convivial excess, especially in taverns.[6] Jacob Duck's painting (fig. 78) shows a soldier holding the narrow stem of a pipe not unlike the one from Scott's collection.[7] The ceramic figure of 'Nobody' (fig. 71), also associated with disorder and misdemeanours, sucks on a pipe with a similarly long stem.[8] These plebeian associations are clear in the 'Wee Three Logerheads' slipware dish from Staffordshire (fig. 93), in which one of the 'logerheads' holds an enormous pipe with smoke shooting from its bowl and his companion a glass of ale (while the viewer is understood to be the third 'logerhead').[9] Taverns were not the only place for such activities. In 1659, the Quaker Thomas Curtis described a Baptist meeting in Reading, in which 'every man with his tobacco pipe in his mouth, made such a smoke in the room, that it stunk exceedingly'.[10] MTC

See: Archer 2013; Flood 1976; Gage and Marsh 1988; Garcia Espuche 2010; Gaskell 1997; Miró i Alaix 2010; Norton 2008; Oswald 1970; Scott 1916; Woudhuysen 1988.

1. It is likely that this pipe was bought by Scott after he published his article in 1916 on the Millington Road pipes: Scott 1916. Our thanks to Craig Cessford for further help in identifying this pipe in Scott's collection.
2. Miró i Alaix 2010, p. 231. These ball courts were also sites of prostitution. On *triquets*, see Garcia Espuche et al. 2009 and Garcia Espuche 2010, pp. 472–5.
3. A significant number were also found near the Dutch consul's house, see Miró i Alaix 2010, p. 233. On the Hostal de l'Alba, see Garcia Espuche 2010, pp. 183–6.
4. Miró i Alaix 2010, pp. 231–2. Mr Scott believed that the Millington Road pipes had been broken during their making and were then probably thrown away like the ceramic wig curler found at the same site. Scott 1916, p. 150.
5. Norton 2008, p. 173.
6. Gaskell 1997.
7. The painting by Duck was one of more than 200 mostly Dutch and Flemish paintings given by Daniel Mesman to the Fitzwilliam Museum in 1834, before the building of it was even completed. These complemented the Founder's family's collection of paintings. See Woudhuysen 1988.
8. Archer 2013, pp. 338–9, no. K.12.
9. Poole 1995b, pp. 44–5.
10. The transcription comes from the Friends House Library Swarthmore Transcript, vol. 1, fol. 664. The spelling has been modernized. In this period, radical religious sects like the Baptists were often associated with loose moral behaviours including smoking and other licentiousness. My thanks to Kate Peters for her transcription and advice on smoking Baptists.

FIG. 91 | CAT. 75

TOBACCO PIPE

English | *c.*1680–1710

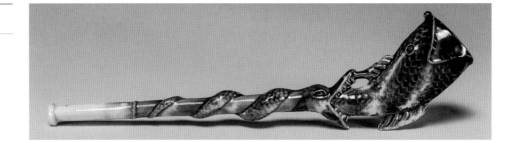

FIG. 92 | CAT. 76

TOBACCO PIPE

Staffordshire | *c.*1750–70

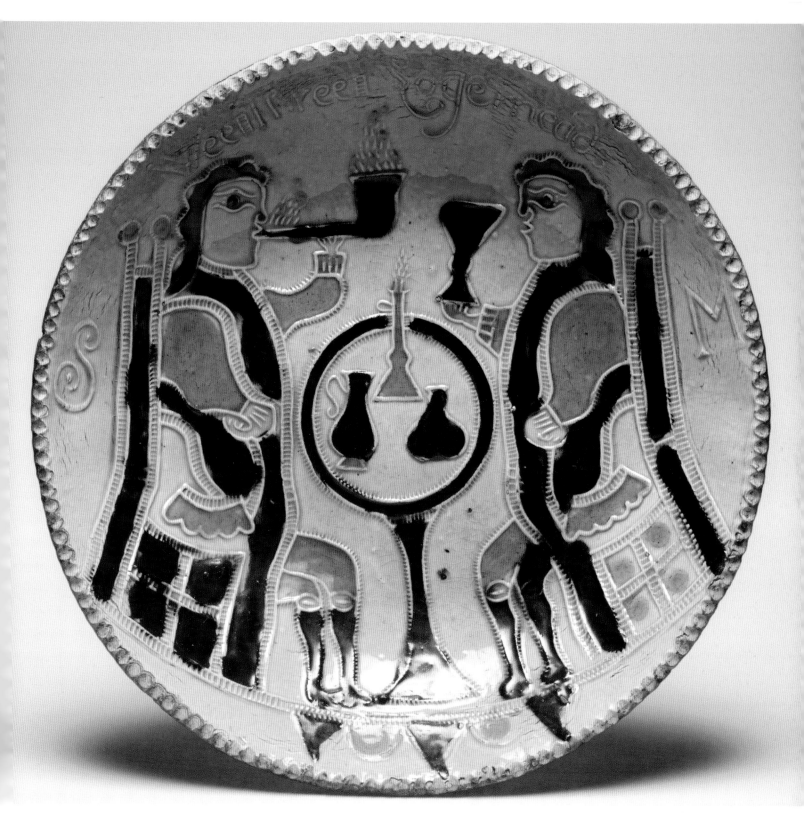

FIG. 93 | CAT. 80

DISH

Samuel Malkin, Burslem, Staffordshire
*c.*1715–30

FIG. 94 | CAT. 77

SNUFFBOX

English | early 18th century (after 1707)

The unknown makers of this tortoiseshell snuffbox used silver plaques of Charles I and his grand-daughter Anne to impart a message of dynastic continuity and legitimacy. After decades of fractured national politics, Queen Anne is presented as the legitimate hereditary successor to the Stuart dynasty. The likenesses of both monarchs were modelled from official medals (that of Anne, for example, after the medal by John Croker struck to commemorate the Union of England and Scotland on 1 May 1707), ownership of which was associated with political loyalty and affection.[1] Between the portrait busts is a plaque depicting the Royal Oak with Charles II and a cherub holding three crowns, symbolic of the kingdoms of England, Scotland and Ireland. A popular royalist story circulated before and after the Restoration, told of how the exiled Charles II hid from Cromwell's troops after the Battle of Worcester in 1651 in an oak tree in the grounds of Boscobel House, Shropshire.

Inscribed 'Thomas Haines', this snuffbox probably belonged to Tom Haines, proprietor of Tom's Coffee House in Devereux Court, London. Coffee houses, in which newspapers and printed religious tracts were widely read and discussed and news disseminated, were central to the development of Restoration and Augustan political culture. JKT

See: Hawkins 1885; Klein 1997; Pincus 1995; Sharpe 2013.

1. Hawkins 1885, vol. 1, p. 350, no. 209 and p. 370, no. 259 (Charles); and vol. 2, p. 299, no. 117 (Anne).

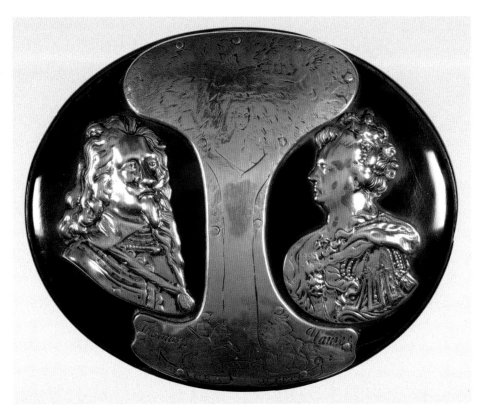

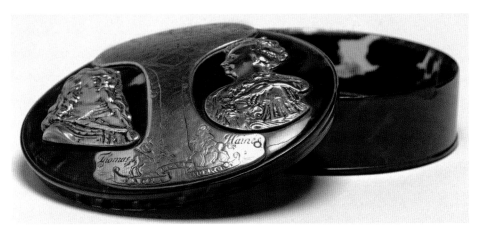

FIG. 95 | CAT. 78

SNUFFBOX

French or English | 1730–60

This palm-size oval snuffbox is the perfect expression of mid-eighteenth-century luxury, fashionability and desire. Made from tortoise-shell with gilt-copper mounts, its exterior is embellished with orientalizing designs in gold piqué work, evoking the exotic. Upon opening the box, the viewer is confronted with a highly stylized representation of an upper-class morning *toilette* on the lid's interior.[1]

Completely absorbed in reading a letter, pre-sumably a love-note from the man portrayed on her enamelled bracelet, the aristocratic woman appears unaware of the young servant bearing expensive and exotic imported luxuries for her delectation: chocolate from Central America (served from a fashionable one-handled silver pot into an equally fashionable white porcelain beaker) sweetened with sugar from the West Indies (served in a matching white porcelain covered basin). In a bright yellow 'Indian' costume, comprising a low turban and tight-fitting robe, the servant would have been interpreted as originating from the East Indies, and considered as exotic as the chocolate and sugar being proffered, and the tobacco from the Americas contained in the snuffbox.

This intimate, almost voyeuristic image, has been carefully set under a protective sheet of glass, secured in place with a gilt-metal mount. Perhaps the gift of a woman to her husband or lover, the snuffbox would have been carried on his person, and every time he opened the lid to take or offer snuff, this secret image would have been revealed. Only a few decades after it was painted, the link between the production of sugar and slavery would shatter such generic and uncritical representations of the exotic; indeed, by the late 1780s, tea and sugar wares were even being made with anti-slavery images on them.[2] VJA

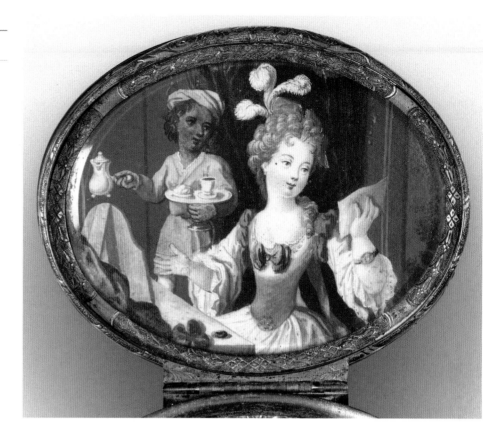

See: Childs 2010; Chrisman-Campbell 2011; Guyatt 2000; Hughes 1971; Le Corbeiller 1966; Murdoch 2014; Murdoch and Zech 2014; Wood 2000.

1. Chrisman-Campbell 2011.
2. In the late 1780s, Josiah Wedgwood mass-produced the jasperware Emancipation Badge for the Society Effecting the Abolition of the Slave Trade (for an example, see Fitzwilliam Museum: c.45-1962) and its central image of the enchained kneeling African male was reproduced on many household wares including plates, tea caddies and tea services: Guyatt 2000 and Wood 2000. See also Childs 2010.

FIG. 96 | CAT. 82

THE MISSES LETHIEULLIER AND CAPTAIN WALKER TAKING TEA AND SNUFF

English | *c.1715*

According to family tradition, this 'conversation piece' portrays two Flemish Huguenot sisters, the Misses Lethieullier of the Manor House, Beckenham (Kent), and Captain Walker, who was apparently engaged to the younger lady seated beside him.[1] The women are dressed in mantuas and matching petticoats - the height of English fashion in the 1710s – as well as pearl chokers and topknots, while the army officer's eye-catching red suit with large lace frill, full-bottomed wig, white gloves and elegant high heels, show him to have been equally fashion-conscious.[2] This small-scale, intimate interior scene (in stark contrast to Grand manner large-scale portraiture popular with the aristocracy) shows the habits of the 'middling sort': seated on tall black ladder-back chairs around a circular ebony tea-table, the protagonists politely take tea and snuff. Behind them is a large fireplace lined with plain white Delftware tiles and embellished with a made-to-measure overmantle painted with a landscape scene.

The sisters' tea-table is decked with all the paraphernalia required by the genteel classes for the ritual of tea: blue and white Chinese export porcelain teaware (tea bowls, saucers, sugar basin and slop bowl), a small unglazed red stoneware teapot, either an import from Yixing, or a European imitation, like those being made at Meissen (see, for example, fig. 102), and a set of matching silver tea spoons (similar to those shown in fig. 117); on a separate round table, within easy grasp of both sisters, stands a silver kettle likely made in England. The specificity with which all of these items have been recorded render them likely to be 'portraits' of treasured possessions owned by the siblings rather than merely studio props supplied by the artist. The fact that until recently this painting was believed to show a Dutch room,[3] proves how similar English and Dutch interiors were at this time, thanks to global trade and pan-European notions of fashionability.

Commodities and habits, previously only affordable and fashionable among the aristocracy became more widely available during the first decades of the eighteenth century, including inhaling snuff – powdered scented tobacco.[4] Believed to have antiseptic qualities, the habit of taking snuff spread across the sophisticated world of Europe's royal and princely courts during the second half of the seventeenth century, having become fashionable at the French court a century earlier, thanks to Catherine de' Medici (1519–89) having acquired it for her sickly son, François II (1544–60), as an antidote to his migraines.[5] In England, the habit became established amongst elite circles during the Great Plague (1665–6), and by the early eighteenth century, it had also become popular with the 'middling sorts'. Commonly associated with male luxury consumption, the habit was by no means exclusively male; women were equally partial to the fashion as shown in this painting.

Snuff was expensive and needed to be kept dry, so it was stored in covered tobacco jars often made in porcelain and finely painted (fig. 169). When required for use, small amounts were transferred to portable, airtight, hinged boxes, normally made in precious materials, like gold, silver, silver-gilt, or tortoiseshell (see, for example, figs 94, 95, 167 and 168). Occasionally, snuffboxes were even incorporated into the top of cane handles (fig. 172). Status symbols *par excellence*, snuffboxes were often extremely elaborate as when not being carried on the body, they were displayed on desks and dresser-tables. They were often given as gifts – between rulers and ambassadors as well as between lovers – and the quality and value of the snuffbox sent a clear message to the recipient.

Gentlemen tended to keep their snuffboxes in waistcoat pockets or, from the 1680s, in separate pockets made of soft leather, silk or quilted linen which were sewn into the seams of loose-fitting breeches. This was preferable to keeping them in their coat pockets where, together with 'snuff napkins' (large handkerchiefs normally 45 to 60 cm square, used to wipe excess snuff from the face, or lain over the shoulders to protect garments from falling snuff) they would have caused an unsightly bulge, ruining the line of their coats and advertising their presence to pick-pockets. Ladies also kept their snuff boxes and other small necessities in separate pockets, which, tied round the waist above the under-petticoat, were accessed through openings in the upper gown.[6]

Taking snuff was just as much a social ritual as taking tea, and using a snuffbox required the same sort of gentility and social competence as drinking tea or manipulating a fan. There is evidence to suggest that, as with fans, there was an international language of the snuffbox, with inevitable national and regional variations: the type of box used, and the manner in which snuff was offered could indicate certain relationships (existing or desired) especially when snuff-taking occurred between the sexes, as it does here. In the painting, the officer has put down his tea bowl and saucer, opened up his silver box and, with his ungloved right hand, now proffers its contents to his fiancée, whilst looking at her most intently. Having also put down her tea cup, she takes a pinch of snuff with her right hand whilst quite deliberately returning his glance. The carefully-rendered gestures and glances in this picture certainly suggest a close understanding between the two parties. The older sister is clearly excluded from this amorous liaison: still drinking her tea, the spinster holds her bowl and saucer in her right hand and clasps the edge of the table with her left. She must content herself with the company of the mean-looking black cat at her feet, and that of the viewer, whose gaze she meets with her own. VJA

See: Edwards 1954; Fock 2001; Murdoch 2014; Murdoch and Zech 2014.

1. Murdoch 2014, p. 3; see also Edwards 1954, no. 42 (repr.), pp. 43 and 147. I am exceedingly grateful to Ana Debenedetti, Tessa Murdoch and Heike Zech for their help with this entry.
2. A similar suit is in the V&A: T.327-1982; these were especially fashionable *c.*1700-05. For further discussion of male and female fashion in the eighteenth century, see Peter McNeil and Giorgio Riello's essay in the present volume.
3. Following previous attributions to J. Maurits Quinkhard (1688–1772) and Hermann van der Mijn (1684–1741), the painting was ascribed to Nicolaes Verkolje (1673–1746): see Edwards 1954, pp. 43 and 147, no. 42; and Kauffmann 1973, p. 295, no. 367. See also Fock 2001, p. 217, fig. 168. The painting is now considered to have been made in England, by an unknown artist, possibly of Dutch origin.
4. For further discussion of snuff, snuffboxes and its uses, see Murdoch and Zech 2014, especially Murdoch 2014.
5. Murdoch 2014, p. 3.
6. For a pair of English yellow quilted female silk pockets of *c.*1745, see V&A: T.87A&B-1987. For further discussion about pockets, see: http://www.vam.ac.uk/content/articles/a/history-of-pockets/.

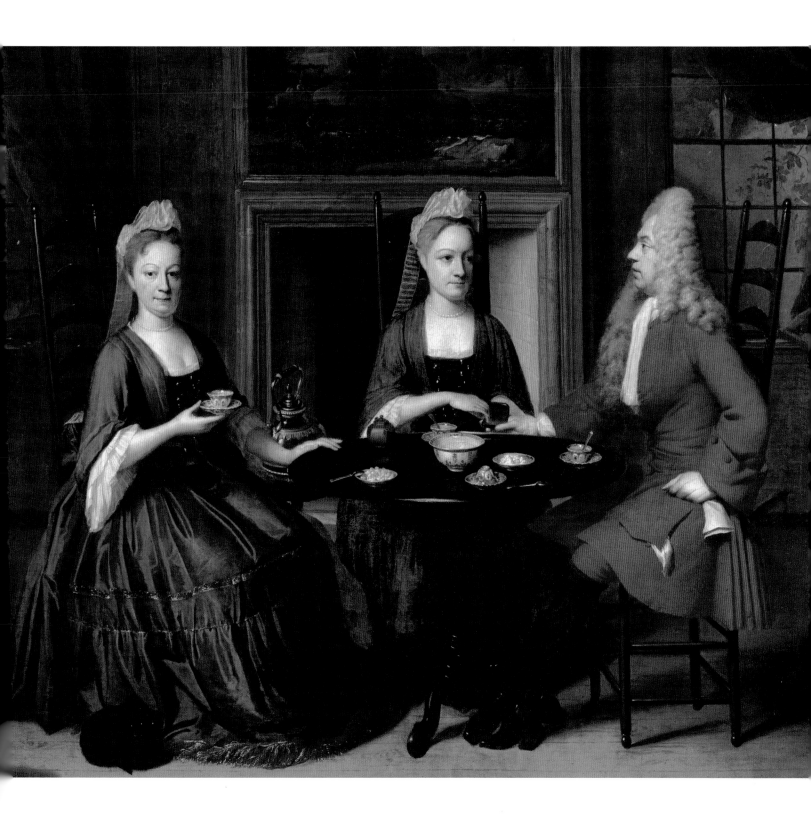

TEA

'I can enjoy my afternoon, and return, smiling and refreshed, to face the little ritual of our tea. The order never varies. Two slices of bread and butter each, and China tea. What a hide-bound couple we must seem, clinging to custom because we did so in England.'[1] So mused the protagonist of *Rebecca*, the novel written by Daphne du Maurier in 1938. Tea drinking has been rooted in British culture since the late eighteenth century (fig. 96). Although Great Britain was one of the major coffee consumers in Europe at the beginning of the eighteenth century, half a century later, tea had supplanted coffee as the preferred hot drink of not only the wealthy elite but of the entire social spectrum.[2] This expansion was made possible by the strength of the East India Company and England's emergence as a global power.[3] Likewise, it responded to the development of a local culture of tea consumption. In spite of coming from China, tea was absorbed and appropriated by the English, rapidly placing it at the heart of their domestic and social lives.[4]

Perhaps the most visible manifestation of the English appropriation of tea can be found in the creation of teaware. Local potteries created a vast array of speciality articles to facilitate the new practices of tea consumption, incorporating innovations such as the use of sugar and milk, many based on silver models. Tea caddies, like the green, lead-glazed, earthenware example made in Staffordshire *c*.1755–65 (fig. 97), were specially designed for loose tea. Elaborate tea sets also became fashionable. The hybrid hard-paste porcelain tea service decorated with sprays of flowers in pink enamel and gilt (fig. 99) was also made in Staffordshire *c*.1785, and comprises a teapot (of silver shape), milk jug, covered sugar basin, slop basin, two plates of different sizes, two tea bowls, two coffee cups and two saucers (for use with either the tea bowls or coffee cups). The miniature Delftware tea set made by an unidentified factory in Liverpool, *c*.1750–60 (fig. 98), comprises similar objects and would have allowed children to reproduce social behaviours associated with tea with their imaginary guests. AF

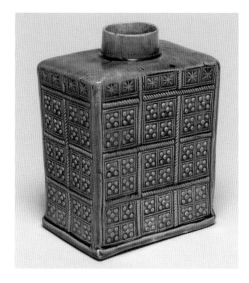

FIG. 97 | CAT. 86

TEA CADDY

Staffordshire | *c*.1755–65

See: Archer 2013, pp. 296–8, no. H.16; Du Maurier 1975; Hobhouse 1986; McCants 2008, pp. 172–200; McCants 2013; Richards 1999; Schivelbusch 1992; Walvin 1997.

1. Du Maurier 1975, p. 11.
2. Schivelbusch 1992, p. 81; Richards 1999, p. 3.
3. See the essay by Berg and Clifford in this volume.
4. Walvin 1997.

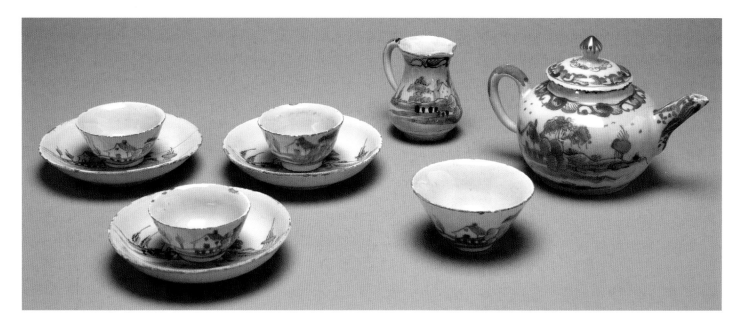

FIG. 98 | CAT. 92

TOY TEA SERVICE

Liverpool | *c*.1750–60

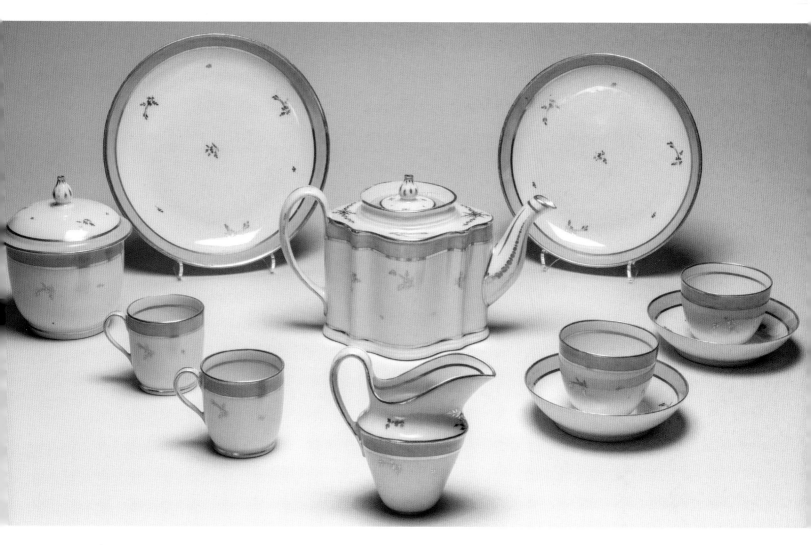

FIG. 99 | CAT. 94

PART TEA AND COFFEE SERVICE

New Hall Porcelain Factory,
near Newcastle-under-Lyme, Staffordshire
*c.*1785

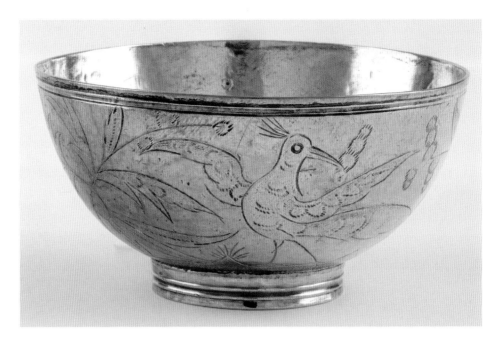

FIG. 100 | CAT. 83

TEA BOWL

London | 1683/4

This small, hemispherical, silver tea bowl is an early example of the English obsession with all things Chinese. It was made in 1683/4 by an unidentified London silversmith in imitation of (more expensive) imported Chinese porcelain tea bowls. Like the contemporary silver wall-sconces (fig. 199), it has been flat-chased with 'novel' Chinese-inspired vignettes of Chinamen, pagodas, hoho birds and stylized scrolling foliage – a radically different aesthetic from the highly embossed dense decoration of most late seventeenth-century domestic silver.

Whilst visually appealing, the handle-less cup is a functional disaster: silver is an excellent conductor of heat, so when filled with freshly made tea, it would quickly have become too hot to hold, let alone drink from. Consequently, silver tea bowls were a short-lived phenomenon and most were melted down, making this example a rare survival. They were replaced by porcelain tea bowls without handles (fig. 101) or tea cups with a single handle (fig. 112), their precise shape and decoration varying between manufactories and constantly changing to keep up with the latest fashions. Silver was still employed at the tea-table of the well-to-do, but only for kettles, teapots, milk jugs, sugar basins and teaspoons (for silver teaspoons, see figs 96 and 117). VJA

See: Beevers 2008; Porter 2010; Sloboda 2014.

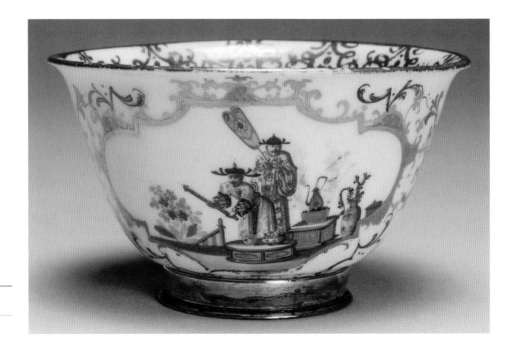

FIG. 101 | CAT. 84

TEA BOWL

Meissen | c.1725–30

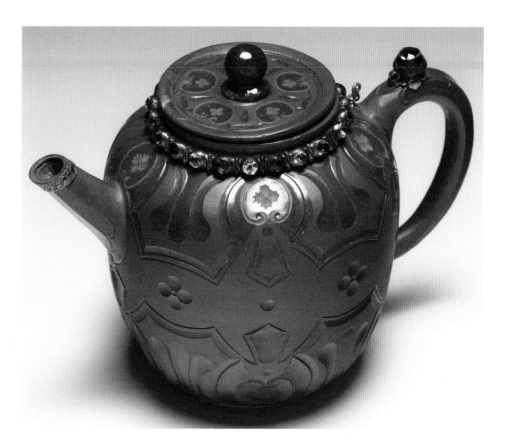

FIG. 102 | CAT. 89

TEAPOT

Meissen | *c.*1710–20

This one-person teapot encapsulates the early eighteenth-century obsession with luxury Chinese imports, above all tea and ceramics, and technological innovations. It is mould-cast in a hard red stoneware invented by the alchemist Johann Friedrich Böttger (1682–1719) in 1707 – the year before he discovered the Arcanum or secret formula for true (hard-paste) porcelain – in imitation of the unglazed red stonewares produced in Yixing (Jiangsu province), which had been exported to Europe since the seventeenth century. Launched as 'red porcelain' or 'jasper porcelain' at the 1710 Leipzig Easter Fair (the annual market which promoted Saxony's industries and luxury goods), it was the first ceramic body to be commercially manufactured by the Saxon Royal Porcelain Manufactory, which had been founded earlier that year by Augustus the Strong, Elector of Saxony and King of Poland at Meissen, fifteen miles upriver from Dresden (his capital).

An instant hit with the wealthy elite of Europe, Meissen red stoneware (also known as 'Böttger stoneware') was used to make ornamental figures and reliefs as well as 'useful wares' such as teawares, tankards, tureens and vases, their shapes initially based on Chinese porcelain and European silver owned by the Elector. Although some were left plain, a great deal were highly decorated. Some had pastes applied to their surfaces to replicate highly prized hard-stone vessels, others were covered in black glazes to evoke rare Japanese lacquerwork, and still others, like this teapot, were cut and wheel-polished to resemble glass – no doubt by some of the 30 Bohemian craftsmen employed in February 1710 for this sole purpose. This teapot was further enhanced by an amethyst and rock crystal band, set in silver around its neck, a large rock crystal in a silver-gilt mount (to form a thumbpiece on the handle) and a gilt-metal rim around the tip of its spout. Although notionally functional, this luxury teapot (like most early Meissen wares) was almost certainly intended for display. Initially very popular, Meissen red stoneware was quickly superseded by Meissen white porcelain, which became the new 'must-have' from the early 1710s. VJA

See: Bolz 1982; Bolz 2000; Cassidy-Geiger et al. 2008; Goder et al. 1982; Syndram and Weinhold 2009.

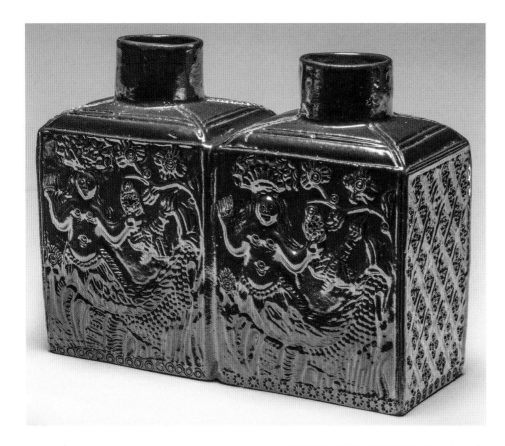

FIG. 103 | CAT. 87

DOUBLE TEA CADDY

Nottingham | *c.*1770

By the latter half of the eighteenth century, tea was the most fashionable hot beverage in England, particularly in the domestic environment. This brown salt-glazed stoneware double tea caddy, consisting of two compartments attached on their narrowest side, was used to store this luxury commodity in a 'middling sort' or gentry home. Its long sides are charmingly decorated with identical moulded reliefs of a mermaid holding a comb and mirror, and the initials of its maker or owner, 'E.H.', and its date of production or acquisition, '1770', are scratched on the base. Brown salt-glazed stoneware was being made by James Morley of Nottingham by 1693 when he was sued by John Dwight of Fulham for infringing his patent of 1684.[1]

The Nottingham stoneware industry expanded fairly quickly in the early eighteenth century, and in his *Tour thro the Whole Island of Great Britain*, written in the 1720s, Daniel Defoe noted the great increase in potteries or 'earthenware houses [...] since the increase of tea drinking: for the making of fine stone-mugs, tea-pot cups etc'. When this tea caddy was made, production was at its peak, and was to decline after about 1790. JKT

See: Ellis 2010; Kowaleski-Wallace 1994; Oswald et al. 1982, pp. 102–38; Weatherill 1988.

1. Oswald et al. 1982, pp. 102–38.

CHOCOLATE AND COFFEE

Chocolate and coffee were exotic foods which became associated with new ideas, practices and spaces in early modern Europe. The introduction of chocolate was met with fear and delight. Its Mesoamerican associations with hospitality and spirituality were detected by early Spanish explorers and these were transmitted to aristocratic European drinkers in the seventeenth century.[1] In turn, the Eastern origins of coffee piqued the curiosity of European scholars, and, by the eighteenth century, coffee became linked to the new sociability of Parisian literary cafés where politeness and Enlightenment learning were 'performed'.[2]

These new foods were imbued with all sorts of qualities by Europeans – as aphrodisiacs, spiritual aids, stimulants and miracle cures – but it was, above all, their novelty, luxury and exoticism with which they were associated, and these values were expressed in the vessels used for preparing, serving and drinking chocolate and coffee.

European chocolate-ware incorporated not only the spirit of its Mesoamerican origins but also the shape of Mesoamerican vessels.[3] Both the silver chocolate pot from France (fig. 106) and the porcelain chocolate pot made in Nymphenburg (fig. 105), evoke, in different ways, the round shape of a *tecomate*, a drinking vessel often made out of the bottom part of a dried gourd, or a *jícara*, a drinking vessel specifically for drinking chocolate, often made out of pottery (as illustrated in fig. 76).[4]

European consumers would have identified these vessels as chocolate-ware from the distinctive position of the handles emerging from their bellies, compared to the position of the arched handle of the pear-shaped silver coffee pot from London (fig. 104). The decoration on the chocolate pots is the kind which could have appeared on a number of objects associated with other luxury goods in this period, such as tea or tobacco – a classical scene with floral motifs on the porcelain pot or the fleurs-de-lys and family arms with a heart-shaped spout and acorn-shaped finial on the silver one. This decoration 'Europeanizes' these vessels associated with the novelty and exoticism of 'new worlds', but the material from which they are all made – silver and porcelain – resonates with ideas of European luxury.

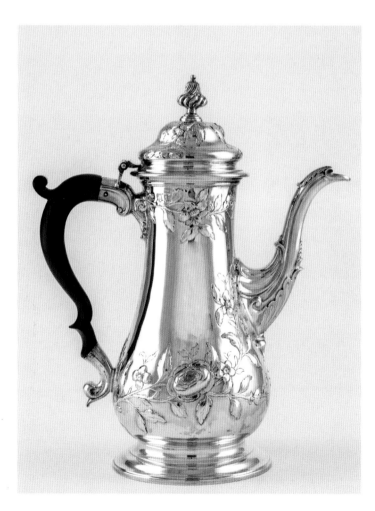
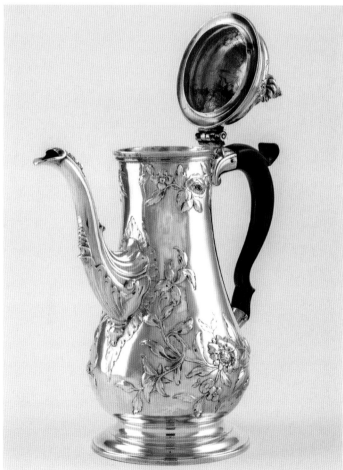

FIG. 104 | CAT. 102

COFFEE POT

John Swift, London | 1763–4

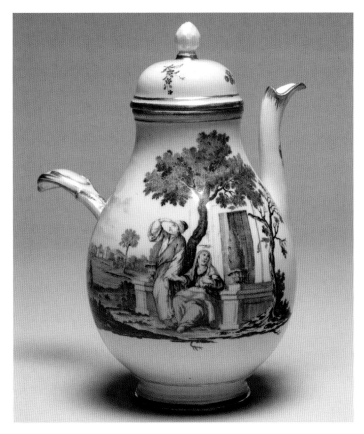
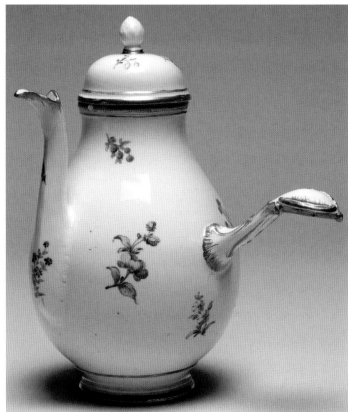

FIG. 105 | CAT. 100

CHOCOLATE POT

Nymphenburg | *c.*1765

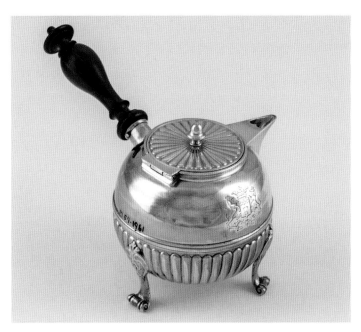
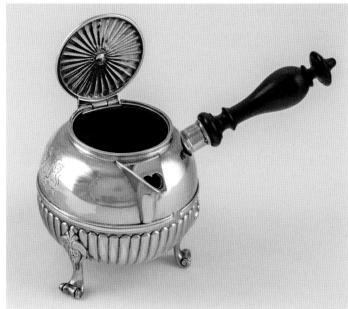

FIG. 106 | CAT. 98

CHOCOLATE POT

Michel II Delapierre, Paris | 1758/9

While coffee and chocolate pots had distinctive features, it is often hard to tell apart cups for hot beverages from this period. The early eighteenth-century white Meissen cup or handled beaker with leaves rising up from the bottom (fig. 107) could have been used for coffee or chocolate. While the English soft-paste porcelain cup, cover and saucer (fig. 108) may have been used for chocolate, the Derby factory's records and sale catalogues suggest that it was probably sold as a cup to serve caudle, a warm mixture of wine or ale with eggs and spices for invalids.[5] There was less confusion in Spain, where a whole new kind of tableware was created solely for the serving of chocolate – the *mancerina*, a small saucer with a fixed holder at its centre, inside of which sits the *jícara*, echoing the gourd-shape of a Mesoamerican vessel.[6] While the chocolate sets of *mancerinas* and *jícaras* made by the Alcora porcelain factory in Spain are well known, similar sets made out of cheaper tin-glazed earthenware or maiolica from Liguria and Umbria have been found in the foundations of the Born neighbourhood of Barcelona.[7] MTC

See: Cowan 2005; Earle 2014; Hammond 1991; Ledger and Pemberton 2010; Miró i Alaix 2010; North 2008; Norton 2006; Norton 2008; Soler Ferrer 2010; Spary 2012.

1. Earle 2014. In seventeenth-century Spain, for instance, aristocratic parties without chocolate were considered worthless, and one wealthy Spaniard even built a designated chocolate room (*pieza de chocolate*) in his house. Norton 2008, p. 178.
2. Cowan 2005, Part I; Spary 2012, chapter 3. For Germany, see North 2008, chapter 9.
3. Norton 2006.
4. My thanks to Rebecca Earle for clarifying these distinctions. There is a ceramic *tecomate* in the Museum of Archaeology and Anthropology, Cambridge (1980.1117), which has been identified as a chocolate pot from the excavation of an early Maya site, *c.*200 BC, in Cuello, Belize (Hammond 1991). My thanks to Chris Wingfield and Trisha M. Biers for their help and advice.
5. For English soft-paste caudle cups, see Ledger and Pemberton 2010; also see Ibid., p. 99, pl. 8, for a similar cup.
6. There are two *mancerinas* in the Fitzwilliam's collection (C.2136-1928 and EC.10-1939). The first, in the shape of a bird with outspread wings, was collected by Glaisher, although he seems to have had little idea of its specific function. He writes in his manuscript catalogue: 'I have seen other cup-holders like this, generally in the middle of a plate. It may be that the drink contained in the cup was hot and so needed a holder' (Fitzwilliam Museum, Glaisher MS catalogue, vol. 5, no. 2781).
7. Soler Ferrer 2010, pp. 113–37; Miró i Alaix 2010.

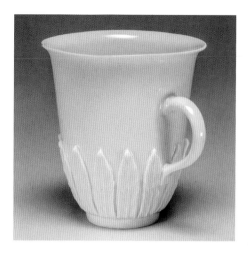

FIG. 107 | CAT. 95

CHOCOLATE BEAKER

Meissen | *c.*1713–20

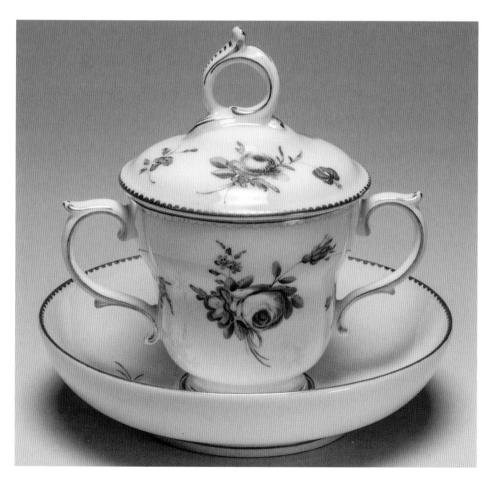

FIG. 108 | CAT. 97

COVERED CUP AND SAUCER

Chelsea-Derby | *c.*1770-5

FIG. 109 | CAT. 101

COFFEE POT

Staffordshire | *c.1763–70*

Staffordshire red stoneware was highly
fashionable for tea-, coffee- and chocolate-
wares between *c.*1750 and 1775, recalling luxury
Yixing unglazed red stonewares imported from
China. This coffee pot, whose pear-shaped form
derives from more expensive examples in silver,
can be dated quite specifically to the mid-1760s,
thanks to a moulded-applied relief on one side.
This represents Britannia with a lion and a
shield bearing a Union Jack and '45', an allusion
to issue number 45 of John Wilkes' journal,
The North Briton, in which he attacked the
King's Speech at the opening of parliament on
23 April 1763. The resulting prosecution of the
MP, who fled to France in 1764, caused a furore
over free speech and parliamentary privilege,
which recurred even more vociferously when
he returned and was imprisoned (1768–70).[1]
While punch bowls were produced with blatant
pro-Wilkes slogans,[2] the allegiance expressed
by this coffee pot is much more subtle. JEP

See: Archer 2013; Cash 2006; Dawson 2010; Poole 1995b.

1. Cash 2006, chapters 9–10.
2. Dawson 2010, pp. 82–3, no. 27; Archer 2013, pp. 107,
no. B.44, and 259, no. F.35.

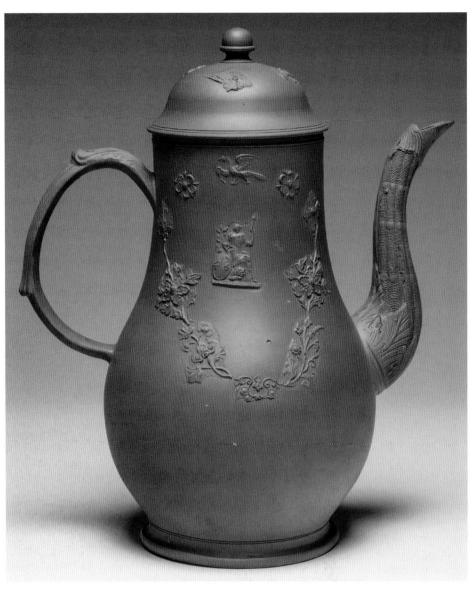

FIG. 110 | CAT. 96

COFFEE BEAKER

Imperial Porcelain Factory, Vienna | *c*.1765–75

This delicate porcelain cup, painted in polychrome enamels and trimmed with gilding, was made by the Imperial Porcelain Manufactory in Vienna, *c*.1765–75.[1] Its handle reveals that it was a European design intended for hot beverages, most likely coffee, given its small beaker-like shape, but it could also have been used for chocolate. It would originally have been accompanied by a saucer possibly of the *trembleuse* type, which had a central raised ring or basket to hold the cup in place and prevent spillage by a 'tremulous' hand.[2] In fact, handling fine porcelains required refined manners and manual dexterity, central to polite sociability.[3] Portraying an elegantly dressed woman with a closed fan in her hand, it bears the French inscription '*a l'angloise* [sic]', meaning 'in the English manner'. This was a contemporary term to describe the more informal style of English fashions and reflects the Anglomania that swept Europe in the later eighteenth century.[4] AF

See: Hellman 1999; Neuwirth 1982; Ribeiro 1984; Richards 1999; Steele 2002.

1. Neuwirth 1982, pp. 72–3, nos. 92–3.
2. Ibid., pp. 62–3, no. 64. See also Steele 2002.
3. Richards 1999, p. 97. See also Hellman 1999.
4. Ribeiro 1984, pp. 68–9, no. 85.

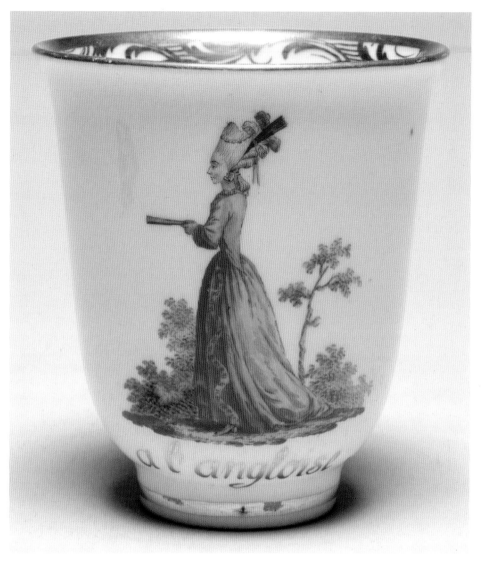

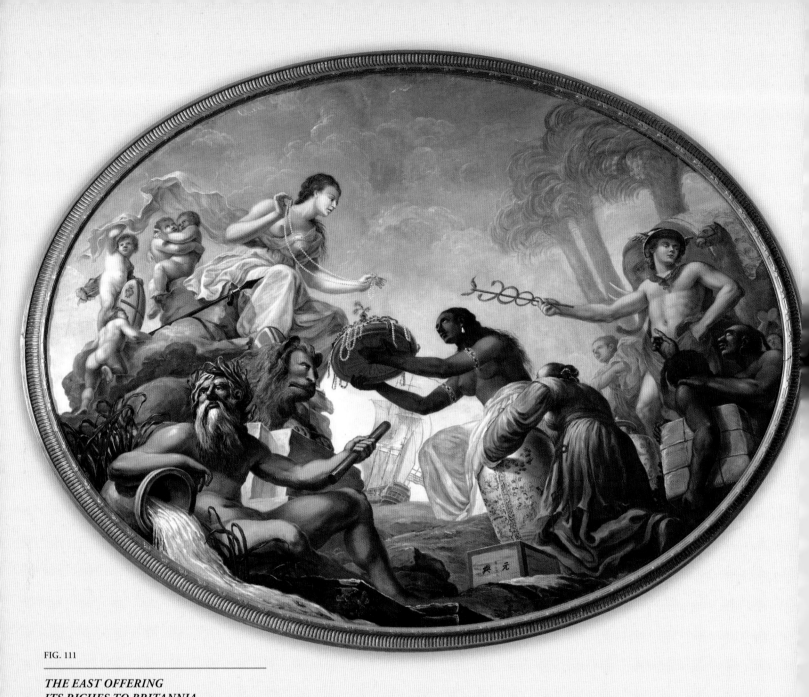

FIG. 111

THE EAST OFFERING
ITS RICHES TO BRITANNIA

Spiridione Roma, oil on canvas | **1778**

FORMERLY CEILING OF THE REVENUE ROOM,
EAST INDIA COMPANY HOUSE, NOW BRITISH LIBRARY,
LONDON

GLOBAL OBJECTS

Maxine Berg and Helen Clifford

Set into the ceiling of the Revenue Room at East India Company House, an allegorical painting depicted *The East offering its riches to Britannia* (fig. 111).[1] The Italian painter Spiridione Roma represented the different East Indian provinces offering up their goods, under the supervision of Mercury, the god of merchandise. Calcutta presents a basket of gems spilling over with ropes of pearls; China delivers up large blue and white porcelain vases and a chest of tea; Madras and Bombay are represented by a bale of cotton; Bengal by an elephant, a palm tree and a camel; while Persia in the distance brings silks and drugs. One can almost smell the spices and tea, feel the fragile smoothness of the porcelain, and hear the fall of the heavy silk. By 1778, when this painting was completed, Europeans enjoyed unprecedented access to raw materials and commodities from across the globe, made possible by the East India Company ships that Roma placed in the centre of his painting. Their presence was 'material evidence of a punishing encounter driven by a desire for the smell, taste, colour and texture of exotic stuffs'.[2]

Europeans between the sixteenth and eighteenth centuries transformed their material and consumer cultures in a newly enhanced encounter with goods appealing to the senses from far parts of the world. This was first experienced as a trade in luxuries: precious cargoes brought new sensory experiences to Europe's elites – tobacco and coffee, pepper and spices, cocoa, sugar and tea.[3] They were pleasurable goods of the body, some addictive, consumed in domestic and public contexts of sociability. They came with clothing textiles, silk and fine cotton, printed and embroidered, alongside the Persian carpets associated with Eastern luxury, and exotic porcelain accoutrements for drinking the new hot drinks, coffee, chocolate and tea. The goods fell outside the fine luxuries denied to non-aristocratic social groups in societies with strict sumptuary laws. Not forbidden, but expensive, they contained the possibilities of new behaviours and social interactions.[4] For example, the exquisite Vincennes tea cup required careful handling in polite company (fig. 112).[5] These goods also motivated elites to spend on acquiring objects and displaying and experiencing these in new social settings instead of maintaining large groups of retainers. They stimulated other social groups, merchants, tradespeople and, in time, working people to work harder, and to engage more fully in market-driven activity to create a new work culture and, eventually, modern consumerism.[6]

These goods give us insight into a global history that brings together the development of luxury and consumer culture, wider world trade, and development of Europe's own industries and manufactures. The objects show us different forms and designs, the hot drinks came in various qualities, types and tastes, and reception brought cross-cultural production and use. The supply of many of these goods was not restricted by rarity, as in the case of precious stones and metals; it was limited by access through shipping, trade and organization of production to supply larger, wider world markets. The key transformation of the seventeenth and eighteenth centuries was a shift into a modern global trade in colonial groceries and Asian exportware. This was achieved through a major increase in shipping, trade and a reorganization of trade through East India companies. Large mercantile sectors of private traders and new production processes and plantation agricultures brought large volumes of these global objects and groceries to Europe to be experienced by significant parts of its populations.

If we look to that trade with Asia, between 1500 and 1795, 11,000 European ships set out for the Cape route to India, South-east Asia and China; 8,000 of these returned; many of those that stayed engaged in the private intra-Asian trade which was equally vital in the chain of acquiring goods for Europe. There was a trade between Asia and Europe by the eighteenth century of 50,000 tons a year, or one pound of Asian goods per person for a European population of *c.*100 million. New World trade grew twice as quickly. New World cocoa and tobacco were soon followed by plantation developments of sugar and coffee, complementing a rapidly growing tea trade with China.[7]

The rapid growth in the tea trade from the eighteenth century fuelled the wide extension of a tea drinking culture in Europe, and especially in Britain.[8] The tea drinking came with another Chinese import, porcelain. This, in turn, generated innovation in ceramic production in Europe, as porcelain manufacture developed there. There were also many new varieties of earthenware and stoneware introduced. Tea drinking, furthermore, connected closely with rapidly expanding sugar consumption, supplied from West Indian plantations. Tea drinking brought into Europe two widely-spread colonial groceries, and a major luxury manufacture which was to have transformative effects on Europe's own industries. Increasing the supply of these goods from afar was achieved through monopoly trading companies competing with each other and also engaging with private traders in the intra-Asian trade. These companies, the best known being the English East India Company, the Dutch East India Company (VOC) and the French East India Companies, but also the less-well-known Danish and Swedish Companies and the short-lived Ostend Company, competed back in Europe, selling their goods at auction to foreign and domestic merchants. The East India companies brought porcelain from China, accessing a system of production in China already well advanced for wider world trade. Large-scale production concentrated in one major Chinese centre, Jingdezhen, deployed modular systems and division of labour. The industry responded easily to differing cultural and geographical tastes, supplying a global exportware in different qualities and volumes so as to provide both an exotic collectable and also the expected prop of polite civility.[9]

True hard-paste porcelain had no commercial substitute in Europe, until Meissen began production in c.1709–10. This Chinese porcelain defined the 'Orient' to European consumers, to a greater degree than all other objects brought from Asia.[10] When the English East India Company bought their first shipment of tea in 1669, the attendant porcelain was valued at only £10, and it was only from 1685 that appreciable quantities were included in their manifestos. Merchants sent out to China European models for tea and chocolate cups, saucers, plates, bowls, teapots and other items, and by the 1720s the orders for one ship included 1,000–2,000 thousand each of plates, cups, saucers and bowls. The British alone imported between 1 and 2 million pieces of Chinese porcelain a year by the early eighteenth century. Porcelain was also imported from Japan by the Dutch, especially during the later years of the Ming dynasty, and after its fall, when Chinese production and export were greatly disrupted. A new taste for Kakiemon ware was developed in Europe through the VOC's trade with Japan. This desire for Chinese and Japanese porcelain was not limited to Britain: the sheer scale of the trade was immense across Europe. The Dutch imported 43 million pieces from the beginning of the seventeenth century to the end of the eighteenth century. Cumulatively, the English, French, Danish and Swedish companies imported another 30 million pieces, while in one year (1777–8) European ships unloaded 700 tons of porcelain. The porcelain was bought at auction by specialized dealers known as 'chinamen', who then resold it through a whole range of distributors including, in Britain, 'toymen' who retailed luxury ornamental goods, china and glass throughout the regions, such as Benjamin Layton from Bath (fig. 50). By the 1750s these dealers in imported wares from China had already spent 40 or 50 years building up an extensive network that radiated from London.[11]

Rapid growth in the porcelain and wider China trade from the early eighteenth century connected to a new expansion of the tea trade. Tea entered European markets in much higher volumes from the early eighteenth century. Tea imports into Britain more than tripled from the beginning of the century to 1718, and it became the key commodity of the English East India Company's trade by the last third of the century. These highly profitable markets were tapped by all the European companies trading to Asia, and they competed in a direct trade to Canton to bring a variety of black teas, ranging from Bohea to Congo, Peckoe and Linchisin as well as less-long-lasting green teas such as Heysan, Singlo, Bing or Imperial. The short-lived but highly competitive Ostend Company imported as much as the English: over 7 million pounds between 1719 and 1728. When the company was prohibited, its personnel and strategy were shifted to the Swedish company, and in this highly competitive framework, the tea trade escalated. Large amounts of the tea brought in by the wider European companies were smuggled into Britain, where the tea duties were high, rising by the early 1780s to 119 per cent. In 1783, the warehouses contained 5.9 million pounds of legal tea, while 7–8 million pounds were smuggled in. The Tea Commutation Act of 1784 reduced the duty to 12.5 per cent, and in 1785 there were 16.3 million pounds in the warehouses, and by 1800–01, 21 million pounds.[12]

Tea drinking spread quickly down the social scale during the century, with a rapid uptake in the Netherlands and Britain. Nearly all households in the Netherlands possessed tea- and coffee-wares by the early eighteenth century; this was a widespread breakable, fragile material culture.[13] By the 1740s between 30 and 50% of inventories in different parts of Britain recorded chinaware. Bristol consumers who owned chinaware between 1720 and 1780 had an average of more than fourteen pieces. Even early in the eighteenth century, Samuel Parrett, a poor tinplate maker worth only £11.10s., had eleven pieces of a china coffee service. By the early 1780s, Catherine Hutton could comment that Joseph Priestley came to take tea with her father William 'without ceremony'.[14]

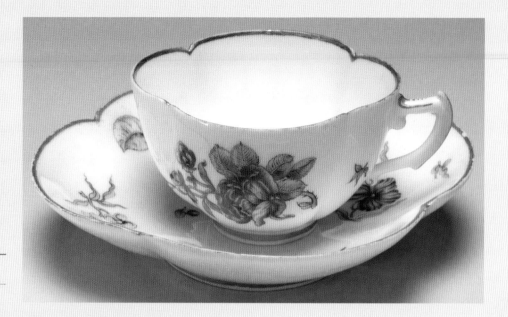

FIG. 112 | CAT. 85

CUP AND SAUCER

Vincennes | *c.*1750–2

Some of this chinaware was certainly exportware-quality porcelain from China, but Europe soon responded with its own innovative ceramics. Duty on imported porcelain rose steadily over the century: English tariffs in 1704 were 12.5%, rising by the early 1790s to half the auction value. Europeans soon produced their own porcelains. They had from the Renaissance attempted to imitate this desirably translucent ceramic, although the results evaded its exact qualities until the beginning of the eighteenth century. Red stoneware Yixing wares, commonly known as 'Porcelain Rouge', were exported from China in the seventeenth century. In 1685, Peter Muguet reported that: 'The Chinese teapots are made from a reddish clod of earth or impressed in clay'.[15] The arrival of 82 such teapots in London in 1699 is noted in the East India Company records. The Chinese red stoneware inspired European imitation into the eighteenth century, for example in Staffordshire red dry-bodied stone-ware, as seen in the later chocolate pot of *c.*1760–5 with an imitation Chinese seal mark impressed underneath (fig. 113) and a coffee pot of roughly the same date, which includes a Chinese figure under a parasol (fig. 109). In 1698, Celia Fiennes went to Staffordshire with the intention of seeing 'the making of the fine tea potts, Cups and saucers of the fine red Earth in imitation and as Curious as that which Comes from China'. This factory belonged to John Philip and David Elers. Of Dutch birth and German extraction, they had been silversmiths by training, and the precise engine-turned forms of their ceramics drew emulatively from this precious metal. They also introduced slip-casting for their redwares, possibly because of their knowledge of casting silver. J.F. Böttger's red stonewares, made at the Meissen works in Saxony, which appeared from *c.*1708, were an offshoot of experiments in making porcelain and artificial hard stones. The early pieces were often faceted like gemstones, and in some cases embellished with pastes, making these wares sparkling jewellery for the tea-table, such as the extraordinary teapot from Meissen (fig. 102).

In fact, it was not until 1709 that Böttger produced the first hard-paste porcelain in Dresden, and the Royal Porcelain Factory at Meissen was established in 1710. This ceramic body was used to create functional and decorative wares, often in imitation of Chinese and Japanese shapes drawn from court and aristocratic collections, such as the tea bowl, saucer and slop basin with chinoiserie decoration of *c.*1725–30 (fig. 101). Japanese Kakiemon ware had been much collected during the later seventeenth century and its decoration was greatly imitated at Meissen in hard paste and by the French soft-paste factories.

English soft-paste porcelain manufacturers followed suit; see, for example, the octagonal soup plate made by the Chelsea Porcelain Factory in the mid-eighteenth century (fig. 230). The new Bow factory built *c.*1747 was contemporaneously called New Canton, as inscribed on an inkwell dated 1750 (fig. 115), and Worcester (referred to in its foundation document of 1751 as 'Worcester Tonquin Manufacture') copied the brightly coloured geometric Japanese Imari patterns and colours, which the factories in Delft were already imitating in tin-glazed earthenware, as can be seen in a double spice-box, from the early eighteenth century (fig. 114). But, unlike the Chinese producers, these European manufacturers focused on expensive products, using artists and modellers to produce both imitations of Oriental ware and a new European ornamental ware. In the design of these new goods they also looked to silverware, highly valued in Europe: Böttger's fine white early hard-paste porcelain chocolate beaker of *c.*1713–20, made in imitation of Chinese blanc-de-chine, takes its shape and decoration, known as cut-card work, from French Huguenot-inspired silverware (fig. 107).

FIG. 113 | CAT. 99

CHOCOLATE POT

Staffordshire | *c.*1760–5

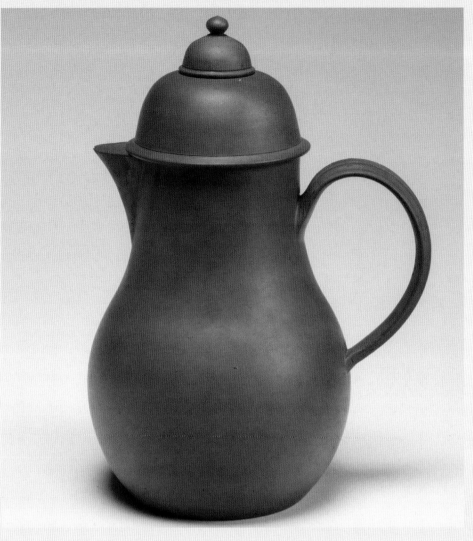

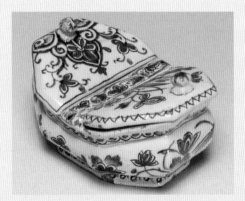

FIG. 114 | CAT. 192

DOUBLE SPICE-BOX WITH TWO LIDS

Greek A Factory, Delft | *c.*1701–22

FIG. 115 | CAT. 167 ▶

INKWELL

Bow | 1750

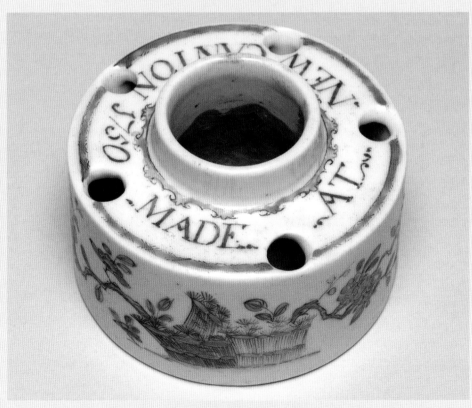

The relationship between silver and ceramics was complicated, especially in the early years when the exotic, costly hot beverages first arrived. Silver teapots often imitated celadon or porcelain wine ewers in the search for a suitable form.[16] The first silver teapot that survives in England, however, hallmarked 1670, looks like a conical tinware coffee pot. It is only identifiable as such because it is engraved 'This silver tea-pott was presented to ye Comtte of ye East India Company'.[17] It is to the merchants who brought these new goods to Europe that we might look for innovation in design.

The real product innovation developed in the earthenware sector, especially in Staffordshire, where new technologies focused on materials and decoration, especially transfer printing, as well as specific organizational structures, which created a cost-effective product that the new middle classes and tradespeople could afford.[18] These were developed in small pottery works in highly concentrated regions. It is noticeable that all the major centres except north Staffordshire and Leeds in Yorkshire developed in or close to ports: London, Bristol, Liverpool and Tyneside, while Worcester is on a river. New qualities of taste and aesthetics, manners, and eating and drinking cultures, were combined with technological change (for example, press-moulding and slip-casting) and industrial development. This technological change allowed potteries to move away from forms inspired by Chinese or silver prototypes and developed new ideas for teaware such as teapots in the shape of fruit and vegetables (fig. 212). However, Staffordshire blue and white ware imitated not just Chinese products, but the whole complex of a relatively standardized product, of good quality, and produced on a large scale. This entailed the technologies and industrial organization to manufacture on a large scale to consistent quality, and to make a relatively standardized product to which variations could be adapted.[19]

Staffordshire approached manufacture in a different way to China, using small bottle-ovens, located in specialized areas, linked with industrial towns, villages and suburbs. In these places a nucleus of 'useful knowledge' of craftsmen's skills was created, fostering systematic experimentation and competitive imitation. Staffordshire earthenware and stoneware became one of Britain's leading exportware products; more of it was supplied to America by 1790 than to anywhere else in the world, where it made up most of that country's table-, tea- and toiletwares. Staffordshire ware, following the model of Chinese blue and white, quickly established itself as a global product, one of the new array of modern, fashionable and high-quality British products.

The British linked imitation of Oriental luxury goods to new technologies and new materials. The web of imitation and innovation could be complex, crossing many geographical and cultural boundaries. For example, the tin-glazed earthenware teapots produced by Lambertus van Eenhoorn at the Metal Pot Factory in Delft c.1691–1724 (fig. 118) were inspired by black lacquerwork imported from China and Japan (itself imitated by European japanning), as seen in the Venetian mirror-frame (fig. 173). These were in turn imitated by the Staffordshire potteries c.1750–70, as shown by the red dry-bodied stoneware teapot with black lead-glaze and oil-gilding (fig. 119). Technologies connected with an eighteenth-century admiration for industrial replication. British earthenware became a great success story of imitation, even presenting patents with a goal of imitating Dutch Delftware or Chinese porcelain. New products, Staffordshire-ware as well as Worcester and Derby porcelain, became branded in international markets. They became fashion leaders, building on selling their goods in toy and china shops, connecting retailing to the new proliferation of galleries and exhibition spaces.

The china sellers made use of trade cards and new advertising techniques to offer information and to educate a receptive population about the consumption of novelty.[20] For example, John Cotterell 'China-Man and Glass-Seller' operated from the 'Indian Queen & Canister' near the Mansion House, London. His trade card of c.1750 shows his shop sign flanked by a china vase and bowl and a canister marked 'FINE TEA'.[21] Chinaware and tea were sold together, and constantly associated with a generalized exoticism.

Tea dealers and grocers lost no opportunity to use their own trade cards and bill heads to convey the fashionability of tea and its associated products. Of the 91 London grocers' trade cards in the Heal Collection in the British Library, over a third incorporate tea- or China-related symbols, such as the canister, tea tub or tea chest or 'Chinaman' (compared with only eight who advertised coffee or West Indian associations).[22] The 1766 bill head of Francis Morley, Grocer and Tea Dealer in St Paul's Yard, Cheapside, London, depicts his shop sign of the 'Green [tea] Canister', hanging in a fashionable chinoiserie Rococo frame (fig. 49). Green tea was more expensive than black, and its consumption implied a difference of taste in both senses of the word. Twenty or more years later the messages conveyed by these trade cards had become more complex. William Barber, Tea Dealer in Leadenhall Street, London (conveniently close to the East India Company offices), draws upon a range of exotic imagery on his trade card to engage his customers (fig. 116). To the right, a Chinese figure waters a tea bush, suggesting freshness and proximity to source. To the left, a European woman reclines in elegant *déshabillé* on a sofa, drinking tea from a newly fashionable tea urn, and converses with

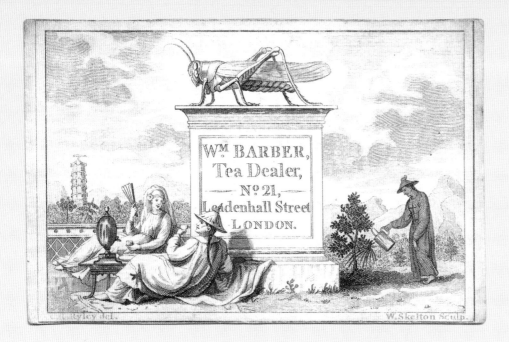

FIG. 116 | CAT. 50

TRADE CARD OF WILLIAM BARBER

London | *c.*1785–1800

a recumbent Chinese male figure with a pigtail, a pagoda in the background. Here implied reality and accuracy are combined with imagination, in a dialogue centring on tea. On the reverse of the trade card, the printed list of items for purchase enforces the idea that this Eastern promise is well within the consumer's grasp.

Tea culture spread to colonial America, and with it a strong taste for Chinese and British ceramics. George Washington paid £37.16s. for his 193-piece dinner set of Nankeen blue and white at the end of the American Revolution (roughly the cost of a young male slave, bought by a London family at the same time). By the 1790s, English refined earthenware made up most of the tea- and tablewares in America, and accounted for the highest proportion of British ceramics exports. A British cream-ware tea set cost between five and fifteen pounds; it was a prized possession among American trading and middle classes who left estates valued between 200 and 700 pounds.[23]

Tea tended to be taken in private, and it may be for this reason that the array of wares invented to accompany its consumption soon outstripped those for coffee and chocolate, which in England at least were more often drunk in coffee houses. By the early eighteenth century, the teapot and tea bowl or cup were joined by kettles (one early example of 1679, called 'an Indian furnace', suggests that the name for the device was not yet widely known) and stands, milk or cream jugs, which

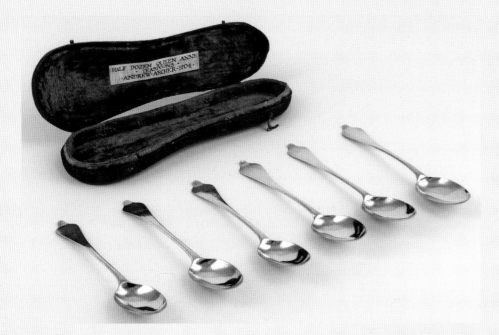

FIG. 117 | CAT. 209

SET OF SIX TEASPOONS AND CASE

Andrew Archer, London | 1705/6

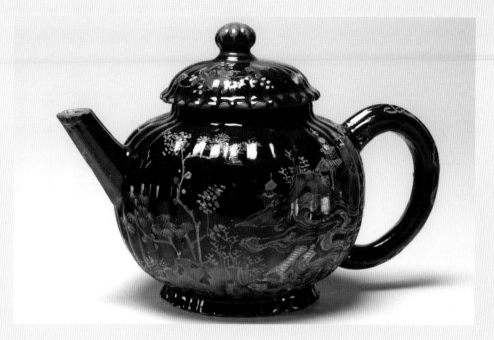

TEAPOT

Metal Pot Factory, Delft | *c.*1691–1724

appeared from the 1720s as the fashion for taking tea in the Chinese style faded.[24] There were also covered sugar bowls in a variety of shapes and decoration, such as a Worcester soft-paste example with transfer-printed vignettes of classicizing buildings and follies in parkland painted in polychrome enamels (fig. 218), silver teaspoons such as the set of six made in the first decade of the eighteenth century (fig. 117), spoon trays and large salvers called tea-tables, as well as delicately pierced strainers, tongs and, later still, urns. A Dutch wall plaque depicts some of the equipment associated with the serving of tea, including spittoons, tea urns and teapots (fig. 120).

The habit of taking tea of different sorts, both green (unfermented) and black (fermented), and with sugar, led to the production of caddies to contain them all (figs 97 and 103).[25] The demand for 'sets' of teawares further stimulated innovation and supply. They were certainly prized. When Mary Charlton died in 1735 she was careful to note that her daughter should inherit her 'silver lamp and tea kettle and all the other plate [...] belonging to the said tea table', which seems to have been kept in a special 'japan cabinet'.[26] As early as 1713 Daniel Defoe commented on the 'Encrease of those trades that attend' upon tea, coffee and chocolate, 'whence we see the most noble shops in the City taken up with the most valuable Utensils of the tea-table'. De la Rochefoucauld in 1784 observed that in England 'Tea drinking gave the rich an opportunity to show off their fine possessions: cups, tea-pots, etc made to the most elegant designs.'[27]

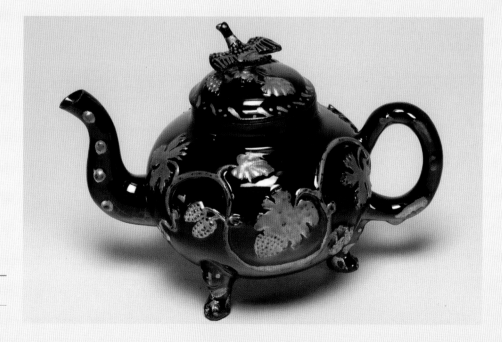

TEAPOT

Probably Staffordshire | *c.*1750–70

Tea drinking extended rapidly down the social scale from the mid-eighteenth century, and especially from the 1780s after the Commutation of the tea tax. Tea prices declined throughout the eighteenth century, especially after 1784 when tariffs were sharply reduced. Prices fell from 12s.–36s. per pound in 1720 to 10s.–25s. per pound in 1785.

Tea drinking was closely associated with rising sugar consumption, as black tea imports in different qualities and types rose. While green tea is more potent, it also has a mild, subtle taste and aroma, but black tea is full-bodied and more suited to the addition of sugar (and milk). Sidney Mintz has suggested that the universal acceptance of the bitter hot beverages of tea, coffee and chocolate were only made possible through the addition of cane sugar, which was first imported to Britain in 1610.[28] Sugar consumption rose from 4 lbs per person in 1700–9 to 8 lbs in the 1720s; by the 1770s, consumption per person was 11 lbs, and in the 1790s it had risen to 13 lbs.[29] From the last decades of the eighteenth century, four fifths of sugar came from the British and French colonies of the West Indies. No tea or coffee equipage was complete without its covered sugar bowl, usually part of a complete service, such as the pink and white New Hall Porcelain Factory tea service, made in Staffordshire in the late eighteenth century (fig. 99), although other wares were invented or adapted from others, like sugar casters and sifter spoons.

Tea drinking among the poor became associated with work, rather than a domestic ritual. It involved sociability at work in making it; it was stimulating, hot and sweet, making palatable a cold meal of bread and cheese. The luxuries of an earlier generation had become the cheap, accessible necessity of the common people, the result of Britain's emergence as a global power.

The authors would like to thank Julia Poole, formerly Keeper of Applied Arts, for showing us the ceramic collections at the Fitzwilliam Museum and offering suggestions on a first draft of this essay. The authors also wish to thank the European Research Council, under the European Union's seventh framework Programme (FP/2007-2013 ERC Grant Agreement no. 249362).

1. British Library, F245. Oil on canvas, oval, 228 x 305 cm.
2. McAleer 2014, p. 199.
3. Schivelbusch 1992.
4. Cowan 2005; Norton 2006; Norton 2008; and Berg 2005, pp. 229–34.
5. Berg 2005, p. 230; Vickery 2009, pp. 273–5.
6. De Vries 2008.
7. De Vries 2010.
8. McCants 2008.
9. Berg 2004, pp. 118, 122.
10. There was a very brief production in England in the late seventeenth century, probably at Vauxhall, known as the Duke of Buckingham's porcelain, before Meissen became the first commercial producer c.1709–10. With thanks to Julia Poole for this information.
11. Young 1999, p. 154; Brett 2014.
12. Ashworth 2003, pp. 182, 230; Mui and Mui 1984, pp. 91–3, 129–31; Mui and Mui 1989, pp. 250–1.
13. McCants 2008; McCants 2013; and De Vries 2008, pp. 129–33.
14. Berg 2005, p. 232.
15. Brown 1995, p. 69, quoting from *Tractatus Novi Potu Caphe de Chinesium The' et de Chocolata*.
16. See, for example, the wine pot and cover from the Kangxi period (1662–1722) in the Fitzwilliam Museum: C.33& A-1933.
17. V&A: M.399-1921: London 1670/71, sponsor's mark 'TL' unidentified.
18. Berg 2005, pp. 131–45.
19. See, for example, the pearlware plate by Wedgwood (C.9-1915) or the pearlware dish drainer from Staffordshire (C.3-1991) in the Fitzwilliam Museum.
20. Berg and Clifford 2007.
21. Lambert 2001, p. 18, cat. no. 23.
22. Heal 1988.
23. Miller et al. 1994.
24. Inventory of Ham House, Surrey 1679, quoted in Clayton 1983, p. 98.
25. Richard, 7th Viscount Fitzwilliam (d. 1816), for example, acquired a cased set of two tea caddies and a sugar box, each engraved with his coat-of-arms, c.1812. Fitzwilliam Museum: M.7.1-4-1965.
26. Pointon 1997, p.316.
27. Quoted in Clifford 1999, p. 161.
28. Mintz 1985.
29. Burnett 1969, p. 180.

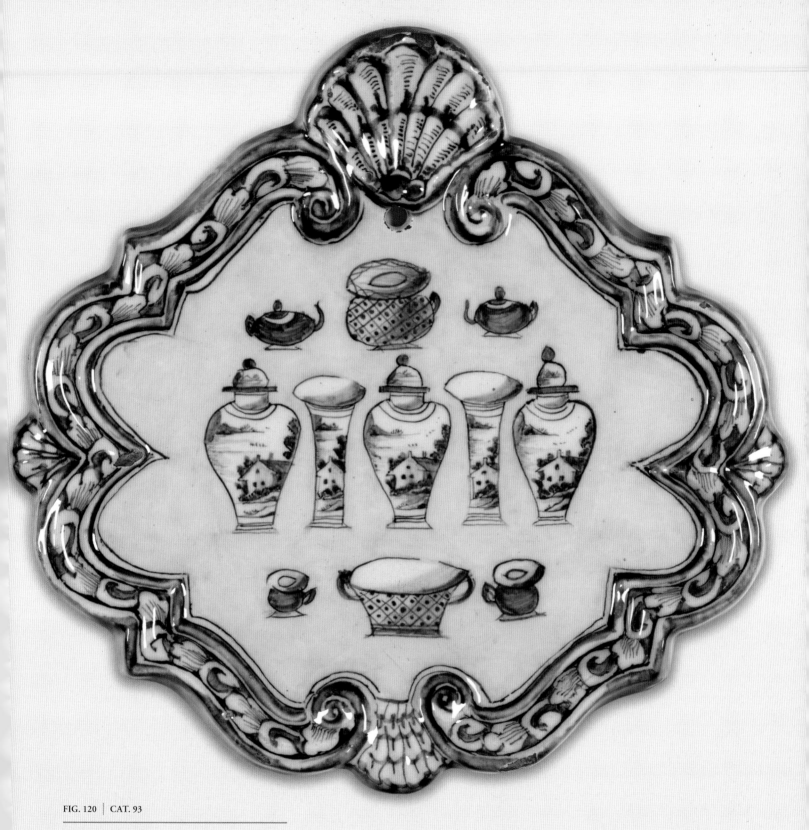

FIG. 120 | CAT. 93

WALL PLAQUE

Delft | second half 18th century

FOUR

THE FASHIONABLE BODY

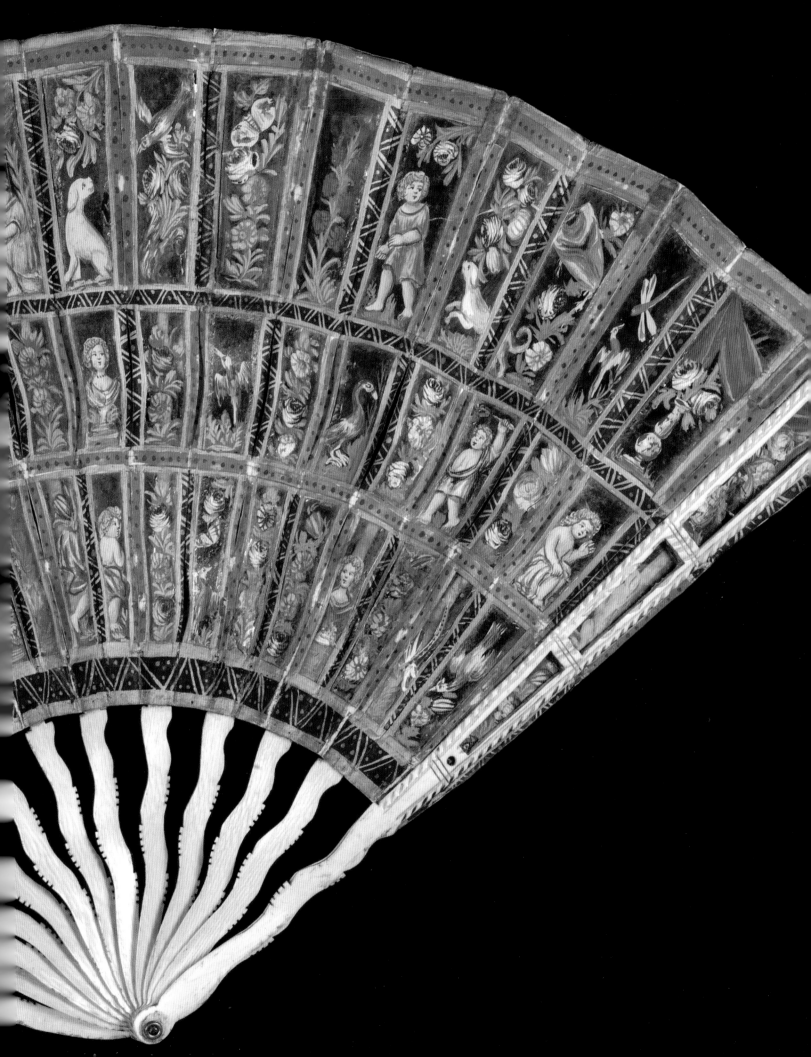

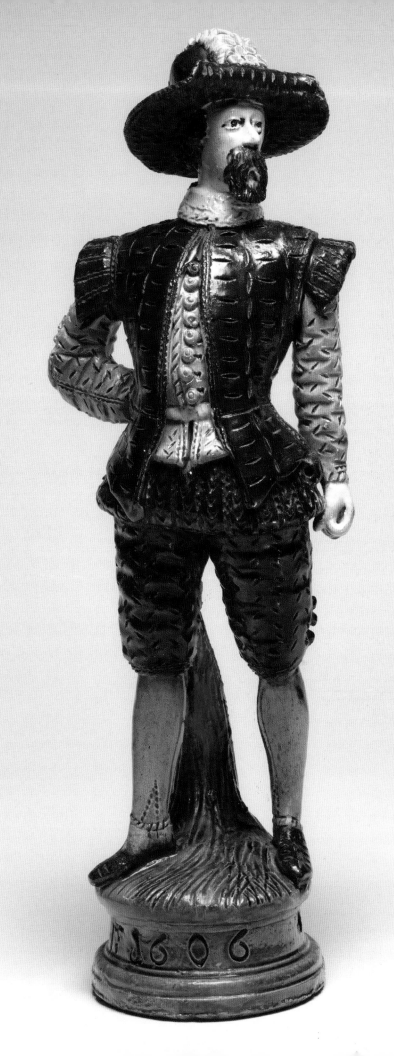

FIG. 121 | CAT. 107

A MAN IN A SLASHED COSTUME

German, probably Saxony | 1606

INTRODUCTION

Painting, architecture and sculpture often dominate our sense of the Renaissance. Yet this cultural movement became visible to many through a new world of fashion. Tailoring was transformed by new materials and techniques of cutting and sewing, as well as by the demand for a tighter fit, particularly for men's clothing.[1] Enterprising merchants created wider markets for fashion innovations and 'chic' accessories. Artistic representations of the clothed body proliferated as never before. Mirrors enticed more people to experiment with their appearance, not only catching their reflections in looking-glasses on walls, but carrying small pocket versions close to their body (fig. 122).

This new type of consumption and aesthetic appreciation depended on the assemblage of a whole range of goods that shaped the body into the right comportment. Detachable parts of armour or garments, rings, toothpicks, berets, purses, gloves, feathers, hair-pieces or shoes brought self-display to life. The honestone relief portrait of a woman from the 1520s shows her at the height of fashion with a beret perched on her head (fig. 142). In turn, the German earthenware figure of 1606 (fig. 121) sports a belt, buttons and a feathered hat. The slashings of the cloth exaggerate the modishness and cost of this particular style.[2] Even facial hair, such as the beard on this figure, could distinguish and ally people and identities.[3]

Such style statements are central to the appreciation of this period's visual interests, forged by courts, the Church and other wealthy patrons alongside urban dwellers. In 1500, 154 European cities had at least 10,000 inhabitants; by 1600 their number had risen to 220. Urbanites created concentrated markets for goods, and towns held markets and fairs, which drew upon increasingly productive economic hinterlands.

Aspiring young men and women – from artists to clock-workers, mercenary soldiers to urban courtesans, perfumers to female embroiderers – were intrigued by the possibility of experimenting with social roles as much as with aesthetic experiences through dress. Pawning, second-hand markets, renting, gift-giving, theft, lotteries, auctions as well as inheritance practices all made goods accessible to broader sections of society.[4] Meanwhile, entrepreneurs ensured that cheaper imitations of desired goods came on the market, so rare objects could turn into something familiar. Canons of taste needed to be redefined more rapidly. Courts did not always dictate fashion; taste travelled in many directions, not just from the top down.

Relatively few items of dress from this period survive, and these are not often exhibited, as they can be damaged by light. Yet, it is crucial to take them out of their boxes and to look at them closely so as to appreciate the skill with which many were made and which gave them their appeal. Clothes and armour were expected to 'make' men and women; that is, to transform their moral and emotional qualities. This process went in many directions, as early modern people shaped their identities in relation to different groups, self-images and kinds of object. That is why wardrobes and armouries could become storehouses of fantasies and anxieties, as well as accommodating expectations of what a person ought to look and be like. A nuanced understanding of the role of dress in processes of self-perception can only be achieved through exploring exactly what was worn and how these items were made. UR

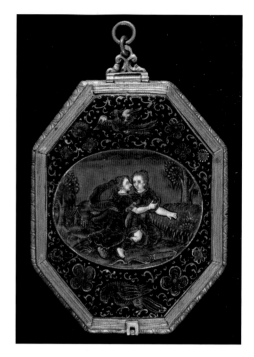

FIG. 122 | CAT. 125

PORTABLE MIRROR

Probably François I Limosin, Limoges, Haute-Vienne | *c.1600–20*

See: Allerston 1999; Currie 2007; Fisher 2001; Jones and Stallybrass 2000; Rublack 2010; Welch 2008b.

1. Currie 2007; Rublack 2010.
2. On slashing, see Rublack 2010.
3. Fisher 2001.
4. Allerston 1999; Welch 2008b.

AN ELIZABETHAN STASH

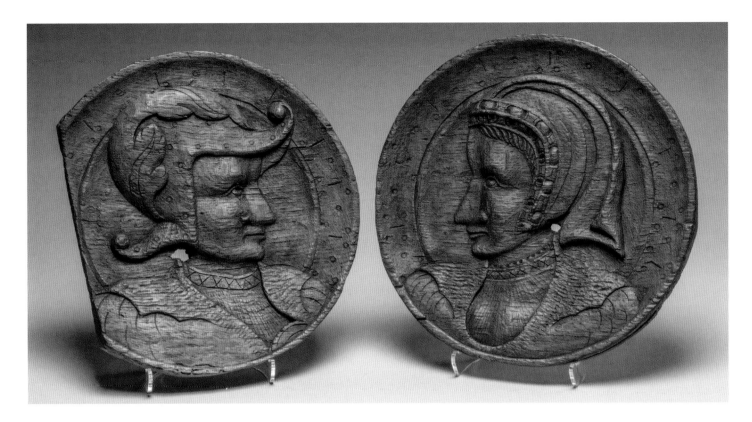

FIG. 123 | CATS 103–104

PORTRAIT ROUNDELS

English | *c.*1530–40

News of the discovery by London navvies of the 'Cheapside hoard' – a priceless collection of jewels buried in the cellar of a seventeenth-century goldsmith – hit the British press in March 1914. Visitors to the new London Museum were awestruck by this dazzling array of Elizabethan and Jacobean jewellery.[1] Some 60 years earlier, in 1852, a more modest 'hoard' had been uncovered in Cambridge, during repairs to the Old Court of Corpus Christi College. According to a report published by the archaeologist and botanist Charles Babington, workmen removing the floorboards of the so-called 'Shoemaker's Room' had discovered not glittering jewels but a variety of Elizabethan footwear and other leather goods: a white purse (fig. 124); a small white glove with a 'ruffle' at the wrist; a delicate pair of slashed shoes (fig. 125); slippers with slashing on the toes and thick cork soles; a shoe accompanied by a wooden clog fastened by a peg; and another single shoe, again with slashing.[2]

Although left in a state of disrepair, this rare collection of Elizabethan leather goods attests to the skill of the shoemaker and the modishness of his clients.[3] Other nearby finds included fragments of religious texts, a comb, knife and pipe, and a handsome pair of wooden roundel reliefs, depicting the heads of a man and woman in profile (fig. 123), each with a hole in the centre where they were once affixed to the wall, presumably looking at one another.

While the Cheapside builders took their findings to a local pawnbroker, the Cambridge hoard found its way into the hands of the 'under porter' of the College, one Mr Bailey. Fortunately for posterity, Bailey soon afterwards emigrated to America, at which point the Cambridge Antiquarian Society acquired the stash. It was transferred to the Museum of Archaeology and Anthropology at its foundation in 1883. MRL

See: Babington 1859, pp. 50–4; Forsyth 2013; Rublack 2013, pp. 41–85.

1. Forsyth 2013, p. 13.
2. Babington 1859.
3. Rublack 2013.

FIG. 124 | CAT. 105

PURSE

English | 1550–1600

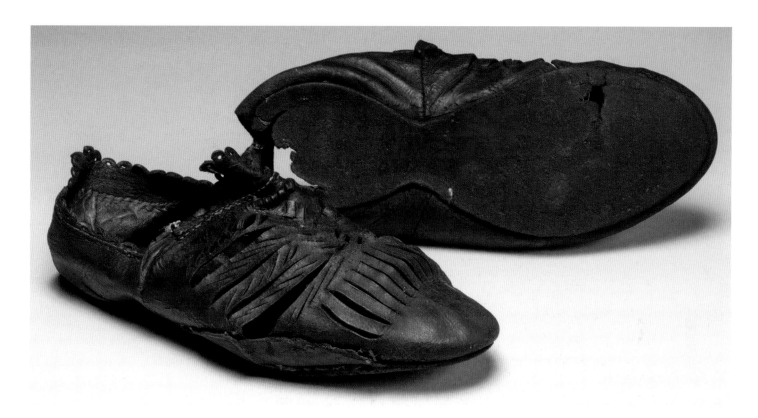

PAIR OF SHOES

English | 1550–60

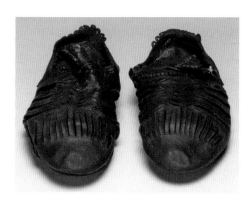

Leather clothing often changes shape to accommodate the wearer's body, and this pair of Elizabethan shoes bears the imprint of the owner's feet. With elaborate slashes and pinks (decorative cuts), these shoes allowed brightly coloured stockings or netherhose to show through, creating a striking effect for one fashion-conscious Cantabrigian.

Clearly treasured, they show wear from pounding the streets of Cambridge and have been patched with leather. Perhaps this is why they were discovered in the 'Shoemaker's Room' in Corpus Christi College.

Between about 1500 and 1900, old shoes were sometimes placed into walls or fireplaces during construction to ward off evil. The Northampton Museum keeps an index that currently lists approximately 1,900 concealed shoes found across the United Kingdom, North America and Europe.[1] Stuffed beneath the floorboards once unfashionable and tired, these shoes had a second function protecting Corpus' students and fellows. SP

See: Babington 1859; Gilchrist 2012; Northampton 2012; Riello 2009.

1. Northampton 2012.

DRESSING THE MALE BODY

As Shakespeare's Polonius declares in *Hamlet*, 'the apparel oft proclaims the man'.[1] Though the Fitzwilliam Museum does not formally collect costume, portraits such as *Young man in a fur cloak*, attributed to the workshop of the Venetian painter Jacopo Tintoretto (fig. 128), offer a glimpse into early modern clothing. Clothing accounted for a significant proportion of household expenditure across the social spectrum, and a fur cloak probably cost many times the price of a portrait. Even wealthy fashion-followers such as the diarist Samuel Pepys rented clothing to wear in portraits.[2]

Early modern people expected to be able to identify one another's social and economic position, nationality and gender at a glance, so clothing was more than purely a visual display of wealth. Many European cities controlled fashion through sumptuary laws, which prohibited people of certain social ranks from wearing certain colours, fabrics or styles.

Inferiors were expected to show 'hat honour' by removing headwear in the presence of a superior. Made in a vast range of styles and materials, and owned by men and women across the social spectrum, hats could be embellished and personalized with accessories such as the Limoges enamel medallion (fig. 127). Although now mounted as a pendant, two pierced holes suggest it might originally have been attached to a hat. Its miniature scene of Roman warriors would have appealed to any Renaissance humanist familiar with classical literature, and might have suggested the wearer's martial prowess.

Inside the home, a man might replace his hat with a linen nightcap, as covering one's head was considered good for the brain.[3] Though feminine to modern eyes, this example (fig. 126), completely covered in polychrome embroidered flowers, spangles and metallic bobbin lace, was suitable masculine attire in seventeenth-century England. A similar cap is shown in the portrait of the shipwright and naval officer Phineas Pett (1570–1647).[4] Masculinity, social status and personal style could all be communicated through accessory and dress. SP

See: Cavallo and Storey 2013; Corfield 1989; Hunt 1996a; Jones and Stallybrass 2000.

1. Shakespeare 2006, act 1, scene 3, line 71.
2. Pepys 1983, vol. 10, p. 98, as cited in Jones and Stallybrass 2000, p. 40.
3. Cavallo and Storey 2013, pp. 79 and 134.
4. National Portrait Gallery, London (no. 2035).

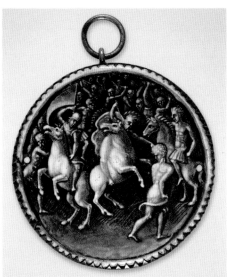

FIG. 127 | CAT. 110

HAT BADGE

Possibly Pierre II Pénicaud, Limoges, Haute-Vienne | *c*.1550–75

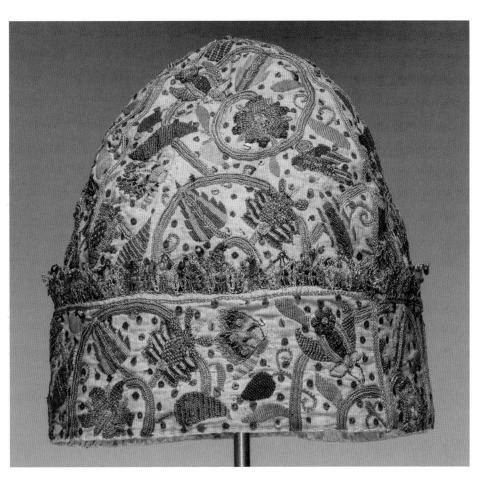

FIG. 126 | CAT. 111

MAN'S CAP

English | late 16th / early 17th century

FIG. 128 | CAT. 117 ▶

YOUNG MAN IN A FUR CLOAK

Workshop of Jacopo Tintoretto | 1558

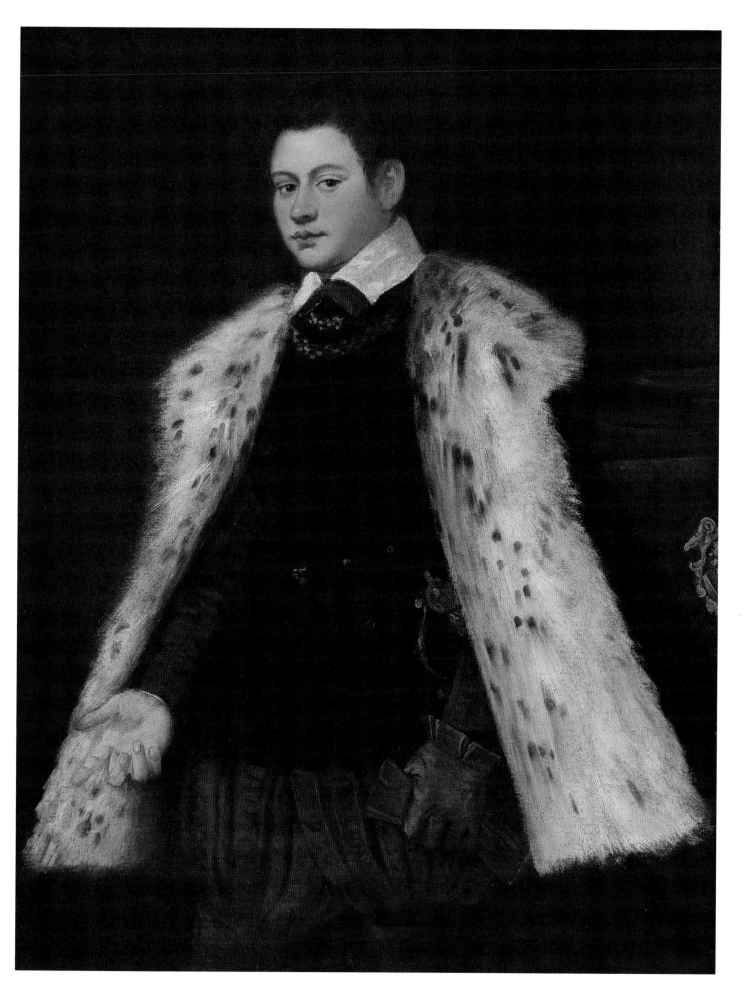

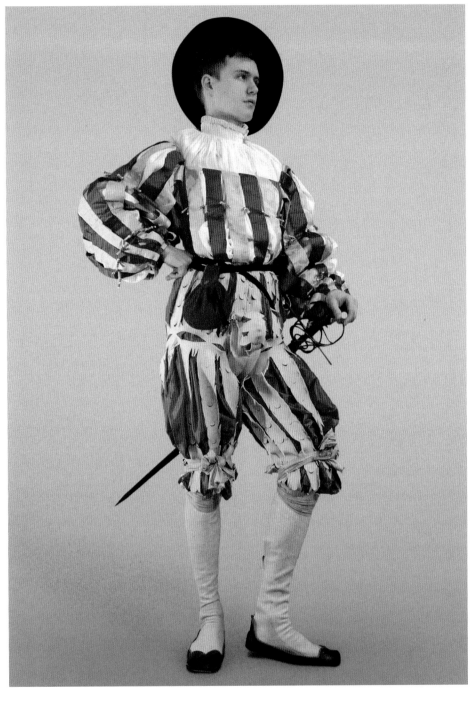

FIG. 130

MATTHÄUS SCHWARZ'S
TRACHTENBUCH

Augsburg | 1530

FIG. 129 | CAT. 116

RECONSTRUCTION OF MATTHÄUS SCHWARZ'S SLASHED COSTUME OF 1530

There can be no better guide to the Renaissance fascination with dress and self-conscious display than Matthäus Schwarz of Augsburg. Schwarz was born in 1497 and worked as chief account-ant for the Fugger family. Aged 23, he started a unique project: his 'little book of clothes'.[1] For the following 40 years, he commissioned innovative clothes and had these recorded for posterity in coloured images. In 1560, Schwarz bound 137 of these together.

This hand-made reconstruction, the work of Jenny Tiramani, the Olivier and Tony award-winning Director of the School of Historical Dress, London, is an interpretation of the outfit he wore at the Imperial Diet of Augsburg in 1530 (fig. 130). It shows the height of colourful, joyous Renaissance fashion. Schwarz signalled his taste through the quality of its production. The leg garment was made of leather and had been dyed to match exactly the doublet, which consists of alternating panes of damask and cheaper silk satin. UR

See: Rublack 2010.

1. *Klaidungsbüchlein*. The manuscript is in the Herzog Anton Ulrich Museum, Braunschweig, Germany.

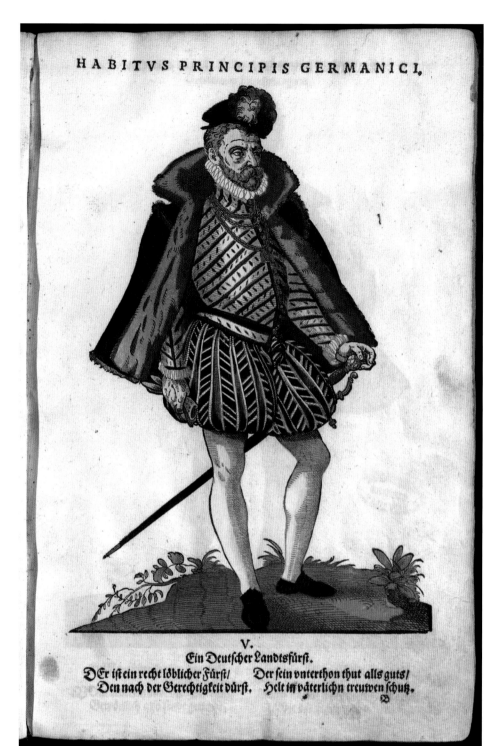

HABITVS PRINCIPIS GERMANICI.

V.
Ein Deutscher Landtsfürst.

DEr ist ein recht löblicher Fürst/ Der sein vnterthon thut alls guts/
Den nach der Gerechtigkeit dürst. Helt in väterlich treuwen schutz.

FIG. 131 │ CAT. 109

TRACHTENBUCH

Hans Weigel, Nuremberg │ 1577

The second half of the sixteenth century witnessed the emergence of a new genre: the printed costume-book. One of the first and most comprehensive books was created by the woodcut artist Hans Weigel in Nuremberg in 1577, with help from his prolific colleague Jost Amman. This was the most lavishly printed costume-book that had appeared in Europe to date, although the even more extensive volumes produced by the Venetian Cesare Vecellio, in 1590 and 1598, are better known today. Many of the depictions by Vecellio (and his Nuremberg cutter Chrieger) were based on Weigel. The *Trachtenbuch* comprised 219 single-page woodcuts in a generous format, which illuminators could colour. Costume-books were looked at and read by men and women. They disseminated knowledge of different customs across the globe, offered regional and national guides to style, and propagated a strong moral code for self-comportment. UR

See: Rosenthal and Jones 2008; Rublack 2010; Wilson 2005.

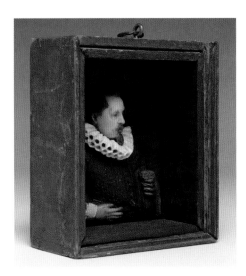

FIG. 132 | CAT. 108

A BEARDED MAN HOLDING GLOVES

Georg Holdermann, Nuremberg | *c.*1600–25

Small-scale, low-relief portraits in coloured wax originated in sixteenth-century Italy, and quickly became a popular alternative to medals as a means of recording an identity in a portable format. Although fragile and sensitive to heat and light, wax portraits were valued for their naturalism. While some were set into lockets and worn as portable mementos,[1] others, like the present example, were framed in wooden boxes with glass fronts and hung on walls.

By the late 1500s, Nuremberg had become a renowned production centre for such wax images, with Georg Holdermann (1585–1629), the presumed author of this portrait, a leading exponent.[2] Many Nuremberg patricians had themselves immortalized in wax.[3]

This carefully modelled portrait of an unknown man is smaller than most, which gives it a particular intimacy. Whilst the sitter's physiognomy has been faithfully recorded, so too has his fashionable attire. The large ruff, textured doublet with buttons and fur-trimmed brown leather gloves reveal him to be a man of means and taste, while his proud comportment and elegant gestures attest to his education and refined manners. Given its ephemeral nature, many works of art in wax have not stood the test of time. The fact that this portrait is so well preserved is testimony to the care of successive owners. VJA

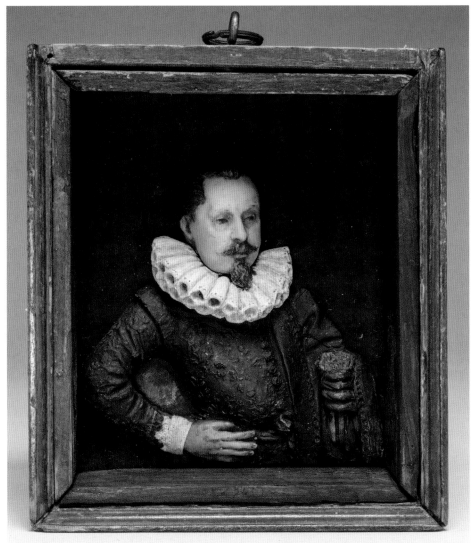

See: Kammel and Lorenz 2008, pp. 84–5; *Oxford Art Journal* 2013 (36/1); Penny 1993, pp. 215–6; Pyke 1973; Scholten 2013, p. 141; Trusted 2007a, pp. 27–31.

1. For example, *Don Carlos* by Antonio Abondio: V&A: A.525-1910.
2. Pyke 1973, pp. 69–70. It was Pyke who bequeathed the present bust to the Fitzwilliam Museum in 1996.
3. For example, Johann Wilhelm von Loeffelholz (1558–1600), *c.*1600, and Georg Volckamer von Kirchsittenbach (1560–1633), *c.*1630 (Germanisches Nationalmuseum, Nuremberg: pl.0.797, and pl.0.781 respectively).

FIG. 133 | CAT. 118

COMPOSITE ARMOUR

European, mainly South German | *c.*1530–60

This steel armour for field use is typical of German pieces made after 1500 which, mirroring fashions in civilian dress, moved away from the more slender 'Gothic' forms towards a bulky outline that emphasized bodily mass. Its medially ridged, deep-bellied breastplate is a precursor to the 'goose-belly' or 'peascod' shape of later sixteenth-century breastplates and waistcoats. The armoured codpiece also reflects contemporary fashions: its cuplike form dates it quite specifically to *c.*1530–60, as later examples are more upwardly pointing and, by 1570, they had gone out of fashion. The restrained surface decoration, consisting of 'black from the hammer' surfaces with recessed bands and borders and roped edges, is also typical, and contrasts with the 'fluted' flaring or parallel ridges which had been popular from *c.*1515–40.

Although the armour appears to be a complete 'suit', it is in fact a composite, made up of elements taken from several different but roughly contemporary and stylistically similar examples. The practice of 'associating' pieces often involved modifying the form or colour of particular parts to make them fit together better, physically and/or visually. This sort of 'restoration', typically demanded by nineteenth- and early twentieth-century collectors who wanted complete 'knights' for display in serried ranks, is no longer considered an acceptable curatorial practice. VJA

See: Williams 2002, esp. p. 428.

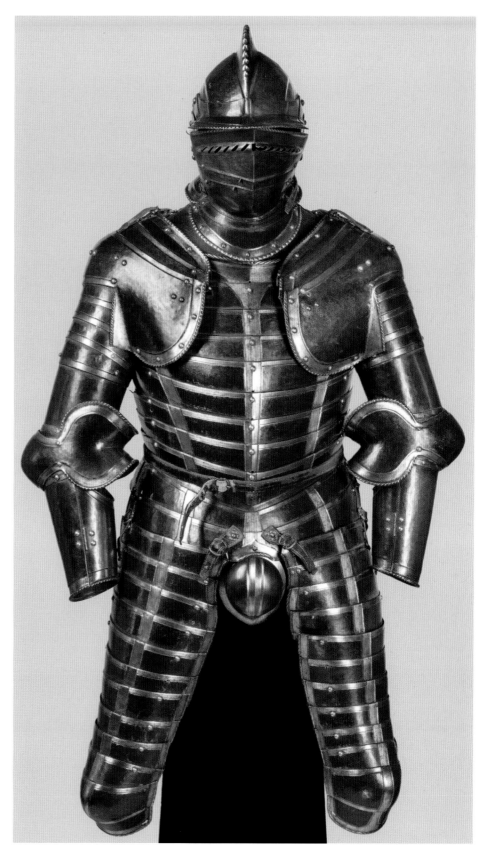

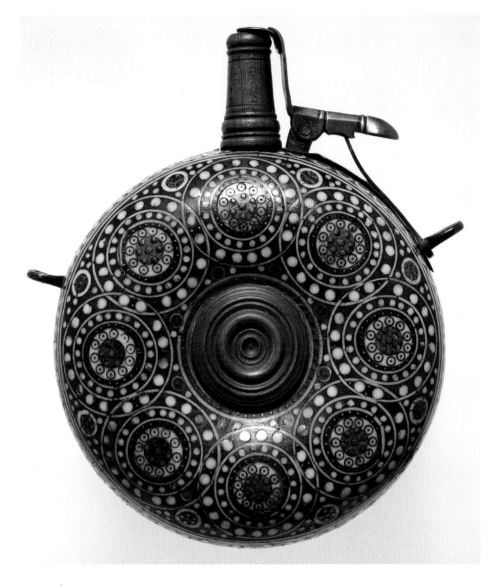

FIG. 134 | CAT. 112

POWDER FLASK

European | *c.1600–20*

In early modern Europe, armour and weaponry were as much about fashion, aesthetics, social status and wealth, as violence, intimidation and self-protection. An integral part of daily life, arms crop up constantly in sumptuary laws, household inventories, courtesy books and conduct manuals, and are frequently portrayed in costume books (figs 130 and 131), portraits (fig. 128) and funerary monuments, as well as on all manner of domestic objects from pharmacy jars (fig. 33) and tankards (fig. 89) to cap badges (fig. 127) and embroideries (fig. 276).

Armour was worn – by those who could afford it – not only for protection in battle, tournaments and training sessions, but also for self-conscious display in military parades, triumphal entries, ceremonial processions and private festivities.

While the less well-off used mass-produced, low-quality munition armour which they purchased at markets, fairs and shops, or acquired from second-hand dealers, the wealthy commissioned made-to-measure 'garnitures' from master armourers. These were made of superior materials, and often possessed up to four times the hardness and tensile strength of their cheaper counterparts (fig. 133). Eye-wateringly expensive and often reflecting the height of contemporary civilian fashion, such deluxe armour came with additional 'pieces of exchange' that could be swapped in depending on the type of martial activity being undertaken. Thus Sir John Smythe, a professional Elizabethan soldier, ordered a light cavalry armour in fine steel from Augsburg in the 1580s, but had additional components made by armourers at Greenwich to enable conversion for infantry use.[1]

Such garnitures were usually lavishly embellished with fashionable inlaid, embossed, etched and/ or engraved decoration, often of a mythological, historical, religious or heraldic kind, and often personalized with an individual's coat-of-arms, initials or emblems. Very expensive armour might also incorporate gilding and/or silvering, sometimes combined with blueing or russeting.

The finest armour demanded metal-working skills of the highest order, which were nurtured in cities across Europe, particularly in northern Italy (Milan and Brescia) and southern Germany (Augsburg, Nuremberg, Landshut and Innsbruck). Many other cities or rulers employed foreign experts: King Henry VIII employed German, Flemish, Dutch and Italian craftsmen at the Royal Armoury in Greenwich. Often professional painters, sculptors and goldsmiths were involved in designing and decorating armour, sword hilts, scabbards and firearms.

Similarly, while swords, guns and associated equipment (figs 134 and 135) were deployed in military combat and in duels to restore honour, they were also used in non-martial contexts, such as sporting contests and hunting expeditions. Particularly ornate examples were carried and worn about town as fashion accessories by image-conscious noblemen keen to be regarded as 'men-at-arms' even if they had never seen active service on the battlefield.

Swords, in particular, were clear status symbols in the early Renaissance since, in times of peace, only noblemen were allowed to carry them in public.[2] Cologne, Passau and Solingen (Germany) and Toledo (Spain) were all famous centres for sword production.

Like armour, weapons were often personalized through inscriptions or coats-of-arms. Whether purchased directly from the manufacturer, looted from battlefields, won in tournaments or acquired as gifts, armour and weapons were certainly treasured possessions. Prized pieces were often bequeathed to significant individuals as tokens of affection or esteem, or were hung over tombs as funerary achievements. Arms and armour were also avidly collected by wealthy individuals and were prominently displayed in entrance halls or dedicated armouries to impress and intimidate visitors, and to assert individual and dynastic authority. VJA

See: Capwell 2011; Capwell 2012; Fliegel 2008; Patterson 2009; Terjanian 2012.

1. Royal Armouries, Leeds: II.84, III.1430, III.1431, VI.51, VI.115, VI.116.
2. Travellers were exempted from this rule and permitted to carry swords for self-defence.

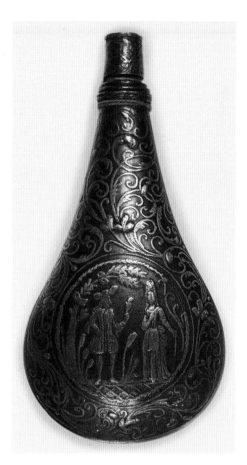
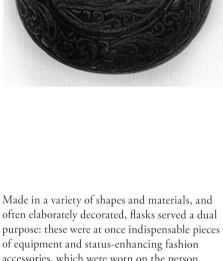

FIG. 135 | CAT. 113

PRIMING FLASK

European | c.1700–60

A number of accessories were necessary in order to load a gun in the sixteenth and seventeenth centuries. Powder flasks (fig. 134) carried, measured and dispensed gunpowder into the barrel. Priming flasks contained finer gunpowder for priming the pans of muzzle-loaded guns, so as to create the initial spark that ignited the powder in the barrel. Some flasks had eyelets to attach them to a bandolier, which would have been hung across the shoulder or waist and used to carry a range of implements. Others, like this example, had no suspension loops and were designed to be carried in pockets or pouches.

Made in a variety of shapes and materials, and often elaborately decorated, flasks served a dual purpose: these were at once indispensable pieces of equipment and status-enhancing fashion accessories, which were worn on the person even when a firearm was not being used.

This pear-shaped steel priming flask is covered with inlaid silver decoration, including two vignettes of a courting couple which have become worn through frequent handling. Possibly intended to be read in combination as a 'before' and 'after' scenario, this amorous iconography makes it likely that the flask was originally the gift of a wealthy lady to her husband or lover. VJA

See: Patterson 2009.

DRESSING THE FEMALE BODY

Over the course of the early modern period, an ever-increasing range of accessories became available to adorn wealthy women from head (fig. 69) to toe (figs 164 and 165), with elegant fans (figs 147–149) and sparkling jewels (figs 156, 269, 270 and 279).

Portraiture (figs 143, 144, 157 and 256) can be a useful tool for understanding early modern female dress (see 'Dressing the male body'), but informal wear such as these eighteenth-century under-bodices (figs 138 and 139) is rarely depicted – suitable for wearing around intimates indoors, it would have been too relaxed and revealing for formal portraiture.

While small decorated purses and bags also do not often appear in visual sources, they survive in relatively large numbers, perhaps indicating that they were worn on special occasions or used as containers for gifts. Sometimes called 'sweet bags', they could be filled with scented herbs and flowers, and perhaps the decorative flowers on this seventeenth-century example (fig. 136) hint at this usage.[1] After all, anyone wealthy enough to own a purse covered in silver-gilt and silk would have rarely needed to carry coins.

Accessories could denote social transitions, such as that from childhood to adulthood. In 1735, Grace Boyle wrote to tell her friend about London: 'Many things have happened to me since I came here viz. the borring [piercing] of my Ears, Papa's giving me a pair of £100 earrings […] So I think I came to town to some purpose.'[2]

Made of marcasite and mother-of-pearl, these earrings (fig. 137) were probably less expensive than Grace's pair, though they would have certainly sparkled in evening candlelight at the social occasions enjoyed by young adults.

Extant accessories and intimate wear complicate our understanding of early modern dress, as they reveal what is not shown in portraiture. They also hint at key moments in their owners' lives – indoor socializing, evening parties and rites of passage. SP

See: Berg and Clifford 1999; Morrall and Watt 2008; Pointon 2009a; Ribeiro 1984.

1. Morrall and Watt 2008, see esp. pp. 189–91, nos 40–3.
2. London, 18 September 1735, Strafford Papers, Add. MS 22, 256 (36), British Library, London. As cited by Pointon 2009a, p. 91.

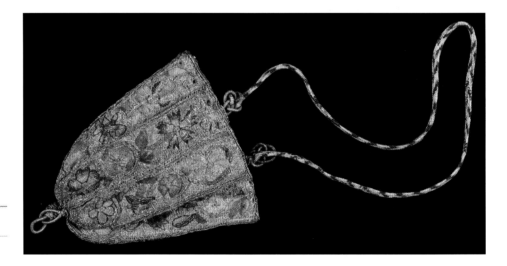

FIG. 136 | CAT. 124

PURSE

English | *c.*1600–25

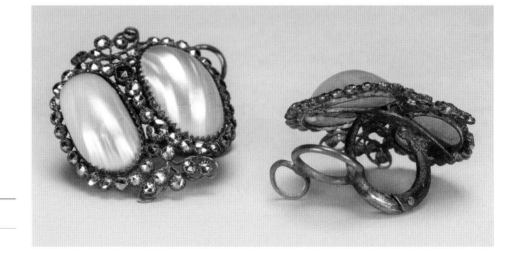

FIG. 137 | CAT. 126

PAIR OF EARRINGS

English | *c.*1790–1800

see fig. 138 (overleaf) ▶

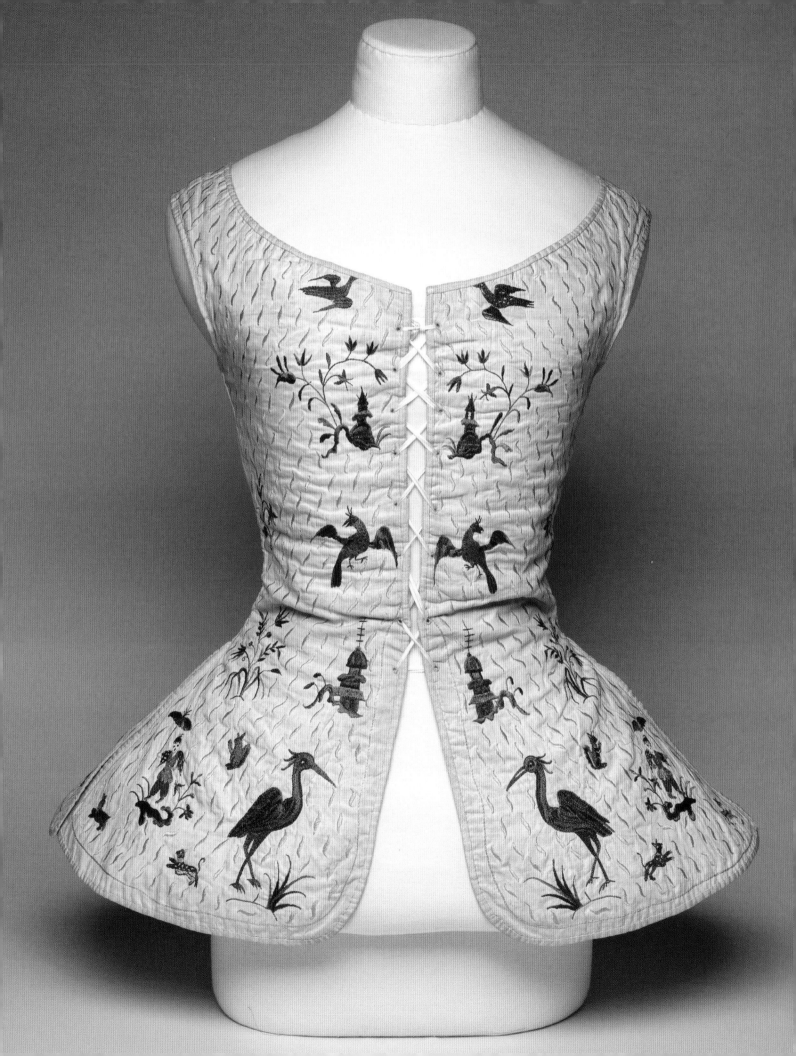

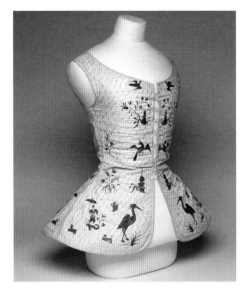
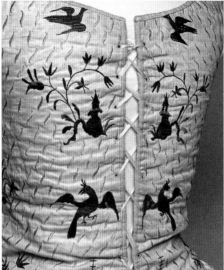
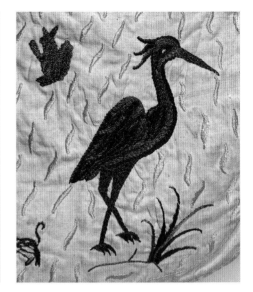

FIG. 138 | CAT. 128

UNDER-BODICE

English | *c.*1700–30

Large storks, sprouting plants, pagodas, squirrels and men jauntily holding parasols cover both sides of this woman's cream linen under-bodice. Far-Eastern imports with exotic designs inspired fantasies of Asia, and led to a vogue in chinoiserie: European design imitating Chinese art.

Similar birds with outstretched wings, fantastic flowers and exotic figures appeared in contemporary pattern books. The *Treatise of Japanning and Varnishing* (1688) encouraged Europeans to 'borrow a part from one, a figure from another, birds flying or standing from a third' when decorating objects with exotic designs.

For those emulating 'Indian' style, it advised: 'never croud up their ground with many Figures, Houses, or Trees, but allow a great space to little work'.[1] Whether the under-bodice's imaginative designs were embroidered in silk by the wearer, or purchased already decorated, they show the influence of Chinese and Indian textiles.

By the early eighteenth century, dresses often had open bodices to reveal embroidered stomachers (figs 140 and 141) or an under-bodice. Fig. 138 is not embroidered on the upper back, suggesting that this area was not meant to be seen. This padded garment, and a similar cord-quilted example (fig. 139), provided warmth and comfort, but neither was designed to shape the body.

Under-bodices (also known as jumps or waist-coats) simply enabled a woman to conform to a fashionable style when, amongst friends, she removed her boned support. Undress or *déshabillé* was acceptable in such circumstances, but could give the wrong impression if worn outdoors. In the satirical periodical, *The London Spy*, women seen outside in 'wadded waistcoats […] without stays' were mocked as 'tripping about in search of their Foolish admirers'.[2] Whimsical and unboned this under-bodice may have been, but its wearer would not have wanted to seem loose herself. SP

See: Beevers 2008; Campbell 2002; Ribeiro 2005; Riello 2013b; Stalker and Parker 1688; Vincent 2009.

1. Stalker and Parker 1688, p. 40.
2. Edward Ward, *The London Spy* (1704), as quoted in Ribeiro 2005, p. 312.

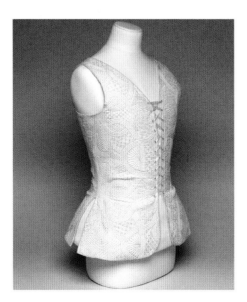
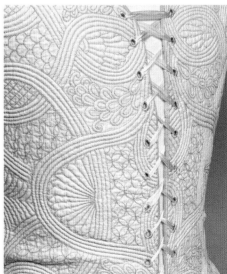

FIG. 139 | CAT. 129

UNDER-BODICE

English | *c.*1700–30

STOMACHERS

English | *c.1700–20 and c.1730–40*

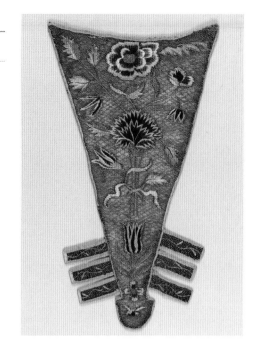

Stomachers, a part of female dress from the sixteenth to the eighteenth centuries, are decorative panels that covered the front of a bodice. This early eighteenth-century example (top) is embroidered with a stylized rose, carnation and tulips, and is completely covered in silver threads couched in a lattice design. With six embroidered tabs and a narrow low point, this fashionable piece would have been even more eye-catching in candlelight. Another slightly later example (below), wider in shape and less ostentatious in its use of metallic threads, still makes an impact through an explosion of brightly coloured stylized and symmetrical flowers and leaves on a background quilted in meander pattern.

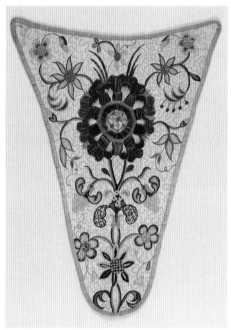

Stomachers could be used interchangeably, either complementing or contrasting with the colours and designs of the rest of an outfit, and for very special occasions would be adorned with jewellery.

Accessories such as jewelled stomachers did not simply ornament the body and personalize an outfit. They could also be given to friends and family as tools of sociability. In 1768, Sarah, Lady Cowper, lent a diamond stomacher to Lady Spencer, 'which added to her own jewels made her very brilliant'.[1] Borrowed accessories could signal political and social alliances and were closely scrutinized at court.[2] SP

See: Delany 1861–2; Greig 2013; Hart and North 1998.

1. Letter from Lady Sarah Cowper to Mary Dewes Port, 16 October 1768, in Delany 1861–2; as cited by Greig 2013, p. 499.
2. Greig 2013.

FIG. 142 | CAT. 119

YOUNG WOMAN WEARING A BERET

Nuremberg | *c.1520–30*

Likely fashioned in Nuremberg, this small honestone portrait relief of an unidentified female sitter attests to the important place of women in Renaissance Germany and, in certain cases, their high visibility. It may have been carved after a drawing by the famous Augsburg-born medallist Hans Schwarz (1492–after 1521), perhaps in preparation for a medal. At any rate, a similar portrait appears in the 1523 bronze medal of the Nuremberg goldsmith's wife, Lucia Dorer.[1]

The desire of certain women to be portrayed without a hood or veil, in order to reveal their faces and inventive hairstyles, and wearing a beret (a piece of headwear originally designed for men) suggests their support for a Renaissance refashioning of female identity: experimenting with gender fluidity and displaying new values of feminine virtue and beauty.[2] By wearing certain items, women visually enforced a message that they were divinely endowed with beauty and not just interested in lascivious fashions. SI

See: Rublack 2010.

1. Germanisches Nationalmuseum, Nuremberg: inv. no. med 6766. See also Rublack 2010, p. 231.
2. Ibid.

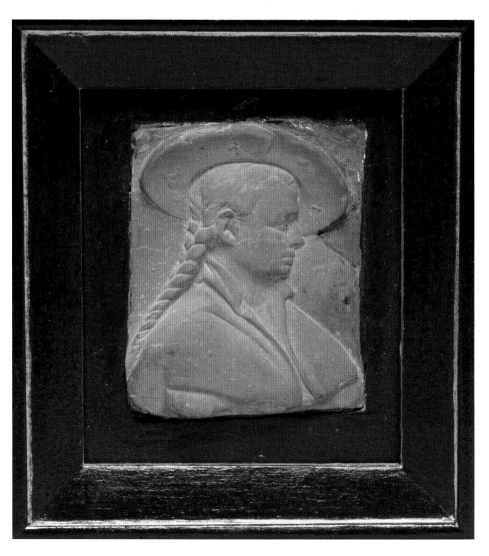

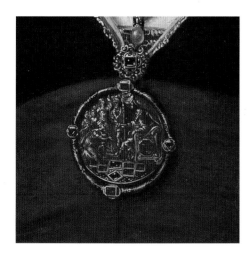

FIG. 143 | CAT. 127

UNKNOWN LADY

Han Eworth, English | *c.1550–5*

This type of monumental, three-quarter-length portrait in oils, in which the subject is shown standing, with fairly generalized features, head slightly to one side and hands clasped, was reserved for elite Tudor patrons. It was painted by the Flemish émigré Hans Eworth, who enjoyed particular success during the short-lived reign of Mary Tudor (1553–8) and cultivated the patronage of many powerful Catholics.

Variously identified as Mary Tudor, Lady Jane Grey and Lady Anne Penruddocke, the sitter is clearly a wealthy English aristocrat, fashionably dressed in red and black silk with black velvet inserts and gold trim, and bedecked with jewels. Her restrained and demure pose, milky, unblemished flesh, long fingers and noble brow speak of her breeding, gentility and intelligence.

From her prominent girdle-prayerbook and large gold medallion depicting Esther before Ahasuerus, it is clear that the sitter, whether Catholic or Protestant, also wished to publicize her Christian piety, and associate herself with this Old Testament heroine. Esther was upheld in contemporary prescriptive literature as a paragon of female virtue, being beautiful, pious, brave, modest in dress and obedient to her husband. VJA

See: Bleyerveld 2000–1; Hearn 1995, pp. 63–76, esp. pp. 66–7; Morrall and Watt 2008, pp. 248–50; Strong 1969; Strong 1995; Tait 1985, esp. pp. 30–2; Walsham 2004.

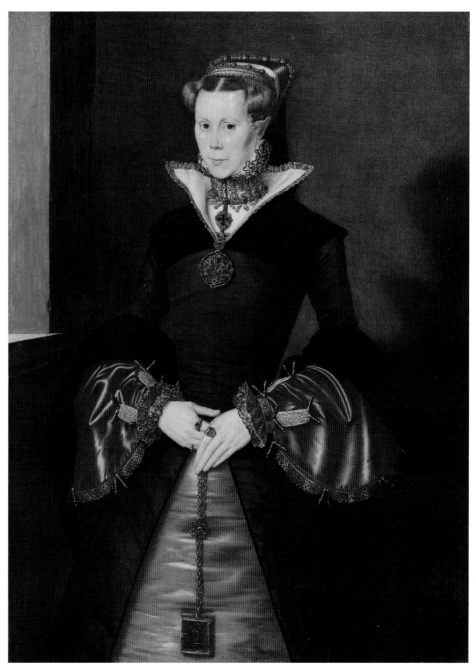

FIG. 144 | CAT. 121

LOCKET WITH PORTRAIT MINIATURE

**School of Isaac Oliver, English
early 17th century**

Intimate and jewel-like, portrait miniatures became popular within English courtly circles during the reign of Henry VIII, being a radically different alternative to traditional large-scale formal oil portraits for public settings (fig. 143).

While some were secreted away in storage boxes or cabinets and shown only occasionally to privileged guests, others were designed to be carried or worn on the person. Some portrait miniatures were set into lockets, such as this gold one covered in blue smalt and mounted with an enamelled suspension loop to permit it to be worn on a fine gold chain.

When opened, it reveals a fashionably dressed Elizabethan aristocrat, possibly Elizabeth, Countess of Rutland (1585–1612), daughter of the courtier Sir Philip Sidney and – according to her friend, the playwright Ben Jonson – an accomplished poet in her own right. It is an essay in white: white-painted face (with a suitably prominent forehead to indicate intelligence) set off by a pure white costume (diaphanous veil, opulent white-starched lace headpiece and ruff with cutwork, and bodice with lace neckline and fur trim). The only flashes of colour come from the delicate turquoise jewels sewn onto the dress and the gold mounts of the pearl earrings. Symbolic of purity and virtue, the white costume also indicated wealth and status, as this colour was expensive to achieve and keep clean. VJA

See: Bayne-Powell 1985, esp. pp. 168–9; Finsten 1981, esp. p. 50; Hearn 1995, pp. 117–45; Murdoch et al. 1981.

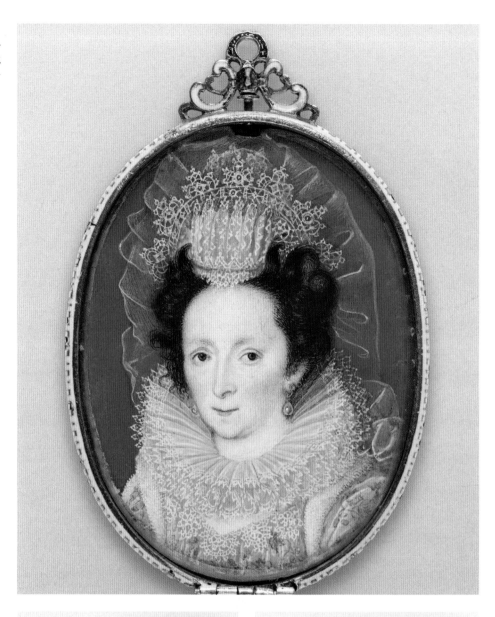

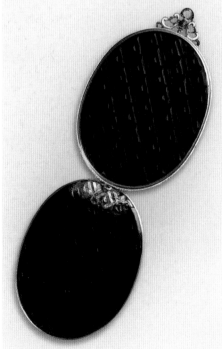

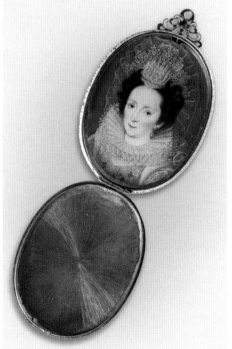

FIG. 145 | CAT. 120

DISH

Brislington, Somerset | 1688

This Brislington Delftware dish is a product
of heated contemporary discourse about the
extravagance of women's headwear. From the
late 1670s headdresses, generically known as
'topknots', grew increasingly tall, and by 1690
they had become tower-like structures of ribbons
and lace, much taller than the pleated-ribbon
topknots worn by the animals depicted.[1]

They and the verses were copied from a
broadside ballad,[2] one of at least ten known
which adopted either a moralizing anti-topknot
stance, or a feisty defence of women's right to
wear what they chose.[3] The writer asks if women
want to wear topknots now that they are worn
by animals like these – a cat was slang for
prostitute, owls were considered foolish and
apes as vain, undiscerning copyists. JEP

See: Archer 2013; Day 1987; De Marly 1975; McShane and
Backhouse 2010.

1. De Marly 1975; Archer 2013, pp. 62–3, no. A.91.
2. Folger Shakespeare Library, Washington, D.C., A.40.6;
Archer 2013, p. 63, fig. 13.
3. Day 1987, vol. 4, pp. 310, 362–3 and 365–7; McShane
and Backhouse 2010.

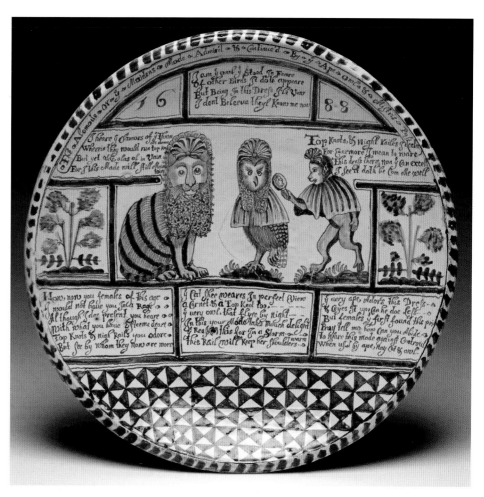

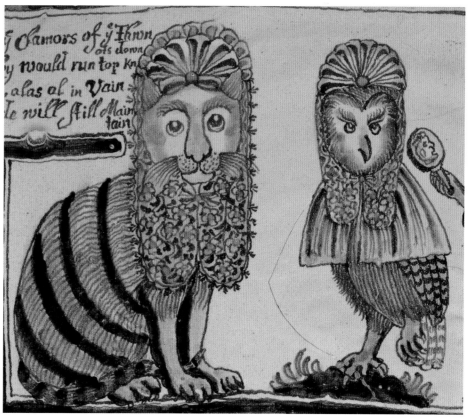

FANS

'Women are armed with Fans as Men with Swords, and sometimes do more Execution with them.' So quipped Joseph Addison (1672–1719), founder of the *Spectator*, on 27 June 1711, in his satirical letter, which sent up the fashionable obsession with the 'correct usage' and supposed 'secret language' of the fan in early eighteenth-century England.[1]

While fans have been used globally for centuries as cooling devices, status symbols and fashion accessories, the folding variety with pleated leaves was introduced into Europe from the Far East in the sixteenth century by merchant traders and missionaries (fig. 146).

Compact and easy to carry when closed, these Eastern imports were much in vogue among upper-class women by the mid-seventeenth century; the less well-off tended to use cheaper fixed feather fans.

A rise in demand from the 1660s led to increased Chinese and Japanese imports by the Dutch, English and French East India Companies, and the development of a fan industry in Europe, organized by specialized guilds, such as the French Association de Eventaillistes in 1673 and the English Guild of Fan Makers, which was incorporated as the Worshipful Company of Fan Makers in 1709.

A fan's *monture* (sticks and guards) could be made from luxury materials such as ivory, mother-of-pearl or tortoiseshell, often carved, pierced or inlaid with gold, silver and/or precious stones. Cheaper alternatives like bone or wood could be painted to simulate more expensive materials. Fan leaves were crafted from fine vellum, kid, silk or paper, and during the mid- to late seventeenth century thin slices of mica (a thin glass-like material) were often added to give lustre (fig. 148). From *c.*1650–*c.*1730, varnished brisé fans were also made in the Netherlands, England and France.

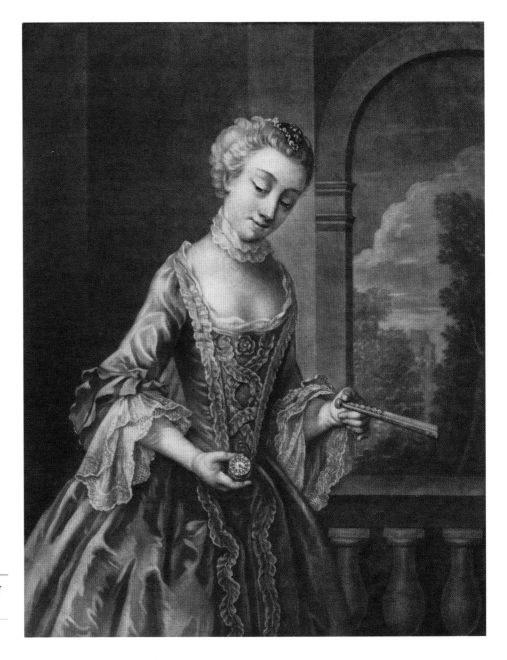

FIG. 146 | CAT. 130

A WOMAN HOLDING A SMALL WATCH AND A CLOSED FAN

British | *c.*1750–70

These consist solely of ivory sticks tied together at their tops with a tough thin cord, knots of fine silk or a decorated ribbon, painted in oils, often with classical or Oriental scenes (fig. 147). Lace fans were also popular from the 1730s until the end of the century.

Fan-leaves were almost always decorated on both sides: either painted by hand or, from the 1720s, machine-printed. England was the biggest maker and exporter of these cheaper printed fans. The expanding decorative repertoire available to producers included Chinese or Japanese motifs, themes from the Bible, ancient history, or popular fiction, as well as generic pastoral and romantic scenes, classical ruins or *trompe l'oeil* (figs 149 and 186).

By the later eighteenth century, contemporary political, religious and social events were also portrayed, as well as popular pastimes and leisure pursuits, reflecting prevailing attitudes and social customs.

Popular as gifts, top-end examples were purchased from 'toyshops', which purveyed expensive luxuries for adults – fans, watches, snuffboxes, patch boxes, canes and buckles – as well as children's playthings.[2] Cheaper fans were sold at fairs and booths.

In fashionable circles, it was said that a woman's mood was reflected in her use of her fan, with Joseph Addison commenting ironically in his 1711 satire: 'there is scarce any Emotion in the Mind that does not produce a suitable Agitation in the Fan; insomuch, that if I only see the Fan of a disciplin'd Lady, I know very well whether she laughs, frowns, or blushes'.[3] VJA

See: Addison 1711; Armstrong 1985; Brett 2014; Gray Bennett 1988.

1. Addison 1711.
2. Brett 2014.
3. Addison 1711.

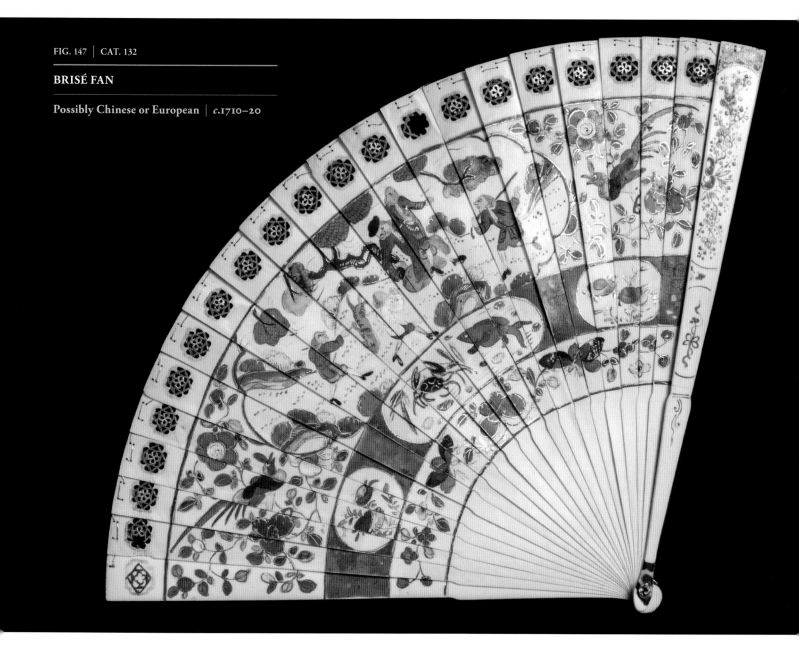

FIG. 147 | CAT. 132

BRISÉ FAN

Possibly Chinese or European | *c.1710–20*

FIG. 148 | CAT. 131

FOLDING FAN, KNOWN AS THE MESSEL MICA FAN

European | late 17th century

This highly unusual late seventeenth-century folding fan demonstrates material innovation: the leaf is constructed from three tiers of translucent mica (a shiny silicate mineral), mounted between paper strips. Painted and gilded, the mica panels are decorated with numerous miniature female and child figures, portrait busts, butterflies, birds, dogs and floral sprays. The sticks and guards of this luxury object have been crafted from bone.

This exceptional fan is one of only four of its type still in existence; similar designs and the use of mica (for the entire leaf) suggest that this group of late seventeenth-century fans was made by the same artisan or within the same Western European workshop. Considering its innovative material structure, this fashionable accessory would have been a precious and expensive acquisition and almost certainly in the possession of a woman of considerable means.
JKT

See: Alexander 1984; Armstrong 1984; Scrase et al. 2005, p. 145.

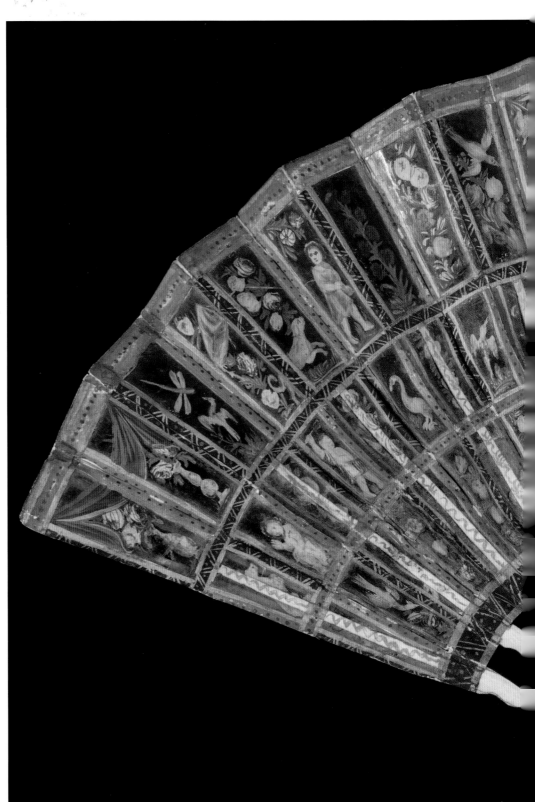

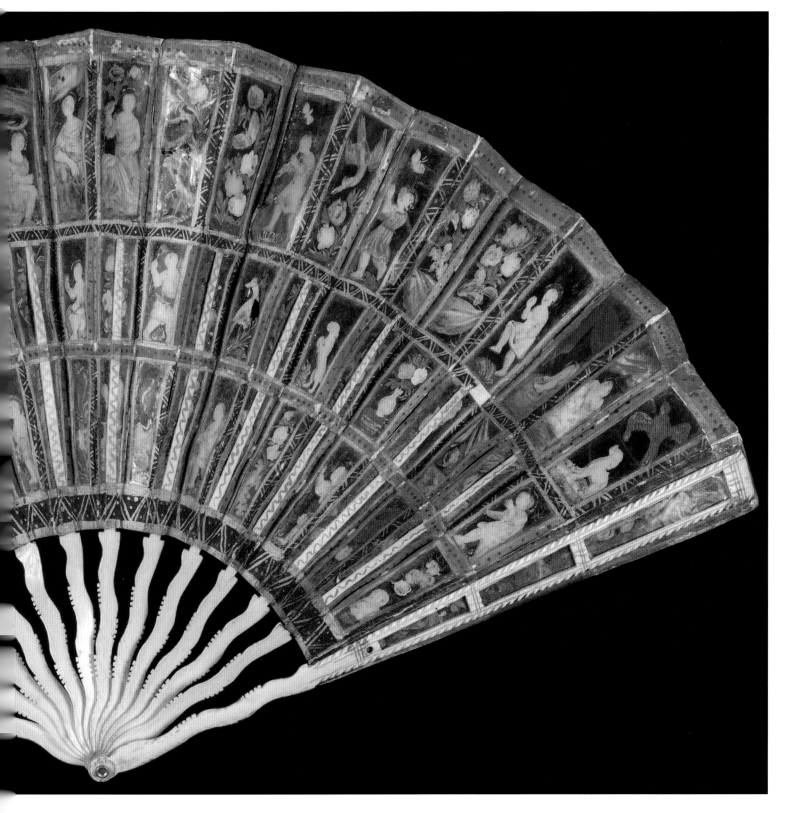

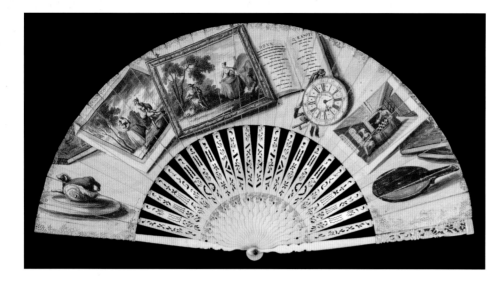

FIG. 149 | CAT. 133

FOLDING *TROMPE L'OEIL* FAN

English | *c.*1750

This mid-eighteenth-century English painted folding fan displays contemporary 'polite' cultural accomplishments, pastimes and leisure pursuits. Through the use of perspective techniques and the depiction of objects upon an actual object, it encourages the activity of viewing, and certainly demonstrates the artist's mastery. From left to right the playful *trompe l'oeil* design features a ham on a plate with dog; the corner of a book; two pastoral dancing and musical scenes: the first an unframed black and white 'print' signed 'Jno Faber fecit 1737',[1] the second a framed painting or coloured engraving; an open book titled *Donn Quiksott* (perhaps a parody of Don Quixote); a pocket-watch inscribed '-(J)EWELL' and 'LONDON';[2] an unframed coloured picture of draught players within an elite panelled domestic interior; two books; and the soundbox of a lute.

On the reverse of the leaf are books, music scores and a flute. Painted folding fans featuring pastoral and mythological scenes and pastimes of the privileged were luxury accessories in eighteenth-century France, a trend which perhaps inspired the maker of this remarkable object.

We do not know who commissioned this fan, but it must have been made after 1737 (the date on the Faber print) and likely *c.*1750, judging from the style of the watch. It was probably used and/or displayed within a domestic environment in which dancing, music, games and literature were enjoyed. Since fans, as used by middling- and upper-class women, were understood to communicate non-verbal language, this example might have revealed the cultural accomplishments of its owner.

The depiction of literature upon the surface of this fan is a particularly interesting motif as eighteenth-century fashions and literary marketplaces were closely intertwined. Following the success of Samuel Richardson's novel *Pamela, or Virtue Rewarded*, first published in 1740, scenes from the book were even produced on *Pamela* fans (a fan was used by the novel's heroine) and marketed to readers of the novel.[3] JKT

See: Baillie 1969; Batchelor 2007; Giusti 2009; Keymer and Sabor 2009; O'Connell 2004; Solkin 1993.

1. Victoria Avery has suggested verbally that this is likely to stand for John Faber Junior, a Dutch printmaker based in London from *c.*1698 until his death in 1756, who was the leading mezzotint engraver of his day. For Faber's biography, see O'Connell 2004.
2. A watchmaker by the name of Jewell was recorded in London in 1771, Baillie 1969, p. 172.
3. Keymer and Sabor 2009, pp. 143–4.

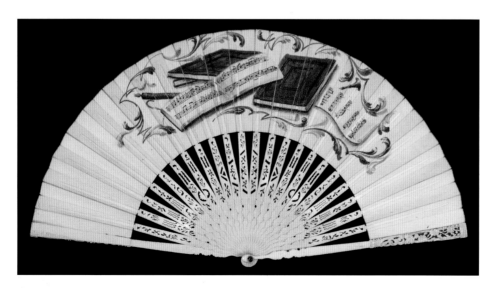

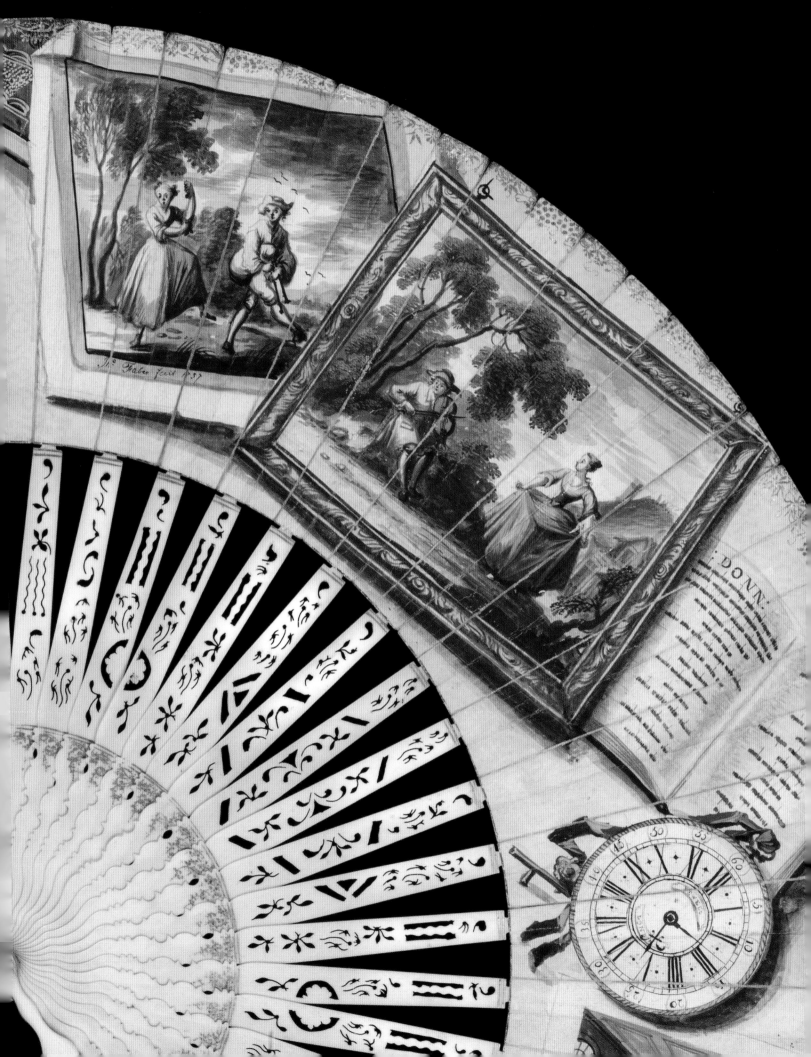

WATCHES

In 1541, the Italian humanist Lilio Giraldi (1479–1552) wrote that he had 'often seen a watch, which admirably showed the hours, placed in the handle of an eyeglass of Pope Leo X, of which he availed himself while hunting and travelling'.[1]

First developed in Italy c.1500 from portable spring-driven clocks, mechanical watches were made across Western Europe with centres of excellence in France (Paris, Blois, Lyon), southern Germany (Nuremberg and Augsburg), Flanders (Brabant), Switzerland (Geneva) and England (London). By the 1540s, watch movements had become compact enough to be incorporated into jewels, rings or other precious objects.

Until the mid-seventeenth century, watches were notoriously unreliable, losing time and requiring resetting by more accurate public clocks or by church or civic bells. This was famously noted by Thomas Middleton (1580–1627) in his play *Women Beware Women*: 'Bianca: How goes your watches, ladies? What's o'clock now? First Lady: By mine, full nine. Second Lady: By mine, a quarter past.'[2] In the seventeenth and eighteenth centuries, major improvements to the mechanisms of watches would bring greater precision.

Early watches gave relatively limited information and possessed just one rotating 'hour' hand and a radial dial that was subdivided to register only 30- or fifteen-minute intervals (figs 151 and 153). However, as mechanical accuracy increased, so did the number of rotating hands – first the 'minute' hand and then the 'seconds' hand (fig. 152) – and the number of subdivisions of the main radial dial. Additional features (or 'complications') included dials that displayed the days of the month and the lunar phases, and bells that struck the hour, so that the time could be heard as well as seen.

Watchmaking became a highly skilled craft, and watchmakers belonged to trade-guilds, such as the London-based Worshipful Company of Clockmakers (formed by Royal Charter in 1631), and normally signed their mechanisms. Fake signatures of particularly eminent masters were sometimes applied fraudulently to a mechanism to increase its retail value, either when it was first made, or later on. The watch (fig. 153) was made in London, c.1690, but the mechanism is certainly not by the famous watchmaker Thomas Tompion, as the signature claims.

Watches were protected from damage, dust and dirt by one or more cases, sometimes made by the watchmakers themselves, and sometimes by goldsmiths or professional case-makers, who rarely signed their work. Most watchcases were made in gold or silver, and were engraved, embossed, enamelled and/or inlaid with gems. In Geneva, watchcases were crafted from rock crystal and hardstones. Some cases were shaped, such as the one formed as a human skull (fig. 151), which recalls the verse from Psalm 89, 'Remember how short my time'. Recording the passage of time, and thus serving as *memento mori*, watches were often associated with skulls in other artforms, such as still-life *vanitas* paintings, or portraits. The unknown collector portrayed by Venceslao Verlin in 1768, for example, has a human skull at his feet, over which a watch has been draped (fig. 1).

Watches were status symbols, designed to be seen, held and admired, and in this they were not unlike fans, whose leaves were often decorated with watches (fig. 149). Watches could be hung on a chain around the neck, suspended from a chatelaine (fig. 162), kept in a pocket or, in later times, worn by women on the wrist. When not being carried or worn, watches were removed from their cases and set into decorative watchstands, which served both to display and protect them (fig. 150).

Originally, watches were the preserve of the wealthy elite, made to order, or purchased from luxury 'toyshops' which also sold snuff-boxes, canes, fans and other *objets de vertu*. As increasing numbers of people were able to tell the time, and wished to know it, demand for watches increased. Cheaper models were made, which were even hawked by pedlars (fig. 43).[3]

Whether expensive or cheap, watches were handled and consulted many times a day, creating an intimacy which, over the course of a lifetime, gave them a particularly powerful personal significance. Often received as presents, they invariably became prized possessions. Watches were frequently given or bequeathed to a beloved friend or relative and were then passed down the generations and treasured as heirlooms – even when they no longer worked. VJA

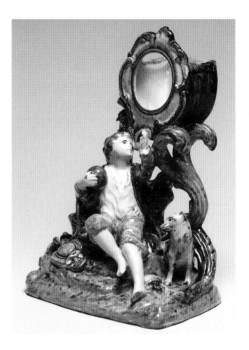

FIG. 150 | CAT. 141

WATCH STAND

French, possibly Nevers | c.1760

See: Berg 2005, p. 227; Cardinal 1985; Daniels 1981; Fairchilds 1993; Fontaine 1996; Fontaine 2003; Glennie and Thrift 2002; Hunt 1996b; Landes 2000; Thompson 2007; Vincent and Leopold 2009; Voth 1998.

1. Taken from Vincent and Leopold 2009.
2. Thomas Middleton, *Women beware Women*, act 4, scene 1, lines 1–2.
3. Fontaine 1996 and Fontaine 2003.

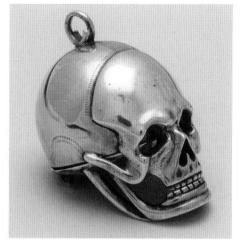
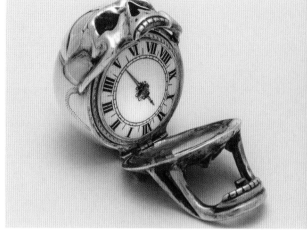

FIG. 151 | CAT. 135

VERGE SKULL-SHAPED WATCH

Raymond Champenois, Paris
*c.*1670

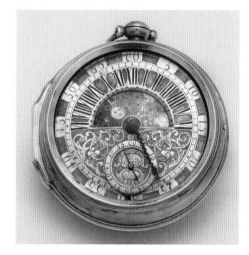
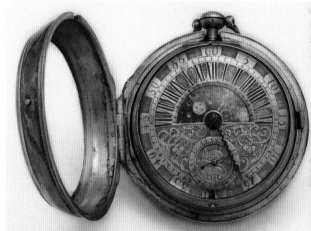

FIG. 152 | CAT. 136

VERGE WATCH

Luke Richards, London | *c.*1685

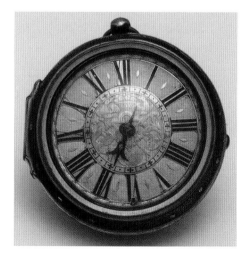
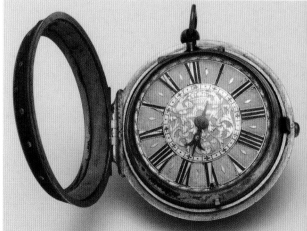

FIG. 153 | CAT. 137

VERGE WATCH

English, London | *c.*1690

FIG. 154 | CAT. 139

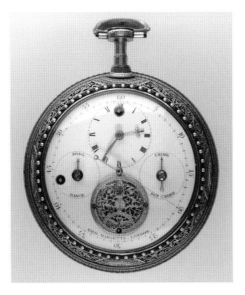
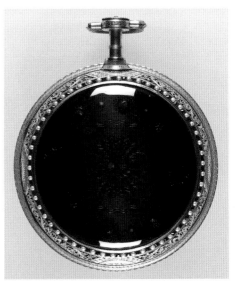

CYLINDER MUSICAL COACH WATCH WITH AUTOMATED SCENE

George Margetts, London | *c.*1780

For use at home and on the road, this large and rare coach watch was designed as much to delight the eye and ear as to tell the time. Protected by a gilt-brass case (set with tiny pearls and imitation rubies in red glass) and glass cover, the white enamel face has a circular time dial (top) with hour and minute hands and an outer radial dial with a seconds hand for precision time-telling, all controlled by a cylinder escapement.

The watch plays two different tunes, 'Song' or 'Dance', selected via the left dial. The chosen tune can be played automatically at 3, 6, 9 or 12 o'clock by selecting 'Chime' on the right dial, or on demand by depressing the push-piece at the top of the watch. Whenever the music is played, an automated scene of a water-mill pond is activated at the back of the watch, in which a water-wheel rotates and five boats pass by in succession.

Originally visible through a glass cover, the automaton is now hidden by a blue smalt cover, probably added in the late nineteenth century, whose inside is painted with another rustic scene of travellers on horses. VJA

See: Britten 1982, p. 648; Daniels 1970, pp. 350–8.

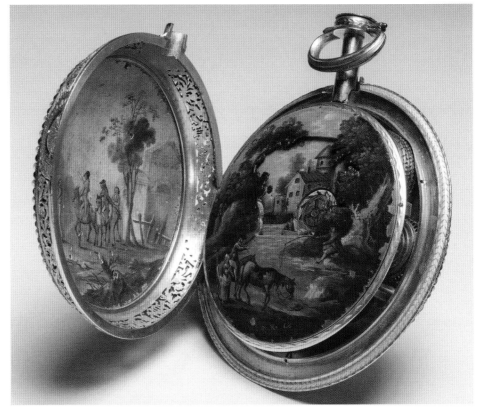

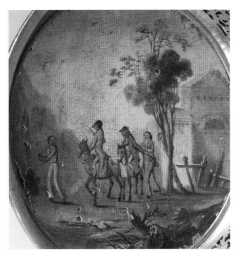

FIG. 155 | CAT. 140

VERGE REPEATER WATCH, FOR THE OTTOMAN MARKET

European, probably Swiss | *c.1790*

This watch was probably made in Switzerland, *c.*1790, for the London-based clock and watch maker, George Prior (1735–1814) specifically for export to the Ottoman Empire. It has Turkish numerals and a triple case to protect the movement from dry and dusty environments.

From the mid-eighteenth century, such watches were often given by English merchants as tributes to the Sultan and other key figures to facilitate trade, and they tended to be more complicated and ornate than watches made for the domestic market.

With a tortoiseshell and gilded-brass outer case, and gold inner cases, this watch is particularly luxurious. In addition to being able to 'read' the time from the face, the owner could 'hear' the time sounded out to within a quarter hour by pushing the repeater button at the top. It is signed by Prior, who exported so many watches to the Ottomans that a corrupted form of his name, 'pyrol', was used in Turkey to denote an English watch. VJA

See: White 2012.

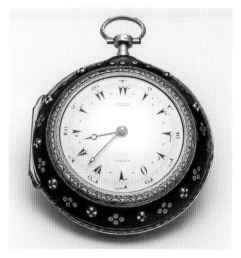
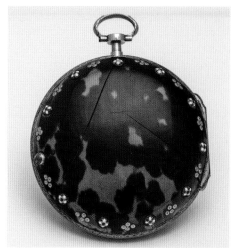
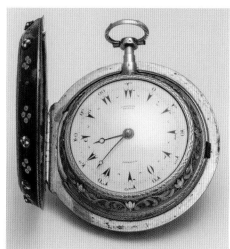
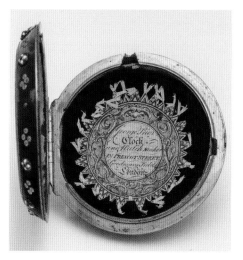
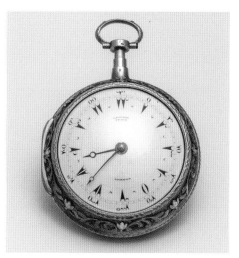
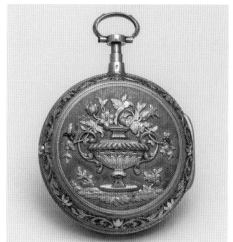

MINIATURE TREASURES

Most of what Edmund de Waal's family owned was lost with the annexation of Austria by the Nazis in 1938. As the family fled, a loyal servant could not have removed a cumbersome clock from their Viennese palace without detection but, as de Waal relates in the memoir of his family's collection of seventeenth-century Japanese *netsuke*, the size of these finely carved pieces allowed them to be returned to their rightful owners after the end of the war.[1] While miniature things can easily be lost, they can also be hidden, and their capacity to be kept secret makes them especially alluring.[2]

As John Mack, in his book on *The Art of the Small*, has suggested, viewers have a different relationship with the miniature compared to the gigantic.[3] Isabella d'Este could hold one of her Roman cameos in her *studiolo*, turn it over, touch its engraved edges, 'possess' it in a way that she could never have possessed a building like the Pantheon, no matter what its price.[4] The smallness of an object allows exclusive access to its owner; it can be held or kept close to the body, hidden from anyone. In this way, the young couple depicted in the miniatures by Gervase Spencer (fig. 157) could have kept each other close to their bodies, worn hanging from their necks, or hidden under the folds of a dress or pressed tight under a waistcoat, keeping their love secret, if they wished, their union echoed by the matching pearl border around the edges of the each portrait. An image of Spencer, looking up from his work table, also reminds us of the precision and care required for the execution of such small objects.[5]

However, this gold pendant, with a seated goddess, set with emeralds, rubies and hanging pearls from early seventeenth-century Spain (fig. 156), was most certainly meant to be seen: the jewels and pearls would have shone brilliantly against the dark velvet or damask cloth of an aristocratic woman, perhaps at the court of Philip IV.

Jewellery and other accessories, for men and women, often carried political meanings in the courts of Europe, demarcating political loyalties or family allegiances.[6]

Scent bottles could also be kept close to the body or suspended from a belt or chatelaine. The scent bottle from Naples (fig. 158) displays the political affinities of Lady Mary Hervey (1700–68), whose personal arms appear on one side and a portrait of the exiled claimant to the throne, Charles Edward Stuart, popularly known as Bonnie Prince Charlie, on the other.[7] Personal love and political loyalty could be expressed simultaneously in small tokens or objects, even for the less well-off, in the decades after the English Civil War (fig. 159).[8] MTC

See: De Waal 2010; Forsyth 2013; Mack 2007; McCall 2013; McShane 2009; Welch 2005.

1. De Waal 2010, pp. 277–83.
2. Mack 2007, chapter 1, and Forsyth 2013.
3. Mack 2007, p. 204.
4. Welch 2005, chapter 9.
5. Fitzwilliam Museum: P.72-1961.
6. See, for example, McCall 2013.
7. See Poole 2007.
8. McShane 2009, pp. 876–7.

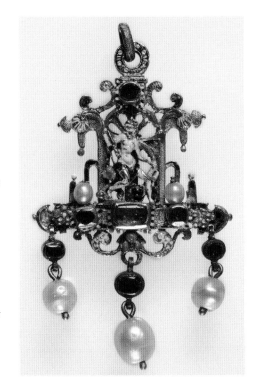

FIG. 156 | CAT. 145

PENDANT

Spanish | c.1600–25

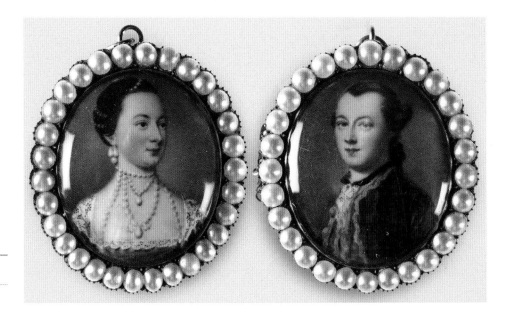

FIG. 157 | CAT. 151

PAIR OF MINIATURE PORTRAITS

Gervase Spencer, English | c.1760

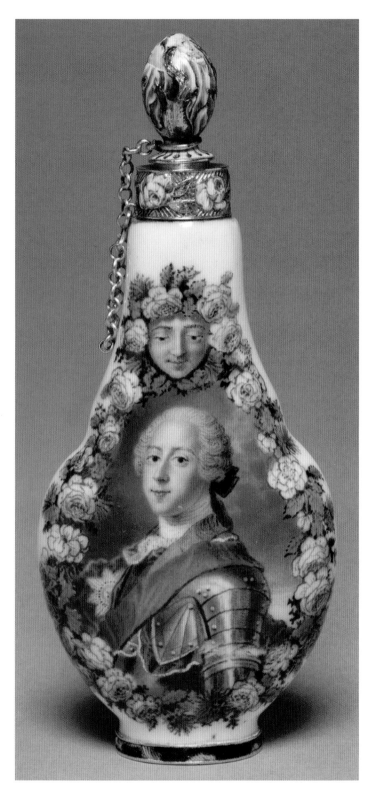
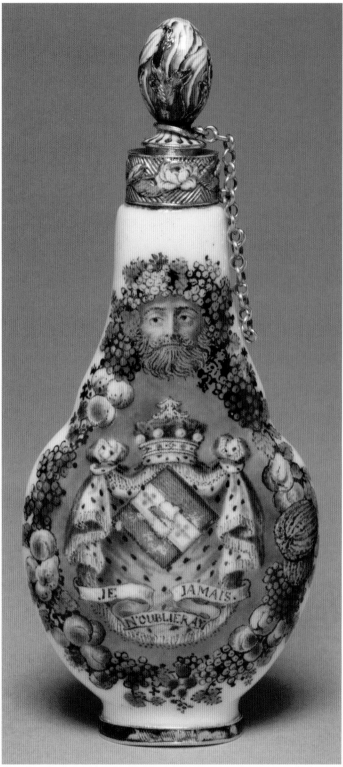

FIG. 158 | CAT. 146

SCENT BOTTLE

Capodimonte, probably painted
by Giovanni Sigismondo Fischer,
with English mounts | *c.*1753–60

FIG. 159 | CAT. 150

HEART-SHAPED BOX

English | late 17th century

Adorned with a silver portrait medallion of
Charles II, this hinged tortoiseshell box was
made in late seventeenth-century England,
perhaps at the Restoration in 1660, or after the
death of the king in 1685. Following civil war,
regicide and republican government, the image
of Charles II – on coins, medals and prints –
was hugely important to the restoration and
legitimization of the Stuart dynasty. 'Love'
was understood to be an essential element of
the contractual obligation between subject and
state in post-Restoration political culture, thus
this heart-shaped box might have been a symbol
of the loving bond between the object's owner
and the monarch.

While this was a luxury item, crafted from
precious and exotic materials, there was also
great demand for objects displaying political
love and loyalty fashioned in relatively ordinary
materials, such as earthenware dishes and
pewter tankards. JKT

See: Jones 1979; McShane 2009; Sharpe 2013.

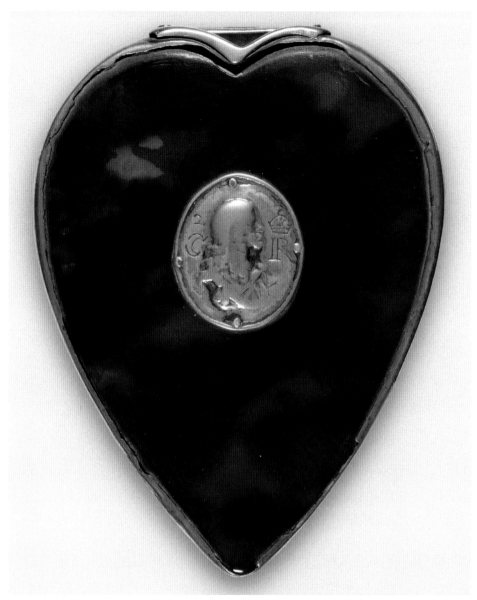

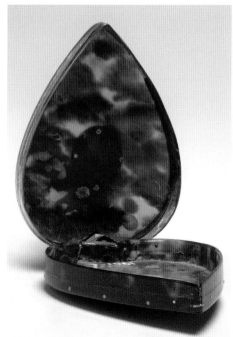

FIG. 160 | CAT. 170

OVAL SNUFFBOX

Probably Italian | early 18th century
with an Italian portrait miniature, dated 1615

Typical in material and shape, this early eighteenth-century snuffbox bears two intriguing images. On its tortoiseshell lid, in silver piqué work, a child hangs from the branches of a palm tree while an unfurled banner proclaims that virtue 'CRESCIT SUB PONDERE' ('grows under weight'). Judging from contemporary writings, this popular classical motto was often used in Christian or political contexts in connection with virtuous men flourishing in spite of persecution.[1]

Glued inside the lid is a much earlier circular portrait miniature, likely also Italian, of an unknown boy in a red jacket and white ruff. The gold inscription, 'Æta.3.1615', indicates that the sitter was aged three in 1615 when the portrait was made. Given its diminutive size, the portrait likely started life inside a locket, and may have been transferred to the snuffbox to make way for a new image. Inserting the miniature inside the lid was a deliberate act of remembrance, which then rendered the box as much a container for memories as for snuff. VJA

See: Fraser 1831; Gauden 1649/51.

1. During the early Commonwealth, the weighted-down palm tree became emblematic of the sufferings of Charles I in royalist iconography – for example, William Marshall's frontispiece to John Gauden's *Eikon Basilike: the pourtraicture of his sacred Majestie in his solitudes and sufferings* (London, 1649) – and it seems to have been used later on in Jacobite contexts. But it was deployed more generally to encourage those who were being persecuted or afflicted: on 2 February 1721, for example, the Reverend Ebenezer Erskine exhorted an acquaintance 'to flourish like the palm tree; concerning which some tell us that *sub pondere crescit* (it grows under a weight)': Fraser 1831, p. 253.

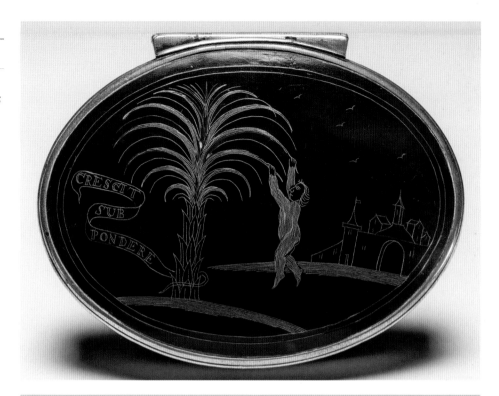

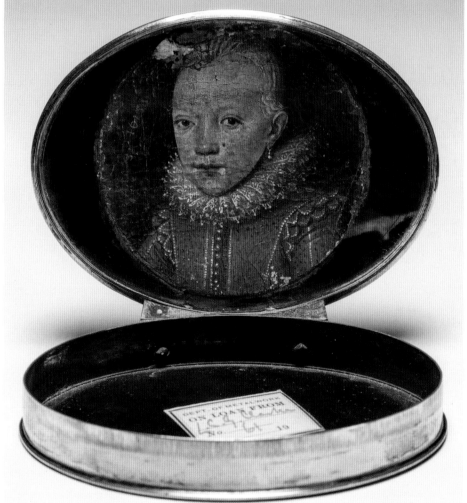

FIG. 161 | CAT. 148

CHATELAINE WITH ÉTUI AND TWO THIMBLE CASES

Probably English | *c.*1760

This elaborate and eye-catching waist-hung chatelaine would have been a desirable female accessory in the second half of the eighteenth century. Like most examples, it is made from gilt-metal and lavishly decorated with Rococo ornamentation. Its main component is an étui – an ornamental container packed with miniature implements for everyday domestic tasks and personal hygiene. Étuis could either be carried in a pocket (like fig. 171) or attached to a chatelaine.

This paricular étui with hinged lid contains a pair of scissors, folding knife, pair of ivory memorandum leaves hinged with a gilt button, nibbed pen, spoon and combined tweezers and ear-spoon. Two tools are now missing but, judging from the contents of complete examples, the lost equipment was probably a bodkin, nail-file and/or toothpick. This chatelaine also carries a pair of hinged-lid thimble cases, the left one with its original thimble still inside. Other contemporary chatelaines have pendant egg-shaped screw-top containers ('breloques') for small breath-freshening sweets.[1] VJA

See: Meininghaus 2003, pp. 2096–8.

1. See the enamelled example made in the West Midlands, *c.*1765–75: V&A: c.492: 1 to 7-1914.

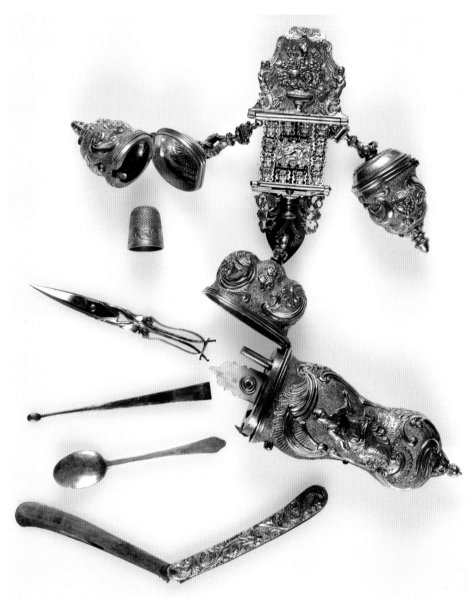

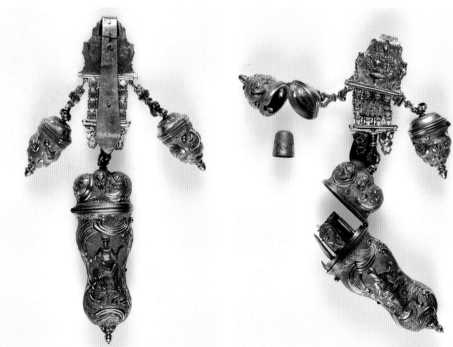

FIG. 162 | CAT. 138

CYLINDER WATCH AND CHATELAINE

William Webster, Stephen Goujon and George Michael Moser, London | **1761/2**

Chatelaines, or 'equipages' in eighteenth-century parlance, were used to attach watches and seals or small *nécessaires* to a lady's waist. This exquisite example in the Rococo style comprises a watch with winding key, three quartz seals (with coat-of-arms and heads of ancient philosophers) and a gold heart-shaped locket containing woven hair beneath a rock crystal cover with 'TOI SEUL ME FIXE' ('I am constant to you alone') on an enamelled ribbon. The watch's gold repoussé outer case is decorated with Venus presenting arms to her son Aeneas, an episode from Virgil's *Aeneid*.

This luxury timepiece was made by three of mid-eighteenth-century London's most outstanding craftsmen: William Webster (movement), Stephen Goujon (case-maker) and George Michael Moser (gold-chaser, described upon his death in 1783 by Sir Joshua Reynolds as England's best goldsmith).

According to Miss Whitehurst, who donated the watch and chatelaine to the Museum in 1836, they were 'presented to my mother on her marriage in 1755 [sic]'. VJA

See: Edgcumbe 2000, pp. 85–97, 112; Scrase et al. 2005, p. 158.

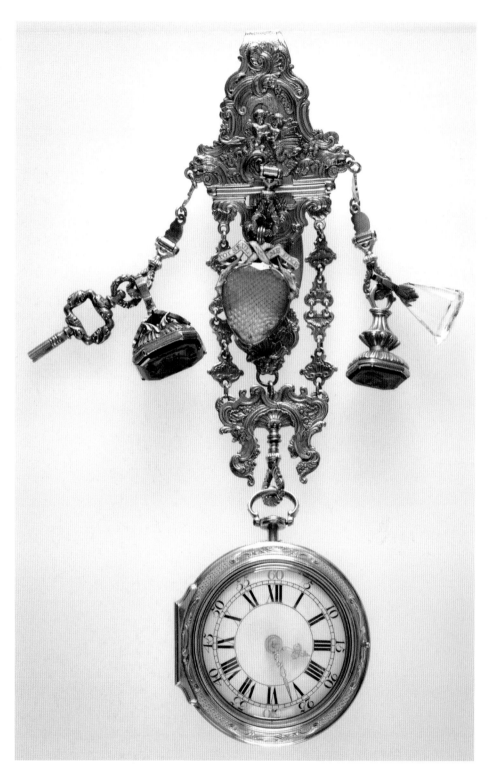

FASHIONABLE FOOTWEAR

In the early modern period, shoemaking was often referred to as 'the gentle craft'. Although most shoemakers were relatively poor and produced ordinary footwear for the populace, the London guild of shoemakers (the Worshipful Company of Cordwainers) wanted to project a more sophisticated image. The two patron saints, Crispin and Crispian, were the characters of many popular stories, including the legendary marriage of Crispin and Ursula, daughter of Emperor Maximinus, represented on this dish (fig. 163).

The image can, however, also be read as the encounter between a lady and her shoemaker. The fitting of made-to-measure shoes was a central part of the services offered by fashionable shoemakers. Customers would have their measurements taken and shoes produced to fit the length and width of their foot and their taste.

Whilst gentlemen normally wore leather shoes, ladies' shoes were made of expensive fabrics such as fine woollens, silks and velvets (fig. 164). Ladies also wore pattens, that is to say platforms or clogs that encased the shoe (fig. 165).

These could be made to match the fabrics used for the shoe's upper, and were removed once a lady entered into a private space. Pattens were necessary to navigate the muddy world of early modern Europe. Henri Misson, in his *Memoirs and Observations* (1698), reported how 'the streets of London are so dirty that the women are forc'd to raise themselves upon Pattens […] to keep themselves out of the dirt and wet'.[1]

Fashionable shoes – both for men and women – had high heels. Heels were not used to display one's legs but signified social status. High heels allowed the richest in society to tower over the poorer. The relationship between high heels and social rank had its best expression in the famous red heels of Louis XIV. Protocol established that only the king and courtiers could wear red heels in France. This made the red heel one of the most sought-after fashion accessories in Europe. GR

See: Bossan 2004; McNeil and Riello 2005; Misson 1719; Riello 2006a; Riello and McNeil 2006; Steele 1999; Swann 1982.

1. Misson 1719, p. 32.

FIG. 164 | CAT. 152 ▶

PAIR OF SHOES

English | *c.*1700–30

These beautiful yellow silk taffeta shoes, tied with green ribbons, are hardly practical footwear. The exaggerated pointed toes and thick curving three-inch heels were designed with fashion in mind, rather than function. Their stylish owner – named 'Mary Browne' according to a handwritten note found tucked inside one shoe – would probably have only worn them indoors, covering them with pattens if she stepped outside.

Embroidered carnations, roses and trailing foliage cover the yellow ground in vibrant bursts of pink, green, yellow and blue. Only semi-naturalistic, the bright tones and fantastic forms are clearly influenced by imported Indian and Chinese textiles. Mary might have paired her shoes with a contrasting silk dress to further emphasize their riotous colour and exoticism.

As was common until the end of the eighteenth century, these shoes were made on 'straights', so there is no difference in shape between the left and right sides. SP

See: Riello 2006a; Riello and McNeil 2006.

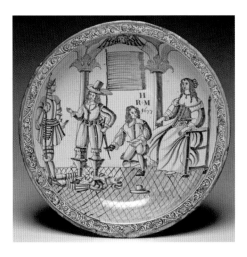

FIG. 163 | CAT. 154

DISH

**Probably Richard Newnham,
Pickleherring Pottery, Southwark | 1677**

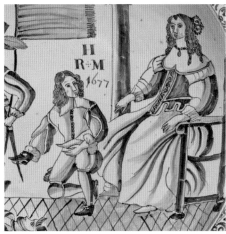

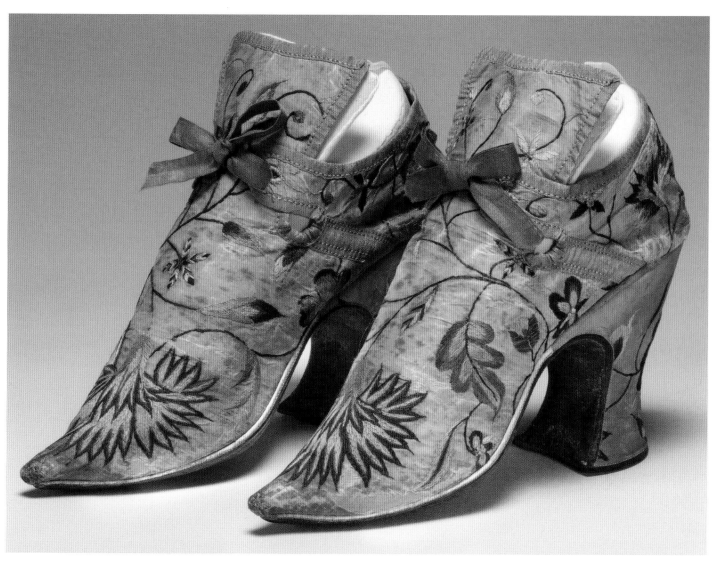

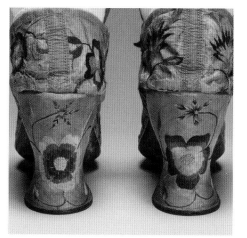

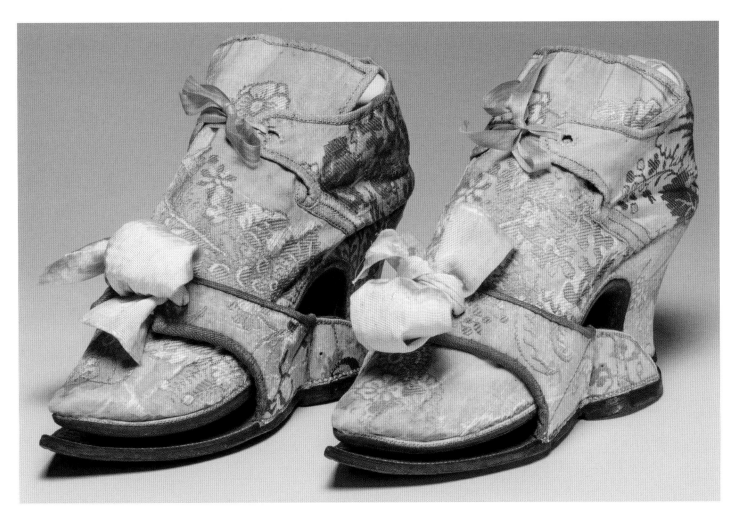

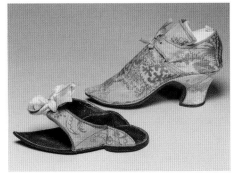

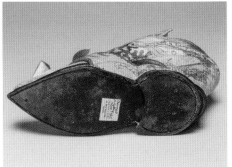

FIG. 165 | CAT. 153

PAIR OF SHOES AND PATTENS

English | *c.*1730–40

LUXURY AND FASHION IN THE LONG EIGHTEENTH CENTURY

Peter McNeil and Giorgio Riello

> *Porters and shoe-blacks at Paris wear their muffs with the same bonne grace as a president of the parliament; and so does every smart coachman and footman, when they attend their masters. Luxury is carried to as great a length by the modern French, as it was by the old Romans.*
> THICKNESSE 1768, p. 58

THE CHANGING MEANING OF LUXURY IN THE EIGHTEENTH CENTURY

The improbably named Philip Thicknesse, in his set of advice to Britons venturing to visit eighteenth-century France, could not stop noticing that luxury was now practised even by porters and shoe shiners. Half a century earlier his comments would have caused shock, but during the first half of the eighteenth century the very meaning of luxury and the nature of luxury goods had substantially changed. In previous centuries luxury had been the prerogative of the established elites, not the aspiration of the lower orders of society. Luxury was associated with refined consumption by rulers and their courts, with splendour and the adoption of polite manners and superior taste. These manifestations of luxury reached their apotheosis at the court of Louis xiv of France, the Sun King. Versailles was a splendid setting to demonstrate the highest levels of 'civilization', as Norbert Elias calls the progressive learning of polite manners and etiquette.[1]

For the rest of the European population, the practice of luxury was abhorred as an effeminate affectation and a danger to the moral strength of society. By the first decades of the eighteenth century, however, the idea of luxury came to assume more positive and democratic undertones. The Dutch philosopher Bernard Mandeville (1670–1733) in his 1714 *Fable of the Bees* told his readers that luxury was not a vice but a positive force of commerce and prosperity. Without luxury, he claimed, merchants would stop trading and the economy would be run to a halt: 'mercers, upholsterers, tailors and many others,' he said, 'would be starved in half a year's time, if pride and luxury were at once to be banished from the nation.'[2] This interpretation of luxury was particularly influential in the way in which David Hume and Adam Smith, two of the most talented thinkers of the century, understood luxury as a partly economic force rather than simply a moral discourse.[3] In Britain and France, in particular, luxury came to be associated with commercial exchange, booming business and prosperity.

This change of attitude towards luxury was the result of the creation of new forms of luxury goods that were more affordable than the traditional luxury of the elites. Jan de Vries contrasts the 'old luxury' of royal courts and the European nobility with such 'new luxury': 'Where the Old Luxury served primarily as a marker, a means of discrimination between people, times and places', he claims, 'the New Luxury served more to communicate cultural meaning, permitting reciprocal relations – a kind of sociability – among participants to consumption.'[4] What he means is that new forms of luxury goods appeared that were not aimed at achieving grandeur, but at satisfying the needs for enjoyment, novelty and delectation of a much wider number of consumers. This shift therefore took place earlier than many theorists of fashion and consumption propose, before the so-called 'century of fashion', 1860–1960. These goods ranged from Wedgwood buckles to printed fans, from pearl-set portrait miniatures and gem- and gold-set snuffboxes (fig. 167) to porcelain cane handles (figs 166 and 172) and metal buttons, from wigs with novel fastenings to silver and crystal *toilette* sets, folio and framed prints, novel candlesticks, ingenious playing-card tables, portable writing desks and porcelain tea services (fig. 99). Luxury goods were not simply about pleasurable spending; they also changed people's aesthetic outlook and delight in objects of everyday usage.

Fashionable accessories, furnishing and other small luxuries could also be legitimately acquired by everyone who could afford them. This was possible because the medieval sumptuary laws, regulations whose aim was to limit the use of certain luxurious materials including cloth of gold and silver for

dress to the aristocracy and the Church, were either not renewed or ignored. The combined effect of changing ideas and access to new and cheaper commodities made luxury the buzzword of what has been called the 'polite and commercial society' of that time.[5] The eighteenth century saw the unstoppable success of cheaper goods made of more affordable materials: copies of Asian goods such as Indian cottons, Chinese porcelains (fig. 204) and Japanese lacquer; or altogether new goods created by new inventions or the application of new technologies. These rarely required enormous financial investment, thus making it easier for the new popular luxuries (also called 'populuxuries') to be replaced on a regular basis.[6] They became part of the world of fashion, with their shapes, patterns and decoration changing regularly. Luxury was no longer about possessing something expensive and unique, but about owning something *à la mode*. A gown made with the latest chintz pattern, or the newest Parisian-styled parasol were props for social play and competition. Luxuries had not just a commercial value, but through the evolution of fashion came to shape an everyday life crafted by and within shopping, leisure, the sharing of ideas and polite conversation.

This novel world of eighteenth-century fashion and luxury was vast and complex. Three characteristics, however, are worth consideration. First, the importance of what we call 'portable luxury'. New luxury was not just affordable but often smaller and worn or carried on the body: hats, gloves, fans and parasols were among the many new populuxuries that could be easily paraded and shown off. The second important aspect of luxury is that it inaugurated new ways of presenting, displaying and using goods. New luxury came to be part of social performance in salons, assembly rooms and even the street: luxury became visible, public and widely discussed. And finally, rituals of fashionability were continued in the more private space of houses, with the interaction of public and private tastes but also the need to display or be discreet concerning luxury. All this came to shape the daily lives of families and households in different ways across Europe (figs 1 and 96).

PORTABLE LUXURIES AND THE FASHIONING OF THE BODY

How did porters and other manual labourers acquire fashionable luxury items? Traditional forms of retailing such as fairs and markets remained important in the eighteenth century. These were annual, seasonal or weekly events that brought together cattle sellers, peasants vending their produce, hawkers and artisans. Those without immediate access to a market town could rely instead on a vast number of pedlars selling small wares door-to-door (figs 37 and 39–48). When the French pedlar Hubert Jenniard was attacked and killed by soldiers in Crozon in 1761, it was recorded that he had on him 18 rings, 72 knives, 4 mirrors, 16 snuffboxes, 16 scissors, 7 ivory needles, 42 shoe buckles, 12 kerchiefs, 16 combs, 9 flutes, 12 pens, 6 earpicks, 1 crystal flask, 5 brushes, 5 bells, 5 crosses and 170 pairs of buttons.[7] This is a striking list as it demonstrates how important small accessories and instruments of grooming were to fashion at this time and the very large amounts carried into the countryside by one pedlar. Pedlars carried with them not just the goods but also information about the latest fashion: prints but also pocket books (first introduced in England in 1761) that illustrated the fashion in dress and headdress of the year, along with calendars and other practical information.[8]

Richer customers had access to an even wider variety of goods through urban and metropolitan shops, with sometimes extensive shop windows and elaborate interiors (figs 54 and 58). In Paris, the largest and most fashionable shops were those of the *marchand merciers*, which retailed everything from pins to *nécessaires* (wooden travelling boxes containing silver, glass and porcelain vessels and tools for smoking, eating, drinking or makeup) elaborate ormolu-mounted porcelain and clocks or a lady's *Bonheur du jour* (writing desk). These shops also cleaned, repaired and moved precious luxuries for important clients such as the Royal Mistress Madame de Pompadour.[9] The new luxuries of the eighteenth century were also represented very widely, in paintings, sign-boards, trade cards, bill heads, periodicals, respectful prints and caricatures. The 1768 bill head of the London chandler, Robert Towson, shows a finely worked chandelier, an object associated with luxury, as illuminating an entire room with a chandelier using wax candles would have been especially expensive (fig. 51).[10] The new luxuries also appeared as props in plays and musical entertainments. As the author of a satirical travel guide to Paris noted in 1790: 'The grand props of the Parisian commerce, are the variation of fashions, and the progress of bookselling.'[11]

Historians have argued that both men and women were engaged in a 'culture of consumption' that involved all classes. Consider the case of a teenage boy of modest background. The celebrated painter Sir Joshua Reynolds' young provincial nephew, Samuel Johnson (b. 1754), wrote a series of letters to his mother living in the country whilst he was residing in London. Age 21, he described 'a new great Coat which am exceedingly pleas'd with; it is a light colour with a light green collar, made in the new fashion; the colour of the Coat depends on one's fancy but the green Capes [collars at that date] are almost universal'.[12] He must have become accustomed to fashion, for in a letter that year to his

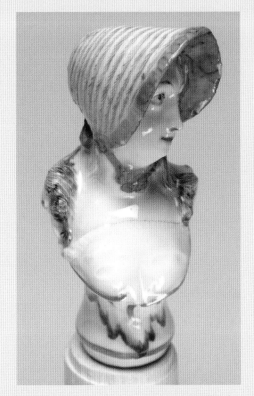

FIG. 166 | CAT. 115

CANE HANDLE

Neudeck or Nymphenburg | *c.1759–60*

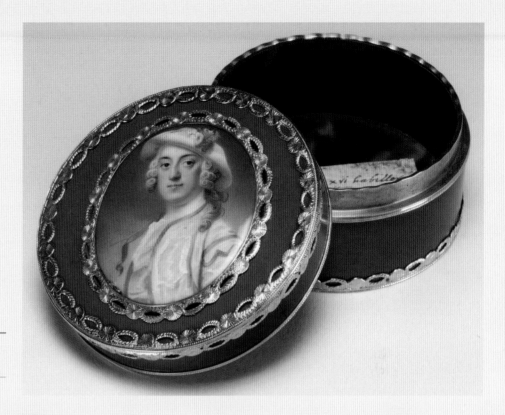

FIG. 167 │ CAT. 172

CIRCULAR SNUFFBOX
with portrait miniature

Paris │ 1763/4 (portrait *c*.1745)

dismayed mother, who was horrified at the thought of her son's Devonshire curls being plaited and dressed, he wrote:

> *This is in defence of my tail, which I must wear in London where none but clergymen and boys wear their hair untied; the place only makes the difference; a tail here is the same as curls in the country, and silk stockings the same as worsted; but if it is only for my hair and not for my head that you are concern'd I can assure you that it is in better order than it has been for months.*[13]

As a young man who had to leave London some weekends for lack of a decent suit, Johnson's fashionable ambitions were far from uncommon. As historians such as Daniel Roche have indicated, the taste for novelty and luxury snowballed during the consumer revolution of the mid- to late eighteenth century in France as well as in England, when second-hand and cheaper versions of the suits, dresses, laces and ribbons of the rich flooded into the wardrobes of merchants, artisans, shopkeepers and even servants.[14]

More colour and pattern became available within the dress and homes of the middling classes than ever before. A wider range of choices and more wearable styles were produced not just for the gentleman but also for the artisan and labourer. Historian John Styles has shown that young English men of the eighteenth century engaged with fashion on many levels, from saving to acquire a pocket-watch to desiring a waistcoat. The earlier watch (fig. 153), from the late seventeenth century, would have fitted neatly in a waistcoat pocket. Both men and women wore chatelaines, which would have been hung from the waistband with a hook and might include a watch as well as seals and keys (figs 161 and 162). This engagement with contemporary fashion was not simply a metropolitan phenomenon, but extended to the provinces and the countryside. Styles' argument is that it was not necessary to engage with all parts of a fashionable wardrobe to feel fashionable, but that certain accessories or aspects might be amplified in order to be 'up to date'.[15]

Gloves and shoes, which transformed the extremities, are good examples of such coveted accessories. Gloves were greatly valued in early modern life as they marked a liminal zone of the body, 'gentled' the hand of both elite men and women from symbolic and actual pollution, and were intimately connected with gift exchange.[16] The gloves of both elite men and women were embroidered in the seventeenth century, but women's gloves were also sometimes printed in the eighteenth century, a fashion that became particularly marked at the turn of the nineteenth century.[17]

Shoes served not just to protect the foot but also to display social difference. Women's shoes were often made of high-quality fabrics – silks and glossy woollen fabrics called calamancos – and were worn with protective 'pattens' that helped ladies with walking in parks, pleasure gardens and in the

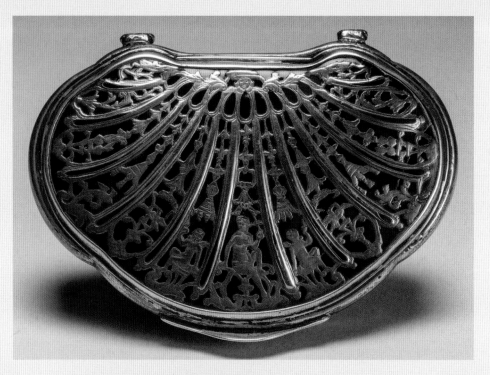

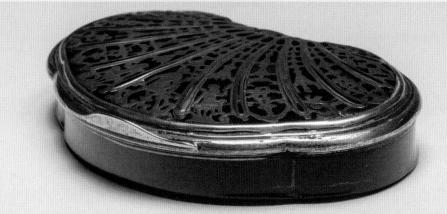

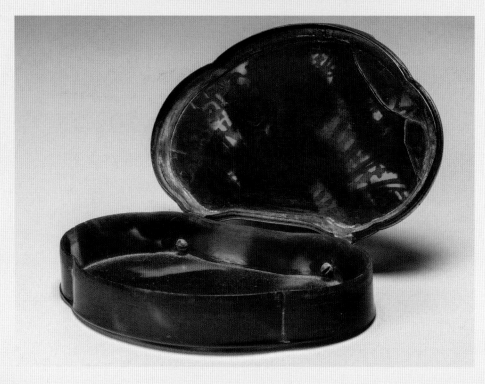

FIG. 168 | CAT. 171

SHELL-SHAPED SNUFFBOX

French | *c.*1710–30

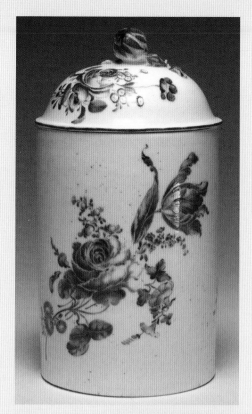

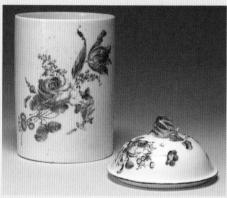

FIG. 169 | CAT. 81

COVERED TOBACCO JAR

Mennecy | *c.*1750–60

new squares that appeared in metropolises like Paris and London and summer destinations such as Bath and Tunbridge Wells (figs 164 and 165).[18] Men's shoes were instead made of sturdy black and brown leather, but expensive types could boast substantial heels (fig. 96), sometimes coloured red.

All men aspired to possess at least a set of buckles for their shoes, but whilst the labouring classes had to make do with copper or Sheffield plate buckles, the rich wore buckles worth sometimes hundreds of pounds, sometimes decorated with diamonds. Newspapers speculated on their expense, making such extravagant claims that 'Last Friday a pair of diamond shoe-buckles were carried home, by a jeweller in the city, to a lady of quality at the West End of the Town, valued at 2500 guineas, with which she was to appear at Court.'[19] Buckles became a visible sign of social distinction as recounted by the German Carl Philip Moritz, who visited the Haymarket Theatre in London in 1782 and was irritated by a young fop sitting behind him, who 'continually put his foot on my bench in order to show off the flashy stone buckles on his shoes; if I didn't make way for his precious buckles he put his foot on my coat tails'.[20]

LUXURY AND DISPLAY

The world of luxury did not just enter into public debate, it also became visible in the public arena. Urban streets lined with shop windows became a feature of consumer culture. By the end of the eighteenth century, town centres were provided with walking facilities that allowed easier browsing (fig. 54). Sophie Von La Roche marvelled in the diary of her visit to London of 1786 about metropolitan street life:

What number of people, too! How happy the pedestrian on these roads, which alongside the houses are paved with large, clean paving-stones some feet wide, where many thousands of neatly clad people, eminent men, dressy women, pursue their way safe from the carriages, horses and dirt.[21]

By the early nineteenth century, Paris also had spaces where pedestrians could walk and look into shop windows where populuxuries were displayed.[22] Their display, however, continued after purchase, especially in spaces designed for the purpose, such as pleasure gardens and interiors like the Rotunda at Ranelagh Gardens and the Pantheon in London, or the Colisée and the Palais Royale in Paris, where rain or mud could be avoided, and where new luxury fashions were likely to be safer.[23]

Display and social interactions were mediated by a variety of objects. Snuff, scented tobacco carefully held in precious snuffboxes, was much used in the eighteenth century. Snuffboxes, along with silver sword knots, are a part of masculine luxury consumption that is little remembered today. The exquisite snuffbox made out of tortoiseshell, and inlaid and engraved with silver, from early eighteenth-century France, would have laid flat on a dresser table or inside a jacket pocket; its decoration with a naked woman flanked by cherubs probably identifies it as an object owned by a man (fig. 168). Another snuffbox, made from tortoiseshell and red lacquer, shows a man dressed in pink and white, with a straw hat and a posy of flowers at its front, at the height of fashionability for mid-eighteenth-century Paris; the man depicted might have had it made as a keepsake for his lover (fig. 167). While it was the Swiss who were famed for their fabrication (as well as that of watches and enamelled jewellery), the use of snuff and snuffboxes was particularly common in France. In Samuel Foote's play *A Trip to Calais* (1778) the English tourists observe French shoe-blacks who take snuff with the manners of the high-born: 'See how politely they offer their snuff to each other.'[24] Snuff as well as tobacco for smoking was also stored in tobacco pots, such as the one with the typical floral decoration of the Mennecy porcelain factory (fig. 169). With a twisted delicate rose bud as its knob, tobacco pots such as this were often indistinguishable from the *toilette* pots on the dressing tables of both men and women.

The English successfully produced cheaper versions of snuffboxes and other 'toys', a range of decorative items from cane handles (fig. 172) and steel buttons, to children's rattles and whistles. Jewellery too, often adorned with gems and stones, was widely used across the social spectrum (fig. 137). The richest ladies could afford extremely expensive *parures* of diamonds, often to match specific outfits, such as the *tremblant* diamonds of the mid- to late eighteenth century, highly appropriate for the lightweight silks and ruched furbelows of that fashion moment. More popular jewellery included a variety of lockets and rings used to contain things – portrait miniatures, hair, inscriptions – which found customers across all social classes (figs 261, 264 and 266).

One of the most astonishing fashionable items of the eighteenth century was the wig (figs 95, 96, 110, 158 and 167). Worn both by men and women, wigs became common in England after the Restoration of 1660. Until the end of the seventeenth century, they were rather large, becoming

smaller in the following century. Yet, they still needed to be powdered at each wearing, combed out regularly and redressed, and occasionally deloused by the barber or hairdresser.

In the 1770s, the hair of the most fashionable was powdered not only in the 'natural' shade of grey-white, but also in green, violet and light red. Improving upon 'nature' and treating the head as a space of artful display was central to the fashion imagination of the eighteenth century. When people travelled, they nearly always had anxieties about managing their hair: one Richard Cumberland, when pursuing diplomatic relationships in Spain in 1780, took a hairdresser with him, for 'the convenience of my wife and daughters'.[25]

Wigs, however, were another of those items that became popular even among rural folks. The Swede Pehr Kalm noted in 1748 that 'all labouring-folk' of England went 'through their usual every-day duties with all *Peruques* on the head. Few, yes, very few, were those who only wore their own hair'.[26]

LUXURY AND DOMESTICITY

Today we mistakenly think that fashion and luxury are mostly about sartorial appearances. In the eighteenth century, both concepts were often associated with increasing standards of domestic comfort and complexity. In the course of the century, new forms of silver were popularized such as tea kettles, chocolate and coffee pots, baskets, wine cisterns, fountains and plateaux for tables on which candlesticks, cruets, salts or casters were placed, these in turn were filled with small luxuries such as wax candles, spices, sugar and salt (figs 104 and 106).[27] From humble Staffordshire tea caddies, to the more expensive tea- and coffeewares made in centres such as Vienna (fig. 110), people viewed but also carried, poured and drank from wares that sometimes also carried copies of illustrated fashion innovations, thus emphasizing the fashionability of their consumer-driven life.

A variety of other fashionable and luxury objects accompanied the quotidian gestures in the lives of elite and middle-class houses alike. These might be candelabra, candle holders and snuffers that implied the use of expensive wax rather than tallow candles, such as with the white glass candlestick, painted in enamel with butterflies and flowers (fig. 170); the wall and mantle clocks that defined the cadence of time within the household and provided decoration for an interior; the complex dinner services of porcelain with beautiful sauce pots and soup tureens, game sets inlaid in perfumed woods or made of enamelled porcelain; but also musical instruments, prints, paper-hangings (wallpaper), painting and lacquered mirrors that reflected and multiplied the visual effect of all these objects (fig. 173).

Elite houses included a series of spaces specifically designed to display luxury and fashionable manners. Novel drinks of tea, coffee and chocolate, for instance, were often served in spaces that were transitional between public and private, and where the half dress of *déshabillé* might be worn. Fashion and luxury mixed in particular in the creation of a series of garments designed to be used only in the intimacy of one's home. That does not mean that they were concealed from public view; quite the opposite. Men's kimono-cut robes called 'banyans' were made of printed cottons, and for the richest and more refined, of Chinese, Italian or French silk. Their wearers might be seen conversing with friends or doing their business at their desk in such informal attire (fig. 1).

Women too wore informal robes after waking up. This was particularly the case during the morning *toilette*, an act that especially in France became a ritual for the members of the higher classes. One eighteenth-century commentator said that it took ladies the entire morning to apply rouge to their cheeks and heavy doses of pomades and paints.[28] The *toilette* was a long but not a lonely affair: a lady would have needed a series of maids to dress her and the act itself was accompanied by conversations with fashionable suppliers (*petits-maîtres*), hairdressers and sometimes a coterie of friends and dependants, maybe a lover if they were lucky. The lady would be in front of a small table covered with a white taffeta or embroidered muslin cloth (fig. 95).

A *service de toilette* could include as many as two dozen pieces, among which might be found powder boxes, boxes for patches (to put on one's face), pots for *pomade*, cups, glass bottles and an array of miscellaneous items that included basins and ewers, trays, brushes, knives, tweezers, eyelash combs and anything else necessary to transform one's body into an object of beauty. The most expensive and complex of such groups of objects were made of silver, sometimes gold or gold-plated, or in fine porcelain (figs 158 and 159).

By the mid-eighteenth century, the spectacle of the *toilette* had its purpose-built piece of furniture that allowed all accoutrements, including the mirror, to be hidden when not in use.[29] In turn, miniature sets were made to carry or keep and admire on the dresser. The delicate pink enamel *étui* held,

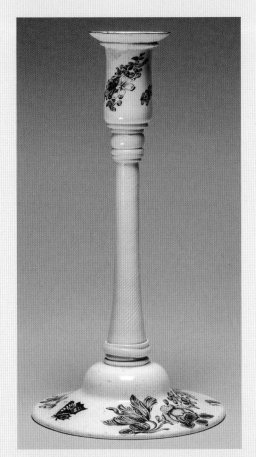

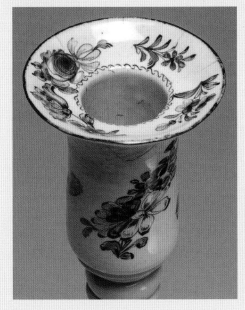

FIG. 170 | CAT. 182

CANDLESTICK

Probably South Staffordshire | *c.*1755–60

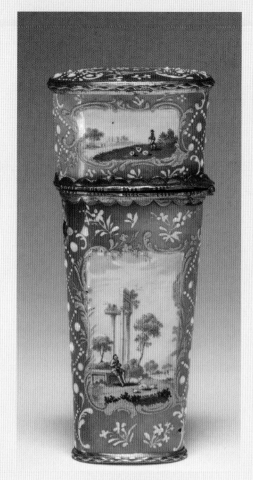
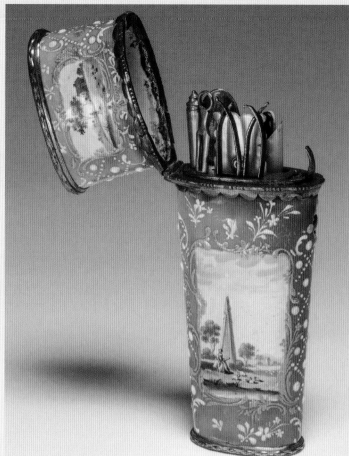
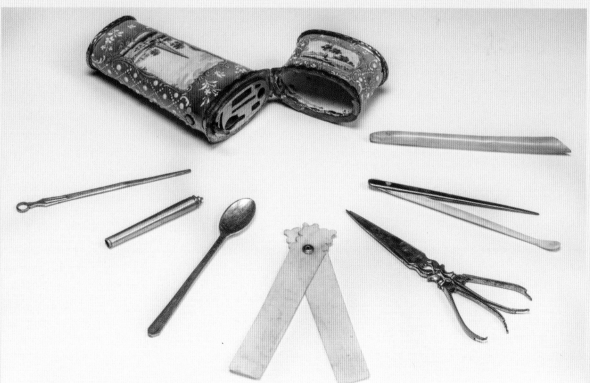

FIG. 171 | CAT. 149

ÉTUI

English | *c.*1760–70

in different compartments within it, a pair of scissors, a small spoon, a bodkin, a pencil holder, all made of brass, as well as a pair of ivory memorandum leaves hinged with a gilt button and a small ivory earpick with hinged tortoiseshell toothpick in a quill case (fig. 171). While similar to those fashionable in Paris, this *étui* was probably made in Staffordshire or London.

The practice of the *toilette* became fashionable not just among the elites who could afford complex and expensive sets of objects, but also among the rising middle classes. The latter third of the century saw a mania for exquisite small perfume burners in both porcelain and silver, which carried an archaeological mood of the ancient world. They replaced the larger tripods of the earlier part of the eighteenth century and are therefore a good example of the tendency towards miniaturization, intimacy and small scale that characterizes both decorative arts, luxury and fashion in the late eighteenth century.

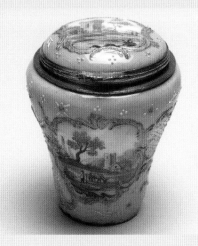

Miniaturization was accompanied by portability, as the French word for furniture (*meuble*) indicates, meaning 'movable'. Unlike the nineteenth- and twentieth-century conception of a home, much eighteenth-century furniture was made to be moved around at will (fig. 184). This explains the enormous proliferation and novelty of furniture types. Such furniture was, as Mimi Hellman explains, not just moving but also 'performing'. The fashion for such furniture, both French and also the ingenious multi-purpose English work (portable stairs, or a harlequin dressing table and desk) spread across Western Europe via the medium of something very new, the fashion magazine and furnishing guide. The most successful among the latter was Chippendale's *Gentlemen and Cabinet-Maker's Director*, first published in 1754, which carried designs for the Gothic, Chinese and Modern taste, the latter being the Rococo. Here an array of new luxuries from pier-glass sconces to dressing and china tables could be surveyed and adapted for local taste and needs.[30]

CONCLUSION

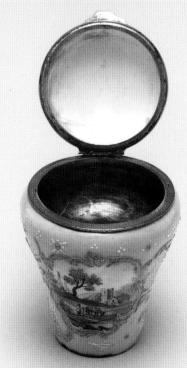

The eighteenth century saw a proliferation of luxury. A vast number of commodities became affordable not just for the rich elites but also for the aspiring middling classes and even more modest consumers among the lower orders of society. The very concept of luxury changed: no longer seen as a marker of status, many luxury goods came to be part of fashionable consumption. Luxury entered the public arena and became a tool of social performance, civilized life, sometimes amusement and pleasure. In the eighteenth century, luxury became 'cool'. This prompted a reinterpretation of the significance of luxury in society: no longer just a problem or a moral flaw, luxury became a force of social and economic progress.

1. Elias 2000.
2. Mandeville 1795, p. 42.
3. Maxine Berg and Helen Clifford, 'Introduction', in Berg and Clifford 1999, p. 3.
4. De Vries 2003, p. 43.
5. Langford 1989.
6. Fairchilds 1993.
7. 'Inventaire des marchandises et effets de colporteur [Hubert Jenniard] déclarés par Corentine Penchoat, à Crozon, le 6 Février 1761', Archives départementales du Finistère, 18B, 'inventaire des pièces de la procedure criminelle instruite à Crozon, le 27.2.1762', cited in Cadiou 1990, vol. II, p. 100. Information courtesy of Philippe Jarnoux, Université de Bretagne Occidentale.
8. Buck and Matthews 1984, p. 35.
9. Sargenston 1996, p. 33.
10. Hellman 2011. Twenty years after this bill was written up, Tonson had moved from Golden Square in Westminster to Craven Hill in Bayswater and was bankrupt (*London Gazette*, 26 February 1788). See the entry in the Fitzwilliam online catalogue for P.12931-R. The bill was part of a remarkable survival of bills and receipts for the Blathwayt family, who lived in Golden Square from 1764 to 1786.
11. Caraccioli 1790, vol. 1, p. 138.
12. Radcliffe 1930, pp. 4–41.
13. Ibid., p. 96
14. Roche 1994.
15. Styles 2007.
16. Stallybrass and Jones 2001.
17. Pasalodos Salgrado 2009, p. 23.
18. Riello 2006a, pp. 58–89.
19. *London Evening Post*, 16–19 January 1768, p. 3, column 2.
20. Moritz 1965, p. 61.
21. Von La Roche 1933, p. 86.
22. Bedarida and Sutcliffe 1980, pp. 385–6.
23. Brewer 1997, pp. 56–68; Ogborn 1998.
24. Foote 1778, p. 22.
25. Cited by Herzog 1996, p. 24.
26. Both cited by Festa 2005, p. 52.
27. Williams 2010, p. 24.
28. Du Pradel 1705, p. 182.
29. Chrisman-Campbell 2011.
30. For a recent facsimile edition, see Chippendale 2005.

FIG. 172 | CAT. 114

CANE HANDLE WITH SNUFFBOX

Bilston, Staffordshire | *c.*1750–75

FIG. 173 | CAT. 180

FRAMED MIRROR

Venice | 18th century

From compact cosmetic kits to those that spanned the walls of the palace of Versailles, mirrors were both alluring luxuries and every-day objects in early modern Europe. Sabba da Castiglione, a Renaissance humanist priest and collector, owned many treasures, including a marble bust by Donatello, but explained, 'ask me which item of furnishing or which ornament would please me most to have in my house, I would immediately respond: a steel mirror [...] I would hold it more dear, because it represents reality more than the others.'[1]

Mirror-making technology evolved during the early modern period, and by the eighteenth century, when this elegant Venetian example was made, mirrors had reached new heights of pop-ularity and availability. Mirrors had been made from highly polished metal until the fourteenth century when 'silvering' mixtures began to be applied to cloudy, green-tinged convex glass. When the Venetians discovered *cristallo* glass in the mid-fifteenth century, mirror-makers started to exploit this new medium, fashioning the clearest mirrors that had ever been made. As the secrets of *cristallo* and sheet glass spread, more magnificent mirrors became possible.

Fashioned from costly materials, mirror-frames could be as precious as the mirrors themselves. One of a set of four, this mirror has been encased in a curvaceous red and black lacquered and gilded frame, inlaid with contrasting iridescent mother-of-pearl, painted with Chinese-style figures, and festooned with a canopy – typical of Italian Rococo aesthetics. Allegorized as representing both vices and virtues, mirrors were also treasured for their more practical uses. As Étienne La Font de Saint-Yenne, the eighteenth-century art critic, proclaimed, 'Piercing walls to enlarge rooms, & to add something new; return-ing with interest the light rays that they received, whether sunlight or candles, how could man born enemy of shadows, & of all that can cause sadness, have defended himself against liking an embellishment that increases happiness while illuminating it.'[2] KT

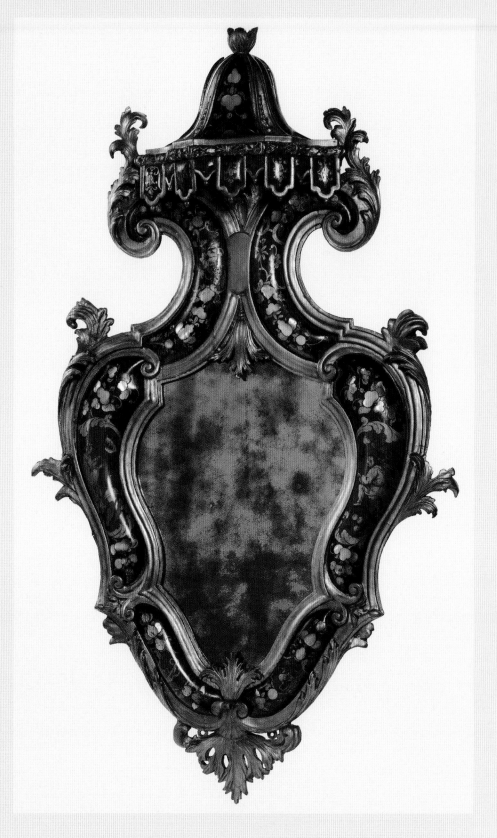

See: Edwards 1996; Goldberg 1985; La Font de Saint-Yenne 1747; Melchior-Bonnet 2001; Pendergrast 2004; Schechner 2005, pp. 137–62; Thornton 1997; Walker and Hammond 1999.

1. As cited by Thornton 1997, pp. 106–10.
2. La Font de Saint-Yenne 1747, p. 14. 'Percer les murs pour en aggrandir les appartemens, & y en joindre de nouveau; rendre avec usure les raïons de la lumière qu'elles reçoivent, soit celle du jour, ou celle des flambeaux, comment l'homme ennemi né des ténébres, & de tout ce qui peut en occasionner la tristesse, auroit-il pu se défendre d'aimer un embellissment qui l'égaïe en l'éclairant.'

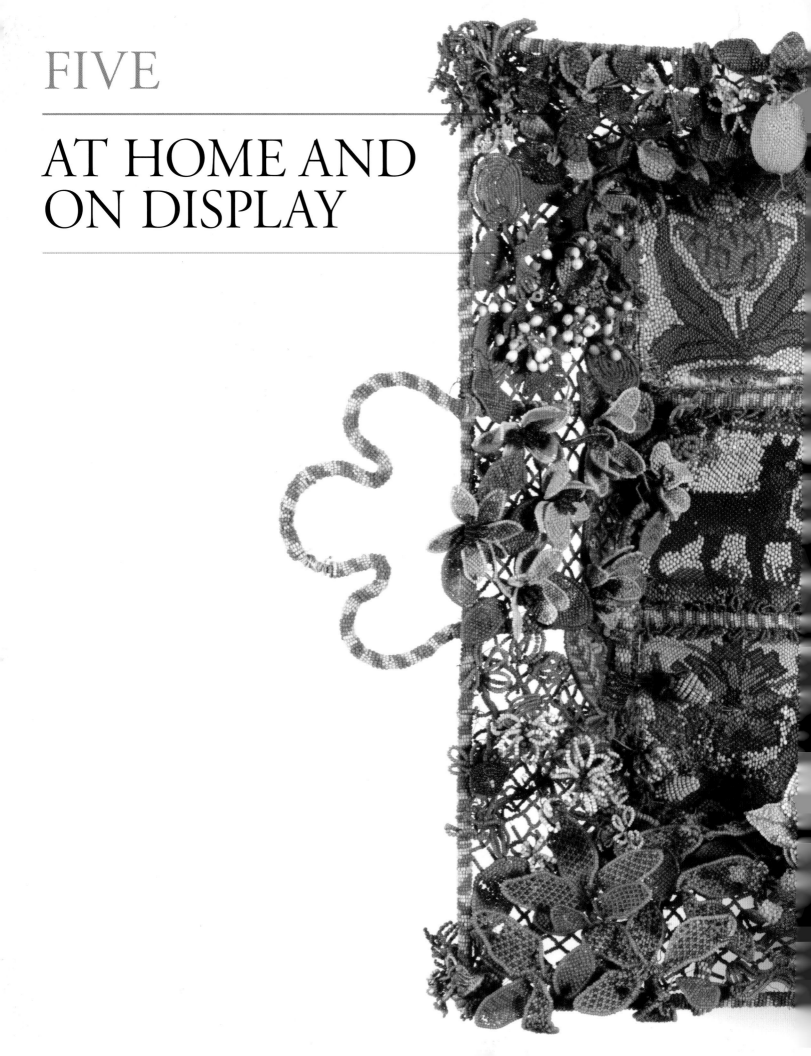

FIVE

AT HOME AND ON DISPLAY

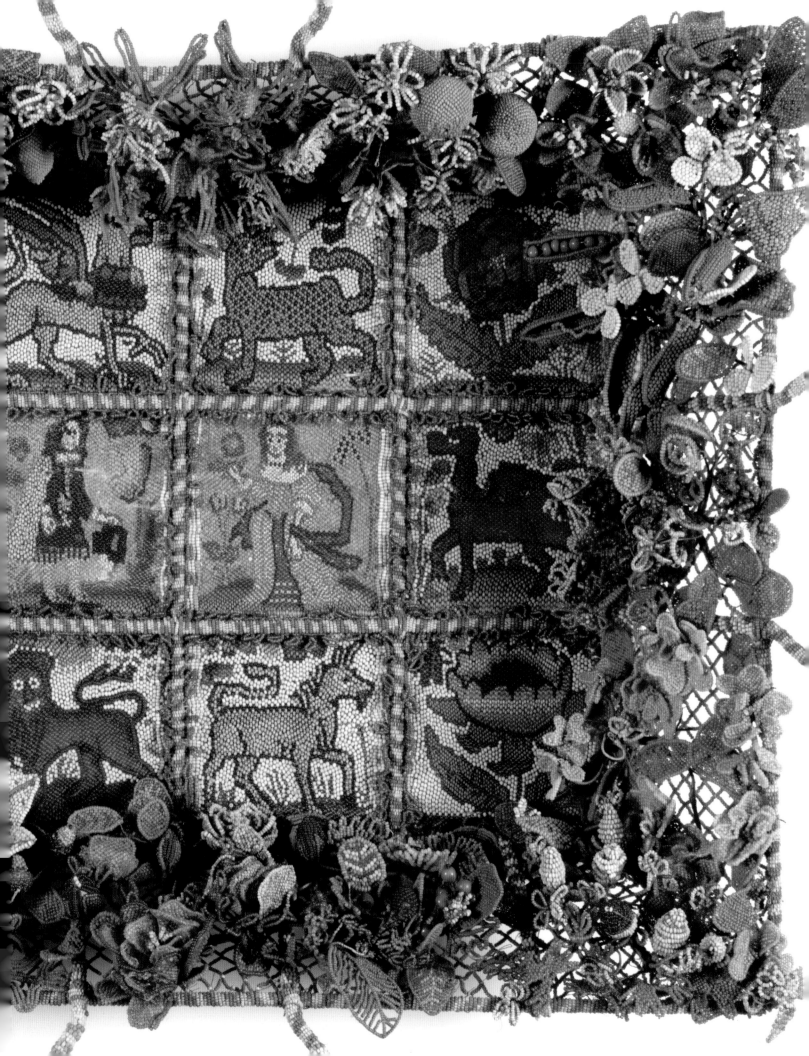

INTRODUCTION

'Well made dresser, graceful Dresser, dresser pleasing to everyone, dresser in which the gifted craftsman has not stinted of his skill, dresser of sweet smelling Cypress, prominent in the room. Gleaming & smooth dresser, decorated with beautiful ornaments of every kind.' So the Parisian writer and publisher Gilles Corrozet began his encomium to the 'dressouer', which formed part of his *Domestic blazons, comprising the decoration of a fair house*, published in 1539.[1]

One of the results of the proliferation of material goods during this period was that even ordinary homes became places of display, and new types of furniture evolved to store and show off the family's treasures. At the start of our period, the standard means of storing treasured possessions was the chest: a box made of wood or metal that opened from the top.[2] While this functioned well to secure and transport belongings, it did not facilitate display. During the course of our period, front-opening cupboards, dressers and sideboards would grow in popularity, not least because they provided a surface on which to stand ornamental pieces. As Francesco Sansovino commented in his 1581 description of Venice, the 'dressers displaying silverware, porcelain, pewter and brass, or damascene bronze are innumerable'.[3] Meanwhile, cabinets containing small drawers allowed a collector to sort her or his most precious objects and draw them out to show visitors.[4]

A three-tiered cupboard, covered in fine linen and bearing a vase of flowers and other ornate objects, stands in the corner of the dining room in the painting of the Bodmer family saying grace in preparation for a meal (fig. 175). But this elaborate storage unit is just one element in a larger choreography. A fourteen-piece service, cutlery, serving vessels, pewter cups with gilded edges (for the children), and glass adorn the table; the windows are glazed with expensive bottle-glass and bear religious images; colourful ceramic plates are ranged along a high shelf; and a fantastic tiled stove stands next to a large decorative wall tablet, which beseeches Christ to 'protect us from the fires of hell'.[5] Display was not just what the theorist Thorstein Veblen called 'conspicuous consumption'; it was also about the projection of moral values.

The spectacular collector's cabinet, made in mid-seventeenth-century Antwerp and now in the Fitzwilliam collection (fig. 174), is painted with scenes of the Prodigal Son, to remind us of the continuing anxieties about the dangers of overspending. By the eighteenth century, the anxiety had lessened, and political economic writers of the Enlightenment celebrated the consumption of goods, eliding wealth with virtue within republican discourses, and linking the spread of commerce with civilization.[6]

Technological changes, the expansion of global trade networks, and the growth of European markets in the eighteenth century broadened the possibilities to buy and display goods in the home for a much wider group of people. By the end of the eighteenth century, tea and coffee services could be found in the inventories of Naples, Amsterdam and London.[7]

Tea services were admired and displayed on sideboards, inkstands on desks, vases on mantelpieces and patch boxes on dressers. A whole range of ornamental porcelain items was available, preferably made by Meissen, but there were many imitations in cheaper earthenware to be coveted. The specialization of interior spaces also brought new kinds of furniture: the tea-table, for example, was related to new forms of sociability or, to quote Amanda Vickery, the 'escalation of domestic sociability', while the 'writing desk for ladies', or *secrétaire*, was related to the emergence of women as targeted consumers.[8]

These new pieces of furniture were used not only to display fashionable objects which reflected the good taste of their owners but also, as Dena Goodman and others have shown in their study of eighteenth-century French desks, to hide the secrets of their owners and were instrumental in creating new and modern identities.[9] MRL MTC

See: Ago 2013; Ajmar-Wollheim and Dennis 2006; Berg 2005; Clemente 2011; Fortini Brown 2004; Goldgar 2007; Goodman 2003; Goodman 2007; Goodman 2009; Hont and Ignatieff 1986; Jervis 1989; Krohn and Miller 2009; McCants 2008; McCants 2013; Morrall 2012; Sargentson 2007; Thornton 1997; Vickery 2009.

1. Jervis 1989, esp. p. 24.
2. Ajmar-Wollheim and Dennis 2006, pp. 120–1.
3. Quoted in Fortini Brown 2004, p. 3.
4. Thornton, 1997, pp. 69–75; Krohn and Miller 2009, pp. 256–9; Goldgar 2007, chapter 2.
5. Morrall 2012, p. 127.
6. For a summary of these debates, see Berg 2005, chapter 1; see also Hont and Ignatieff 1986.
7. Clemente 2011; McCants 2008; McCants 2013; and Vickery 2009, chapter 8.
8. Vickery 2009, chapter 10.
9. See Goodman 2007 and Sargentson 2007. See also Goodman 2003 and Goodman 2009, chapter 6.

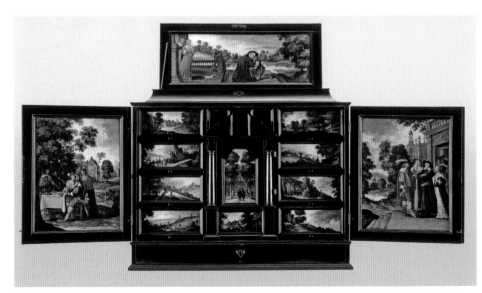

FIG. 174

CABINET

Antwerp | *c.*1640

FITZWILLIAM MUSEUM, CAMBRIDGE (M.54-1997)

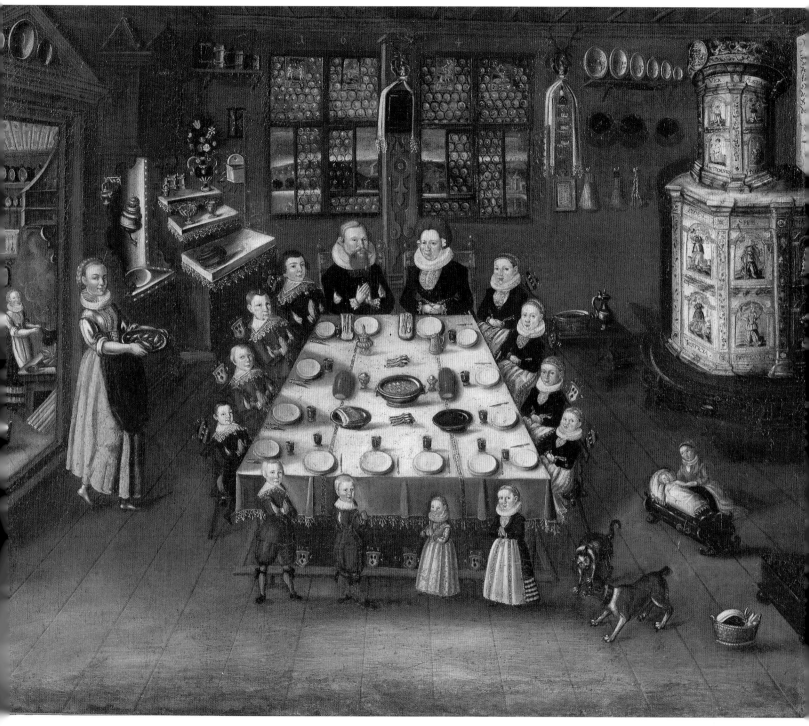

FIG. 175

*HANS CONRAD BODMER AND HIS
FAMILY*

Attr. Heinrich Sulzer, Swiss | 1643

THE ITALIAN RENAISSANCE STUDY

When evening comes, I return home and go into my study. On the threshold I strip off my muddy, sweaty, workday clothes, and put on the robes of court and palace, and in this graver dress I enter the antique courts of the ancients and am welcomed by them, and there I taste the food that alone is mine, for which I was born. There I make bold to speak to them and ask the motives for their actions, and they, in their humanity reply to me. And for the space of four hours I forget the world, remember no vexations, fear poverty no more, tremble no more at death: I pass into their world.[1]

Thus Machiavelli, in a letter to a friend, conjured up the humanist ideal of the study – an earthly paradise of solitude, tranquillity and bookishness, where learned men might put aside all thoughts of the world, commune with the ancients and dedicate themselves to the life of the mind.

The fact was that it took a great deal of effort and expense in order to create such a haven. And in reality, the men (and occasionally women) who commanded such spaces often had to devote as much time to their worldly affairs as to their classical studies (fig. 176).

Furthermore, the *studiolo* was a far more public space than Machiavelli admitted, a place of male sociability and display. Apart from the paraphernalia of writing – the quill pens, inkstand, paperweight, ruler and pounce pots from which one shook sand to blot excess ink, as well as the caskets used to store such items (fig. 179) – scholars, clerics and businessmen were keen to impress visitors to their studies with their collections of art objects, antiquities and medals.[2]

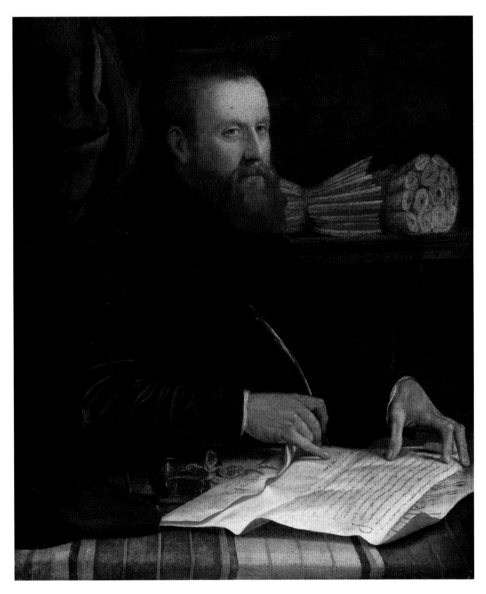

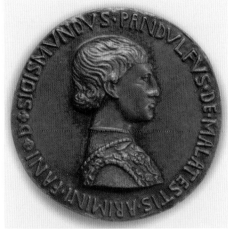

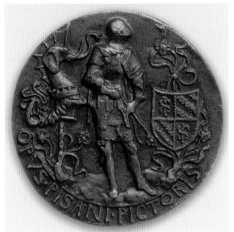

FIG. 176 | CAT. 164

F. DE PISIA, A PAPAL NOTARY

Jacopino del Conte, Florence
second half 16th century

FIG. 177 | CAT. 159

MEDAL OF SIGISMONDO PANDOLFO MALATESTA

Pisanello, Italian | c.1445

The nobleman and mercenary Sigismondo Malatesta was a renowned patron of the arts, and it was he who in *c*.1445 commissioned bronze portrait medals first of himself and then of his mistress, Isotta degli Atti, from the artist Pisanello (figs 177 and 178). The images of Sigismondo wearing armour, and his beautiful lover with her strikingly fashionable hairstyle are an antidote to Machiavelli's portrayal of the study as a retreat from the world. MRL

See: Thornton 1997.

1. Quoted in Thornton 1997, p. 32.
2. Ibid., pp. 71–2, 88 and 105, on the prevalence of medals in the study.

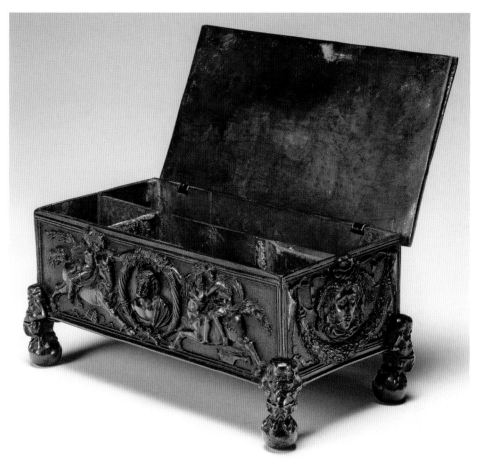

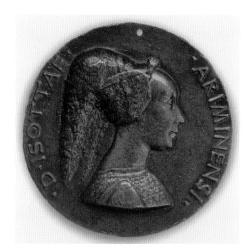

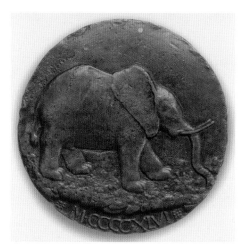

FIG. 178 | CAT. 158

MEDAL OF ISOTTA DEGLI ATTI

Pisanello, Italian | 1446

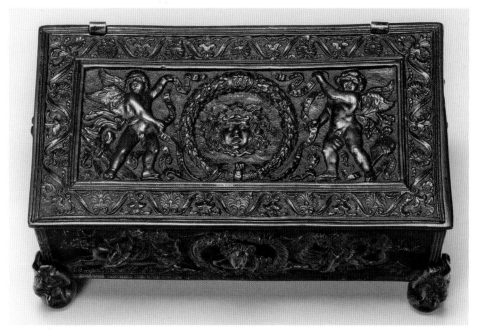

FIG. 179 | CAT. 161

WRITING CASKET

Possibly Rome | late 15th / early 16th century

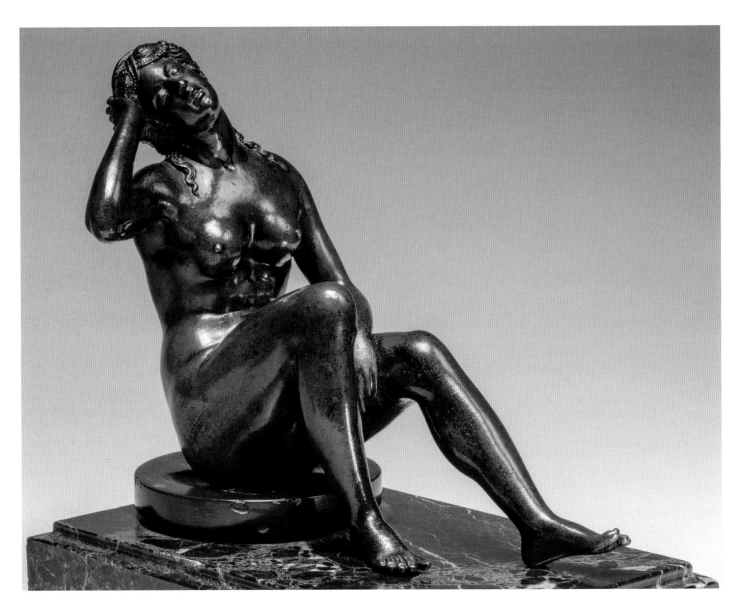

FIG. 180 | CAT. 162

SLEEPING NYMPH

North Italian | **early 16th century**

Avidly commissioned and collected from the mid-fifteenth century onwards, bronze statuettes (small-scale, free-standing sculptures of humans and animals, often inspired by antique prototypes or subject matter) were indicators of wealth, erudition and refined taste. They were usually displayed on shelves, desks and tables in the study or bedchamber, where they could be easily admired, scrutinized and handled. The warm tonality and sensual reflective surfaces of polished bronze made it ideal for nude figures – especially when they were sexually explicit, as with this sleeping nymph whose genitalia have been carefully delineated.

Much of the original black patina has been worn away through repeated handling, especially around the thighs, waist and breasts. The nymph's raised right arm and buttocks were originally supported by a separately cast tree stump and low mound.[1] Despite the loss of this element and the resulting anomalous pose, the exquisitely wrought nymph was clearly valued too highly to discard. VJA

See: Avery and Dillon 2002; Krahn 2003, pp. 116–19, no. 28.

1. The tree and mound are present in a version in Berlin, Bode-Museum, inv. no. 2793.

FIG. 181 | CAT. 160

OIL LAMP

Workshop of Severo da Ravenna, Padua or Ravenna | *c.*1500–50

Italian Renaissance homes were illuminated by braziers, lanterns, candlesticks and oil lamps (fixed, suspended, or hand-carried). Although candlesticks provided the commonest form of illumination, oil lamps were said to produce a more even flame and a less unpleasant smell. Lamps came in all shapes and sizes, from cheap, mass-produced terracotta examples for servants in the kitchen, to expensive, elaborately decorated ones in bronze, often inspired by antique exemplars, for use in the study or bedchamber.

This lamp was clearly designed to amuse. It is shaped as a grimacing satyr's head with wide open mouth (via which the oil was introduced) so, when lit, it would look as though the satyr were breathing fire. The cast-in handle and completely flat underside indicate that, originally, it was a stand-alone piece. Subsequently, a screw was soldered onto the underside so it could be fixed onto the claw-foot stand, presumably to make it easier to carry and more stable when set down. VJA

See: Radcliffe 1972; Thornton 1997, pp. 44–6.

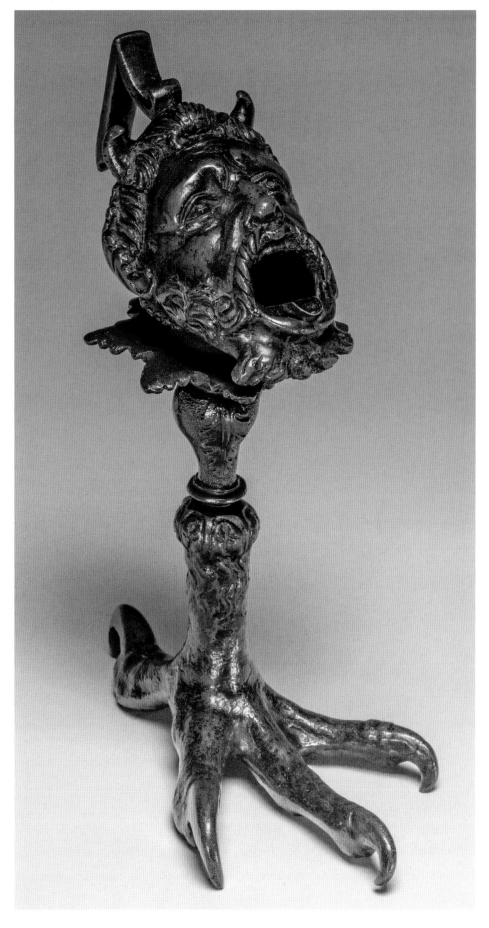

FIG. 182 | CAT. 183

FLOOR TILE

Workshop of Antonio dei Fedeli, Pesaro
1493

Not until the second half of the fifteenth century did colourful maiolica tiles become popular in Italian homes and churches. Their designs were at first usually geometrical and adapted motifs from pots, bowls and pharmacy jars.[1] More complex patterns were probably avoided because the tiles were expected to suffer severe wear and tear.

This example comes from a series of tiles commissioned from Pesaro in 1493 by the Marquis Francesco II Gonzaga for his villa at Marmirolo, and features the Gonzaga device symbolizing fidelity: a seated white hound, muzzled and leashed. Upon arriving at the Castel San Giorgio in Mantua in June 1494, Isabella d'Este, Francesco's wife, requisitioned some of the tiles for the floor of her study; her daughter's governess claimed that 'they were almost necessary since under the floorboards were found many rats' nests'.[2] It was typical of the Renaissance consumer to combine functional and decorative considerations in this way. MRL

See: Casali 1981; Mallet 1981; Poole 1995a; Poole 1997; Thornton 1997.

1. Poole 1997, p. 28.
2. Thornton 1997, p. 48.

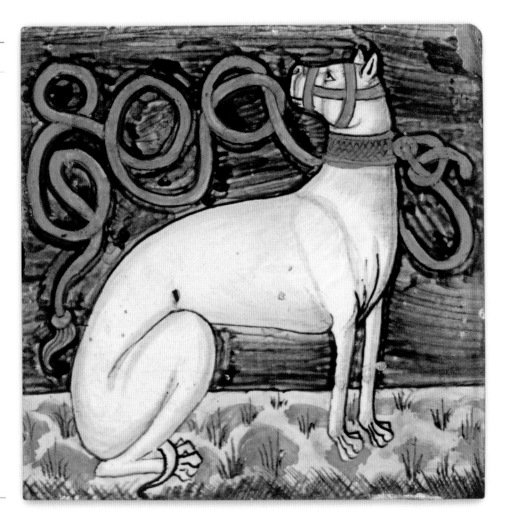

FIG. 183 | CAT. 163

INKSTAND

Probably Patanazzi workshop, Urbino
*c.*1575–1605

A Renaissance humanist, eager to display his
knowledge of the classical world in his *studiolo*,
would have treasured this fashionable maiolica
inkstand, dominated by an *all'antica* reclining
river god, with a vase-shaped inkpot at his feet
painted to simulate marble. The rectangular
base is decorated with grotesque ornamentation,
often seen on the walls of contemporary Italian
palaces, and derived from the Ancient Roman
frescoes at the Golden House of Nero, which
had been unearthed in the late fifteenth century.

Perhaps a metaphor for the process of writing,
the pensive river god pours forth water from
a vase, just as the owner could have used ink
to pour knowledge onto a page. According
to a recipe recorded by Ugo da Carpi (*c.*1480–
*c.*1520/32), ink could be made from a mixture
of crushed gallnuts (oak-galls), rainwater,
German vitriol, gum arabic and vinegar.[1]
With its inkpot and a drawer to store writing
implements, such as quills, scissors and knives,
the inkstand's owner would have been ready
to pen an important letter, a commentary on
a rediscovered classical text, or even an original
masterpiece. KT

See: Da Carpi 1535; Poole 1995a, p. 405, no. 435; Syson and
Thornton 2001; Thornton 1997; Wheeler 2009.

1. Da Carpi 1535, fol. 44v, cited in Wheeler 2009, pp. 98–9.

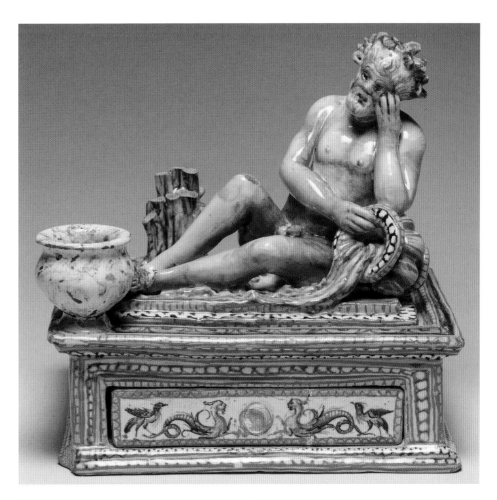

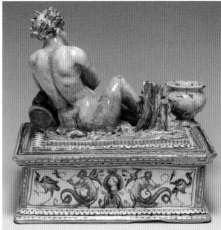

THE EIGHTEENTH-CENTURY DESK

Servants and messengers criss-crossed the city streets of Europe, holding close letters folded and sealed with wax, the ink sometimes seeping through the page. The letters, often replied to within hours, and sometimes provoking several exchanges during the course of a day, not only brought lovers together and ruined reputations, as in Pierre Choderlos de Laclos' epistolary novel of 1782, *Les liaisons dangereuses*, but also permitted women an intellectual life outside of the household.[1] Beyond the city, and along a burgeoning but still bumpy network of roads, letters – contained in leather bags carried in coaches – also served to strengthen cosmopolitan networks of knowledge and maintain intellectual friendships in the Age of Enlightenment, such as that of Ferdinando Galiani in Naples and Louise d'Épinay in Paris between 1769 and 1782.[2]

These missives were composed on the desks of women and men across Europe, surrounded by the instruments with which they needed to write and by which they needed to see. The eighteenth-century German stoneware inkstand (fig. 187), with its artful modelling of musician figures with amusing expressions, would certainly have caught the eye of its original owner, as it did Dr Glaisher's when he bought it in 1919.[3] Although less sophisticated than another German inkstand made of hard-paste porcelain (fig. 188), this stoneware example was perfectly functional. There are places for the missing ink box and pounce pot or sand box as well as for quill pens in the tray at the front.[4] The necessary stick of sealing wax, a seal with which to stamp it when warm along the letter's edge, and a pen-knife to sharpen the quills could have fitted in the tray or been strewn on the desk as in Boilly's *trompe l'oeil* table-top (fig. 184).[5]

Alternatively, the seal, or a number of seals, to mark the identity or multiple identities of the writer, might have swung from a chatelaine, such as this English one, from the early 1760s (fig. 162). There is also a place for a candle to shine light on the desk and to heat the sealing wax. For additional light, the delicate English soft-paste porcelain candlestick with floral motifs (fig. 185), also from the 1760s, could have sat on the desk and then been moved closer to what was being written or taken away to bed. As literacy rates increased during the Enlightenment, the proliferation of this kind of writing paraphernalia, in a variety of materials and styles, gave new shopping opportunities to women and men of varied means.[6]

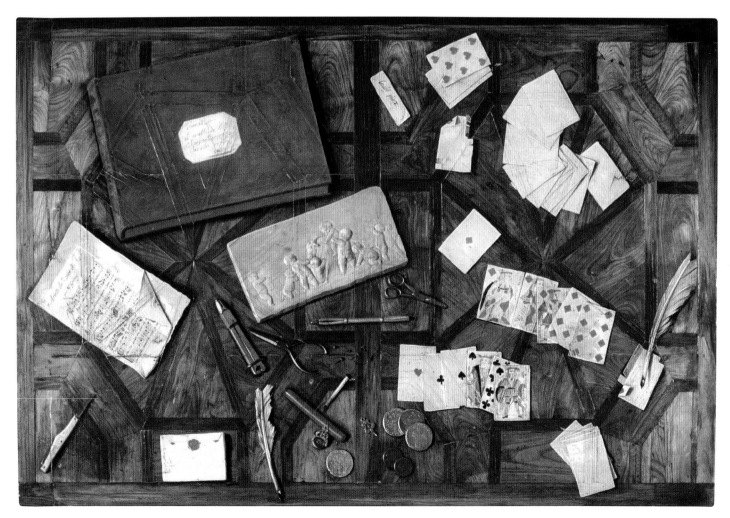

FIG. 184 | CAT. 165

WRITING TABLE

Louis-Léopold Boilly, French | before 1793

The sealed letter face down on the Boilly table-top and the dated letter on the back of the Italian fan with the *trompe l'oeil* image of a desk scattered with papers (fig. 186) highlight the prominence of letter-writing and its resonance in this period. Both objects may have served as eighteenth-century versions of Tumblr, revealing the owner's musical tastes and favourite things through a selection of objects depicted realistically. The painting by Venceslao Verlin of *An Italian Collector in his Study* of 1768 (fig. 1) has a similar function, demonstrating, above all, the taste and accomplishments of the sitter, who places himself in front of a harpsichord, suggesting that he also had musical ambitions, like Richard, 7th Viscount Fitzwilliam (fig. 257), who is known to have moved to Paris after his graduation from Cambridge in 1764 to study the keyboard and musical composition.[7]

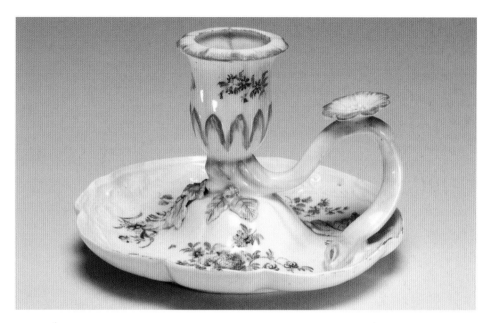

FIG. 185 | CAT. 169

CHAMBER CANDLESTICK

Derby | *c.*1760

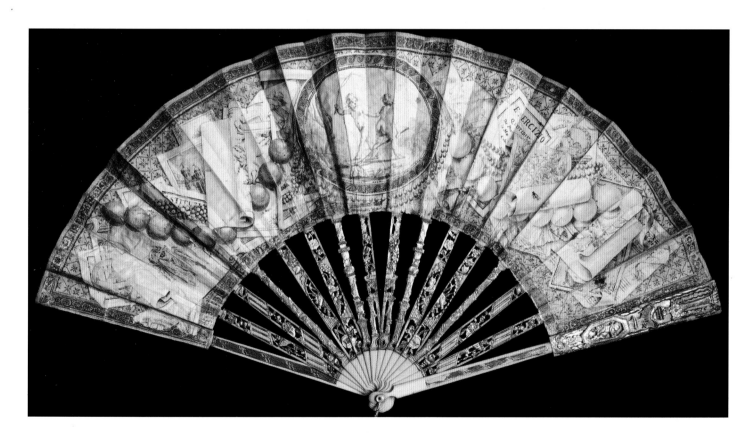

FIG. 186 | CAT. 134

FOLDING *TROMPE L'OEIL* FAN

Francesco Stagni, possibly Bologna | 1771

On top of the harpsichord are a number of objects which show the discernment, education and modishness of this collector from Tuscany or Piedmont. The bronzes and cameos could have been found in the *studiolo* of a humanist, signifying his intellectual foundation in ancient history and texts. The parrot at his shoulder, the turban on his head, the Turkish carpet and the candlestick in the shape of a Chinese figure all resonate with contemporary interest in the East. A gold snuffbox is placed directly in front of him. At his feet, there is a small evaporation apparatus in a bell jar, and a container that may have been used for heating substances for analysis and identification; these indicate his engagement with current scientific interests. Finally, the engravings on the wall behind him, after Watteau's *Embarquement pour Cythère* (1733) and *La mariée de village* (1729), suggest a choice between the distractions of love and an honest marriage. It is possible that this portrait was commissioned just before the sitter's marriage, the point at which his old identity as collector was to be subsumed by his new one as *paterfamilias*.[8] MTC

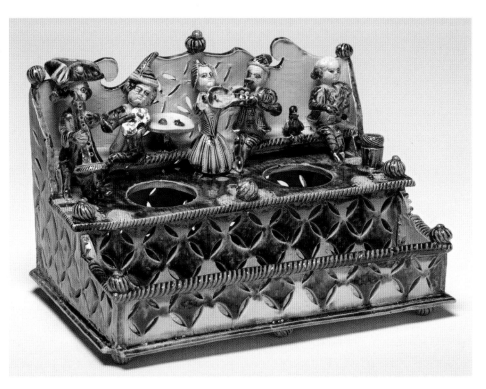

See: Dulac and Maggetti 1992–7; Goodman 2003; Goodman 2009; Hellman 1999; Laclos 2007; North 2008; Siegfried 1995; Steegmuller 1992.

1. Goodman 2009, pt IV.
2. For their correspondence, see Dulac and Maggetti 1992–7. For their story in English, see Steegmuller 1992.
3. Glaisher writes: 'Considering what an uncongenial material the clay of stoneware is, the modelling is remarkable' (Glaisher MS catalogue, vol.19, no. 3830).
4. A pounce pot or sand box usually did not contain sand but powdered cuttlefish bone or pulverized gum sandarac. It was used to prepare unsized paper and to dry ink. My thanks to Julia Poole for this information.
5. On Boilly, see Siegfried 1995.
6. Goodman 2009, chapter 5.
7. Fitzwilliam had inscribed one of his music books with 'R.Fitzwilliam, Paris. 1765': Fitzwilliam Museum: MU.MS.100.
8. This identification of the engravings comes from the entry on the National Trust website. Available at: www.nationaltrustcollections.org.uk/object/207799 (accessed 8 September 2014).

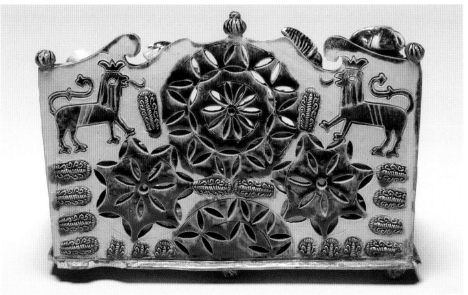

FIG. 187 | CAT. 166

INKSTAND

Westerwald | first half 18th century

FIG. 188 | CAT. 168

INKSTAND

Fürstenberg, Brunswick | *c.*1765–80

This elegant inkstand was produced at Fürstenberg, Germany's second-oldest porcelain factory (after Meissen).[1] Designed for maximum functionality, it comprises an oval stand with shallow sides (to facilitate picking up), elevated on four paw-feet (for maximum stability when set down). At the back is an integral candlestick, useful when writing in low light and for melting wax when sealing letters. At the front are two raised rings to hold the removable cylindrical inkwell and pounce pot (for the resinous powder used to dry ink) firmly in place when the ink-stand was being carried.

Highly functional, this inkstand is also very fashionable. It combines straight-sided neoclassical forms and restrained gilding with typical Rococo decoration: a pale yellow ground and shaped reserves filled with images of theatrical-like figures in pastoral landscapes.[2] It may well have belonged to a well-educated woman who practised the fashionable art of letter-writing.[3] AF

See: Chartier et al. 1997; Daybell 2001; Ehrard 1963; Goldgar 1995; Goodman 1994; Goodman 2003; Goodman 2009; Jedding et al. 1988; North 2008.

1. Jedding 1988.
2. Ehrard 1963.
3. Chartier et al. 1997; Goodman 2003; Daybell 2001.

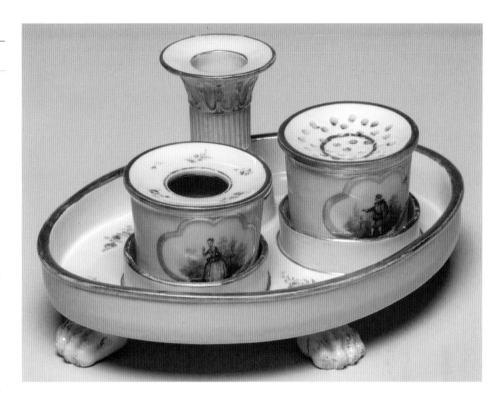

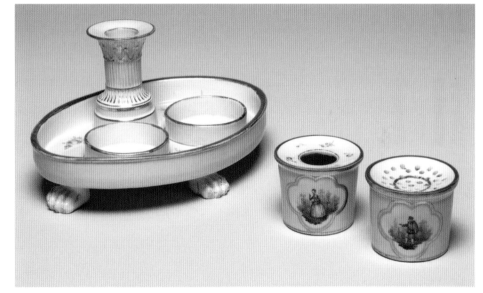

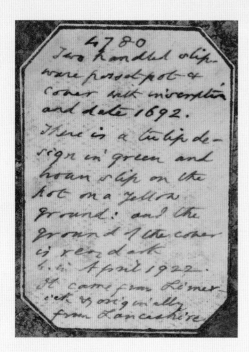

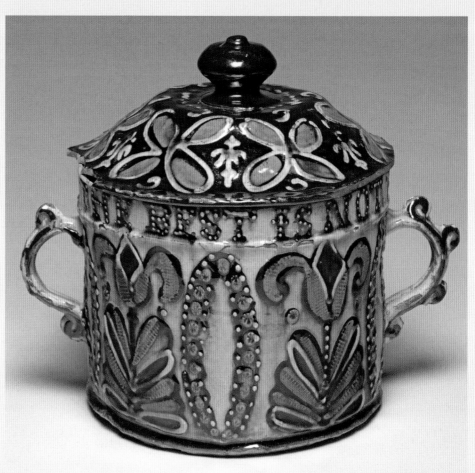

FIG. 189 | CAT. 70

POSSET-POT AND COVER
with detail of paper label on underside

Staffordshire | 1692

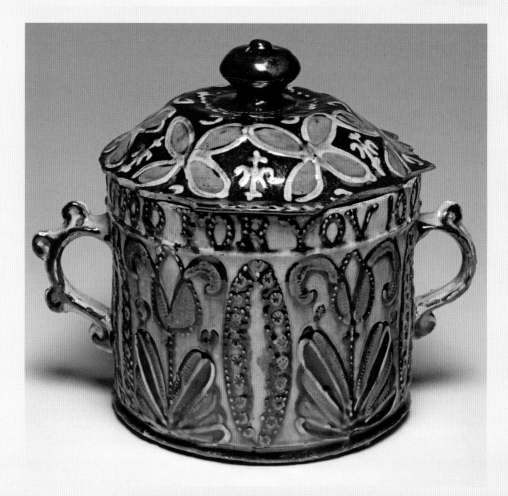

'EVERYDAY' OBJECTS AND THE GLAISHER COLLECTION

Melissa Calaresu

FITZWILLIAM MUSEUM, CAMBRIDGE (VOL. 31, ITEM 4780)

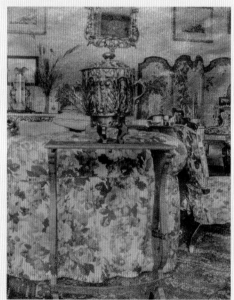

FIG. 190

NOTEBOOK OF DR J.W.L. GLAISHER

Cambridge | *c.*1922

The history of an object is often impossible to separate from the history of its collection. This is especially true of 'everyday' objects for which there is often no evidence concerning their production or original owners. The 'biography' of an object could more easily be written if it were given by Louis xv of France to Maria Theresa of Austria, such as the exquisite ice-cream cup tray, or *soucoupe à pied pour tasses à glace*, in the Fitzwilliam, made by the Sèvres porcelain factory in 1758, with its trail of account books and letters.[1] In contrast, very little is known about the 'shoemaker' who left a stash some time during the reign of Elizabeth I and which was only discovered 300 years later under the floorboards in Corpus Christi College, Cambridge (figs 124–125). Beyond the difficulty of documenting non-elite, ordinary objects, the very conception of the term 'everyday' is not unproblematic.[2] In particular, what has survived, by definition, is not ordinary. The journey which an 'everyday' object makes to reach a museum display-case is filled with hazards. Most objects break, crack or disintegrate with use, and while some get recycled or reused (often for different functions from those for which they were originally made), they more commonly end up in a rubbish heap. The survival of an ordinary object from the early modern period in a museum collection today is then as extraordinary as that of the Sèvres porcelain piece. This essay examines the history of the collecting of some of the objects in this catalogue, as a way of exploring further the idea of the 'everyday' as well as understanding the history of the objects themselves.

In his preface to *A Short Account of English Pottery* from 1901, F.W. Phillips advises the young collector to begin by exploring the 'primitive wares' in the English earthenware room at the British Museum: 'There, step by step, the progression of the art may be traced from the 10th to 19th centuries. Do not attempt too much on the first day; confine yourself to observing the Mediaeval wares, the Wrotham and Toft wares, and perhaps the Stone-wares; but on no account allow yourself to be beguiled into looking at the Porcelain and pretty things of later years.'[3] Despite these implicit hierarchies, Phillips' advice reflected an expanding interest, from the 1890s, for the more ordinary earthenwares produced in England in contrast to the more upscale market for eighteenth- and early nineteenth-century European and English porcelain. Phillips had his own showroom in Hitchin, not far from Cambridge and '45 minutes from King's Cross Station'; his 'short account' was, in fact, a sales catalogue in which 'the *Genuineness* and authenticity of each piece is *absolutely guaranteed*' [his italics].[4] This interest in the study of authentic artefacts from England's early history has been seen as a response to the rapid social changes in this period, from about 1890 to 1930, as more and more people moved to cities and there developed a distinct nostalgia for the rural and artisanal. This new demand was met by an expanding art market which included a whole range of new kinds of objects which would not have been sold in the great auction houses of London or Paris 50 years before.[5] Handbooks published for this growing public of collectors expounded on the 'primitive vitality' of these earlier wares and their Englishness and considered their naïvety preferable to the hardness and perfection of the later porcelain. The writer of the 1933 volume on pottery in the Library of English Art writes: 'Few collectors [...] will fail to find the amiable incompetence of the delftware, even without its charming decoration, vastly more sympathetic than the hard efficiency of its supersessor.'[6]

One of the great English ceramics collections formed in this period and which reflected this new taste was put together by one of the most significant benefactors of the Fitzwilliam Museum, Dr J.W.L. Glaisher (1848–1928). As it turns out, he bought a mid-seventeenth-century English Delftware 'tulip charger' described and illustrated in Phillips' sales catalogue of 1900.[7] The collecting tastes and practices of Glaisher, a lifetime bachelor fellow of mathematics at Trinity College, followed those laid out by Phillips.[8] Glaisher maintained throughout his collecting life an interest in these simpler earthenware pieces (although later he was not able to resist buying porcelain too), criss-crossing the country by train, scouring antiques shops, consulting London sales catalogues, even arranging his own excavation of the Wrotham potteries site, in order to acquire the best pieces for his collection.[9]

He left an extraordinarily meticulous record of his purchases in 41 handwritten notebooks, with entries of up to ten pages long in which he describes the object and the circumstances in which it was bought (fig. 190).[10] Many pieces still have the handwritten labels he applied to their bases (fig. 189). By Glaisher's death, he had formed one of the greatest collections of English ceramics in the world, and this new taste now dominated the market.[11]

All but one of the ceramic objects discussed in this essay come from Glaisher's collection. They were all once treasured possessions, often marking important days in the calendar or memorable events in the lives of their owners. Glaisher was particularly interested in objects that were named and dated, for example, with the name and birthdate of a child or with a pair of initials, probably those of a bride and groom or a married couple. Posset-pots, such as the one dated 1692 (fig. 189), may have been made to commemorate a betrothal or wedding and would have been used on the day, the lid removed, held by both handles, and then passed around from guest to guest; depending on the consistency of the posset and whether the pot had a spout, the warm liquor would have been sipped from the lip of the pot or sucked up through its spout, with the remaining custard spooned out to share among the guests.[12] This pot would then have been kept high up on a dresser or on a stand (as it appears in the photograph in Glaisher's catalogue; see fig. 190), out of danger and protected from day-to-day wear and tear, and only brought out once a year for another round of ceremonial drinking on Christmas Eve.[13] In this sense, it was far from 'everyday' and most certainly a family heirloom, as attested by the efforts of Glaisher's friend who had first spotted it in a house in Ireland and noted that 'it was a family piece and they would not part with it'.[14] The pot's appeal was clear with its jolly inscription, 'The best is not too good for you', in capital letters around its belly, perhaps a tribute from the groom to his wife. Most importantly, its rustic credentials could be traced back 'to its original home among farmers in Lancashire'.[15] While the very particular form of posset-pot was unique to Britain, they were not only made for prosperous farmers. They were also made for regular use in a variety of materials, including silver and glass. The decoration of these more expensive pots reflected contemporary fashions enjoyed by their wealthier urban owners, such as Glaisher's treasured Delftware example painted with chinoiserie decoration (fig. 207), and which was illustrated in the bottom left-hand corner of his ex-libris (fig. 191).[16]

Nonetheless, there were unique ceramic objects produced specifically for the rural market and these were especially coveted by Glaisher and his contemporary collectors, such as the north Devon harvest jug dated 1724 (fig. 192). It is a very rare survival of what was a common practice in the agricultural calendar in one corner of England. Its handle is burnished by seasons of use to celebrate harvest end. Full of cider or ale, it would have been too heavy to carry to the field so, if it had been used to slake the thirst of agricultural workers, it would have been passed around the table at the farmer's house or just outside his door. It is more likely, however, that the jug, like the posset-pot, was an engagement or wedding present, which was commissioned by the groom's family, hoping that it would bring good fortune and be prized by generations to come. Under a mustard-yellow lead-glaze, the slip-coated jug is incised with stylized busts of a man and woman facing towards a heart enclosing the initials 'W H', all three elements bearing the date '1724'. There are tulips and birds around the belly of the jug and thistles under the handle and heart. The inscription around its shoulders, written in an English perhaps echoing the open vowels of the West Country, celebrates the enjoyment of a 'good drink' after a day's hard work in the fields.[17] The Englishness of its origins and inscription was particularly attractive to later collectors, even if the incised decoration (*sgraffito*) and tulips also suggest the influence of the extensive commercial and cultural links of Devon's ports with Europe.[18]

City- and country-dwellers alike had access to a whole range of new ceramic goods from pedlars who made their way from village to village, to grocers' shops in many provincial towns, and to the more sophisticated shops of London and other cities such as Bath.[19] The trade card of Benjamin Layton 'China-Man and Glass-Seller' (fig. 50) demonstrates the variety of ceramic goods sold by an individual merchant – from earthenwares to creamwares to porcelain.[20] The objects included in the present catalogue testify to the fluidity in the exchange of forms across materials and artisanal traditions. A traditional pear-shaped jug to serve beer or ale at the table could be made in a variety of materials for different markets. One could compare the harvest ale jug with the silver beer jug from 1739/40 (fig. 193). Its handle is in the shape of a dolphin with its classical associations and there is an empty cartouche ready for an owner's name or coat-of-arms to be engraved. The cartouche made it possible to personalize the object, just as the harvest jug was commissioned as a one-off piece. However, the differences between these two objects were not only ones determined by their material value; that is, silver versus fired clay. Contemporary users would have associated one with metropolitan drinkers of beer, and the other with their country cousins, who generally drank locally-brewed ale.[21] These associations would eventually change with the increased consumption of new 'intoxicants', following the expansion of trade to Asia and America. The new hot drinks such as tea, coffee and chocolate required new forms of ceramics from which to serve and drink them; they also created new forms of sociability.[22]

FIG. 191

EX-LIBRIS OF DR J.W.L. GLAISHER

George W. Eve | *c.*1907

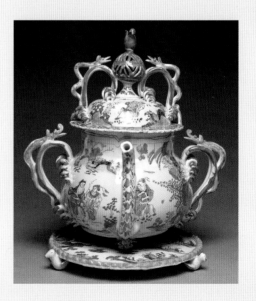

see fig. 207 on p. 191

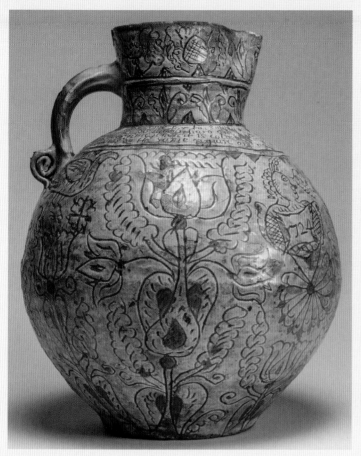
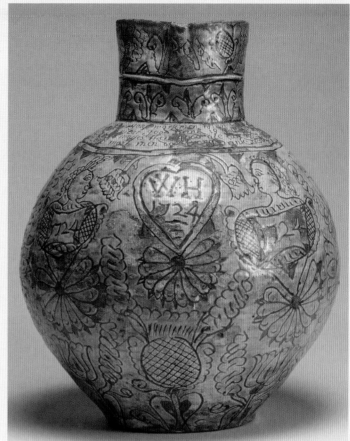

FIG. 192 | CAT. 66

HARVEST JUG

North Devon | 1724

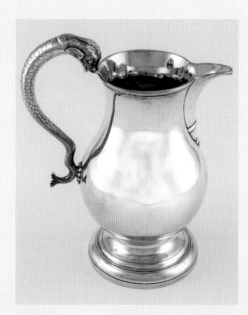
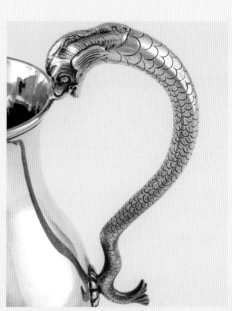

FIG. 193 | CAT. 67

BEER JUG

London | 1739/40

The technological advancements of the pottery industries in England, which produced the cheaper slipware and painted tin-glazed earthenware (or Delftware) in the seventeenth century discussed above, and the finer Staffordshire wares of the early eighteenth century (see below) not only increased the decorative possibilities of English ceramics, but also allowed for a proliferation of new functions and forms for different markets.[23] English potteries responded to new consumer habits created by the expansion of new trade networks. The silver tea bowl with the delicately engraved Chinese-style decorations (fig. 100) indicates the association of tea with elite consumption in the late seventeenth century, when it was made, even if the cup would have been impossible to hold when it was full of hot tea. Less than 50 years later, the tea bowl would become the tea cup. As the section on tea in this catalogue shows, a variety of earthenware was made to store and serve tea for the expanding market of tea drinkers. By the end of the eighteenth century, the ceramic teapot would replace the ceramic ale jug as the object given pride of place in many people's homes.[24]

In fact, the eighteenth century witnessed an explosion of luxury goods and their imitations. Certain materials had been associated with luxury from the Renaissance, or even earlier. Their value was determined, in part, by their rarity or by their association with the classical world – the gems and stones from which Roman cameos had been made, or certain kinds of marble mined from quarries in antiquity. These associations did not disappear and, in fact, they resonated for an even wider public by the eighteenth century. Agate, for instance, had been used to make bowls and jewellery since antiquity (see, for example, fig. 194). Agate continued to be used as a precious material into the early modern period, as can be seen in a seventeenth-century Italian agate and gold spoon and an eighteenth-century English snuffbox, both in the Fitzwilliam.[25] While several European factories had cracked the secret of hard-paste porcelain by the early eighteenth century, so that it quickly became a 'new luxury', many English potteries continued to experiment with clays and glazes, producing ceramics that were much cheaper than porcelain to make, and buy. The mid-eighteenth-century salt-glazed agateware scent flask (fig. 195) was made in Staffordshire for this wider market. Although certainly not as precious as the porcelain scent flask (fig. 158) made around the same time in Naples, it would nevertheless have been valued and admired for its circular shell-pattern, as made evident by the arched ridge incorporated on its back so it could be displayed on a dresser. A similar process was developed to simulate marble on lead-glazed earthenware products such as the sugar bowl from about 1745 (fig. 196), also made in Staffordshire.

Both producers and consumers registered distinctions between these different kinds of agatewares and marbled wares; some were produced using special techniques to combine and form different colours of clay, while others were made simply using slips to create the same effect. However, the value of these objects lay not simply with the material that they imitated, but also the technological expertise required to create such spectacular effects. In fact, Wedgwood made some extraordinary agateware pieces, such as the vase in the Fitzwilliam collection, which was based on a French neo-classical design and gilded in parts to signal its elite status.[26] The Staffordshire marbled sugar bowl (fig. 196) signalled luxury to its owner and to those she would have invited for tea, not only by its marbled decoration, but also by its function to hold sugar – originally a luxury good, by the eighteenth century sugar was widely popular. The marbled effect, like the tulip motif, and the chinoiserie style, all evoked luxury, new and old. Their use across a range of materials from ceramics to textiles allowed a greater number of households to share in the consumption of fashionable goods. In turn, the potteries responded to the desire of these new consumers for 'novelties' by producing items such as cauliflower-shaped creamware sugar bowls, which were manufactured by several Staffordshire potters, including Josiah Wedgwood and William Greatbatch (fig. 197).[27]

This essay has shown the variety of ceramic wares available to emerging markets in the early modern period. In this respect, historians have noted the changing boundaries of luxury and necessity.[28] The production of 'populuxe' goods, such as watches, desks and even ceramics, which looked like luxury items but which were made from cheaper materials, blurred these boundaries by the eighteenth century.[29] We also know that many households had a variety of kitchen and tableware made from pewter, tin and ceramic but also a few pieces of silver and, later, porcelain. An eighteenth-century print by Christoph Kilian (fig. 198) shows the selling of tinware, in a variety of familiar forms, at a street-side kiosk or fair, reminding the viewer of the ubiquity of this cheaper metalware in early modern households, rich and poor, even if tin objects are less likely to appear in modern museum inventories. It also shows us that not all shoppers bought their goods in upmarket galleries and shops, these new spaces which, for historians of consumption, mark shopping as an emerging leisure activity in the eighteenth century.[30] A lot of kitchen- and tableware in the early modern period was made of less expensive wood, so once cracked or broken it was just as likely to have been discarded onto the fire as to have been repaired.[31] The 1612 print by Ambrogio Brambilla indicates the kinds of kitchen objects sold on the street of seventeenth-century Rome, including sieves, funnels and cutting boards, which hardly ever make it into the permanent collections of museums (fig. 35 and details on p. 182). Not surprisingly, new archaeological evidence has expanded our picture of the use of 'everyday' objects.

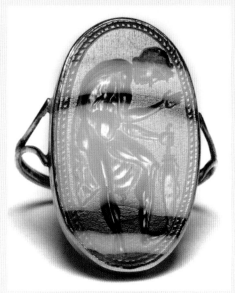

FIG. 194

BANDED AGATE RINGSTONE
with intaglio of Ajax or Theseus

Etruscan | 4th century BC

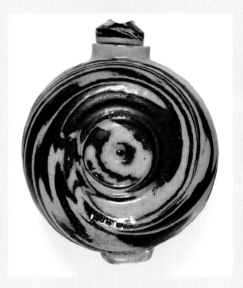

FIG. 195 | CAT. 147

SCENT FLASK WITH SCREW STOPPER

Staffordshire | mid-18th century

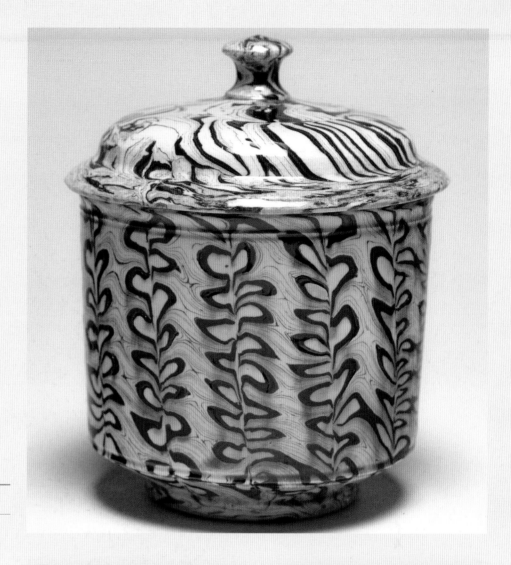

FIG. 196 | CAT. 200

COVERED SUGAR BOWL

Staffordshire | *c.*1745–55

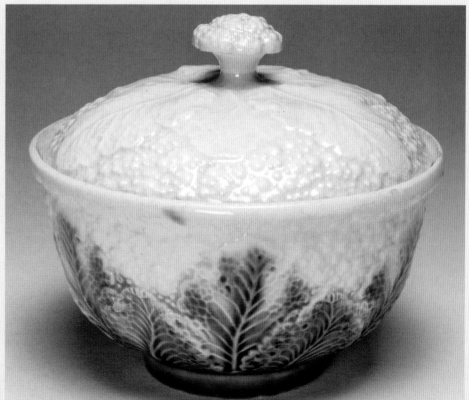

FIG. 197 | CAT. 197

COVERED SUGAR BOWL

Probably Staffordshire | *c.*1759–75

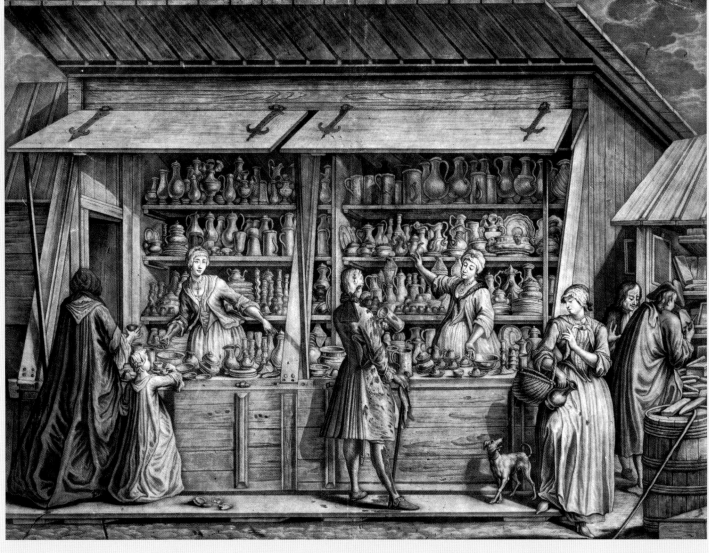

FIG. 198

A DEALER IN TINWARE

Christoph Kilian, mezzo, touched proof
18th century

Details from fig. 35 (pp. 48–49) showing
ambulant vendors selling (from left to right):
spoons and wooden cutting boards; sieves;
repaired copper pots and pans; baskets;
and bellows

While unusual, the recent excavation of the remains of a popular neighbourhood in Barcelona, demolished in the early eighteenth century in order to build a military fortress after the fall of the city in 1714, giving way to an esplanade, and a vegetable market later in the nineteenth century, has uncovered an incredible range of ordinary objects. Their analysis has supplemented earlier studies of detailed notarial inventories, even if inventories remain indispensable in helping to piece together the complexity of the material world of this period and some types of objects get left out of them.[32]

Glaisher was often content to buy chipped, broken or repaired objects if they were of significant interest to him, but these kinds of objects can also shed new light on their use and value in early modern society. Historians of 'everyday' material culture are keen to study objects not only within a history of their production and consumption, but also within a history of repair, recycling and survival.[33] This new historiography takes us further away from the 'object biography', which depends on knowing the provenance of the objects that Glaisher and other collectors so prized, and which has dominated the study of early modern material culture.[34] As this catalogue shows, museum collections remain central to our understanding of 'everyday' objects, even if they were most certainly 'treasured possessions'. Glaisher's particular affection for collecting early English ceramics, as well as his commitment to recording in great detail the context in which they were bought, have created an invaluable source to recover the 'vitality' of lives lived in early modern England. We are also reminded that further study of collecting practices must be undertaken, as what survives continues to shape what we study as historians.

1. Fitzwilliam Museum: C.2-1957. Peters 2005, vol. 2, pp. 307–8, service, 58-3.
2. See the introduction in Hamling and Richardson 2010. See also Pennell 2010.
3. Phillips 1901, p. ii.
4. Ibid., p. 30.
5. Brears 1996, pp. 30–42; see also Herrmann 1999. My thanks to Heidi Egginton for these references.
6. Honey 1933, p. 52. Honey also suggests that there was a consequent lower price for English porcelain: 'Wedgwood ware is completely out of fashion, and even the finest vases may sometimes be had at sales for a tenth of the price they fetched fifty years ago.' Ibid., p. 246.
7. Rackham 1987, vol. 1, p. 188, cat. 1490; Phillips 1901, p. 35, and plate 10. My thanks to Julia Poole for bringing this to my attention.
8. For the best biography to date, see Poole 2013.
9. Glaisher only began collecting ceramics in 1892 or 1893, when he was already 43 or 44.
10. Glaisher MS catalogue, Fitzwilliam Museum, vol. 31, [4780].
11. Although Honey notes in 1933 that: 'Dr Glaisher's death a few years ago has reduced by half or more the price of English slipwares and blue-dash chargers, for which he had been willing to pay almost any sum if a specimen took his fancy.' Honey 1933, pp. 246–7.
12. Day 2000, pp. 19–22.
13. Jewitt 1878, vol. 1, p. 107.
14. Glaisher MS catalogue, vol. 31, [4780] .
15. Glaisher included photos of the pot and even 'of the house of the pot' in his entry: Glaisher MS catalogue, vol. 31, [4780]: see fig. 190.
16. Courtauld 2007, pp. 116–19.
17. The inscription reads: 'Now i am come for to supply your workmen when in haruist dry when they do labour hard and sweat good drink is better far than meat. In winter time when it is cold i likewayes then good ale can hold All seasons do the same require and most men so strong drink desire.'

18. Grant 1983, pp. 58–60. Glaisher was thrilled later to have bought a second north Devon harvest jug with the date 1703/4 (Fitzwilliam Museum: GL.C.58-1928), in his MS catalogue (Glaisher MS catalogue, vol. 31, [4269]). However, this jug is unlikely to be genuine. Our thanks to John Edgeler for his advice on the two jugs.
19. Stobart 2013, chapter 10.
20. Dawson 2010, pp. 15–17; Hildyard 2004.
21. Withington 2011, pp. 638–9. Compare the beer jug with a simpler stoneware jug, acquired by Glaisher, with detailed incised decoration of flowers, stars and complex patterns, and a cartouche with 'ALE' written at its centre (Fitzwilliam Museum: C.1245-1928).
22. On coffee, for instance, see Cowan 2005. For an alternative story in warmer climates, see also Calaresu 2013c.
23. Berg 2005, chapter 3.
24. See Vickery 2009, pp. 271–6; and McCants 2013.
25. See MAR.M.176-1912 and M.5-1981 respectively.
26. C.659 and A-1928.
27. Berg 2005, chapter 1.
28. Jones and Spang 1999.
29. Fairchilds 1993 and Goodman 2003.
30. On shops and galleries in eighteenth-century London, see Walsh 1995 and Walsh 2003; on sites of consumption in early modern Europe, see Welch 2012; on selling on the street, see Calaresu and van den Heuvel 2015.
31. On the kinds of materials used for kitchen and table ware, including what was known as 'treen' ware in the household of Alice LeStrange, see Whittle and Griffiths 2012, chapter 5.
32. Garcia Espuche 2010; see, for example, Garcia Espuche et al. 2012. For an excellent example of a study that combines the use of inventories with an attention to material culture, see Cavallo and Storey 2013. On the limits of inventories, see Pennell 2009 and Riello 2013a.
33. Historians have been particularly inspired by the work of the French historian, Michel de Certeau; see De Certeau 2011, Part I, and, for example, Pennell 2010.
34. Appadurai 1986.

EMBELLISHING THE EVERYDAY

The ceramics collector and great benefactor of the Fitzwilliam Museum, Dr J.W.L. Glaisher was thrilled when he found this early seventeenth-century French earthenware fire cover or *couvrefeu* (fig. 201); he noted in his manuscript catalogue that it 'is quite perfect and is the finest piece of foreign slipware I have seen'.[1] Glaisher admired the piece for its decoration, a very rare survival of an ordinary object, which would not have made it to the shop in Boulogne in 1913, where it was acquired by Glaisher, had it not been given and treasured as a wedding present three hundred years earlier.

This fire cover would have been kept in front of the hearth when not in use for cooking, as a safety precaution to prevent sparks flying out when the fire was unattended, and letting the ashes behind it emanate warmth into the kitchen. The kitchen was situated at the heart of many houses and served a variety of functions – a place to eat, sit, sleep, pray and read (or be read to) – although others had only a brazier and no fireplace.[2] Not until the seventeenth century, and then only for the wealthier in some parts of Europe, do we see specialization in the functions and furniture of different rooms such as dining rooms or bedrooms and, later, morning rooms or sewing rooms.[3]

Keeping the cold and dark at bay were two of the main preoccupations of householders in early modern Europe. For most people, windows had to be kept small to keep in the heat and were usually covered with oiled cloth until later in the period. Candles were a constant and expensive drain on household expenses and used sparingly and with care.[4] Street lighting only appeared in some European cities from the late seventeenth century, and the countryside was kept in the dark until much later.[5] By the end of the seventeenth century in England, glassware was more widely available to the middling classes, and used to make lamps such as the leaded glass lamp (fig. 200),[6] but silver wall-sconces decorated with fashionable chinoiserie decorations would certainly have been the preserve of the elite (fig. 199). Indeed, the possibility of 'conspicuous illumination' continued into the eighteenth century, with the use of chandeliers and *torchères* (large floor-bound candelabras) for only the wealthiest of households and on very special occasions. And, so, finding their way across a dimly lit room continued to add to the social anxieties of Parisian aristocrats in this period.[7]
MTC

See: Ago 2013; Barley 1961; Charleston 1984; DeJean 2011; Garrioch 1994; Hellman 2011; Kelsall 1995; Koslofsky 2011; Loughman and Montias 2000; Richardson and Hamling 2015; Roche 2000; Sarti 2002; Thornton 1978.

1. Glaisher Manuscript Catalogue, Fitzwilliam Museum, vol. 30, no. 4728.
2. Ago notes the small number of rooms designated specifically as kitchens in seventeenth-century Roman inventories. Ago 2013, pp. 66–9.
3. There is great variation on when and where this specialization of the function of rooms takes place in early modern Europe. Ago, for example, sees this specialization in the naming of rooms already in place in early seventeenth-century Rome. Ibid., pp. 65–9. Compare Montias' work on Dutch inventories, in Loughman and Montias 2000. In England, this change was not just in wealthy households. It is obvious from the plans of houses as well as household inventories of late sixteenth- and seventeenth-century farmhouses that there were bedchambers or a best bedchamber-cum-living rooms upstairs, and that multifunctional halls were being divided into kitchens and parlours. See Barley 1961. My thanks to Julia Poole for this information on England.
4. Sarti 2002, pp. 117–8; Roche 2000, chapter 5.
5. Koslofsky 2011, chapter 5.
6. Charleston 1984, pp. 109–96; Kelsall 1995, esp. pp. 37 and 81.
7. Hellman 2011.

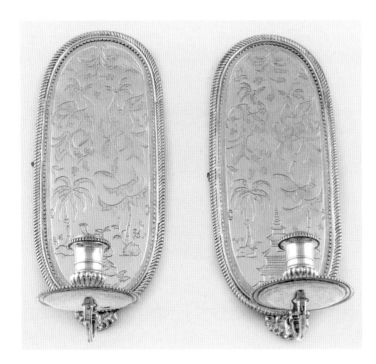

FIG. 199 | CAT. 179

PAIR OF WALL SCONCES

English | *c.*1680

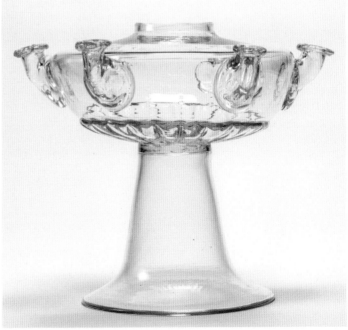

FIG. 200 | CAT. 181

SIX-NOZZLED LAMP

English | *c.*1700–25

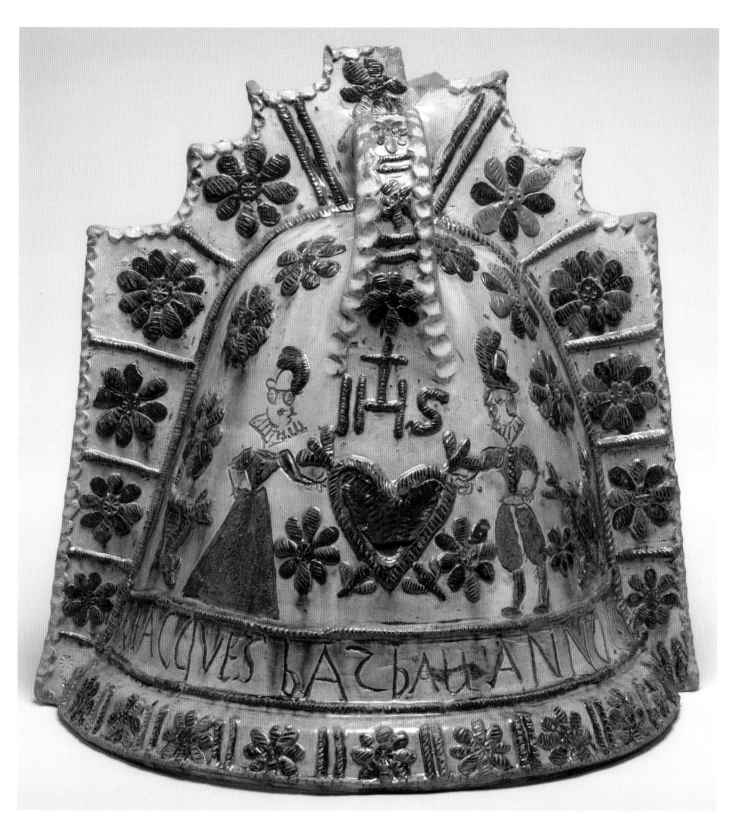

FIG. 201 | CAT. 187

FIRE COVER

Northern France | 1616

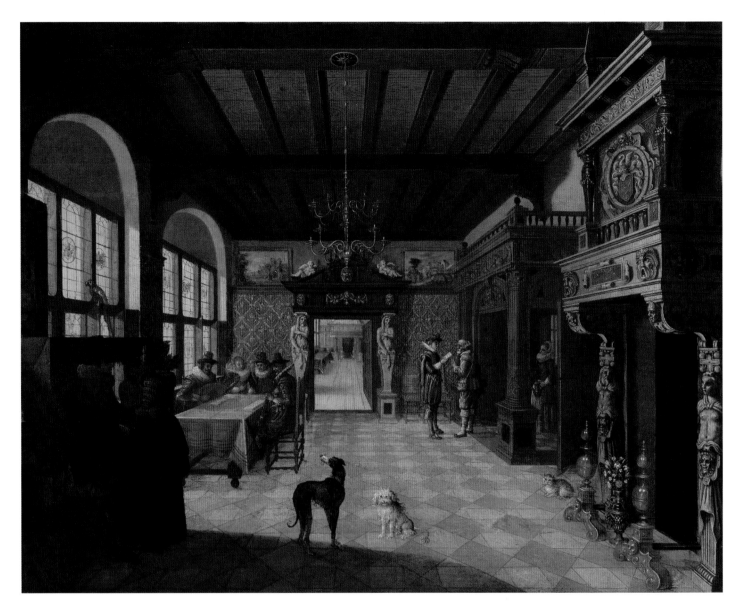

FIG. 202 | CAT. 157

INTERIOR OF A HALL

Nicolaes de Gyselaer, Dutch | 1621

This light and spacious Dutch reception room suggests extraordinary wealth. Embellished with a marble-slabbed floor, wood-beamed ceiling and red gilt-leather wall-hangings, it is dominated by the bi-coloured marble fireplace and doorway, held up respectively by classicizing herms and caryatids (sculptures used as architectural supports), and by the gilded gallery. Such fixtures were rarely included in inventories and it is hard to verify the authenticity of this representation of a Dutch home.[1] Based on a model from a sixteenth-century architectural pattern book, the room is depicted as strangely uncluttered.[2]

Admittedly, there are two landscapes hung by the door, a flower-filled silver vase and brass firedogs in the hearth, and a brass chandelier hanging from the ceiling, but where are the Delftware ornaments, the Asian porcelain, or the silver tableware which crowd Dutch still lifes in this period? By the door, a man receives a letter, some musicians are playing in the corner, and a woman and her servant are shown in conversation, but it is the animals which provide most of the narrative interest: a parrot, forlornly looking out of the window, might suggest more exotic climates, and there are two dogs, one looking at the viewer, the other at the bird. A cat looks on warily. MTC

See: Loughman 2006; Riello 2006b; Riello 2013a.

1. On inventories, see Riello 2006b and Riello 2013a. Loughman warns against assuming that paintings of Dutch interiors from this period represent real interiors; pine, for instance, was preferred to the marbled floors depicted here and in many other Dutch paintings. Loughman 2006, p. 95.
2. Loughman 2006, p. 76.

DELFTWARE

Originally known as 'Delft Porceleyne' on account of its dazzling white surface and blue decoration, Delftware is the modern term used to describe Dutch and British tin-glazed earthenware made in imitation of Chinese and Japanese porcelain. The once-fired biscuit-ware was coated with a thick glaze containing tin-oxide, which made it white and opaque. If desired, it was then painted with a limited range of colours – blue, green, yellow, brownish-purple and sometimes red – before a second firing. This technique was introduced into the northern Netherlands and England in the late sixteenth century by Protestant immigrants from the southern Netherlands, and by the early 1600s the industry was established in several Dutch cities, such as Haarlem, Rotterdam, Amsterdam, Utrecht and Delft. Founded in 1602, the Dutch East India Company created new trade links with the East, and generated vast wealth through trade, and growing markets for domestic goods, useful and ornamental. In addition to tea, silk and spices, Chinese porcelain was imported in vast quantities until the early 1640s, which led to a craze for blue and white porcelain.

Following the fall of the Ming dynasty in 1644 and the disruption of Chinese porcelain production due to civil war, declining imports of Jingdezhen blue and white porcelain led to the production of high-quality imitations by Dutch potters in tin-glazed earthenware. From the 1650s, Delft became the pre-eminent producer, hence the name 'Delftware'.[1] Over twenty potteries operated in Delft, producing utilitarian wares (often undecorated), tiles (fig. 203) and one-off commissions for special events such as marriages or appointments to office.[2] Quality and prices varied between factories. The Greek A Factory, for example, produced high-end wares (fig. 208) and even counted royalty amongst its clients: Mary II of England ordered numerous flower vases for personal use and at her death owed the factory £122 14s 9d for 'Dutch China or ware', while her husband, William III, commissioned several grandiose pieces from this and other Delft factories as royal gifts.

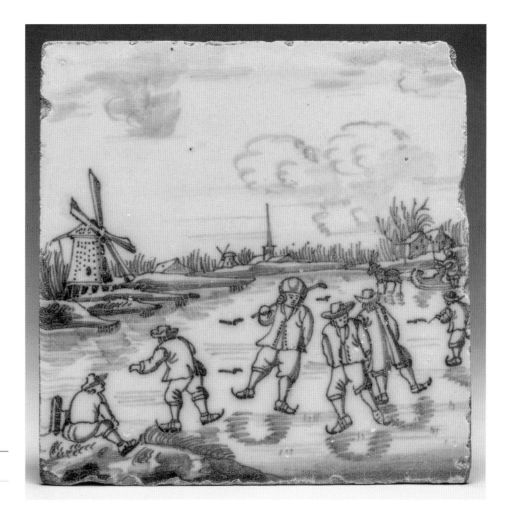

FIG. 203 | CAT. 184

TILE

Dutch | 18th century

Delftware enjoyed huge popularity in late seventeenth- and early eighteenth-century Britain, and was produced in Southwark and Lambeth (London), Bristol and Brislington, Liverpool and Wincanton (Somerset) as well as in Belfast, Dublin and Glasgow. Sold via markets, fairs, travelling salesmen and pedlars, it was eagerly acquired by the aspiring 'middling sorts' and lesser gentry. It was also exported to North America and the West Indies. English Delftware remained fashionable until the 1760s, when it was eclipsed, on the one hand, by cream-ware and later pearlware (fine lead-glazed earthenwares, which were lighter, harder and able to withstand boiling water better without cracking) and, on the other, by affordable English blue and white porcelain made by Bow and Worcester (less expensive than that made at Chelsea).

Dutch and English Delftware was decorated in various styles to appeal to diverse tastes. The early eighteenth-century Dutch birdcage (fig. 205) was painted with Western landscapes and figures in overglaze blue cobalt to imitate late Ming Chinese blue and white porcelain, while the mid-eighteenth-century English chamber pot (fig. 204) is decorated with Chinese-style figures in a palette emulating so-called *famille rose* Chinese porcelain of the Yongzhen period (1723–35). VJA

See: Aken-Fehmers et al. 1999–2003; Archer 2013, esp. p. 348, no. L.4; Erkelens 1996; Hume 2003; van Dam 1991; van Dam 2004.

1. Aken-Fehmers et al. 1999–2003; van Dam 2004.
2. van Dam 1991.

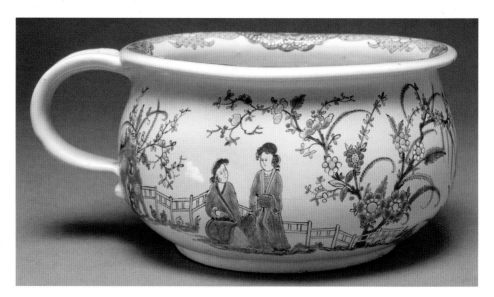

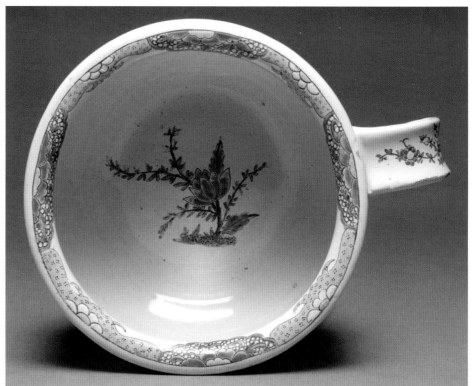

FIG. 204 │ CAT. 178

CHAMBER POT

Liverpool │ *c.*1750–60

FIG. 205 │ CAT. 175 ▶

BIRDCAGE WITH PARROT ON PERCH

Delft │ first half 18th century

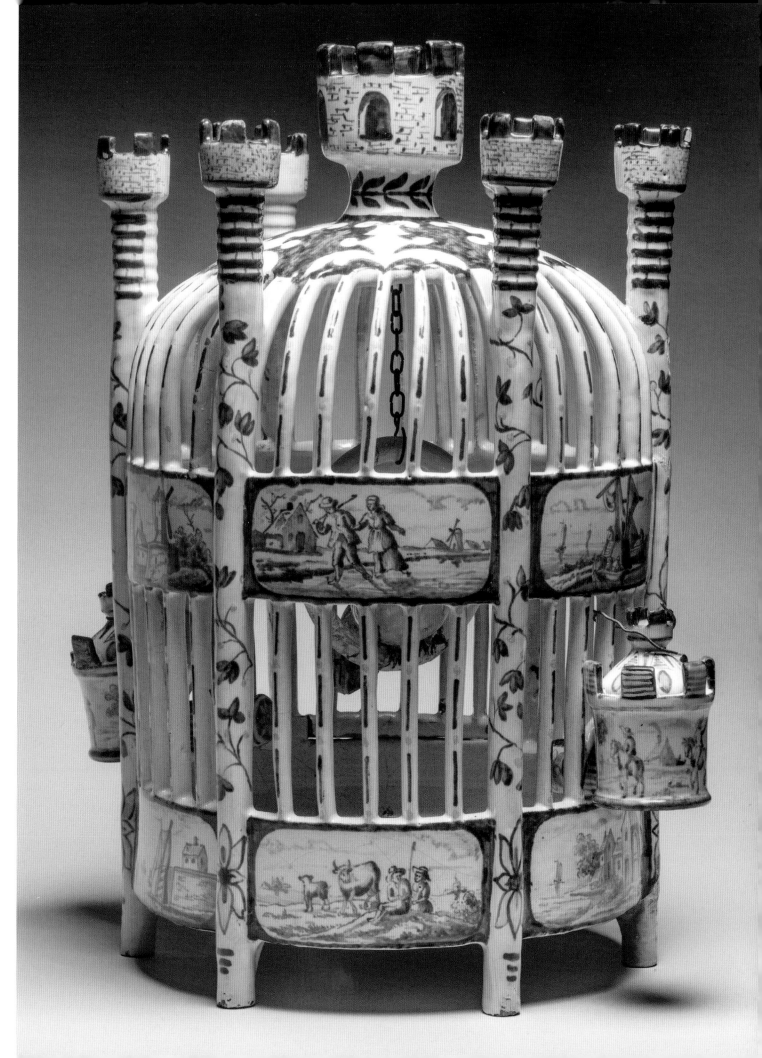

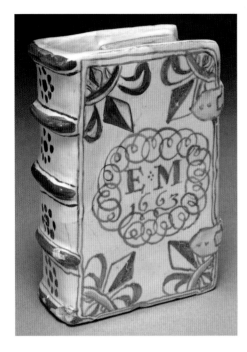

FIG. 206 | CAT. 186

HAND-WARMER

Probably London | 1663

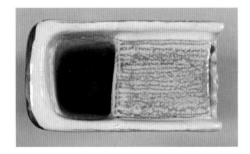

This tin-glazed earthenware object was probably commissioned and gifted on a special occasion, such as the betrothal or marriage of 'EM' in 1663. A number of other surviving examples of seventeenth-century English Delftware books are ornamented with personal messages of romantic love or religious devotion. Probably made in London, its decoration may have been inspired by Dutch tiles with fleurs-de-lys corners. Its precise function is mysterious since there is a lack of contemporary written evidence to explain how such items were used. As is typical of book-shaped earthenware, the internal structure is composed of two hollow chambers with an interconnecting hole. It most likely functioned as a hand-warmer, with hot water being poured into the aperture adjacent to the spine. Alternatively, it may have been a flower holder or simply a decorative ornament for display in the home. JKT

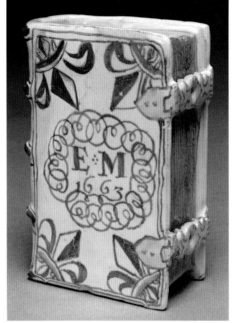

See: Archer 2013, p. 332, no. K.5; Dawson 2010; Lipski 1984.

FIG. 207 | CAT. 177

POSSET-POT WITH SALVER

Brislington, Somerset | 1685–6

Posset is a warm drink composed of milk curdled with wine or beer, sugar and spices. The mixture was sometimes thickened with bread or biscuit crumbs and eggs, which formed a crust above the liquid layer.[1] In seventeenth-century England, posset was drunk at festive occasions such as weddings, and also consumed as a remedy for illnesses and as a restorative drink for women after childbirth. The posset-pot's sucking spout enabled the user to drink the whey directly from the jug as the milk curdled. A large number of English posset-pots dated between 1631 and 1766 survive, many of which were given as gifts.

This exceptionally ornate example, decorated in cobalt blue with Chinese figures and exotic landscapes in imitation of late Ming porcelain, is dated 1685 and bears three initials in a pyramidal arrangement – 'T' over 'CA' – on its base. In England, initials arranged in this format indicated a married couple, and so this posset-pot may have been commissioned to celebrate their nuptial union. Its salver (stand), decorated with European figures, has the same initials but is dated 1686, indicating that it was commissioned by or for the same couple but a year after the posset-pot. JKT

See: Archer 2013, pp. 200–1, no. D.18; Glanville and Lee 2007; May 2012.

1. For posset recipes, see May 2012, pp. 292–4.

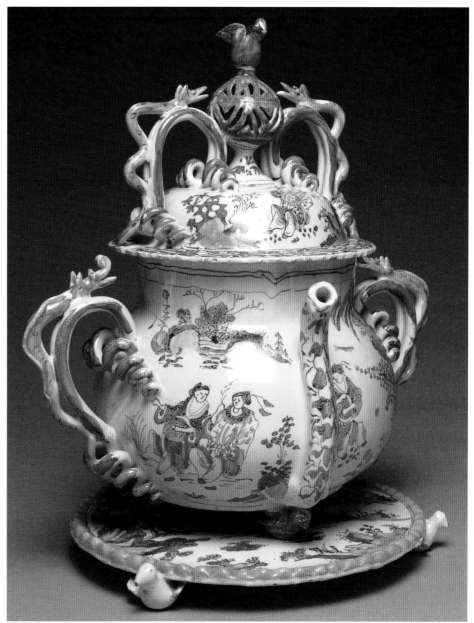

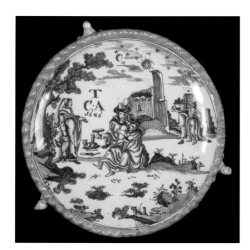

FIG. 208 | CAT. 174

WATER CISTERN

Greek A Factory, Delft | *c.*1700

This very unusual 'Delft Porceleyne' house-shaped cistern was made in the Greek A Factory in Delft. Under the proprietorship of Adriaen Kocks (1686–1701), this was one of the most successful potteries in the city, boasting William of Orange and his wife, Mary Stuart, among its clients.[1] Curiously, the cistern is not decorated to resemble the outside of a house but rather with views of an elegant courtyard and garden that might have been seen from its windows.[2] The playfully decorated roof lifts off so that it can be filled with water, and the silver spigot in the shape of a merman blowing a conch shell and riding a dolphin projects from the central fountain painted on the front as if part of it. The undecorated back indicates that the cistern would probably have stood on a side-table against a wall. The quality of the painting is superb, and when it was acquired by Dr Glaisher in 1907, he felt it really completed his collection of Dutch Delftware: 'I now feel that with the pieces I have already in my collection it is quite satisfactory as representing blue delft at its apogee.'[3] JEP

See: Aken-Fehmers et al. 1999–2003; Kybalová 1973; Sotheby's 1995.

1. Aken-Fehmers et al. 1999–2003, vol. 1, pp. 68–9.
2. For cisterns with interior views, see Kybalová 1973, p. 57, no. 53; Sotheby's, 4 June 1995, p. 18, lot 37.
3. Fitzwilliam Museum, Cambridge, Glaisher MS Catalogue, vol. 6, no. 2889.

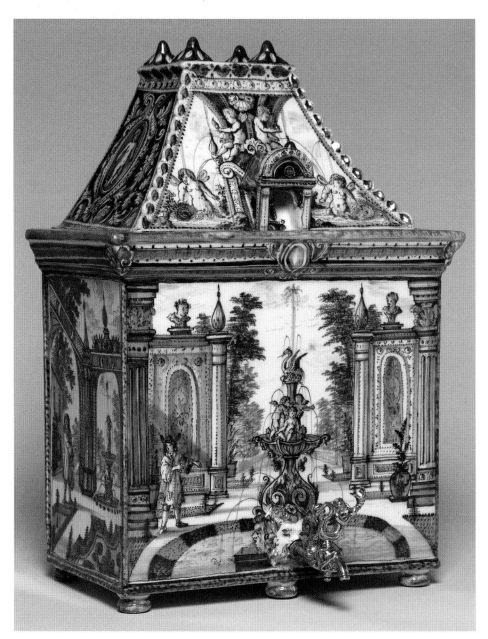

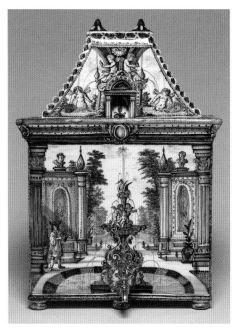

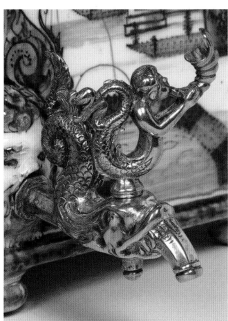

FIG. 209 | CAT. 176

FLOWER VASE

Metal Pot Factory, Delft | *c.*1700–10

The seventeenth-century passion for horticulture in the Dutch Netherlands coincided with the development of tin-glazed earthenware manufacture, for which Delft became famous after 1650.[1] This conjunction resulted in the production of an extraordinary variety of imaginatively shaped vases for tulips and other flowers.[2] Many of them had short spouts to support the flower stems, variously arranged in circular tiers at the top of a vase, in fan-shaped formations, or, as here, vertically on the sides, or corners of pyramidal vases or larger stands.[3] This colourful example was made in the Metal Pot Factory during the proprietorship of Lambertus van Eenhoorn (1694–1721). It has fanciful lizard handles, Oriental-style plant decoration and four tiers of spouts on all four sides, indicating that it was intended to be seen in the round. JEP

See: Aken-Fehmers 2007; Erkelens 1996; Pavord 1999.

1. Pavord 1999.
2. Erkelens 1996, pp. 41–93.
3. Aken-Fehmers 2007, p. 196.

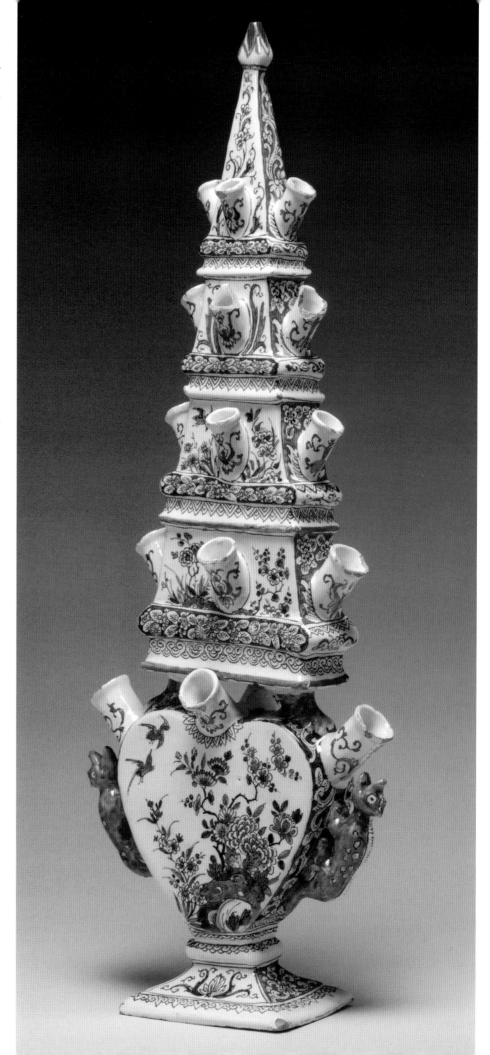

PINEAPPLE MANIA

In England, Delftware tiles were used mainly for fireplace surrounds (as can be seen in fig. 96), or for larger areas in service rooms, dairies and bath houses. They were made and painted by hand until the introduction of transfer printing in one colour by John Sadler and Guy Green at Liverpool in 1756.[1] Most printed tile designs between then and about 1780 comprised a scene after a print or book illustration within a Rococo-style scrolled frame. The Liverpool Delftware tile (fig. 210) shows an elegantly dressed couple in a garden with a pineapple plant in a pot, the design an adaptation of plate 32 in *The Ladies Amusement* (1762 or 1771).[2]

First brought to Europe by Christopher Columbus after his second visit to the New World in 1493, pineapples only reached Britain in 1632. The first reliable crops of English-grown pineapples are thought to be those raised by the Dutch gardener of Matthew Decker (1679–1749) in his gardens at Richmond in *c.*1714–16.

In 1716, on the occasion of George 1's visit, Decker famously served pineapple at dinner; and in 1720 he commissioned a painting of one of his prize pineapple plants, described as 'worthy of the royal table' (fig. 211). This painting was later inherited by Decker's grandson, Richard, 7th Viscount Fitzwilliam (fig. 257), founder of the Fitzwilliam Museum, who in turn bequeathed it to the University of Cambridge at his death in 1816.[3]

From the 1720s onwards, pineapple cultivation became a popular hobby for wealthy gentry and choice specimens often formed the *pièce de résistance* of fashionable desserts. Between October 1759 and March 1760, during the 4th Duke of Bedford's Lord Lieutenancy of Ireland, his confectioner, Thomas Bridgeman, purchased numerous pineapples, some costing as much as 2s. 6d.[4]

Around the time that the Duke was being served pineapple, a fashionable lady would have been serving tea from her amusing earthenware pineapple-shaped teapot (fig. 212), another product of eighteenth-century pineapple mania, this time from the Staffordshire potteries. JEP VJA

See: Archer 2013, p. 398, no. M.124; *Ladies Amusement* 1762; Lausen-Higgins 2010; Paston-Williams 1993, p. 214; Ray 1973, pp. 65–84, 250–1, 258–9; Ray 1994, p. 60, cat. D4-11; Woudhuysen 1988.

1. Ray 1973, pp. 65–84.
2. *Ladies Amusement* 1762. Archer 2013, p. 398, no. M.124.
3. Fitzwilliam Museum: acc. no. 357; Woudhuysen 1988, p. 44, cat. 41.
4. From the Woburn Abbey Collection, Box MR/4/10/2, Bill 34 (dated 1761, Jan 13).

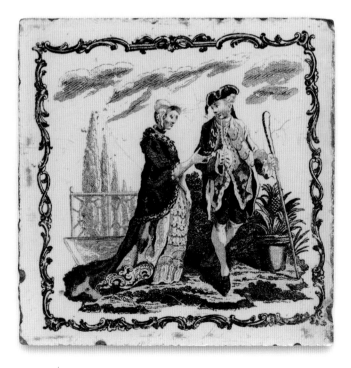

FIG. 210 | CAT. 185

TILE

Liverpool | *c.*1765–75

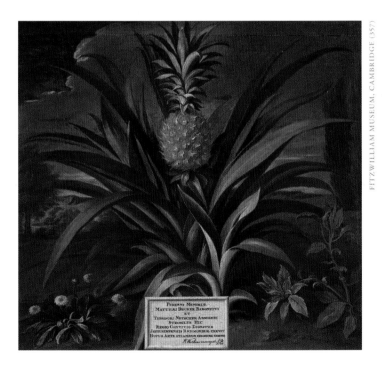

FITZWILLIAM MUSEUM, CAMBRIDGE (357)

FIG. 211

PINEAPPLE GROWN IN THE GARDEN OF SIR MATTHEW DECKER, RICHMOND

Theodorus Netscher, oil on canvas | 1720

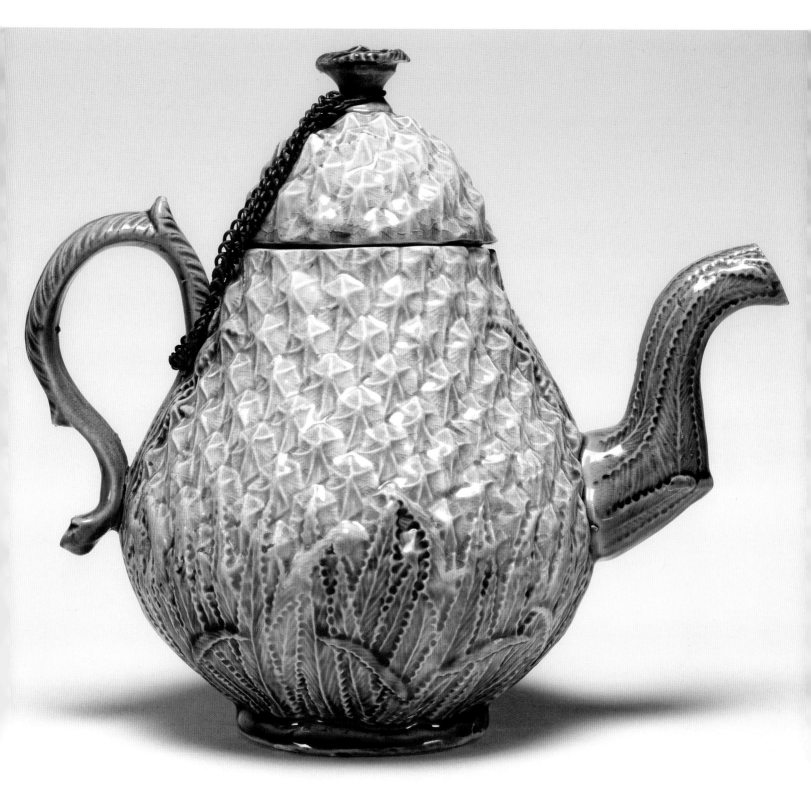

FIG. 212 | CAT. 90

TEAPOT

Staffordshire | *c.1755–65*

SALT

Before becoming a food seasoning for everyday use, salt had long been extracted and commercialized. Salt was used as the main food preservative and an occasional flavouring since early times. Once the Crusades had re-established trade with the East, from the Middle Ages the taste for spices flooded into European dishes. Some authors have even suggested that this taste had led Europeans to their conquests overseas.[1] Of the spices introduced into Europe, pepper was the most widely used (fig. 219) and would later become the inseparable companion to salt on the table (fig. 217).

Although spices were no longer the privilege of wealthy families by the end of the fifteenth century, they remained a precious commodity used only on special occasions.[2] Spice-boxes and salts were treasured possessions, highly elaborated and decorated. The bronze salt (fig. 213) is cast from a model attributed to the Venetian sculptor Girolamo Campagna. It represents a kneeling youth supporting a shell on his shoulders. As salt was mainly found in the sea, shells and sea creatures were frequently used to decorate salts. Earlier in the sixteenth century, Giulio Romano had included marine motifs in his designs for silver salts for the Gonzaga court in Mantua, many of which are now conserved in the Fitzwilliam Museum.[3] In this typically Mannerist example (fig. 214) designed for display on a *credenza* (sideboard), a large shell for holding salt is supported by putti astride dolphins and embellished with a seated Venus.

Other representations on salt wares draw on the ancient metaphor of salt as a primordial substance, symbolizing either corporeal, earthly or sacred properties, and its consequent ceremonial use, and hence the choice of decoration on the Limoges salt (fig. 216).[4] On the other hand, the salt with scrolls was a popular design from the mid-seventeenth century and evoked the ceremonial use of salt by Christians during baptism.[5] This tin-glazed earthenware example (fig. 215) was made probably in London in the 1720s, at a time when many salts had already turned into everyday objects.[6] AF

See: Hayward 1970; Kurlansky 2002; Oman 1957; Schivelbusch 1992; Shaw and Welch 2011; Spary 2012; Walvin 1997.

1. Schivelbusch 1992; Kurlansky 2002.
2. Shaw and Welch 2011, p. 210.
3. PD.6-1948. See Hayward 1970.
4. See Schivelbusch 1992, pp. 3–4.
5. See Oman 1957.
6. See the maiolica salt depicted in Brambilla's grid (fig. 35).

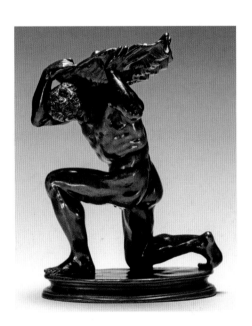

FIG. 213 | CAT. 189

SALT

Venice | late 16th/early 17th century

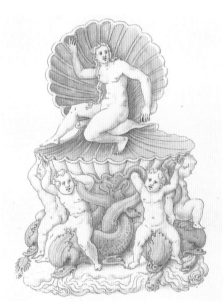

FIG. 214

DESIGN FOR A SALT

Giulio Romano, from *Libro de dessegni per far vasella di argento et oro …* pen and brown ink, yellow and grey wash on paper | first half 16th century

FITZWILLIAM MUSEUM, CAMBRIDGE (PD.6-1948.F.2)

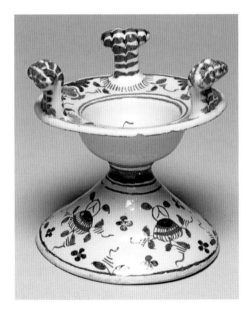

FIG. 215 | CAT. 191

SALT

English | c.1720–30

FIG. 216 | CAT. 188

SALT

Attr. Colin Nouailher, Limoges | *c.*1542–5

Limoges painted enamel tableware, such as
standing cups and ewers, began to be made in
the late 1530s, and hexagonal salts exist dated
between 1540 and 1547. However, because
enamelled copper is easily damaged, they were
almost certainly intended for display on a buffet,
rather than for daily use. This salt, attributed
to Colin Nouailher, was probably one of a pair
which together illustrated the *Ages of Love*,
an amorous version of the *Ages of Man*.[1] On
each of four sides a man or woman makes a
statement about love-making at 40, 50, 70 and
80. The other two sides are occupied by the
fickle goddess Fortuna, closely associated with
the passing of time,[2] and a jester, emblematic
of folly, who warns against overindulgence in
the 'game of love'.[3] Heads of Paris and Helen
(respectively on the salt pan and base) may
represent the prime of life, or indicate that
either love is a gamble or that falling in love
precipitately may lead to disaster, given that
Paris won the love of Helen but ultimately
lost his life in the Trojan War. JEP

See: Higgott 2011; Patch 1927.

1. For a pair, see Higgott 2011, pp. 210–19, no. 64 (a and b),
one dated 1542.
2. Patch 1927.
3. Depending on how one interprets the term 'abus', the
jester's statement may be translated either 'It seems to the old
that by overindulgence the game of love may be lost [for ever]'
or 'It seems to the old, mistakenly, that the game of love may
be lost [for ever].' Considering the 80-year-old's statement,
and the fact that 'abus' could be understood as 'error' or
'mistake' in sixteenth-century France, the latter translation
may be more correct.

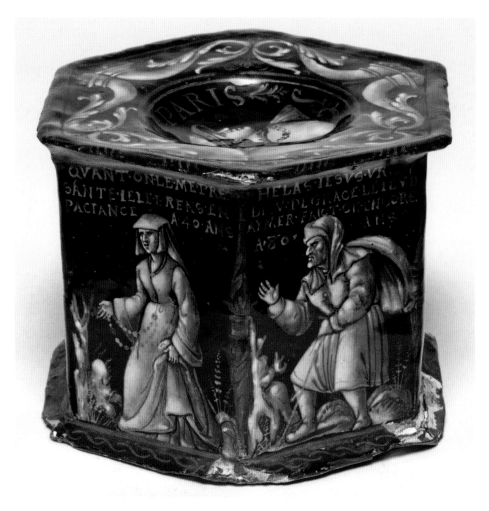

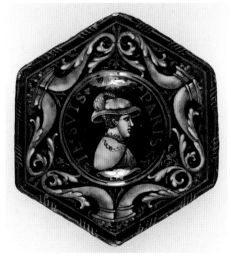

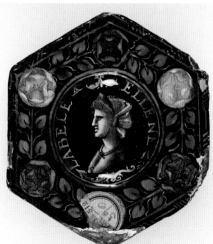

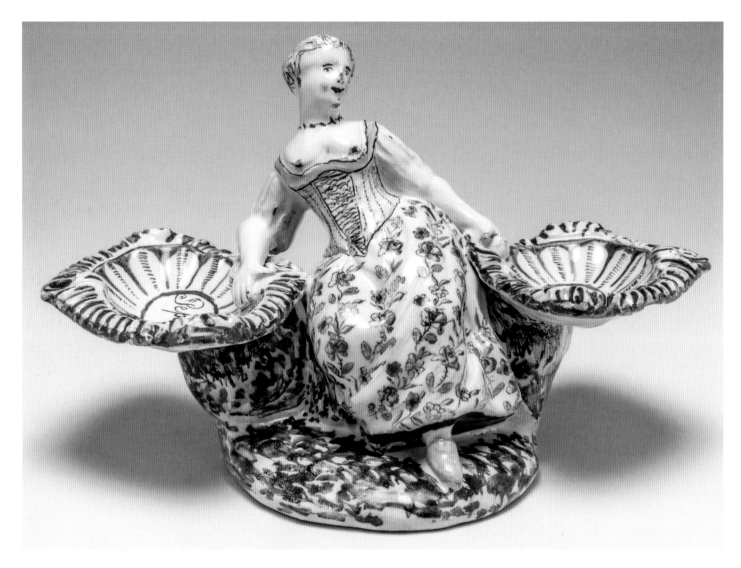

FIG. 217 | CAT. 190

SALT AND PEPPER STAND

Delft | c.1750–60

Decorative ceramic figures started to be combined with functional ceramics, such as inkwells and candlesticks, in sixteenth- and seventeenth-century Europe.[1] By the mid-eighteenth century, the fashion for porcelain figures as table decoration made such hybrid pieces immensely popular. Figures holding shells or baskets for sweet-meats or condiments might be made singly, in pairs or as part of a centrepiece or *surtout*.[2] Factories in Delft and elsewhere produced comparable, if cheaper, items in tin-glazed earthenware, such as covered dishes topped by figures,[3] and figures supporting containers. This young woman sits on a mound with two baskets labelled 'Sout' and 'Peper' (Dutch for 'salt' and 'pepper') balanced beside her. Her bodice has a fashionable decolleté neckline, but the extent of visible bosom seems to hint that like many young working women, she was willing to sell other favours. The model was probably influenced by a Meissen or Mennecy porcelain salt.[4] JEP

See: Archer 2013; Stahl 1994; Tietzel 1980.

1. See Archer 2013, p. 274, no. G.5 for the English Delftware seated figure of a youth holding a basin for salt on his lap and two candle-holders on his shoulders of c.1655–80: Fitzwilliam Museum, Cambridge (C.1421–1928).
2. Stahl 1994, p. 158, no. 5.2.7.
3. Tietzel 1980, pp. 197–8, nos 79–80.
4. Roth and Le Corbeiller 2000, pp. 56–7, no. 28.

SUGAR

Sugar, that almost invisible sweet companion to our everyday drinks and meals, has attracted the attention of a number of scholars interested in explaining large historical phenomena such as the development of capitalism in relation to colonialism, changes in gender relations, and the emergence of new social classes and new practices of consumption. The history of sugar may well epitomize the articulation of new global networks as well as changing models of domesticity and everyday practices.[1]

Although human beings have always enjoyed the taste of sweet substances, sugar in the way we know it and use it today is an early modern discovery. Since sugar cane entered Western Europe from New Guinea in successive waves, early records document various uses of sugar.[2] It was thought to have medical benefits – the accounts of a Florentine apothecary in 1504 reveal that sugar was the main commodity purchased from the shop.[3] Sugar was also used as a preservative for food and a precious spice. In the fifteen and sixteenth centuries, royal courts commissioned highly elaborate sugar sculptures, both spectacular and edible, to display on their tables.[4]

From being a luxury, sugar progressively became a necessity by the mid-eighteenth century, when it spread as a sweetener and reached the growing working classes.[5] This development was sustained by the heyday of British and French exploitation of sugar plantations in their colonies, using slaves who worked under extreme conditions. Sugar became a 'murderous commodity', in the words of Vincent Brown.[6] The expansion of sugar as a sweetener triggered the creation of new wares specifically designed to contain it on the table – such as the soft-paste porcelain sugar bowl with cover (fig. 218) – or to shake crushed sugar over fruits and desserts – such as the largest silver caster in the set of three, the other two designed for mustard and pepper (fig. 219). AF

See: Brown 2008; Carney 2008; Day 2002; Day 2011; Hobhouse 1986; Jones and Spang 1999; Mintz 1985; Mintz 1999; Shaw and Welch 2011; Sussman 1994.

1. Mintz 1985; Sussman 1994; Brown 2008.
2. Mintz 1999, p. 87.
3. Shaw and Welch 2011, p. 191.
4. Day 2002 and Day 2011.
5. Mintz 1985. For a discussion on the changing notions of luxury and necessity, see Jones and Spang 1999.
6. Brown 2008, p. 117.

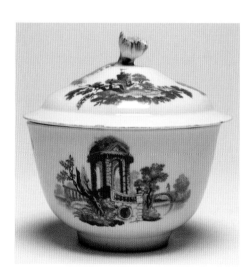
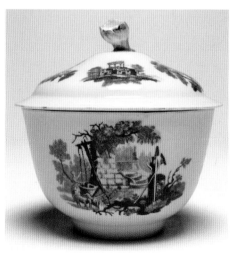
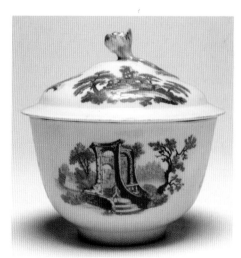

FIG. 218 | CAT. 198

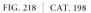

COVERED SUGAR BOWL

Worcester | *c.1765–70*

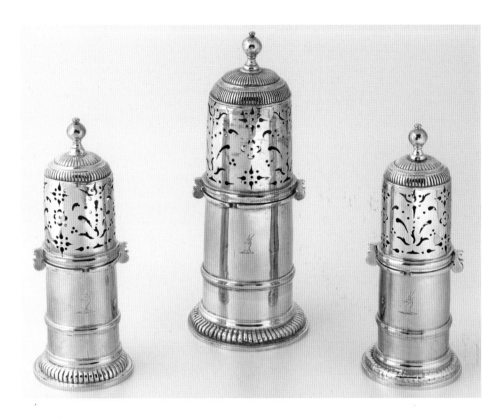

FIG. 219 | CAT. 193

SET OF THREE LIGHTHOUSE CASTERS FOR SUGAR, PEPPER AND MUSTARD

Chester | 1704/5

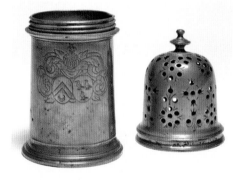

FIG. 220 | CAT. 194

SUGAR CASTER

Étienne Bacquet, Paris | 1696

This tapering cylindrical caster with a pierced screw top echoes the form of silver examples which were made from around 1680 in Paris, but are now very rare.[1] On its base it has the control mark for Paris 1696 and the maker's mark of Étienne Bacquet (master 1680; died 1713) incorporating the words 'ETIN FIN'.[2] This indicates that it was made of first quality pewter (*étain fin*), which was 90–95 per cent tin alloyed with lead, copper and antimony. The paired coats-of-arms engraved on the side denote that it belonged to a married couple. The sugar caster would have been used during the service of fruit for the dessert. The apertures in the cover are large because sugar was not so finely granulated as it is today. It had to be cut from a sugar cone and then be crushed and beaten. JEP

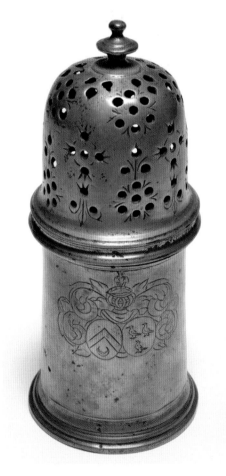

See: Bimbinet-Privat 2002; Boucaud and Schonn 2013.

1. Bimbinet-Privat 2002, pp. 172–4.
2. Boucaud and Schonn 2013, pp. 74, 95; see also p. 344 for two casters by Étienne Bacquet.

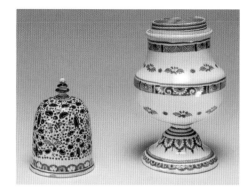

FIG. 221 | CAT. 195

SUGAR CASTER

Rouen | *c.*1720–40

If we are to speak about the ordinary and the everyday, we should not forget the inherent ephemerality of many objects. Everyday objects were manipulated, broken and discarded. Their cracks and flaws reveal how men and women interacted with different objects in their day-to-day life.[1] This sugar caster was made, broken and repaired with glue and staples, most likely in the nineteenth century. By that time, ceramics were central in the consumption of material goods. Along with their production and sale, their intrinsically breakable nature favoured the development of a ceramic-repairing trade.

This tin-glazed earthenware sugar caster was made in Rouen, one of France's main centres for the manufacture of pottery since the sixteenth century, its radiating decoration in blue and red being typical. Its baluster-shaped body imitates silver sugar casters, which at that time were being replaced by the increasing proliferation of ceramic ones. Sugar casters were a European invention, designed to enable the fashionable West Indian sweetening agent to be shaken over food at the dining table. To this end, the cover was pierced with holes and screw-threaded to permit it to remain tightly screwed to the body when shaking out sugar. This mechanism shows to what extent this sugar caster was made to be used and not only to be admired. Furthermore, this caster is likely to have been broken while being used; it was then repaired in a way that privileged function over display. Despite its rather unsightly appearance, it was evidently considered worthy of salvaging, restoring and keeping, and was eventually purchased by Dr Glaisher for his pre-eminent collection of ceramics. AF

See: *Faïences françaises* 1980; Gay-Mazuel 2011; McCants 2013; Mintz 1985; Pennell 2010; Richards 1999.

1. Pennell 2010.

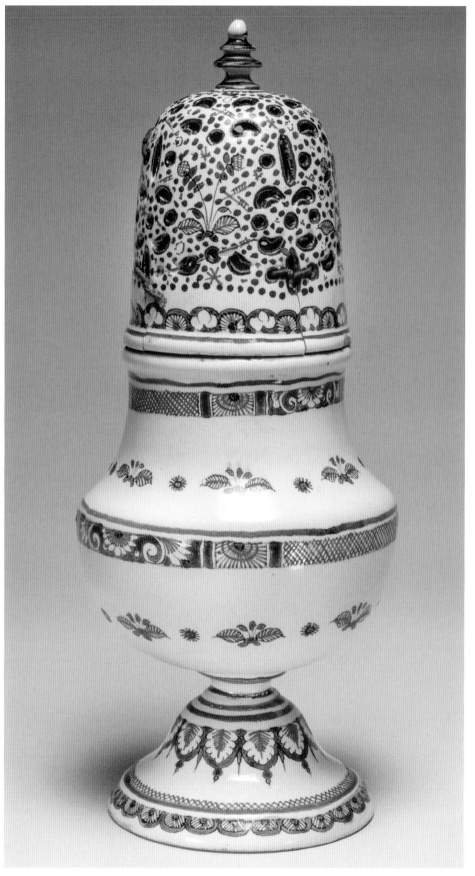

FIG. 222 | CAT. 196

COVERED SUGAR BASIN

Mennecy | *c.*1760

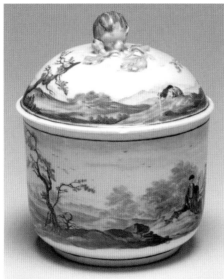
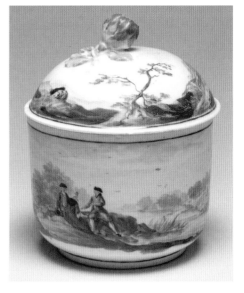
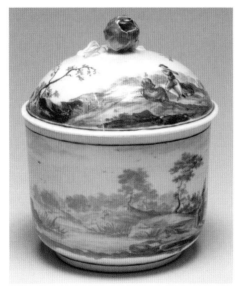
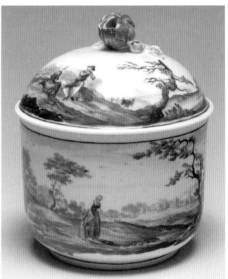

Covered sugar basins proliferated in the eighteenth century, accompanying the growing use of sugar as a sweetener for new hot beverages. This soft-porcelain example was made about 1760 in the Mennecy porcelain factory, which had been established *c.*1737 by the French nobleman Louis-François-Anne de Neufville, Duc de Villeroy (1695–1766) to produce wares in competition with Chantilly and Vincennes.[1] Although high quality and expensive, Mennecy wares were not as luxurious as their coloured-ground and gilded Sèvres counterparts and were consequently much cheaper. While much Mennecy porcelain was decorated with bouquets and sprays of flowers, this sugar basin has landscapes populated by 'polite' figures including, on the lid, a docile goat-herd playing a pipe to a seated female companion. It would have been part of a tea or coffee service for use in an aristocratic or wealthy bourgeois household, carried by servants into the bedchamber or boudoir (private sitting rooms) as part of the morning *toilette* ritual as depicted on the underlid of the tortoiseshell snuffbox (fig. 95) or into the salon or garden later on in the day.[2] The Mennecy factory produced other types of sugar containers, including covered sugar tureens with matching stands and pierced spoons (for sifting sugar) for use in elegant dining rooms during the dessert course. VJA

See: Chrisman-Campbell 2011; Dawson 1994; Duchon 1988; Findlen 2013; Finlay 1998; Fregnac 1964; Richards 1999.

1. Duchon 1988; Dawson 1994, pp. 51–2.
2. Fregnac 1964, pp. 140–1; Chrisman-Campbell 2011.

FIG. 223 | CAT. 199

COVERED SUGAR BOWL

Sèvres | 1769 and later

This soft-paste porcelain covered sugar bowl (*pot à sucre*) was made at Sèvres, the most distinguished and successful porcelain factory in mid-eighteenth-century France, at a time when a number of commercial porcelain factories were competing for the patronage of the king and a growing market of wealthy buyers. It belongs to the Calabre range of teaware (in production by autumn 1752), which offered the *sucrier* in two sizes. The first recorded sale of Calabre teaware was on 12 May 1753 to the *marchand mercier* Lazare Duvaux, whose most prominent client was Mme de Pompadour, mistress of Louis XV.[1] *Marchands merciers* like Duvaux furnished the homes of wealthy Parisians, providing them with a range of furniture and decorative objects, such as Oriental porcelain figures, fans and lacquer.[2]

The exotic birds painted on this sugar bowl recall contemporary naturalist illustrations resulting from the new scientific explorations: the fascination with the exotic is here merged with a taxonomic interest and 'commodified' in domestic teaware.[3] The basin bears the date letter Q and the painter's mark N, indicating that it was decorated in 1769 by François-Joseph Aloncle (1734–81), who had been at Sèvres since 1758. However, although scale grounds were used on teawares around this date, the gilded scale decoration of the green ground is not typical of Sèvres, and, given that the base is slightly blackened round the footing, it is certain that the sugar basin has been redecorated at least in part: either the birds are original but the scale decoration was added over an original green ground, or the sugar basin was sold 'in the white' (i.e. undecorated) and entirely decorated at a later date and given a counterfeit mark. The redecoration was most likely effected in the late nineteenth century when luxury objects from the period before the French Revolution were in high demand.[4] AF

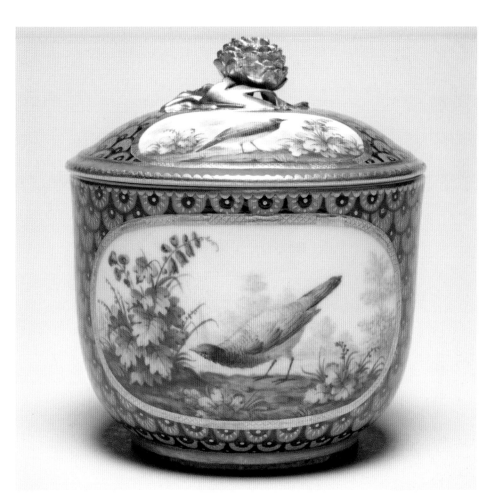

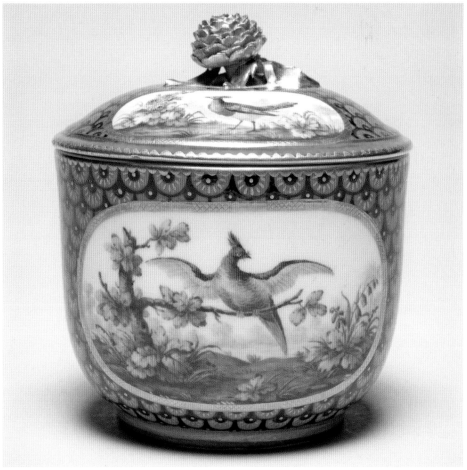

See: Brunet 1974, pp. 214–15, 217; Courajod 1873; Finlay 1998; Goodman 2009; Kisluk-Grosheide et al. 2013; Litchfield 1921; Préaud and d'Albis 1991; Richards 1999; Roth and Corbeiller 2000, pp. 187–9; Sargentson 1996; Savill 1988, vol. 3, pp. 995–6; Stammers 2014.

1. Préaud and d'Albis 1991, p. 122, no. 45. Duvaux left an account of the items purchased by his clients between 1748 and 1758 in the second volume of his journal, which was discovered and published in the nineteenth century. It has become an important source for the history of decorative arts in eighteenth-century France: see Courajod 1873, vol. 2.
2. Sargentson 1996; Goodman 2009, chapter 6.
3. Richards 1999, pp. 188–9.
4. On the market for eighteenth-century French decorative arts in the nineteenth century, see Kisluk-Grosheide et al. 2013. For an autobiographical account of an antiques dealer in this period, including a section on porcelain, see Litchfield 1921. Most recently, see also Stammers 2014.

DINING

In 1556, the Portuguese explorer Fernando Mendes Pinto described the surprise of those serving him at a Japanese banquet: 'For as all their people are accustomed to eat with two sticks, they think it very dirty to eat with the hands as we are wont to do.'[1] Mendes Pinto's comment shows that, even in the middle of the sixteenth century, the use of a fork was not customary for most Europeans. Nonetheless, the 'invention' of the fork, and other changes to dining practices in this period, have become benchmarks of what has been called the 'civilizing process', as Europeans made their way towards an identifiably more polite, and hygienic, modern age.[2] This elaboration of dining etiquette and service at the table were materialized in new forms of tableware.

The exquisite Renaissance maiolica plate (fig. 226) had once been owned by Isabella d'Este, Marchese of Mantua, probably a gift from her daughter, the Duchess of Urbino, in 1524.[3] The plate is typical of the brightly coloured maiolica wares, often decorated with stories from classical mythology and personalized with family arms, emblems and mottoes (as here), which were commissioned as part of large dinner services by early sixteenth-century Italian elites. Although only 22 complete pieces of this service survive, Lorenzo de' Medici kept a large set of maiolica dishes ('beautiful, from Montelupo') in his kitchen pantry, according to the inventory at his death in 1492.[4] While Isabella's and Lorenzo's silver was an 'old luxury' and would have been displayed on a sideboard or *credenza*, as seen in the print by Diana Scultori (fig. 225), maiolica was a 'new luxury' and, although used for serving and eating food, would have visibly reminded guests of their hosts' erudition, taste and wealth.[5]

From the 1730s, services in European porcelain were also produced for a growing market of wealthy buyers. Guests would have been served *à la française*, that is, two courses with a variety of dishes of soup, fish and roasted meats, served simultaneously, followed on special occasions by dessert. Special dishes were often required, such as the soft-paste porcelain soup plate from the Chelsea porcelain factory, decorated with flowers and insects in polychrome onglaze enamels (fig. 227). A great number of serving dishes and spoons were also needed at the table, like the unusual silver spoon for straining olives (fig. 238), or perhaps for other condiments in liquid to accompany the meat course. By the middle of the century, cookery books for a wider readership illustrated the setting of tables, to imitate those of aristocratic households, such as the illustration from Vincenzo Corrado's *The Gallant Cook* (Naples, 1773) (fig. 224).[6]

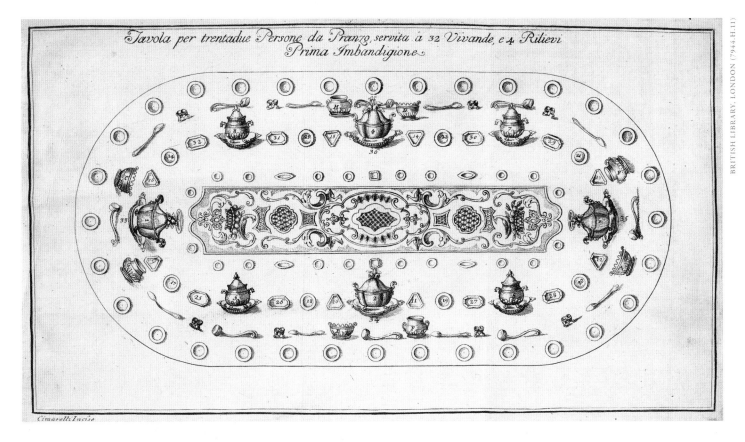

FIG. 224

'TABLE FOR LUNCH FOR 32 PEOPLE, WITH 32 DISHES AND 4 "REMOVES": FIRST-COURSE SETTING'

From Vincenzo Corrado's, *Il cuoco galante*
Naples | 1773

FIG. 225 ▶

PREPARATIONS FOR THE WEDDING BANQUET OF CUPID AND PSYCHE

Diana Scultori, engraving | 1575

Cheaper tableware such as the tin-glazed earthenware sweetmeat stand painted in blue (fig. 233) and the creamware centrepiece from Leeds (fig. 234) would have dominated any table, temptingly arranged with an assortment of sweetmeats to impress guests.[7] The first piece from the middle of the eighteenth century recalls the nautical themes of earlier tableware such as the Nautilus shell cup (fig. 10) and the bronze salt (fig. 213) from the sixteenth century. The hanging baskets and latticework of the second centrepiece from the end of the eighteenth century mimic more expensive silver centrepieces or *epergnes* (fig. 232). MTC

See: Ajmar-Wollheim and Dennis 2006; Boxer 1951; Clayton 1985; Corrado 1990; Coryate 1978; Day 2014; Elias 2000; Grieco 2006; Liefkes 2006; Poole 1997; Richards 1999; Stapleford 2013; Wilson 2012.

1. Cited in Boxer 1951, p. 29.
2. Elias 2000, pp. 107–9. For Thomas Coryate's remarks on the use of forks when eating meat in Italy in the early seventeenth century, see Coryate 1978, pp. 90–1; for forks in general: Clayton 1985. See also the introduction on cutlery by Suzanna Ivanič in the present volume and Wilson 2012.
3. Poole 1995a, p. 305.
4. Stapleford 2013, pp. 34 and 169.

5. This 1575 engraving on three plates, by Diana Scultori, one of the very few female printmakers of her time, is related to Giulio Romano's frescoes in Palazzo Te, Mantua, a favourite pleasure palace of Federico II Gonzaga, the son of Isabella d'Este. It shows the preparations for the wedding banquet of Cupid and Psyche (Fitzwilliam Museum, Cambridge: 37.1-82, 37.1-83, 37.1-84). On meals and tableware in the Italian Renaissance, see also Grieco 2006 and Liefkes 2006.
6. For a facsimile of the third edition of Corrado's recipe book (1786), see Corrado 1990. Eliza Smith's cookery book, first published in 1727, included table settings and menus and went through sixteen editions; see a facsimile of the 1758 edition: Smith 1994.
7. Richards 1999, pp. 156–63. For recreations of dessert tables from the Jacobean to the Georgian periods, see Ivan Day's Historic Food website (www.historicfood.com/galleries.htm), accessed 11 October 2014.

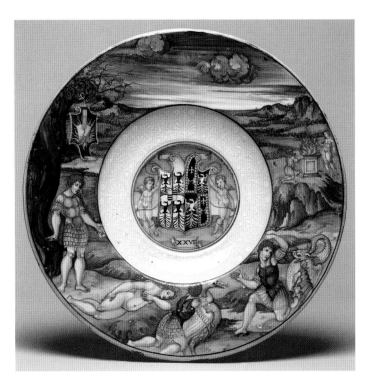

FIG. 226 | CAT. 211

DISH

From the Isabella d'Este service, painted by Nicola di Gabriele Sbraghe or Sbraga, Urbino
*c.*1524–5

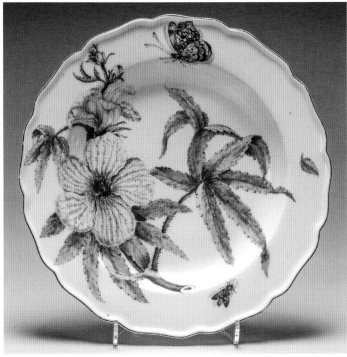

FIG. 227 | CAT. 213

SOUP PLATE

Chelsea | *c.*1755

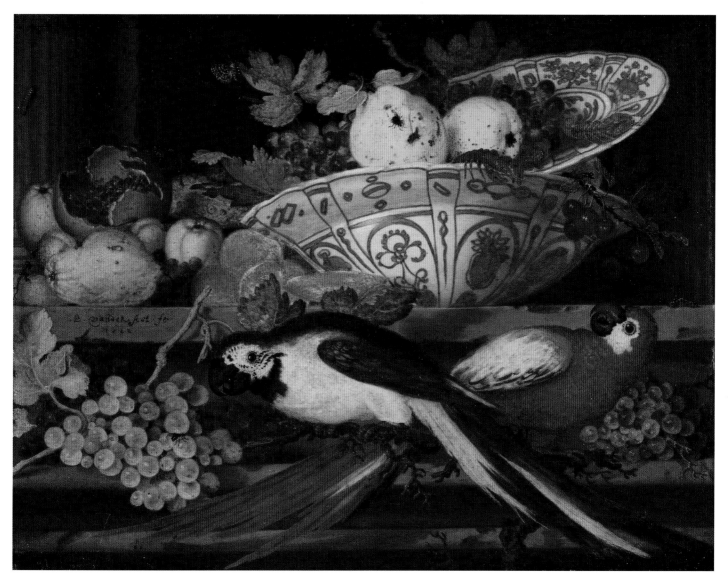

FIG. 228 | CAT. 202

STILL LIFE WITH FRUIT AND MACAWS

Balthasar van der Ast, Utrecht | 1622

Painted in Utrecht by the 28-year-old Balthasar van der Ast almost certainly for speculative sale, this colourful and brightly illuminated still life portrays an abundance of luxury items. Succulent ripe fruit (green, red and black grapes, cherries, pears, apricots and a pomegranate) and other expensive foodstuffs, including small crayfish, provide the backdrop for some truly exotic imports: a pair of macaws from the New World and a pair of late Ming blue and white *kraak* porcelain dishes from China.

Known by the Dutch as *klapmuts* on account of their shape (which resembled the seventeenth-century broad-brimmed hat typically worn by sailors), these shallow bowls with flattened rims appear to have been manufactured by the Chinese exclusively for European consumers in response to Western dining etiquette. The horizontal rim (a redundant feature in Chinese dining-ware) was used by well-educated diners as a cutlery rest as well as somewhere to put condiments and to dispose of rejected food elements, such as bones. Imported in vast quantities by the Dutch East India Company in the seventeenth century, *klapmuts* came in various sizes, and while some were used for dining, others were kept for display, and appear frequently as costly and fashionable luxuries in still-life paintings, as seen here.

Painted in oil on a small copper plate, this cabinet-style picture was clearly designed for close-up scrutiny, and intended to delight the eye and appeal to the senses. However, as with most Dutch still lifes, it also carried an implicit moralizing message warning against worldly vanity and recalling the brevity of life: the porcelain will break and the ripe fruit will rot. A similar *vanitas* theme is made more explicit in Pieter Claesz's muted, almost monochrome *Still life*, which was painted eight years later in Haarlem (fig. 2). Characteristic of *ontbijtjes*, a sub-genre of still-life painting that portrayed simple 'breakfast pieces' and often intended to be a reminder against gluttony, it shows an empty silver-gilt *tazza*, an overturned Berkemeyer glass, and a half-peeled lemon, symbolic of the bitter-sweet nature of life. VJA

See: Ketel 2011; Lloyd 2004; Rinaldi 1989; Slive 1995.

FIG. 229 | CAT. 212

BOXED SET OF TWELVE FRUIT TRENCHERS

English | *c.*1600

Thanks to limited use and careful storage in their original container, these 12 circular sycamore platters are in pristine condition and are rare survivals of Tudor domestic arts in wood. Probably originally owned by a wealthy Elizabethan household, this luxury boxed-set may well have been acquired as a marriage or New Year gift. Plain on one side, and painted on the other with fruit and flowers as well as biblical inscriptions and proverbs, these colourful roundels with additional gilding were designed as post-prandial entertainment at the end of special dinners, typically at New Year. Used plain side up to eat fruit as well as sugar plums, marzipan and other sweetmeats after dinner, guests would then flip them over to reveal the painted images and texts. Intended to amuse and stimulate witty conversation, the verses could then be recited or sung in turn, often to the accompaniment of a lute. Some trencher-sets had themes: one in the British Museum is based on friendship, another in the V&A has satirical verses from John Davies' *The Twelve Wonders of the World*, composed especially for trenchers at a New Year dinner *c.*1600, while a third set in the Fitzwilliam is decorated with applied hand-coloured engravings of sibyls.[1] VJA

See: Church 1894, pp. 47–54; Forsyth 2002; Jones 2010; Meads 2001; Morrall 2012, esp. pp. 130–1; Watson 1862.

1. British Museum: 1896,0807.8.a-l; V&A: w.30 to M-1912; and Fitzwilliam Museum: M.5.1-13 and A-1920.

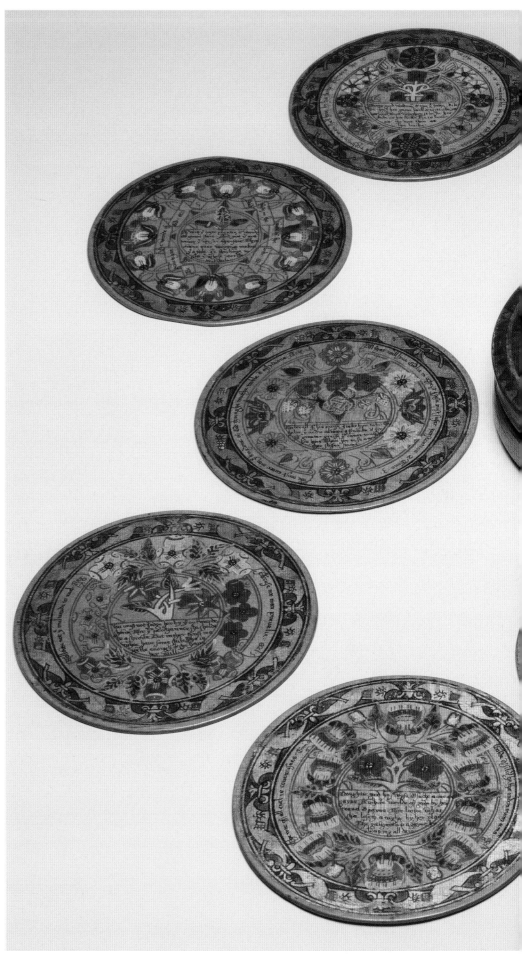

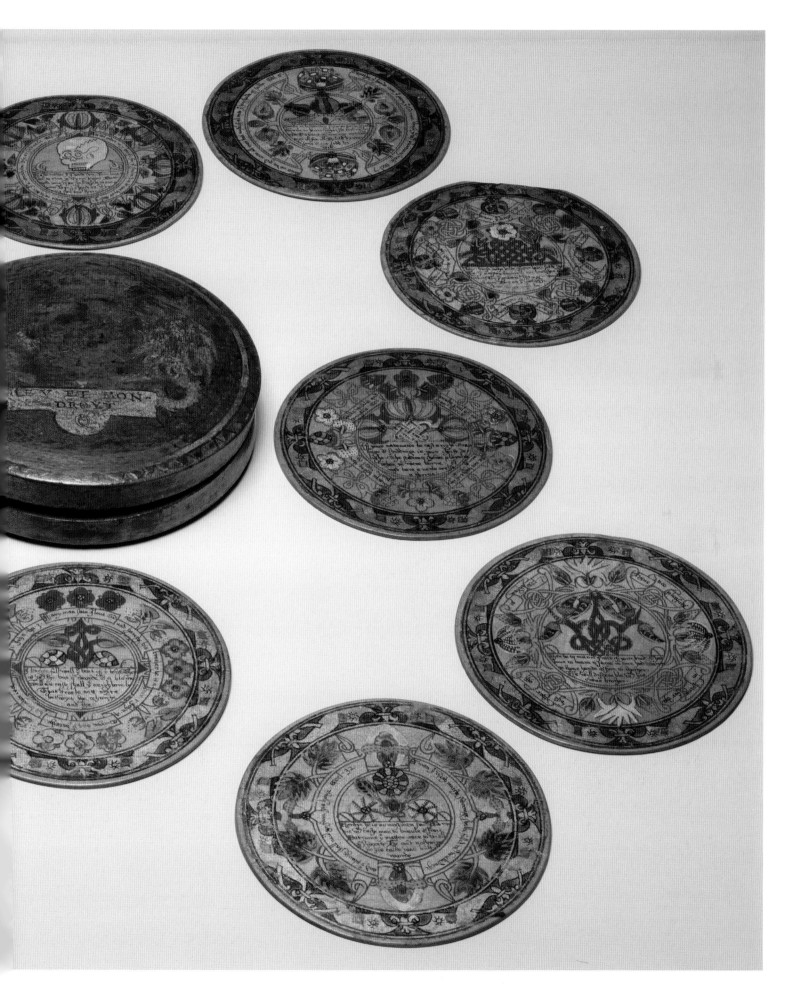

AT HOME AND ON DISPLAY **209**

FIG. 230 | CAT. 214

SOUP PLATE

Chelsea | c.1752–5

English dinner menus in the mid-eighteenth century indicate that soup was usually one of the dishes in the first course. This deep octagonal soft-paste porcelain plate probably resembles those described in lot 82 on the third day of the 1755 Chelsea sale as 'Ten fine octagon soup plates Hob in the well'. The design was copied either from a prized Japanese Kakiemon original, or possibly a version made at Meissen.[1] The scene represents an event in the childhood of a Chinese statesman known in Japan as Shiba Onko, who saved his playmate from drowning in a massive pottery jar by throwing stones at it until it broke. The English title reputedly derives from Hob, the hero of *The Country Wake*, a farce of 1696 by Thomas Doggett, adapted in 1711 by Colley Cibber as *Flora or Hob-in-the Well*, and performed several times later in the century. JEP

See: Ayers et al. 1990; Chelsea 1755.

1. Ayers et al. 1990, pp. 152, no. 122, and 198, no. 192.

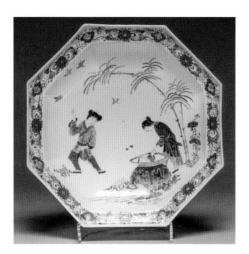

FIG. 231 | CAT. 215

DISH

Thomas Chamberlain, London | c.1750–60

In the third quarter of the eighteenth century, pewter was still widely used for dining despite the development of white salt-glazed stoneware and creamware. Plates and dishes were made of fine pewter, an alloy largely of tin and copper, and were sometimes engraved with the crest or coat-of-arms of affluent purchasers. This dish made by Thomas Chamberlain of King Street, Soho,[1] bears the unregistered arms of David Garrick (1717–79), the celebrated actor and manager of the Drury Lane Theatre.[2] It was probably made after Garrick's marriage in 1749 to Eva Maria Veigel, and is likely to have formed part of a service with 31 plates and dishes bearing Garrick's arms or crest, mostly by Chamberlain, which are now owned by the Shakespeare Birthplace Trust, Stratford-upon-Avon. JEP

See: Burke 1884; Cotterell 1929; Oman 1958.

1. Cotterell 1929, p. 178, no. 873, illustrated pl. LCIf.
2. Burke 1884, p. 389; Oman 1958, p. 385, note 9.

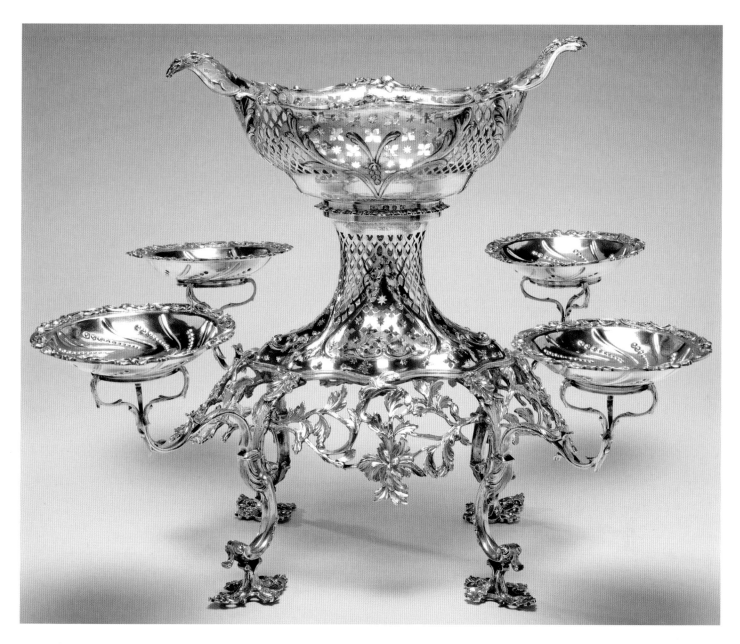

FIG. 232 | CAT. 217

EPERGNE

Emmick Romer, London | 1759/60

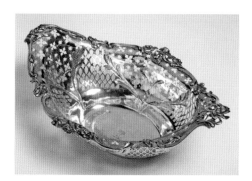

By the mid-eighteenth century, elaborately decorated silver centrepieces, or *epergnes*, had become *de rigueur* on the grandest English dining-tables during dessert – the third and final course of dinner if served *à la française* – and were often given as wedding gifts. Made in London in 1759/60, and engraved with the owner's coat-of-arms,[1] this fashionable Rococo *epergne* is a typical example with its large detachable central basket and smaller removable dishes supported on radiating branches.

Once the table had been cleared of the second course dishes and the cloth removed, the *epergne* dressed with assorted fresh or candied fruits would be brought in and placed centre-stage, surrounded by other elegant tablewares in silver, porcelain or glass, and figures in either porcelain or sugar-paste. In very grand settings, these items might even be placed on mirrored glass plateaux, which would reflect not only the splendid table ornaments, but also the candlelight and ceiling decorations. VJA

See: Fearn 2002; Glanville and Young 2002; Grimwade 1976, esp. p. 56, no. 638, p. 646; Winterbottom 2011b, esp. p. 41.

1. Greyhound courant in front of an oak tree: the crest of several families, including Daly, Kennedy, Molloy or O'Mulloy.

FIG. 233 │ CAT. 216

SWEETMEAT STAND

Possibly German │ *c*.1750–60

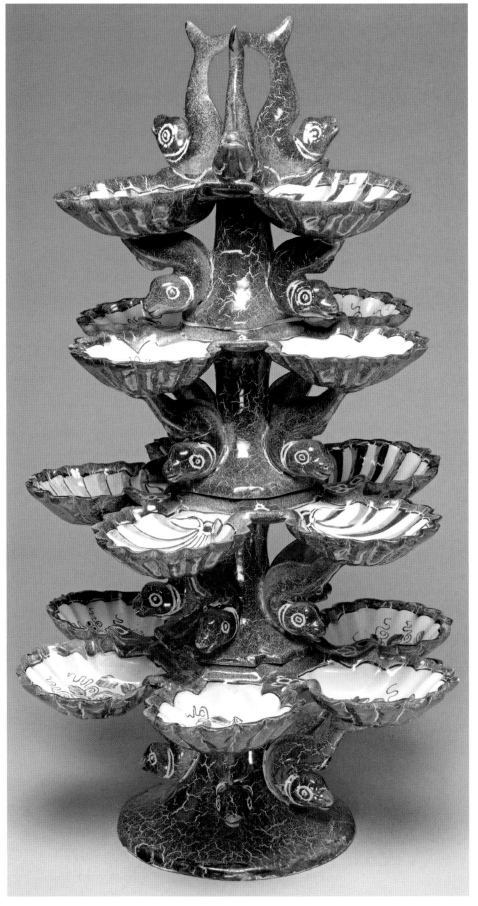

FIG. 234 | CAT. 218

CENTREPIECE or
GRAND PLATT MENAGE

Probably Leeds Pottery, Leeds | *c.*1780–1800

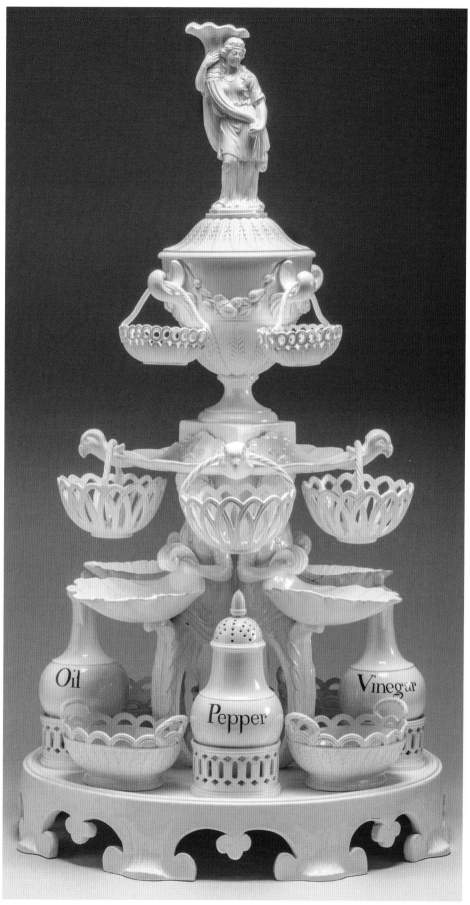

CUTLERY

The increasing use of the fork from the early modern period onwards pointed to a new concern for manners and cleanliness. This has been seen as a crucial piece of evidence for the 'civilizing process' of society. For sociologist Norbert Elias, the fork was an 'embodiment of a specific standard of emotions'.[1] Indeed, Thomas Coryate in his famous travelogue, *Coryat's Crudities hastily gobled up in five moneths travells* [...] *newly digested in the hungry aire of Odcombe* [...] *and now dispersed to the nourishment of the travelling members of this kingdome* (1611), wrote at length about the use of cutlery. He observed that in Italy men 'do always at their meals use a little fork when they cut their meat'.[2] The reason for this was that an Italian 'cannot endure to have his dish touched with fingers, seeing all men's fingers are not alike clean'.[3] Coryate was so impressed by this practice that he adopted it when he returned home to Somerset, telling his readers about 'my fork'.[4]

Whilst large cutlery sets proliferated within the home, the itinerant life of many necessitated individual items of cutlery to be carried about the person and used solely by their owner (fig. 237). Thus, a person's fork, knife, or spoon became an object through which gentility and wealth could be displayed (fig. 235). Coryate explained that forks were often made of iron or steel, but, if owned by a 'Gentleman', of silver (fig. 236).[5]

The desire to proclaim one's identity drove a diverse market for ingeniously designed and elaborately patterned cutlery such as the objects included in this volume. Whilst it can be argued that the increasing use of the fork symbolized 'progress' in society, these objects bring us back to the reality of everyday life in the early modern period: the importance of displaying wealth and status at every opportunity, but also a joy in dining and in owning treasured objects. SI

See: Coryate 1978; Elias 2000.

1. Elias 2000, p. 107.
2. Coryate 1978, p. 90.
3. Ibid., p. 91.
4. Ibid., p. 91.
5. Ibid., p. 90.

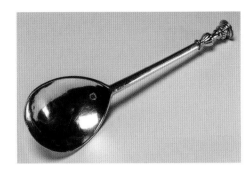

FIG. 235 | CAT. 203

SEAL TOP SPOON

London | 1572/3

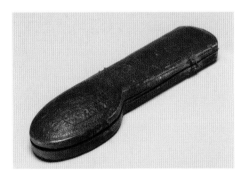

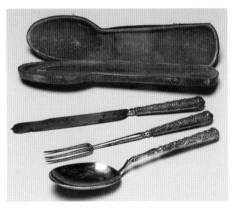

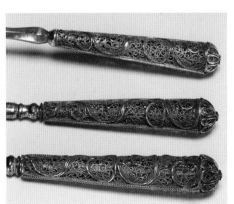

FIG. 236 | CAT. 208

CASED CUTLERY SET

Augsburg | late 17th century

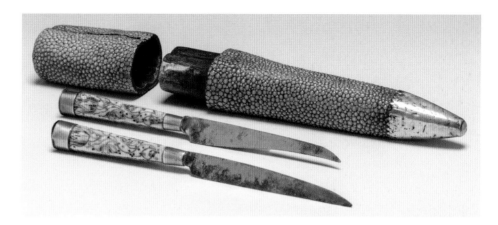

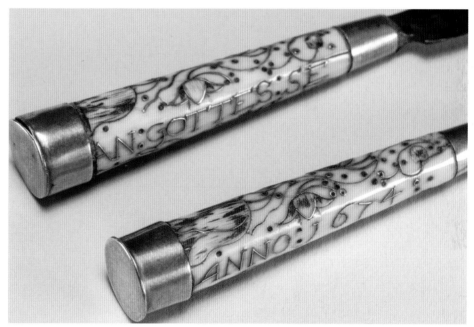

FIG. 237 | CAT. 54

TRAVELLING KNIFE SET

Probably German | *c.*1674

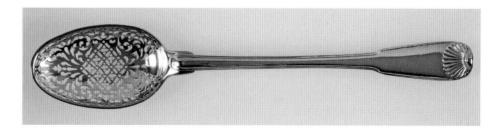

FIG. 238 | CAT. 210

STRAINING SPOON FOR OLIVES

Claude Jouguet, Paris | 1738/9

FIG. 239 | CAT. 205

SPOON

German | 17th century

This ivory spoon looks too beautiful to be used, yet it is perfectly designed for eating with. It has been weighted precisely so that it balances easily in the hand, and the back has been carved flat so the spoon rests upright when set down on the table. The handle's finial is carved in the shape of a young woman in seventeenth-century German dress with a distaff and spindle, traditional female attributes signifying virtuous womanly work. The theme derives from the Book of Proverbs, chapter 31, which describes how an ideal and 'noble' Christian woman should behave in the home, serve her family and work diligently, and, in particular, verse 19, which reads: 'She layeth her hands to the spindle, and her hands hold the distaff.' It was not unusual for household items to be themed around such biblical references.[1] This item, engraved with an unidentified coat-of-arms and crest, may have formed part of a set of spoons intended to exhibit the godly values of the owner/s. SI

See: Morrall 2012.

1. Morrall 2012.

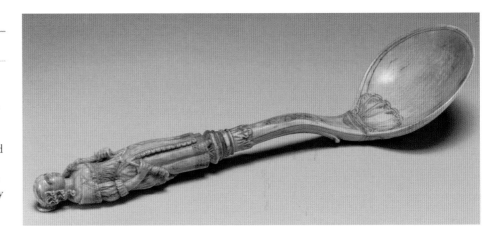

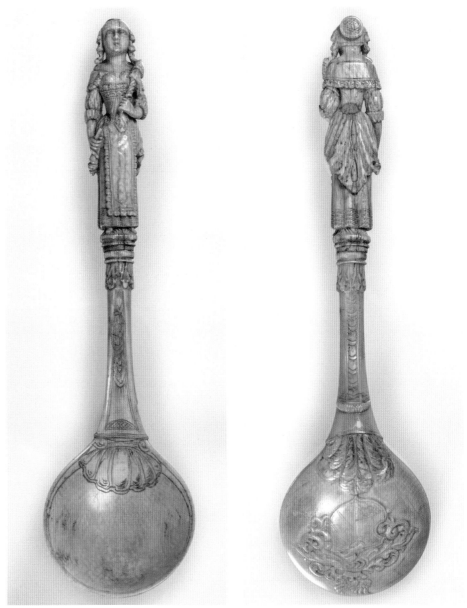

FIG. 240 | CAT. 207

FOLDING SPOON

German | late 17th century

This German folding spoon shows how at meal-times a small part of 'home' could be taken out of one's pocket even when dining elsewhere. Comprising two hinged oval bowls that could be flipped open, the spoon's sturdy yet compact design meant it could be slipped into a pocket or bag without fear of breakage. Made from humble fruitwood rather than a more 'noble' material, it is robustly carved with great character.

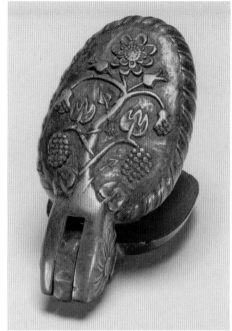

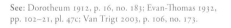

The back of the handle is decorated with beautiful stylized tulips, vine leaves and grapes within a 'gadrooned' border; its interior is enlivened with a woman on horseback, her flowing hair mirroring the horse's swishing tail. The curtains draped in the background and the rider's gesture suggest a theatrical scene. When lifting the spoon for eating, the owner would have come face to face with the woman. This spoon encapsulates the enjoyment of mealtimes and provides a rare glimpse of early modern humour. SI

See: Dorotheum 1912, p. 16, no. 183; Evan-Thomas 1932, pp. 102–21, pl. 47c; Van Trigt 2003, p. 106, no. 173.

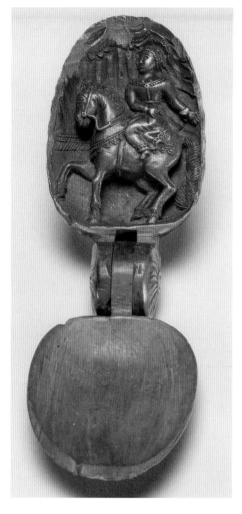

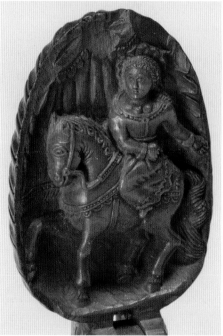

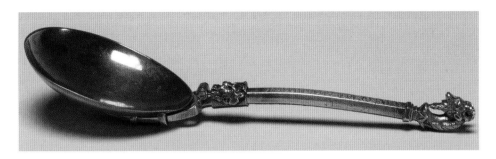

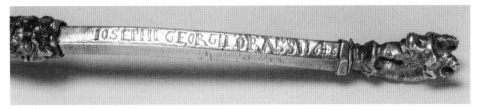

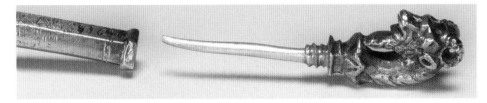

FIG. 241 | CAT. 204

COMBINED SPOON AND FORK

Probably Hans Jacob Holzalb, Zurich
mid-17th century

An indicator of wealth and gentility, this curious multi-purpose piece of folding cutlery was likely made in Zurich by the silversmith Hans Jacob Holzalb, recorded as active between 1634 and 1657. The inscription 'IOSEPHI GEORGU ORASSI 1646' on the silver handle identifies one of its owners and the shield engraved on the back identifies another. The novelty and multi-functionality of this combined spoon and fork undoubtedly contributed to its preservation despite being rather scratched and worn through use.

The ingenious lion's-head cuff allowed the owner to switch between spoon and fork, and the finial in the form of a goat's head unscrews to reveal a toothpick. Its small size made it easily portable, with the looping of the goat's horns perhaps allowing it to be hung on a chain. SI

See: Krauss et al. 1994.

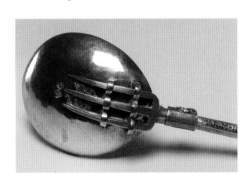

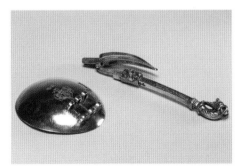

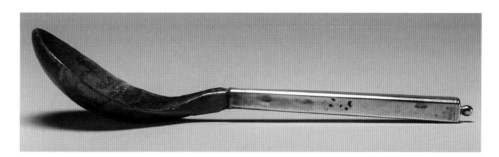

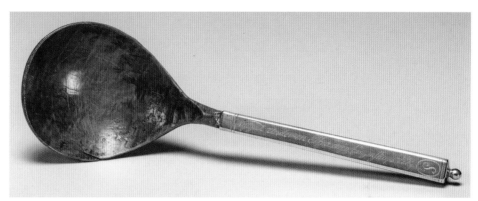

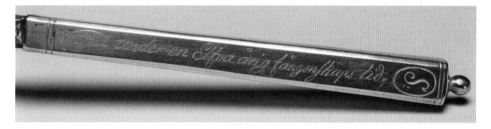

FIG. 242 | CAT. 206

SPOON

Scandinavian
second half 17th / first half 18th century

The deeply personal nature of spoons in early modern Europe is well known: godparents gave apostle spoons to godchildren at christenings; brides and grooms exchanged spoons at weddings; and grieving parents commissioned funeral spoons to commemorate recently deceased children.[1] This Scandinavian spoon, comprising a fruit-wood bowl glued onto a slightly later silver handle, commemorates something quite different. The Swedish inscription '*Nyttjad under en Elfra årig fångenskaps tid*' engraved along the handle reveals that it was 'used during an 11-year imprisonment'.[2]

The handle is also initialled 'S', presumably referring to the owner, perhaps a literate man or at least one who valued words. The inscription shows a certain pride in his internment and/or survival of it, as well as the value he accorded the wooden spoon that had kept him company during his long incarceration. Nothing further is known about the owner, but this spoon indicates surprising insights into an early modern individual's attitude towards imprisonment and his attachment to things. SI

See: Winterbottom 2011a.

1. Winterbottom 2011a, pp. 20–1.
2. Thanks to Mette Eilstrup-Sangiovanni for this translation.

EMBROIDERY AND TEXTILES

In *The Praise of the Needle* published in 1631, John Taylor celebrated the needle as 'an Instrument / Of profit, pleasure and of ornament / Which mighty Queens have grac'd in hand to take'.[1] But though both male and female professionals created needlework for financial 'profit', embroidery for 'pleasure' was associated with women. Taylor's poem prefaced a popular pattern book, *The Needles Excellency*, which encouraged women to emulate 'mighty Queens' in their own domestic space.

Although embroideries and other textile works required significant investments of time and money, materials such as silk threads, spangles and glass beads became increasingly affordable. By the seventeenth century, even non-elite women in rural areas were able to buy an impressive range of goods from haberdashers or petty chapmen.

Needlework, whether for ornament or for repairing clothing, became so connected with domestic femininity that by the mid-eighteenth century sewing rolls filled with thread, thimbles, needles, pins and scissors were termed 'Hussifs' or 'Housewifes'. This late eighteenth-century example (fig. 243) has been embroidered in Rococo stitches of brightly coloured silk. Decorated with stylized anchors and a ship, it may have been gifted to a sailor to encourage him to remember his love back on shore as he repaired his uniform aboard ship.

Needlework schools taught women a diverse range of stitches and offered access to a large number of patterns. At home, pattern books like *The Needles Excellency* gave women design inspiration. As Taylor advertised, patterns were 'farre fecht' – sourced from across the world – 'From scorching Spaine […] to the Indies West', and this diversity was deemed educative, 'good for Ladies thought'.[2]

The late eighteenth-century map sampler (fig. 244) demonstrates the high level of technical skill and geographical knowledge that a young amateur could acquire. Though the anonymous maker carefully embroidered men traversing the European continent, women could discover – and leave their mark on – the expanding world through their needle. SP

See: Humphrey 1997; Morrall and Watt 2008; Spufford 1984; Taylor 1631.

1. Taylor 1631, n.p.
2. Ibid.

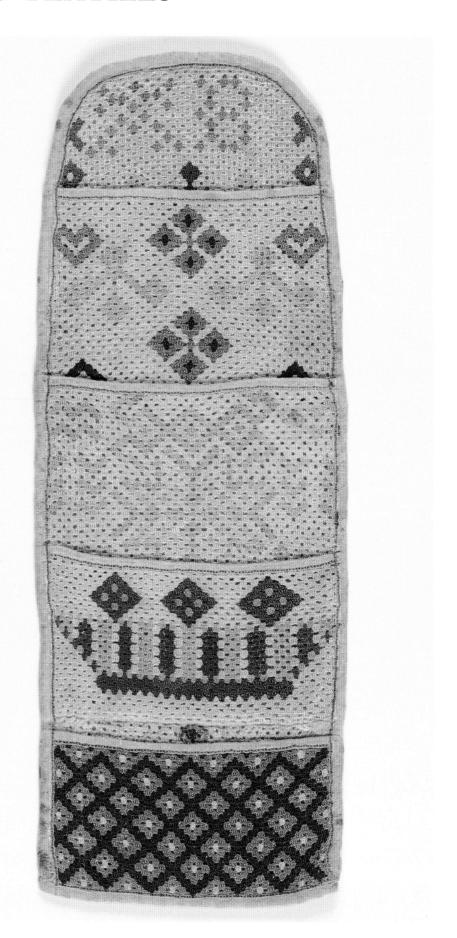

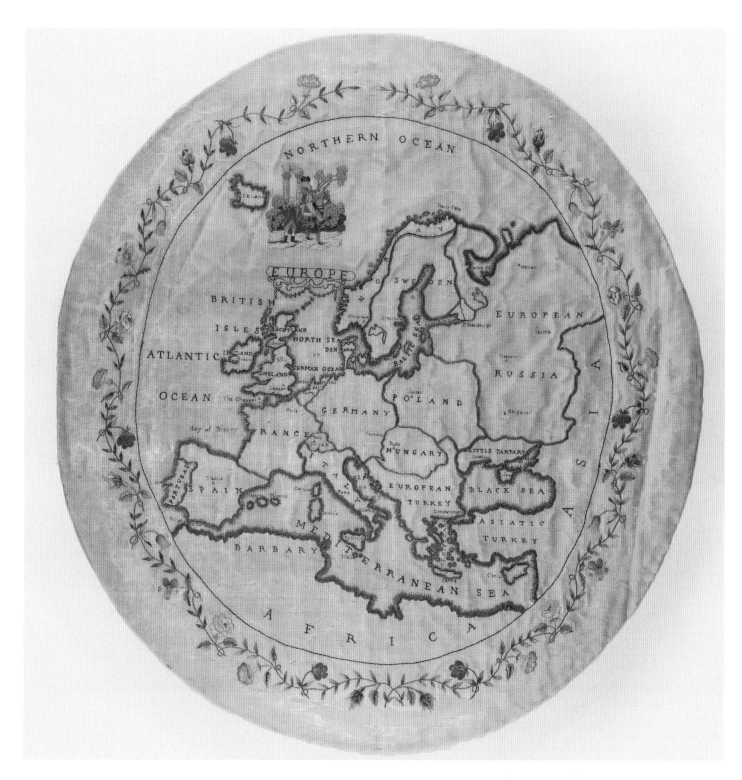

FIG. 244 │ CAT. 222

OVAL MAP SAMPLER

English │ *c.*1780–90

SEWING ROLL ('HUSSIF')

English │ late 18th century

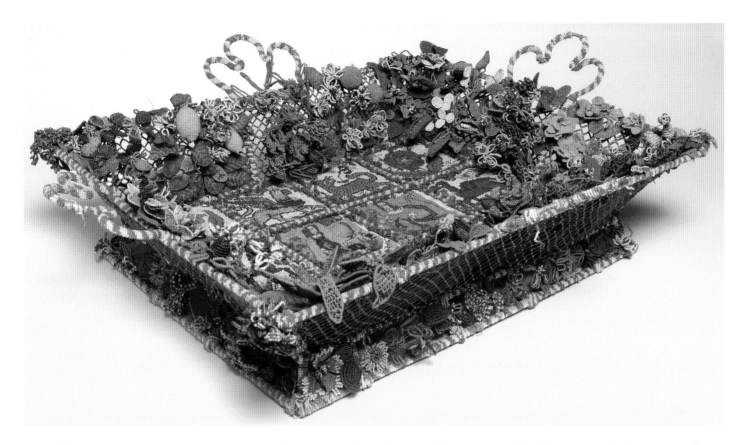

FIG. 245 | CAT. 226

BEADWORK BASKET

English | **late 17th century**

Replete with exotic flora and fauna and a fashionable couple centre-stage, this spectacular beadwork basket may have been produced in a professional workshop and acquired as a christening or betrothal gift. Alternatively, it could have been made as a demonstration of needlework skills by an educated girl from an affluent family able to afford the glass beads imported from Venice or Amsterdam as well as the wire frame, likely purchased ready-made from a specialized retailer.

Beadwork was popular in seventeenth-century England and used to enliven all manner of small-scale objects for the home, including baskets, caskets, mirror-frames, cushion-covers and pictures.

Unlike light-sensitive polychrome silks and wools, beads had the advantage of retaining their vibrant colour, as the words worked onto a beadwork panel dated 1657 proclaim: 'natvrs flowers soon doe fade fvl long we last cavse art vs made'.[1]

Whatever its intended purpose – layette for a newborn baby's clothes and linen, basket for the gloves or herbs traditionally distributed to guests at weddings, or decorative centrepiece for a domestic setting – this beadwork basket was clearly a treasured possession, likely passed down the female line for several generations as a cherished heirloom. VJA

See: Morrall and Watt 2008; Vickery 2009, pp. 231–56.

1. V&A: T.39-1928.

FIG. 246 | CAT. 221

SAMPLER

Ann Smith, Scottish or English | 1766–7

One day in 1766, Ann Smith took up some woollen cloth, her needle and coloured silks and started to embroider this pictorial sampler, using five different stitches.[1] Within a stylized floral border enlivened by mirror-image parrots and rampant lions, she stitched more flowers and animals, two moralizing religious verses loosely based on Psalm 119 and Romans 5:19, and *The Temptation of Adam and Eve* within five wide horizontal bands. Having recorded the year in which she started the sampler, Ann also recorded the date she completed it, making it unusually autobiographical.[2] Possibly from Scotland or the borders, we know nothing of Ann apart from the fact that she completed a second sampler some five and a half years later.[3] She may have been from an affluent family and made her samplers for display and as proof of her good upbringing, needlework skills and domesticity. Alternatively, she may have attended a charity school, and made them as fundraisers and as proof of her employability as a maid.[4] Whatever their original purpose, Ann's samplers, like so many others, ended up being collected from the nineteenth century onwards, more often than not by women, who clearly felt a particular affinity with these affordable domestic 'female' works of art.[5] VJA

See: Humphrey 1984, esp. p. 28, no. 65; Humphrey 1997; Humphrey 2008; Morrall and Watt 2008; Scrase et al. 2005, pp. 156–7; Tarrant 1978.

1. 'A.S. Began This 1766.' Cross, Montenegrin cross, tent, eyelet and stem stitch.
2. 'Ann Smith Finished This Work March 4 1767.'
3. Fitzwilliam Museum: T.1-2008. With a longer religious verse and the numerals 1–19, it records, 'Ann Smith Finished This Work October 30th In The Year 1772.' For the stylistic elements in both samplers that could indicate Ann's Scottish origins, see Tarrant 1978.
4. For further discussion of charity school samplers, see: http://www.fitzmuseum.cam.ac.uk/gallery/samplers/.
5. Dr J.W.L. Glaisher is the exception that proves the rule: he bequeathed his exceptional collection of English seventeenth-century samplers to the Fitzwilliam Museum in 1928, and it was he who encouraged his friend, Mrs Longman (a daughter of Sir Arthur Evans, the famous archaeologist), to follow suit. She bequeathed her important collection of English and Continental samplers to the Museum in 1938, including the present example.

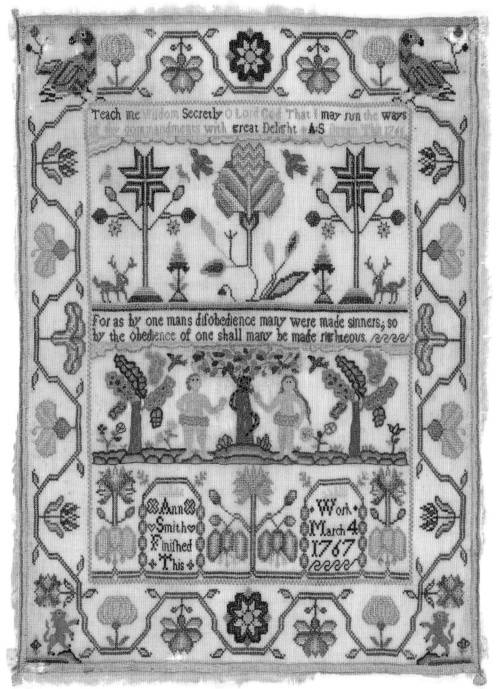

FIG. 247 | CAT. 227

UNFINISHED SILK PICTORIAL EMBROIDERY

English | early 18th century

This unfinished pictorial embroidery clearly shows the original underdrawing and retains the binding tapes used for mounting it in a work-frame. The skilfully drawn landscape is decorated with a combination of naturalistic, exotic and purely fanciful images reflecting the chinoiserie style, which had become increasingly popular on English embroidery from the 1770s. Despite the drawing giving little indication of shading or details, the worked embroidery is rich in both, yet this luxurious effect has been achieved by a very limited range of stitches, long and short stitch predominating. Texture and definition have been given to the flora and fauna by the use of a vibrant palette of coloured silks stitched with finesse and precision, exemplified by the depiction of the disproportionately large snail.

Towards the end of the seventeenth-century, embroidery became increasingly employed to enhance utilitarian objects such as sets of bed-hangings and covers for upholstered seating furniture, mainly stitched with woollen threads using robust stitches associated with crewel and canvas work. However, as in this unfinished example, traditional pictorial embroidery continued, often reflecting contemporary fashions and using expensive imported materials. CH

See: Morrall and Watt 2008.

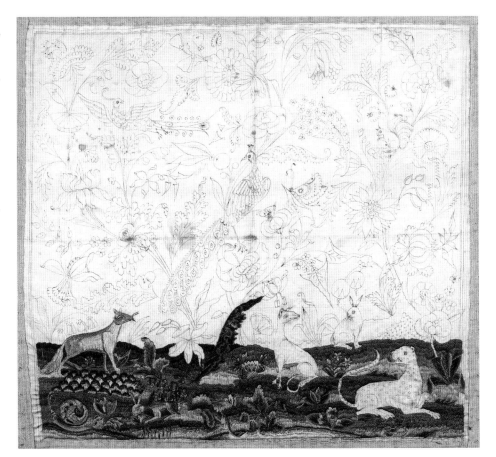

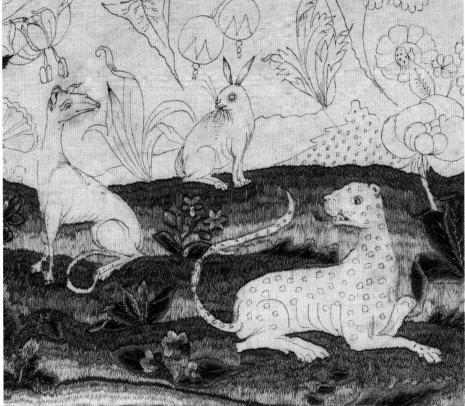

HALF-MADE PURSE ON MOULD
and PURSE

English | late 18th century

A project abandoned by its unknown maker, this semi-complete object (fig. 248) demonstrates the method by which many purses were made before crochet became widespread in early nineteenth-century Europe. Still attached, the likely earlier ebony thimble mould is the foundation upon which this purse was worked in buttonhole stitch (often termed *en feston*). Two rows of holes at the top still hold the securing threads. When completed, these rows would be cut and a draw-string attached to make a dainty functional carry-case (fig. 249). These purses, known as 'reticules', 'ridicules' or 'indispensibles', were fashionable from the later eighteenth century onwards and were carried by ladies who had no space for pockets in their stylish high-waisted Empire gowns. One 1808 periodical noted:

'No lady of fashion now appears in public without a ridicule – which contains her handkerchief, fan, card-money, and essence-bottle. They are at this season usually composed of rich figured sarsnet, plain satin or silver tissue, with correspondent strings and tassels – their colours appropriated to the robes with which they are worn.'[1]

Though fashions shifted from the Renaissance to the Enlightenment, purses remained popular accessories throughout the period (figs 70 and 136). These examples demonstrate how women could personalize their outfits while keeping their precious belongings to hand. SP

See: Arthur 1995; Cumming et al. 2010; Groves 1966; *La Belle Assemblée* 1808; Lester and Oerke 2004; Wilcox 1999.

1. *La Belle Assemblée* 1808, p. 46.

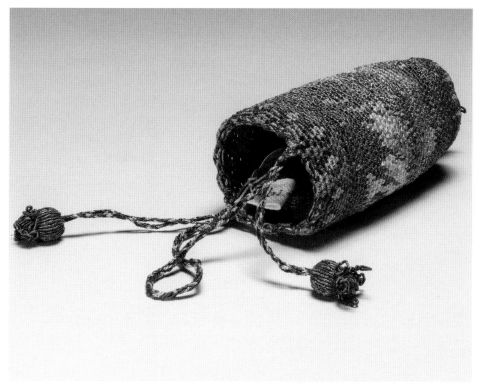

COMMEMORATING THE LIFE CYCLE

'I will that all my moveable goodes, Chattells, and debtes to me owinge within such convenient time as myne executrice maye, be devided into three equall partes and porcions.'[1]

Of all the stages of the life cycle commemorated by objects in this volume there is no doubt that death played the greatest role. Every single object discussed here was once owned by someone now deceased; in many cases, they were passed on to family members by the owner's will and testament. By the transition of a 'moveable good' after death to a relative, friend or servant, an object took on a new role as a material of memory.[2]

Acts of material commemoration were sometimes more consciously enacted, as in the mourning rings that incorporated the hair of the deceased (figs 261–262 and 264–268). The desire to retain something of a loved one's body is powerful, and lay behind the eighteenth-century impulse to create death masks, described by Marcia Pointon as 'extreme portraits'. A plaster cast of the face of 'the philanthropic Mr Howard', who died in Russia in 1790, was sent all the way back to London to be placed in the hands of his executor, Samuel Whitbread (fig. 252).

Families and individuals were of course equally keen to commemorate marriages and births. The eighteenth-century cult of sensibility is reflected in the proliferation of objects that record affective relationships: wedding rings, marriage plates, christening spoons, an infant's cap embroidered with 'sweet babe' (fig. 251), or a fan, illustrating a loving couple, presented as a gift from husband to wife (fig. 250). But it would be a mistake to understand the giving of such gifts solely in terms of celebration. Like the 'chattells' listed in a will, christening and marriage gifts also recorded and embodied the movements of property that marked the life cycle. MRL

See: Davis 2000; Jones and Stallybrass 2000; Pointon 2014.

1. Will of John God, 1577, National Archives, Kew, Prob. 11/60.
2. Davis 2000, pp. 48–51.

FIG. 250 | CAT. 234

MARRIAGE FAN

European | *c.*1760

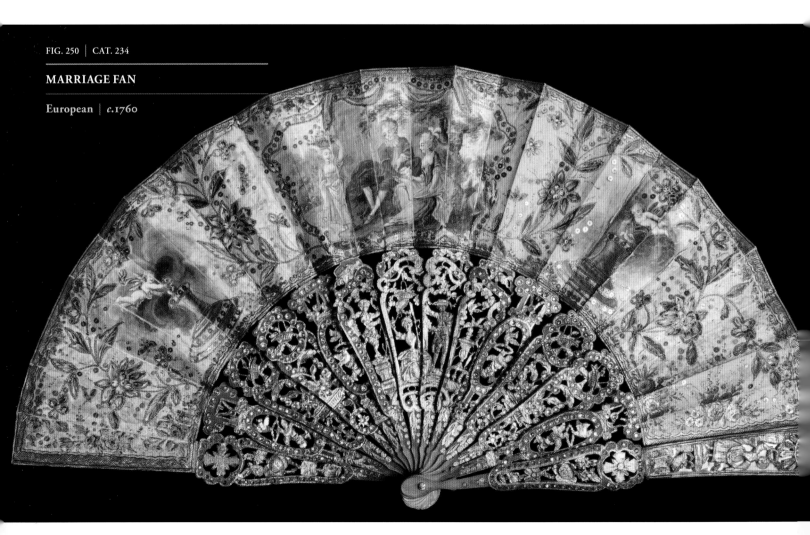

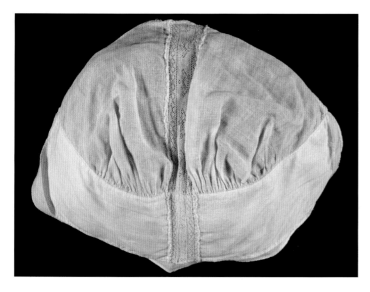

FIG. 251 | CAT. 229

INFANT'S CAP

English | 18th century

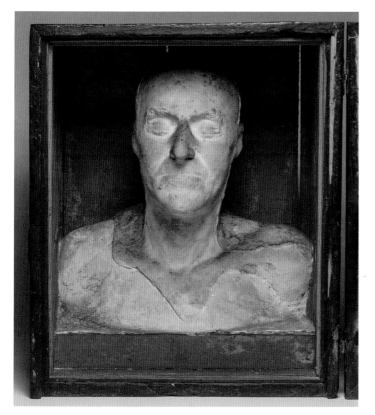

FIG. 252 | CAT. 247

BUST INCORPORATING DEATH MASK
OF JOHN HOWARD (1726–90)

Russian | 1790

MODEL CRADLES FOR JOHN WALKER AND MARY OVERTON

Staffordshire | 1708 and 1729

It is generally assumed that these slipware cradles were given as gifts, either on the occasion of a marriage in the hope of future children, or at christenings to celebrate a successful birth. Both examples exhibited here are christening gifts, most likely from slipware-producing Stafford-shire. The John Walker crib displays his name and the year '1708', as well as the initials 'HS' and 'EC', a possible reference to his parents. The relatively elaborate slip-trailed decoration under lead-glaze includes stylized flowers and a crowned figure, presumably Queen Anne.[1] In comparison, Mary Overton's crib bears a simple, dotted pattern with text.

Staffordshire christening records suggest possible matches with a John Walker, christened in Walsall on 24 February 1708, and a Mary Overton christened in Weeford on 11 June 1729. These two cribs are representative of the early eighteenth-century examples from the extensive collection of 35 cribs in the Fitzwilliam Museum. Though many cribs survive and give an invaluable insight into the material culture of poor to middling members of society, there is no documentation relating to their use and meaning. Their careful preservation, however, indicates that they were treasured, and the curved rockers on which they stand show that they were meant to be played with, handled and enjoyed – not just displayed. SI

See: Barker and Crompton 2007; Christie's 2011; Grigsby 1993.

1. Compare the crowned figure on the early eighteenth-century Staffordshire cradles of William and Martha Smith (Fitzwilliam Museum, c.251-1928) and on that of John Meir (Christie's Sale 2515, Lot 6, 24 January 2011).

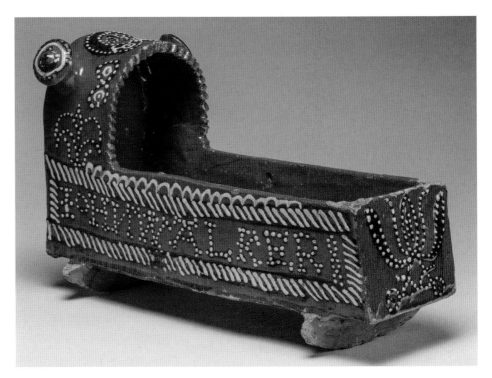

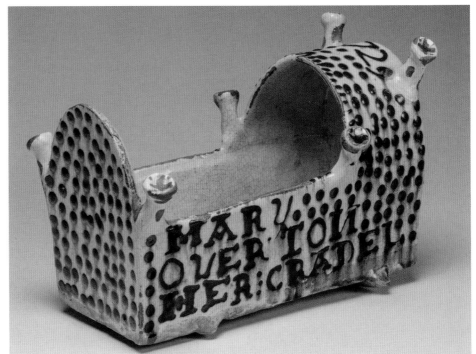

FIG. 255 | CAT. 232

MONEY-BOX

George Adlam, Brislington, Somerset | 1717

This tin-glazed earthenware dog-shaped money-box has been brightly decorated with blue and yellow/red spots and a yellow collar. It has a large slit on its shoulder to take coins, which could only be extracted by shaking it till the coins fell out, or breaking it – which is probably why only one other like it is known.[1] The money-box was made for Ann Wittin, whose name is written in capitals on the dog's collar and again on the underside of the base: 'Ann Wittin / was born ye 14 of / october 1717 J(?)W.' She may have been the Ann Whitten christened at Temple Church, Bristol, on 31 October 1717. Likely a christening gift from 'JW' (almost certainly a parent, godparent or other relative), the money-box was probably made at nearby Brislington by a potter called George Adlam, whose name appears on the only other known example.[2] The loss of glaze on the dog's nose and the fact that its tail has been snapped off might perhaps have resulted from careless handling by Ann and/or subsequent owners, perhaps overly keen to extract a coin. JEP VJA

See: Archer 2013, p. 346 no. 1.1; Grigsby 2000; Jackson et al. 1982.

1. Grigsby 2000, p. 387, D.350.
2. Jackson et al. 1982, p. 51.

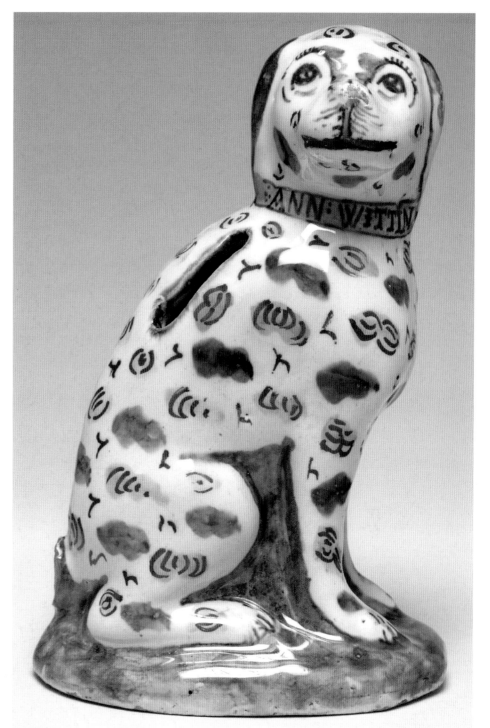

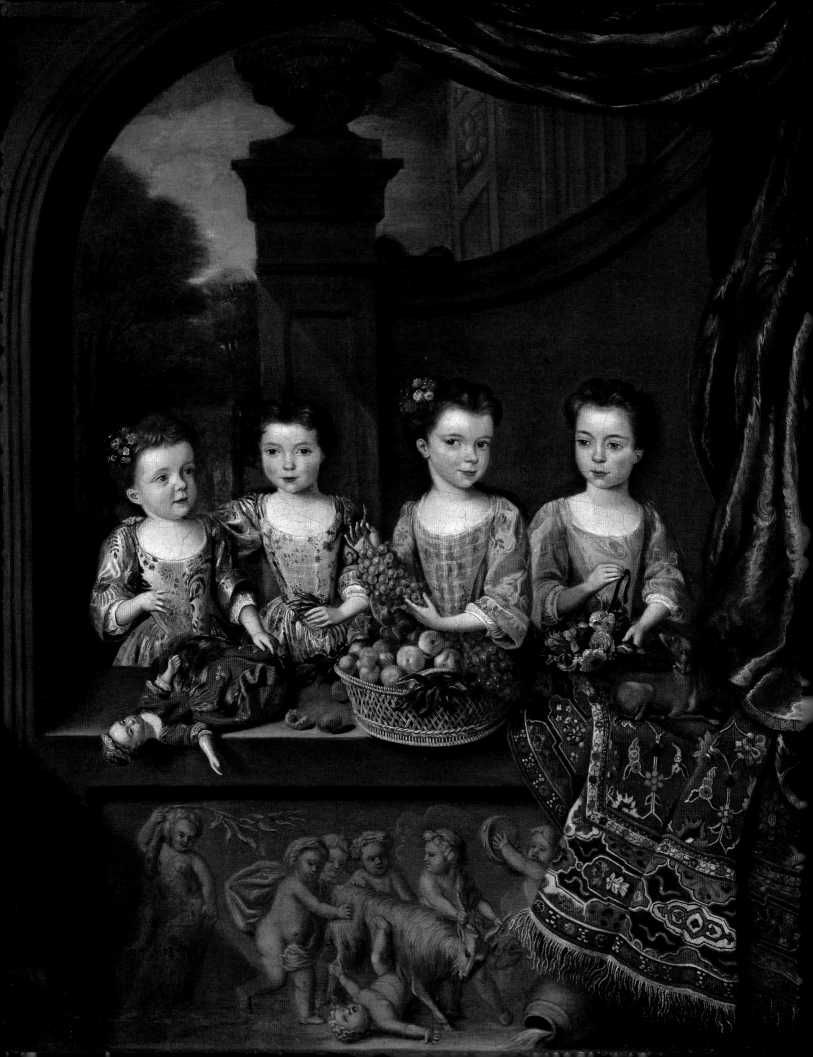

FIG. 256 | CAT. 2

THE DAUGHTERS OF SIR MATTHEW DECKER

Jan van Meyer | 1718

A luxuriant curtain is pulled aside to reveal Elizabeth, Mary, Catherine and Henrietta Maria, the daughters of Sir Matthew Decker (1679–1749), a wealthy Dutch merchant who had settled in England in 1700. Dressed in fine clothes, each girl delicately holds or gestures towards a treasured possession: a china doll, a silvered lattice-work basket piled high with ripe fruit, a bouquet of highly cultivated roses and a docile lapdog. While undoubtedly 'status symbols', these objects bear additional symbolic meaning: the unblemished grapes allude to their virginity; the perfect peaches to their virtue and honour; the dog, their good breeding.

Their demure composure and 'polite' actions are deliberately contrasted with the unruly behaviour of the rambunctious putti carved on the classicizing plinth directly below. This pretty quartet is as much 'on display' and 'commodified' as the objects-cum-attributes they hold up for the viewer's inspection. Evidently a treasured possession, this portrait passed down the family line, until it reached Richard, 7th Viscount Fitzwilliam (son of Catherine, the girl with the grapes; fig. 257). Upon his death in 1816, it was bequeathed, together with the rest of his art collection, library and £100,000, to the University of Cambridge – and it is this 'Founder's Bequest' that led to the creation of the Fitzwilliam Museum. VJA

See: Retford 2006; Woudhuysen 1988.

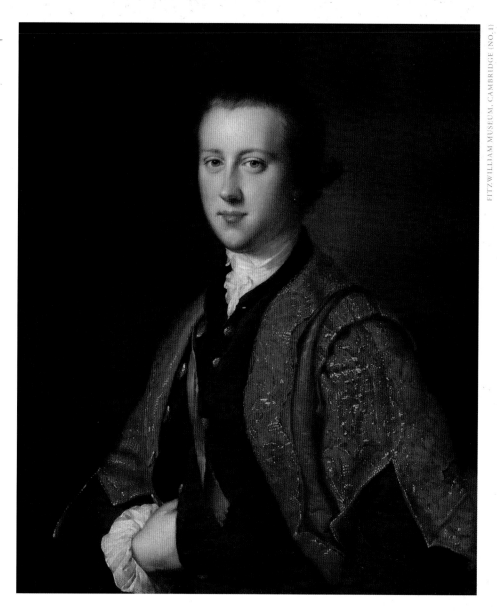

FIG. 257

THE HON. RICHARD FITZWILLIAM, 7TH VISCOUNT FITZWILLIAM OF MERRION

Joseph Wright of Derby, oil on canvas | 1764

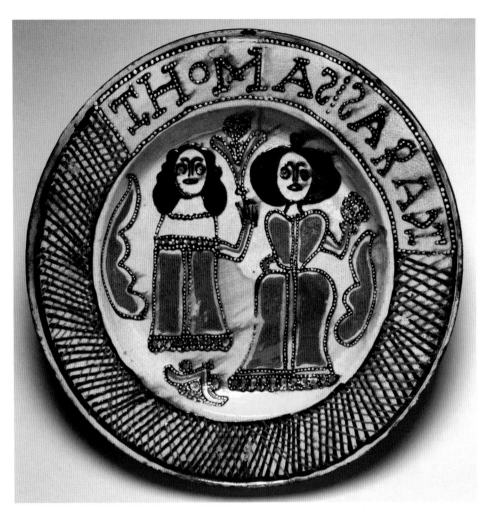

FIG. 258 | CAT. 235

DISH

Staffordshire | *c.*1675–1700

In early modern Europe, across all social orders, significant stages in the life cycle, birth, marriage and death, were commemorated and negotiated through material culture. In the case of courtship, betrothal and marriage – rites of passage whose respective boundaries were very ambiguous – objects did not simply have symbolic value, but were themselves essential features of the union. From a popular perspective, the exchange or gifting of rings, and more quotidian objects such as ribbons, embroidered handkerchiefs, belts and even shoes, represented marital ideals such as devotion, fidelity and love, but also acted as a formal contract between the couple.

Slipware objects produced in North Stafford-shire, a major centre of pottery manufacture in the seventeenth and eighteenth centuries, were sometimes dated and personalized to commemorate major events in the life cycle, including christenings and weddings. This large slipware dish features a man and a woman, each holding aloft flowers, with the names 'Thomas' and 'Sara' written on the rim. Since male and female figures holding flowers were a traditional symbol of courtship, it is likely that this dish was made to commemorate either the betrothal or marriage of a couple with these names. Large dishes of this kind were generally made for decorative purposes, and it is likely that this dish was displayed in the home of 'Thomas' and 'Sara' as an enduring material declaration of their commitment to and affection for one another.

English slipware has traditionally been viewed as a crude, rather unskilled and unselfconscious type of material culture, but there is now compelling evidence to suggest the contrary: its workshop production involved different skills and processes, with a specialized division of labour from the late seventeenth century. Further, it is very likely that the 'naïve' decorative style typical of English slipware, as found on this dish, was quite deliberate, designed to appeal to the demands of a growing national market. JKT

See: Cooper 1984; Dean 1994; Dean 2000, pp. 230–44; Grigsby 1993; Matthews-Grieco 2006; McClanan and Encarnación 2002; Rackham 1987; Sarti 2002; Weatherill 1971.

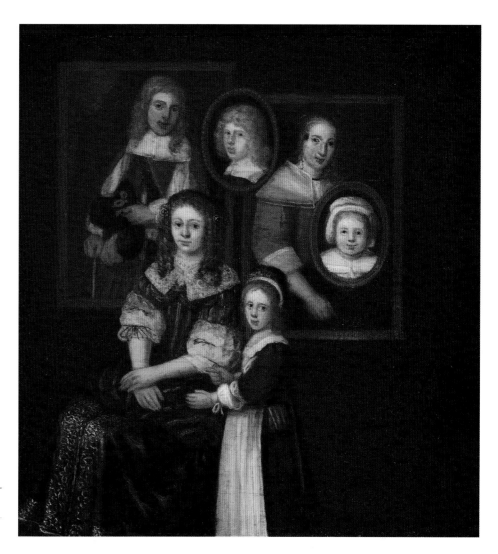

FIG. 259 | CAT. 248

FAMILY GROUP

Abraham Willaerts | 1660

The period from the Renaissance to the Enlightenment witnessed a massive rise in the incidence of portraiture – a phenomenon which has often been associated with the 'rise of individualism'. And yet we know that portraits were often hung in groups that emphasized the position of the 'sitter' in relation to family, lineage or institution.[1] It is collective rather than individual identity that is emphasized in this family group by the Dutch artist Abraham Willaerts (*c*.1603–69).

The painting is only 18.7 by 17.5 cm and yet it contains six figures. In the foreground, a little girl clings to the woman beside her, perhaps her elder sister. They stand in front of four framed portraits, two rectangular canvases depicting a man and woman and two small oval panels representing a boy and a girl. Sadly, the identity of the family is unknown – its commemorative function lost to time. MRL

See: Burke 1997; Earp 1902, p. 216; Gerson et al. 1960, p. 143; Pointon 2013.

1. Burke 1997, p. 26.

FIG. 260 | CAT. 246

HEAD INCORPORATING DEATH MASK OF CHARLES TALBOT (1660–1718)

London | 1718

Dubbed 'the king of hearts' by William III, Charles Talbot, Duke of Shrewsbury (1660–1718), one-time Lord High Treasurer, Lord-Lieutenant of Ireland and Lord Chamberlain, died in London on 1 February 1718, aged 57.[1] Shortly after he expired, a wax or plaster cast of his face would have been taken as a permanent and accurate record of his physiognomy – standard practice for deceased royalty, nobility and other eminent individuals.[2] This death mask would have served as a mould from which replicas could be made for use in funeral ceremonies, models for posthumous portraits, and display in libraries, museums and universities. Given that this is a fully three-dimensional head in wax with applied hair eyebrows it may have been the head for Talbot's funeral effigy. As such it would have had particular significance, which explains its survival, and the fact that a purpose-built case with glass cover was made for its display. It was acquired at an unknown date by Richard, 7th Viscount Fitzwilliam,[3] and bequeathed to the University of Cambridge with the rest of his art collection in 1816. VJA

See: Benkard 1929; Goudie 2013; Handley 2008; *Oxford Art Journal* 2013 (36/1); Ricci 2012; White 1949.

1. White 1949, pp. 720–4; Handley 2008.
2. Ricci 2012.
3. Possibly inherited, given that his maternal aunt, Henrietta Maria, was married to the Hon. John Talbot (*c.*1712–56), a distant cousin of Charles Talbot.

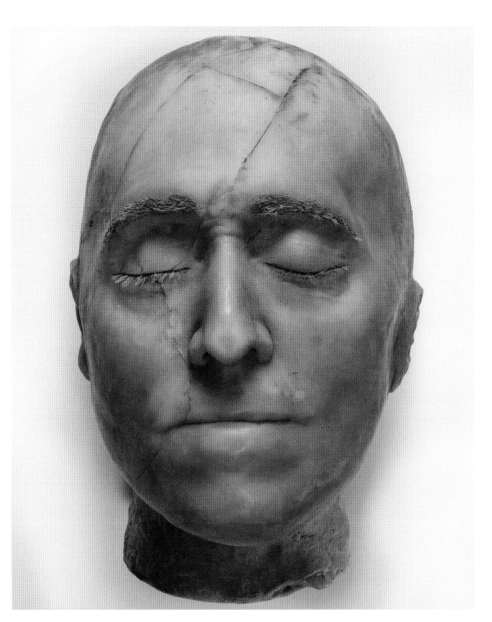

MOURNING RINGS

Even as everyday material comforts became more widely available, life remained uncertain, with mortality rates remaining high across Europe's population. Around 1650, the popularity of mourning jewellery as a coping mechanism began to increase, especially in England.

Dressed in sombre black for the mourning period, usually only those closest to the departed wore memorial jewellery, often a ring. The deceased occasionally garnered more posthumous attention – either because of their elite status or their pre-emptive desire to be mourned properly. Samuel Pepys, the famous diarist, re-corded a 'List of all the Persons to whom Rings and Mourning were presented upon the occasion of Mr. Pepys's Death and Funeral'.

Pepys specified that 128 mourning rings be dispensed at his funeral, allocating £100 for their purchase.[1] Some funeral-goers accumulated a quantity of mourning rings, forming commemorative collections to pass down to future generations.

Mourning rings might be costly, made of gold decorated with precious materials – pearls (fig. 261), amethysts (fig. 268) or garnets (fig. 267) – while others were fashioned from more affordable gilt-metal. Memorial jewellery containing hair delicately woven into beautiful patterns, a physical remnant of the deceased, became increasingly popular during the eighteenth century. Others depicted sorrowful scenes painted on ivory (figs 262 and 263), sombre symbols like the urn (fig. 264) or they preserved the lost soul's gaze in a painted eye miniature (fig. 265).

Despite this commodification of bereavement, many objects still represented tragic loss, such as a humbler ring that memorializes two young siblings who died two years apart: N.B. and W. Toms (fig. 266). This dainty ring, possibly made for their mother, holds two different coloured locks of hair. Minute stars that punctuate the ring's octagonal glass surface are its only embellishment, perhaps meant to catch the light. On the underside, the inscription recording the children's names touched only the wearer's skin – another poignant reminder of their presence. KT

See: Hallam and Hockey 2001; Holm 2004; Llewellyn 1991; Miller 1982; Pointon 1999b; Pointon 2009c.

1. Pointon 1999b, pp. 127–8.

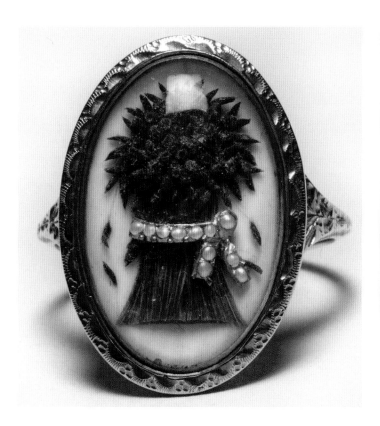

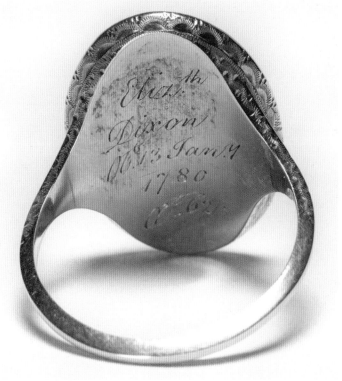

FIG. 261 | CAT. 237

MOURNING RING COMMEMORATING ELIZABETH DIXON

English | 1780

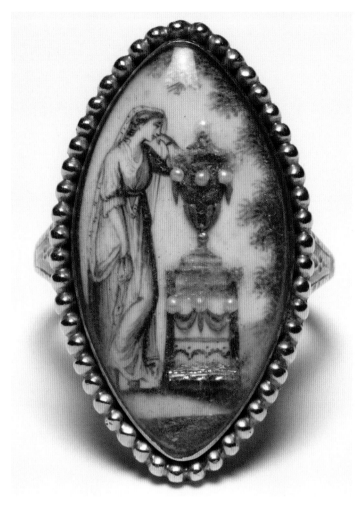

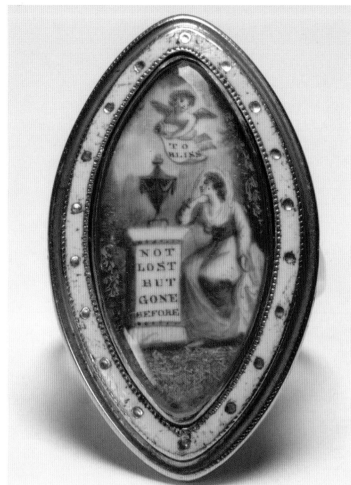

this page clockwise

FIG. 262 | CAT. 238

MOURNING RING COMMEMORATING THE REV'D THOMAS NEALE

English | 1782

FIG. 263 | CAT. 239

MOURNING RING COMMEMORATING GARSFORD GIBBS

English | 1788

FIG. 264 | CAT. 240

MOURNING RING COMMEMORATING CATHARINE HARRIS

English | 1793

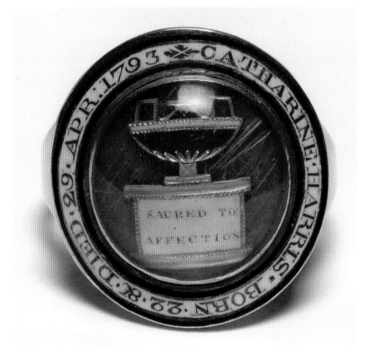

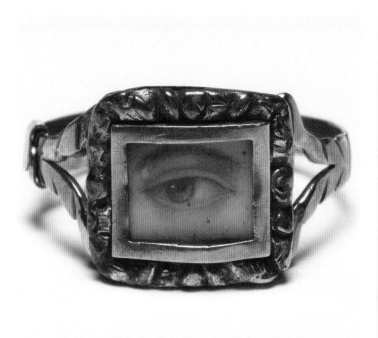

FIG. 265 | CAT. 244

MOURNING RING WITH EYE

English | *c.*1790–1800

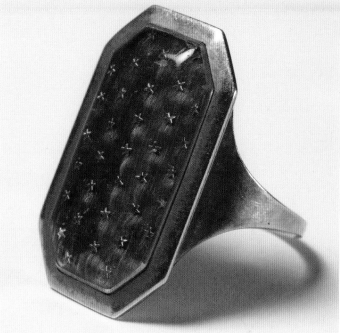

FIG. 266 | CAT. 241

**MOURNING RING COMMEMORATING
N.B. AND W. TOMS**

English | 1794

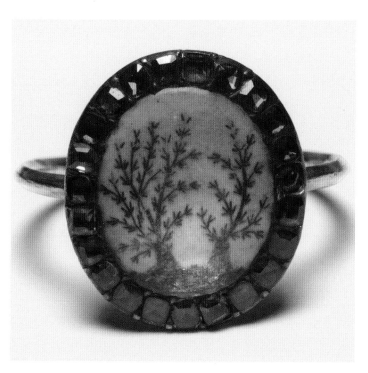

FIG. 267 | CAT. 242

**MOURNING RING
COMMEMORATING JUDITH STUBBS**

English | 1769

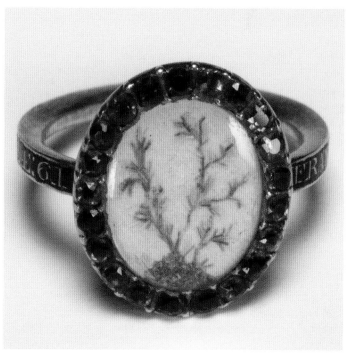

FIG. 268 | CAT. 243

**CHILD'S MOURNING RING
COMMEMORATING FRANCES GREENE**

English | 1767

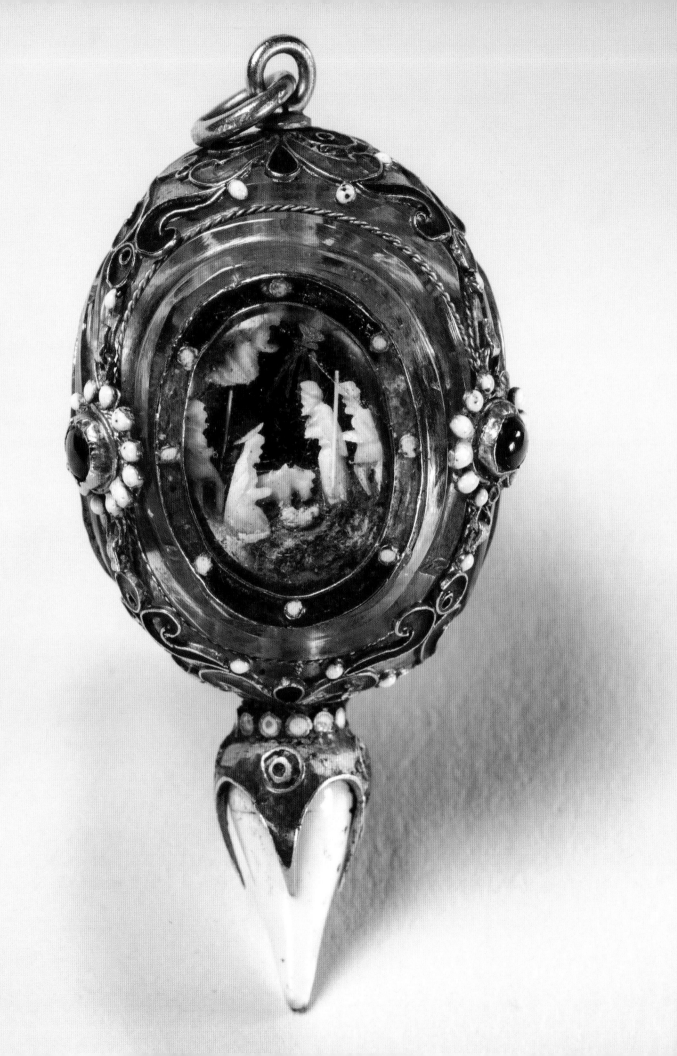

DEVOTIONAL OBJECTS

Mary Laven

'God give them sense'. This was the cry of Gerold Edlibach, a 76-year-old Catholic living in Zurich, who in 1524 witnessed the systematic breaking up and removal of his city's sacred treasures: the images, idols, relics and furnishings of the Great Minster.[1] The old man's anguished exclamation gives us an immediate insight into the spiritual value accorded to objects in this period. It also draws attention to the onset of the Reformation as a moment of intense contestation of the question of holy matter, when preachers struck fear into the hearts of their congregations regarding the deceptive power of images 'graven' of 'gold, silver, or other metal, stone, wood, clay or plaster […] and fashioned after the similitude and likeness of man or woman'.[2]

The vexed debates of Edlibach and his contemporaries about the significance of material objects to Christian religion were evident not only in the episodes of iconoclasm (whether violent or carefully controlled) that marked the triumph of the Reformation in cities across Central and Northern Europe.[3] They were also abundantly apparent in a steady stream of writerly worry regarding idolatry and superstition. This anxiety was not an invention of the Reformation. The historian Caroline Walker Bynum has explored tensions regarding 'Christian materiality' in late medieval culture. While, from the twelfth century, there were innovations in the materiality of religious art (from animated processional statues to stained glass) and, from the fourteenth century, devotion to bleeding hosts or holy dust was increasing, the centuries before the Reformation also experienced renewed concern regarding the incorrect use of images and objects.[4] From the early sixteenth century, however, Protestant critiques of Romish idolatry, voiced from the pulpits and publicized in myriad forms of print, made Catholic prelates, theologians and inquisitors even more jumpy about unorthodox or sensual attachment to things.[5]

While much scholarly literature has engaged with the material culture of churches, shrines and processions – public spaces of worship – I shall here focus instead on private, personal and domestic objects of devotional significance.[6] For, as Church authorities of every affiliation issued prescriptions on the role of material things in religious practice, so the laity invested more and more in objects as signifiers of faith, carried on the body and displayed in the home.[7]

There is perhaps something counter-intuitive about juxtaposing the themes of acquisition and devotion. Piety is often assumed to take one out of the material realm. And the growth in consumerism witnessed from the fifteenth to the eighteenth centuries in Europe is commonly associated with a simultaneous process of secularization. Yet the cornucopia of objects with devotional functions or motifs that spilled out across Protestant and Catholic Europe suggests a more complex relationship between material goods and spiritual well-being.

We have become used to seeing the Renaissance as the starting-block for an age of commodification, when – in John Hale's memorable phrase – 'the rain of non-necessities' began to fall 'from the commercial skies', an allusion to Leonardo da Vinci's famous drawing of this subject (fig. 30).[8] While the new profusion of goods was first evident in fifteenth-century Italy and Flanders and later powered by global contacts with Asia and the Americas, the 'consumer revolution' of the seventeenth century is generally located in north-west Europe. It is the democratization of spending on non-essentials that has particularly struck historians of England and the Netherlands. These broad trends in the history of consumption reached a climax in the Enlightenment with an immense range of luxuries and pleasures available to eighteenth-century shoppers. This proliferation of 'worldly goods' is abundantly illustrated in this book, in the elaborate tableware and ornaments that decked out the home, in fine clothes and accessories, in cherished personal treasures like watches or rings, and in ephemeral treats like chocolate or sugar, consumed and displayed in ornate cups and casters.[9]

◄ see fig. 269 (overleaf)

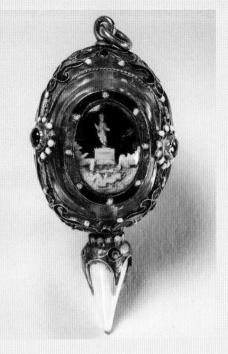

FIG. 269 | CAT. 143

RELIGIOUS PENDANT

Spanish | c.1600–25

What is less often spoken about is the simultaneous surge in the production of items of religious significance. Evidence from Italian archives attests to the ubiquity of devotional objects in household inventories, testaments, marriage transactions and records of pawned goods during this period.[10] Listed among people's possessions we find repeated references to rosaries, coral beads that symbolized the blood of Christ, *agnus dei* (discs of wax impressed with the figure of the 'Lamb of God', which had been blessed by the reigning pope) and little crosses. On the supply side, street traders can be located selling paternoster beads, crucifixes and wax figurines of Christ, the Virgin and Saints, while the Roman customs authorities processed barrel-loads of glass and enamel rosaries.[11]

These documents give some sense of the array of small portable devotional objects owned by individuals and often worn on the body in fifteenth- and sixteenth-century Italy. Although the production and consumption of such goods could take on new significance in the era of the Reformations, the emergence of these objects as widespread devotional accessories clearly pre-dates the religious conflicts of the sixteenth century, and was paralleled in other regions where spending power permitted. Thus testamentary evidence from Northern Europe at the start of the fifteenth century records women leaving rosaries to their female friends and kinswomen. The example of the prosperous Douai spinster, Marie Narette dit De Sandemont, who bequeathed her 'best amber rosary' to a female relative reminds us that these were treasured possessions, of sentimental as well as spiritual and material worth.[12]

The pearwood prayer bead (fig. 278) made in Flanders in the early sixteenth century, is a demonstration of the feats of artistry that might be bestowed upon a single devotional artefact. It takes us a long way from the mass-produced beads that entered Rome in barrels, and must be seen as a vehicle for the display of the woodcarver's skill as well as for devotion. A standard rosary presented a series of beads in numbered sequence; thus ten small beads marking the Ave Marias might be interspersed by a larger Paternoster bead. This Flemish example, while possibly adorning a chaplet of smaller rosary beads, could also be used as a singular object of devotion. It opened up to allow the owner to contemplate two scenes depicting female saints: St Cecilia playing the organ and the Madonna and Child. Profoundly tactile, it was an object that facilitated a more intense moment of meditation than the routine prayers associated with the rosary. Its closing mechanism also enhanced the sense of intimacy between the minuscule figures within and the bead's owner.

The carved wooden bead was just one example of the kind of devotional accessory that Catholics across Europe liked to keep close to their bodies. Such precious objects became markers of identity in the turbulent decades of the Reformation and Counter-Reformation. This was especially true in those regions of Central and Northern Europe that underwent traumatic religious upheavals and divisions. Hence the silver-gilt devotional pendant, created in the form of a miniature book (fig. 279), served as a manifesto of religious beliefs for its German owner. For the Catholic reader, the leaves depicting episodes from the life of Christ would have instantly recalled illustrations from the popular rosary manuals that were published and republished during the course of the sixteenth century. The

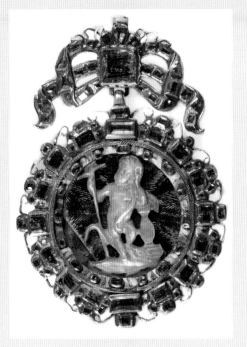
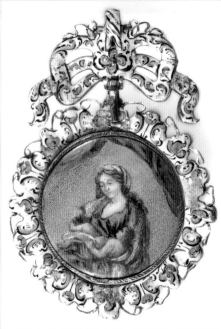

FIG. 270 | CAT. 144

RELIGIOUS PENDANT
front and back

Spanish | 17th century

final two pages depicting the Pope and a female saint were a statement of belonging to the Roman Catholic Church.

In Spain, where devotional jewellery was extremely fashionable, the religious conflicts of the sixteenth century presented a less pressing context. Here, Catholic identity was more to do with 'purity' from Jewish and Islamic contamination than it was with defining Roman doctrines against a Protestant 'other'. A rock crystal pendant with miniature reliefs (fig. 269), mounted in gold and studded with garnets, echoes some of the characteristics of the Flemish prayer bead, although the media could not be much more different. This three-sided jewel is just the right size to be held in the palm of the hand and carefully rolled over to reveal each of the three scenes from the life of Christ: the *Adoration of the Shepherds*, the *Crucifixion* and the *Resurrection*. Like the Flemish example, this Spanish pendant may well have been worn on a rosary. In the wake of Philip III's sumptuary laws of 1600, devotional jewels of this kind became highly modish; every bit as stunning as secular gems, they provided their wearers with a form of display that would not infringe the laws prohibiting excessive personal ornamentation.[13]

Equally lavish is another religious pendant from Spain, featuring a mother-of-pearl figure of the infant Christ (fig. 270) holding a staff in the form of a crucifix and trampling on Satan, represented as a serpent. The piece is larger than the three-sided example; it is made of gold, enamelled in green and set with diamonds and emeralds. Its appearance is far bolder than the other two pendants discussed, and the green of the enamelling when combined with the emeralds is overwhelming. The surprise comes when one turns the object over only to discover a Virgin and Child enamelled in pinks and blues, surrounded by a delicate pink and white decorative border. But while the two sides contrast each other aesthetically, the message of the redemptive power of the Christ Child is reinforced.

Expanding markets, usually associated with the proliferation of 'worldly goods', presented consumers with new opportunities for acquiring devotional jewellery. At the same time, interior design was a growth area, and well-heeled shoppers rendered their homes sacred as well as beautiful by incorporating spiritual motifs into the décor of their living spaces. This is powerfully revealed in the ceramic stoves that were a marker of status and a provider of comfort in Northern European homes. Prized for their smokeless technology and elegant architectural form, these functional objects drew on the visual culture of the Church in order to present in miniature scenes from the life of Christ or of the saints. The warmth emanating from the stove attracted members of the family to draw near and to contemplate the stories that were represented on each tile; devotion was thereby transported to the very centre of the home.[14]

The Fitzwilliam's green stove tile (fig. 271) depicting the *Crucifixion* probably emanated from Germany in the late sixteenth century, and is hard to place securely in either a Protestant or Catholic context. Long ago ripped out of context and placed in a museum, objects such as this one often conceal an elusive religious history. The principal reformers, Luther, Calvin and Zwingli,

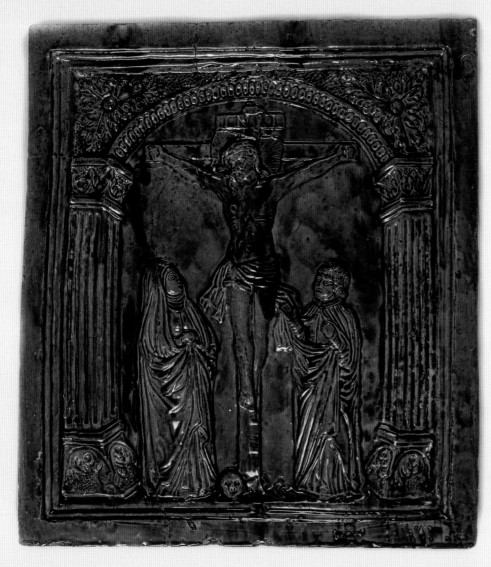

FIG. 271 | CAT. 258

STOVE TILE

German | late 16th century

while condemning idolatry, all sanctioned the use of biblical images at home for didactic purposes, and although it is true that the Reformed community often favoured the representation of stories from the Old Testament, this was not to the exclusion of scenes from the life of Christ. Thus the eighteenth-century tiles found around the fireplace of a house at Peas Hill in central Cambridge feature *Samson and the Lion*, and *David and Goliath*, alongside the *Annunciation* and the *Prodigal Son*.[15]

Despite the fact that the Dutch Republic embraced the Reformed (Calvinist) Church, a large Catholic population enjoyed relative freedom to profess the old faith privately. Although we are apt to associate Delftware with a Protestant aesthetic, this distinction is not in fact clear cut. Thus the ostentatiously pious Delftware money-box (fig. 272), with its blue and white portrayal of New Testament scenes on its lowest tier (the *Kiss of Judas*, the *Temptation in the Wilderness* and the *Crowning with Thorns*) and Old and New Testament scenes on the middle tier (*Elisha and the Children*, the *Angel with the Fiery Sword*, *Christ led captive from Gethsemane*), topped with cherubs, might have appealed to either a Catholic or a Reformed household.[16] Likewise, the beautiful oval panel of Christ, seated in a boat, rowed by a woman on a Dutch waterway (fig. 273), could have adorned Protestant or Catholic walls. However, the inscription, 'I press toward the mark for the prize of the high calling of God in Christ Jesus', from the letter of St Paul to the Philippians, 3.14, might suggest a Reformed context; St Paul was a prominent source for Protestant thought.

Other objects are easier to place, because of their function or geographical context. The spread of holy water stoups (fig. 274) in homes across Italy, Spain and France in the seventeenth and eighteenth centuries is evidence of Catholic renewal after the Council of Trent. Serial production of ceramics at centres like Deruta ensured that middling-status families could afford to adorn their homes with devotional sculptures, such as the *Virgin and Child* (fig. 275). With less of a financial outlay, pilgrims might acquire a souvenir, such as a small bowl from the shrine at Loreto (fig. 284), to bring back to

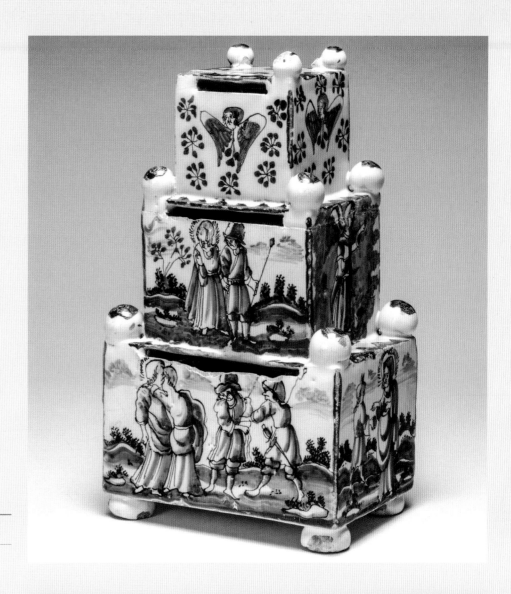

FIG. 272 | CAT. 257

THREE-TIER MONEY-BOX

Possibly Delft | *c.*1680–1700

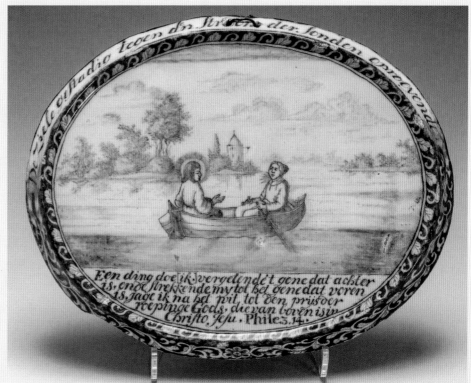

FIG. 273 | CAT. 259

OVAL WALL PANEL

Delft | *c.*1700–50

display on the sideboard at home. The Protestant Reformation has long been associated with the laicization of religion, and the recentring of piety within the household, but it is becoming clear that Catholicism during this period was undergoing its own process of domestication.[17]

The colourful maiolicas of the Catholic south found their parallel in English Delftware. A favourite biblical theme to be found on large display plates was the Fall (fig. 283). While the moral message is clear enough, there is also an appealing eroticism about the depiction of the full-figured, naked Adam and Eve in the Garden of Eden: an image of marital sexuality for a newlywed English Protestant couple. In turn, the Tree of Knowledge was a popular theme on the embroidery that employed the hands of pious young girls (fig. 246). The contrast between the crude depiction of Adam and Eve on these two English objects and the same theme represented on a fine rock crystal plaque from Central Europe (fig. 280) is striking. The latter object is tentatively attributed to the glassworker Caspar Lehmann, who was active at the Catholic Court of Rudolph II in Prague in the early seventeenth century. Yet the iconography of the sinning couple, wrought in different media and applied with varying degrees of skill, is markedly similar across the three objects.

This brief survey of devotional objects from the fifteenth to the eighteenth centuries began with the ideological conflicts that rendered religious materiality highly controversial. Those controversies were in turn played out in the different material cultures fostered by Protestant and Catholic communities. Thus objects contributed to a powerful process of identity-formation. To be a Catholic was not just to believe in transubstantiation or to attend Mass; it was also to place a figure of the *Madonna and Child* in one's home or to hang a devotional pendant around one's neck. To be a Reformed Protestant was not only to accept the doctrine of Double Predestination and to reject the hierarchies of Rome; it was also to surround oneself with pious inscriptions and to instruct one's children with images from the Bible, painted on tiles or earthenware dishes.

And yet it is clear that the religious materialities of the major confessions, Catholic, Lutheran and Reformed, were not discrete. In particular, no religious community held the monopoly on representing scenes from the Old and New Testaments. In surveying this wide range of devotional treasures, regional styles and indigenous media are often more distinctive than religious divisions. What is most striking is the influx, across Europe and across the confessions, of devotional clutter into the home. This domestication of piety was a facet of the consumer revolution that is often forgotten.

1. Johnston and Scribner 1993, pp. 55–7. Research for this essay was undertaken during a Leverhulme Major Research Fellowship (2011–13), and has been developed as part of a project funded by the European Research Council and hosted by the University of Cambridge, 'Domestic Devotions: the Place of Piety in the Renaissance Italian Home, 1400–1600' (principal investigators: Abigail Brundin, Deborah Howard, Mary Laven).
2. Clark 2007, p. 165.
3. For a nuanced account of iconoclasm, see MacCulloch 2003, pp. 558–62.
4. Bynum 2011, pp. 15–24.
5. Caravale 2011, esp. pp. 191–223.
6. On the material culture of public devotion, see Duffy 1992; Webster 1998; Spicer 2012.
7. For pioneering contributions on the material culture of the Protestant home, see Gaimster 2003; Rublack 2005, pp. 173–80; and Hamling 2010. I am grateful to Alexandra Walsham for allowing me to read an unpublished paper entitled 'Domesticating the Reformation: Material Culture,

Memory and Confessional Identity in Early Modern England'.
8. Hale 1993, p. 173; Welch 2005.
9. Jardine 1996, pp. 37–90, on 'goods in profusion'; McKendrick et al. 1982; Schama 1987; Weatherill 1988; Brewer and Porter 1993; Bermingham and Brewer 1995; Jones and Spang 1999; Berg 2005; De Vries 2008; and Vickery 2009.
10. Gabotto 1906, pp. 266–76; Morse 2007; Giannuzzi 1995. For examples of devotional objects found among lists of pawned goods, see Archivio di Stato di Macerata, Archivio comunale di Montefano, Monte di Pietà (libro dei pegni), 188, 189, 191. Thanks to Alessia Meneghin for alerting me to the potential of pawn records as a source for locating devotional objects.
11. Grimaldi 2001, pp. 470–91; Esch 1995, pp. 72–87.
12. Howell 2010, pp. 175–6, 179.
13. Gere and Tait 1984, vol. 1, pp. 41–3.
14. Gaimster 2003, p. 124.
15. Archer 2013, pp. 356–71.
16. Rackham 1935, vol. 1, p. 330.
17. Roper 1989; Hamling 2010.

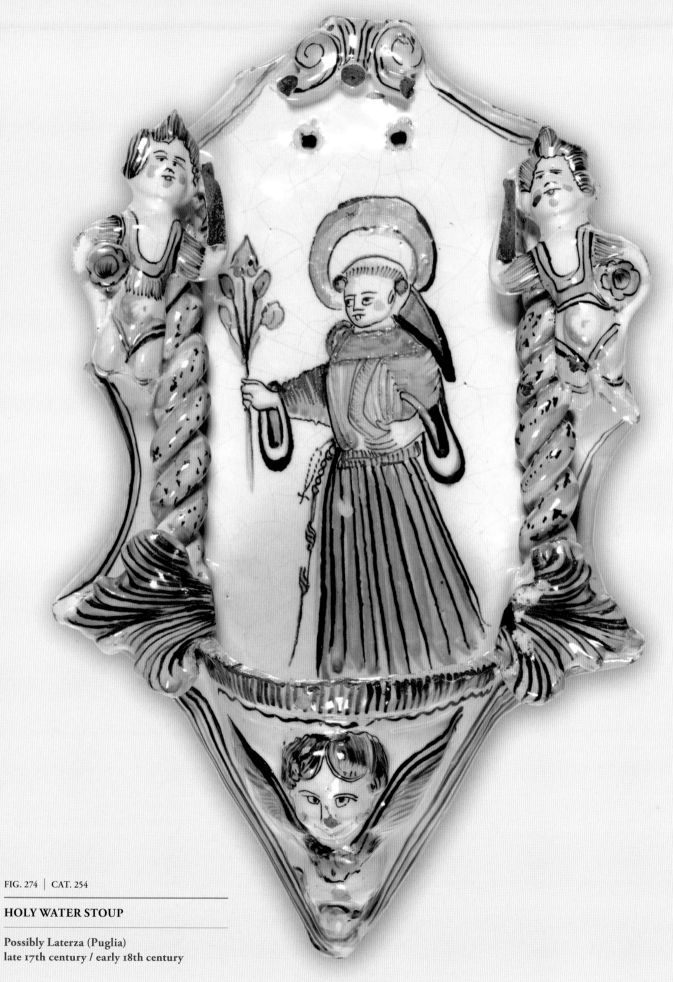

FIG. 274 | CAT. 254

HOLY WATER STOUP

Possibly Laterza (Puglia)
late 17th century / early 18th century

SPIRITUAL BELONGINGS

Clearly dated 1700 and proudly initialled by the two women who made it, 'AB' and 'EB', an extraordinary example of raised-work embroidery tells the shocking story of King David and Bathsheba in a series of pictorial vignettes based on popular engraved prototypes (fig. 276).[1] In the top left corner, David ogles Bathsheba (wife of Uriah) as she bathes – the centrepiece of the embroidery and the incitement to adultery. Bottom left, having slept with Bathsheba and made her pregnant, David vainly attempts to persuade Uriah to leave his military post and make love to his wife in order to mask the unborn baby's paternity. Top right, Uriah, who refuses to do so, is murdered in battle at David's command; and bottom right, David is admonished for his sinful behaviour by the Prophet Nathan.

The moral of the story relies on knowledge of 2 Samuel XI, verse 27: 'And when the mourning was past, David sent and fetched Bathsheba to his house, and she became his wife, and bare him a son. But the thing that David had done displeased the LORD.' The embroidery is a warning against the sins of adultery. It was passed down through generations of a Norfolk family, lovingly treasured by its female custodians.

One 'Granny Ringwood' in the early twentieth century wrote that the Lion and the Unicorn, the Royal Arms of Great Britain which appear on David's canopy, represent the emblems of Judah and Ephraim: 'a testimony to our identity with the Israelites – a silent witness to our nation's Hebrew origin'. Miss L.G. Utting, who gave the piece to the Museum in 1954, recounted the family tradition that 'AB' and 'EB' were 'two maiden aunts'. Maidens they likely were, for embroidery from this period was usually accomplished by young women at home, to whom the story of David and Bathsheba would have conveyed an appropriate moral message. Other examples, probably based on the same set of engravings, survive in Oxford and New York, though it is noticeable that nowhere is Bathsheba so well wrapped in towels as in the Cambridge example.

The depiction of David and Bathsheba with its vibrant tones and gorgeous decorative motifs (from the rainbow-coloured snail in the centre to the delicate foliage and flowers that fill in the gaps) demonstrates how objects of moral and spiritual import could also bring colour and beauty into the home. In Catholic Europe, homes were ornamented with numerous devotional images. An inventory from Puglia dated 1635 lists no fewer than 65 religious paintings. These included images of Christ and the Virgin, the Apostles and a wonderful array of saints – from local heroes ('the protector of Brindisi' or St Nicholas of Bari) to champions of reform and renewal (Francis Xavier, Carlo Borromeo, Philip Neri).[2]

Hand-coloured woodcuts were a cheaper alternative to original artworks.[3] From the sixteenth century onwards, the maiolica workshops of Italy churned out reliefs of the Virgin Mary – brightly coloured panels designed to be hung on the wall or placed outside over the front door.[4] The well-worn example from Deruta (fig. 275), ceramics capital of central Italy, by contrast represents the *Virgin and Child* fully in the round. Inscribed on the grass around the Virgin's feet, 'CF / PC / 1676 16 […] / S M', and on the back of the throne, 'A.D. 22 D. / MARZO / 1676 / .CDF. / P', it may have been made to celebrate the wedding of 'CF' and 'PC' on 22 March 1676. Its many chips and cracks do not detract from the brilliant colour of the Virgin's orange and yellow striped gown and her star-spangled cloak: a beacon of light in the poorly lit home of CF and PC. MRL

See: Giannuzzi 1995; Henry 2011; Morrall and Watt 2008; Poole 1995a; Poole 1997; Scrase et al. 2005.

1. Morrall and Watt 2008, pp. 236–8, note the source for the similar examples in the Ashmolean Museum, Oxford and the Metropolitan Museum, New York, in engravings after Maarten de Vos in Gerard de Jode's *Thesaurus Sacrarum Historiarum Veteris Testamenti* of 1585.
2. Giannuzzi 1995, p. 239.
3. Henry 2011, p. 254.
4. Poole 1997, p. 112.

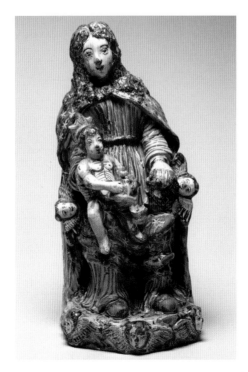

FIG. 275 | CAT. 255

VIRGIN AND CHILD ENTHRONED

Deruta | 1676

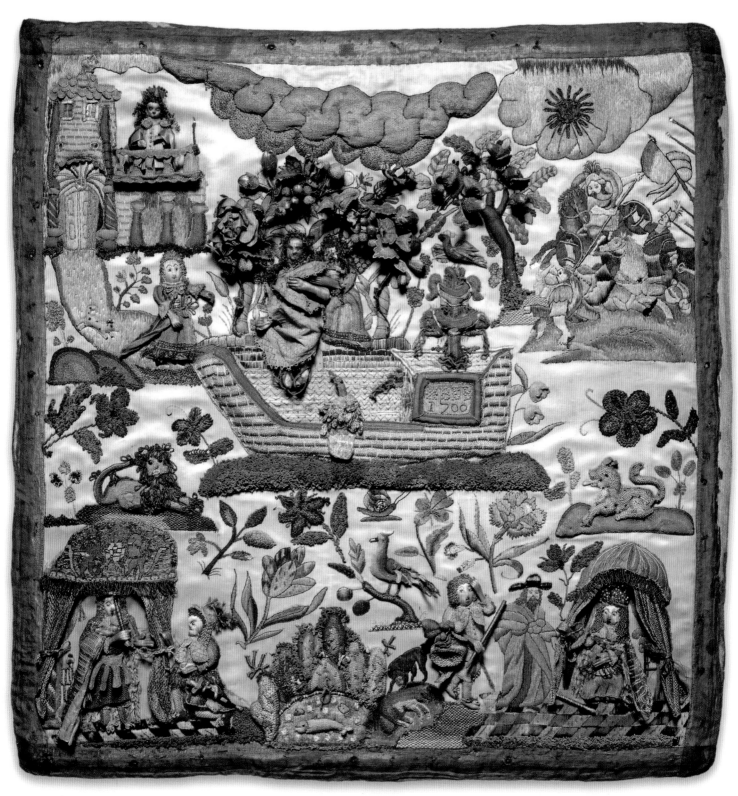

FIG. 276 | CAT. 250

RAISED-WORK PANEL

English | 1700

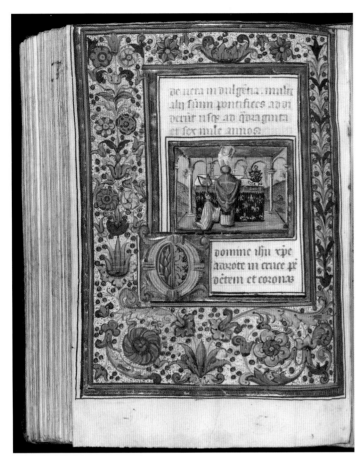
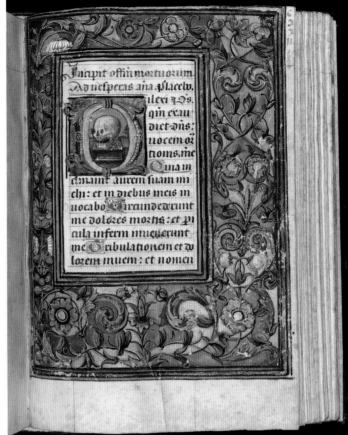

FIG. 277 | CAT. 251

BOOK OF HOURS

Rodericus de Avila, Castile
before 1495

Illuminated books of hours were bestsellers in the late fifteenth century. The survival of so many examples testifies to their status as prized possessions, treasured by families not only for their beauty but as sources of spiritual sustenance. Tangible objects, passed down from generation to generation, they embodied what the historian Virginia Reinburg has called 'an archive of prayer'.

Created in the unstable context of late fifteenth-century Spain, this exquisite example, copied by the scribe Rodericus de Avila and lovingly re-bound by a seventeenth-century owner, was commissioned by a nobleman soldier, one Don Fernando de Sales of the Acuña family, who was appointed governor of the Kingdom of Galicia in 1480 in recognition of his role in Queen Isabella's campaign to annexe the territory. The book was not for himself but was a gift for the Bishop of Pamplona: a bid for patronage as well as a tool of prayer. MRL

See: Reinburg 2012.

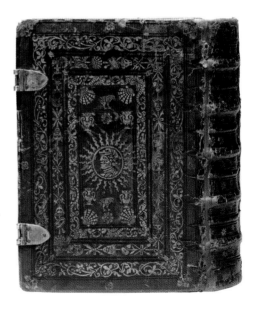

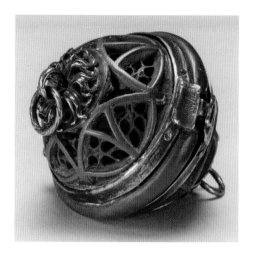

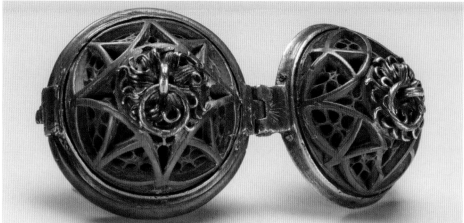

FIG. 278 | CAT. 252

PRAYER BEAD

Flemish | *c.1500–25*

The fashion for intricately carved prayer beads coincided with the rise of devotion to the rosary in the late fifteenth century. The first Company of the Rosary was established by Dominicans in Cologne in 1475, and similar organizations rapidly sprang up in France, the Low Countries, Bohemia, Hungary, Poland and Italy. The confraternities, which cost nothing to join, had no required meetings and were open to all regardless of gender or social status, gave a new lease of life to lay devotion. As one Venetian prayer manual proclaimed, everyone could meditate on the rosary, whether 'in your home, walking on a journey, sleeping or waking'.[1]

This delicate Flemish bead would once have assisted just such private devotions, albeit for a moneyed worshipper. About the size of a walnut, the carved sphere probably formed part of a string of rosary beads hanging from a girdle. Pearwood has a distinctive pinkish-brown colour and a smooth, silky texture. Yielding cleanly to the plane, it is as satisfying to carve as it is to handle. Upon opening the silver clasp, the owner would have marvelled at the tiny figures within: the Virgin and Child in one half and St Cecilia and an angel in the other. Although we do not know for whom the bead was made, the choice of saints, both depicted with long flowing locks, might suggest a female owner. Themes found on other Flemish prayer beads include the *Three Magi* and the *Life* and *Passion of Christ*. Our example may have been possessed by someone who enjoyed a particular association with the Roman martyr Cecilia, patron saint of music, depicted here playing the organ while the angel works the bellows. MRL

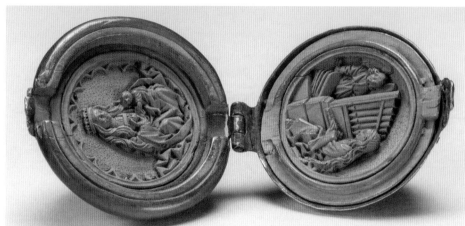

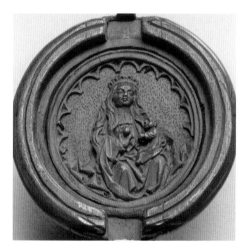

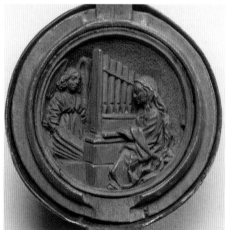

See: Da Castello 1522; Lowden and Cherry 2008; Winston-Allen 1997.

1. Da Castello 1522, fol. 8r.

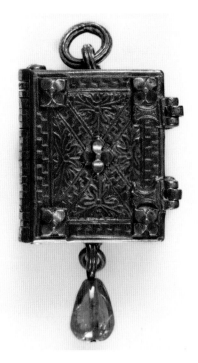

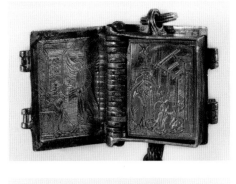
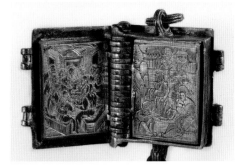
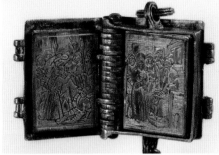
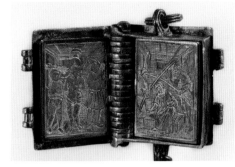
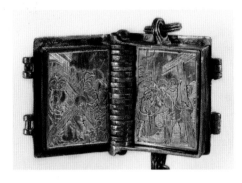
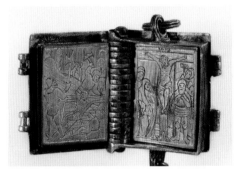
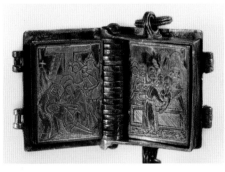
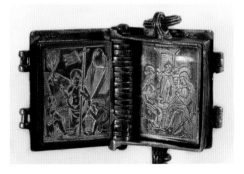
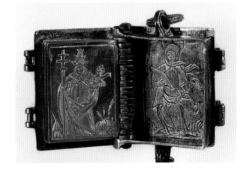
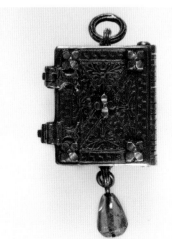

FIG. 279 | CAT. 142

BOOK-SHAPED PENDANT

German | 16th / early 17th century

Six centimetres high and containing nine leaves, this miniature book wrought of silver-gilt tells the story of Christ. After the Joyful Mysteries of the *Annunciation* and *Nativity*, the 'reader' of the book is invited to contemplate the Sorrowful Mysteries of the *Passion*, and finally the Glorious Mysteries of the *Resurrection*. The triumphant message is endorsed with images of the Pope and a female saint that enable us to place this object securely within a Catholic context.

In the *Annunciation*, the Virgin Mary kneels piously at her desk, just as the owner might have done when meditating upon these images. The polished pale amethyst bead that dangles from the book reminds us that this is a fundamentally tactile object, one to be rubbed as well as read, a sensory enhancement to prayer. The closure mechanism, incorporating a fake fore-edge, allows this devotional treasure to keep its secrets hidden away. MRL

See: Winston-Allen 1997.

FIG. 280 | CAT. 253

PLAQUE

Attr. Caspar Lehmann, Prague
late 16th / early 17th century

The image of Adam and Eve appeared in nu-
merous guises. It reminded viewers of Original
Sin and was popular with both Catholics and
Protestants.[1] It became a wide-spread trope
repeated on plates, paintings and, in this rare
example, engraved rock crystal. Rock crystal
resembled glass in its colourless clarity and could
be worked in the same way as gemstones. This
piece is attributed to Caspar Lehmann (*c.*1563/5
–1622), a pioneering glass-engraver working at
the court of the Holy Roman Emperor Rudolf
II in Prague.[2] It may therefore have been made
for a German or Bohemian patron who wished
to display their piety. The scene is witnessed
by an audience consisting of a snail, newt and
toad, and magnified by the domed crystal that
enhances the effect of a 'captured' image. This
novel rendering of the *Temptation* shows that
spiritual belongings could also be fashionable
and appeal across religious divides. SI

See: *Czechoslovakian Glass* 1981; Pešek 1982, pp. 263–7.

1. Pešek 1982, p. 264
2. *Czechoslovakian Glass* 1981, p. 19

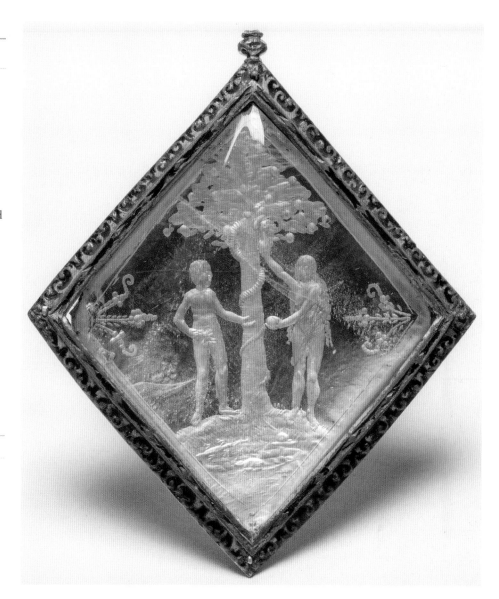

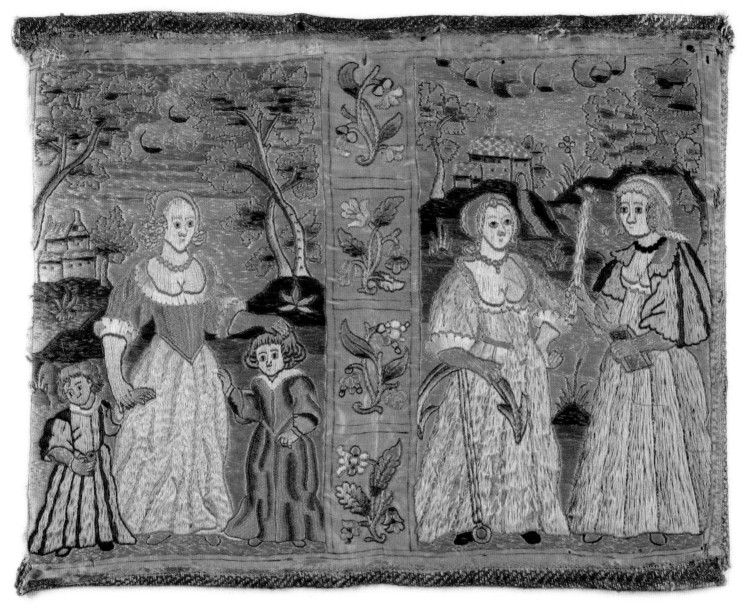

FIG. 281 | CAT. 249

BOOK COVER

English | c.1625–50

This book cover depicts exactly the kinds of virtues that its maker was hoping to demonstrate in her act of carefully embroidering silk floss onto satin. These virtues are personified as three women – Faith (holding a cross and a book), Hope (with an anchor) and Charity (with two children). Although the Reformation saw widespread destruction of devotional images, religious imagery continued to fill domestic spaces in post-Reformation England, often through textiles and embroidery, which brought colour and comfort into the home.

The meditative practices of embroidery and reading were deemed essential for any devout Protestant Englishwoman. This cover makes explicit the connections between faith, femininity, reading and needlework, and showcases the talent of its maker. Perhaps it was intended to cover a Bible, or one of the popular conduct books, which advised women to read, sew and follow the examples of biblical and classical femininity. SP

See: Hamling 2010; Morrall and Watt 2008.

FIG. 282 | CAT. 261

TOTA PULCHRA ES

Fray Eugenio Gutiérrez de Torices, Segovia
1690

Wax, the most ephemeral sculptural material, was frequently used to create artworks for religious contexts. Catholic shrines were often bedecked with wax votives representing healed parts of the body, sometimes sold by apothecaries (as seen, for example, in fig. 19).[1] Small wax images were carried in religious processions and, in the eighteenth century, wax heads of saints were displayed alongside reliquaries in sacristies.[2] In Spain, where naturalism was particularly desired in religious sculpture, coloured wax images were popular as devotional aids, but few have survived. Preserved within its original gilt-ebony frame, this detailed relief was lovingly created in 1690 by a Spanish sculptor-friar in his Monastery of the Virgen de la Merced, Segovia; it is modestly signed and dated beneath the coat-of-arms of his order.[3] In remarkable condition, it shows the Virgin as described in the ancient prayer 'Tota pulchra es', an antiphon used during the Feast of the Immaculate Conception.[4] It would likely have been hung in the bed-chamber or private chapel of a wealthy Mercedarian devotee and used to aid prayers and other devotional activities. VJA

See: Daninos 2012; Guerzoni 2012; Panzanelli 2008; Trusted 2007b.

1. Guerzoni 2012, esp. pp. 15–17; Daninos 2012; Panzanelli 2008; and essay by Evelyn Welch in the present volume.
2. See, for example, the set of twelve wax busts of Franciscan saints in the Redentore church, Venice.
3. A paper label stuck on the back states 'Fr. Eugenius Gutierrez de Torices ordinis Bᵃ Mᵃ de Mercedes Redemptionis captiviorum in suo segobiensi monasteri fat. 1690'. This was the Royal, Celestial and Military Order of Our Lady of Mercy and the Redemption of the Captives, a Catholic mendicant order whose members were known as Mercedarians.
4. 'Tota pulchra es, Maria, et macula originalis non est in te. Vestimentum tuum candidum quasi nix, et facies tua sicut sol. Tota pulchra es, Maria, et macula originalis non est in te. Tu gloria Jerusalem, tu laetitia Israel, tu honorificentia populi nostri. Tota pulchra es, Maria.' ['You are all beautiful, Mary, and the original stain [of sin] is not in you. Your clothing is white as snow, and your face is like the sun. You are all beautiful, Mary, and the original stain [of sin] is not in you. You are the glory of Jerusalem, you are the joy of Israel, you give honour to our people. You are all beautiful, Mary.']

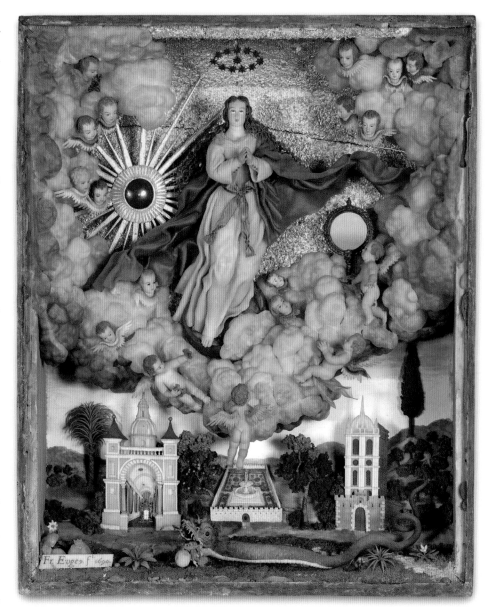

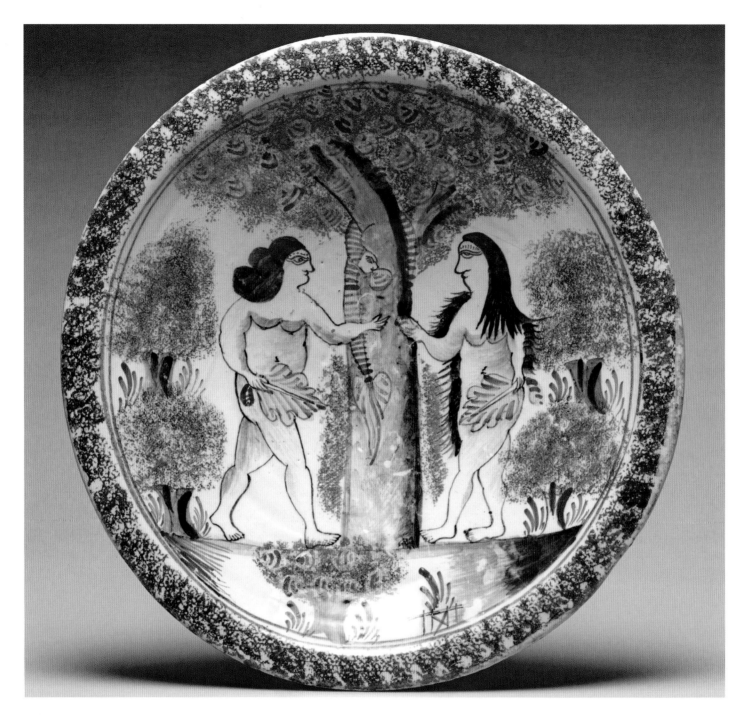

FIG. 283 | CAT. 260

CHARGER

Bristol or Brislington, Somerset | *c.1735–45*

This English Delftware charger depicts the Tree of Knowledge, laden with tantalizing fruit, and the scantily clad figures of Adam and Eve at the moment of the *Temptation* (or the *Fall*) in the Garden of Eden. This decisive event, which triggered humanity's expulsion from Eden, was a popular theme on seventeenth- and eighteenth-century English Protestant domestic goods, such as prints and ceramics, and also in embroidery.

Flanking the Tree, Eve presents an apple to Adam, as the biblical narrative dictates. However, both reach for another fruit proffered by the wily serpent, perhaps referencing John Calvin's theory of their mutual fall. Since Adam and Eve were considered in Christian theology to be the first married couple, this plate may have been given to a newly wedded husband and wife.

Intended more for display than practical use (though some may have been used as fruit bowls), decorative earthenware chargers were often prominently displayed on a sideboard or mantelpiece, serving to remind their middle-class owners of Original Sin and the dangers of temptation, while demonstrating social prestige. KT

See: Archer 1997; Archer 2013, p. 27, no. A.42; Dawson 2010; Hamling 2010; Morrall 2008; Poole 1981; Rackham 1935.

FIG. 284 | CAT. 256

PILGRIM'S SOUVENIR BOWL

Pesaro or Loreto | 18th century

A small maiolica bowl bears an image of the
Madonna of Loreto and her shrine, the Holy
House or *Santa Casa*. According to legend, in
the late thirteenth century, angels physically
transported the Virgin's home (in which the
Annunciation of Christ's birth by Archangel
Gabriel had taken place) from Nazareth to
Loreto. With a church built specially to protect
the shrine around 1500, Loreto, a hilltop town
near the Adriatic coast, became one of the most
popular pilgrimage sites in early modern Europe.

Inscribed in purple manganese 'CON. POL[VERE].
DI. S. CASA' ('With dust of the Holy House'),
souvenir bowls like this were made by mixing
dust from the holy site with clay and holy water
– their form alluding to the Virgin's bowl (*Santa
Scodella*), another relic preserved at Loreto.
Serving as a permanent memento of a visit to
the shrine, this bowl may well have been used
by the pilgrim back at home to hold holy water
for use in his or her private devotions. KT

See: Pointon 2009b; Poole 1995a; Poole 1997; Wilson 1989.

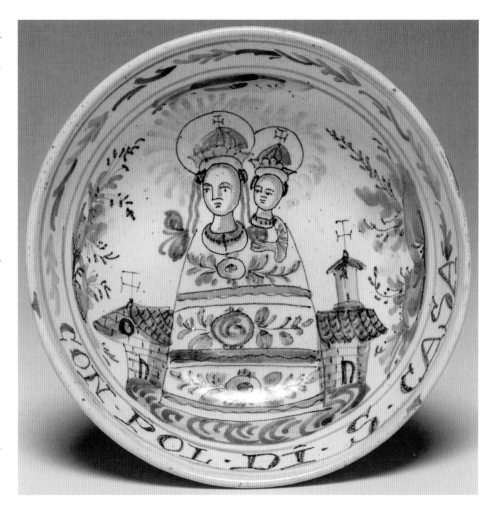

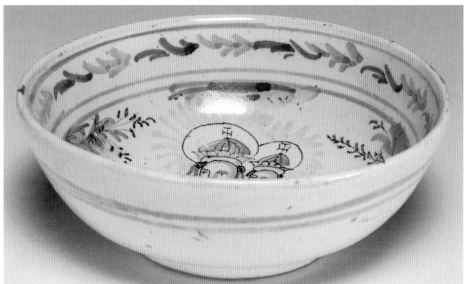

UNDER LOCK AND KEY

The accounts of the Kentish gentleman Edward Dering, for the years 1617–28, are bursting with references to the purchase and mending of locks and keys: padlocks, stock locks, horse locks, gate locks, 'a little box lock', 'a new spring locke and 3 keyes to ye hall doore', 'a locke for my study dore', and even 'a little silver lock and key' to hang in his wife's hair.[1]

It stands to reason that, in an age when personal possessions proliferated, so too would the means for containing and securing them (fig. 285). And it is no surprise that these functional devices would themselves sometimes be fashioned as decorative objects, treasured in themselves, preserved and collected, as is evident in the beautiful array of French iron keys at the Fitzwilliam, part of the significant bequest of C.B. Marlay in 1912. Two sixteenth-century examples draw on classical designs to incorporate Corinthian capitals, prancing horses and winged female grotesques, while a seventeenth-century key with fine comb wards is personalized with the initials 'P.F.' (figs 286–288).

Chests, coffers, coffrets and caskets could also be personalized to indicate their use or ownership and decorated in a variety of materials – ivory, textiles, wood, leather, copper, brass and gold.[2] The function of two caskets, both probably made in the late sixteenth century or early seventeenth century (figs 289 and 290) is not clear, however, because of their very small size. One might be tempted to consider them as simply decorative – for example, the first has a chequered pattern even on its underside, while the second has a cityscape at night on its front and top – but they both have intricate locking mechanisms. Miniature containers such as these might have been the kind made for travellers to carry small valuables close to them.

Larger and more ordinary containers can be found in most households and would have held linen and other domestic goods. For example, all of the inventories from the Born district in seventeenth-century Barcelona contained chests and coffers of some sort.

More than half of these households owned five or more chests (*caixes*) and many of them came with a description, for example, bride's chests (*caixa de nuvia*), children's chests (*caixa de criatura*), chests in the style of Genova (*a la genovesa*) or in the style of a nun (*a tall de monja*).[3] By the eighteenth century, we know from the Old Bailey Proceedings in London, that even those without a room of their own, a servant, for example, would have owned a box that could hold their meagre possessions and be locked securely.[4] MRL MTC

See: Garcia Espuche 2010; Hilkhuijsen et al. 1986; Pessiot 2007; Vickery 2008; Winters 1999; Yeandle undated.

1. Yeandle undated.
2. Winters 1999, pp. 84–91.
3. Garcia Espuche 2010, pp. 444–7.
4. Vickery 2008, pp. 163–72.

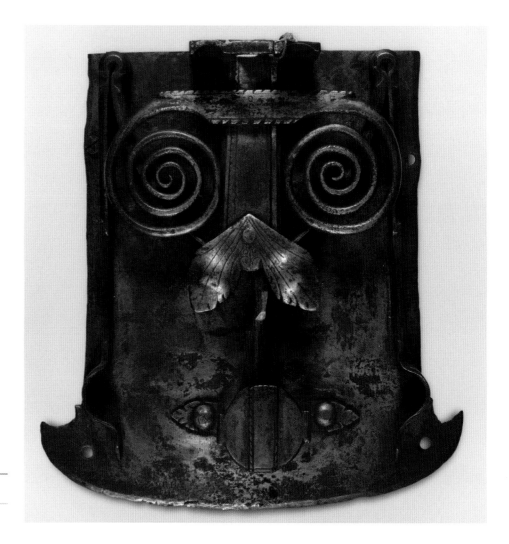

FIG. 285 | CAT. 265

LOCKPLATE

European | **17th century**

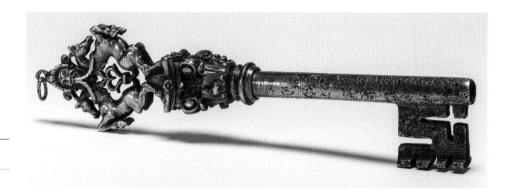

FIG. 286 | CAT. 262

KEY

French | 16th century

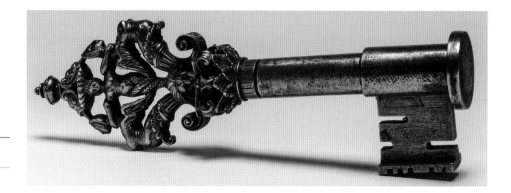

FIG. 287 | CAT. 263

KEY

French | 16th century

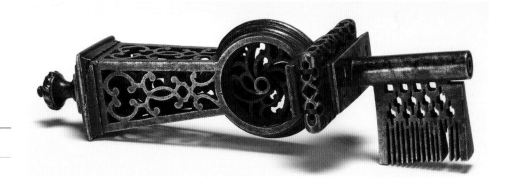

FIG. 288 | CAT. 264

LANTERN KEY

French | 17th century

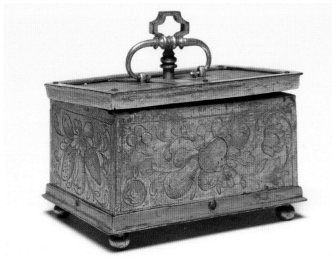

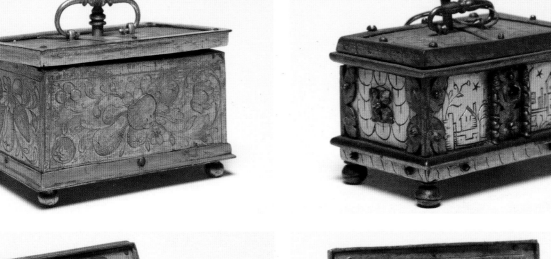

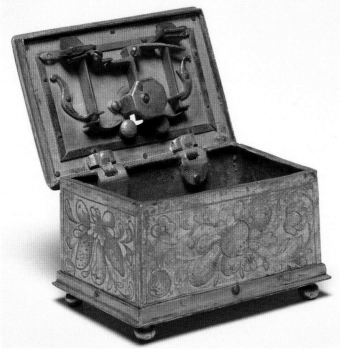

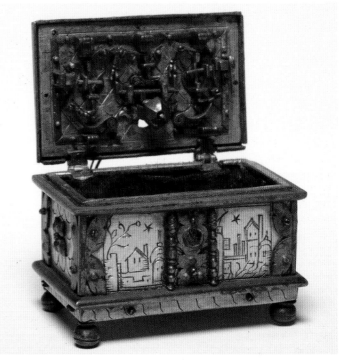

FIG. 289 | CAT. 267

MINIATURE CASKET

German | *c.*1600–30

FIG. 290 | CAT. 268

MINIATURE CASKET

German | *c.*1580–1620

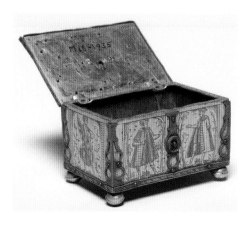

FIG. 291 | CAT. 266

MINIATURE CASKET

Workshop of Michael Mann, Nuremberg
*c.*1600–30

Lockable boxes were made in diverse sizes and
materials for storing and safeguarding mundane
and precious objects both in the home and on
the move. Nuremberg and Augsburg were key
metal-working centres and home to skilled crafts-
men like Michael Mann, who was famous for
creating miniature strongboxes in fire-gilt brass
and copper on spherical feet with hinged lids
fitted with a moveable carrying handle, and
complex interior locking devices with multi-
shooting bolts, presumably designed for jewels.
The top of this fine front-locking example is
engraved with an elegantly dressed European
lady and gentleman in early seventeenth-century
costume, while the four sides are engraved with
images of Turks, and the base with a townscape
– which implies it was intended to be picked up
and viewed from all angles. Indeed, it was clearly
the casket's decorative charm and appealing dim-
inutive scale that saved it from being discarded
when the locking mechanism broke and was re-
moved at an unknown point in its biography. VJA

See: Berger 1998, pp. 117–38; Winters and Bliss 1999, p. 88,
no. 36.

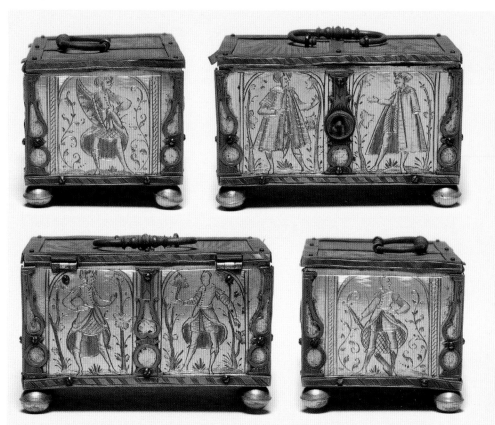

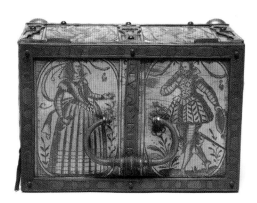

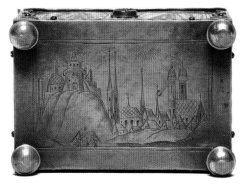

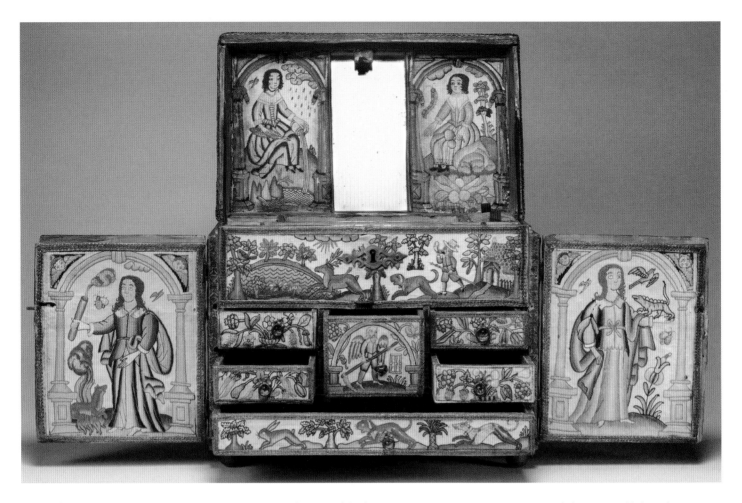

FIG. 292 | CAT. 219

CABINET

English | *c.1650–75*

Personifications of the five senses – Taste (with fruit and a monkey), Touch (with a hawk), Sight (gazing into her mirror), Sound (strumming a lyre) and Smell (with flowers and a hunting dog) – decorate the top, front and sides of this embroidered cabinet. At the back, Orpheus serenades exotic animals. Inside, Old Father Time (with hourglass and scythe) is surrounded by personifications of the four elements identifiable by their attributes: Fire, for example, clutches a fizzing firework. At least five tradespeople and artisans contributed to this cabinet: a shopkeeper supplied silks, metal threads and satin; a draftsman drew scenes inspired by prints; a professional or a skilled amateur embroidered the panels; and an upholsterer or joiner attached them to the box.[1] Finally, a leather-worker supplied a now-lost storage box.

An expensive belonging itself, this cabinet, with several secret compartments hidden behind shallow drawers, was once filled with treasured possessions, kept under lock and (now lost) key. SP

See: Staples 2008.

1. Similar boxes exist made by 11-year-old girls. Staples 2008, pp. 25–6.

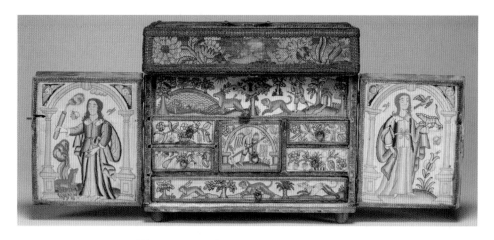

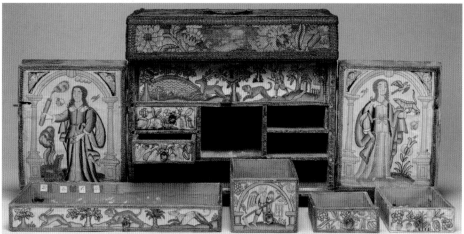

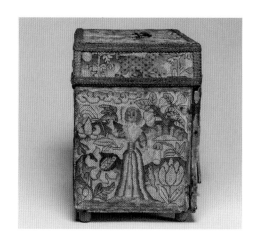

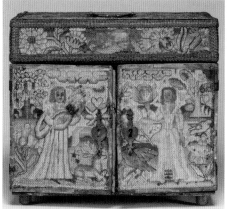

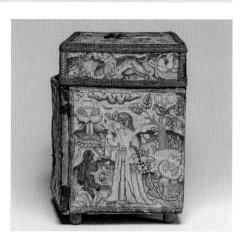

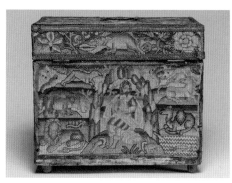

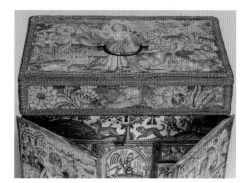

PAIR OF MEDAL CABINETS
MADE FOR WILLIAM DRAPER II

English | *c.*1745

Judging from their 'on-laid' leatherwork, which is more typical of contemporary book-binding, these spectacular portable medal cabinets were made in England, *c.*1745. When unlocked, the front face pulls down to reveal twelve trays (original oak bottoms with later mahogany coin-trays) with tooled-leather fronts and gilt-copper drawer-pulls. Attached to the inside of both fronts is a fold-out leather panel (one lined with pink silk and headed 'TABLE', the other with yellow moiré fabric and headed 'TABLE DES MEDAILLES') with twelve columns for recording in chalk the contents of each drawer.

Sporting the Draper arms in their pediments, these identically dimensioned cabinets, which unlock with the same key, were likely commissioned as a non-matching pair by John Evelyn's grandson, William Draper II of Addiscombe Place, near Croydon in Surrey, given that they formed part of his estate sold on 3 April 1760. With gilded woodwork, silver carrying-handles and coloured gilded leatherwork, these display cabinets were luxury showpieces, admired as much on their own account as for the numismatic treasures carefully secured within. VJA

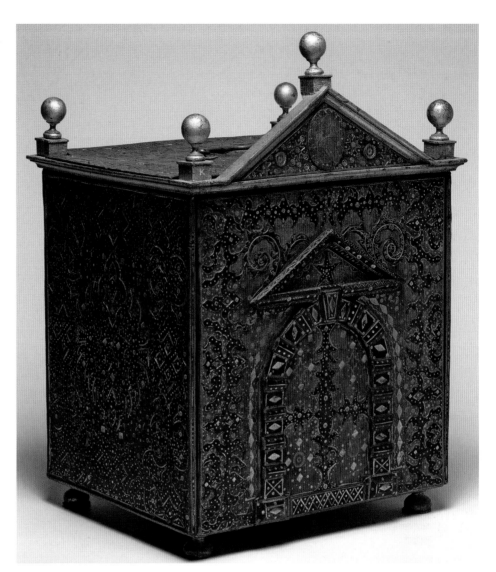

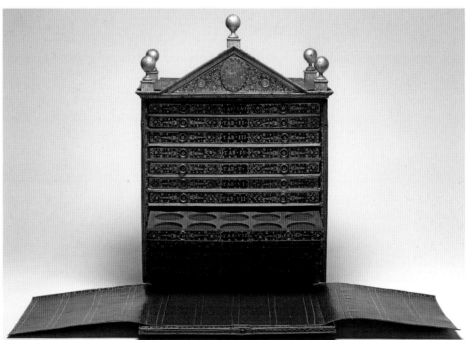

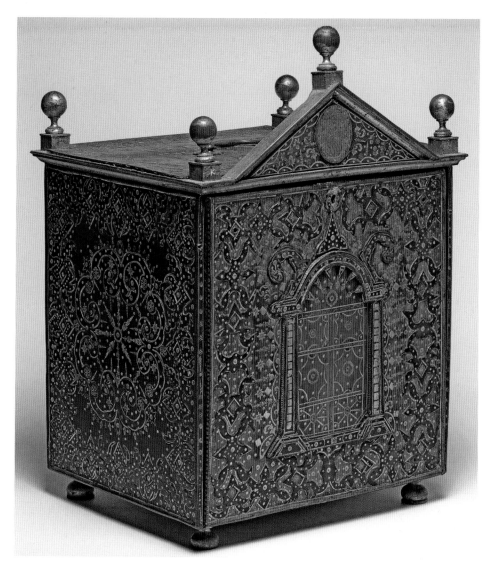

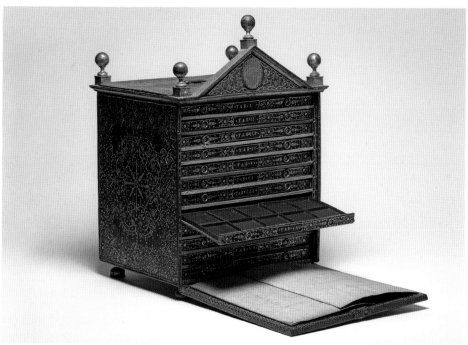

SUMMARY CATALOGUE

The following list of exhibits is correct at the time of going to press. Unless otherwise specified, all objects are from the Fitzwilliam Museum's collection.

CAT. 1 | FIG. 12
Standing cup and cover
Franz Fischer or Vischer (active 1600–53), Nuremberg, early 17th century (before 1618). Silver-gilt, embossed and chased, bowl and cover shaped as a bunch of grapes with a cast figure on the stem, the foot engraved: 'HERMEN FISSINGER ANNO 1618'. 33.3 x 8.3 cm. C.B. Marlay Bequest (MAR.M.50 & A-1912).

CAT. 2 | FIG. 256
The Daughters of Sir Matthew Decker
Jan van Meyer (c.1681–after 1741), English, 1718. Oil on canvas. Signed and dated on the balustrade: 'I. De Meyer, 1718'. 77.5 x 66.1 cm. Founder's Bequest, 1816 (437).

CAT. 3 | FIG. 10
Nautilus shell cup
Shell probably engraved in China, c.1580–85, mounted by an unidentified silversmith (mark: 'TR'), London, 1585/6 Nautilus shell, engraved with Chinese scenes, mounted in silver-gilt with engraved, cast, and chased marine decoration. 24.4 x 19 cm. L.D. Cunliffe Bequest, 1937 (M/P.4-1938).

CAT. 4 | FIG. 9
Coconut cup and cover
Probably German, c.1560–1600. Coconut shell, mounted in silver-gilt with an engraved hunting scene round the neck 32.8 x 10.5 cm. C.B. Marlay Bequest (MAR.M.56 & A-1912).

CAT. 5 | FIG. 68
Goblet
Jacopo Verzelini (1522–1606), Crutched Friars Glasshouse, London, c.1577–8; engraved by Anthony de Lysle, London, 1578. Dark soda glass, blown and diamond point engraved with a frieze of hounds, a stag and a unicorn, and panels, inscribed: 'AT', 'RT' and '1578'. 21.6 cm high. Purchased from Sir Hugh Dawson with the Beves, Marlay and Glass Duplicates funds and with grant-in-aid from the Victoria and Albert Museum (C.4-1967).

CAT. 6 | FIG. 83
Lidded jug or flagon
German, probably Frechen (near Cologne, Rhineland), c.1570–5, with mounts by an unidentified silversmith (mark: incuse leaf), London, 1576/7. Brown salt-glazed stoneware ('tigerware'), mounted in silver-gilt. 22.8 x 14.4 cm. Given by the Friends of the Fitzwilliam Museum EC.32-1941.

CAT. 7 | FIG. 11
Lidded jug or flagon
Turkish (Ottoman Anatolia), Iznik, c. 1580–92, with mounts by an unidentified silversmith (mark: 'IH'), London, 1592/3 Fritware, painted underglaze in blue, turquoise-green, red and black with pomegranates and hyacinths, mounted in silver-gilt. 26.2 x 14.2 cm. Purchased from Mallet & Sons (18.11.1948) with the F. Leverton Harris Fund, and from the Albert Leopold Reckitt Bequest (M.16-1948).

CAT. 8 | FIG. 13
Saucer dish
Chinese, Zhangzhou (Pinghe county, Fujian province), late 16th century. Hard-paste porcelain ('swatow ware'), painted overglaze in turquoise-blue and black with Arabic inscriptions from the Qur'an and Islamic creed, and the statement that it was made for Fantad Khan, servant of Akbar Kahn (third Mughal Emperor). 8.4 x 35.5 cm diam. Given by W.M. Tapp, LLD (C.49-1932).

CAT. 9 | FIG. 73
Lobed bowl
Chinese, Jingdezhen (Jiangxi province), c.1580–1600, with mounts by an unidentified silversmith (mark: 'R'), probably London, late 16th or early 17th century. Hard-paste porcelain (*kraak* ware), painted underglaze in blue, mounted in silver-gilt. 13.4 x 24.4 cm diam. L.D. Cunliffe Bequest, 1937 (OC.4A-1938).

CAT. 10 | FIG. 8
Large dish
Italian, probably the Veneto, either Padua or Manardi factory, Bassano, 17th century. Tin-glazed earthenware (maiolica), painted in the style of Isnik ware of c.1570–1600, and inscribed 'GD/B'. 8.8 x 48.8 cm. Purchased from Sotheby's (20 May 1932) with the Glaisher Fund (C.22-1932).

CAT. 11 | FIG. 7
Basin dish
Italian, probably Venetian, first half 16th century. Gilt-brass, chased with a radiating design of arabesques and panels of interlace derived from Islamic metalwork. 6.4 x 53 cm diam. Purchased with the F. Leverton Harris Fund (M.21-1950).

CAT. 12 | FIG. 29
Pilgrim flask
Italian, Murano (Venice), 16th century. Colourless and opaque white glass (*vetro a retorti* and *lattimo* canes), blown, with four applied suspension loops, 21 x 10.9 cm. C.B. Marlay Bequest (MAR.C.134-1912).

CAT. 13 | FIG. 28
Tazza
Italian, Murano (Venice), late 16th/early 17th century. Clear glass (*cristallo*) with moulded bowl and hollow wythern stem. 15.7 x 17.6 cm. C.B. Marlay Bequest (MAR.C.118-1912).

CAT. 14 | FIG. 26
Diptych sundial
Paul Reinmann (c.1557–1609), Nuremberg, 1608. Ivory, engraved and painted. 1.6 (closed)/11.2 (open) x 9 x 11 cm. Lent by the Whipple Museum of the History of Science, University of Cambridge (Wh.1688).

CAT. 15 | FIG. 23
Lidded tankard
Unidentified silversmith (marks: 'SA'), Augsburg, c.1570–1600. Silver, chased and etched with strapwork enclosing cast medallions of Charity, Hope and Temperance after designs by Peter Flötner, with later gilding. 17 x 11.3 cm (diam. of base). C.B. Marlay Bequest (MAR.M.39-1912).

CAT. 16 | FIG. 25
Lute
Marx (or Max) Unverdorben (active c.1550–80), Venice, c.1550–80. Marquetry of ivory, ebony, walnut and yew. 50 x 33 cm. Lent by the Victoria and Albert Museum, London (193-1882).

CAT. 17 | FIG. 27
Door-knocker
Italian, Venice, late 16th century. Copper alloy, probably bronze, cast and chased, with Hercules between two lions. 31.5 x 26 cm. Given by Charles Fairfax Murray (M.27-1917).

CAT. 18 | FIG. 31
Mortar
Italian, Venice, early 16th century. Copper alloy, probably bronze, cast and chased, with nature-cast lizard. 14.5 x 10.4 cm (diam. of base)/16.5 cm (diam. of top). Given anonymously from the collection of Lt Col. the Hon. M.T. Boscawen, DSO, MC, in his memory (M.18-1979).

CAT. 19 | FIG. 24
Perfume burner
Vincenzo Grandi (c.1493–c.1578) and/or Gian Girolamo Grandi (1508–60), Padua, c.1530–60. Copper alloy, probably bronze, cast and chased, in imitation of an antique cinerary urn. 34.1 x 20.9 cm. Bequeathed by the Hon. Mrs Pamela Sherek from the collection of the late Lt Col. the Hon. M.T. Boscawen, DSO, MC, in his memory (M.7 & A-1997).

CAT. 20 | FIG. 15
Pharmacy jar with one handle
Italian, probably Florence or Siena, c.1440–60. Tin-glazed earthenware, painted in blue with a geometric design comprising debased Kufic script, knots and cross-hatched compartments. 24.5 x 16 cm (including handle). H.S. Reitlinger Bequest, 1950, transferred from the Reitlinger Trust, Maidenhead, 1991 (C.181-1991).

CAT. 21 | FIG. 16
Pharmacy jar
Italian, probably Pesaro, c.1470–90. Tin-glazed earthenware, painted with four busts of boys of different ages separated by gothic foliage, peacock's feather eye motifs and small fruits on scrolling foliage. 26.8 x 20.3 cm diam. F. Leverton Harris Bequest, 1926 (C.60-1927).

CAT. 22 | FIG. 17
Spouted pharmacy jar
Italian, probably Pesaro, c.1470–1500. Tin-glazed and painted earthenware, labelled 'OXIMEL SIMPˣ' (simple oximel, a syrup made by evaporating a mixture of clarified honey and vinegar). 23.8 x 17 cm. Purchased with the Glaisher Fund (C.2B-1932).

CAT. 23 | FIG. 18
Pharmacy jar
Italian, probably Castel Durante, c.1530–60. Tin-glazed earthenware, painted with stylized foliage, a pharmacy badge, and labelled 'VNGᵀᵒ D CERVSA' (*unguentum cerussa*, white lead ointment); 'L2/2' incised on base (the 'L' probably for *libbre*, pounds). 22 x 11.9 cm diam. Dr J.W.L. Glaisher Bequest (C.2187-1928).

CAT. 24 | FIG. 20
Two-handled pharmacy jar
Italian, Florence or Florence district, c.1420–50. Tin-glazed earthenware, painted in raised blue (*zaffera a rilievo*) on both sides with a pair of rampant lions back to back surrounded by sprays of stylized oak foliage. 25.8 x 23 cm. L.C.G. Clarke Bequest, 1960 (c.77-1961).

CAT. 25 | FIG. 33
Two-handled pharmacy jar
Italian, probably Siena, Montelupo or elsewhere in Tuscany, c.1510–30. Tin-glazed earthenware, painted with a woman (Fortitude?) holding a shield and spear in a landscape surrounded by grotesques, and labelled 'SLI Rᴼ I P' (*salvia ridotto praeparatio*; reduced sage preparation). 37 x 31 cm. H.S. Reitlinger Bequest, 1950; transferred from the Reitlinger Trust, Maidenhead, 1991 (c.185-1991).

CAT. 26 | FIG. 34
Pharmacy jar
Italian, Venice, probably workshop of Domenego da Venezia (1520/5–1569/74), c.1560–75. Tin-glazed earthenware, painted on one side with a cartouche enclosing a profile bust of a young man, and on the other, a label inscribed 'Mostarda Fᴬ' (*Mostarda fina*, a fruit pickle). 39.5 x 28.9 cm. C.B. Marlay Bequest (MAR.C.68B-1912).

CAT. 27 | FIG. 36
The Market Stall
Willem van Mieris (1662–1747), Netherlands, c.1730. Oil on panel. 41.9 x 35.9 cm. Founder's Bequest (36)

CAT. 28 | FIG. 40
Girl selling carp
German, Meissen, Saxony, c.1745–50. Hard-paste porcelain, painted in enamels, after plate 6 in the second set of *Études prises dans le bas Peuple ou les Cris de Paris*, engraved after drawings by Edmé Bouchardon (1698–1762), published in 1737; mark: faint crossed swords underglaze in blue. 19 x 12 cm. Given by Lord and Lady Fisher through the National Art Collections Fund, now The Art Fund (c.29-1954)

CAT. 29 | FIG. 41
Peasant woman selling apples
German, Meissen, Saxony, c.1745–50. Hard-paste porcelain, painted in enamels, modelled by J.J. Kaendler (1706–75); no mark. 17.7 x 11.9 cm. Given by Lord and Lady Fisher through the National Art Collections Fund, now The Art Fund (c.23-1954)

CAT. 30 | FIG. 38
Street cook with stove
English, Bow, c.1757–60. Soft-paste porcelain painted in enamels; copied from a Meissen figure by Christophe Huet (1700–59). 15.6 x 6.2 cm. From the Statham Collection accepted by H.M. Treasury in lieu of Inheritance Tax and allocated to the Fitzwilliam Museum (c.24-1992)

CAT. 31 | FIG. 39
Cheesemonger
German, Neudeck or Nymphenburg, Bavaria, c.1755–65 Hard-paste porcelain, painted in enamels, from a model by Franz Anton Bustelli (1723–63). 17 x 12.2 cm. Dr J.W.L. Glaisher Bequest (c.3179B-1928)

CAT. 32 | FIG. 44
Trinket Seller
German, Meissen, Saxony, c. 1745–50. Hard-paste porcelain, painted in enamels; mark: faint crossed swords in blue. 18.7 x 6.5 cm. Given by Lord and Lady Fisher through the National Art Collections Fund, now The Art Fund (c.9-1954)

CAT. 33 | FIG. 43
Tyrolean Woman selling Trinkets
German, Meissen, Saxony, c.1745–50. Hard-paste porcelain, painted in enamels and gilded; mark: crossed swords underglaze in blue; from a model by J.J. Kaendler (1706–75), reworked by Peter Reinicke (1711–68) in 1744. 16.7 x 6.3 cm. Given by Lord and Lady Fisher through the National Art Collections Fund, now The Art Fund (c.3-1954)

CAT. 34 | FIG. 42
Map Seller
German, Meissen, Saxony, c.1750. Hard-paste porcelain, painted in enamels and gilded, from a model by Peter Reinicke (1711–68) in 1744, after pl. 1 in the third

set of *Études prises dans le bas Peuple ou les Cris de Paris*, engraved after drawings by Edmé Bouchardon, published in 1739; mark: crossed swords underglaze in blue. 16.9 x 10.5 cm. Given by Lord and Lady Fisher through the National Art Collections Fund, now The Art Fund (c.26-1954).

CAT. 35 | FIG. 37
Knife, Scissor and Comb Seller
German, Meissen, Saxony, c.1745–7. Hard-paste porcelain, painted in enamels and gilded, after pl. 3 in the fourth set of *Études prises dans le bas Peuple ou les Cris de Paris*, published in 1742. 18.7 x 10.5 cm. Given by Lord and Lady Fisher through the National Art Collections Fund, now The Art Fund (c.31-1954).

CAT. 36 | FIG. 45
Do you want any matches?
Anthony Cardon (1772–1813) after Francis Wheatley (1747–1801). Stipple print in colour of pl. 4 of *The Cries of London*, published by Colnaghi & Co., 1794. 41.7 x 32.5 cm. G.E. Beddington Bequest (P.7-1959).

CAT. 37 | FIG. 46
Fresh gathered peas young Hastings
Giovanni Vendramini (1769–1839) after Francis Wheatley (1747–1801). Stipple print in colour of pl. 7 in *The Cries of London*, published by Colnaghi & Co., 1795. 41 x 31.5 cm (trimmed). G.E. Beddington Bequest (P.44-1959).

CAT. 38 | FIG. 47
Sweet China oranges sweet China
Luigi Schiavonetti (1765–1810) after Francis Wheatley (1747–1801). Stipple print in colour of pl. 3 in *The Cries of London*, published by Colnaghi & Co., 1794. 41.9 x 32.6 cm. G.E. Beddington Bequest (P.23-1959).

CAT. 39 | FIG. 48
New mackrel, new mackrel
Niccolo Schiavonetti (1771–1813) after Francis Wheatley (1747–1801). Stipple print in colour of pl. 5 in *The Cries of London*, published by Colnaghi & Co., 1795. 41.4 x 31.2 cm (trimmed). G.E. Beddington Bequest (P.25-1959).

CAT. 40 | FIG. 54
The church of St Mary-le-Bow in Cheapside, London
Thomas III Bowles (c.1712–67), London, c.1762–73. Engraving with hand colouring, a reissue of an earlier plate. 25 x 42.1 cm. C.B. Marlay Bequest (P.13247-R).

CAT. 41 | FIG. 50
Hand bill of Benjamin Layton
'China-Man and Glass-Seller', London, c.1769
Letterpress within decorative border on laid paper: '*Benjamin Layton*, / China-Man *and* Glass-Seller, / (from LONDON) / At his CHINA, GLASS, and *Staffordshire* WARE-HOUSE / opposite St. Michael's Church, *Walcot-Street*, BATH; / SELLS ALL SORTS OF / *Foreign* and *English* CHINA; / LIKEWISE / A great Variety of fine Cut GLASSES, / with both *Flower'd* and *Plain* ditto. / ALSO A GREAT ASSORTMENT OF / Best Cream-Colour WARE, / Such as *Plates* and *Dishes*, &c. / WITH / Stone and Earthen WARES, / WHOLESALE OR RETALE, at the very lowest Prices. / Good STONE PLATES at 2s. per Dozen. / Smaller ditto at 1s. 6d. for Dozen. / And all other GOODS Cheap in Proportion. / N.B. CHINA Rivetted and Rim'd in the neatest Manner. / Also safely Pack'd up.' Inscription on verso (handwritten in ink): 'Bath ye 14 April 1769 / Bo.t of Benjamin Layton / 14 Stone Chamber-pots 8d 0.8.0 4 Stone hand Basons 10d 0.3.4 4 Tumblers 0.2.0 1.13.4 / Rec.d the contents in full / Benj. Layton'. 19.5 x 15.5 cm. S.G. Perceval Bequest, 1922 (P.12923-R).

CAT. 42 | FIG. 51
Bill head of Robert Towson 'Wax Chandler',
London, c.1768
Unknown printmaker. Engraving on laid paper, with printed inscription: 'London [...] 17 [...] / Bought of Rt Towson Wax Chandler / In King Street Golden Square'; inscription in sheet centre (handwritten in ink): 'Blathwayt Esq March 1st [17]68 / £ L d / To 12 l of Sparm Light 1.1.0 / Receiv'd 1 March 1768 the above in full / & all Demands Rob Towson'. Sheet: 15.8 x 18.9 cm. S.G. Perceval Bequest, 1922 (P.12931-R).

CAT. 43 | FIG. 57
Trade card of Thomas Griffith 'Trunkmaker',
London, 1775
Engraving on laid paper: 'Thomas Griffith / Trunk Maker

/ at the Acorn in Mary-lebon Street / near Golden Square / LONDON / Makes & Sells all sorts of Strong / Travelling Trunks, Leather Portmanteaus, Vallees, / for Bedding, Canteens, Magazines, for Powder, Fire / Buckets, & Drinking Leather Jacks, Cudgel Hilts & / Ink Bottles, Travelling Standishes, & Wig Boxes, Strong / Cases for Plate, China & Glasses, & all sorts of Leather / Work at the Lowest Prices'; inscription in sheet upper centre (handwritten in ink): 'July 20 / 75 / Pd Griffith / a large chest'; inscription on verso (handwritten in ink): 'Mr Blaithwaite / July 20th 1775 B.t of Jos. Griffith A Large Strong Chest Iron Squar'd Best Lock 5.5.0 A small Packing Case 0.2.6 Square g. a Chest 0.2.6 5.10.0 Rece.d the Contents In full J Griffith'. Sheet: 19.8 x 14.8 cm. S.G. Perceval Bequest, 1922 (P.12928-R).

CAT. 44 | FIG. 55
Trade card of James Wade 'Tea, Coffee, Chocolate and Snuff seller', Bristol, 1754
Letterpress on laid paper: 'JAMES WADE, / At the SHOP the Upper-End of *Broad-Street*, / (Late of Mrs. ELIZABETH NOBLETT, his Partner, Deceas'd) / Continues to sell WHOLESALE OR RETAIL, / All Sorts of Tea, Coffee, and Chocolate, / Of the *finest* Flavour and Quality, as Cheap as in *London*. / > The TEA and COFFEE were purchased at the last *India* Sale, and are of the / newest Import; and the CHOCOLATE is made in the neatest Manner. / ALSO, SNUFFS of all Sorts. / *** STARCH and BLEWS, and LOAF-SUGAR, on the *lowest Terms*. / Printed by EDWARD WARD, at the *King's-Arms* on the *Tolzey*.'; inscription on sheet right (handwritten in ink): 'Mr Wade's bill / pd Feby. 28=1754'; inscription on verso (handwritten in ink): 'Mrs Blaithwd Feby ye 6th 1754 / ½ lb of Bohea Tea 5 / 0.2.6 / ½ lb of Green do 7 / 0.3.6 / 2 ½ lb Canisters 5 0.0.10 / 2 lb of Chocolate 3 / 10 0.7.8 0.14.6 Rec'd 28 Feb the Contents of the above / P. Sa.h Dyer'. 9.9 x 15.5 cm. S.G. Perceval Bequest, 1922 (P.12926-R).

CAT. 45 | FIG. 56
Trade card of Papegay 'Ladies Shoemaker from Paris', London, 1779
Unknown printmaker. Etching and engraving on laid paper with printed inscription: 'Papegay / Ladies Shoe Maker / FROM PARIS / No.77 / King Street, Golden Square'; inscription on sheet lower centre (handwritten in ink): 'Mrs Blathwayt, 29 Aous 1779 Aous 29 une paire de Sabous de Callemande 0.8.0 Garnie 0.1.6 1780 Fevrier 2 une paire de Sabous de Callemande 0.8.0 Garnie 0.1.6 Mars 24 une paire de Soulies de Castois 0.10.0 Ditto 31 une paire de Soulies de Callemande 0.8.0 £ s d 1.17.0 A London le 3 Avril 1780 Recus S (J?) Papegay In fols al demans'. Sheet: 20.2 x 19.9 cm. S.G. Perceval Bequest, 1922 (P.12990-R).

CAT. 46 | FIG. 49
Bill head of Francis Morley 'Grocer and Tea Dealer', London, 1766
Unknown printmaker. Engraving on laid paper with inscription on sheet upper centre in mixture of printed and handwritten in ink: '[Willm. Blathwaite Esq] London [Aprill 14] 17[66]'; on plate centre, printed: 'Bought of Francis Morley / Grocer and Tea Dealer. At the Green Canister against St Paul's Church Yard Cheapside'; inscription on sheet centre (handwritten in ink): 'Fine Green 1 [0 0] 10 / Coffee 1 / 2 6 [0] 3 / 1 Loaf 9 6 [0] 6.9 / Stone blue 1 [0] 2 / £1.1.9. Sheet: 15.8 cx 19.6 cm. S.G. Perceval Bequest, 1922 (P.12939-R).

CAT. 47 | FIG. 53
Bill head of John Pitts 'Ironmonger & Brazier', London, 1766
Unknown printmaker. Engraving on laid paper: printed inscription on plate centre: 'London / Bought of John Pitts Ironmonger & Brazier At ye Three Bells, in Great Queen Street, Lincolns Inn Fields'; on sheet centre (handwritten in ink): '1 large & Engraved Door plate 0.5.0 / May 16th 1768 / Rec.d the Contents in full of all demands / Pd J Pitts'. Sheet: 10.5 x 19.4 cm. S.G. Perceval Bequest, 1922 (P.12960-R)

CAT. 48 | FIG. 60
Trade card of Rowe Brown 'Breeches Maker', London, c.1772
Barak Longmate (1737–93). Etching with engraved lettering on laid paper; printed inscription on plate centre: 'Rowe Brown / Breeches Maker at the Mitre & Breeches, / in Silver Street Golden Square, / London. / Makes & Sells all Sorts of Buck & Doe / Skin Breeches, in the best & neatest manner; / Also Black Sham & all other Colours, / not to be distinguished from Cloth'; inscription on verso (handwritten

in ink): 'Blythward Esq. / Bought of Rowe Brown / Jun 8th 1772 / To fore pair of Livery Breeches 4.12.0 / To tow (sic) pair for Coach.n & Postillion 0.3.0 / Rec'd in full of all demands 4.15.0 / Pd Rowe Brown / June 4: 1772 pd / Brown'. Sheet: 21.1 x 16.8 cm. S.G. Perceval Bequest, 1922 (P.12615-R).

CAT. 49 | FIG. 52
Tradesman's list of Gubbins, Towne and Whitehead, 'Linen drapers', London, c.1775
Letterpress on laid paper: 'GUBBINS, TOWNE, / AND / WHITEHEAD, / Successors to the late MR. BAXTER, / AT THE / NAKED-BOY, in HENRIETTA-STREET, COVENT GARDEN, / SELL ALL SORTS OF / Childbed linen [... 14 lines listing items for sale, in two columns] / WHOLESALE and RETAIL. / N.B. Ladies French Quilted Waistcoats, and Stays of all Sorts'; inscription on verso (hand-written in ink): 'Mrs. Blathwaite / Dr. to Gubbins & Co / A pr. Silken Stays 1.11.6 / A Bush [?] / 0.1.0 / 1.12.6 / Rec. Apl. 5 1775 the / full Contents for self & Co. / A. Whitehead'. 18.7 x 15.8 cm. S.G. Perceval Bequest, 1922 (P.12670-R).

CAT. 50 | FIG. 116
Trade card of William Barber 'Tea Dealer', London, c.1785–1800
William Skelton (1763–1848) after Charles Reuben Ryley (c.1752-1798). Etching and engraving; a vignette of a Chinese tea plantation and a European lady reclining and taking tea in the company of a Chinaman who leans against a monumental plinth inscribed: 'WM. BARBER, / Tea Dealer, / no.21, / Leadenhall Street / LONDON', crowned with a colossal grasshopper (perhaps Barber's shop-sign). 8 x 12.6 cm. S.G. Perceval Bequest, 1922 (P.12867-R).

CAT. 51 | FIG. 58
Trade card of William Cornish's Tea Warehouse, Bristol, c.1790–1800
Jacob Cook (fl. 1790s) and George Johnson (fl. 1810-26) Etching and engraving; an image of Cornish's teashop and (below) a printed inscription: 'Cornish's / TEA WAREHOUSE, / 26 CLARE STREET, / BRISTOL. / Coffee, Chocolate, Cocoa, / Lump, Loaf and Refined Sugars'. 12 x 8 cm. S.G. Perceval Bequest, 1922 (P.12870-R).

CAT. 52 | FIG. 59
Trade card of John Vaughan Clarke 'Tea Dealer, Grocer, Pastry Cook & Confectioner', Bristol, c.1790–1800
Jacob Cook (fl. 1790s). Etching and engraving; a woman holding an anchor (a personification of Hope?) seated on a beach and pointing to a large rock with a printed inscription: 'Clarke, / TEA DEALER, GROCER. / Pastry Cook & Confectioner. / No.6 Wine Street, / BRISTOL.', with two further printed inscriptions above and below the framed image: 'Coffee, Chocolate & Cocoa' and 'Paste & Flour. Baking for Dinner'. 5.9 x 8 cm. S.G. Perceval Bequest, 1922 (P.12869-R).

CAT. 53 | FIG. 61
Travelling set of three beakers and caster, known as 'Ralph Lord Hopton's Little Kitchin of Silver Plate'
Silver; largest beaker: Pierre Maugin, Paris, c.1645-55; smaller beakers: possibly Monten family, The Hague, c.1649-50. Domed cover, inscribed 'Ralph Lord Hopton's Little Kitchin of Silver Plate'. 11.75 cm high. Given to Gonville and Caius College by Richard Watson (MA 1636) who was chaplain to Ralph, first Lord Hopton (c.1596-1652). Lent by the Master and Fellows of Gonville and Caius College, Cambridge.

CAT. 54 | FIG. 237
Travelling knife set
Probably German, c.1674. Unidentified cutler's mark: a star above (illegible). Steel, ivory and silver; case of wood covered in pearl ray shagreen with white metal mount. One knife handle is engraved and inlaid in silver wire with 'AN: GOTTES: SE / EN: IST: ALLES' and the other, 'GELEGEN / ANNO: 1674'. Case: 17 cm high; knives: 13.5 and 13.3 cm long. Given by T.J.G. Duncanson from the Frank Smart Collection (M.51A-C-1930).

CAT. 55 | FIG. 64
Travelling canteen
Thomas Townley, London, c.1685. Beaker and cutlery: silver, the cutlery with detachable handles; the knife with steel blade; the beaker engraved with putti and floral motifs, engraved with the monogram 'JEM' and on the underside, 'The Guift [sic] of The Hono[ura]ble Lady Tipping April ye 15. 1708'. Case of wood covered in shagreen, with green velvet lining and silver binding. Case: 11.8 x 10 cm diam.; beaker:

8.1 x 8 cm diam.; knife: 17.6 cm long; fork: 16.5 cm long; spoon: 18.5 cm long; bowl 4.2 cm wide; spice-box: 5.3 x 3.7 x 1.1 cm depth. Lent by Jonathan Gray from the Bill Gray Collection (AAL.38-2009).

CAT. 56 | FIG. 65
Verge alarm coach watch
Movement: Thomas Windmills, London, c.1725; case probably by Sarah Jaques and John Lee, London. Movement: brass, silver and steel, engraved 'Thomas Windmills LONDON 7303'. Dial: silver champlevé with blued steel hour and minute hands. Case: silver, pierced and chased with four repoussé panels from Aesop's Fables. Interior stamped with maker's mark incuse 'SI IL'. Case: 13.9 x 12.6 diam. x 6.1 cm depth. L.C.G. Clarke Bequest, 1960 (M.109-1961).

CAT. 57 | FIG. 78
Soldier with a girl
Jacob A. Duck (c.1600–67), Netherlands, c.1650-60. Oil on copper. 15.5 x 13.2 cm. Daniel Mesman Bequest, 1834 (338).

CAT. 58 | FIG. 77
A boy drinking
Cornelis Picolet (1626–73), Netherlands, mid-17th century. Oil on panel. 15.5 x 12.3 cm. Daniel Mesman Bequest, 1834 (406).

CAT. 59 | FIG. 85
Lidded peg tankard
Neils Enevoldsen (active 1648–61), Copenhagen, 1648 Silver, embossed and engraved; the tankard stands on four cast bear feet and has eight pegs inside; cover engraved with a coat-of-arms within a floral border, and has a cast bear thumbpiece. 22.6 x 23.2 x 19.2 cm diam. L.C.G. Clarke Bequest, 1960 (M.56-1961).

CAT. 60 | FIG. 86
Tankard
English, early 18th century. Pewter (unmarked), decorated with gadrooning. 13.4 x 9.6 cm (diam. of base). A.F. de Navarro Bequest (NAV.34-1933).

CAT. 61 | FIG. 89
Hunting mug
English, Vauxhall (Type A), dated 1729. Brown salt-glazed stoneware with applied sprigs of George II and Queen Caroline, beefeaters, and a clockwise hare hunt. Inscribed (around top): 'Lett us Drink whilst we have Breath for there is no Drinking after Death', and lower down, 'Mary Culliford 1729'. 20.9 x 20 cm. Dr J.W.L. Glaisher Bequest (C.1197-1928).

CAT. 62 | FIG. 80
Ale glass
English, c.1750. Lead glass, with waisted bowl, air twist stem and domed foot. 28.7 x 9.7 cm diam. Donald H. Beves Bequest (C.269-1961).

CAT. 63 | FIG. 62
Trade card of Harker at the Talbot, Malton Innkeeper
Unknown printmaker, c.1765–80. Engraving on laid paper; printed inscription on plate centre: 'HARKER / AT THE TALBOT, MALTON / NEAT POST CHAISE' and below: l s d / Eating / Wine / Punch / Negus / Rum Brandy & c / Tea & Coffee / Ale Porter & Tobacco / Cyder / Servants Eating & Liq / Horses Hay & Corn / Chaise £'; the bill comes to 16/5 (Eating: 3/9; Wine 5/; Tea: 2/3; Ale Porter 11d; Servants: 4/6). 15.7 x 10 cm. S.G. Perceval Bequest, 1922 (P.12951-R).

CAT. 64 | FIG. 63
Trade card of John Ringrose at Bluitt's Inn, York
Unknown printmaker, c.1786–90. Engraving on laid paper; printed inscription on plate centre: 'J Ringrose, / BLUITTS INN, YORK' and (below), handwritten in ink: 'July 4 l s D / Tea 0.1.0 / Supper 0.6.0 / Wine 0.3.9 / Rum 0.0.3 / Malt Liqs 0.0.6 / Stroberreys 0.0.6 / Wax Candles 0.2.0 / 5 Breakfast 0.3.0 / Sev.ts Eating & Liqs 0.6.0 / [Total:] 1.3.0 / Lobster -.1.4 / [Grand total:] 1.4.4'. 19.7 x 10.6 cm. S.G. Perceval Bequest, 1922 (P.12956-R).

CAT. 65 | FIG. 87
Puzzle jug
English, probably London (either Lambeth Pottery or Rotherhithe Pottery), 1686. Tin-glazed earthenware, with pierced body containing a two-headed bird, painted in blue and manganese-purple, the foot encircled by Chinese *ju-i*

motifs, the body decorated with flowers, leaves and insects, the handle with Chinese scrolls; initialled and dated (on the shoulder) 'P/NM/1686'. 23 x 15 cm. Dr J.W.L. Glaisher Bequest (C.1441-1928).

CAT. 66 | FIG. 192
Harvest jug
English, North Devon, 1724. Earthenware, slip-coated with incised decoration under lead-glaze, bulbous body, initialled and dated at front 'WH 1724' within a heart, with a thistle below and the crude busts of a man and woman, each above a cartouche with the date repeated, on either side; below the handle is a thistle, whilst over the rest of the body except the shoulder are birds and formal tulips. On the shoulder is the inscription: 'Now i am come for to supply your workmen / when in haruist dry when they do labour hard and sweat good drink is better far than meat. / In winter time when it is cold i likewayes then good ale can hold / All seasons do the same require and most men so strong drink desire'. 32.5 cm high. Dr J.W.L. Glaisher Bequest (GL.C.59-1928).

CAT. 67 | FIG. 193
Beer jug
English, London, 1739/40. Silver, with gilded interior, a blank Rococo cartouche engraved on the front under the spout, the handle cast in the form of a dolphin. 22.2 x 17.9 cm. Lent by Jonathan Gray from the Bill Gray Collection (AAL.30-2009).

CAT. 68 | FIG. 79
Jug
English, London or Bristol, 1749. Tin-glazed earthenware, painted in blue, on the front, a putto holds a punch bowl over a family dining surrounded by scrollwork with the date '1749' below; at left: three serving men, one of whom holds a mug; at right: a lady and gentleman strolling in a garden and a man spilling liquid from a jug. 18.2 x 23.6 cm. Dr J.W.L. Glaisher Bequest (C.1533-1928).

CAT. 69 | FIG. 84
Bottle for Claret
English, probably Southwark, 1647. Tin-glazed earthenware, painted in blue with 'CLARIT/1647' between stars. 11.6 x 10 cm. Dr J.W.L. Glaisher Bequest (C.1304-1928).

CAT. 70 | FIG. 189
Posset-pot and cover
English, Staffordshire, 1692. Slip-coated earthenware, slip-trailed with tulips and vesica motifs, and the inscription 'THE BEST IS NOT TOO GOOD FOR YOV 1692' under lead-glaze; the cover is probably associated (i.e. contemporary but not original to the pot). 22.8 x 29 cm. Dr J.W.L. Glaisher Bequest (C.286 & A-1928).

CAT. 71 | FIG. 88
Spirit flask
English, Nottingham, 1723. Brown salt-glazed stoneware, incised 'Ioseph Poyne 1723'. 11.4 x 10.5 cm diam. Dr J.W.L. Glaisher Bequest (C.1232-1928).

CAT. 72 | FIG. 81
Ceremonial goblet
English, or possibly Norwegian, late 17th century. Lead glass, with moulded gadrooning round bowl base and on the cover, applied scrolls on the knopped finial, and a figure-of-eight stem. 53.8 cm high. Donald H. Beves Bequest (C.608 & A-1961)

CAT. 73 | FIG. 82
Drinking glass
English, c.1765. Lead glass, with ogee-shaped bowl, and red and opaque white twist stem. 13.5 x 7.1 cm diam. Donald H. Beves Bequest (C.553-1961)

CAT. 74 | FIG. 90
Punch bowl
English, London, probably William Griffith, Lambeth High Street, 1758. Tin-glazed earthenware, painted in blue with some red and yellow; interior decorated with a hunting scene within a scrolled border and a ribbon inscribed 'Prosperity to Fox Hunting 1758'; exterior with an Oriental coastal landscape. 11.8 x 30.7 cm diam. Dr J.W.L. Glaisher Bequest (C.1601-1928).

CAT. 75 | FIG. 91
Tobacco pipe
English, Oswald Type 8, c.1680–1710. Brown clay, fired, undecorated. 39.2 cm long x 4.5 cm high; bowl 2 cm (diam.).

Lent by the Museum of Archaeology and Anthropology, University of Cambridge (1966.222).

CAT. 76 | FIG. 92
Tobacco pipe
English, Staffordshire, c.1750–70. Earthenware, the bowl moulded in the form of a fish being eaten by a snake coiled round the stem, and decorated with coloured lead-glazes. 16.6 cm long x 2.4 cm high. Given by Frank Partridge (EC.2-1941).

CAT. 77 | FIG. 94
Snuffbox
English, London, early 18th century (after 1707). Tortoiseshell, with applied cast silver plaques of Charles I and Queen Anne flanking the Boscobel Oak (which harboured Charles II after the Battle of Worcester, 1651), engraved at its base with two horsemen, and the inscriptions 'Thomas Haines' and on a ribbon below 'SACRA IOVI QUERCUS' (sacred oak of Jove) from Ovid's *Metamorphoses*. 3.5 x 11 cm. Given by C. Fairfax Murray (M.12-1917).

CAT. 78 | FIG. 95
Snuffbox
French or English, c.1730–60. Tortoiseshell, with chased gilt-metal mounts, and gold piqué point decoration. Inside the lid: a vignette in bodycolour, probably on card, under glass, showing a lady at her *toilette* whilst attended by a servant bringing hot chocolate. 1.6 x 8 cm. Given by Dr and Mrs J.C. Burkill (M.58-1984).

CAT. 79 | FIG. 71
Nobody smoking a pipe
English, probably Brislington, Somerset, 1675. Tin-glazed earthenware painted in blue, turquoise green and orange, and inscribed on the underside of the base, '*M*/*R*M*/*1675*', probably derived from the woodcut frontispiece to the play, *Nobody and Somebody*, London, 1606. 23.4 x 10.6 cm (diam. of base). Dr J.W.L. Glaisher Bequest (C.1433-1928).

CAT. 80 | FIG. 93
Dish
English, Samuel Malkin, Burslem, Staffordshire, c.1715–30 Earthenware, moulded and decorated with slip under lead-glaze; the initials 'S' and 'M' and the inscription 'Wee three Logerheads' are moulded integrally with the dish. 6.7 x 35.5 cm diam. Purchased with the Glaisher Fund (EC.3-1942).

CAT. 81 | FIG. 169
Covered tobacco jar
French, Mennecy, c.1750–60. Soft-paste porcelain, painted with flowers in polychrome enamels; incised 'DV' on base 16.4 x 8.7 cm diam.; diam of cover: 9 cm. Given by Mrs W.D. Dickson (C.9 & A-1947).

CAT. 82 | FIG. 96
The Misses Lethieullier and Captain Walker taking tea and snuff
Dutch or English, c.1715–16. Oil on canvas. 63.5 x 76.2 cm Lent by the Victoria and Albert Museum, London (P.51-1962).

CAT. 83 | FIG. 100
Tea bowl
Unidentified silversmith (mark: GS with crown above and crescent below), English, London, 1683/4. Silver with engraved chinoiserie decoration of scrolling foliage and ho-ho birds. 4.1 x 8.2 cm diam. Purchased with the F. Leverton Harris Fund (M/P.1-1944).

CAT. 84 | FIG. 101
Tea bowl, saucer and slop bowl
Germany, Meissen, Saxony, c.1725–30. Hard-paste porcelain, painted in enamels with chinoiserie, lustred and gilded. Mark: 35 in gold. Cup: 4.5 x 7.8 cm diam.; saucer: 12.5 cm diam.; slop bowl: 18 cm diam. Given by Sir Richard Jessel (C.10A-C-1972).

CAT. 85 | FIG. 112
Cup and saucer (*Gobelet* **or** *tasse à quatre pans ronde et soucoupe***)**
French, Vincennes, c.1750–2. Soft-paste porcelain, of quatrefoil form, painted with flowers in polychrome enamels and gilded. Cup: 4.8 x 10 cm (with handle); saucer: 3 x 13.2–14.1 cm diam. Given by the Friends of the Fitzwilliam Museum (C.9 & A-1951).

CAT. 86 | FIG. 97
Tea caddy
English, Staffordshire, c.1755–65. Earthenware, press-moulded with a row of asterisks above a geometrical pattern under green lead-glaze. 12 x 9.2 x 6.5 cm deep. Dr J.W.L. Glaisher Bequest (C.698-1928).

CAT. 87 | FIG. 103
Double tea caddy
English, Nottingham, or possibly Crich, Derbyshire, c.1770. Lustrous brown salt-glazed stoneware, moulded with two mermaids on each side, with the initials 'EH' and '1770' scratched on the base. 13 x 16 x 6 cm deep. Dr J.W.L. Glaisher Bequest (C.1240-1928).

CAT. 88 | FIG. 118
Teapot
Dutch, Metal Pot Factory, Delft, c.1691–1724. Earthenware, tin-glazed black, and painted in polychrome with chinoiserie landscapes; mark: 'LVE' monogram (for Lambertus van Eenhoorn, proprietor of the factory 1694–1721) with part of a '5' below. 13 x 17.5 cm. Dr J.W.L. Glaisher Bequest (C.2723 & A-1928).

CAT. 89 | FIG. 102
Teapot
German, Meissen, Saxony, c.1710–20. Böttger red stoneware, mould-cast, cut, polished and embellished with an amethyst and rock crystal band set in silver around the neck; a single rock crystal in a silver-gilt mount forms the thumbpiece on the handle, and the rim of the spout has a gilt-metal mount 10.5 x 4 cm. Given by L.C.G. Clarke, MA (EC.48-1943).

CAT. 90 | FIG. 212
Teapot
English, Staffordshire, c.1755–65. Dark cream earthenware, moulded in the shape of a pineapple, and decorated with yellow and green lead-glazes. 15.3 x 17 cm. Dr J.W.L. Glaisher Bequest (C.707 & A-1928).

CAT. 91 | FIG. 119
Teapot
English, probably Staffordshire, c.1750–70. Red dry-bodied stoneware with applied moulded vine sprays, black lead-glaze and oil-gilding. The pot stands on three lion's mask and paw feet, and has a crabstock handle and spout, and a bird finial on the cover (head restored). 12 x 18.1 cm. Dr J.W.L. Glaisher Bequest (C.709 & A-1928).

CAT. 92 | FIG. 98
Toy tea service
English, Liverpool, c.1750–60. Tin-glazed earthenware, painted in blue with landscapes, comprising a teapot, jug, slop bowl and three cups and saucers. Teapot: 9.2 cm high; jug: 6.3 cm high; slop bowl: diam. 6.8 cm; cups: 2.6–2.9 cm high; saucers: diam. 10.2 cm. Dr J.W.L. Glaisher Bequest (C.1554 & A-1-1928).

CAT. 93 | FIG. 120
Wall plaque
Dutch, Delft, second half 18th century. Earthenware, moulded with two shells and scrolled round the edge, and painted in blue with vases, spittoons, baskets and teapots reserved in a yellow ground. 23 x 24.5 cm. Dr J.W.L. Glaisher Bequest (C.2672-1928).

CAT. 94 | FIG. 99
Part tea and coffee service
English, New Hall Porcelain Factory, near Newcastle-under-Lyme, Staffordshire, c.1785 (pattern no. 223). Hybrid hard-paste porcelain, painted in pink enamel and gilded, comprising a silver-shape teapot, milk jug, covered sugar basin, slop basin, two tea bowls, two coffee cans, two saucers and two plates of different sizes. Teapot: 14.4 x 24.1 cm; sugar basin: 13.5 x 10.3 cm diam.; basin: 14 x 15.2 cm diam.; jug: 11.5 cm high; plate (1): 3.1 x 20.1 cm diam.; plate (2): 3.2 x 23.8 cm diam.; coffee can: 6.6 cm high; tea bowl: 6.1 x 7.6 cm diam.; saucer: 3.2 x 13.1 cm diam. Given by Miss Stephanie Godfrey (C.11A-L-1988).

CAT. 95 | FIG. 107
Chocolate beaker
German, Meissen, Saxony, c.1713–20. Hard-paste porcelain, unpainted in imitation of blanc de chine, with applied decoration. 8 x 7.5 cm (8.8 cm with handle). Given by Lt Col. Kenneth Dingwall, DSO (C.4-1923).

CAT. 96 | FIG. 110
Coffee beaker
Austrian, Imperial Porcelain Factory, Vienna, c.1765–75. Hard-paste porcelain, painted in polychrome enamels and gilded, with a lady holding a closed fan and the inscription, 'a l'angloise [sic]' (in the English manner) in gold. Mark: a shield underglaze in greyish-blue; '10' and 'o' in red enamel 7 x 8 cm. C.B. Marlay Bequest (MAR.C.52-1912).

CAT. 97 | FIG. 108
Covered cup and saucer, probably for chocolate or caudle
English, Chelsea-Derby, c.1770–5. Soft-paste porcelain, painted in enamels with flowers. Cup: 13 x 12.7 cm; saucer: 3.8 x 14.5 cm diam. Given by Mrs W.D. Dickson (C.85 & A & B-1932).

CAT. 98 | FIG. 106
Chocolate pot
Michel II Delapierre (master 1737; recorded 1785), French, Paris, 1758/9. Silver, partly gadrooned and engraved with an unidentified coat-of-arms; the turned wooden handle at right angles to the spout; supported on three feet. 9.4 x 15.8 cm (including handle). L.C.G. Clarke Bequest, 1960 (M.59-1961).

CAT. 99 | FIG. 113
Chocolate pot
English, Staffordshire, c.1760–5. Red dry-bodied stoneware, thrown and turned; the domed lid has a smaller second lid fitting into a circular aperture in its top; base impressed with a pseudo-Chinese seal mark. 21.5 x 15.3 cm. Dr J.W.L. Glaisher Bequest (C.450 & A & B-1928).

CAT. 100 | FIG. 105
Chocolate pot
German, Nymphenburg, c.1765. Hard-paste porcelain, painted in enamels and gilded. Mark: a shield and 'o' impressed. 17.3 x 15.5 cm. Given by Mrs W. D. Dickson (C.61 & A-1950).

CAT. 101 | FIG. 109
Coffee pot
English, Staffordshire, c.1763–70. Red dry-bodied stoneware, with a moulded handle and spout and mould-applied sprigs of Britannia with a lion, the Union Jack, a shield bearing the number '45' and a Chinese figure under a parasol. 21.7 x 20.3 cm. Dr J.W.L. Glaisher Bequest (C.463 & A-1928).

CAT. 102 | FIG. 104
Coffee pot
John Swift, London, 1763–4. Silver with a wooden handle; pear-shaped body and domed cover embossed and chased with Rococo-style scrolls and flowers. 28.8 x 23.5 cm. C.B. Marlay Bequest (MAR.M.21-1912).

CAT. 103 | FIG. 123
Portrait roundel
English, c.1530–40. Wood, carved in relief with an unidentified male head in right profile, found in Corpus Christi College, Cambridge, in 1852. 23.9 x 21.9 cm. Lent by the Museum of Archaeology and Anthropology, University of Cambridge (1883.692 G[1]).

CAT. 104 | FIG. 123
Portrait roundel
English, c.1530–40. Wood, carved in relief with an un-identified female head in left profile, found in Corpus Christi College, Cambridge, in 1852. 24.1 x 24.7 cm. Lent by the Museum of Archaeology and Anthropology, University of Cambridge (1883.692 G[2]).

CAT. 105 | FIG. 124
Purse
English, 1550–1600. White leather, purse shaped with button on the bottom and two braided buttons on the top edge, top edge decorated with slits; found under the floor of the Shoe-maker's Room, Old Court, Corpus Christi College, Cambridge, in 1852. 15.8 cm long x 9 cm wide (opening). Lent by the Museum of Archaeology and Anthropology, University of Cambridge (1883.692 F).

CAT. 106 | FIG. 125
Pair of shoes
English, 1550–60. Black leather with slashes, found under the floor of the Shoe-maker's Room, Old Court, Corpus Christi College, Cambridge, in 1852. Right shoe 25.4 x

10.1 cm (max); left shoe 26 x 9.8 cm (max). Lent by the Museum of Archaeology and Anthropology, University of Cambridge (1883.692 B).

CAT. 107 | FIG. 121
A man in slashed costume
German, probably Saxony, 1606. Earthenware decorated with opaque white, brown, green, and yellow glazes and inscribed on the base 'IF 1606'. 36.2 x 16.5 cm. Purchased with funds given by Professor Stanley Cook in memory of his wife (EC.4-1942).

CAT. 108 | FIG. 132
A bearded man holding gloves
Georg Holdermann (1585–1629), Nuremberg, c.1600–25
Wax, coloured flesh-pink, red, brown and black, mounted in a glass-fronted wooden box. Box 11 x 10 x 4.7 cm. Edward Joseph Pyke Bequest (M.4-1996).

CAT. 109 | FIG. 131
attr. Hans Weigel (1549–c.1578),
Habitvs praecipvorvm popvlorvm … Trachtenbuch …
Nuremberg, 1577. Book with hand-coloured woodcuts on paper, mostly by Jost Amman (1539–91), bound in late 16th-century calf, with gilt decoration, in England; stamped with initials 'GC' twice on upper and lower corners. Trinity College Library, Cambridge: L.11.33 (illustrated: frontispiece and plate V, leaf B1/recto). Lent by the Master and Fellows of Trinity College, Cambridge.

CAT. 110 | FIG. 127
Hat badge or ensign converted to a pendant
Possibly by Pierre II Pénicaud (active mid-16th century), Limoges, Haute-Vienne, c.1550–75. Copper, enamelled in grisaille technique with a battle scene, and pierced by two holes for attachment to a hat, set in a circular metal mount with a suspension loop. Mount: 6 x 4.8 cm diam. L.C.G. Clarke Bequest, 1960 (M.118-1961).

CAT. 111 | FIG. 126
Man's cap
English, late 16th/early 17th century. Linen, embroidered with polychrome silks, silver and silver-gilt threads, and silver spangles edged with metal thread bobbin lace; with a design of coiling stems with flowers and foliage enclosing birds and butterflies. 28.6 x 29 cm. Given by L.C.G. Clarke (T.9-1947).

CAT. 112 | FIG. 134
Powder flask
European, c.1600–20. Circular, inlaid with brass and ivory. 15.2 x 13.5 x 4.8 cm. James S. Henderson Bequest (HEN.M.452-1933).

CAT. 113 | FIG. 135
Priming flask
European, c.1700–60. Steel, inlaid with silver in relief showing two vignettes of a courting couple. 9.8 x 5 cm. Given by T.G. Duncanson from the Frank Smart Collection (M.68 & A-1930).

CAT. 114 | FIG. 172
Cane handle with snuffbox
English, Bilston, Staffordshire, c.1750–75. Baluster-shaped, copper, enamelled handle for a walking cane, set with a gilt-metal snuffbox, and painted with three polychrome miniatures on a pale blue ground. 5.5 x 4.5 cm diam. L.C.G. Clarke Bequest, 1960 (M.101-1961).

CAT. 115 | FIG. 166
Cane handle
German, Neudeck or Nymphenburg, Bavaria, c.1759–60. Hard-paste porcelain, press moulded in the form of the bust of a young woman, painted in polychrome enamels and gilded. 8 x 3.5 cm. Purchased with the Dr F.R. Cowper Reed Fund (C.8-1950).

CAT. 116 | FIG. 129
Reconstruction of Matthäus Schwarz's slashed costume of 1530 based on illustration no. 102 in his *Trachtenbuch*
Jenny Tiramani, London, 2012. White linen shirt, red silk satin and yellow silk damask paned doublet, yellow deerskin hose with red silk taffeta interlining, black sheep's wool knitted cap, black leather horn-toed shoes, black silk velvet sword girdle and red silk velvet bag. Lent by Jenny Tiramani, The School of Historical Dress, London.

CAT. 117 | FIG. 128
Young man in a fur cloak
Workshop of Jacopo Tintoretto (1518–94), Venetian, 1558. Oil on canvas, dated 'MDLVIII'. 117.5 x 92.1 cm. C.B. Marlay Bequest, 1912 (M.80).

CAT. 118 | FIG. 133
Composite armour
European, mainly South German, c.1530–60. Composite armour, comprising a collar, cuirass with skirt and long tassets, codpiece, pair of pauldrons and burgonet and buffe. Steel, hammered, shaped, riveted, hinged, with incised decoration and recessed borders, with brass and iron rivets and buckles. 134 x 76 x 47 cm. Given by Mrs E.W. Stead and Mr Gilbert Stead (M.1.4A-E-1936).

CAT. 119 | FIG. 142
Young woman wearing a beret
German, Nuremberg, c.1520–30. Honestone, carved in relief, possibly after a drawing by Hans Schwarz (1492–after 1521) 5 x 4.2 cm; framed: 12.4 x 11.4 x 2.4 cm. C.B. Marlay Bequest (MAR.M.264-1912).

CAT. 120 | FIG. 145
Dish
English, Brislington, Somerset, 1688. Earthenware tin-glazed pale duck-egg blue, and painted in blue. A cat, an owl and a monkey wearing lace headdresses and tippets, six verses from a satirical ballad, 'The Alomode or yᵉ Maiden's Mode Admir'd & Continue'd by yᵉ Ape Owl & Mistris Puss' and '1688'. 8.3 x 39.5 cm diam.. Dr J.W.L. Glaisher Bequest (C.1443-1928).

CAT. 121 | FIG. 144
Locket with portrait miniature
Portrait: school of Isaac Oliver (1556(?)–1617), English, early 17th century. Watercolour on vellum on card, possibly depicting Elizabeth, Countess of Rutland (1585–1612). Locket: gold, blue smalt and enamel. Portrait: 5.4 x 4.2 cm. L.D. Cunliffe Bequest, 1937 (3867).

CAT. 122 | FIG. 69
Woman's coif
English, c.1575–1625. Linen, embroidered in polychrome silk, silver and silver-gilt thread. A design of coiling stems terminating in alternating sprays of oak leaves and strawberries. 20.3 cm high. Given by the Friends of the Fitzwilliam Museum (T.6-1946).

CAT. 123 | FIG. 70
Purse
English, c.1580–1600. Linen, embroidered in polychrome silk, silver and silver-gilt thread worked in a geometric diaper pattern. 8 x 7.25 cm. Donor unknown, found in a drawer in the Fitzwilliam library (T.13-1943).

CAT. 124 | FIG. 136
Purse
English, c.1600–25. Linen, embroidered in polychrome silk, silver and silver-gilt thread; drawstring missing. Each of the eight compartments decorated with coiling stems bearing flowers. Purse: 7.5 x 7.6 cm; height with tassel and strap: 24.5 cm. S.G. Perceval Bequest (T.3-1922).

CAT. 125 | FIG. 122
Portable mirror in octagonal gilt-metal frame
Probably by François I Limosin (c.1580–1646), Limoges, Haute-Vienne, c.1600–20. Copper plaque decorated in translucent and opaque enamels, the border partly over *paillons* (silver foil), and gilded. Gilt-metal frame enclosing a mirror with Diana and Callisto. 10.4 x 7.2 cm. L.D. Cunliffe Bequest, 1937 (M.11-1938).

CAT. 126 | FIG. 137
Pair of earrings
English, c.1790–1800. Mother-of-pearl surrounded by marcasites set in silver openwork. 2 x 2.3 x 1.2 cm. Given by Mrs J. Hull Grundy (M.4A & B-1984).

CAT. 127 | FIG. 143
Unknown Lady
Hans Eworth (active 1540–74), English, c.1550–5. Oil on panel. 109.9 x 80 cm. Bruce Stirling Ingram Bequest (PD.1-1963).

CAT. 128 | FIG. 138
Under-bodice
English, c.1700–30. Cream linen, the upper part padded and

lined with cream linen, the fronts and skirt lined with cream silk. Embroidered, with the exception of the upper part of the back, in puce, green, brown and cream silk threads in satin and chain stitches with chinoiserie and animal motifs against a background scattered with slender leaves. Edges bound with silk ribbon. Bust: 72 cm; waist: 62 cm; shoulder to hem: 57 cm long; nape to waist: 31 cm long. Given by J.N. Peyton (T.26-1981).

CAT. 129 | FIG. 139
Under-bodice
English, c.1700–30. Linen, lined and interlined with linen, quilted with cord padding with cream silk in back stitch, eyelet holes in front (for cord lacing), and bound with silk ribbon. Interlacing design enclosing a variety of contemporary quilting patterns. Bust: 80 cm; waist: 65 cm; shoulder to hem: 55 cm long; nape to waist: 38 cm long. Given by Miss Barr and Miss Prentis (T.1-1940).

CAT. 130 | FIG. 146
A Woman holding a small watch and a closed fan
British, c.1750–70. Mezzotint showing a young woman, three-quarter length, standing; wearing a low dress with elaborate lace sleeves, and holding a closed fan in her left hand, and a small watch in her right. 34.4 (plate-mark trimmed) x 25.3 cm. Bought from the Perceval Fund with the aid of a donation from Louis C.G. Clarke, MA (P.379-1947).

CAT. 131 | FIG. 148
Folding fan, known as the Messel Mica Fan
European, late 17th century. Mica panels painted with polychrome flowers, children and dogs, mounted in double paper, with bone sticks and guards. 25.8 cm long (guards) x 45 cm wide (open). Purchased with a grant from the National Heritage Memorial Fund and a gift from the Friends of the Fitzwilliam Museum (M.359-1985).

CAT. 132 | FIG. 147
Brisé fan
Possibly Chinese or European, probably painted in Holland, c.1710–20. Ivory sticks, pierced, painted in red, green, slate blue, brown, black, and gold, the head strengthened with tortoiseshell, decorated with Chinese-style decoration. 25.5 cm long (guards) x 39 cm wide (open). Purchased with a grant from the National Heritage Memorial Fund and a gift from the Friends of the Fitzwilliam Museum (M.85-1985).

CAT. 133 | FIG. 149
Folding *trompe l'oeil* fan
English, c.1750. Paper (or skin?) leaf painted in polychrome body colour with a ham on a plate, a print, a painting, a book, a watch and a lute, and on the back with books and sheet music; pierced bone sticks and carved bone guards. 25.7 cm long (guards) x 49 cm wide (open). Purchased with a grant from the National Heritage Memorial Fund and a gift from the Friends of the Fitzwilliam Museum (M.205-1985).

CAT. 134 | FIG. 186
Folding *trompe l'oeil* fan
Francesco Stagni, possibly Bologna, 1771. Drawn and painted on 'chickenskin' (thin kid); sticks and guards of ivory, pierced and gilt. Dated 1771 on front and back and signed by Francesco Stagni. The fan is decorated to give the impression of a desk scattered with papers and strings of coloured pearls. The design on the back includes a drawing of a letter, headed 'Bologna, June 1771', and is signed 'Gaspare Lamar'. 28.4 cm long (guards) x 51.5 cm wide (open). Purchased with a grant from the National Heritage Memorial Fund and a gift from the Friends of the Fitzwilliam Museum (M.2-1985).

CAT. 135 | FIG. 151
Verge watch shaped as a skull
Raymond Champenois (d. 1678), Paris, c.1670. Movement: silver, brass and steel, engraved 'Champenois A Paris'. Dial: white enamel on gold plate with blued steel sword-shaped hour hand. Case: silver shaped as a skull, lower jaw opening to reveal dial. Case: 4.2 x 2.8 x 3.3 cm. F.G. Smart Bequest (M/P.54-1913)

CAT. 136 | FIG. 152
Verge watch
Movement: Luke Richards, London, c.1685; inner case possibly by Urian Berrington (d. c.1716). Movement: silver, brass and iron, engraved 'L Richards London'. Dial: silver champlevé with blued steel waved minute hand and small seconds hand. Centre of seconds ring has two cartouches, the top engraved 'Ri / chards', the lower 'London'. Central blued

steel disc with inset silver moon, gold sun and plain steel clouds and stars. Inner case: plain silver body, stamped inside 'vb', scratch marks '4191' and 'u/-/-', 'AD1648 5 (reversed) m' and '366'. Associated outer case of plain silver with steel catch, lining missing. Verge watch with seconds and sun and moon dial in silver pair case. 3.3 x 5.4 cm diam. F.G. Smart Bequest (M/P.37 & A-1913).

CAT. 137 | FIG. 153
Verge watch
English, London, c.1690. Inner case possibly by either William Cooper or William Ginn. Movement: Silver, steel, iron, and brass, engraved 'Tho,Tompion LONDON', although not by him. Dial: gold with centre scene of fruit bowl being pecked by flanking birds, with foliage decoration and a cherub above 6 o'clock, and blued steel hand. Inner case: plain silver-gilt, stamped inside with maker's mark 'WC' or 'WG'. Outer case: dark shagreen covering. 3 x 5.5 cm diam. S.G. Perceval Bequest, 1922 (PW.52 & A-1923).

CAT. 138 | FIG. 162
Cylinder watch and chatelaine
Movement: William Webster (active 1734–66), London, 1761/2; inner and outer case: Stephen Goujon (active 1720–after 1760); chasing of outer case: George Michael Moser (1706–83). Movement: silver, steel, iron and brass, engraved 'WM WEBSTER EXCHANGE ALLEY 2553' and on cap 'WM WEBSTER LONDON 2553'. Dial: white enamel on copper with gold, Louis XV type hands. Inner case: plain gold with London hallmark for 1761, stamped '2553' maker's mark incuse 'SG'. Outer case: gold repoussé bezel and body, with maker's mark incuse 'SG', signed at bottom 'G.M. Moser. f.', with a scene of *Venus presenting arms to Aeneas*. Watch papers: one in muslin(?) with polychrome roses; the other in paper printed 'All sorts of / Repeating & other / WATCHES & CLOCKS / Made and sold by / W. Webster / in Exchange Alley / LONDON'. Chatelaine: gold, cast and chased, with a key, three seals, and a heart-shaped locket. Locket contains woven hair under glass, with the words 'TOI SEUL ME FIXE' (I am constant to you alone) reserved in gold on a white enamelled ribbon. Overall: 14.1 cm high; outer watch case: 5.6 cm high; inner watch case: 5.2 cm high; chatelaine: 11.3 cm high. Given by Miss Whitehurst (M.2 & A-C-1836).

CAT. 139 | FIG. 154
Cylinder musical coach watch with automated scene
Movement: George Margetts (1748–1808), London, c.1780; bells: Andrew Traecher. Movement: brass and steel, engraved 'Geo. Margetts LONDON', with automaton of mill pond scene, with water-mill, fishermen and a driver watering his horses, and five water boats. Dial: white enamel on copper, with 'CHIME' and 'NOT CHIME' options; and 'SONG' and 'DANCE' options; plain gold second hand, minute hand missing, hour hand beetle, chime and song/dance hands with heart-shaped pointers. Bells: nest of five, scratched inside largest 'Drury London', '3⅓' over '14¾' and 'c/16'; next bell 'd/18' and 'Andrew Traecher / 6 Grand Hotel / Buildings / London / 291192'; next bell 'e/20'; next bell 'f/21'; smallest bell 'g/23'. Case: gilt-brass, pierced and chased with musical trophies, set with pearls and imitation rubies in red glass, with later blue smalt back cover, interior painted with scene of travellers on horses in front of a classicizing building. Watch plays two tunes. Case: 11.3 cm high, 9.4 cm diam. (without bow). F.G. Smart Bequest (M/P.36-1913).

CAT. 140 | FIG. 155
Verge repeater watch for the Ottoman market
European, probably Swiss, made for George Prior (1765–1812), London, c.1790. Movement: blued steel, brass, silver, steel, and iron, engraved 'Ge. Prior 15736 LONDON', also on cap. Dial: white enamel on copper with Turkish numerals, inscribed 'GEORGE PRIOR / LONDON', with blued steel 'Breguet' type hands. Inner case: gold cut and pierced band with plain back, stamped inside '15736' and maker's mark 'I.E.', stamped with horse's head. Outer case: gold of four colour types, with foliage patterns and classicizing vase with flowers; stamped inside '15736' and maker's mark 'I.E.'. Fake set of London hallmarks. Protective case: tortoiseshell on gilt-brass, with gilt and enamelled pins. Watch paper: paper printed 'George Prior / Clock / and Watch maker / IN PRESCOT STREET / Goodmans Fields / London'. Protective case: 7.8 cm high; outer case: 7.2 cm high; inner case: 6.8 cm high. F.G. Smart Bequest (M/P.35-1913).

CAT. 141 | FIG. 150
Watch stand
French, possibly Nevers, c.1760. Tin-glazed earthenware,

painted in polychrome, with figures of a barefooted boy and a dog. 24.5 x 17.5 cm. Dr J.W.L. Glaisher Bequest (c.2330-1928).

CAT. 142 | FIG. 279
Book-shaped pendant
German, 16th/early 17th century. Silver-gilt with a pale amethyst pendant, with nine turnable leaves engraved with the *Annunciation*, *Nativity*, scenes from the *Passion*, a Pope, and a female saint. 6 x 2.8 cm. C.B. Marlay Bequest (MAR.M.281-1912).

CAT. 143 | FIG. 269
Religious pendant
Probably Spanish, c.1600–25. Rock crystal enclosing reliefs of the *Adoration of the Shepherds*, *Crucifixion* and *Resurrection*, in an enamelled gold mount set with three cabochons of garnet (almandine?). 5.1 cm high. C.B. Marlay Bequest (MAR.M.280-1912).

CAT. 144 | FIG. 270
Religious pendant
Spanish, 17th century. Gold, set with emeralds and two diamonds and a carved mother-of-pearl figure of the Infant Christ on a background of gold, engraved and enamelled in translucent green (basse-taille enamelling); the back enamelled in opaque white, pink and black and set with an enamelled plaque in blue pink and grey-black of the Virgin and Child; circular with a bow at the top. 7.8 x 5.5 cm. Given by Mrs Louise Hayden Taylor (M.2-1970).

CAT. 145 | FIG. 156
Pendant
Spanish, c.1600–25. Gold, enamelled and set with an emerald, rubies and hanging pearls, with seated semi-nude goddess. 6.5 x 3.8 cm. L.D. Cunliffe Bequest, 1937 (M/P.19-1938).

CAT. 146 | FIG. 158
Scent bottle
Capodimonte, probably painted by Giovanni Sigismondo Fischer, c.1753–5, with mounts by a recognized, but unidentified, London goldsmith, c.1755–60. Soft-paste porcelain, painted in enamels and mounted in gold decorated with translucent and opaque enamels, with (on one side) a half-length portrait of Prince Charles Edward Stuart (1720–88) and (on the other) the arms and motto 'JE N'OUBLIERAY JAMAIS' of Lady Mary Hervey (1699/1700–68), wife of Lord Hervey of Ickworth (d. 1743). 10.6 x 4.7 cm. Purchased with the S.V. Finn Fund, and grants from The Art Fund and the MLA/V&A Purchase Grant Fund (C.28 & A-2007).

CAT. 147 | FIG. 195
Scent flask with screw stopper
English, Staffordshire, mid-18th century. Brown and white salt-glazed agateware. 2.7 x 5.5 cm diam. Dr J.W.L. Glaisher Bequest (c.565-1928).

CAT. 148 | FIG. 161
Chatelaine with étui and two thimble cases
Probably English, c.1760. Metal alloy, cast, embossed, chased and gilt, decorated with classical figures, putti and Rococo scrolls. The chatelaine comprises three hinged sections; the uppermost with a long spatulate hook; the central one comprising 13 small linked plaques; the lowest with openwork scrolls either side of a swivel loop. Suspended from the top section are two thimble cases (A and B) with hinged lids, one with its original thimble (C). Suspended from the lowest section is a shaped triangular étui (D) oval in section, with hinged lid and sprung button clasp. The fitted interior contains a pair of steel scissors (E), a folding knife (F), a silver spoon (G), an earpick/pair of tweezers (H), a pencil case (I) and a pair of ivory memorandum leaves hinged with a gilt button (J). Overall: 20 cm high; étui: 11 cm high; thimble cases: 4.5 cm high. C.B. Marlay Bequest (MAR.M.289 & A-G-1912).

CAT. 149 | FIG. 171
Étui
English, c.1760–70. Enamelled copper with gilt-metal mounts. The sides and cover are decorated with four landscapes framed by gold scrollwork reserved in a pink ground with white sprigs and trelliswork enclosing spots. The étui contains: a pair of steel and brass scissors (A), a brass bodkin (B), a brass spoon (C), a brass pencil holder (D), a pair of ivory memorandum leaves hinged with a gilt button (E), and a small ivory ear pick with hinged tortoiseshell toothpick (F) in a quill case (G). 9.4 x 4 cm. C.B. Marlay Bequest (MAR.M.287 & A-G-1912).

CAT. 150 | FIG. 159
Heart-shaped box
English, late 17th century. Tortoiseshell (turtle shell) with silver mounts, the top set with an oval portrait medallion of Charles II with '2/c' to left and 'R' below a crown to right. 6.9 x 5.2 x 1 cm. L.C.G. Clarke Bequest, 1960 (M.87-1961).

CAT. 151 | FIG. 157
Pair of miniature portraits of an unidentified man and woman, possibly Lord and Lady Torphichen
Gervase Spencer (1715–63), English, c.1760. Watercolour and bodycolour on ivory in a frame set with pearls. 3.1 x 2.7 cm. Given by Mrs W.D. Dickson, 1945 (3923 and 3924).

CAT. 152 | FIG. 164
Pair of shoes
English, c.1700–30. Yellow silk taffeta, bound with ribbon; floss silk embroidery in French knots, long and short, satin and split stitches; tied with ribbon. Design of scrolling stems with leaves and flowers. H. 13.3 (at back); H. of heel: 7.5 cm; length: 17.8 cm. Given by Miss A. Newton (T.1-1957).

CAT. 153 | FIG. 165
Pair of shoes and pattens
English, c.1730–40. Brocaded silk with a cream background and polychrome floral design, lined with linen and green silk. The pattens have leather soles and heels, are lined with scarlet flannel bound with green braid and have cream silk bows. H. 12.5 cm (at back); length: 21 cm. Miss Grace Clarke Bequest (T.9-1940).

CAT. 154 | FIG. 163
Dish
Probably Richard Newnham, Pickleherring Pottery, Southwark, 1677. Tin-glazed earthenware, painted in blue with Crispin, Crispianus and Ursula, and inscribed 'H/R+M / 1677'; the figures (excepting the prostrate one) were copied from two woodcuts forming the double frontispiece to the 1675 edition of Thomas Deloney's *The Gentle Craft*, first published in 1597 or 1598. 8.3 x 39.2 cm diam. Dr J.W.L. Glaisher Bequest (c.1334-1928).

CAT. 155 | FIG. 140
Stomacher
English, c.1700–20. Linen, embroidered with polychrome silk and silver thread in satin stitch and couched and laid work, bound with greenish-yellow and golden-yellow ribbon. A spray of rose, carnation and tulip reserved in a background covered by silver thread couched in a lattice design. 31.8 x 18.5 cm. Given by Mrs Gurney (T.1-1908).

CAT. 156 | FIG. 141
Stomacher
English, c.1730–40. Linen, embroidered with polychrome silk and silver thread, with a spray of stylized flowers, the background quilted in a vermicular design. 31.5 x 23.3 cm Spencer G. Perceval Bequest (T.6-1922).

CAT. 157 | FIG. 202
Interior of a Hall
Nicolaes de Gyselaer (active 1616–54), Dutch, 1621. Oil on panel, signed and dated. 51.3 x 64.1 cm. Founder's Bequest, 1816 (422).

CAT. 158 | FIG. 178
Medal of Isotta degli Atti (1432–74), mistress of Sigismondo Malatesta
Antonio di Puccio, known as Pisanello (1395–1455), Italian, 1446. Bronze, cast; obverse, bust portrait of Isotta, facing right, and 'D ISOTTAE ARIMINENSI'; reverse, an elephant in a flower-filled meadow and the date, 'M CCCC XLVI'. Diam. 8.2 cm. Arthur W. Young Bequest, 1936 (CM.YG.1957-R)

CAT. 159 | FIG. 177
Medal of Sigismondo Pandolfo Malatesta (1417–68), Lord of Rimini and Fano
Antonio di Puccio, known as Pisanello (1395–1455), Italian, c.1445. Bronze, cast; obverse: bust portrait of Sigismondo facing right, wearing over a shirt of mail a surcoat embroidered with heraldic four-petalled Malatesta roses, encircled by 'SIGISMVNDVS PANDVLFVS DE MALATESTIS ARIMINI FANI D'; reverse: Sigismondo standing wearing armour, with to left and right respectively his casque and arms on heraldic rose trees, and below, 'OPVS . PISANI . PICTORIS'. Diam. 8.8 cm. Arthur W. Young Bequest, 1936 (CM.YG.1956-R).

CAT. 160 | FIG. 181
Oil lamp
Italian, Padua or Ravenna, c.1500–50. Workshop of Severo Calzetta (Severo da Ravenna; active 1496; d. before 1543) Copper alloy, probably bronze, cast and chased, in the form of a satyr's head on claw foot stand. 20.2 x 8.9 x 15.8 cm. Bequeathed by the Hon. Mrs Pamela Sherek, from the collection of the late Lt. Col. the Hon. M.T. Boscawen, DSO, MC, in his memory (M.12-1997).

CAT. 161 | FIG. 179
Writing casket
Italian, possibly Rome, late 15th/early 16th century; or later, after a late 15th-century model. Copper alloy, probably bronze. 10.2 x 21.5 x 12 cm. Bequeathed by the Hon. Mrs Pamela Sherek, from the collection of the late Lt Col. the Hon. M.T. Boscawen, DSO, MC, in his memory (M.41-1997).

CAT. 162 | FIG. 180
Sleeping nymph
North Italian, early 16th century. Copper alloy, probably bronze. 14.7 x 8.8 x 15 cm. Bequeathed by the Hon. Mrs Pamela Sherek, from the collection of the late Lt Col. the Hon. M.T. Boscawen, DSO, MC, in his memory (M.40-1997).

CAT. 163 | FIG. 183
Inkstand
Italian, Urbino, probably Patanazzi workshop, c.1575–1605. Tin-glazed earthenware, painted in polychrome, with a river god, inkwell in the shape of a classical vase spattered to resemble marble, the sides and drawer decorated with grotesques. 21 x 22.1 x 17.8 cm. H.S. Reitlinger Bequest, 1950; transferred from the Reitling Trust, 1991 (C.229 & A-1991).

CAT. 164 | FIG. 176
F. De Pisia, a Papal Notary
Jacopino del Conte (1510–98), Florence, second half 16th century. Oil on canvas. 84.7 x 71.1 cm. Given by Joseph, 1st Lord Duveen, 1933 (1653).

CAT. 165 | FIG. 184
Writing table
Louis-Léopold Boilly (1761–1845), French, before 1793. Rosewood, with painted *trompe l'oeil* decoration on top of geometrical marquetry top, with lyre-end standards. 76.2 x 111.8 x 76.2 cm. Lent by the National Trust from Wimpole Hall, Cambridgeshire (206627.1).

CAT. 166 | FIG. 187
Inkstand
German, Westerwald, first half 18th century. Stoneware, painted in blue and salt-glazed, with figures of bandsmen. 14.9 x 20.6 x 14 cm. Dr J.W.L. Glaisher Bequest (C.2058-1928).

CAT. 167 | FIG. 115
Inkwell
English, Bow, dated 1750. Soft-paste porcelain, painted in enamels in *famille-rose* style after a Kakiemon original, with bamboo and scrolling prunus branches growing from banded hedge, the top inscribed 'MADE AT NEW CANTON 1750'. 5.5 x 9 cm diam. Given by Lord and Lady Fisher (C.8-1951).

CAT. 168 | FIG. 188
Inkstand
German, Fürstenberg, Brunswick, c.1765–80. Hard-paste porcelain, decorated with yellow ground colour, reserves painted in polychrome enamels with male and female figures in gardens, and gilding; mark (on underside): 'F'. Inkstand: 9.6 x 19.2 cm; pounce pot: 4.9 x 5.8 cm diam.; inkwell: 4.9 x 5.9 cm diam. Given by Mrs W.D. Dickson (C.197-1932).

CAT. 169 | FIG. 185
Chamber candlestick
English, Derby, c.1760. Soft-paste porcelain, moulded, and decorated with applied flowers and leaves and painted with bouquets of mixed flowers in polychrome enamels. Mark: a gold anchor on inside of dish. 8.2 x 12.5 cm. Given by Mrs W.D. Dickson (C.90-1932).

CAT. 170 | FIG. 160
Oval snuffbox
Probably Italian, early 18th century, containing an Italian portrait miniature, dated 1615. Tortoiseshell with silver mounts, and silver piqué decoration on the lid of a child hanging off the branches of a palm tree, and on a ribbon

the inscription 'CRESCIT SUB PONDERE' (it flourishes under a weight/burden). Inside the lid is a circular miniature of an unknown boy wearing a red jacket and white ruff, inscribed in gold 'AEta.3.1615'. 8.1 x 6.2 x 1.6 cm. L.C.G. Clarke Bequest, 1960 (M.82-1961).

CAT. 171 | FIG. 168
Shell-shaped snuffbox
French, c.1710–30. Tortoiseshell with silver mounts, the lid inlaid with silver piqué work. 9.3 x 6.8 x 1.9 cm. L.C.G. Clarke Bequest, 1960 (M.75-1961).

CAT. 172 | FIG. 167
Circular snuffbox
French, Paris, 1763/4, the miniature attributed to Jean André Rouquet (1701–58), or an unidentified Swiss artist, c.1745. Red lacquer, lined with tortoiseshell and mounted in gold. Marks: illegible maker's mark; warden's mark z for Paris, 1763/4; charge and discharge marks of Jean-Jacques Prévost (1762–8). 3.3 x 6.3 cm diam. L.C.G. Clarke Bequest, 1960 (M.77 & A-1961).

CAT. 173 | FIG. 1
An Italian collector in his study
Venceslao Verlin (1740–80), Italian, 1768. Oil on panel. 24.2 x 31.5 cm. Lent by the National Trust from Wimpole Hall, Cambridgeshire (207799).

CAT. 174 | FIG. 208
Water cistern
Dutch, Greek A Factory, Delft, c.1700. Tin-glazed earthenware, shaped as a house, painted in blue, with three views of a formal garden, the silver spigot shaped as a merman riding a dolphin and blowing a conch. Mark: 'AK' for Adriaen Kocks, proprietor of the factory from 1686 to his death in 1701. 42 x 27.2 x 16.5 cm. Dr J.W.L. Glaisher Bequest (C.2416 & A-1928).

CAT. 175 | FIG. 205
Birdcage with parrot on perch
Dutch, Delft, first half 18th century. Tin-glazed earthenware, exterior of cage painted in blue and yellow with landscape scenes, inside a parrot on a perch. 44 x 36 cm diam. Dr J.W.L. Glaisher Bequest (C.2649-1928).

CAT. 176 | FIG. 209
Flower vase
Dutch, Metal Pot Factory, Delft, c.1700–10. Tin-glazed earthenware, on heart-shaped base with lizard handles, painted in blue, green, yellow, and red with Oriental flowering plants and birds; marks: 'FO', 'LVE' monogram (for Lambertus van Eenhoorn, proprietor of the factory 1694–1721), 'C', 'PD' and '4'. 42.9 x 17.4 cm. Dr J.W.L. Glaisher Bequest (C.2615-1928).

CAT. 177 | FIG. 207
Posset-pot with salver
English, Brislington, Somerset, 1685 (pot), 1686 (salver). Tin-glazed earthenware, painted in blue; the pot is decorated with a seated stag and Chinese figures in Oriental landscapes, the base inscribed 'IG/T/CA/85'; the salver has figures in a landscape, probably *Lot and his Daughters*, and 'T/CA/1686'. Pot: 31 cm high; stand: 1.5 x 23.8 cm diam. Dr J.W.L. Glaisher Bequest (C.1504 & A & B-1928).

CAT. 178 | FIG. 204
Chamber pot
English, Liverpool, c.1750–60. Tin-glazed earthenware, painted overglaze in polychrome enamels with Chinese figures in an Oriental landscape with a fence, rocks and flowering plants in a palette emulating *famille rose* Chinese porcelain of the Yongzhen period (1723–35). 11 x 24 cm. Dr J.W.L. Glaisher Bequest (C.1728-1928).

CAT. 179 | FIG. 199
Pair of wall sconces
English, c.1680. Silver, the oval backplates engraved with chinoiserie scenes with buildings, ho-ho birds, Chinese figures and exotic plants. Sconces: (A) 26.7 x 11 cm; (B) 27.2 x 11 cm. L.C.G. Clarke Bequest, 1960 (M.52A & B-1961).

CAT. 180 | FIG. 173
Framed mirror
Italian, Venice, 18th century. Gilt wood, red and black lacquer, inlaid with mother-of-pearl, and painted in gold with Chinese figures, with possibly later glass mirror; one of a set of four. 97.5 x 57.5 x 12 cm. Mrs Jessie Lloyd Bequest (M.7A-1940).

CAT. 181 | FIG. 200
Six-nozzled lamp
English, c.1700–25. Lead-glass; the bowl is blown-moulded with gadroons around its lower part, and stands on a hollow trumpet-shaped foot. 22 x 15.7 cm diam. (of foot). Given by Sir Ivor and Lady Bachelor (C.5-1998).

CAT. 182 | FIG. 170
Candlestick
English, probably South Staffordshire, c.1755–60. Opaque white glass painted in polychrome enamels, with a removable enamelled copper drip pan. 23 x 12 cm diam. L.C.G. Clarke Bequest, 1960 (C.555 & A-1961).

CAT. 183 | FIG. 182
Floor tile
Italian, Pesaro, workshop of Antonio dei Fedeli (d. 1508), 1493. Tin-glazed earthenware painted in blue, green, dark yellow and manganese-purple with a seated hound, muzzled and leashed; from an order of floor tiles decorated with Gonzaga devices made for the villa of Francesco II Gonzaga (1466–1519) at Marmirolo, but also used in the *studiolo* of his wife, Isabella d'Este, in the Castello San Giorgio in Mantua. 23.9 x 23.9 x 4.7 cm. F. Leverton Harris Bequest, 1926 (C.61-1927).

CAT. 184 | FIG. 203
Tile
Dutch, 18th century. Tin-glazed earthenware, painted in blue with a skating scene. 12.6 x 12.6 x 0.9 cm. Dr J.W.L. Glaisher Bequest (C.2816-1928).

CAT. 185 | FIG. 210
Tile
English, Liverpool, c.1765–75. Tin-glazed earthenware, transfer-printed onglaze in black with a gentleman and lady in a garden with a pineapple in a pot. 12.6 x 12.6 x 0.6 cm. Dr J.W.L. Glaisher Bequest (C.1731-1928).

CAT. 186 | FIG. 206
Hand-warmer
English, probably London, 1663
Tin-glazed earthenware, in the shape of a book, painted in blue, pale green and yellow; initalled and dated 'E M/1663' on both sides. 11.3 x 7.9 x 4 cm. Dr J.W.L. Glaisher Bequest (C.1428-1928).

CAT. 187 | FIG. 201
Fire cover
French, Northern France, 1616. Red earthenware, coated with pale slip, with incised, painted and applied decoration, and the inscription, 'JACQVES BATBAU ANNO 1616'. 40.6 x 44 x 21.5 cm. Dr J.W.L. Glaisher Bequest (C.1814-1928).

CAT. 188 | FIG. 216
Salt
French, Limoges, attributed to Colin Nouailher, c.1542–5. Copper, enamelled in grisaille with a little turquoise, mulberry, and pale-green, and gilded. On the top and base are heads of Paris and Helen respectively, and on the six sides, standing figures of Fortuna, a jester, two women aged 40 and 70 and two men aged 50 and 80, each with an inscription. 8.3 x 10.9 cm. Frank McClean Bequest (M.50-1904).

CAT. 189 | FIG. 213
Salt
Girolamo Campagna (1549–1621), Venice, late 16th or early 17th century (model); early 17th century or later (casting). Copper alloy, probably bronze, cast in the form of a kneeling youth supporting a shell and chased, with dark brown patina. 20.5 x 14.4 x 12 cm. L.D. Cunliffe Bequest, 1937 (M.5-1938).

CAT. 190 | FIG. 217
Salt and pepper stand
Dutch, Delft, c.1750–60. Tin-glazed earthenware, in the shape of a young woman with two baskets, painted in blue, green, yellow and manganese-purple, the baskets' interiors inscribed: 'Sout' (salt) and 'Peper' (pepper). 12 x 20.4 cm. Dr J.W.L. Glaisher Bequest (C.2726-1928).

CAT. 191 | FIG. 215
Salt
English, probably London, but possibly Brislington, Somerset, or Bristol, c.1720–30. Tin-glazed earthenware, painted in blue, green and red with scrolls and stylized floral sprays. 11.2 cm high. Dr J.W.L. Glaisher Bequest (C.1660-1928).

CAT. 192 | FIG. 114
Double spice-box with two lids
Dutch, Greek A Factory, Delft, c.1701–22. Tin-glazed earthenware, painted in blue and red with floral motifs inspired by Japanese Imari porcelain; one lid is a 'marriage'; mark: 'APK' monogram in red (for Pieter Kocx, proprietor 1701–22). 6.7 x 11 cm. Dr J.W.L. Glaisher Bequest (C.2718-1928).

CAT. 193 | FIG. 219
Set of three lighthouse casters for sugar, pepper and mustard
English, Chester, 1704/5. Maker's mark on the largest (sugar) caster, probably Nathaniel Bullen. Britannia standard silver, the two small casters engraved with the initials 'M' over 'RL', and all three engraved with a (later) unidentified stag's head crest. 17.8, 14.5 and 14.2 cm high. L.C.G. Clarke Bequest (M.37.1-3-1961).

CAT. 194 | FIG. 220
Sugar caster
Étienne Bacquet, Paris, 1696. Pewter, engraved with two unidentified coats-of-arms. Marks: Paris controle mark and maker's mark. 17 x 8.5 cm diam. A.F. de Navarro Bequest (NAV.182-1933).

CAT. 195 | FIG. 221
Sugar caster
French, Rouen, c.1720–40. Tin-glazed earthenware, painted in blue and red, repaired. 23 x 10 cm. Dr J.W.L. Glaisher Bequest (C.2288 & A-1928).

CAT. 196 | FIG. 222
Covered sugar basin
French, Mennecy, c.1760. Soft-paste porcelain, lead-glazed and painted in soft shades of blue, green, greyish-green, dark pink, red, purple, several shades of brown, grey and black enamels with figures in a continuous landscape. Overall: 12.4 cm high; basin: 7.3 cm high; bowl: 9.7 cm diam.; cover: 10.2 cm diam. Purchased from Collins & Clarke on 30 April 1959 with the Duplicate Objects and Donation Fund (C.1 & A-1959).

CAT. 197 | FIG. 197
Covered sugar bowl
English, probably Staffordshire, c.1759–75. Cream earthenware, press-moulded and decorated with green and yellowish cream lead-glazes, of Chinese covered tea bowl form, moulded to resemble a cauliflower, the convex cover (A) with six leaves radiating from the shallow cauliflower knob. 10 x 11.5 cm diam. Given by Mrs E.S. Jenkins (C.6 & A-1951).

CAT. 198 | FIG. 218
Covered sugar bowl
English, Worcester, c.1765–70. Soft-paste porcelain, transfer-printed onglaze in purple and painted in polychrome enamels with vignettes of classical buildings, and a ruined castle or folly in parkland, and gilt. 11.2 x 11.5 cm. W.S. Hadley Bequest (C.36 & A-1927).

CAT. 199 | FIG. 223
Covered sugar bowl (pot à sucre Calabre)
French, Sèvres, with date letter for 1769, but the decoration was probably added later. Soft-paste porcelain, thrown and moulded, decorated with a green ground overlaid by a gilded scale pattern, reserves painted in polychrome enamels with exotic birds in landscapes, and gilding. Marks: in blue enamel, interlaced Ls enclosing Q with script N beneath, the mark of François Joseph Aloncle (1734–81), working 1758–81. 10.2 x 8.9 cm (diam. of bowl); 9.1 cm (diam. of cover). L.C.G. Clarke Bequest, 1960 (C.40 & A-1961).

CAT. 200 | FIG. 196
Covered sugar bowl
English, Staffordshire, c.1745–55. Lead-glazed brown and white agateware. 12 x 10.2 cm diam. Dr J.W. L. Glaisher Bequest (C.647 & A-1928).

CAT. 201 | FIG. 2
Still life with glass, lemon and a knife
Pieter Claesz (1597–1661), Haarlem, 1630. Oil on panel; signed 'CS' and dated. 25.1 x 32.7 cm. Daniel Mesman Bequest, 1834 (294).

CAT. 202 | FIG. 228
Still life with fruit and macaws
Balthasar van der Ast (1593/4–1657), Utrecht, 1622.

Oil on copper; signed and dated 'B. van der Ast fe[cit] 1622'. 20.5 x 26.8 cm. Daniel Mesman Bequest, 1834 (295).

CAT. 203 | FIG. 235
Seal top spoon
Unidentified silversmith (mark: crescent enclosing a mullet), English, London, 1572/3. Silver with remnants of later gilding, the spoon has a hexagonal stem and a fig-shaped bowl pricked on the back with the initials 'CR'. 17.8 cm long; bowl: 4.8 cm wide. T.H. Riches Bequest, 1935 (M.5-1950).

CAT. 204 | FIG. 241
Combined spoon and fork
Probably Hans Jacob Holzalb (active 1634–57), Zurich, mid-17th century. Silver, the fig-shaped bowl is attached by six loops on its back to a three-pronged fork, the base of the fork's handle is hinged and the folding mechanism held in place by a slide in the form of a lion's mask; the goat's head terminal of the handle unscrews to reveal a toothpick, the handle is inscribed on the front, 'IOSEPHI GEORGU ORASSI 1646', the back of the bowl is engraved with a later un-identified coat-of-arms. 14.9 cm long; bowl: 4.7 cm wide. C.B. Marlay Bequest (MAR.M.104-1912).

CAT. 205 | FIG. 239
Spoon
German, 17th century. Ivory, the back of the bowl is carved with a coat-of-arms, and the handle terminates in a woman dressed in contemporary dress holding a distaff. 21 cm long; bowl: 5.5 cm wide. C.B. Marlay Bequest (MAR.M.166-1912).

CAT. 206 | FIG. 242
Spoon
Scandinavian, second half 17th/first half 18th century. Fruit wood (bowl) and silver (handle), the front of the hollow square-cross-sectioned handle inscribed 'Nyttjad under en Elfra årig fångenskaps tid' (used during an eleven-year imprisonment) and initialled 'S'. 17 cm long; bowl: 5 cm wide. C.B. Marlay Bequest (MAR.M.159-1912).

CAT. 207 | FIG. 240
Folding spoon
German, late 17th century. Wood, carved on the inside with a woman on horseback and on the outside with a tree and vine. 13.5 cm long; bowl: 4.7 cm wide. C.B. Marlay Bequest (MAR.M.145-1912).

CAT. 208 | FIG. 236
Cased cutlery set
Unidentified silversmiths, German, Augsbug, late 17th century. Spoon bears mark 'I over CL' possibly for Johann Christoph Laminet; knife bears unidentified maker's mark of a seven-pointed star. Silver, parcel-gilt, all with silver filigree handles, the knife with a steel blade, in tooled and gilt-leather case. Knife: 17.7 cm long; fork: 15.4 cm long; spoon: 15.7 cm long; case: 19.3 cm long. From the Frank Smart Collection, given by T.J.G. Duncanson, 1930 (M.58A-D-1930).

CAT. 209 | FIG. 117
Set of six teaspoons and case
Andrew Archer, English, London, 1705/6. Gilt Britannia Standard silver, each spoon has oval bowl with rat-tail on the back, and a dog-nose terminal with later engraved initials 'EP'. The spoon-shaped case is covered in shagreen and lined with green velvet. Spoon: 12 cm long; bowl: 2.4 cm wide. Given by Miss Julie Gollan though the National Art Collections Fund, now The Art Fund (M.5-1953).

CAT. 210 | FIG. 238
Straining spoon for olives
Claude Jouguet (master 1719; d. 1767), French, Paris, 1738/9 Silver, with fiddle pattern handle and pierced bowl, the back of the handle is engraved with an unidentified coat-of-arms of a bird. 31.3 cm long; bowl: 5.3 cm wide. L.C.G. Clarke Bequest, 1960 (M.65-1961).

CAT. 211 | FIG. 226
Dish from the Isabella d'Este service
Italian, painted by Nicola di Gabriele Sbraghe or Sbraga, Urbino, c.1524–5. Tin-glazed earthenware, painted in polychrome; on the rim: Peleus and Thetis derived from a wood-cut illustration in Giovanni dei Bonsignori's *Ovidio metha-morphoseos vulgare* (Venice, 1497) with a shield decorated with gold bars in a crucible, a device of Isabella d'Este (1474–1539), widow of Francesco Gonzaga, 4th Marchese

of Mantua (1466–1519); in the well: the arms of Gonzaga impaling Este, and 'XXVII', another device of Isabella. 3.9 x 30.2 cm diam. Purchased with the Glaisher Fund (EC.30-1938).

CAT. 212 | FIG. 229
Boxed set of twelve fruit trenchers
English, c.1600. Wood (sycamore or beech?), painted and gilt, each with one plain side, and one decorated with a 'posy', a biblical inscription, fruit, flowers and strapwork, the box bears the Royal Arms and motto 'DIEU ET MON / DROYT'. Trenchers: 13.2 cm diam.; box: 3.2 x 16.6 cm diam. Given by Mrs T.T. Greg (M.4.1-13 & A-1920).

CAT. 213 | FIG. 227
Soup plate
English, Chelsea, red anchor period, c.1755. Soft-paste porcelain, painted in polychrome onglaze enamels with flowers and insects. 3.7 x 24 cm diam. Given by Mrs W.D. Dickson (C.91-1950).

CAT. 214 | FIG. 230
Soup plate
English, Chelsea, raised anchor or early red anchor period, c.1752–5. Soft-paste porcelain, painted in enamels in Kakiemon style with 'Hob in the Well' pattern. 4.7 x 22 cm diam. Given by Sir John Plumb, FBA through the Friends of the Fitzwilliam Museum (C.17-1983).

CAT. 215 | FIG. 231
Dish
Thomas Chamberlain, English, London, c.1750–60. Pewter, cast and hammered, engraved with the unregistered coat-of-arms of the celebrated actor David Garrick (1717–79). 2 x 25 cm diam. A.F. de Navarro Bequest (NAV.13.1-1933).

CAT. 216 | FIG. 233
Sweetmeat stand
European, possibly German, c.1750–60. Tin-glazed earthenware, press-moulded in parts, painted in blue, the stand has four tiers of shells supported by the tails of dolphins attached to a central pillar, with three more at the top, tails uppermost. 47.5 x 27.5 cm diam. Dr J.W.L. Glaisher Bequest (C.1550-1928).

CAT. 217 | FIG. 232
Epergne
Emmick Romer (1724–c.1795), London, 1759/60. Silver, the oval openwork stand has four cast legs, four arms supporting small detachable circular dishes each engraved with a crest (greyhound courant in front of an oak tree) and a central detachable oval basket, the crest used by several families, including Daly, Kennedy, Molloy or O'Mulloy. 35 x 28 cm (central basket). C.B. Marlay Bequest (MAR.M.19 & A-1-1912).

CAT. 218 | FIG. 234
Centrepiece or 'Grand platt menage'
English, probably Leeds Pottery, Leeds, Yorkshire, c.1780–1800. Cream-coloured earthenware (creamware), moulded in parts, and lead-glazed, comprising a circular base with four cruet bottles and four oval baskets, a central pillar supporting a tier of shell dishes, a tier with four openwork baskets hanging from birds' heads, a vase with four smaller baskets hanging from its scroll handles and, on the summit, a standing male classical figure holding a cornucopia. Overall: 63.5 x 37 cm diam. Dr J.W.L. Glaisher Bequest (C.1063.1-12-1928).

CAT. 219 | FIG. 292
Cabinet
English, c.1650–75. Wood, covered in ivory satin with polychrome silk embroidery with personifications of the five senses and four elements, Orpheus and Father Time; hinged lid with carrying handle and two doors at front, which open to reveal drawers including a secret ring-holder hidden behind a shallow drawer. 23.6 x 27.1 x 16.5 cm. Given by Mrs W.D. Dickson (T.8-1945).

CAT. 220 | FIGS 293–294
Pair of medal cabinets
English, c.1745. Gilded wood, and coloured and gilded 'on-laid' leather, with silver carrying-handles, pull-down fronts and fold-out leather tray list (one lined with pink silk, the other with yellow moiré) for twelve interior trays with leather fronts and gilt-copper drawer-pulls; Draper arms applied to the pediments. 46.5 x 32.5/33 x 28.5 cm. Given by A.A. Vansittart, Trinity College, Cambridge, 1864 (CM.TR.1903-R & CM.TR.1904-R).

CAT. 221 | FIG. 246
Sampler
Ann Smith, English or Scottish, 1766–4 March 1767. Wool canvas, embroidered in polychrome silk, with floral border with a parrot in upper corners and lion rampant in lower corners; five horizontal bands, two of inscriptions, one of stylized plants with birds and deer, a pictorial band depicting *Adam and Eve* and a final band of two cartouches, flanked by stylized plants and containing the maker's name and finishing date. 43.25 x 31.5 cm. Mrs A.H. Longman Bequest (T.37-1938).

CAT. 222 | FIG. 244
Oval map sampler
English, c.1780–90. Cream silk backed by linen, embroidered in polychrome silk in back and stem stitch with French knots, the map shows Europe, North Africa, Turkey and the western edge of Asia, with a vignette of two male travellers at top left edge with painted details. 52.5 x 49.5 cm. Mrs A.H. Longman Bequest (T.142-1938).

CAT. 223 | FIG. 243
Sewing roll ('hussif')
English, late 18th century. Linen, embroidered in polychrome silk rococo stitch, with silk lining and ribbon binding, decorated with stylized anchors and a ship. 26.5 x 10 cm. S.G. Perceval Bequest (T.2-1922).

CAT. 224 | FIG. 248
Half-made purse on mould
English, late 18th century. Blue, green and pink silk with silver thread, partially worked in buttonhole stitch, decorated with five pink geometrical flowers and leaves alternating with lozenges; on an earlier ebony thimble mould with a row of eleven holes around the top, which enable a foundation thread for the first row to be attached to the mould. 4.5 x 4.5 cm. Miss R.N. Howard Bequest (T.192-1928).

CAT. 225 | FIG. 249
Purse
English, late 18th century. Brown, pink, and blue silk thread with silver and silver-gilt thread worked in buttonhole stitch, rose sprays between bands of lozenges with a five-pointed star at the base. Plaited drawstrings with tassels. 10.5 x 4.5 cm. Miss R.N. Howard Bequest (T.191-1928).

CAT. 226 | FIG. 245
Beadwork basket
English, late 17th century. Polychrome glass beads threaded on iron wire and attached to iron wire frame of silver layette shape, inside base decorated with twelve panels of exotic and mythological animals and centrally placed male and female figure, with applied three-dimensional flowers, leaves and citrus fruit decorations around the inside edges of the basket, and outside edges of its foot. 14 x 56 x 46 cm; with handles 17.5 x 65.5 x 54.5 cm. Given by Miss Eddington (T.162-194:6).

CAT. 227 | FIG. 247
Unfinished silk pictorial embroidery
English, early 18th century. Silk satin work in polychrome silk over under-drawing of a landscape with exotic chinoiserie flowers and birds. 38.75 x 41.5 cm. Mrs A.H. Longman Bequest (T.135-1938).

CAT. 228 | FIG. 3
Christening robe
English, 1750–80. Ivory silk, trimmed with cream braid with applied silk fringing. The robe is open down the front, the front and back of the bodice is shaped by vertical tucks. The cuffed sleeves are detachable. Shoulder to hem: 79 cm long; neck to hem: 76.5 cm long; cuff to cuff: 44 cm long; waist: 42 cm wide. Given by J.N. Peyton (T.18-1981).

CAT. 229 | FIG. 251
Infant's cap
English, 18th century. Linen, the bonnet made in five pieces (brim, plain ungathered frill in two pieces, and two back sections), inset between the two pieces of the frill is a strip of hollie-point worked with the words 'SWEET BABE', inset between the two back sections, another worked with coronets, two drawstrings across the lower edge at the back, tying in the centre, and a button hole on the right side of the brim. 12 x 12 cm. Given by J.N. Peyton (T.19-1981).

CAT. 230 | FIG. 253
Model cradle
English, probably Staffordshire, 1708. Red earthenware,

slip-trailed under lead-glaze; inscriptions: 'HS', 'JOHN WALKER' and 'HS 1708 EC'. 20.6 x 17.2 x 34.3 cm. Dr J.W.L. Glaisher Bequest (c.256-1928).

CAT. 231 | FIG. 254
Model cradle
English, probably Staffordshire, 1729. Buff earthenware, spotted and slip-trailed under lead-glaze; inscriptions: on one side, 'MARY / OVERTON / HER CRADEL'; on top, '1729'. 18.4 x 15.6 x 24.5 cm. Dr J.W.L. Glaisher Bequest (c.237-1928).

CAT. 232 | FIG. 255
Money-box
English, George Adlum or Adlam, Brislington, Somerset, 1717. Buff earthenware, moulded in the shape of a dog, tin-glazed and painted in blue, green, yellow and red, with pierced slot on its shoulder to take coins, inscriptions (on dog's collar): 'ANN WITTIN 1717'; (on the base): 'Ann Wittin / was born ye 14 of / october 1717 J(?) w'. 14.9 x 10 cm. Dr J.W.L. Glaisher Bequest (C.1462-1928).

CAT. 233 | FIG. 5
Tea caddy
English, probably Bovey Heathfield Pottery, Bovey Tracey, Devon, 1795. Pearlware with four heart-shaped reliefs with children playing; two entitled 'SPORTIVE INNOCENCE' and two 'MISCHIEVOUS SPORT', painted underglaze in blue and brown. At the top of three sides is the painted inscription: 'Eliz.th Taylor / Born march / 18th 1795'. 12.7 x 8.5 cm deep. Dr J.W.L. Glaisher Bequest (c.753-1928).

CAT. 234 | FIG. 250
Marriage fan
European, c.1760. Double leaf of silk, painted in bodycolour, gold and silver with an amorous couple, putti and flowers, and decorated with gold tambour work and sequins; sticks and guards of horn, shaped, pierced, silvered, gilt and set with clear paste brilliants; guards also backed by iridescent shell. 25.2 cm long (guards) x 47.2 cm wide (open). Purchased with a grant from the National Heritage Memorial Fund and a gift from the Friends of the Fitzwilliam Museum (M.222-1985).

CAT. 235 | FIG. 258
Dish
English, Staffordshire, c.1675–1700. Slip-coated earthenware with slip-trailed decoration under lead-glaze, comprising a stylized couple each holding aloft a flower, inscribed around the rim at the top, 'THOMAS SARA >T'. 6.5 x 45.7 cm diam. Dr J.W.L. Glaisher Bequest (c.218-1928).

CAT. 236 | FIG. 4
Heart-shaped brooch
English or Scottish, 17th century. Silver, inscribed on the reverse, 'My hart and I untill I dy'. 3 x 2.8 cm. Lent by the Museum of Archaeology and Anthropology, University of Cambridge (1923.862 A).

CAT. 237 | FIG. 261
Mourning ring commemorating Elizabeth Dixon
English, 1780. Gold, long oval bezel with chased border surrounding, under glass, a wheatsheaf of hair bound with pearls on ivory. Inscription on back of bezel: 'Elizth / Dixon / Obt 13 Jany / 1780 / Aet 62'. L. (bezel) 3 cm; D. (hoop) 2.3 cm. S.G. Perceval Bequest, 1922 (PER.M.241-1923).

CAT. 238 | FIG. 262
Mourning ring commemorating the Rev'd Thomas Neale
English, 1782. Gold, the marquise-shaped bezel enclosing a painting on ivory of a woman mourning beside an urn made of hair on a pedestal decorated with seed pearls, the whole scene beneath overhanging trees. Inscription on back of bezel: 'Revd / Thos / Neale / died Mar 26 / 1782 / Aged 48'; possibly Rev. Thomas Neale (b. 1733), who was an alumnus of Emmanuel entered there 1752. L. (bezel) 3 cm; D. (hoop) 2 cm. S.G. Perceval Bequest, 1922 (PER.M.243-1923).

CAT. 239 | FIG. 263
Mourning ring commemorating Garsford Gibbs
English, 1788. Gold and white enamel, the marquise-shaped bezel enclosing a painting on ivory under glass. A cherub holding a scroll inscribed 'TO BLISS' hovers over a mourning woman seated beside an urn on a pedestal, inscribed NOT / LOST / BUT / GONE / BEFORE'. Inscription on back of bezel: 'Garsford / Gibbs / Obt 25 Dec / 1788 / aet 15'. L. (bezel) 3.3 cm; D. (hoop) 2 cm. S.G. Perceval Bequest, 1922 (PER.M.259-1923).

CAT. 240 | FIG. 264
Mourning ring commemorating Catharine Harris
English, 1793. Gold, enamelled in white and black, the circular bezel inscribed 'CATHARINE . HARRIS . BORN . 22 . 8C [OCT.]. DIED . 29 . APR : 1793'. In the middle, under glass, on a hair background, is a gilt metal and enamelled urn on a pedestal inscribed 'SACRED TO AFFECTION'. L. (bezel) 2 cm; D. (hoop) 2.1 cm. S.G. Perceval Bequest, 1922 (PER.M.276-1923).

CAT. 241 | FIG. 266
Mourning ring commemorating N.B. and W. Toms
English, 1794. Gilt-metal, with a glazed long octagonal bezel, enclosing hair of two different colours set with rows of small metal stars. Inscribed on the back, 'NB Toms / ob 19 Dec / 1794 Aet 5 ys / W Toms / ob : 28 Mars / 1786 Aet 11 ys.' H. (bezel) 2.7 cm; D. (hoop) 2 cm. S.G. Perceval Bequest, 1922 (PER.M.272-1923).

CAT. 242 | FIG. 267
Mourning ring commemorating Judith Stubbs
English, 1769. Gold, with a glazed oval bezel set with garnets, enclosing two (rosemary?) bushes of hair. Inscribed on the back, 'Miss / Judith Stubbs / Ob: 29 / July / 1769 Aet 50. H. (bezel) 1.5 cm; D. (hoop) 2 cm. S.G. Perceval Bequest, 1922 (PER.M.228-1923).

CAT. 243 | FIG. 268
Child's mourning ring commemorating Frances Greene
English, 1767. Gold, the oval bezel is set with amethysts, surrounding, under glass, a bush of hair on a white ground, the hoop bears the inscription 'FRANCES. GREENE. OB: 27. JULY. 1767. AE: 61' reserved in black enamel. H. (bezel) 1.2 cm; D. (hoop) 1.5 cm. Given by Mrs J.C. Burkill (M.26-1979).

CAT. 244 | FIG. 265
Mourning ring with eye
English, c.1790–1800. Gold, with a rectangular silver bezel with cast and chased border, in which is set a rectangular, plain gold frame enclosing, under glass, a miniature painting on ivory of a blue eye. H. (bezel) 1.9 cm; D. (hoop) 1.7 cm. Sue Purdy Bequest (M.4-2000).

CAT. 245 | FIG. 6
Mourning pendant commemorating 'T.G', an adopted child
English, 1790. Rose gold, with, under oval glass, an enamel and gilt-metal urn on a pedestal inscribed 'T.G. ob: 1790' on a fair hair ground, surrounded by the inscription in gilt metal, 'SACRED . TO . THE . MEMORY . OF . AN . ADOPTED . CHILD' reserved in white enamel. 3.9 x 3 cm. S.G. Perceval Bequest, 1922 (PER.M.274-1923).

CAT. 246 | FIG. 260
Head incorporating death mask of Charles Talbot (1660–1718)
London, 1718. Wax, cast, with applied hair eyebrows and eye lashes. 26 x 17 x 21.5 cm. Founder's Bequest (M.6 & A-1816).

CAT. 247 | FIG. 252
Bust incorporating death mask of John Howard (1726–90)
Russian, 1790. Plaster cast in pine case painted black, and on a sunk panel on the front, inscribed in red, 'This Case / with the Mask of the philanthropic / MR HOWARD / (who died 20th Jan: 1790) / was sent from Cherson in Russia / to his Kinsman & Executor / Samuel Whitbread Esq / WHOSE SON / THE LATE SAMUEL WHITBREAD ESQR M.P. GAVE / IT TO MR GEORGE GARRARD A.R.A. BY WHOM IT WAS / PRESENTED TO THE FITZWILLIAM MUSEUM, 1822.' Bust: 38 x 39 x 23.5 cm; box: 49 x 41.5 cm. Given by George Garrard, ARA (M.2 & A-1822).

CAT. 248 | FIG. 259
Family group
Abraham Willaerts (c.1603–69), Dutch, 1660. Oil on panel, signed and dated lower right, 'A Willae 1660'. 18.7 x 17.5 cm. Daniel Mesman Bequest (534).

CAT. 249 | FIG. 281
Book cover
English, c.1625–50. Silk satin worked in polychrome silks, with female personifications of Charity with two children (on one side), and Hope with an anchor and Faith with a cross and book (on the other side); the panel to cover the spine is decorated with floral sprays. 21.5 x 29.5 cm. Lady St John Hope Bequest (T.4-1952).

CAT. 250 | FIG. 276
Raised-work panel
English, 1700. Silk satin worked in linen, silk and metal threads, seed pearls, feathers and mica with episodes from the Old Testament story of David and Bathsheba, based loosely on engravings, initialled 'AB' and 'EB' and dated '1700'. 61 x 58 cm. Given by Mrs L.G. Utting (T.5-1954).

CAT. 251 | FIG. 277
Book of Hours
Rodericus de Avila, Spanish, Castile, late 15th century (pre 1495); binding 17th century. Commissioned by Don Fernando de Sales (d. 1495) as a gift for the Bishop of Pamplona, probably Cesare Borgia (1475–1507, Bishop of Pamplona, 1491–2). Parchment flyleaves and 249 illuminated folios, with brown leather binding over wooden boards, with gold-stamped decorations, catchplates and clasps. 15.5 x 11.3 cm. Frank McClean Bequest, 1904 (MS McClean 74).

CAT. 252 | FIG. 278
Prayer bead
Flemish, c.1500–25. Pearwood or sandalwood, two hemispherical parts, hinged together and fastened with silver mounts and clasp. The outsides are carved with pierced 'flamboyant' tracery; interiors carved with the Virgin and Child, and St Cecilia playing an organ with an attendant angel. 4.3 x 4 cm diam. C.B. Marlay Bequest (MAR.M.262-1912).

CAT. 253 | FIG. 280
Plaque
Attributed to Caspar Lehmann (c.1563/5–1622), Prague, late 16th or early 17th century. Rock crystal, wheel-engraved in intaglio with *The Temptation*, set in a lozenge-shaped gold frame, enamelled in black. 7.5 x 8.5 x 1 cm. Given by Mrs W.D. Dickson (M.9-1930).

CAT. 254 | FIG. 274
Holy water stoup
Italian, possibly Laterza (Puglia), late 17th century or early 18th century. Dark buff earthenware, tin-glazed on the front and painted with a tonsured saint (probably Anthony of Padua or Dominic) holding a bunch of lilies, book and rosary; the shield-shaped back with two suspension holes at the top below moulded scrolls, and at the bottom a receptacle for holy water, formed by an applied half-cone moulded in relief with a winged cherub's head. 27 x 17.5 cm. Dr J.W.L. Glaisher Bequest (C.2275-1928).

CAT. 255 | FIG. 275
Virgin and Child enthroned
Italian, Deruta (Umbria), 1676. Dark buff earthenware, moulded and modelled in the round, tin-glazed on the exterior and on the hollow interior. Painted in dark blue, green, yellow, brownish-orange and manganese-purple, inscribed on the base, 'CF / PC / 1676 16.. / SM' and on the back, 'A.D. 22D. MARZO / 1676 / .CDF / ? P'. 38.5 x 18.4 (wide at base) x 24 cm (deep at base). Dr J.W.L. Glaisher Bequest (C.2201-1928).

CAT. 256 | FIG. 284
Pilgrim's souvenir bowl
Italian, possibly Pesaro or in/near Loreto, 18th century. Tin-glazed earthenware, painted in polychrome with the Virgin holding the Christ Child in front of the Holy House of Loreto, probably copied from a woodcut, and inscribed around the rim 'CON. POL[VERE]. DI. S[ANTA]. CASA' (with dust of the Holy House). 3.9 x 10.9 cm diam. Dr J.W.L. Glaisher Bequest (C.2244-1928).

CAT. 257 | FIG. 272
Three-tier money-box
Dutch, possibly Delft, c.1680–1700. Tin-glazed earthenware, painted in blue and manganese-purple with (bottom tier) the *Kiss of Judas*, *Temptation in the Wilderness* and *Christ crowned with Thorns*; (middle tier) *Elisha and the Children*, the *Angel with the Fiery Sword* (twice) and *Christ led captive from Gethsemane*; and (top tier) a cherub surrounded by flowers. 21.6 x 13.7 x 9 cm. Dr J.W.L. Glaisher Bequest (C.2598-1928).

CAT. 258 | FIG. 271
Stove tile
German, late 16th century. Buff earthenware rectangular tile, moulded in relief with *The Crucifixion* set under a foliage-decorated arch supported on two fluted pilasters, covered with a dark green lead-glaze. 43 x 38 x 3.8 cm. Given by T.D. Barlow (C.21-1910).

CAT. 259 | FIG. 273
Oval wall panel
Dutch, Delft, c.1700–50. Tin-glazed earthenware, painted in blue, with an image of Christ in a boat rowed by a woman on a Dutch waterway and, below, an inscription from Philippians 3:14; around the top of the frame: 'De Ziele gestadig tegen den Stroom der Sonden oproeyende' (The soul steadily rowing against the stream of sin). 18 x 9 cm. Dr J.W.L. Glaisher Bequest (C.2544-1928).

CAT. 260 | FIG. 283
Charger
English, Bristol (Limekiln Lane: Josiah Bundy or James Gaynard), or perhaps Brislington, Somerset, c.1735–45. Buff earthenware, tin-glazed bluish-white, painted and sponged in blue and green, and painted in yellow and red with *The Temptation*; the reverse is also tin-glazed. 7.4 x 34 cm diam. Dr J.W.L. Glaisher Bequest (C.1620-1928).

CAT. 261 | FIG. 282
Tota pulchra es
Fray Eugenio Gutiérrez de Torices (active 1653–1709), Spanish, Segovia, 1690. Coloured wax, modelled in high relief, of the Virgin Mary as described in the antiphon 'Tota pulchra es' in original gilt-ebony frame, signed and dated on cartouche at lower right, 'Fr. Eugeo ft. 1690'. 35.3 x 28.9 cm. Lent by Coll & Cortes, London.

CAT. 262 | FIG. 286
Key
French, 16th century. Chiselled iron, with top formed as capital, crowned with finial composed of two addorsed leaping horses, tied together with leafy bower spouting from mouth of a green-man mask. 14.6 x 3.2 cm. C.B. Marlay Bequest (MAR.M.219-1912).

CAT. 263 | FIG. 287
Key
French, 16th century. Chiselled iron, with top formed as capital, crowned with finial composed of a central mermaid with a pair of addorsed bare-breasted harpies trapped in her folded arms. 15.5 x 5 cm. C.B. Marlay Bequest (MAR.M.221-1912).

CAT. 264 | FIG. 288
Lantern key
French, 17th century. Chiselled iron with pierced work decoration. 14 cm long. C.B. Marlay Bequest (MAR.M.223-1912).

CAT. 265 | FIG. 285
Lockplate
European, 17th century, Iron. 21.8 x 20.6 cm. Given by Miss E. Rothwell in memory of the late W.E. Miller, FSA (M.10-1940)

CAT. 266 | FIG. 291
Miniature casket
Workshop of Michael Mann (active 1580s–after 1630), Nuremberg, c.1600–30. Gilt-brass with copper mounts, engraved on the top and sides with figures of men and women, and on the base with a view of a town, small ball feet, hinged lid with central handle and strap engraved 'MICHEL MAN', internal lock mechanism lost. 4.5 x 7.4 x 4.8 cm. Given by Charles Holden-White (M.16-1935).

CAT. 267 | FIG. 289
Miniature casket
German, c.1600–30. Gilt-copper, with ferrous metal lock mechanism, the lid engraved with a man and woman, the sides with fruit and flowers, and the base with a chequer pattern. 4.4 x 6.5 x 4.3 cm. Given by Charles Holden-White (M.26-1935).

CAT. 268 | FIG. 290
Miniature casket
German, c.1580–1620. Gilt-brass, with ferrous metal and silver mounts and ferrous metal mechanism, the top and front engraved with buildings, the sides with scale pattern set with quatrefoils and the back and base with formal plant and geometrical designs. 4.5 x 4.9 x 3.1 cm. Given by Charles Holden-White (M.27-1935).

CREDITS

CONTRIBUTING AUTHORS

Dr Victoria Avery FSA is Keeper of Applied Arts at the Fitzwilliam Museum, Cambridge, having been an Associate Professor in the History of Art Department, University of Warwick. She has published extensively on Italian Renaissance sculpture, and was awarded the Premio Salibeni 2012 for her British Academy-funded monograph, *Vulcan's Forge in Venus' City: The Story of Bronze in Venice, 1350–1650* (2011).

Professor Maxine Berg is Professor of History at the University of Warwick and Fellow of the British Academy. She is Founding Director of the Global History and Culture Centre, and has recently directed the four-year European Research Council project, 'Europe's Asian Centuries: Trading Eurasia 1600–1800' She has written extensively on industry and consumption in the eighteenth century. Recent books include *Luxury and Pleasure in Eighteenth-Century Britain* (2005) and the edited volumes *Writing the History of the Global: Challenges for the Twenty-first Century* (2012) and *Goods from the East: Trading Eurasia 1600–1800* (forthcoming 2015).

Professor Peter Burke taught at the University of Sussex before coming to Cambridge in 1979 as Fellow of Emmanuel College. He was Professor of Cultural History at Cambridge until his retirement in 2004. His 25 books include *The Italian Renaissance* (1972, 5th edn 2014); *Popular Culture in Early Modern Europe* (1978, 3rd edn 2009); and *Eyewitnessing* (2001).

Dr Melissa Calaresu is the Neil McKendrick Lecturer in History at Gonville and Caius College, Cambridge, and has written on the Grand Tour, autobiographical writing, urban space, political reform and, most recently, the making and eating of ice cream in eighteenth-century Naples. She is co-editor of *Exploring Cultural History: Essays in Honour of Peter Burke* (2010), *New Approaches to Naples c.1500–c.1800: The Power of Place* (2013) and *Food Hawkers: Selling in the Street from Antiquity to the Present Day* (2015).

Dr Helen Clifford is an Honorary Fellow in the Department of History, University of Warwick. She has recently been involved in two major projects, 'Trading Eurasia – Europe's Asian Centuries 1600–1800' at Warwick; and 'The East India Company at Home 1757–1857' at University College London. She has published extensively on luxury goods in the early modern period, combining academic work with curating the Swaledale Museum in Reeth, North Yorkshire.

Amparo Fontaine is a PhD candidate in History at the University of Cambridge, where she had previously obtained an MPhil in Early Modern History. She works on music in eighteenth-century France and Italy. Her research interests include material and visual culture, the history of knowledge, consumption, emotions and the senses.

Carol Humphrey is Honorary Keeper of Textiles at the Fitzwilliam Museum, Cambridge, and an expert in English Embroidery and Samplers. She has published extensively on these subjects, including *Samplers* (1997) and *Quaker School Girl Samplers from Ackworth* (2008).

Suzanna Ivanič is a doctoral researcher at the University of Cambridge working on religious materiality in seventeenth-century Prague. Her research interests span religion, travel, Central Europe and material and visual culture. Forthcoming publications include 'Traversing the local and universal in the Catholic Renewal' in *Cultural and Social History*.

Dr Jasmine Kilburn-Toppin completed a PhD at the Royal College of Art/Victoria and Albert Museum in 2013 and is currently a Postdoctoral Fellow at the Paul Mellon Centre for Studies in British Art. Research interests include the built environments and material cultures of artisanal guilds in post-Reformation London.

Dr Mary Laven is Reader in Early Modern History at the University of Cambridge and a Fellow of Jesus College. She has written extensively about aspects of religion in Renaissance and Counter-Reformation Italy and is now working on 'Domestic Devotions', an inter-disciplinary, collaborative project, funded by the European Research Council.

Dr Alexander Marr is University Lecturer in the History of Art, University of Cambridge and a Fellow of Trinity Hall. He works primarily on the intellectual aspects of Western art and architecture in the sixteenth and seventeenth centuries and is the director of the European Research Council project *Genius before Romanticism: Ingenuity in Early Modern Art and Science*.

Professor Peter McNeil FAHA is Professor of Design History and Associate Dean, Research, at the University of Technology, Sydney and Professor of Fashion Studies at Stockholm University. His research interests are primarily the cultural history of fashion and its interaction with other aspects of art, design and material culture. In June 2014 he was appointed Distinguished Professor by the Academy of Finland (for Aalto University).

Sophie Pitman is an AHRC-funded PhD student in History at St John's College, Cambridge, where she works on clothing and material culture in early modern London. She holds degrees from Jesus College, Oxford (BA), and the Bard Graduate Center (MA) and was a Frank Knox Fellow at Harvard University.

Dr Julia Poole was formerly Keeper of Applied Arts at the Fitzwilliam Museum. Her publications include *Italian Maiolica and Incised Slipware in the Fitzwilliam Museum* (1995), *English Pottery* (1995) as well as articles on ceramics and glass in the household accounts of the 4th Duke of Bedford (2002, 2009) and mirror theft in eighteenth-century London (2011). She is preparing a catalogue of the Fitzwilliam's Limoges painted enamels.

Professor Giorgio Riello is Professor of Global History at the University of Warwick. He is the author of *A Foot in the Past* (2006) and *Cotton: The Fabric that Made the Modern World* (2013). He has also edited several books on the history of textiles, dress and fashion in early modern Europe and Asia.

Professor **Ulinka Rublack** is Professor of Early Modern European History at the University of Cambridge and a Fellow of St John's College. Her most recent monograph is a study of the role of Renaissance dress to create visual realities and stimulate cultural debate, *Dressing Up: Culture Identity in Renaissance Europe* (2010).

Katherine Tycz is a PhD candidate in the Department of Italian, University of Cambridge. As part of the research team of 'Domestic Devotions: The Place of Piety in the Renaissance Italian Home, 1400–1600', a project funded by the European Research Council, she is researching text, material culture and devotion in early modern Italy.

Professor **Evelyn Welch** is Professor of Renaissance Studies at King's College London. She is co-author of *Making and Marketing Medicine in Renaissance Florence* (2011) and author of *Shopping in the Renaissance* (2005). Between 2010 and 2013 she led the Humanities in the European Research Area funded project, 'Fashioning the Early Modern: Creativity and Innovation in Europe, 1500–1800'.

KEY TO CONTRIBUTING AUTHORS

AF	Amparo Fontaine
AM	Alexander Marr
CH	Carol Humphrey
EW	Evelyn Welch
GR	Giorgio Riello
HC	Helen Clifford
JEP	Julia Poole
JKT	Jasmine Kilburn-Toppin
KT	Katherine Tycz
PB	Peter Burke
PM	Peter McNeil
MB	Maxine Berg
MRL	Mary Laven
MTC	Melissa Calaresu
SI	Suzanna Ivanič
SP	Sophie Pitman
UR	Ulinka Rublack
VJA	Victoria Avery

LENDERS TO THE EXHIBITION

Cambridge
- The Master and Fellows of Gonville and Caius College
- The Master and Fellows of Trinity College
- Museum of Archaeology and Anthropology, University of Cambridge
- Whipple Museum of the History of Science, University of Cambridge

Cambridgeshire
- Wimpole Hall, The National Trust

London
- Coll & Cortes
- Jenny Tiramani, The School of Historical Dress
- The Victoria and Albert Museum (V&A)

PHOTOGRAPHY

Unless otherwise stated below, all images copyright the Fitzwilliam Museum, Cambridge.

- Fig. 1: © National Trust Images/ Andreas von Einsiedel
- Figs 14 and 19: Castello di Issogne, Val d'Aosta, Italy, Giraudon/Bridgeman Images
- Figs 21, 22, 67: © Trustees of the British Museum
- Figs 25, 96, 198: © Victoria and Albert Museum, London
- Fig. 30: Royal Collections Trust © Her Majesty Queen Elizabeth II, 2014/ Bridgeman Images
- Fig. 32: Civica Raccolta delle Stampe 'Achille Bertarelli', Castello Sforzesco, Milan
- Fig. 35: by permission of the Pepys Library, Magdalene College, Cambridge
- Figs 61: by permission of the Master and Fellows of Gonville and Caius College, Cambridge/Professor Yao Liang
- Fig. 66: Marquess of Bath, Longleat House, Warminster, Wiltshire
- Fig. 74: © The British Library Board

(450.b.25, frontispiece)
- Fig. 75: © Aberdeen Art Gallery & Museums Collections
- Fig. 76: © Hermitage, St Petersburg, Russia/Bridgeman Images
- Fig. 111: British Library, London, UK © British Library Board/ Bridgeman Images
- Fig. 129: © Jenny Tiramani, London
- Fig. 130: © Herzog Anton Ulrich-Museum, Brunswick, Kunstmuseum des Landes Niedersachsen/ Museumsfotograf
- Fig. 131: by permission of the Master and Fellows of Trinity College, Cambridge
- Fig. 175: Swiss National Museum, DEP-3721, © Dr Paul Hess, Zurich
- Fig. 184: © National Trust
- Fig. 224: © The British Library Board (7944.h.11)

BIBLIOGRAPHY

Adams 2001 | Adams, Yvonne, *Meissen Figures 1730–1775: The Kaendler Period* (Atglen, 2001).

Adams and Redstone 1981 | Adams, Elizabeth, and David Redstone, *Bow Porcelain* (London, 1981).

Addison 1711 | Addison, Joseph, 'No. 102. Wednesday, June 27, 1711', *The Spectator* (27 June 1711).

Adhyatman 1999 | Adhyatman, Sumarah, *Zhangzhou (Swatow) Ceramics: Sixteenth to Seventeenth Centuries Found in Indonesia* (Jakarta, 1999).

Ago 2013 | Ago, Renata, *Gusto for Things: A History of Objects in Seventeenth-century Rome*, trans. Bradford Bouley and Corey Tazzara (Chicago and London, 2013).

Ajmar-Wollheim and Dennis 2006 | Ajmar-Wollheim, Marta, and Flora Dennis (eds), *At Home in Renaissance Italy*, exh. cat., Victoria and Albert Museum, London: 5 October 2006–7 January 2007 (London, 2006).

Aken-Fehmers 2007 | Aken-Fehmers, Marion S. van, *Delfts aardewerk. Geschiedenis von een nationaal product, Deel IV, Vazen met tuiten: 300 jaar pronkstukken* (Zwolle, 2007).

Aken-Fehmers et al. 1999–2003 | Aken-Fehmers, Marion S. van Loet, A. Schledorn, Titus M. Eliëns et al., *Delfts aardewerk: Geschiedenis van een nationaal product*, 3 vols (Zwolle, 1999–2003).

Alexander 1984 | Alexander, Hélène, *Fans* (London, 1984).

Allerston 1999 | Allerston, Patricia, 'Reconstructing the second-hand clothes trade in sixteenth- and seventeenth-century Venice', *The Costume Society*, 33 (1999), pp. 46–56.

Appadurai 1986 | Appadurai, Arjun (ed.), *The Social Life of Things: Commodities in Cultural Perspective* (Cambridge, 1986).

Archenholz 1789 | Archenholz, Johann Willem von, *A Picture of England* (London, 1789).

Archer 1997 | Archer, Michael, *Delftware. The Tin-glazed Earthenware of the British Isles. A Catalogue of the Collection in the Victoria and Albert Museum* (London, 1997).'

Archer 2000 | Archer, Ian W., 'Material Londoners?', in Lena Cowen Orlin (ed.), *Material London, ca. 1600* (Philadelphia, 2000), pp. 174–92.

Archer 2013 | Archer, Michael, *Delftware in the Fitzwilliam Museum* (London, 2013).

Armstrong 1984 | Armstrong, Nancy, *Fans: A Collector's Guide* (London, 1984).

Armstrong 1985 | Armstrong, Nancy, *Fans from the Fitzwilliam* (Cambridge, 1985).

Arthur 1995 | Arthur, Liz, *Embroidery at the Burrell Collection, 1600–1700* (London, 1995).

Ashworth 2003 | Ashworth, William, *Customs and Excise* (Oxford, 2003).

Atasoy et al. 1989 | Atasoy, Nurhan, Julian Raby and Yanni Petsopoulos, *Iznik: the Pottery of Ottoman Turkey* (London, 1989).

Avery 2011 | Avery, Victoria, *Vulcan's Forge in Venus' City: The Story of Bronze in Venice, 1350–1650* (Oxford, 2011).

Avery and Dillon 2002 | Avery, Victoria, and Jo Dillon, *Renaissance and Baroque Bronzes from The Fitzwilliam Museum, Cambridge* (London, 2002).

Ayers et al. 1990 | Ayers, John, Oliver Impey, and J.V.G. Mallet, *Porcelain for Palaces: The Fashion for Japan in Europe 1650–1750* (London, 1990).

Aynsley and Grant 2006 | Aynsley, Jeremy, and Charlotte Grant (eds), *Imagined Interiors: Representing the Domestic Interior since the Renaissance* (London, 2006).

Babington 1859 | Babington, Charles, 'On some Antiquities found in Corpus Christi College in the year 1852',

Antiquarian Communications, 1 (1859), pp. 50–4.

Baillie 1969 | Baillie, G.H., *Watchmakers and Clockmakers of the World* (London, 1969).

Baines 1998 | Baines, Anthony, *Catalogue of Musical Instruments in the Victoria and Albert Museum. Part II: Non-keyboard instruments* (London, 1998).

Baker 2005 | Baker, David J., '"The Allegory of a China Shop": Jonson's "Entertainment at Britain's Burse"', *English Literary History*, 72 (2005), pp. 159–80.

Baker 2012 | Baker, David J., *On Demand. Writing for the Market in Early Modern England* (Stanford, CA, 2012).

Balduinus 1647 | Balduinus, Benedictus, *De calceo antiquo* (Amsterdam, 1647).

Barker and Crompton 2007 | Barker, David, and Steve Crompton, *Slipware in the Collection of the Potteries Museum & Art Gallery* (London, 2007)

Barley 1961 | Barley, Maurice, *English Farmhouse and Cottage* (London, 1961).

Bartholin 1647 | Bartholin, Thomas, *De armillis* (Copenhagen, 1647).

Baskins 1998 | Baskins, Cristelle, *Cassone Painting, Humanism and Gender in Early Modern Italy* (Cambridge, 1998).

Batchelor 2007 | Batchelor, Jennie, 'Reinstating the "Pamela Vogue"', in Jennie Batchelor and Cora Kaplan (eds), *Women and Material Culture, 1660–1830* (Basingstoke and New York, 2007), pp. 163–75.

Baudrillard 1968 | Baudrillard, Jean, *Le système des objets* (Paris, 1968).

Bayne-Powell 1985 | Bayne-Powell, Robert Lane, *Catalogue of Portrait Miniatures in the Fitzwilliam Museum, Cambridge* (Cambridge, 1985).

Bedarida and Sutcliffe 1980 | Bedarida, François, and Anthony Sutcliffe, 'The Street in the Structure and Life of the City. Reflections on Nineteenth-Century London and Paris', *Journal of Urban History*, 6/2 (1980), pp. 379–96.

Beevers 2008 | Beevers, David (ed.), *Chinese Whispers: Chinoiserie in Britain, 1650–1930* (Brighton & Hove, 2008).

Bénézet 1999 | Bénézet, Jean-Paul, *Pharmacie et médicament en Méditerranée occidentale: (XIIIe–XVIe siècles)* (Paris, 1999).

Benkard 1929 | Benkard, Ernest, *Undying Faces. A Collection of Death Masks* (London, 1929).

Bennett 2010 | Bennett, Jane, *Vibrant Matter: A Political Ecology of Things* (Durham and London, 2010).

Berg 2003 | Berg, Maxine, 'Asian luxuries and the making of the European consumer revolution', in Berg and Eger 2003, pp. 228–44.

Berg 2004 | Berg, Maxine, 'In Pursuit of Luxury: Global History and British Consumer Goods in the Eighteenth Century', *Past and Present*, 182 (2004), pp. 85–142.

Berg 2005 | Berg, Maxine, *Luxury and Pleasure in Eighteenth-Century Britain* (Oxford, 2005).

Berg and Clifford 1998 | Berg, Maxine, and Helen Clifford, 'Commerce and the Commodity: Graphic Display and Selling New Consumer Goods in Eighteenth-Century England', in Michael North and David Ormrod (eds), *Art Markets in Europe, 1400–1800* (Aldershot and Burlington, 1998), pp. 187–200.

Berg and Clifford 1999 | Berg, Maxine, and Helen Clifford (eds), *Consumers and Luxury: Consumer Culture in Europe 1650–1850* (Manchester, 1999).

Berg and Clifford 2007 | Berg, Maxine, and Helen Clifford, 'Selling Consumption in the Eighteenth Century: Advertising and the Trade Card in Britain and France', *Cultural and Social History*, 4/2 (2007), pp. 145–70.

Berg and Eger 2003 | Berg, Maxine, and Elizabeth Eger

(eds), *Luxury in the Eighteenth Century: Debates, Desires, and Delectable Goods* (Basingstoke, 2003).

Berger 1998 | Berger, Ewald, *Prunk-Kassetten. Ornamental Caskets* (Stuttgart, 1998).

Bermingham and Brewer 1995 | Bermingham, Ann, and John Brewer (eds), *The Consumption of Culture, 1600–1800* (London, 1995).

Berry 2002 | Berry, Helen, 'Polite Consumption: Shopping in Eighteenth-Century England', *Transactions of the Royal Historical Society*, 6th ser., 12 (2002), pp. 375–94.

Bimbinet-Privat 2002 | Bimbinet-Privat, Michèle, *Les orfèvres et l'orfèvrerie de Paris au XVIIe siècle*, 2 vols (Paris, 2002).

Bleyerveld 2000–1 | Bleyerveld, Yvonne, 'Chaste, Obedient and Devout. Biblical Women as Patterns of Female Virtue in Netherlandish and German Graphic Art, ca. 1500–1750', *Simiolus*, 28/4 (2000/1), pp. 219–50.

Blome 1686 | Blome, Richard, *The Gentleman's Recreation* (London, 1686).

Blumin 2008 | Blumin, Stuart M., *The Encompassing City: Streetscapes in Early Modern Art and Culture* (Manchester, 2008).

Bode 1908 | Bode, Wilhelm von, *Ancient Oriental Carpets* (Leipzig, 1908).

Bode 1911 | Bode, Wilhelm von, *Die Anfänge der Majolikakunst in Toskana* (Berlin, 1911).

Bolz 1982 | Bolz, Claus, 'Formen des Böttgersteinzeugs im Jahre 1711', *Keramik-Freunde der Schweiz*, 96 (March 1982), pp. 7–40.

Bolz 2000 | Bolz, Claus, 'Steinzeug und Porzellan der Böttgerperiode – Die Inventare und die Ostermesse des Jahres 1719', *Keramos*, 167/168 (April 2000), pp. 3–174.

Bonham's 2013 | Bonham's sale catalogue, *British and European Glass including the Meyer Collection*, London, 1 May 2013 (London, 2013).

Bossan 2004 | Bossan, Marie-Josèphe, *The Art of the Shoe* (New York, 2004).

Boucaud and Schonn 2013 | Boucaud, Philippe, and Michel Schonn, *Étains et Maître Potiers d'Étain: Paris 1643–1791* (Paris, 2013).

Bourdieu 1979 | Bourdieu, Pierre, *La distinction* (Paris, 1979).

Bouza 2007 | Bouza, Fernando, 'Letters and portraits: economy of time and chivalrous service in courtly culture', in Francisco Bethencourt and Florike Egmond (eds), *Cultural Exchange in Early Modern Europe: Correspondence and Cultural Exchange in Europe, 1400–1700* (Cambridge, 2007), pp. 145–62.

Boxer 1951 | Boxer, Charles Ralph, *The Christian Century in Japan, 1549–1650* (Berkeley; Los Angeles, 1951).

Brears 1996 | Brears, Peter, 'Bygones in *The Connoisseur*', *Folklife*, 34 (1996), pp. 30–42.

Bremer-David 2011 | Bremer-David, Charissa (ed.), *Paris: Life and Luxury in the Eighteenth Century*, exh. cat., J. Paul Getty Museum, Los Angeles, 26 April–7 August 2011; Museum of Fine Arts, Houston, 18 September–10 December 2011 (Los Angeles, 2011).

Brennan 1988 | Brennan, Thomas Edward, *Public Drinking and Popular Culture in Eighteenth-Century Paris* (Princeton, NJ, 1988).

Brett 2014 | Brett, Vanessa, *Bertrand's Toyshop in Bath: Luxury Retailing 1685–1765* (Wetherby, 2014).

Brett-James 1935 | Brett-James, Norman G., *The Growth of Stuart London* (London, 1935).

Brewer 1997 | Brewer, John, *The Pleasures of the Imagination: English Culture in the Eighteenth Century* (London, 1997).

Brewer and Porter 1993 | Brewer, John, and Roy Porter (eds), *Consumption and the World of Goods* (London, 1993).

Britten 1982 | Britten, F.J., *Old Clocks and Watches and their Makers* (9th edn, London, 1982).

Brondi 1926 | Brondi, Maria Rita, *Il liuto e la chitara. Richerche storiche sulla loro origine e sul suo sviluppo* (Bologna, 1926).

Brown 1995 | Brown, Peter, *In Praise of Hot Liquors: The Study of Chocolate, Coffee and Tea-Drinking 1600–1850, Fairfax House, York* (York, 1995).

Brown 2004 | Brown, Bill, 'Thing Theory', in Bill Brown (ed.), *Things* (Chicago and London, 2004), pp. 1–22.

Brown 2008 | Brown, Vincent, 'Eating the Dead: Consumption and Regeneration in the History of Sugar', *Food and Foodways*, 16/2 (2008), pp. 117–26.

Brunet 1974 | Brunet, Marcelle, *The Frick Collection, An Illustrated Catalogue, Volume VII – Porcelains Oriental and French* (New York, 1974).

Brusa 1879 | Brusa, G.B., *Raccolta di Battitori a Venezia* (Venice, 1879).

Buck and Matthews 1984 | Buck, Anne, and Harry Matthews, 'Pocket Guides to Fashion: Ladies' Pocket Books Published in England, 1760–1830', *Costume*, 18 (1984), pp. 35–58.

Burckhardt 1878 | Burckhardt, Jacob, *The Civilization of the Renaissance in Italy*, trans. S.G.C. Middlemore (London, 1878).

Burke 1884 | Burke, Bernard, *The General Armory of England Scotland and Wales; Comprising a Registry of Armorial Bearings from the Earliest to the Present Time* (London, 1884).

Burke 1987 | Burke, Peter, 'The Presentation of Self in the Renaissance Portrait', in Peter Burke (ed.), *The Historical Anthropology of Early Modern Italy: Essays on Perception and Communication* (Cambridge, 1987), pp. 150–67.

Burke 1997 | Burke, Peter, 'Representations of the Self from Petrarch to Descartes', in Roy Porter (ed.), *Rewriting the Self: Histories from the Renaissance to the Present* (London, 1997), pp. 17–28.

Burke 1998 | Burke, Peter, *The European Renaissance* (Oxford, 1998).

Burke 1999 | Burke, Peter, 'Humanism and Friendship in Sixteenth-Century Europe', in Julian Haseldine (ed.), *Friendship in Medieval Europe* (Stroud, 1999), pp. 262–74.

Burnett 1969 | Burnett, John, *A History of the Cost of Living* (Harmondsworth, 1969).

Bury 2001 | Bury, Michael, *The Print in Italy, 1550–1620* (London, 2001).

Bynum 2011 | Bynum, Caroline Walker, *Christian Materiality: An Essay on Religion in Late Medieval Europe* (New York, 2011).

Cadiou 1990 | Cadiou, Didier, 'La vie quotidienne dans les paroisses littorales de Camouet, Crozon, Roscankel et Telgnac, d'après les inventaires après décès', MA thesis, Université de Bretagne Occidentale, 1990.

Calaresu 2007 | Calaresu, Melissa, 'From the Street to Stereotype: Urban Space, Travel, and the Picturesque in Late Eighteenth-Century Naples', *Italian Studies*, 62/2 (2007), pp. 189–203.

Calaresu 2013a | Calaresu, Melissa, 'Costumes and Customs in Prints. Travel, Ethnography and the Representation of Street-Sellers in Early Modern Italy', in Roeland Harms, Joad Raymond and Jeroen Salman (eds), *Not Dead Things. The Dissemination of Popular Print in England, Wales, Italy and the Low Countries, 1500–1820* (Leiden, 2013), pp.181–212.

Calaresu 2013b | Calaresu, Melissa, 'Collecting Neapolitans: The representation of street life in late eighteenth-century Naples', in Melissa Calaresu and Helen Hills (eds), *New Approaches to Naples c.1500–c.1800: The Power of Place* (Farnham and Burlington, 2013), pp. 175–202.

Calaresu 2013c | Calaresu, Melissa, 'Making and Eating Ice Cream in Naples: Rethinking Consumption and Sociability in the Eighteenth Century', *Past and Present*, 220/1 (August 2013), pp. 35–78.

Calaresu 2015 | Calaresu, Melissa, 'Food selling and urban space in early modern Naples', in Calaresu and van den Heuvel 2015.

Calaresu forthcoming | Calaresu, Melissa, 'Street luxuries: Selling food on the street in early modern Rome', in Sarah Carter and Ivan Gaskell (eds), *Oxford Handbook of History and Material Culture* (Oxford, forthcoming).

Calaresu and van den Heuvel 2015 | Calaresu, Melissa, and Danielle van den Heuvel (eds), *Food Hawkers: Selling in the Streets from Antiquity to the Present* (Farnham and Burlington, 2015).

Campbell 2002 | Campbell, Myrtle, 'Embroidered Bodices: An East India Company Connection?', *Costume*, 36 (2002), pp. 56–64.

Canepa and van der Pijl-Ketel 2008 | Canepa, Teresa, and Christine van der Pijl-Ketel, *Kraak porcelain: The Rise of Global Trade in the Late 16th and Early 17th Centuries* (London and Lisbon, 2008).

Cao and Luo 2006 | Cao, Jianwen, and Luo Yi Fei, 'Kraak Porcelain discovered at some kiln sites in Jingdezhen City in recent years', *Oriental Art*, 50/4 (2006), pp. 16–24.

Capwell 2011 | Capwell, Tobias, *Masterpieces of European Arms and Armour in the Wallace Collection* (London, 2011).

Capwell 2012 | Capwell, Tobias, *The Noble Art of the Sword. Fashion and Fencing in Renaissance Europe 1520–1630*, exh. cat., The Wallace Collection, London, 17 May–16 September 2012 (London, 2012).

Caraccioli 1790 | Caraccioli, Louise-Antoine, *Letters on the Manners of the French, and on the Follies and Extravagancies of the Times, Written by an Indian at Paris*, trans. C. Shillito, 2 vols (London, 1790).

Caravale 2011 | Caravale, Giorgio, *Forbidden Prayer: Church Censorship and Devotional Literature in Renaissance Italy*, trans. Peter Dawson (Farnham and Burlington, 2011).

Cardinal 1985 | Cardinal, Catherine, *The Watch: From its Origins to the XIXth Century* (Secaucus, NJ, 1985).

Carney 2008 | Carney, Judith, 'Reconsidering sweetness and power through a gendered lens', *Food and Foodways*, 16/2, (2008), pp. 127–34.

Carswell 1998 | Carswell, John, *Iznik Pottery* (London, 1998).

Casali 1981 | Casali, Mariarosa Palvarini Gobio, 'Ceramic tiles for the Gonzaga', in Chambers and Martineau 1981, pp. 44–5.

Cash 2006 | Cash, Arthur H., *John Wilkes, The Scandalous Father of Civil Liberty* (New Haven and London, 2006).

Cassidy-Geiger et al. 2008 | Cassidy-Geiger, Maureen, et al., *The Arnhold Collection of Meissen Porcelain: 1710–50*, exh. cat., The Frick Collection, New York, 25 March–29 June 2008 (New York and London, 2008).

Cavallo and Storey 2013 | Cavallo, Sandra, and Tessa Storey, *Healthy Living in Late Renaissance Italy* (Oxford, 2013).

Chambers and Martineau 1981 | Chambers, David, and Jane Martineau (eds), *Splendours of the Gonzaga*, exh. cat., Victoria and Albert Museum, London, 4 November 1981–31 January 1982 (London, 1981).

Charleston 1984 | Charleston, R.J., *English Glass and the Glass Used in England, c.400–1940* (London, 1984).

Chartier et al. 1997 | Chartier, Roger, Alain Boureau and Cécile Dauphin (eds), *Correspondence: Models of Letter-Writing from the Middle Ages to the Nineteenth Century*, trans. Christopher Woodall (Oxford, 1997).

Chelsea 1755 | *A Catalogue of the Last Year's large and valuable Production of the Chelsea and Porcelain Manufactory* (London, 1755).

Childs 2010 | Childs, Adrienne L., 'Sugar Boxes and Blackamoors: Ornamental Blackness in Early Meissen Porcelain', in Alden Cavanaugh and Michael E. Yonan (eds), *The Cultural Aesthetics of Eighteenth-Century Porcelain* (Farnham and Burlington, 2010), pp. 159–78.

Chippendale 2005 | Chippendale, Thomas, *The Gentleman and Cabinet-maker's Director* (Leeds, 2005).

Chrisman-Campbell 2011 | Chrisman-Campbell, Kimberley, 'Dressing to impress: The morning toilette and the fabrication of femininity', in Bremer-David 2011, pp. 53–73.

Christie's 2011 | Christie's sale catalogue, *Syd Levethan: The Longridge Collection*, New York, 24 January 2011 (New York, 2011).

Chrzan 2013 | Chrzan, Janet, *Alcohol: Social Drinking in Cultural Context* (New York, 2013).

Church 1894 | Church, Arthur, *Minor Arts as Practised in England* (1894).

Clark 2007 | Clark, Stuart, *Vanities of the Eye: Vision in Early Modern European Culture* (Oxford, 2007).

Clayton 1985 | Clayton, Michael, *The Collectors' Dictionary of Silver and Gold of Britain and North America* (Woodbridge, 1985).

Clayton 1997 | Clayton, Tim, *The English Print, 1688–1802* (New Haven and London, 1997).

Clemente 2011 | Clemente, Alida, *Il lusso "cattivo": Dinamiche del consumo nella Napoli del Settecento* (Rome, 2011).

Clifford 1999 | Clifford, Helen, 'A commerce with things: The value of precious metalwork in early modern England', in Berg and Clifford 1999, pp. 147–69.

Clifford 2002 | Clifford, Helen, 'Knives, Forks and Spoons, 1600–1830', in Glanville and Young 2002, pp. 54–7.

Cook 2007 | Cook, Harold J., *Matters of Exchange: Commerce, Medicine, and Science in the Dutch Golden Age* (New Haven and London, 2007).

Cooper 1984 | Cooper, Ronald G., *English Slipware Dishes* (London, 1984).

Corfield 1989 | Corfield, Penelope, 'Dress for Deference and Dissent: Hats and the Decline of Hat Honour', *Costume*, 23 (1989), pp. 64–79.

Corneille 1637 | Corneille, Pierre, *La galerie du Palais, ou l'Amie Rivalle* (Paris, 1637).

Corrado 1990 | Corrado, Vincenzo, *Il cuoco galante* [Naples, 1786] (Bologna, 1990).

Coryate 1978 | Coryate, Thomas, *Coryat's Crudities 1611* (London, 1978).

Cotterell 1929 | Cotterell, Howard Herschel, *Old Pewter, its Makers and Marks* (London, 1929).

Courajod 1873 | Courajod, Louis, *Livre-Journal de Lazare Duvaux marchand-bijoutier ordinaire du Roy 1748–1758, précédé d'une étude sur le gout et sur le commerce des objets d'art au milieu du XVIIIe siècle*, 2 vols (Paris, 1873).

Courtauld 2007 | Courtauld, Amelia, 'Liquid refreshment', in Glanville and Lee 2007, pp. 116–9.

Cowan 2005 | Cowan, Brian, *The Social Life of Coffee: The Emergence of the British Coffeehouse* (New Haven and London, 2005).

Cox and Dannehl 2007 | Cox, Nancy, and Karin Dannehl, *Perceptions of Retailing in Early Modern England* (Aldershot and Burlington, 2007).

Croce 1625 | Croce, Giulio Cesare, *Chiacciaramenti sopra tutti li traffichi e negoccii che si fanno ogni giorno sù la piazza di Bologna. Composti da Giulio Cesare Croce, opera da ridere* (Bologna, 1625).

Crossley 1993 | Crossley, Robert, 'Circulatory Systems of Puzzle Jugs', *English Ceramic Circle Transactions*, 15/1 (1993), pp. 73–98.

Crowe 2002 | Crowe, Yolande, *Persia and China: Safavid Blue and White Ceramics in the Victoria and Albert Museum, 1501–1738* (London, 2002).

Csikszentmihalyi 1981 | Csikszentmihalyi, Mihaly, *The Meaning of Things* (Cambridge, 1981).

Cumming et al. 2010 | Cumming, Valerie, C.W. Cunnington and P.E. Cunnington, *The Dictionary of Fashion History* (Oxford, 2010).

Cunnally 1994 | Cunnally, John, 'Ancient Coins as Gifts and Tokens of Friendship during the Renaissance', *Journal of the History of Collections*, 6 (1994), pp. 129–43.

Currie 2007 | Currie, Elizabeth, 'Diversity and design in the Florentine tailoring trade, 1550–1620', in Michelle O'Malley and Evelyn Welch (eds), *The Material Renaissance* (Manchester, 2007), pp. 154–73.

Czechoslovakian Glass 1981 | *Czechoslovakian Glass, 1350–1980*, exh. cat., Corning Museum of Glass, Corning, New York, 2 May–1 November 1981 (New York, 1981).

D'Andrea 1923 | d'Andrea, Francesco, *Ricordi* (Naples, 1923).

Da Carpi 1535 | da Carpi, Ugo, *Thesauro de scrittori. Opera artificiosa laquale con grandissima arte, per pratica come per goemetria insegna a scriuere diuerse sorte littere [...] intagliata per Ugo da Carpi* (3rd edn, Rome, 1535).

Da Castello 1522 | da Castello, Alberto, *Rosario della gloriosa Vergine Maria* (Venice, 1522).

Da Castiligione 1554 | da Castiglione, Sabba, *Ricordi* (first published 1549; edn consulted: Venice, 1554).

Daniels 1970 | Daniels, George, 'The Astronomical Watch by George Margetts in the possession of The Royal Institution, and some other timekeepers of Margetts', *Antiquarian Horology*, 6 (March 1970), pp. 350–8.

Daniels 1981 | Daniels, George, *Watchmaking* (London, 1981).

Daninos 2012 | Daninos, Andrea (ed.), *Waxing Eloquent: Italian Portraits in Wax*, trans. Catherine Bolton (Milan, 2012).

Davis 2000 | Davis, Natalie Z., *The Gift in Sixteenth-Century France* (Oxford, 2000).

Dawson 1994 | Dawson, Aileen, *A Catalogue of French Porcelain in the British Museum* (London, 1994).

Dawson 2010 | Dawson, Aileen, *English & Irish Delftware, 1570–1840* (London, 2010).

Day 1987 | Day, W. G. (ed.), *Catalogue of the Pepys Library at Magdalene College, Cambridge, The Pepys Ballads*, 5 vols (Cambridge, 1987).

Day 2000 | Day, Ivan, *Eat, Drink & Be Merry* (London, 2000).

Day 2002 | Day, Ivan, *Royal Sugar Sculpture: 600 Years of Splendour* (Barnard Castle, 2002).

Day 2011 | Day, Ivan, *Ice Cream: A History* (Oxford, 2011).

Day 2014 | Day, Ivan, Historic Food. Available at www.historicfood.com (accessed 25 August 2014).

Daybell 2001 | Daybell, James (ed.), *Early Modern Women's Letter Writing* (Basingstoke, 2001).

Dean 1994 | Dean, Darron, 'A Slipware Dish by Samuel Malkin: An Analysis of Vernacular Design', *Journal of Design History*, 7/3 (1994), pp. 153–67.

Dean 2000 | Dean, Darron, 'The Design of English Slipware, 1600–1720', *English Ceramic Circle Transactions*, 17/2 (2000), pp. 230–44.

De Certeau 1980 | De Certeau, Michel, *L'invention du quotidien* (Paris, 1980).

De Certeau 2011 | De Certeau, Michel, *The Practice of Everyday Life*, trans. Steven F. Rendell (1st edn 1988, edn consulted: Berkeley, CA, and London, 2011).

De Marly 1975 | De Marly, Diana, 'The vocabulary of the female headdress 1678–1713', *Waffen-und Kostümkünde*, 17 (1975), pp. 61–70.

De Vivo 2007 | De Vivo, Filippo, 'Pharmacies as Centres of Communication in Early Modern Venice', *Renaissance Studies*, 21/4 (2007), pp. 505–21.

De Vries 2003 | De Vries, Jan, 'Luxury in the Dutch Golden Age in Theory and Practice', in Berg and Eger 2003, pp. 41–56.

De Vries 2008 | De Vries, Jan, *The Industrious Revolution: Consumer Behavior and the Household Economy, 1650 to the Present* (Cambridge, 2008).

De Vries 2010 | De Vries, Jan, 'The Limits of Globalization in the Early Modern World', *Economic History Review*, 63/3 (2010), pp. 710–33.

De Waal 2010 | De Waal, Edmund, *The Hare with the Amber Eyes: A Hidden Inheritance* (London, 2010).

DeJean 2011 | DeJean, Joan, 'A new interiority: The architecture of privacy in eighteenth-century Paris', in Bremer-David 2011, pp. 33–51.

Delany 1861–2 | Delany, Mary, *The autobiography and correspondence of Mary Granville, Mrs Delany: with interesting reminiscences of King George the Third and Queen Charlotte*, 6 vols (London, 1861–2).

Dominici 1860 | Dominici, Giovanni, *Regola del governo di cura familiare* (Florence, 1860).

Dorotheum 1912 | Dorotheum *Katalog der Besteck Sammlung: Franz Emmerich Graf Lamberg* (Vienna, 1912).

Douglas and Isherwood 1978 | Douglas, Mary, and Baron Isherwood, *The World of Goods* (New York, 1978).

Duchon 1988 | Duchon, Nicole, *La manufacture de porcelaine de Mennecy Villeroy* (Le Mée-sur-Seine, 1988).

Duffy 1992 | Duffy, Eamon, *The Stripping of the Altars: Traditional Religion in England, 1400–1580* (New Haven and London, 1992).

Dulac and Maggetti 1992–7 | Dulac, Georges, and Daniel Maggetti (eds), *Ferdinando Galiani, Louise d'Epinay: Correspondence (1769–1782)*, 5 vols (Paris, 1992–7).

Du Maurier 1975 | Du Maurier, Daphne, *Rebecca* (1st edn, 1938; edn consulted: London, 1975).

Du Pradel 1705 | Du Pradel, Jean, *Traité contre le luxe des hommes et des femmes, et contre le luxe avec lequel on élève les enfans de l'un & de l'autre sexe* (Paris, 1705).

Eamon 2003 | Eamon, William, 'Medical Self-Fashioning, or How to Get Rich and Famous in the Renaissance Medical Marketplace', *Pharmacy in History*, 45 (2003), pp. 123–9.

Earle 2014 | Earle, Rebecca, 'Chocolate in the Historical Imagination' (unpublished paper for 'Luxury and the Ethics of Greed in the Early Modern World' conference, Villa I Tatti, Florence, September 2014).

Earp 1902 | Earp, F.R., *A Descriptive Catalogue of the Pictures in the Fitzwilliam Museum* (Cambridge, 1902).

Edgcumbe 2000 | Edgcumbe, Richard, *The Art of the Gold Chaser in Eighteenth-Century London* (Oxford, 2000).

Edwards 1996 | Edwards, Clive D., *Eighteenth-Century Furniture* (Manchester, 1996).

Ehrard 1963 | Ehrard, Jean, *L'idée de la nature en France dans la première moitié du XVIIIe siècle* (Paris, 1963).

Elias 2000 | Elias, Norbert, *The Civilizing Process: Sociogenetic and Psychogenetic Investigations*, trans. Edmund Jephcott, ed. Eric Dunning, Johan Goudsblom and Stephen Mennell (Oxford, 2000).

Ellis 2010 | Ellis, Markman (ed.), *Tea and the Tea-Table in Eighteenth-century England*, 4 vols (London, 2010).

Elsner and Cardinal 1994 | Elsner, Jaś, and Roger Cardinal (eds), *The Cultures of Collecting* (London, 1994).

Englander et al. 1990 | Englander, David, et al., *Culture and Belief in Europe, 1450–1600: An Anthology of Sources* (Oxford, 1990).

Epstein 2004 | Epstein, Stephan R., 'Labour mobility, journeyman organisation and markets in skilled labour in Europe, 14th–18th centuries', in Mathieu Arnoux and Pierre Monnet (eds) *Le technician dans la cité en Europe occidentale, 1250–1650* (Rome, 2004), pp. 411–30.

Erkelens 1996 | Erkelens, A.M.L.E., *'Delffs Porcelijn' van koningin Mary II/Queen Mary's 'Delft porcelain', Ceramiek op Het Loo uit de tijd van Willem III en Mary II/Ceramics at Het Loo from the time of William and Mary* (Zwolle, 1996).

Esch 1995 | Esch, Arnold, 'Roman Customs Registers 1470–80: Items of Interest to Historians of Art and Material Culture', *Journal of the Warburg and Courtauld Institutes*, 58 (1995), pp. 72–87.

Evan-Thomas 1932 | Evan-Thomas, Owen, *Domestic Utensils in Wood* (London, 1932).

Faïences françaises 1980 | *Faïences françaises XVIe–XVIIIe siècles*, exh. cat., Galleries nationales du Grand Palais, Paris, 6 June 1980–25 August 1980 (Paris, 1980).

Fairchilds 1993 | Fairchilds, Cissie, 'The Production and Marketing of Populuxe Goods in Eighteenth-Century Paris', in Brewer and Porter 1993, pp. 228–48.

Fearn 2002 | Fearn, Amelia, 'Serving Sweetmeats', in Glanville and Young 2002, pp. 82–5.

Federici 1588 | Federici, Cesare, *The voyage [...] into the East India* (London, 1588).

Festa 2005 | Festa, Lynn M., 'Personal Effects: Wigs and Possessive Individualism in the Long Eighteenth Century', *Eighteenth-Century Life*, 29/2 (2005), pp. 47–90.

Findlen 2013 | Findlen, Paula (ed.), *Early Modern Things. Objects and their Histories, 1500–1800* (London, 2013).

Finlay 1998 | Finlay, Robert, 'The Pilgrim Art: The Culture of Porcelain in World History', *Journal of World History*, 9/2 (1998), pp. 141–87.

Finsten 1981 | Finsten, Jill, *Isaac Oliver: Art at the Courts of Elizabeth I and James I*, 2 vols (New York, 1981).

Fioravanti 1564 | Fioravanti, Leonardo, *Compendio dei secreti rationali, dell'eccell. medico & cirugico m. Leonardo Fiorauanti bolognese, libri cinque* (Venice, 1564).

Fisher 1948 | Fisher, F.J., 'The Development of London as a Centre of Conspicuous Consumption in the Sixteenth and Seventeenth Centuries', *Transactions of the Royal Historical Society*, 4th series, 30 (1948), pp. 37–50.

Fisher 2001 | Fisher, William, 'The Renaissance Beard: Masculinity in Early Modern England', *Renaissance Quarterly*, 54/1 (2001), pp. 155–87.

Fliegel 2008 | Fliegel, Stephen N., *Arms & Armor. The Cleveland Museum of Art* (New York, 2008).

Flood 1976 | Flood, Robert J., *Clay Tobacco Pipes in Cambridgeshire* (Cambridge, 1976).

Florio 1611 | Florio, John, *Queen Anna's New World of Words, or Dictionarie of the Italian and English tongues, Collected and newly augmented by John Florio* (London, 1611). Available at www.pbm.com/~lindahl/florio/ (accessed 8 April 2014).

Fontaine 1996 | Fontaine, Laurence, *History of Pedlars in Europe*, trans. Vicki Whittaker (Durham, NC, 1996).

Fontaine 2003 | Fontaine, Laurence, 'The Circulation of Luxury Goods in Eighteenth-Century Paris: Social Redistribution and an Alternative Currency', in Berg and Eger 2003, pp. 89–102.

Foote 1778 | Foote, Samuel, *A Trip to Calais; A Comedy in Three Acts [...]* (London, 1778).

Fortini Brown 2004 | Fortini Brown, Patricia, *Private Lives in Renaissance Venice: Art, Architecture and the Family* (New Haven and London, 2004).

Forsyth 2002 | Forsyth, Hazel, 'Trenchers and Porringers', in Glanville and Young 2002, pp. 42–3.

Forsyth 2013 | Forsyth, Hazel, *The Cheapside Hoard: London's Lost Jewels* (London, 2013).

Foyn 2000 | Foyn, W.W. Hamilton, 'Dated London Brown Saltglazed Hunting Mugs 1713–75', *English Ceramic Circle Transactions*, 17/2 (2000), pp. 253–74.

Frame 1983 | Frame, Donald (ed.), *Montaigne's Travel Journal* (San Francisco, CA, 1983).

Fraser 1831 | Fraser, Donald, *The Life and Diary of the Reverend Ebenezer Erskine, A.M. of Stirling, Father of the Secession Church* (Edinburgh, 1831).

Fregnac 1964 | Fregnac, Claude (ed.), *Les porcelaniers du XVIIIe siècle français* (Paris, 1964).

Friedman 2008 | Friedman, J.B., 'The Peddler-Robbed-by-Apes Topos: Parchment to Print and Back Again', *Journal of the Early Book Society*, 11 (2008), pp. 87–120.

Gabotto 1906 | Gabotto, F., 'Inventari messinesi inediti del Quattrocento', *Archivio storico per la Sicilia orientale*, 3 (1906), pp. 251–76.

Gage and Marsh 1988 | Gage, Deborah, and Madeleine Marsh, *Tobacco Containers and Accessories. Their Place in Eighteenth-Century European Social History* (London, 1988).

Gaimster 1997a | Gaimster, David, *German Stoneware 1200–1900* (London, 1997).

Gaimster 1997b | Gaimster, David, 'Regional decorative traditions in English post-medieval slipware', in Ian Frestone and David Gaimster (eds), *Pottery in the Making: World Ceramic Traditions* (London, 1997), pp. 128–33.

Gaimster 2003 | Gaimster, David, 'Pots, Prints and Propaganda: Changing Mentalities in the Domestic Sphere, 1480–1580', in David Gaimster and Roberta Gilchrist (eds), *The Archaeology of the Reformation, 1480–1580* (Leeds, 2003), pp. 122–44.

Garcia Espuche 2010 | Garcia Espuche, Albert, *La ciutat del Born: Economia i vida quotidiana a Barcelona (segles XIV a XVIII)* (2nd edn. Barcelona, 2010).

Garcia Espuche et al. 2009 | Garcia Espuche, Albert, et al., *Jocs, triquets i jugadors*, vol. 3 of *Col·lecció La Ciutat del Born. Barcelona 1700* (Barcelona, 2009).

Garcia Espuche et al. 2012 | Garcia Espuche, Albert, et al., *Interiors domestics. Barcelona 1700*, vol. 8 of *Col·lecció La Ciutat del Born. Barcelona 1700* (Barcelona, 2012).

Garrioch 1994 | Garrioch, David, 'House Names, Shop Signs and Social Organization in Western European Cities, 1500–1900', *Urban History*, 21 (1994), pp. 18–46.

Garzoni 1993 | Garzoni, Tommaso, *Opere* (Ravenna, 1993).

Garzoni 1996 | Garzoni, Tommaso, *La Piazza universale di tutte le professioni del mondo*, ed. Paolo Cherchi and Beatrice Collina, 2 vols (Turin, 1996).

Gaskell 1997 | Gaskell, Ivan, 'Tobacco, Social Deviance, and Dutch Art in the Seventeenth Century', in Wayne Franits (ed.), *Looking at Seventeenth-Century Dutch Art* (Cambridge, 1997), pp. 68–77.

Gauden 1649/51 | Gauden, John, *Eikon basilike: the porutraicture of his sacred Majestie in his solitudes and sufferings* (London, 1649/51).

Gay-Mazuel 2011 | Gay-Mazuel, Audrey, 'Une table dressé en faïence de Rouen pour le service des desserts', *Revue de la Société des Amis du Musé National de Céramique*, 20 (2011), pp. 51–67.

Gentilcore 2003a | Gentilcore, David, 'Apothecaries, "Charlatans", and the Medical Marketplace in Italy, 1400–1750: Introduction', *Pharmacy in History*, 45 (2003), pp. 91–4.

Gentilcore 2003b | Gentilcore, David, '"For the protection of those who have both shop and home in this city?" Relations between Italian charlatans and apothecaries', *Pharmacy in History*, 45 (2003), pp. 108–21.

Gentilcore 2006 | Gentilcore, David, *Medical Charlatanism in Early Modern Italy* (Oxford, 2006).

George 1925 | George, M. Dorothy, *London Life in the Eighteenth Century* (London, 1925).

Gere and Tait 1984 | Gere, Charlotte, and Hugh Tait, *The Art of the Jeweller: A Catalogue of the Hull Grundy Gift to the British Museum*, 2 vols (London, 1984).

Gerson et al. 1960 | Gerson, Horst, et al., *Catalogue of Paintings, Fitzwilliam Museum Cambridge: Vol. I Dutch, Flemish, French, German, Spanish* (Cambridge, 1960).

Gessner 1552 | Gessner, Conrad, *Thesaurus Euonymi Philiatri de remediis secretis* (Zurich, 1552).

Gessner 1576 | Gessner, Conrad, *The newe iewell of health [...]*, trans. George Baker (London, 1576).

Geuter 2008 | Geuter, Ruth, 'Embroidered Biblical Narratives and Their Social Context', in Morrall and Watt 2008, pp. 57–78.

Giannuzzi 1995 | Giannuzzi, Chiara Piccolo (ed.), *Fonti per il Barocco Leccese* (Galatina, 1995).

Gilchrist 2012 | Gilchrist, Roberta, *Medieval Life: Archaeology and the Life Course* (Woodbridge, 2012).

Giusti 2009 | Giusti, Anne Maria, *Art and Illusions: Masterpieces of Trompe l'oeil from Antiquity to the Present Day* (Florence, 2009).

Glanville 1990 | Glanville, Phillipa, *Silver in Tudor and Early Stuart England, A Social History and Catalogue of the National Collection 1480–1660* (London, 1990).

Glanville and Lee 2007 | Glanville, Philippa, and Sophie Lee (eds), *The Art of Drinking* (London, 2007).

Glanville and Young 2002 | Glanville, Philippa, and Hilary Young (eds), *Elegant Eating. Four Hundred Years of Dining in Style* (London, 2002).

Glennie and Thrift 2002 | Glennie, Paul, and Nigel Thrift, 'The spaces of clock times', in Patrick Joyce (ed.) *The Social in Question: New Bearings in History and the Social Sciences* (London, 2002), pp. 151–74.

Goder et al. 1982 | Goder, Willi, et al., *Johann Friedrich Böttger: Die Erfindung des Europäischen Porzellans* (Leipzig, 1982).

Goldberg 1985 | Goldberg, Benjamin, *The Mirror and Man* (Charlottesville, 1985).

Goldgar 1995 | Goldgar, Anne, *Impolite Learning: Conduct and Community in the Republic of Letters, 1680–1750* (New Haven and London, 1995).

Goldgar 2007 | Goldgar, Anne, *Tulipmania: Money, Honor, and Knowledge in the Dutch Golden Age* (Chicago, 2007).

Goldthwaite 1980 | Goldthwaite, Richard, *The Building of Renaissance Florence: An Economic and Social History* (Baltimore and London, 1980).

Goldthwaite 1993 | Goldthwaite, Richard, *Wealth and the Demand for Art in Italy, 1300–1600* (Baltimore and London, 1993).

Goldthwaite 2009 | Goldthwaite, Richard, *The Economy of Renaissance Florence* (Baltimore and London, 2009).

Goodman 1994 | Goodman, Dena, *The Republic of Letters: a Cultural History of the French Enlightenment* (Ithaca, NY, and London, 1994).

Goodman 2003 | Goodman, Dena, 'Furnishing Discourses: Readings of a Writing Desk in Eighteenth-Century France', in Berg and Eger 2003, pp. 71–88.

Goodman 2007 | Goodman, Dena, 'The *Secrétaire* and the Integration of the Eighteenth-Century Self', in Goodman and Norberg 2007, pp. 183–204.

Goodman 2009 | Goodman, Dena, *Becoming a Woman in the Age of Letters* (Ithaca, NY, and London, 2009).

Goodman and Norberg 2007 | Goodman, Dena, and Kathryn Norberg (eds), *Furnishing the Eighteenth Century: What Furniture Can Tell Us About the European and American Past* (New York and London, 2007).

Gordon 2005 | Gordon, Andrew, '"If my sign could speak": The Signboard and the Visual Culture of Early Modern London', *Early Theatre*, 8/1 (2005), pp. 35–51.

Goudie 2013 | Goudie, Allison, 'The Wax Portrait Bust as *Trompe-l'oeil*? A Case Study of Queen Maria Carolina of Naples', *Oxford Art Journal*, 36/1 (2013), pp. 55–74.

Gouk 1988 | Gouk, Penelope, *The Ivory Sundials of Nuremberg 1500–1700* (Cambridge, 1988).

Grammaccini 1985 | Gramaccini, Norberto, 'Das genaue Abbild der Natur – Riccios Tiere und die Theorie des Naturabgusses seit Cennini', in *Natur und Antike in der Renaissance*, exh. cat., Liebieghaus Museum alter Plastik, Frankfurt-am-Main, 5 December 1985–2 March 1986 (Frankfurt, 1985), pp. 198–225.

Grant 1983 | Grant, Allison, *North Devon Pottery: The Seventeenth Century* (Exeter, 1983).

Gray Bennett 1988 | Gray Bennett, Anna, *Unfolding Beauty: The Art of the Fan* (London, 1988).

Greenblatt 1980 | Greenblatt, Stephen, *Renaissance Self-Fashioning: From More to Shakespeare* (Chicago and London, 1980).

Greig 2013 | Greig, Hannah, *The Beau Monde: Fashionable Society in Georgian London* (Oxford, 2013).

Grieco 2006 | Grieco, Allen J., 'Meals', in Ajmar-Wollheim and Dennis 2006, pp. 244–53.

Griffin 2007 | Griffin, Emma, *Blood Sport: Hunting in Britain since 1066* (New Haven and London, 2007).

Grigsby 1993 | Grigsby, Leslie B., *English Slip-Decorated Earthenware at Williamsburg* (Williamsburg, VA, 1993).

Grigsby 2000 | Grigsby, Leslie, *The Longridge Collection of English Slipware and Delftware*, vol. 2, *Delftware* (London, 2000).

Grijp and Mook 1988 | Grijp, Louis Peter, and Willem Mook (eds), *Proceedings of the International Lute Symposium, Utrecht 1986* (Utrecht, 1988).

Grimaldi 2001 | Grimaldi, Floriano, *Pellegrini e pellegrinaggi a Loreto nei secoli XIV–XVIII*. Supplement 2, *Bollettino Storico della Città di Foligno* (Foligno, 2001).

Grimwade 1976 | Grimwade, A.G., *London Goldsmiths 1697–1837: Their Marks and Lives* (London, 1976).

Groves 1966 | Groves, Sylvia, *The History of Needlework Tools and Accessories* (London, 1966).

Guerzoni 2012 | Guerzoni, Guido, 'Use and abuse of beeswax in the early modern age', in Daninos 2012, pp. 43–59.

Guyatt 2000 | Guyatt, Mary, 'The Wedgwood Slave Medallion: Values in Eighteenth-Century Design', *Journal of Design History*, 13/2 (2000), pp. 93–105.

Hale 1993 | Hale, John, *The Civilization of Europe in the Renaissance* (London, 1993).

Hallam and Hockey 2001 | Hallam, Elizabeth, and Jenny Hockey, *Death, Memory and Material Culture* (Oxford, 2001).

Hamling 2010 | Hamling, Tara, *Decorating the 'Godly' Household: Religious Art in Post-Reformation Britain* (New Haven and London, 2010).

Hamling and Richardson 2010 | Hamling, Tara, and Catherine Richardson (eds), *Everyday Objects: Medieval and Early Modern Material Culture and its Meanings* (Farnham and Burlington, 2010).

Hammond 1991 | Hammond, Norman (ed.), *Cuello: An Early Maya Community in Belize* (Cambridge, 1991).

Handley 2008 | Handley, Stuart, 'Talbot, Charles, duke of Shrewsbury (1660–1718)', Oxford Dictionary of National Biography (Oxford University Press, 2004; online edn, January 2008). Available at: www.oxforddnb.com/view/article/26922 (accessed 31 August 2014).

Harding 2008 | Harding, Vanessa, 'Cheapside: Commerce and Commemoration', *Huntington Library Quarterly*, 71/1 (March 2008), pp. 77–96.

Harkness 2007 | Harkness, Deborah E., *The Jewel House: Elizabethan London and the Scientific Revolution* (New Haven and London, 2007).

Hart and North 1998 | Hart, Avril, and Susan North, *Historical Fashion in Detail: The 17th and 18th Centuries* (London, 1998).

Hawkins 1885 | Hawkins, Edward, *Medallic Illustrations of the History of Great Britain and Ireland to the Death of George II*, 2 vols (London, 1885).

Hayward 1970 | Hayward, John, 'Ottavio Strada and the Goldsmiths' Designs of Giulio Romano', *The Burlington Magazine*, 112/802 (1970), pp. 10–14.

Hayward 1976 | Hayward, John, *Virtuoso Goldsmiths and the Triumph of Mannerism, 1540–1620* (London, 1976).

Heal 1988 | Heal, Ambrose, *Sign Boards of Old London Shops* (London, 1988).

Hearn 1995 | Hearn, Karen (ed.), *Dynasties: Painting in Tudor and Jacobean England 1530–1630* exh. cat., Tate Gallery, London, 12 October 1995–7 January 1996 (London, 1995).

Hellman 1999 | Hellman, Mimi, 'Furniture, sociability, and the work of leisure in eighteenth-century France', *Eighteenth-century Studies*, 32/4 (1999), pp. 415–45.

Hellman 2011 | Hellman, Mimi, 'Enchanted night: Decoration, sociability, and visuality after dark', in Bremer-David 2011, pp. 91–113.

Henry 2011 | Henry, Chriscinda, 'What makes a picture? Evidence from sixteenth-century Venetian property inventories', *Journal of the History of Collections*, 23 (2011), pp. 253–65.

Hernmarck 1977 | Hernmarck, C., *The Art of the European Goldsmith, 1430–1830* (London, 1977).

Herrmann 1999 | Herrmann, Frank, *The English as Collectors: A Documentary Source* (London, 1999).

Herzog 1996 | Herzog, Don, 'The Trouble with Hairdressers', *Representations*, 53 (1996), pp. 21–43.

Heydenreich 2007 | Heydenreich, Gunnar, *Lucas Cranach the Elder: Painting Materials, Techniques and Workshop Practice* (Amsterdam, 2007).

Higgott 2011 | Higgott, Suzanne, *The Wallace Collection, Catalogue of Glass and Limoges Painted Enamels* (London, 2011).

Hildyard 2002 | Hildyard, Robin, 'Toasts and Loving Cups, 1640–1830', in Glanville and Young 2002, pp. 104–7.

Hildyard 2004 | Hildyard, Robin, 'London Chinamen and Others', *English Ceramic Circle Transactions*, 18/3 (2004), pp. 447–524.

Hilkhuijsen et al. 1986 | Hilkhuijsen, J.W.L., et al. *Open Slot: sluitwerk en slotemakers in Nederland uit de 15e tot de 19e eeuw* (Groningen, 1986).

Hobhouse 1986 | Hobhouse, Henry, *Seeds of Change. Five Plants that Transformed Mankind* (London, 1986).

Holm 2004 | Holm, Christiane, 'Sentimental Cuts: Eighteenth-Century Mourning Jewelry with Hair', *Eighteenth-Century Studies*, 38/1 (Autumn, 2004), pp. 139–43.

Honey 1933 | Honey, W.B., *English Pottery and Porcelain* (London, 1933).

Honig 1998 | Honig, Elizabeth, *Painting and the Market in Early Modern Antwerp* (New Haven and London, 1998).

Honour 1971 | Honour, Hugh, *Goldsmiths and Silversmiths* (New York, 1971).

Hont and Ignatieff 1986 | Hont, Istvan, and Michael Ignatieff (eds), *Wealth and Virtue: The Shaping of Political Economy in the Scottish Enlightenment* (Cambridge, 1986).

Howard and Ayers 1978 | Howard, David and John Ayers, *China for the West: Chinese Porcelain and other Decorative Arts for Export, Illustrated from the Mottahedeh Collection* (London and New York, 1978).

Howell 2010 | Howell, Martha, *Commerce before Capitalism in Europe, 1300–1600* (Cambridge, 2010).

Hughes 1955 | Hughes, G.B., 'Silver Tumblers and Travelling Sets', *Country Life*, 118 (10 November 1955), pp. 1084–5.

Hughes 1971 | Hughes, G. Bernard, *English Snuff-Boxes* (London, 1971).

Hume 2003 | Hume, Ivor Noël, 'Through the Looking Glasse: or, the Chamber Pot as a Mirror of its Time', in Robert Hunter (ed.), *Ceramics in America 2003* (Milwaukee, WI, 2003), pp. 139–72.

Humphrey 1984 | Humphrey, Carol, *English Samplers at the Fitzwilliam* (Cambridge, 1984).

Humphrey 1997 | Humphrey, Carol, *Samplers* (Cambridge, 1997).

Humphrey 2008 | Humphrey, Carol, *Friends. A Common Thread. Samplers with a Quaker influence* (Witney, 2008).

Hunt 1996a | Hunt, Alan, *Governance of Consuming Passions: A History of Sumptuary Law* (Basingstoke and London, 1996).

Hunt 1996b | Hunt, Margaret R., *The Middling Sort: Commerce, Gender and the Family in England, 1680–1780* (Berkeley, 1996).

Hutton 2008 | Hutton, Ronald, 'Hopton, Ralph, Baron Hopton (bap. 1596, d. 1652)', Oxford Dictionary of National Biography (Oxford University Press, 2004; online edn, January 2008). Available at www.oxforddnb.com/view/article/13772 (accessed 3 August 2014).

Illouz 1997 | Illouz, Eva, *Consuming the Romantic Utopia: Love and Cultural Contradictions of Capitalism* (Berkeley, CA, 1997).

Impey and MacGregor 1985 | Impey, Oliver, and Arthur MacGregor (eds), *The Origins of Museums: the Cabinet of Curiosities in sixteenth- and seventeenth-century Europe* (Oxford, 1985).

Itinerario **1969** | *Itinerario farmaceutico di Firenze* (Milan, 1969).

Jacknis 1985 | Jacknis, Ira, 'Franz Boas and Exhibits', in George W. Stocking (ed.), *Objects and Others: Essays on Museums and Material Culture* (Madison, 1985), pp. 75–111.

Jackson and Jaffer 2004 | Jackson, Anna, and Amin Jaffer, *Encounters: The Meeting of Asia and Europe, 1500–1800* (London, 2004).

Jackson et al. 1982 | Jackson, Reg, Philomena Jackson and Roger Price, 'Bristol potters and potteries 1600–1800: a documentary study', *Journal of Ceramic History*, 12 (1982).

Jardine 1996 | Jardine, Lisa, *Worldly Goods: A New History of the Renaissance* (London, 1996).

Jardine and Brotton 2000 | Jardine, Lisa, and Jerry Brotton, *Global Interests: Renaissance Art between East and West* (London, 2000).

Jedding et al. 1988 | Jedding, Hermann et al., *Weisses Gold aus Fürstenberg, Kulturgeschichte im Spiegel des Porzellans 1747–1830*, exh. cat., Westfälisches Landesmuseum für Kunst und Kulturgeschichte, Münster, 4 December 1988–8 February 1989; Herzog Anton Ulrich-Museum, Braunschweig, 9 March–7 May 1989 (Münster and Braunschweig, 1988).

Jervis 1989 | Jervis, Simon, 'Les Blasons domestiques by Gilles Corrozet', *Furniture History*, 25 (1989); pp. 5–35.

Jewitt 1878 | Jewitt, L.F.W., *The Ceramic Art of Great Britain from Pre-Historic Times down to the Present Day, Being a History of the Ancient and Modern Pottery and Porcelain Works of the Kingdom and of Their Productions of Every Class*, 2 vols (London, 1878).

Johnston and Scribner 1993 | Johnston, Pamela, and Bob Scribner, *The Reformation in Germany and Switzerland* (Cambridge, 1993).

Jones 1928 | Jones, E. Alfred, *Old Silver of Europe and America From Early Times to the Nineteenth Century* (London, 1928).

Jones 1979 | Jones, Mark, *The Art of the Medal* (London, 1979).

Jones 2010 | Jones, Malcolm, *The Print in Early Modern*

England: An Historical Oversight (New Haven and London, 2010).

Jones and Spang 1999 | Jones, Colin, and Rebecca Spang, '*Sans-culottes, sans café, sans tabac*: Shifting realms of necessity and luxury in eighteenth-century France', in Berg and Clifford 1999, pp. 37–62.

Jones and Stallybrass 2000 | Jones, Ann Rosalind, and Peter Stallybrass, *Renaissance Clothing and the Materials of Memory* (Cambridge, 2000).

Jörg 1999 | Jörg, Christiaan J.A., 'The Inter-Asiatic Dutch Porcelain Trade', *Oriental Art*, 45/1 (1999), pp. 71–9.

Jörg 2001 | Jörg, Christiaan J.A., *Porcelain from the Vung Tau Wreck: The Hallstrom Excavation* (Singapore, 2001).

Kammel and Lorenz 2008 | Kammel, Frank Matthias, and Anke Lorenz, 'Faszination der Präsenz: die Wachsbüste des Johann Wilhelm Loeffelholz', in Frank Matthias Kammel and Daniel Hess (eds), *Enthüllungen: restaurierte Kunstwerke von Riemenschneider bis Kremser Schmidt*, exh. cat. Germanisches Nationalmuseum, Nuremberg (Nuremberg, 2008), pp. 83–94.

Keating and Markey 2011 | Keating, Jessica, and Lia Markey, '"Indian" objects in Medici and Austrian-Habsburg inventories', *Journal of the History of Collections*, 23/2 (2011), pp. 283–300.

Kelsall 1995 | Kelsall, Keith, *Glass in 18th-Century England, The Open-Flame Lamp* (Sheffield, 1995).

Ketel 2011 | Ketel, Christine, 'Identification of export porcelains from early 17th Century VOC shipwrecks and the linkage to their cultural identification', The MUA Collection, November 2011. Available at: www.themua. org/collections/items/show/1253 (accessed 31 August 2014).

Keymer and Sabor 2009 | Keymer, Thomas, and Peter Sabor, *'Pamela' in the Marketplace: Literary Controversy and Print Culture in Eighteenth-Century Britain and Ireland* (Cambridge, 2009).

King 1698 | King, William, *A journey to London in the year 1698 after the ingenuous method of that made by Dr. Martin Lyster to Paris, in the same year, witten* [sic] *[…] and newly translated into English* (London, 1698).

Kirchmann 1657 | Kirchmann, Johann, *De annulis* (Schleswig, 1657).

Kirk and Kirk 1900–8 | Kirk, R.E.G., and Ernest F. Kirk (eds), *Returns of Aliens Dwelling in the City and Suburbs of London from the Reign of Henry VIII to that of James I*, 4 vols (Aberdeen, 1900–8).

Kisluk-Groheide et al. 2013 | Kisluk-Grosheide, Danïelle, Deborah Krohn, and Ulrich Lebenn, *Salvaging the Past: Georges Hoentschel and French Decorative Arts from The Metropolitan Museum of Art, 1907–2013* (New Haven and London, 2013).

Klein 1997 | Klein, Lawrence, 'Coffeehouse Civility, 1660–1714: An Aspect of Post-Courtly Culture in England', *Huntington Library Quarterly*, 59/1 (1997), pp. 30–51.

Knowles 1999 | Knowles, James, 'Jonson's Entertainment at Britain's Burse', in Martin Butler (ed.), *Re-presenting Ben Jonson: Text, History, Performance* (New York, 1999), pp. 114–51.

Koozin 1990 | Koozin, Kristine, *The Vanitas Still Lives of Harmen Steenwyck* (Lampeter, 1990).

Kopytoff 1986 | Kopytoff, Igor, 'The Cultural Biography of Things', in Appadurai 1986, pp. 64–91.

Korda 2008 | Korda, Natasha, 'Gender at Work in the Cries of London', in Mary Ellen Lamb and Karen Bamford (eds), *Oral Traditions and Gender in Early Modern Literary Texts* (Aldershot and Burlington, 2008), pp. 117–36.

Koslofsky 2011 | Koslofsky, Craig, *Evening's Empire: A History of the Night in Early Modern Europe* (Cambridge and New York, 2011).

Kowaleski-Wallace 1994 | Kowaleski-Wallace, Elisabeth, 'Tea, Gender and Domesticity in Eighteenth-Century England', *Studies in Eighteenth-Century Culture*, 23 (1994), pp. 131–45.

Krahn 2003 | Krahn, Volker, *Bronzetti Veneziani. Die Venezianischen Kleinbronzen der Renaissance aus dem Bode-Museum Berlin* (Berlin, 2003).

Krauss et al. 1994 | Krauss, Jutta, et al., *Bestecke: Die Egloffstein'sche Sammlung (15.–18. Juhrhundert) auf der Wartburg* (Stuttgart, 1994).

Krohn and Miller 2009 | Krohn, Deborah, and Peter Miller (eds), *Dutch New York between East and West* (New Haven and London, 2009).

Kumin 2007 | Kumin, Beat, *Drinking Matters: Public Houses and Social Exchange in Early Modern Central Europe*

(London, 2007).

Kurlansky 2002 | Kurlansky, Mark, *Salt: A World History* (New York, 2002).

Kybalová 1973 | Kybalová, Jana, *Delftskà Fajàns: ve sbírkách Umeleckoprůmyslového muzea v Praze* (Prague, 1973).

La Belle Assemblée 1898 | *La Belle Assemblée or, Bell's Court and Fashionable Magazine addressed particularly to the Ladies*, vol. v (London, 1808).

Laclos 2007 | Laclos, Pierre Choderlos de, *Dangerous liaisons*, trans. Helen Constantine (London, 2007).

Ladies Amusement 1762 | *The Ladies Amusement: or, whole art of japanning made easy […] Drawn by Pillement and other masters […] second edition* (London, 1762; ed. consulted: facsimile: Newport, Mon., 1959).

La Font de Saint-Yenne 1747 | La Font de Saint-Yenne, Étienne, *Réflexions sur quelques causes de l'état présent de la peinture en France* (Paris, 1747).

Lambert 2001 | Lambert, Julie-Ann, *A Nation of Shopkeepers: Trade Ephemera from 1654 to the 1860s in the John Johnson Collection* (Oxford 2001).

Landes 2000 | Landes, David S., *Revolution in Time: Clocks and the Making of the Modern World* (Cambridge, MA, 2000).

Langford 1989 | Langford, Paul, *A Polite and Commercial People: England, 1727–1783* (Oxford, 1989).

Laughran 2003 | Laughran, Michelle, 'Medicating without "Scruples": The "Professionalization" of the Apothecary in Sixteenth-Century Venice', *Pharmacy in History*, 45 (2003), pp. 95–107.

Lausen-Higgins 2010 | Lausen-Higgins, Johanna, 'A Taste for the Exotic: Pineapple cultivation in Britain', *Historic Gardens*, 2010. Available at: www.buildingconservation. com/articles/pineapples/pineapples.htm (accessed 30 August 2014).

Lawson 2013 | Lawson, Jane A. (ed.), *The Elizabethan New Year's Gift Exchanges, 1559–1603* (Oxford, 2013).

Le Corbeiller 1966 | Le Corbeiller, Clare, *European and American Snuff Boxes 1730–1830* (London, 1966).

Ledger and Pemberton 2010 | Ledger, Andrew, and Rosemary Pemberton, 'Caudle Cups and their Place in English Porcelain 1750–1800', *English Ceramic Circle Transactions*, 21 (2010), pp. 91–114.

Lemay and Zall 1981 | Lemay, J.A. Leo, and P.M. Zall (eds), *The Autobiography of Benjamin Franklin: A Genetic Text* (Knoxville, TN, 1981).

Lemire 1991 | Lemire, Beverly, 'Peddling Fashion: Salesmen, Pawnbrokers, Tailors, Thieves and the Second-Hand Clothes Trade in England, 1700–1800', *Textile History*, 22 (1991), pp. 67–82.

Lester and Oerke 2004 | Lester, Katherine, and Bess Viola Oerke, *Accessories of Dress: An Illustrated Encyclopedia* (First published 1940 as *Accessories of Dress: An Illustrated History of the Frills and Furbelows of Fashion*, edn consulted: Mineola, NY, 2004).

Licetus 1621 | Licetus, Fortunius, *De lucernis antiquorum* (Venice, 1621).

Liefkes 2002 | Liefkes, Reino, 'Luxury Glass for Wine and Beer, 1550–1720', in Glanville and Young 2002, pp. 76–9.

Liefkes 2006 | Liefkes, Reino, 'Tableware', in Ajmar-Wollheim and Dennis 2006, pp. 254–65.

Lipski 1984 | Lipski, Louis, *Dated English Delftware: Tin-Glazed Earthenware 1600–1800* (London, 1984).

Lise and Bearzi 1975 | Lise, Giorgio, and Bruno Bearzi, *Antichi mortai di farmacia* (Milan, 1975).

Litchfield 1921 | Litchfield, Frederick, *Antiques, Genuine and Spurious: An Art Expert's Recollections and Cautions* (London, 1921).

Llewellyn 1991 | Llewellyn, Nigel, *Art of Death: Visual Culture in the English Death Ritual* (London, 1991).

Lloyd 2004 | Lloyd, Christopher, *Enchanting the Eye: Dutch Paintings of the Golden Age* (London, 2004).

Loughman 2006 | Loughman, John, 'Between reality and artful fiction: The representation of the domestic interior in seventeenth-century Dutch art', in Aynsley and Grant 2006, pp. 72–97.

Loughman and Montias 2000 | Loughman, John, and John Michael Montias, *Public and Private Spaces: Works of Art in Seventeenth-Century Dutch Houses* (Zwolle, 2000).

Lowden and Cherry 2008 | Lowden, John, and John Cherry, *Medieval Ivories and Works of Art: The Thomson Collection at the Art Gallery of Ontario* (Toronto, 2008).

Luccarelli 2002 | Luccarelli, Mario, 'Contributo alla conoscenze della maiolica senese', *Ceramica Antica*, 12/10 (November 2002), pp. 32–61.

Luu 2005 | Luu, Lien Bich, *Immigrants and the Industries*

of London 1500–1700 (Aldershot and Burlington, 2005).

MacCulloch 2003 | MacCulloch, Diarmaid, *Reformation: Europe's House Divided, 1490–1700* (London, 2003).

Mack 2007 | Mack, John, *The Art of Small Things* (London, 2007).

Mączak 1995 | Mączak, Antoni, *Travel in Early Modern Europe*, trans. Ursula Philips (Cambridge, 1995).

Maleuvre 1999 | Maleuvre, Didier, *Museum Memories: History, Technology and Art* (Stanford, 1999).

Mallet 1981 | Mallet, J.V.G., 'Floor tiles with Gonzaga devices', in Chambers and Martineau 1981, p. 173.

Mandeville 1795 | Mandeville, Bernard, *The Fable of the Bees; or, private vices, public benefits […]* (London, 1795).

Matthews-Grieco 2006 | Matthews-Grieco, Sara, 'Marriage and Sexuality', in Ajmar-Wollheim and Dennis 2006, pp. 104–19.

May 2012 | May, Robert, *The Accomplist Cook, or the Art and Mystery of Cookery*, facsimile of 1685 edn with foreword, introduction and glossary by Alan Davidson, Marcus Bell and Tom Jaine (Blackawton, Totnes, 2012).

Mayhew 2010 | Mayhew, Henry, *London Labour and the London Poor: A Selected Edition*, ed. Robert Douglas-Fairhurst (Oxford, 2010).

Mazzarotto 1961 | Mazzarotto, Bianca Tamassia, *Le feste veneziane: i giochi popolari, le ceremonie religiose e di governo* (Florence, 1961).

McAleer 2014 | McAleer, John, 'Displaying its wares. Material culture, the East India Company and British encounters with India in the long eighteenth century', in Simon Davies, Daniel Sanjiv Roberts and Gabriel Sanchez Espinosa (eds), *India and Europe in the Global Eighteenth Century* (Oxford, 2014), pp. 199–221.

McCall 2013 | McCall, Timothy, 'Brilliant Bodies: Material Culture and the Adornment of Men in North Italy's Quattrocento Courts', *I Tatti Studies in the Italian Renaissance*, 16/1-2 (2013), pp. 445–90.

McCants 2008 | McCants, Anne E.C., 'Poor Consumers as Global Consumers: The Diffusion of Tea and Coffee Drinking in the Eighteenth Century', *The Economic History Review*, 61/1 (2008), pp. 172–200.

McCants 2013 | McCants, Anne E.C., 'Porcelain for the poor: The material culture of tea and coffee consumption in eighteenth-century Amsterdam', in Findlen 2013, pp. 316–41.

McClanan and Encarnación 2002 | McClanan, Anne, and Karen Rosoff Encarnación (eds), *The Material Culture of Sex, Procreation and Marriage in Premodern Europe* (New York and Basingstoke, 2002).

McCray 1999 | McCray, W. Patrick, *Glassmaking in Renaissance Venice: The Fragile Craft* (Aldershot and Brookfield, VT, 1999).

McKendrick et al. 1982 | McKendrick, Neil, John Brewer and J.H. Plumb, *The Birth of a Consumer Society: The Commercialization of Eighteenth-Century England* (Bloomington, IN, 1982).

McNeil and Riello 2005 | McNeil, Peter, and Giorgio Riello, 'The Art and Science of Walking: Gender, Space, and the Fashionable Body in the Long Eighteenth Century', *Fashion Theory*, 9/2 (2005), pp. 175–204.

McShane 2009 | McShane, Angela, 'Subjects and Objects: Material Expressions of Love and Loyalty in Seventeenth-Century England', *Journal of British Studies*, 48 (2009), pp. 871–86.

McShane and Backhouse 2010 | McShane, Angela, and Clare Backhouse, 'Top Knots and Lower sorts: Print and Promiscuous Consumption in the 1690s', in Michael Hunter (ed.), *Printed Images in Early Modern Britain* (Farnham and Burlington, 2010), pp. 337–57.

Meads 2001 | Meads, Chris, *Banquets Set Forth: Banqueting in English Renaissance Drama* (Manchester, 2001).

Meininghaus 2003 | Meininghaus, Heiner, 'Necessaires: Ein Modeaccessoire des 18. Jahrhunderts', *Weltkunst*, 73/14 (December 2003), pp. 2096–8.

Melchior-Bonnet 2001 | Melchior-Bonnet, Sabine, *The Mirror: A History*, trans. Katharine H. Jewett (New York, 2001).

Miller 1982 | Miller, Pamela A., 'Hair Jewelry as Fetish', in Ray B. Browne (ed.), *Objects of Special Devotion: Fetishes and Fetishism in Popular Culture* (Bowling Green, OH, 1982), pp. 89–106.

Miller 2008 | Miller, Daniel, *The Comfort of Things* (Cambridge, 2008).

Miller et al. 1994 | Miller, George, Ann Smart Martin and Nancy Dickinson, 'Changing Consumption Patterns: English Ceramics and the American Market from 1770–1840', in Catherine E. Hutchins (ed.), *Everyday Life in the*

Early Republic (Delaware, 1994), pp. 219–48.

Milliot 1995 | Milliot, Vincent, *Les 'Cris de Paris', ou, Le peuple travesti: Les représentations des petits métiers parisiens (XVIe–XVIIIe siècles)* (Paris, 1995).

Mintz 1985 | Mintz, Sidney W., *Sweetness and Power. The Place of Sugar in Modern History* (New York and London, 1985).

Mintz 1999 | Mintz, Sidney W., 'Sweet Polychrest', *Social Research*, 66/1, (1999), pp. 85–101.

Miró i Alaix 2010 | Miró i Alaix, Núria, 'L'èxit dels nous productes d'adrogueria: xocolata, te, cafè i tabac', in Albert Garcia Espuche et al., *Drogues, Dolçes i Tabac. Barcelona 1700*, vol. 5 of *Col·lecció La Ciutat del Born. Barcelona 1700* (Barcelona, 2010), pp.214–40.

Misson 1719 | Misson, Henri, *M. Misson's Memoirs and Observations in his Travels over England. With Some Account of Scotland and Ireland. Dispos'd in Alphabetical Order* (London, 1719).

Mitchell 1995 | Mitchell, David (ed.), *Goldsmiths, Silversmiths and Bankers: Innovation and the Transfer of Skill 1550–1750* (London, 1995).

Moritz 1965 | Moritz, Carl Philip, *Journeys of a German in England*, trans. Reginald Nettel (London, 1965).

Morrall 2008 | Morrall, Andrew, 'Regaining Eden: Representations of Nature in Seventeenth-Century English Embroidery', in Morrall and Watt 2008, pp. 79–97.

Morrall 2012 | Morrall, Andrew, 'Inscriptional Wisdom and the Domestic Arts in Early Modern Northern Europe', in Natalia Filatkina, Birgit Ulrike Münch and Ane Kleine-Engel (eds), *Formelhaftigkeit in Text und Bild* (Wiesbaden, 2012), pp. 121–38.

Morrall and Watt 2008 | Morrall, Andrew, and Melinda Watt (eds), *English Embroidery from the Metropolitan Museum of Art 1580–1700: 'Twixt Art and Nature*, exh. cat., Bard Graduate Center for Studies in the Decorative Arts, Design and Culture, New York, 11 December 2008–12 April 2009 (New Haven and London, 2008).

Morrison 2003 | Morrison, Kathryn, *English Shops and Shopping: An Architectural History* (New Haven and London, 2003).

Morse 2007 | Morse, Margaret, 'Creating Sacred Space: The Religious Visual Culture of the Renaissance Venetian Casa', *Renaissance Studies*, 21 (2007), pp. 151–84.

Moryson 1617 | Moryson, Fynes, *An Itinerary Written By Fynes Moryson Gent. (Containing His Ten Yeeres Travell Through the Twelve Dominions of Germany, Bohmerland, [...] France, England, Scotland, and Ireland)*, 3 vols (London, 1617).

Motture 2001 | Motture, Peta, *Bells & Mortars. Catalogue of Italian Bronzes in the Victoria and Albert Museum* (London, 2001).

Mui and Mui 1984 | Mui, Hoh-cheung, and Lorna H. Mui, *The Management of Monopoly: A Study of the East India Company's Conduct of its Tea Trade, 1784–1833* (Vancouver, 1984).

Mui and Mui 1989 | Mui, Hoh-cheung, and Lorna H. Mui, *Shops and Shopping in Eighteenth-Century England* (London, 1989).

Murdoch 2014 | Murdoch, Tessa, 'Snuff-taking, Fashion and Accessories' in Murdoch and Zech 2014, pp. 1–16.

Murdoch et al. 1981 | Murdoch, John, Jim Murrell, Patrick J. Noon and Roy Strong (eds), *The English Miniature* (New Haven and London, 1981).

Murdoch and Zech 2014 | Murdoch, Tessa, and Heike Zech, *Going for Gold. Craftsmanship and Collecting of Gold Boxes* (London, 2014).

Musacchio 2008 | Musacchio, Jacqueline M., *Art, Marriage and Family in the Florentine Renaissance Palace* (New Haven and London, 2008).

Neale 1999 | Neale, J.A., *Joseph and Thomas Windmills, Clock and Watch Makers 1671–1737* (London, 1999).

Neuwirth 1982 | Neuwirth, Waltraud, *Wiener Porzellan, Geschichte der Wiener Porzellanmanufaktur 1718–1864* (Vienna, 1982).

Newton 2002 | Newton, Charles, 'The English at Table: Hogarth to Grossmith', in Glanville and Young 2002, pp. 72–5.

Nichols 2007 | Nichols, Tom, *The Art of Poverty: Irony and Ideal in Sixteenth-century Beggar Imagery* (Manchester, 2007).

Nigronus 1667 | Nigronus, Julius, *De caliga veterum* (Amsterdam, 1667).

North 2008 | North, Michael, *'Material Delight and the Joy of Living': Cultural Consumption in the Age of Enlightenment in Germany* (Farnham and Burlington, 2008).

Northampton 2012 | Northampton Museum and Art Gallery, 'Concealed Shoes,' Northampton Museum and Art Gallery Blog, 19 June 2012. Available at: http://northamptonmuseums.wordpress.com/2012/06/19/concealed-shoes/ (accessed 18 August 2014).

Norton 2006 | Norton, Marcy, 'Tasting Empire: Chocolate and the European Internalization of Mesoamerican Aesthetics', *American Historical Review*, 111 (June 2006), pp. 660–91.

Norton 2008 | Norton, Marcy, *Sacred Gifts, Profane Pleasures: A History of Tobacco and Chocolate in the Atlantic World* (Ithaca, NY, and London, 2008).

Norton 2013 | Norton, Marcy, 'Going to the Birds. Animals as things and beings in early modernity', in Findlen 2013, pp. 53–83.

O'Connell 2004 | O'Connell, Sheila, 'Faber, John (c.1695–1756)', *Oxford Dictionary of National Biography*, Oxford University Press, 2004. Available at: www.oxforddnb.com/view/article/9053 (accessed 29 August 2014).

Ogborn 1998 | Ogborn, Miles, *Spaces of Modernity: London's Geographies, 1680–1780* (New York and London, 1998).

Ogilvie 2011 | Ogilvie, Sheilagh, *Institutions and European Trade: Merchant Guilds, 1000–1800* (Cambridge, 2011).

Oman 1957 | Oman, Charles Chichele, *English Church Plate, 597–1830* (London, 1957).

Oman 1958 | Oman, Carola, *David Garrick* (London, 1958).

O'Malley and Welch 2007 | O'Malley, Michelle, and Evelyn Welch, *The Material Renaissance* (Manchester, 2007).

Orlin 2010 | Orlin, Lena C., 'Empty Vessels', in Hamling and Richardson 2010, pp. 299–308.

Oswald 1970 | Oswald, Adrian, 'The Clay Tobacco Pipe: Its Place in English Ceramics', *English Ceramic Circle*, 8, vol. 7, part 3 (1970), pp. 222–45.

Oswald et al. 1982 | Oswald, Adrian, with R.J.C Hildyard, and R. G. Hughes, *English Brown Stoneware 1670–1900* (London, 1982).

Oxford Art Journal **2013 (36/1)** | Special Issue: 'Theorizing Wax: On the Meaning of a Disappearing Medium', *Oxford Art Journal*, 36/1 (March 2013).

Packard 1960 | Packard, Vance, *The Status Seekers: An Exploration of Class Behavior in America* (London, 1960).

Pantin 2013 | Pantin, Isabelle, 'John Hester's Translations of Leonardo Fioravanti: The Literary Career of a London Distiller', in S. K. Barker and Brenda M. Hosington (eds), *Renaissance Cultural Crossroads: Translation, Print and Culture in Britain, 1473–1640* (Leiden, 2013).

Panzanelli 2008 | Panzanelli, Roberta, 'Compelling Presence: Wax Effigies in Renaissance Florence', in Roberta Panzanelli (ed.), *Ephemeral Bodies: Wax Sculpture and the Human Figure* (Los Angeles, CA, 2008), pp. 13–39.

Pasalodos Salgrado 2009 | Pasalodos Salgrado, Mercedes, 'Guantes estampados: Manos ilustradas', *Data Tèxtil*, 20 (2009), pp. 15–43.

Paston-Williams 1993 | Paston-Williams, Sara, *The Art of Dining: A History of Cooking & Eating* (London, 1993).

Patch 1927 | Patch, Howard Rollin, *The Goddess Fortune in Medieval Literature* (Cambridge, MA, 1927).

Patterson 2009 | Patterson, Angus, *Fashion and Armour in Renaissance Europe: Proud Lookes and Brave Attire* (London, 2009).

Pavord 1999 | Pavord, Anna, *The Tulip* (London, 1999).

Peacey 2008 | Peacey, Jason T., 'Watson, Richard (1611/12–1685)', Oxford Dictionary of National Biography (Oxford University Press, 2004; online edn, January 2008). Available at: www.oxforddnb.com/view/article/28856 (accessed 3 August 2014).

Pechstein et al. 1985 | Pechstein, Klaus, Ralf Schürer and Martin Angerer (eds), *Wenzel Jamnitzer und die Nürnberger Goldschmiedekunst, 1500–1700*, exh. cat., Germanisches Nationalmuseum, Nuremberg, 28 June–15 September 1985 (Nuremberg, 1985).

Peck 2005 | Peck, Linda Levy, *Consuming Splendor: Society and Culture in Seventeenth-Century England* (Cambridge, 2005).

Pendergrast 2004 | Pendergrast, Mark, *Mirror, Mirror: A History of the Human Love Affair with Reflection* (New York, 2004).

Pennell 1998 | Pennell, Sara, '"Pots and pans history": The material culture of the kitchen in early modern England', *Journal of Design History*, 11/3 (1998), pp. 201–16.

Pennell 2000 | Pennell, Sara, '"Great Quantities of Gooseberry Pie and Baked Clod of Beef": Victualling and Eating Out in Early Modern London', in Paul Griffiths and Mark Jenner (eds), *Londinopolis* (Manchester, 2000), pp. 228–49.

Pennell 2009 | Pennell, Sara, 'Mundane materiality, or should small things still be forgotten? Material culture, microhistories, and the problem of scale', in Karen Harvey (ed.), *History and Material Culture: A Student's Guide to Approaching Alternative Sources* (London, 2009), pp. 173–91.

Pennell 2010 | Pennell, Sara, '"For a crack or flaw despis'd": Thinking about ceramic durability and the 'everyday' in late seventeenth- and early eighteenth-century England', in Hamling and Richardson 2010, pp. 27–40.

Penny 1993 | Penny, Nicholas, *The Materials of Sculpture* (New Haven and London, 1993).

Pepys 1983 | Pepys, Samuel, *The Diary of Samuel Pepys: A New and Complete Transcription*, transcribed and ed. Robert Latham and William Matthews, 11 vols (London, 1983).

Pešek 1982 | Pešek, Jiří, 'Výtvarná díla s náboženskou tématikou v pražských předbělohorských interiérech' [Fine art with religious themes in Prague interiors prior to the Battle of the White Mountain], *Umění*, 30 (1982), pp. 263–7.

Pessiot 2007 | Pessiot, Marie (ed.) *La fidèle ouverture ou l'art du serrurier* (Rouen, 2007).

Peters 2005 | Peters, David, *Sèvres Plates and Services of the 18th Century*, 7 vols (Little Berhamsted, 2005).

Phillips 1901 | Phillips, F.W., *A Short Account of Old English Pottery, with an Introduction to the Study of Chinese Porcelain by G.A. Schneider, also a Catalogue of Old China Offered for Sale at the Manor House, Hitchin, Hertfordshire* (Hitchin, 1901).

Pierson 2001 | Pierson, Stacey, *Designs as Signs: Decoration and Chinese Ceramics* (London, 2001).

Pierson 2007 | Pierson, Stacey, *Collectors, Collections and Museums: The Field of Chinese Ceramics in Britain, 1560–1960* (London, 2007).

Pincus 1995 | Pincus, Steven, '"Coffee Politicians Does Create": Coffeehouses and Restoration Political Culture', *Journal of Modern History*, 67/4 (1995), pp. 807–34.

Platter 1937 | Platter, Thomas, *Thomas Platter's Travels in England in 1599*, trans. Clare Williams (London, 1937).

Plotz 2005 | Plotz, John, 'Can the Sofa Speak? A look at Thing Theory', *Criticism*, 47 (2005), pp. 109–18.

Pointon 1997 | Pointon, Marcia, *Strategies of Showing: Women, Possession, and Representation in English Visual Culture, 1665–1800* (Oxford 1997).

Pointon 1999a | Pointon, Marcia, 'Jewellery in eighteenth-century England', in Berg and Clifford 1999, pp. 120–46.

Pointon 1999b | Pointon, Marcia, 'Materializing Mourning: Hair, Jewellery and the Body', in Marius Kwint, Christopher Breward and Jeremy Aynsley (eds), *Material Memories* (Oxford and New York, 1999), pp. 39–57.

Pointon 2009a | Pointon, Marcia, *Brilliant Effects: A Cultural History of Gem Stones and Jewellery* (New Haven and London, 2009).

Pointon 2009b | Pointon, Marcia, 'The Treasury of the Santa Casa at Loreto and its English Visitors', in Pointon 2009a, pp. 247–91.

Pointon 2009c | Pointon, Marcia, 'Secular Memorials: Mourning and Memory in Hair Jewellery', in Pointon 2009a, pp. 293–314.

Pointon 2013 | Pointon, Marcia, *Portrayal and the Search for Identity* (London, 2013).

Pointon 2014 | Pointon, Marcia, 'Casts, Imprints and the Deathliness of Things: Artefacts at the Edge', *Art Bulletin*, 96 (2014), pp. 170–95.

Pomian 1990 | Pomian, Krzysztof, *Collectors and Curiosities: Paris and Venice 1500–1800*, trans. Elizabeth Wiles-Portier (Cambridge, 1990).

Poole 1981 | Poole, Julia E., *English Delftware Dishes from the Glaisher Collection* (Cambridge, 1981).

Poole 1985 | Poole, Julia E., 'Ballads and Hunting Mugs', *English Ceramic Circle Transactions*, 12/2s (1985), pp. 156–60.

Poole 1995a | Poole, Julia E., *Italian Maiolica and Incised Slipware in the Fitzwilliam Museum Cambridge* (Cambridge, 1995).

Poole 1995b | Poole, Julia E., *English Pottery* (Cambridge, 1995).

Poole 1997 | Poole, Julia E., *Italian Maiolica* (Cambridge, 1997).

Poole 2007 | Poole, Julia E., 'Scent flask', Fitzwilliam Museum website 2007. Available at://www.fitzmuseum.

cam.ac.uk/news/recentacquisitions/article.html?845 (accessed 31 August 2014).

Poole 2013 | Poole, Julia E., 'Dr J.W.L. Glaisher: The making of a great collection', in Archer 2013, pp. xiii–xxvi.

Porter 2010 | Porter, David, *The Chinese Taste in Eighteenth-Century England* (Cambridge, 2010).

Préaud and d'Albis 1991 | Préaud, Tamara, and Antoine d'Albis, *La Porcelaine de Vincennes* (Paris, 1991).

Pyke 1973 | Pyke, Edward Joseph, *A Biographical Dictionary of Wax Modellers* (Oxford, 1973).

Rackham 1935 | Rackham, Bernard, *Catalogue of the Glaisher Collection of Pottery and Porcelain in the Fitzwilliam Museum Cambridge* (Cambridge, 1935).

Rackham 1987 | Rackham, Bernard, *Catalogue of the Glaisher Collection of Pottery and Porcelain in the Fitzwilliam Museum Cambridge*, 2 vols (first published 1935, edn consulted: Cambridge, 1987).

Radcliffe 1930 | Radcliffe, Susan M. (ed.), *Sir Joshua's Nephew. Being Letters written, 1769–1778, by a Young Man to his Sisters* (London, 1930).

Radcliffe 1972 | Radcliffe, Anthony, 'Bronze Oil Lamps by Riccio', *Victoria and Albert Museum Yearbook*, 3 (1972), pp. 29–58.

Raff 1994 | Raff, Thomas, *Die Sprache der Materialien. Anleitung zu einer Ikonologie der Werkstoffe* (Munich, 1994).

Ray 1973 | Ray, Anthony, *English Delftware Tiles* (London, 1973).

Ray 1994 | Ray, Anthony, *Liverpool Printed Tiles* (London, 1994).

Reinburg 2012 | Reinburg, Virginia, *French Books of Hours: Making an Archive of Prayer, c.1400–1600* (Cambridge, 2012).

Retford 2006 | Retford, Kate, *The Art of Domestic Life: Family Portraiture in Eighteenth-century England* (New Haven and London, 2006).

Revel 1979 | Revel, Jacques, 'A capital city's privileges: Food supplies in early modern Rome', in Robert Forster and Orest Ranum (eds), *Food and Drink in History* (Baltimore and London, 1979), pp. 37–49.

Reynolds 2013 | Reynolds, Anna, *In Fine Style: The Art of Tudor and Stuart Fashion* (London, 2013).

Ribeiro 1984 | Ribeiro, Aileen, *Dress in Eighteenth-Century Europe, 1715–1789* (London, 1984).

Ribeiro 2005 | Ribeiro, Aileen, *Fashion and Fictional Dress in Art and Literature in Stuart England* (New Haven and London, 2005).

Richards 1999 | Richards, Sarah, *Eighteenth-Century Ceramics: Products for a Civilised Society* (Manchester, 1999).

Richardson 2010 | Richardson, Catherine, ' "A very fit hat": Personal objects and early modern affection', in Hamling and Richardson 2010, pp. 289–99.

Richardson and Hamling 2015 | Richardson, Catherine, and Tara Hamling, *A Day at Home in Early Modern England: The Materiality of Domestic Life, 1500–1700* (New Haven and London, 2015).

Ricci 2012 | Ricci, Giovanni, 'Masks of Power. Funeral Effigies in Early Modern Europe', in Daninos 2012, pp. 61–67.

Riello 2003 | Riello, Giorgio, 'La Chaussure à la mode: Product Innovation and Marketing Strategies in Parisian and London Boot and Shoemaking in the Early Nineteenth Century', *Textile History*, 34/2 (2003), pp. 107–133.

Riello 2006a | Riello, Giorgio, *A Foot in the Past: Consumers, Producers and Footwear in the Long Eighteenth Century* (Oxford, 2006).

Riello 2006b | Riello, Giorgio, 'Cataloguing the Domestic: Inventories', in Aynsley and Grant 2006, pp. 98–9.

Riello 2009 | Riello, Giorgio, 'Things that Shape History: Material Culture and Historical Narratives', in Karen Harvey (ed.), *History and Material Culture* (London, 2009), pp. 24–47.

Riello 2013a | Riello, Giorgio, ' "Things Seen and Unseen: The Material Culture of Early Modern Inventories and Their Representation of Domestic Interiors', in Findlen 2013, pp. 125–50.

Riello 2013b | Riello, Giorgio, *Cotton: The Fabric that Made the Modern World* (Cambridge, 2013).

Riello and McNeil 2006 | Riello, Giorgio, and Peter McNeil (eds), *Shoes: A History from Sandals to Sneakers* (Oxford and New York, 2006).

Rinaldi 1989 | Rinaldi, Maura, *Kraak Porcelain. A Moment in the History of Trade* (London, 1989).

Ringbom 1965 | Ringbom, Sixten, *From Icon to Narrative* (Åbo, 1965).

Roberts et al. 2007 | Roberts, Lissa, Simon Schaffer and Peter Dear (eds), *The Mindful Hand: Inquiry and Invention from the late Renaissance to early Industrialisation* (Amsterdam, 2007).

Roche 1994 | Roche, Daniel, *The Culture of Clothing: Dress and Fashion in the 'Ancien Régime'*, trans. Jean Birrell (Cambridge, 1994).

Roche 1996 | Roche, Daniel, *The Culture of Clothing: Dress and Fashion in the Ancien Régime* (1st pbk edn Cambridge, 1996).

Roche 1997 | Roche, Daniel, *Histoire des choses banales* (Paris, 1997).

Roche 2000 | Roche, Daniel, *A History of Everyday Things. The Birth of Consumption in France, 1600–1800*, trans. Brian Pearce (Cambridge, 2000).

Romano 1981 | Romano, Ruggiero, 'Farmacie e farmacisti a Venezia', in Ruggiero Romano and Angelo Schwarz (eds), *Per una storia della farmacia e del farmacista in Italia: Venezia e Veneto* (Bologna, 1981), pp. 5–7.

Roper 1989 | Roper, Lyndal, *The Holy Household: Women and Morals in Reformation Augsburg* (Oxford, 1989).

Rosenthal and Jones 2008 | Rosenthal, Margaret, and Ann Rosalind Jones (eds), *Cesare Vecellio's Habiti antichi et moderni: The Clothing of the Renaissance World* (London, 2008).

Roth and Le Corbeiller 2000 | Roth, Linda Horvitz, and Clare Le Corbeiller, *French Eighteenth-Century Porcelain at the Wadsworth Atheneum, The J. Pierpont Morgan Collection* (Hartford, CT, 2000).

Rublack 2005 | Rublack, Ulinka, *Reformation Europe* (Cambridge, 2005).

Rublack 2010 | Rublack, Ulinka, *Dressing Up: Cultural Identity in Renaissance Europe* (Oxford, 2010).

Rublack 2013 | Rublack, Ulinka, 'Matter in the Material Renaissance', *Past and Present*, 219 (2013), pp. 41–85.

Sargentson 1996 | Sargentson, Carolyn, *Merchants and Luxury Markets: The 'Marchands Merciers' of Eighteenth-century Paris* (Oxford, 1996).

Sargentson 2007 | Sargentson, Carolyn, 'Looking at Furniture Inside Out: Strategies of Secrecy and Security in Eighteenth-Century French Furniture', in Goodman and Norberg 2007, pp. 205–36.

Sarti 2002 | Sarti, Raffaella, *Europe at Home: Family and Material Culture, 1500–1800*, trans. Allan Cameron (New Haven and London, 2002).

Savill 1988 | Savill, Rosalind, *The Wallace Collection, Catalogue of Sèvres Porcelain*, 3 vols (London, 1988).

Schama 1987 | Schama, Simon, *Embarrassment of Riches* (New York, 1987).

Schechner 2005 | Schechner, Sara J., 'Between Knowing and Doing: Mirrors and Their Imperfections in the Renaissance', *Early Science and Medicine*, 10/2, (2005), pp. 137–62.

Scheffer 1643 | Scheffer, Johann, *De varietate navium* (Strassburg, 1643).

Schivelbusch 1992 | Schivelbusch, Wolfgang, *Tastes of Paradise. A Social History of Spices, Stimulants, and Intoxicants*, trans. David Jacobson (New York, 1992).

Schmidt 2011 | Schmidt, Benjamin, 'Collecting Global Icons: The Case of the Exotic Parasol', in Daniela Bleichmar and Peter C. Mancall (eds), *Collecting Across Cultures: Material Exchanges in the Early Modern Atlantic World* (Philadelphia, 2011).

Scholten 2013 | Scholten, Frits, 'Johan Gregor van der Schardt in Nuremberg', in Peta Motture, Emma Jones and Dimitrios Zikos (eds), *Carvings, Casts & Collectors. The Art of Renaissance Sculpture* (London, 2013, pp. 134–47.

Schreiner 2011 | Schreiner, Michael, 'Lute by Marx Unverdorben, Harvard University, Cambridge Massachusetts', Michael Schreiner Projects, 28 November 2011. Available at: www.schreinerlutes.com/projects.html (accessed 31 August 2014).

Scott 1916 | Scott, Hugh, 'Early Clay Tobacco-Pipes Found Near Barton Road, Cambridge', *Proceedings of the Cambridge Antiquarian Society*, 20 (1916), pp. 147–68.

Scott 2006 | Scott, Alison, 'Marketing luxury at the new exchange: Jonson's entertainment at Britain's Burse and the rhetoric of wonder', *Early Modern Literary Studies*, 12/2 (2006), pp. 1–19.

Scott 2013 | Scott, Katie, 'Edme Bouchardon's "Cris de Paris": Crying food in early modern Paris', *Word & Image*, 29/1 (2013), pp. 59–91.

Scott-Warren 2001 | Scott-Warren, Jason, *Sir John Harington and the Book as Gift* (Oxford, 2001).

Scrase et al. 2005 | Scrase, David, et al., *Treasures of the Fitzwilliam Museum* (London, 2005).

Shakespeare 2006 | Shakespeare, William, *Hamlet*, ed. Ann Thompson and Neil Taylor (London, 2006).

Sharpe 2013 | Sharpe, Kevin, *Rebranding Rule: Images of Restoration and Revolutionary Monarchy, 1660–1714* (New Haven and London, 2013).

Shaw and Welch 2011 | Shaw, James, and Evelyn Welch, *Making and Marketing Medicine in Renaissance Florence* (Amsterdam, 2011).

Sheehan 2000 | Sheehan, James, *Museums in the German Art World* (New York, 2000).

Shesgreen 1990 | Shesgreen, Sean, *The Criers and Hawkers of London: Engravings and Drawings by Marcellus Laroon* (Aldershot, 1990).

Shesgreen 2002 | Shesgreen, Sean, *Images of the Outcast: The Urban Poor in the Cries of London* (Manchester, 2002).

Shirley 2002 | Shirley, Pippa, 'Serving and Cooling Wine', in Glanville and Young 2002, pp. 96–9.

Siegfried 1995 | Siegfried, Susan L., *The Art of Louis-Léopold Boilly: Modern Life in Napoleonic France* (New Haven and London, 1995).

Slive 1995 | Slive, Seymour, *Dutch Painting, 1600–1800* (New Haven and London, 1995).

Sloboda 2014 | Sloboda, Stacey, *Chinoiserie: Commerce and Critical Ornament in Eighteenth-Century Britain* (Manchester, 2014).

Smith 1980 | Smith, Douglas Alton, 'The Musical Instrument Inventory of Raymund Fugger', *Galpin Society Journal*, 33 (1980), pp. 36–44.

Smith 1994 | Smith, Eliza, *The Compleat Housewife: or, Accomplished Gentlewoman's Companion* (fascsimile of 1758 edition; London, 1994).

Smith 2002 | Smith, Douglas Alton, *A History of the Lute from Antiquity to the Renaissance* (2002).

Smith 2004 | Smith, Pamela H., *The Body of the Artisan. Art and Experience in the Scientific Revolution* (Chicago, 2004).

Smith 2006 | Smith, Jeffrey Chipps, *The Art of the Goldsmith in Late Fifteenth-Century Germany: The Kimbell Virgin and Her Bishop* (New Haven and London, 2006).

Smith 2010 | Smith, Pamela, 'Vermilion, Mercury, Blood, and Lizards: Matter and Meaning in Metalworking', in Ursula Klein and Emma Spary (eds), *Materials and Expertise in Early Modern Europe: Between Market and Laboratory* (Chicago, 2010), pp. 29–49.

Smith 2014 | Smith, Pamela, 'Between Nature and Art: Casting from Life in Sixteenth-Century Europe', in Elizabeth Hallam and Tim Ingold (eds), *Making and Growing: Anthropological Studies of Organisms and Artefacts* (Farnham and Burlington, 2014), pp. 45–64.

Smith and Beentjes 2010 | Smith, Pamela H., and Tony Beentjes, 'Nature and Art, Making and Knowing: Reconstructing Sixteenth-Century Life-Casting Techniques', *Renaissance Quarterly*, 63 (2010), pp. 128–79.

Snodin and Styles 2004 | Snodin, Michael, and John Styles, *Design & the Decorative Arts: Tudor and Stuart Britain, 1500–1714* (London, 2004).

Sobel 1999 | Sobel, Dava, *Galileo's Daughter: A Drama of Science, Faith and Love* (London, 1999).

Soldani 1751 | Soldani, Jacopo, *Satire* (Florence, 1751).

Soler Ferrer 2010 | Soler Ferrer, Maria Paz, *Alcora: Cerámica de la Ilustración. La Colección Laia-Bosch en el Museo Nacional de Cerámica* (Valencia, 2010).

Solkin 1993 | Solkin, David, *Painting for Money: The Visual Arts and the Public Sphere in Eighteenth-Century England* (New Haven and London, 1993).

Sotheby's 1995 | Sotheby's sale catalogue, *English and Continental Ceramics and Glass*, 4 June 1995 (London, 1995).

Spallanzani 1978 | Spallanzani, Marco, *Ceramiche Orientali a Firenze nel Rinascimento* (Florence, 1978).

Spallanzani 1994 | Spallanzani, Marco, *Ceramiche alla Corte dei Medici nel Cinquecento* (Florence, 1994).

Spary 2012 | Spary, E.C., *Eating the Enlightenment: Food and the Sciences in Paris, 1670–1760* (Chicago, 2012).

Spicer 2012 | Spicer, Andrew (ed.), *Lutheran Churches in Early Modern Europe* (Farnham and Burlington, 2012).

Spufford 1984 | Spufford, Margaret, *The Great Reclothing of Rural England: Petty Chapmen and their Wares in the Seventeenth Century* (London, 1984).

Stahl 1994 | Stahl, Patricia, *Höchster Porzellan 1746–1796*, exh. cat., Historisches Museum der Stadt Frankfurt am Main, 1994 (Heidelberg, 1994).

Stalker and Parker 1688 | Stalker, John, and George Parker, *A Treatise of Japaning and Varnishing* (Oxford, 1688).

Stallybrass and Jones 2001 | Stallybrass, Peter, and Ann Rosalind Jones, 'Fetishizing the Glove in Renaissance

Europe', *Critical Inquiry*, 28, (2001), pp. 114–32.

Stammers 2014 | Stammers, Tom, 'Collectors, Catholics, and the Commune: Heritage and Counterrevolution, 1860–1890', *French Historical Studies*, 37/1 (2014), pp. 53–87.

Stammers 2015 | Stammers, Tom, 'The myth of la Belle Madeleine: Street culture and celebrity in nineteenth-century Paris', in Calaresu and van den Heuvel 2015.

Stapleford 2013 | Stapleford, Richard (ed. and trans.), *Lorenzo De' Medici at Home: The Inventory of the Palazzo Medici in 1492* (University Park, PA, 2013).

Staples 2008 | Staples, Kathleen, 'Embroidered Furnishings: Questions of Production and Usage', in Morrall and Watt 2008, pp. 23–38.

Steegmuller 1992 | Steegmuller, Francis, *A Woman, A Man, and Two Kingdoms: The Story of Mme d'Épinay and the Abbé Galiani* (London, 1992).

Steele 1999 | Steele, Valerie, *Shoes: A Lexicon of Style* (New York, 1999).

Steele 2002 | Steele, Valerie, *The Fan: Fashion and Femininity Unfolded* (New York, 2002).

Steinhausen 1895 | Steinhausen, Georg (ed.), *Briefwechsel Balthasar Baumgartner des Jüngeren mit seiner Gattin Magdalena geb. Behaim (1582–1598)* (Stuttgart, 1895).

Stobart 2008 | Stobart, Jon, 'Selling (Through) Politeness: Advertising Provincial Shops in Eighteenth-Century England', *Cultural and Social History*, 5/3 (2008), pp. 309–28.

Stobart 2013 | Stobart, Jon, *Sugar and Spice, Grocers and Groceries in England, 1650–1830* (Oxford, 2013).

Stoianovich 1970–1 | Stoianovich, Traian, 'Material Foundations of Preindustrial Civilisation in the Balkans', *Journal of Social History*, 4 (1970–1), pp. 205–62.

Stoklund 2003 | Stoklund, Bjarne, *Tingenes Kulturhistorie* (Copenhagen, 2003).

Stone 1957 | Stone, Lawrence, 'Inigo Jones and the New Exchange', *Archaeological Journal*, 114 (1957), pp. 106–21.

Stone-Ferrier 1991 | Stone-Ferrier, Linda, 'Market scenes as viewed by an Art Historian', in David Freedberg and Jan de Vries (eds), *Art in History/History in Art: Studies in Seventeenth-Century Dutch culture*, (1991), pp. 29–58.

Storey 2011 | Storey, Tessa, 'Face waters, oils, love magic and poison: Making and selling secrets in early modern Rome', in Elaine Leong and Alisha Rankin (eds), *Secrets and Knowledge in Medicine and Science, 1500–1800* (Farnham and Burlington, 2011), pp. 158–60.

Strocchia 2011 | Strocchia, Sharon T., 'The nun apothecaries of Renaissance Florence: marketing medicines in the convent', *Renaissance Studies*, 25/5 (November 2011), pp. 627–47.

Strong 1969 | Strong, Roy, *The English Icon: Elizabethan and Jacobean Portraiture* (London, 1969).

Strong 1995 | Strong, Roy, *The Tudor and Stuart Monarchy: Pageantry, Painting, Iconography* (Woodbridge, 1995).

Sturgis et al. 2011 | Sturgis, Alexander, et al., *The Holburne Museum* (London, 2011).

Styles 2007 | Styles, John, *The Dress of the People: Everyday Fashion in Eighteenth-Century England* (New Haven and London, 2007).

Sussman 1994 | Sussman, Charlotte, 'Women and the Politics of Sugar, 1792', *Representations*, 48 (1994), pp. 48–69.

Swann 1982 | Swann, June, *Shoes* (London, 1982).

Swann 2001 | Swann, Marjorie, *Curiosities and Texts: The Culture of Collecting in Early Modern England* (Philadelphia, 2001).

Syndram and Wienhold 2009 | Syndram, Dirk, and Ulrike Weinhold (eds), *Böttger Stoneware: Johann Friedrich Böttger and Treasury Art* (Dresden, 2009).

Syson and Thornton 2001 | Syson, Luke, and Dora Thornton, *Objects of Virtue: Art in Renaissance Italy* (London, 2001).

Tait 1979 | Tait, Hugh, *The Golden Age of Venetian Glass* (London, 1979).

Tait 1985 | Tait, Hugh, 'The Girdle-prayerbook or "Tablett": An Important Class of Renaissance Jewellery at the Court of Henry VIII', *Jewellery Studies*, 2 (1985), pp. 29–57.

Tait 1991 | Tait, Hugh, *Catalogue of the Waddesdon Bequest in the British Museum, III. The 'Curiosities'* (London, 1991).

Tarrant 1978 | Tarrant, Naomi, *The Royal Scottish Museum Samplers* (Edinburgh, 1978).

Taylor 1631 | Taylor, John, 'The Praise of the Needle', in *The Needles Excellency* (London, 1631), n.p.

Tebbe 2007 | Tebbe, Karin (ed.), *Nürnberger Goldschmiedekunst 1541–1868. Band 2. Goldglanz und Silberstrahl*,

exh. cat., Germanisches Nationalmuseum, Nuremberg, 20 September 2007– 13 January 2008 (Nuremberg, 2007).

Terjanian 2012 | Terjanian, Pierre, *Princely Armor in the Age of Dürer: A Renaissance Masterpiece in the Philadelphia Museum of Art* (New Haven, 2012).

Thicknesse 1768 | Thicknesse, Philip, *Useful hints to those who make the tour of France, in a series of letters written from that Kingdom* (London, 1768).

Thomas 2009 | Thomas, Keith, *The Ends of Life. Roads to Fulfilment in Early Modern England* (Oxford, 2009).

Thompson 2007 | Thompson, David, *The History of Watches* (New York, 2007).

Thornton 1978 | Thornton, Peter, *Seventeenth-Century Interior Decoration in England, France and Holland* (New Haven and London, 1978).

Thornton 1997 | Thornton, Dora, *The Scholar in his Study: Ownership and Experience in Renaissance Italy* (New Haven and London, 1997).

Thornton and Wilson 2009 | Thornton, Dora, and Timothy Wilson, *Italian Renaissance Ceramics: A Catalogue of the British Museum* (London, 2009).

Tietzel 1980 | Tietzel, Brigitte, *Kunstgewerbemuseum der Stadt Köln, Fayence I, Niederlande, Frankreich, England* (Cologne, 1980).

Trivellato 2000 | Trivellato, Francesca, *Fondamenta die Vetrai: Lavoro, tecnologia e mercato a Venezia tra Sei e Seccento* (Rome, 2000).

Trusted 2007a | Trusted, Marjorie (ed.), *The Making of Sculpture. The Materials and Techniques of European Sculpture* (London, 2007).

Trusted 2007b | Trusted, Marjorie, *The Arts of Spain, Iberia and Latin America, 1450–1700* (London, 2007).

Tyler et al. 2008 | Tyler, Kieron, Ian Betts and Roy Stephenson, *London's Delftware Industry: The Tin-glazed Pottery Industries of Southwark and Lambeth* (London, 2008).

Van Dam 1991 | van Dam, Jan Daniël, *Gedateerd Delfts aardewerk. Dated Dutch Delftware* (Amsterdam, 1991).

Van Dam 2004 | van Dam, Jan Daniël, *Delffse Porceleyne. Dutch Delftware 1620–1850* (Amsterdam, 2004).

Van den Heuvel 2008 | van den Heuvel, Danielle, *Women and entrepreneurship: Female traders in the Northern Netherlands c.1580–1815* (Amsterdam, 2008).

Van den Heuvel 2012 | van den Heuvel, Danielle, 'Selling in the shadows: peddlers and hawkers in early modern Europe', in Marcel van der Linden and Leo Lucassen (eds), *Working on Labour: Essays in Honour of Jan Lucassen* (Leiden and Boston, 2012), pp. 125–51.

Van den Heuvel 2013 | van den Heuvel, Danielle, 'Guilds, gender policies and economic opportunities for women in early modern Dutch towns', in Deborah Simonton and Anne Montenach (eds), *Female Agency in the Urban Economy: Gender in European Towns, 1640–1830* (New York, 2013), pp. 116–33.

Van den Heuvel 2015 | van den Heuvel, Danielle, 'Food, markets, and people: Selling perishables in urban markets in pre-industrial Holland and England', in Calaresu and Van den Heuvel 2015.

Van Trigt 2003 | van Trigt, Jan, *Cutlery: From Gothic to Art Deco: The J. Hollander Collection* (Ghent, 2003).

Veblen 1899 | Veblen, Thorstein, *Theory of the Leisure Class* (New York, 1899).

Vickery 2008 | Vickery, Amanda, 'An Englishman's Home Is His Castle? Thresholds, Boundaries and Privacies in the Eighteenth-Century London House', *Past and Present*, 199/1 (2008), pp. 147–73.

Vickery 2009 | Vickery, Amanda, *Behind Closed Doors: At Home in Georgian England* (New Haven and London, 2009).

Vincent 2009 | Vincent, Susan J., *The Anatomy of Fashion: Dressing the Body from the Renaissance to Today* (Oxford and New York, 2009).

Vincent and Leopold 2009 | Vincent, Clare, and J.H. Leopold, 'Seventeenth-Century European Watches' (March 2009), in Heilbrunn Timeline of Art History, The Metropolitan Museum of Art, New York, 2000– ongoing. http://www.metmuseum.org/toah/hd/watc/hd_watc.htm (accessed 11 October 2014).

Von La Roche 1933 | von La Roche, Sophie, *Sophie in London, 1786: Being the Diary of Sophie von La Roche* (London, 1933).

Voth 1998 | Voth, Joachim, 'Time and Work in Eighteenth-century London', *Journal of Economic History*, 58 (1998), pp. 28–58.

Walker and Hammond 1999 | Walker, Stefanie, and Frederick Hammond (eds), *Life and the Arts in the Baroque Palaces of Rome: Ambiente Barocco* (New Haven and London, 1999).

Walsh 1995 | Walsh, Claire, 'Shop Design and the Display of Goods in Eighteenth-century London', *Journal of Design History*, 8/3 (1995), pp. 157–76.

Walsh 2003 | Walsh, Claire, 'Social meaning and social space in the shopping galleries of early modern London', in John Benson and Laura Ugolini (eds), *A Nation of Shopkeepers: Five Centuries of British Retailing* (London and New York, 2003), pp. 52–79.

Walsham 2004 | Walsham, Alexandra, 'Jewels for Gentlewomen: Religious books as artefacts in late Medieval and Early Modern England', in R.N. Swanson (ed.), *The Church and the Book* (Woodbridge, 2004), pp. 123–42.

Walvin 1997 | Walvin, James, *Fruits of Empire: Exotic Produce and British Taste, 1660–1800* (London, 1997).

Watson 1862 | Watson, C. Knight, 'James More Molyneux, Esq., FSA, of Loseley Park exhibited a set of fruit trenchers in their original box, on which C. Knight Watson, Esq., Secretary, furnished the following remarks', *Proceedings of the Society of Antiquaries*, 2nd series, 28 (1862), pp. 89–93.

Weatherill 1971 | Weatherill, Lorna, *The Pottery Trade and North Staffordshire 1660–1760* (Manchester, 1971).

Weatherill 1988 | Weatherill, Lorna, *Consumer Behaviour and Material Culture in Britain, 1660–1760* (London and New York, 1988).

Weatherill 1996 | Weatherill, Lorna, *Consumer Behaviour and Material Culture in Britain, 1660–1760* (2nd edn, London, 1996).

Webster 1998 | Webster, Susan Verdi, *Art and Ritual in Golden-Age Spain: Sevillian Confraternities and the Processional Sculpture of Holy Week* (Princeton, NJ, 1998).

Webster 2004 | Webster, Mary, 'Wheatley, Francis (1747–1801)', *Oxford Dictionary of National Biography* (Oxford, 2004). Available at www.oxforddnb.com/view/article/29182 (accessed 13 August 2014).

Welch 2005 | Welch, Evelyn, *Shopping in the Renaissance: Consumer Cultures in Italy 1400–1600* (New Haven and London, 2005).

Welch 2008a | Welch, Evelyn, 'Space and Spectacle in the Renaissance Pharmacy', *Medicina & storia*, 15 (2008), pp. 127–58.

Welch 2008b | Welch, Evelyn, 'Lotteries in early modern Italy', *Past and Present*, 199 (2008), pp. 71–111.

Welch 2009 | Welch, Evelyn, 'Art on the edge: Hairs and hands in Renaissance Italy', *Renaissance Studies* 23/3 (2009), pp. 241–68.

Welch 2011 | Welch, Evelyn, 'Scented Buttons and Perfumed Gloves: Smelling Things in Renaissance Italy', in Bella Mirabella (ed.), *Ornamentalism: The Art of Renaissance Accessories* (Ann Arbor, 2001), pp. 13–39.

Welch 2012 | Welch, Evelyn, 'Sites of Consumption in Early Modern Europe', in Frank Trentmann (ed.), *The Oxford Handbook of the History of Consumption* (Oxford, 2012), pp. 235–43.

Welsh 2006 | Welsh, Jorge, *Zhangzhou Export Ceramics: The So-called Swatow Wares* (London, 2006).

Wheeler 2009 | Wheeler, Jo, *Renaissance Secrets: Recipes & Formulas* (London, 2009).

White 1949 | White, Geoffrey (ed.), *The Complete Peerage* (London, 1949).

White 2012 | White, Ian, *English Clocks for the Eastern Markets: English Clockmakers Trading in China & the Ottoman Empire 1580–1815* (Ticehurst, 2012).

Whittle and Griffiths 2012 | Whittle, Jane, and Elizabeth Griffiths, *Consumption and Gender in the Early Seventeenth-Century Household: The World of Alice LeStrange* (Oxford, 2012).

Wilcox 1999 | Wilcox, Claire, *Bags* (London, 1999).

Williams 1937 | Williams, Clare, *Thomas Platter's Travels in England in 1599* (London, 1937).

Williams 2002 | Williams, Alan R., *The Knight and the Blast Furnace. A History of the Metallurgy of Armour in the Middle Ages and the Modern Period* (Leiden, 2002)

Williams 2010 | Williams, Elizabeth A., *The Gilbert Collection at the Los Angeles County Museum of Art* (Los Angeles, 2010).

Willmott 2004 | Willmott, Hugh, 'Venetian and Façon de Venise Glass in England', in Jutta-Annette Page (ed.), *Beyond Venice: Glass In Venetian Style, 1500–1750* (New York and Manchester, 2004), pp. 271–307.

Wilson 1989 | Wilson, Timothy, *Maiolica: Italian Renaissance Ceramics in the Ashmolean Museum* (Oxford, 1989).

Wilson 1995 | Wilson, Eric, 'Plague, Fairs and Street

Cries: Sounding Out Society and Space in Early Modern London', *Modern Language Studies*, 25 (1995), pp. 1–42.

Wilson 1996 | Wilson, Timothy, *Italian Maiolica of the Renaissance* (Milan, 1996).

Wilson 2005 | Wilson, Bronwen, *The World in Venice: Print, the City, and Early Modern Identity* (Toronto, 2005).

Wilson 2012 | Wilson, Bee, *Consider the Fork: A History of Invention in the Kitchen* (London and New York, 2012).

Winston-Allen 1997 | Winston-Allen, Anne, *Stories of the Rose: The Making of the Rosary in the Middle Ages* (University Park, PA, 1997).

Winterbottom 2011a | Winterbottom, Matthew, 'Early Spoons', in Sturgis et al. 2011, pp. 20–1.

Winterbottom 2011b | Winterbottom, Matthew, 'Eating and Drinking', in Sturgis et al. 2011, pp. 40–5.

Winters 1999 | Winters, Laurie, *A Renaissance Treasury: The Flagg Collection of European Decorative Arts* (Hudson Hills Press: New York, 1999).

Winters and Bliss 1988 | Winters, Laurie, and Joseph R. Bliss, *A Renaissance Treasure. The Flagg Collection of European Decorative Arts and Sculpture* (New York, 1988).

Witcombe 2008 | Witcombe, Christopher L.C.E, *Print Publishing in Sixteenth-century Rome* (London and Turnhout, 2008).

Withington 2011 | Withington, Phil, 'Intoxicants and society in early modern England', *The Historical Journal*, 54/3 (2011), pp. 631–57.

Woldbye 1984 | Woldbye, Vibeke, 'Shells and the Decorative Arts', *Apollo*, 120 (September 1984), pp. 156–61.

Wood 1981 | Wood, Merry Wiesner, 'Paltry Peddlers or Essential Merchants? Women in the Distributive Trades in Early Modern Nuremberg', *The Sixteenth-century Journal*, 12 (1981), pp. 3–13.

Wood 2000 | Wood, Marcus, *Blind Memory: Visual Representations of Slavery in England and America, 1780–1865* (Manchester, 2000).

Woodfield 1984 | Woodfield, Ian, *The Early History of the Viol* (Cambridge, 1984).

Woudhuysen 1988 | Woudhuysen, Paul (ed.), *The Dutch Connection: The Founding of the Fitzwilliam Museum,* exh. cat., Fitzwilliam Museum, Cambridge, 25 October 1988–8 January 1989 (Cambridge, 1988).

Yeandle undated | Yeandle, Laetitia (ed.), *Sir Edward Dering, 1st bart., of Surrenden Dering and his 'Booke of Expences', 1617–1628.* Available at: www.kentarchaeology. ac/authors/lyeandle.html (accessed 14 August 2014).

Yenişehirlioğlu 2004 | Yenişehirlioğlu, Filiz, 'Ottoman Ceramics in European Contexts', *Muqarnas*, 21 (2004) pp. 373–82.

Young 1995 | Young, Hilary, *The Genius of Wedgwood* (London, 1995).

Young 1999 | Young, Hilary, *English Porcelain 1745–95: Its Makers, Design, Marketing and Consumption* (London, 1991).

Zorach 2008 | Zorach, Rebecca, *The Virtual Tourist in Renaissance Rome: Printing and Collecting the 'Speculum romanae magnificentiae'* (Chicago, 2008).

INDEX

Cambridge 117
 colleges 6
 Corpus Christi College 116, 117, 177
 Gonville and Caius College 60
 Magdalene College 48
 Millington Road 86
 Museum of Archaeology and Anthropology 116
 Peas Hill 242
 Perse School, The 60
 Trinity College 177
 University of 173, 194, 231, 234
Cambridge Antiquarian Society 116
cameos 44, 144, 174, 180
Campagna, Girolamo 196
candelabra 158, 184
candles 23, 154, 158, 161, 172, 184
candle snuffers 14
candlesticks 9, 153, 158, 169, 172, 174, 175, 198
cane handles 90, 153, 157
canes 135, 140
canisters 107
canteens, travelling 62
canvas work 224
cap badges 118, 124
caps 118
carafes 44
Carlizia, Nicola 23
Caroline of Ansbach 9, 84
carpets 3, 103, 174
Carré, Jean 14, 66
carriages 57, 60, 157
carts 57
case-makers 140, 149
cases 62, 63, 140, 142, 143, 148, 149, 158, 225, 234
caskets 28, 166, 222, 256, 259
cassoni 6
Castel Durante 23
casters 60, 110, 158, 199, 200, 201, 239
Catholicism
 5, 30, 38, 40, 74, 131, 239, 240,
 241, 242, 244, 246, 250, 251, 253
caudle 76, 99
cauldrons 6
Cecil, Robert, Lord Burghley 28
Central America 89
centrepieces 198, 206, 211, 222
ceramic/ceramics
 3, 16, 23, 45, 54, 68, 71, 84, 95, 104, 105, 107,
 108, 164, 177, 178, 180, 183, 198, 201, 242, 254
chains 11, 28, 40, 132, 140, 218
chalcedony 35
chalices 78
Chamberlain, Thomas 210
chamber pots 188
chandeliers 154, 184, 186
chandlers 154
Chantilly 202
chargers 177, 254
charlatans 27
Charles I 9, 88
Charles II 9, 88, 146
Charles II of Spain 86
Charlton, Mary 109
chatelaines 140, 144, 148, 149, 155, 172
Cheapside hoard 116
Chelsea porcelain factory 105, 188, 204, 210
chess sets 23
chests 164, 256
children
 3, 5, 6, 27, 44, 65, 92, 135, 157,
 164, 178, 219, 228, 235, 244, 256
childbirth 191
childhood 126, 210
China (country) 16, 18, 68, 74, 92, 100, 103–5, 107, 207
'chinamen' 104
china shops 56, 68, 107, 178
Chinese (decoration)
 18, 70, 71, 82, 85, 94, 105, 107, 135, 174, 180, 188, 191, 210
Chinese exports 16, 21, 71, 95, 103–5
chinoiserie 66, 105, 107, 128, 178, 180, 184, 224
Chippendale 160
chocolate
 44, 58, 74, 86, 89, 97–9, 100, 101, 103,
 104, 105, 108, 109, 110, 158, 178, 239
 beakers *see under* cups
 pots 97–9, 105, 158

Chrieger, Cristoforo 121
christenings 6, 228, 232
christening gifts 6, 71, 226, 228, 229
christening spoons *see under* spoons
Cibber, Colley 210
cider 178
cisterns 158, 192
Claesz, Pieter 4, 207
clay 41, 86, 105, 178, 180, 239, 255
Clifford, Lady Anne 9
clocks 5, 38, 40, 140, 154, 158
clock-makers 115, 140, 143
clogs 116, 150
cloth 26, 27, 37, 44, 58, 153, 158, 184, 223
clothing
 14, 23, 26, 65, 103, 115, 117, 118,
 120, 144, 220, 222, 231, 239
coaches 57, 60, 172
coach watches 63, 142
coats-of-arms
 9, 34, 41, 71, 78, 97, 110, 124, 144, 149,
 178, 200, 204, 210, 211, 216, 253, 262
cobblers 39
cocoa *see* cacao
coconuts 16
coconut cup 16
codpieces 123
coffee 28, 56, 58, 74, 92, 97–9, 101, 103, 107–10, 178
 cups *see under* cups
 houses 88, 108
 pots 97–9, 100, 105, 107, 158
 services 104, 158, 164, 202
coffers 256
coins 6, 9, 126, 229, 262
Colnaghi, Paul 54
Cologne 125, 249
colonialism 65, 199
Columbus, Christoper 194
combs 52, 96, 116, 158
compasses 26, 38
confraternities
 Company of the Rosary 249
'consumer revolution' 48, 155, 239, 244
consumption
 3, 9, 14, 28, 30, 37–40, 44, 45, 50, 65, 66, 68,
 70, 74, 92, 104, 107, 108, 110, 115, 153, 154,
 157, 160, 164, 180, 183, 199, 201, 239, 240
cooks 52
Cope, Walter 68
copper 41, 50, 89, 157, 197, 200, 207, 210, 256, 259, 262
coral 240
Corneille, Pierre 28, 29
Corrozet, Gilles 164
Coryate, Thomas 28, 214
cosmetics 41, 46
Cotterell, John 107
cotton 28, 103, 158
Council of Trent 242
Counter-Reformation, the 240
courtesans 115
courtship 6, 232
couvre-feu see fire-covers
Cowper, Lady Sarah 129 cradles 228
Cranach workshop 39
creamware 108, 178, 180, 188, 206, 210
credenze see sideboards
crewel work 224
cribs 228
cristallo 14, 35, 39, 78, 161
crochet 225
Croker, John 88
Cromwell, Oliver 88
Crozon 154
crucifixes 240, 241
cruets 158
crystal 14, 28, 44, 78, 153, 154
Culliford, John 84
Culliford, Mary 9, 84
Cumberland, Richard 158
cupboards 23, 164
cups 18, 20, 28, 78, 83, 99, 104, 105, 158, 164, 197, 206, 239
 beakers 60, 62, 78, 89, 99, 101, 105
 coffee cups/beakers 92, 97–9, 101
 loving cups 78
 mugs 5, 9, 6, 44, 83, 84, 96
 'pineapple cups' 20

presentation cups 20
standing cups 9, 20, 78
tazze 35, 207
tea bowls 74, 90, 92, 94, 105, 108, 180
tea cups 94, 96, 103, 104
Traubenpokale (grape cups) 20
welcome cups 20, 78
cutlery 62, 65, 164, 214, 218
cutting boards 48, 180
Csikszentmihalyi, Mihaly 3, 5, 9

d'Andrea, Francesco 5
da Carpi, Ugo 171
da Castiglione, Sabba 5, 161
da Vinci, Leonardo 239
damask 120, 144
Danish East India Company 104
Dante 14
Davies, John 208
d'Épinay, Louise 172
d'Este, Isabella 44, 144, 170, 204
de Avila, Rodericus 248
de Certeau, Michel 9
de Gyselaer, Nicolaes 186
de' Landi, Neroccio 46
de Lysle, Anthony 66
de' Medici, Catherine 90
de' Medici, Lorenzo 204
de Neuffville, Louis-François-Anne, duc de Villeroy 202
de Pereda, Antonio 74
de Quincy, Quatremère 10
de Sales, Don Fernando 248
De Sandemont, Marie Narette dit 240
de Sermisy, Claude 27
de Vries, Jan 153
de Waal, Edmund 144
de la Rochefoucauld, François Alexandre Frédéric, duc 109
death 11, 226, 232, 235
death masks 6, 234
decanters 78
Decker, Catherine 231
Decker, Henrietta Maria 231
Decker, Mary 231
Decker, Matthew 50, 194, 231
Defoe, Daniel 96, 109
degli Atti, Isotta 167
Delft 68, 105, 107, 187, 192, 193, 198
 Greek A Factory 187, 192
 Metal Pot Factory 107, 193
Delftware
 5, 66, 68, 70, 71, 82, 85, 90, 92, 107, 133, 177, 178, 180,
 186, 187–8, 190, 192, 193, 194, 198, 242, 244, 254
Derby porcelain factory 99, 107
Dering, Edward 256
Dering, Richard 27
Deruta 5, 242, 246
desks 23, 90, 153, 154, 158, 160, 164, 168, 172–3, 180
dessert 194, 199, 200, 202, 204, 211
Devon 178
devotional objects 5, 239–44, 246–7, 248–55
diamonds 157, 241
Diderot, Denis 38
dining 6, 74, 204–6, 207, 210, 211, 214, 217
dining ware 14, 16, 207
dishes
 5, 14, 16, 21, 28, 68, 86, 133, 146, 150,
 198, 204, 207, 210, 211, 232, 244
distillation 38, 46
Doggett, Thomas 210
dolls 44, 231
Dominicans 249
Donatello 5, 161
door-knockers 34
Dorer, Lucia 130
Dossi, Dosso 16
doublets 38, 47, 120, 122
Douglas, Mary 3, 5, 9
dowries 37
Draper, William II 10, 262
drapers 28, 57
Dresden 52, 95, 105
dress
 38, 115, 118, 120, 123, 126, 129, 131, 154–5, 216, 231, 235
dressers 158, 164, 178, 180
dresses 128, 132, 144, 150, 155

Oliphant, Ebenezer 62
Oliver, Isaac 66, 132
Oliver, Peter 66
Orassi, Joseph George 218
Ostend East India Company 104
Ottoman Empire 19, 143
Overton, Mary 228

paintings
 5, 16, 39, 44, 45, 46, 50, 65, 71, 74, 86, 103, 115, 138,
 140, 154, 158, 164, 173, 194, 207, 233, 246, 251
pamphlets 26
Pamplona, Bishop of 248
Papegay (ladies' shoemaker) 58
paper 46, 134, 136
paperweights 166
parasols 154
parchment 9, 46
Paris
 27, 52, 58, 60, 97, 140, 153, 154, 157,
 158, 172, 173, 177, 184, 200, 203
 Colisée 157
 Galerie du Palais Royal 28
Parrett, Samuel 104
parrots 65, 174, 186, 223
Passau 125
patch boxes 135, 158, 164
pattens 150
pawned goods 115, 240
pawn shops 65, 116
pearls 90, 103, 132, 142, 144, 153, 235
pearlware 6, 188
pearwood 240, 249
pedlars 26–7, 56, 140, 154, 178, 188
pendants 11, 44, 65, 118, 144, 148, 240, 241, 244, 250
penknives 172
pens 154, 166, 172
Penruddocke, Lady Anne 131
pepper 16, 103, 196, 198, 199, 200
Pepys, Samuel 48, 118, 235
perfume 28, 40, 41, 45
perfume burners 30, 40, 160
Persia 71, 103
Persian carpets 103
Pesaro 170, 255
Petrarch 5, 9
Pett, Phineas 118
pewter 37, 65, 66, 74, 78, 146, 164, 180, 200, 210
pharmacies 23, 39, 46
pharmacy jars *see albarelli*
Philip III 241
Philip IV 144
Philip, John 105
Philippines 21
Phillips, F.W. 177
Pickleherring Pottery, Southwark 70
pigments 39, 41
pilgrimage 6, 255
pilgrims 6, 60, 242, 255
pineapples 194
'pineapple cups' *see under* cups
pipes *see under* tobacco
piqué work 89, 147
Pisanello 167
plantations 103, 104, 199
plaster casts 6, 226, 234
plates
 6, 74, 89, 92, 104, 105, 164, 204, 210, 226, 244, 251, 254
Platt, Sir Hugh 66
Platter, Thomas 68
platters 65, 208
playing cards 26, 44, 154
pockets 90, 125, 140, 148, 155, 157, 217, 225
Pointon, Marcia 226
Poland 6, 95, 249
polite lifestyle
 57, 58, 90, 97, 101, 103, 104, 138,
 153, 154, 157, 202, 204, 231
pomades 158
pomanders 40, 45
Pompadour, Mme de 154, 203
porcelain
 28, 50, 52, 68, 89, 94, 95, 97, 101, 110, 153, 154, 157, 158,
 164, 175, 177, 178, 180, 187–8, 191, 198, 199, 204, 211
 blue and white 16, 71, 74, 90, 187–8, 207

Chinese
 16, 21, 35, 65, 66, 68, 70, 74, 90, 94, 95, 104–5,
 107, 154, 164, 186, 187–8, 191, 203, 207
 hard-paste
 16, 21, 35, 65, 66, 68, 70, 74, 92, 94,
 95, 101, 104, 105, 107, 154, 172, 180
 Imari 71, 105
 Japanese 104, 186, 187, 203
 kraak 71, 207
 soft-paste 9, 99, 105, 172, 199, 202, 203, 204, 210
 swatow 21, 71
porringers 37
port 74, 76
portraits
 6, 9, 54, 65, 118, 126, 131, 140, 174, 226, 231, 233, 234
 busts 88, 136
 medallions 146
 medals 167
 miniatures 66, 132, 144, 147, 153, 157
 reliefs 115, 122, 124, 130
portraiture 90, 126, 233
Portugal 71, 204
posset 76, 178, 191
posset pots 6, 44, 178, 191
pottery 16, 71, 74, 97, 177, 201
pounce pots 166, 172, 174, 175
powder boxes 158
powder flasks 124–5
Prague 244, 251
prayer beads 240, 241, 249
presentation cups *see under* cups
Priestley, Joseph 104
priming flasks 125
printing 38
printmakers 27, 54
prints
 26, 27, 28, 29, 38, 44, 48, 54, 57, 85, 138, 146,
 153, 154, 158, 180, 194, 204, 239, 254, 260
Prior, George 143
Protestantism
 5, 38, 65, 74, 131, 187, 239, 241, 242, 244, 251, 252, 254
punch 74, 76
punch bowls 76, 85, 100
purses 28, 115, 116, 126, 225

Qur'an 16, 21
quartz 149
Quiccheberg, Samuel 9
quills 9, 158, 166, 171, 172

Ravenscroft, George 78
recipes 16, 23, 39, 44, 47, 171
Reformation, the 30, 74, 239, 240, 244, 252
Reinburg, Virginia 248
Reinicke, Pieter 52
Reinmann, Paul 33
relics 11, 239, 255
religion 9, 33, 37, 65, 74, 239–45
reliquaries 11, 253
remedies 44, 46, 191
Restoration, The 88, 146, 157
reticules 225
Reynolds, Joshua 149, 154
Rhineland 68
ribbons 26, 27, 40, 46, 133, 135, 150, 155, 232
ribbon-making 38
Richardson, Samuel 138
Richmond, Surrey 194
rings 3, 6, 44, 140, 154, 157, 226, 232, 235–7, 239
Roche, Daniel 3
rock crystal 35, 78, 95, 140, 149, 241, 244, 251
Rococo 85, 107, 148, 149, 160, 161, 175, 194, 211, 220
Roma, Spiridione 103
Romano, Giulio 196
Rome 5, 6, 27, 44, 48, 180, 240, 244
 Golden House of Nero 171
 Pantheon 144
rosary beads 44, 240, 241, 249
rose gold 11
Rotterdam 187
Rouen 201
Rousseau, Jean-Jacques 9
Royalists 60, 88
Royal Oak 88

rubies 142, 144
Rudolph II, Holy Roman Emperor 244
ruffs 47, 122, 132, 147
rum 76, 83

Sadler, John 194
salons 38, 154, 202
salt 158, 196, 198
salt-cellars 44, 196
salts 158, 196, 197, 198
samplers 220, 223
Sansovino, Francesco 164
Santiago de Compostela 6
satin 58, 225, 252, 260
sauce pots 158
saucers 90, 92, 99, 101, 104, 105
saucer dishes 21
Saxony 95, 105
 Royal Porcelain Manufactory *see* Meissen
scabbards 125
Scandinavia 3, 219
scent bottles 9, 144, 180
Scheurl, Paulus 38
Scheffer, Johann 3
Schwarz, Hans 130
Schwarz, Matthäus 30, 120
scissors 26, 148, 154, 158, 171, 220
Scotland 27, 88, 223
 Union with England 88
Scott, Hugh 86
sculpture 45, 50, 115, 168, 186, 199, 242, 253
Scultori, Diana 204
seals 11, 149, 155, 172
secrétaires 164
Segovia, Monastery of the Virgen de la Merced 253
servants 28, 60, 155, 169, 172, 226, 256
serving dishes 21, 164, 204
Sèvres 177, 202, 203
Shakespeare, William 9, 118, 210
Sheffield plate 157
shells 9, 16, 18, 65, 196, 198, 206
sherry 76
Shiba Onko 210
shoemakers 116, 117, 150, 177
shoes 3, 115, 116, 117, 150, 153, 155, 157, 232
 men's 3, 39, 58, 90, 117, 157
 women's 58, 150
shopkeepers 26, 56, 57, 58, 65, 155, 260
shopping 23–30, 45–9, 50–55, 56–9, 65–6, 154, 172, 180
shops
 23, 26, 28, 40, 45, 46, 50, 56, 57, 58, 65–6, 68, 107, 109,
 124, 135, 140, 154, 157, 177, 178, 180, 184, 199, 246
 signs 45, 57, 107
shrines 239, 242, 253, 255
sideboards 164, 196, 204, 244, 254
Sidney, Philip 132
Siena 46
Signorelli, Luca 46
silk
 6, 28, 37, 38, 44, 58, 90, 103, 126, 128,
 131, 134, 135, 155, 157, 158, 187, 262
 embroidery/for embroidery
 220, 222, 223, 224, 252, 260
 satin 120
 taffeta 150
silver
 6, 9, 14, 19, 20, 30, 35, 37, 38, 40, 60, 62, 63, 65, 66,
 68, 78, 83, 88, 89, 90, 92, 94, 95, 97, 100, 105, 107,
 109, 125, 129, 134, 140, 146, 147, 153, 154, 157, 158,
 160, 178, 180, 184, 186, 192, 196, 199, 200, 201,
 204, 206, 211, 214, 218, 219, 239, 249, 256, 262
silver-gilt
 14, 18, 19, 20, 62, 71, 76, 90, 95, 126, 207, 240, 250
silversmiths 14, 20, 65, 68, 94, 105, 218
silverware 44, 105, 164, 186
slavery 89, 108, 199
sledges 60
slipware 5, 86, 180, 184, 228, 232
slop basins 90, 92, 105
Smith, Adam 153
Smith, Ann 223
smoking 86, 154, 157
smuggling 104
Smythe, Sir John 124
snuff 86, 89, 90, 147, 157

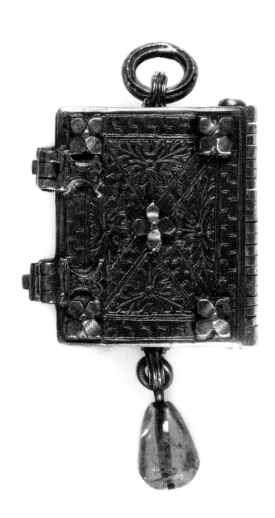